Art Across America

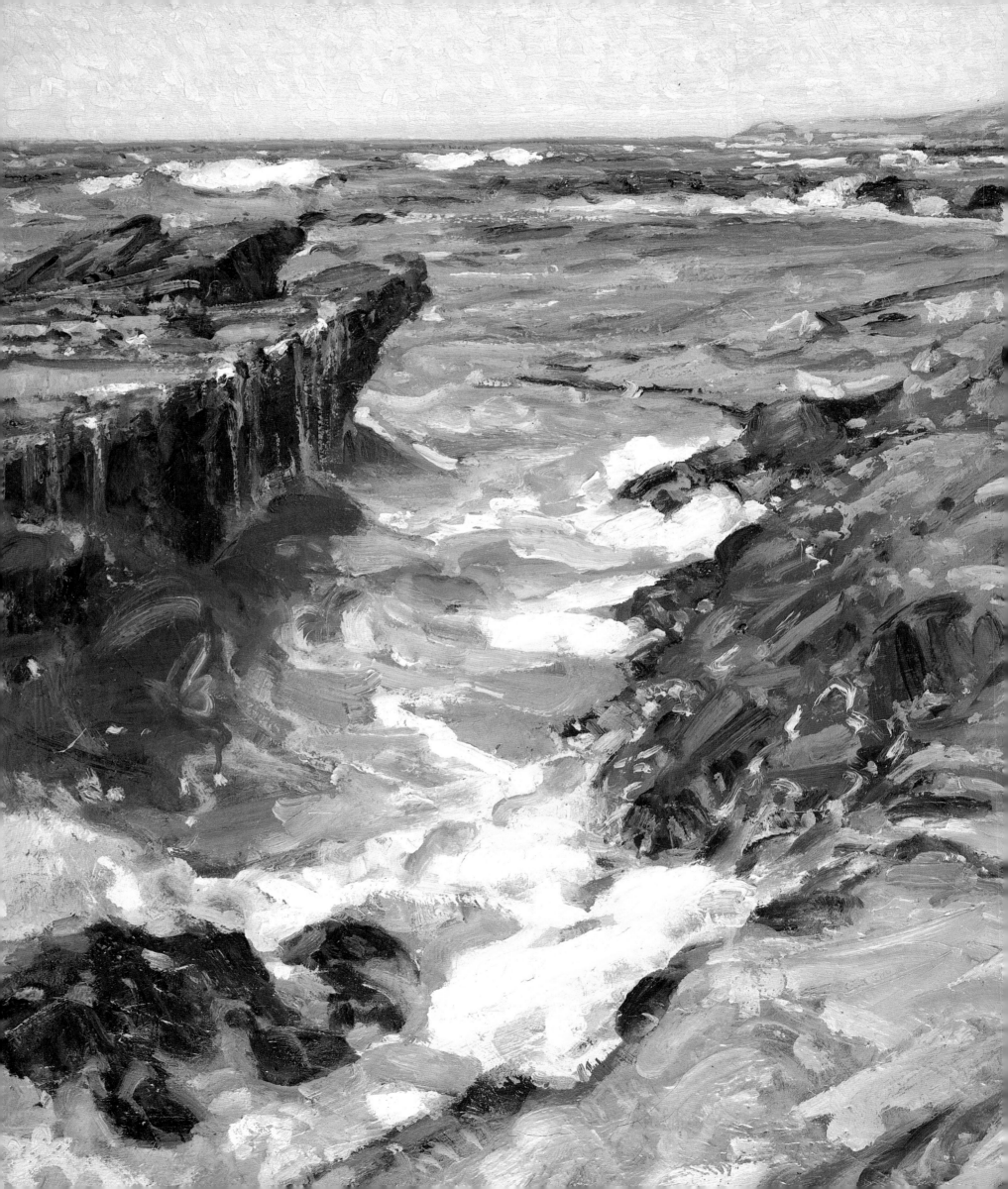

WILLIAM H. GERDTS

Art Across America

TWO CENTURIES
OF REGIONAL PAINTING
1710–1920

VOLUME THREE

ABBEVILLE PRESS, PUBLISHERS, NEW YORK

*This volume is dedicated
to the memory of
J O H N I. H. B A U R,
whose perceptions of both the mainstream and
the more obscure aspects of American art
have provided inspiration for us all.*

EDITORS: Nancy Grubb with Andrea Belloli

DESIGNERS: Nai Chang with John Lynch

PRODUCTION EDITOR: Laura Lindgren

COPY EDITOR: Miranda Ottewell

PHOTO EDITORS: Adrienne Aurichio, Karel
 Birnbaum, Joan Kittredge, and Fay
 Torresyap, with Robin Mendelson and Lisa
 Peyton

MAPS: Sophie Kittredge

PRODUCTION MANAGER: Dana Cole

INDEXER: Catherine M. Dorsey

EDITOR'S NOTE

To make the vast amounts of information in the three volumes of *Art Across America* as easily accessible as possible, we have used the following devices:

Illustrations are numbered sequentially within each volume; each plate number begins with the number of the volume in which it appears. The plate number for each illustration appears not only in the caption but also in the inner margin of the text, alongside the discussion of that work.

Boldface type indicates the primary discussion of any locale that witnessed activity by two or more artists. Sites of particular significance are given a subsection, indicated by an extra space in the text followed by a flush-left opening line. A few lengthy discussions of especially active areas are broken into additional subsections.

Medium-weight type indicates the primary discussion of an artist accompanied by an illustration. If an artist is also represented by one or more illustrations elsewhere in the three volumes, those plate numbers appear in the margin next to the artist's name.

SMALL CAPITAL letters indicate that an artist has one or more illustrations elsewhere in the three volumes. The relevant plate numbers appear in the margin next to the artist's name. When two or more artists' names appear in small capitals in the same line, their marginal plate numbers are separated by semicolons. These cross-references are used only for the first mention of an artist within any subsection.

SLIPCASE, FRONT: John Haberle. *Torn in Transit*, n.d. See plate 1.116.

SLIPCASE, BACK: George Cochran Lambdin. *Roses on a Wall*, 1877. See plate 1.264.

FRONT COVER: Charles Deas. *Long Jakes (The Rocky Mountain Man)*, 1844. See plate 3.26.

BACK COVER: Theodore Wores. *New Year's Day in San Francisco's Chinatown*, 1881. Detail of plate 3.199.

FRONTISPIECE: Selden Connor Gile. *Sausalito*, n.d. Detail of plate 3.219.

Library of Congress Cataloging-in-Publication Data
Gerdts, William H.
 Art Across America: regional painting in America, 1710–1920 / William H. Gerdts.
 p. cm.
 Includes bibliographical references and indexes.
 Contents: v. 1. New England, New York, the Mid-Atlantic—v. 2. The South, the Near Midwest—v. 3. The Far Midwest, the Rocky Mountain West, the Southwest, the Pacific.
 ISBN 1-55859-033-1
 1. Painting, American. 2. Painting, Modern—20th century—United States. 3. Regionalism in art. I. Title.
ND212.G47 1990
759.13—dc20
 90-598
 CIP

Contents

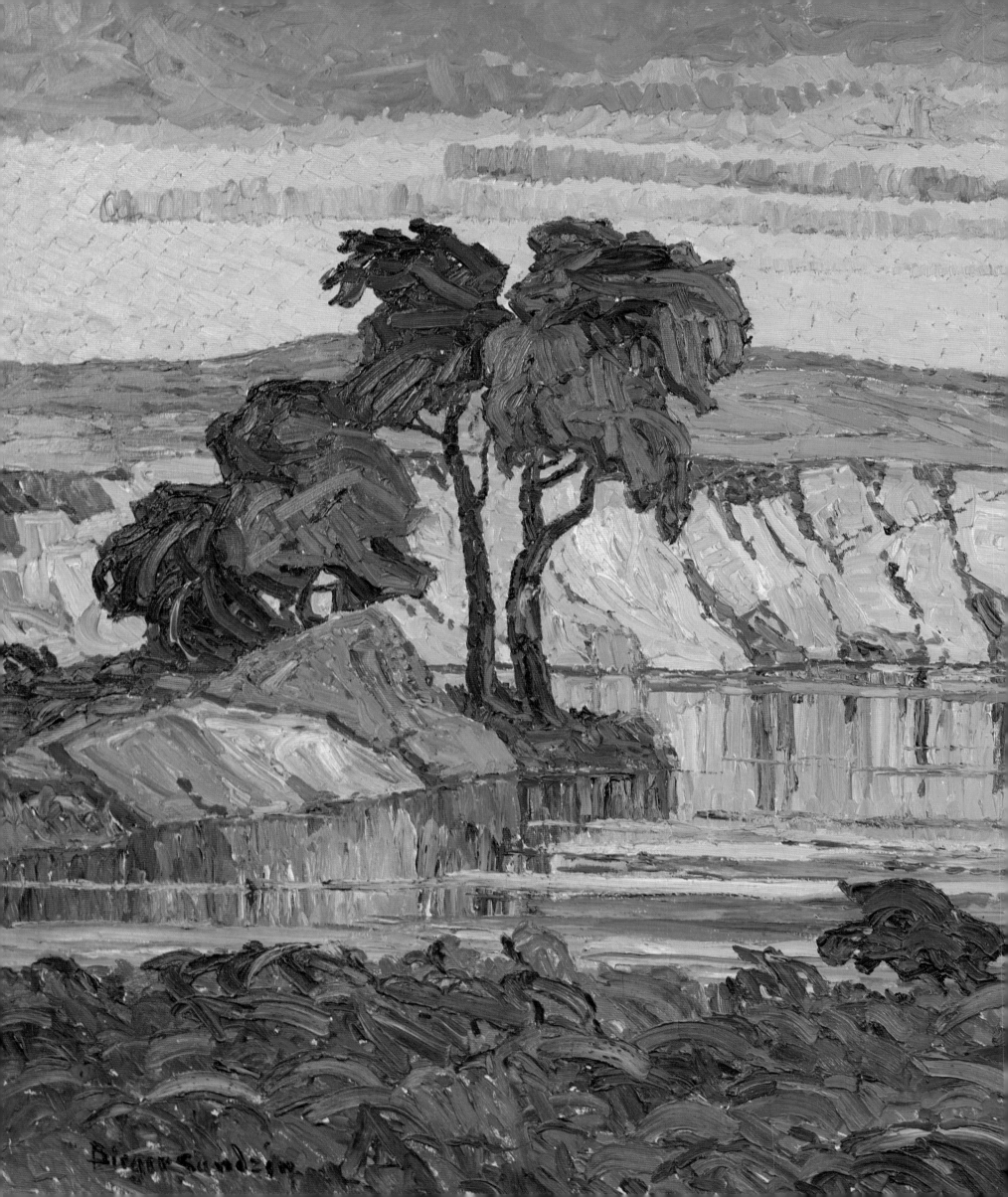

Birger Sandzén

THE FAR MIDWEST

Most of the vast territory between the Mississippi River and the Rocky Mountains, which had been carved out of the Louisiana Purchase in 1803, came to political and cultural maturity quite late. For the most part, the region consisted of farms, with few significant urban centers until late in the period covered here. Distances were great and the transportation networks connected the area only to the East or, by river, to New Orleans. Thus, until the end of the nineteenth century, no sense of regional homogeneity existed— in the arts or otherwise. Art education was encouraged, but in the public schools and in general courses rather than in the specialized professional academies that served that purpose in other regions.

Although Chicago's Central Art Association sent exhibitions throughout the greater Midwest from 1894 to about 1900, this occurred only for a short period. Saint Louis was the only city west of the Mississippi to be selected for the circuit exhibitions of the Society of Western Artists, which began in 1896, despite the fact that individual painters and sculptors from the far midwestern states belonged to the group. Not until 1915, the year after the society's last show, did painters, sculptors, and printmakers from five far midwestern states—Minnesota, Iowa, North Dakota, South Dakota, and Nebraska, along with artists from Wisconsin and Montana—show their work together, in the Annual Exhibition of the Work of Northwestern Artists, organized by the Saint Paul Institute in Minnesota.

3.1 Sven Birger Sandzén
(1871–1954)
Creek at Moonrise, 1921
Detail of plate 3.48

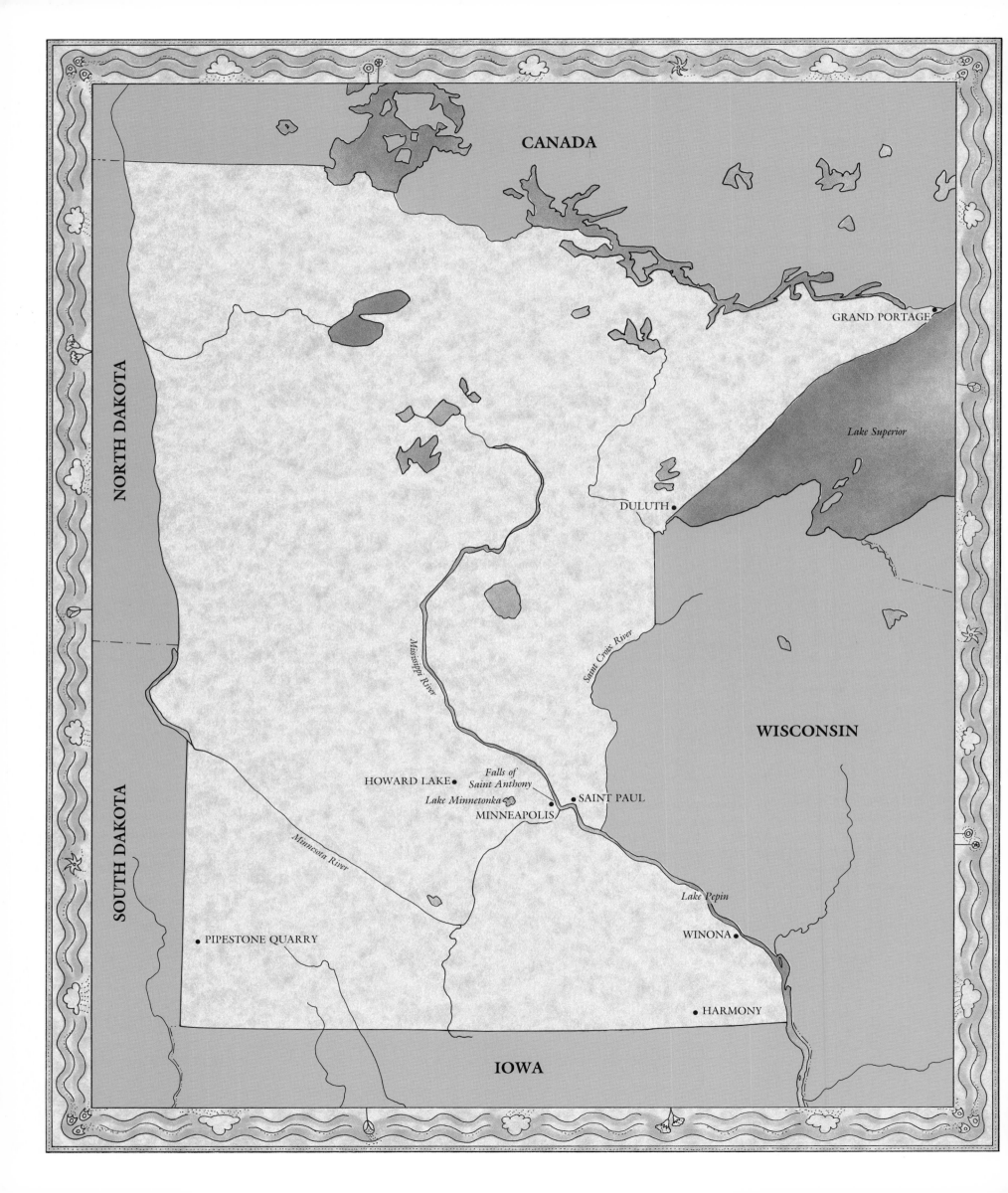

CANADA

NORTH DAKOTA

SOUTH DAKOTA

Lake Superior

GRAND PORTAGE

DULUTH

Mississippi River

Saint Croix River

WISCONSIN

HOWARD LAKE

*Falls of
Saint Anthony*

Lake Minnetonka

SAINT PAUL

MINNEAPOLIS

Minnesota River

Lake Pepin

WINONA

PIPESTONE QUARRY

HARMONY

IOWA

MINNESOTA

In Minnesota a professional art establishment appeared only at the end of the nineteenth century. Not surprisingly, this community was located almost exclusively in **Minneapolis–Saint Paul**. The Minnesota Territory had been established in 1849 and achieved statehood in 1858, with Saint Paul as its capital. However, it was to Fort Snelling (later Minneapolis) that the earliest artists went. Some ventured forth to document the Indian population in addition to depicting the fort itself. Panoramists who included the upper Mississippi in their vast canvases in the 1840s made use of the local Falls of Saint Anthony as a spectacular starting point for their pictorial travelogues. Other painters were attracted by the natural beauty of the wilderness, an attraction abetted by the publication of Henry Wadsworth Longfellow's enormously popular *Song of Hiawatha*, at nearby Lake Minnetonka and Minnehaha Falls.

The earliest explorer-artists in Wisconsin were also the earliest professionals in what is now Minnesota. The first, Samuel Seymour, accompanied Major Stephen H. Long's expedition in 1823, but only one Minnesota scene by him is known to survive. James Otto Lewis, while traveling two years later from Fort Crawford at Prairie du Chien, Wisconsin, sketched Maiden Rock near present-day Winona, Minnesota, a site that

3.16 Seymour is also known to have recorded. Swiss-born PETER RINDISBACHER had settled in the Red River area of Canada in 1821, and a number of his watercolors, now at West Point, depict the Chippewa and other tribes of the region. Though Rindisbacher passed through Fort Snelling, it would be difficult to identify specific works as having been painted in what is now Minnesota.[1]

3.17 By far the best known of the Indian painters who worked in Minnesota was GEORGE CATLIN, who was at Fort Snelling in July 1835, painting portraits of Chippewa and Sioux Indians. Catlin also recorded the fort and the Falls of Saint Anthony and, traveling south by canoe on the Mississippi, made views at Lake Pepin. The following summer he passed through Minnesota again, penetrating to the far southwestern corner of the region to visit Pipestone Quarry, collecting mineralogical specimens and recording the Indians at this remarkable site and others along the Saint Peter's River.

2.206 JOHN MIX STANLEY may have had his first contact with Indian life at Fort Snelling in 1839. He certainly was back in 1853 on his way west with Isaac Ingalls Stevens's Pacific Railroad survey, sketching the Indians and the local landscape; later he worked up these

3.26 sketches into oil paintings in his Washington studio. CHARLES DEAS did the same in the summer of 1841, after spending some time in Prairie du Chien and before settling in Saint Louis; his view of Fort Snelling (Peabody Museum, Harvard University, Cambridge) is one of the most impressive representations of that post. The artist most intimately associated with the fort was **Seth Eastman**, the West Point graduate who was assigned there in 1830 for two years. Having returned to the military academy as assistant professor

1.162 of drawing under ROBERT WALTER WEIR, Eastman then became commandant at the fort from 1841 until 1848. By 1846 he had assembled an Indian gallery of about four hundred scenes, primarily of the Sioux, but also of the Chippewa and of the Seminole Indians he had painted in Florida. Eastman did not romanticize the Indians but detailed their

3.2 appearance, customs, and costumes, often as casually exotic genre subjects, as in *Ballplay of the Sioux on the Saint Peter's River in Winter*, a Minnesota scene. That year a number of Eastman's Minnesota paintings were distributed by the Western Art-Union in Cincinnati and the American Art-Union in New York. He also provided illustrations for two publications by his wife, Mary Eastman: *Dahcotah; or, Lives and Legends of the Sioux around Fort Snelling* (1849) and *American Aboriginal Portfolio* (1853).[2]

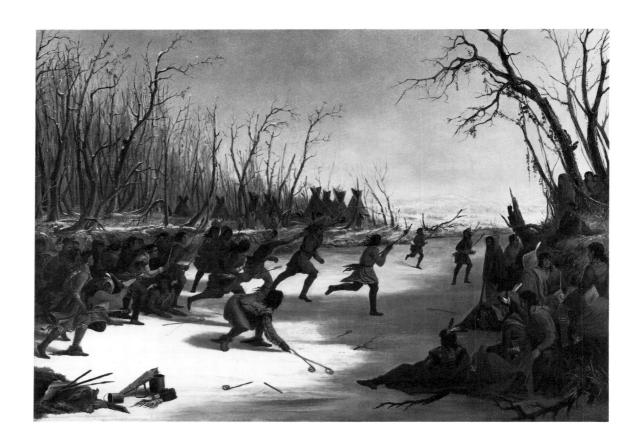

3.2 Seth Eastman (1808–1875)
Ballplay of the Sioux on the Saint Peter's River in Winter, 1848
Oil on canvas, 25¾ x 35¼ in.
Amon Carter Museum,
Fort Worth

Other early artists in the Minnesota Territory included Jacob Caleb Ward, a landscapist from New York and Bloomfield, New Jersey, who visited and sketched Fort Snelling and the Falls of Saint Anthony about 1836; his most notable Minnesota scene was *A View of Soaking Mountain* (location unknown), subsequently engraved for the *New-York Mirror*. Swiss-born John Caspar Wild, who worked in Philadelphia and Cincinnati before settling in Saint Louis in 1839 and in Davenport, Iowa, in 1844, conceived the idea of painting the settlements and frontier forts of the upper Mississippi in his last years. His dramatic view of Fort Snelling rising above the confluence of the Mississippi and Minnesota rivers (Minnesota Historical Society, Saint Paul) was painted in 1844, as was a now-lost view of the Falls of Saint Anthony.[3] The Baltimore artist FRANK BLACKWELL MAYER attached himself to the military in 1851 to record the signing of the Treaty of Traverse des Sioux, near Saint Peter, Minnesota, and while he was unable to negotiate a commission for the large historical rendition he had hoped to paint, his sketchbook (Ayer Collection of the Newberry Library, Chicago) provides a vivid account of the local Indian population. Mayer stayed at the Indian village of Kaposia; there and at Traverse des Sioux he participated more intimately in the daily life of his hosts than any of his predecessors.[4] Captain Alfred Sully, son of Thomas Sully, painted a number of Minnesota watercolors in 1856, including one of Fort Snelling (Beinecke Rare Book and Manuscript Library, Yale University, New Haven, Connecticut), while on duty in the territory.

In the 1840s the panorama painters, who were based primarily in Saint Louis, visited the headwaters of the Mississippi to paint their gigantic "moving pictures." John Rowson Smith appears to have been the first to paint a panorama of the upper Mississippi, with views of Fort Snelling, the Falls of Saint Anthony and Lake Pepin, exhibiting that work (location unknown) in 1848. That same year Samuel Stockwell's panorama (location unknown) was shown, carrying the viewer up one side of the Mississippi to the falls and then down the other side. Stockwell had collaborated for a while with Henry Lewis, who was working on scenes for a panorama of the upper Mississippi during the summers of 1846 and '47. Lewis had also worked for a time with LEON POMAREDE, who visited Minnesota in the spring of 1849. Pomarede was accompanied by the young CHARLES F. WIMAR, who later became one of Saint Louis's most famous artists. Pomarede painted a panorama that was divided into four sections, one of which—the most extensive, to judge

by the guide he prepared to accompany the work—represented the natural wonders and legends of Minnesota, including the Falls of Saint Anthony and tales such as "The Indian Wife" and "The Indian Maiden."[5]

The panoramas of Minnesota scenery attracted professional landscape painters to the region, particularly after statehood was achieved in the 1850s and rail travel from the East became possible in the 1860s. Saint Anthony Falls in Minneapolis and the wilder Minnehaha Falls attracted visiting professionals, such as John Frederick Kensett in 1854, Danish-born Ferdinand Reichardt in 1857, ROBERT S. DUNCANSON in 1862, Jerome Thompson in 1870, JOSEPH RUSLING MEEKER in 1879, and ALBERT BIERSTADT in 1886. Thompson, who had resided in the Saint Paul area in 1861–63, painted local genre scenes and, later, subjects from *Hiawatha*. Lake Pepin, the other favored Minnesota landscape subject, also was painted by Kensett on his 1854 trip and by GEORGE FULLER in 1853, as well as Meeker and Duncanson, Alfred Thompson Bricher in 1866, and others. When EASTMAN JOHNSON visited his sister in Superior, Wisconsin, in 1857, he painted many oils of the Chippewa Indians and their village at Grand Portage on the far northern shore of Lake Superior. In 1871 the eastern landscapist Gilbert Munger painted a detailed panoramic view (Duluth Public Library) of Duluth, the major urban settlement on the Minnesota lakeshore, which was founded in 1852. Duluth was most notably delineated by Bierstadt in 1886 (Jeno and Lois Paulucci, Duluth). Minnesota's broad prairie had little attraction for artists, though Thomas P. Rossiter documented its vast openness in 1865, and more casual scenery was painted on summer excursions by the Milwaukee painter John S. Conway during the 1870s.

If we except Eastman's period of command at Fort Snelling, Jerome Thompson's brief stay in Saint Paul during the early years of the Civil War may have been the first residence by a professional artist in Minnesota. One Ben Cooley from Kalamazoo, Michigan, had been in Saint Paul in 1857, painting portraits, including one of David Olmstead (Minnesota Historical Society, Saint Paul), the city's first mayor. That same year THOMAS CANTWELL HEALY, brother of the more famous GEORGE PETER ALEXANDER HEALY, also visited Saint Paul as a portraitist; he is best known as the finest nineteenth-century portrait painter resident in Mississippi. In 1858 another Michigan artist, ALVAH BRADISH from Detroit and Ann Arbor, painted many portraits in Saint Paul, returning in 1876. Frank Bass, the first Minnesota-born professional, studied in Paris and opened a studio in Saint Paul in 1874, offering instruction and attempting—unsuccessfully—to establish an art academy; he abandoned his artistic career in 1878. The New York City portraitist CHARLES NOEL FLAGG visited Saint Paul each year from 1885 until 1887, obtaining commissions and enjoying a well-received solo show at the Wales Gallery in 1885. He, too, failed in an effort to establish an art school. Gilbert Munger settled in Saint Paul for four or five years about 1868–69, painting the local landscape and scenes of fur traders coming down from the Red River country. The establishment of transcontinental rail transportation enabled Munger to spend part of each year in California, so he also worked up major exhibition pictures of Yosemite and other western scenes in his Saint Paul studio.

More integral to the development of Minnesota art were a number of Scandinavian émigrés. The earliest of these, Danish-born Peter Gui Clausen, studied in Copenhagen and Stockholm before coming to this country in 1866. After a brief stopover in Chicago, he spent the next year painting church frescoes in Minneapolis, and two years later he settled there permanently. Though he also painted portraits, theater scenery, and a panorama, Clausen is best known for his view of the Minnesota waterfalls that attracted so many artists, though his renderings of the Falls of Saint Anthony were now urban scenes contrasting industrial progress with natural forces. A rather mysterious artist who appears to have been in Minneapolis from 1873 until 1880 was Paris-born Alexander Loemans. He had worked in Auburn and Utica, New York, and he is best known for romantic mountain scenes, from both the West and South America, which are indebted to those by his more famous contemporaries, Bierstadt and FREDERIC EDWIN CHURCH.

Though less significant than the influence of the Swedish community in Illinois, the cultural contribution of the Norwegian artists, both folk and professional, in Minnesota

ABOVE:

3.3 Herbjörn Gausta (1854–1924)
Setting the Trap, c. 1908
Oil on canvas, 21 x 26 in.
Luther College, Decorah, Iowa

OPPOSITE:

3.4 Stephen Arnold Douglas Volk
(1856–1935)
After the Reception, 1887
Oil on canvas, 34¾ x 25½ in.
The Minneapolis Institute of
Arts; Gift of Mr. and Mrs. E. J.
Phelps

is important. The earliest Scandinavian society in America concerned with the fine arts was the Norska Konstföreningen in Minneapolis, which attempted to hold regular exhibitions of Scandinavian art from 1887 until 1893. Most notable among the Norwegian artists was **Herbjörn Gausta**, who emigrated to a farm near Harmony, Minnesota, in 1867. He studied at nearby Luther College in Decorah, Iowa, beginning in 1872, and three years later he went to Oslo and Munich for additional instruction. He returned to America in 1882 and, in 1888, settled in Minneapolis for the rest of his career. No finer depiction of the more pleasant aspects of Minnesota farm life can be found than Gausta's *Setting the Trap*. A monumental, naturalistic depiction of a young boy, it reflects an indebtedness to the peasant subjects of Jules Bastien-Lepage and Max Liebermann combined with the bright light and heightened colorism of a modified Impressionism. Much of Gausta's professional activity was devoted to the competent, if routine, production of altarpieces for Lutheran churches, copies of works by European masters.[6]

One motivation for Gausta's decision to settle in Minneapolis in 1888 was surely the growing art establishment there. The Minneapolis Society of Fine Arts, established in 1883, sponsored the Minneapolis School of Fine Arts three years later. This quickly developed into an important teaching institution, with **Stephen Arnold Douglas Volk,**

son of the well-known Chicago sculptor Leonard Volk, as its first director. The younger Volk, who had trained in Paris with the great academician Jean-Léon Gérôme, had begun to make a name for himself in New York City as a painter of Puritan subjects. He remained in Minneapolis for seven years, capably running the art school and painting beautifully crafted portraits, informal likenesses, and figure paintings of great immediacy, such as *After the Reception*, an example of the domestic genre at which he excelled. Another of 3.4
Volk's outstanding Minneapolis pictures is a likeness of his friend the furniture dealer John Scott Bradstreet (Minneapolis Institute of Arts). A pioneer in the Arts and Crafts movement, Bradstreet allowed his shop, the Crafthouse, founded in 1892, to become a meeting place for the art community of Minneapolis and a gallery where local painters could exhibit their work. A concern for handicraft and an anxiety about the tawdry effects of mechanization remained with Volk long after he returned to New York City in 1893 to teach at the Art Students League.[7]

The Minneapolis Society of Fine Arts presented a public exhibition in 1883, and another one in 1886. After that, its exhibitions were temporarily discontinued since the Minneapolis Industrial Expositions, begun that year, featured important displays of art. The first included many works by New York City artists, especially Enoch Wood Perry and WILLIAM BRADFORD, a special selection of over forty paintings by Bierstadt, and a large 1.47
display of pictures by Munich artists. Local painters also were represented: there were portraits by Bradish and Volk and numerous still lifes by now-forgotten painters. The following year a large display of works by Scandinavian artists was featured, as was a selection from the Norska Kunstföreningen and paintings by Volk's students, which became a standard feature of these shows. In 1888 the city's leading art collector, Thomas B. Walker, lent a selection of his holdings to the exposition. Unfortunately, these shows had to be discontinued due to the financial panic of 1893.

The art community in Minneapolis gradually expanded in the 1880s. BARTON HAYS, 2.229
who had long been the leading portraitist in Indianapolis, moved to Minneapolis in 1882, spending the last thirty-two years of his long career there. He continued to paint portraits and occasional landscapes and to teach, but it seems likely that his activity diminished and that much of his attention was devoted to small, pristine fruit still lifes. During the 1880s local painters who were rising to prominence began to appear in the industrial expositions—Nicholas Richard Brewer in 1888, **Alexis J. Fournier** in 1889, and Alexander 1.223
Grinager in 1891; in 1892 Fournier's 226 contributions dominated the exhibition. Born in Saint Paul, Fournier had grown up in Milwaukee, then returned to Minneapolis in 1883. A few years later he may have been one of Volk's first students, attending classes informally for a short time and then becoming Volk's private pupil. Setting up his own studio in 1887, Fournier began to paint vivid naturalist views of contemporary Minneapolis—old Fort Snelling, the river, and the falls juxtaposed with modern-day buildings, bridges, and railroad yards, such as his deliberately unpicturesque *Mill Pond at Minneapolis*. 3.5
The patronage of such wealthy collectors as the railroad baron James J. Hill, and the recompense for his work on a panorama for the World's Columbian Exposition in Chicago, enabled Fournier to travel to Paris for formal study in 1893. Returning regularly to Minneapolis, he became a member of Bradstreet's cultural coterie. In 1902 Fournier was taken up by Elbert Hubbard, the Arts and Crafts proponent and founder of the Roycroft community in East Aurora, New York, who first purchased a work by Fournier and then invited him to reinstall the Roycroft Gallery and become its art director. For many years thereafter Fournier divided his time between his Minneapolis studio and Roycroft, moving from the vivid realism of his early painting to a Barbizon mode.[8]

Another proponent of the Barbizon style in Minneapolis was **Nicholas Richard Brewer**, who was born in rural Minnesota and took his first lessons in Saint Paul late in 1875 from Henry J. Koempel, a little-known German history painter and church decorator who had worked in Cincinnati. Brewer was inspired by the visit to Saint Paul in the early 1880s of the landscapist Homer Martin, who urged him to go to New York City to study with DWIGHT W. TRYON. After doing so Brewer returned to Saint Paul, where he painted 1.48, 1.77
softly brushed scenes of woods. More exciting and colorful is his view of the city, which 3.6

emphasizes its growth and modernity and reveals his receptivity to Impressionism. Brewer was actually more active as a figure painter and portraitist; for the latter he maintained studios in New York City and Chicago at various times and traveled throughout the country on commissions. He wrote, "There can not be found a great painter in all the Middle West who does not retain a hold on New York and live there at least part of the time."[9] Brewer lived to over ninety years of age, and his portrait subjects range from Henry Ward Beecher to Franklin Roosevelt.

Homer Martin, who had offered Brewer such inspiration, was probably the most famous artist to live in Minnesota during the nineteenth century. Toward the end of his career, over a decade after his initial visit, Martin returned and settled in Saint Paul in 1893, slowly succumbing to the cancer that caused his death in 1897. During these years he painted some of his finest canvases, including his famous *Harp of the Winds: A View on the Seine,* but he does not appear to have been inspired by the local landscape. 3.7

One of the finest native figure painters to emerge in the 1890s was **Alexander Grinager**, who studied in Minneapolis with Peter Gui Clausen and went on to Paris in 1887, also visiting Norway. Back in Minneapolis by 1891, Grinager exhibited figural works and Norwegian landscapes at the Industrial Exposition that year. *Boys Bathing*, his 3.8 best-known canvas, is an informal realist depiction of a subject already explored by such American artists as WILLIAM MORRIS HUNT and Thomas Eakins. Grinager's representation 1.60, 1.87 of the banks of the Mississippi is more candid and spontaneous, and its brilliant illumination reflects the impact of Impressionism. His choice of subject—unidealized immigrant children from a local shantytown—looks forward to the urban realism of the Ashcan School. In 1896 Grinager settled in Ossining, New York.[10] Iowa-born **Edwin M. Dawes**, another Impressionist-influenced painter of the Minnesota landscape and of cityscapes, dissolved the industrial forms of local flour mills in shimmering smoke and mist in *Channel to the* 3.9 *Mills*. Dawes later moved to Southern California.

When Volk left Minneapolis in 1893, he was replaced at the School of Fine Arts by **Robert Koehler**. Born in Hamburg, Koehler had grown up in Milwaukee, where he studied under HENRY VIANDEN. He went to the National Academy of Design in New York 2.298 City and, in 1873, to Munich. In 1875 financial distress sent Koehler back to New York. He studied at the newly formed Art Students League, and four years later he was able to

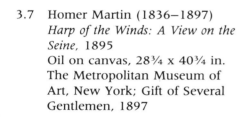

3.7 Homer Martin (1836–1897)
Harp of the Winds: A View on the Seine, 1895
Oil on canvas, 28¾ x 40¾ in.
The Metropolitan Museum of Art, New York; Gift of Several Gentlemen, 1897

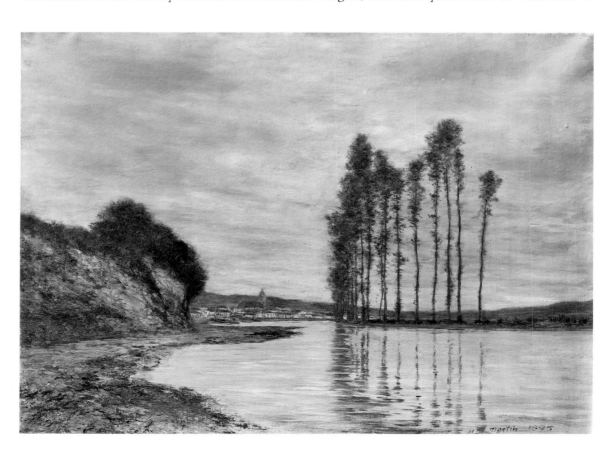

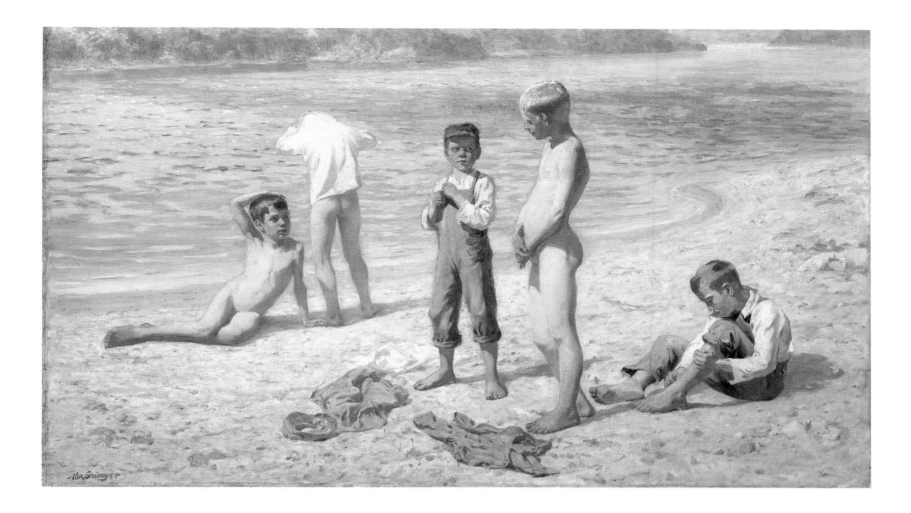

return to Munich, where he remained for thirteen years, continuing his training and conducting a private art school in 1887. While there he painted a number of powerful images of class struggle, including *The Socialist*, exhibited in 1885, and the monumental *Strike* (1886; both in the collection of Lee Raymond Baxandall, Oshkosh, Wisconsin). Koehler returned to this country in 1892, assuming the directorship of Volk's school the following year. He remained there until his death in 1917. Curiously, Koehler's art changed radically in the 1890s, when the socially concerned imagery of his Munich days was replaced by lyrical scenes of elegant women in interiors and poetic views of figures on the streets of Minneapolis. Formally, the clear, precisely delineated forms of *The Strike*

3.10 gave way to the soft, Whistlerian harmonies of *Rainy Evening on Hennepin Avenue,* an urban reflection of the Tonal aesthetic.[11]

Koehler was not only one of Minneapolis's principal painters for over twenty years but also a leading figure in the local art world. He was president of the Minneapolis Art League, which held its first annual exhibition in 1895, and the founder, in 1903, of the Minnesota State Art Society, which he directed for seven years. Beginning in 1904 this organization circulated art exhibitions throughout the state, offering prizes and acquiring works by Minnesota artists. The exhibitors were divided almost evenly between Minnesota and out-of-state residents. Other groups of the period included the Studio Club, a student sketching society; the Chalk and Chisel Club, founded in 1895; and the Skylighter's Club, an arts and culture group founded by John Scott Bradstreet, which later became the Minneapolis Arts and Crafts Society.

The Minneapolis Society of Fine Arts was reactivated as an exhibiting agency in 1900, instituting a series of annuals that concentrated on the work of nationally recognized artists, thus exposing Minneapolis artists and art lovers to a broad spectrum of contemporary work. Works by the best-known local painters such as Alexis J. Fournier, Herbjörn Gausta, and Koehler were occasionally included; the Minneapolis art establishment was also recognized in such shows as the Special Exhibition of Paintings, held in February 1902.

3.8 Alexander Grinager
(1865–1949)
Boys Bathing, 1894
Oil on canvas, 34 x 59 in.
The Minneapolis Institute of Arts; Gift of Mr. and Mrs. Alexander Grinager

The most elaborate artistic endeavor in the state at the end of the nineteenth century was the building and decoration of the new State Capitol in Saint Paul. A vast mural scheme of scenes from Minnesota's history was carried out by some of the nation's leading figures in the mural revival: Edwin Blashfield, Kenyon Cox, JOHN LA FARGE, Frank Millet, HOWARD PYLE, and Rufus Zogbaum. Stephen Arnold Douglas Volk, by then resident in New York City, was also a member of this group, creating for the governor's reception room *Father Hennepin Discovering the Falls of Saint Anthony* and *The Second Minnesota Regiment at the Battle of Mission Ridge*. Other than Volk and the architect, Cass Gilbert, who came from Saint Paul, the local art community and others with connections to the state appear not to have been involved. Other mural commissions that went to artists outside Minnesota included those for the Merchants National Bank in Winona and the Farmers National Bank in Owatonna, both painted by Chicago's Albert Fleury.

1.88
1.309

OPPOSITE:
3.9 Edwin M. Dawes (1872–1934)
Channel to the Mills, 1913
Oil on canvas, 51 x 39½ in.
The Minneapolis Institute of
Arts; Anonymous gift

ABOVE:
3.10 Robert Koehler (1850–1917)
*Rainy Evening on Hennepin
Avenue,* c. 1910
Oil on canvas, 24 × 24¾ in.
The Minneapolis Institute of
Arts; Gift of friends of Mr. Koehler

3.11 David Ericson (1869–1946)
Morning of Life, 1907
Oil on canvas, 27 x 22¼ in.
Tweed Museum of Art,
University of Minnesota,
Duluth

A number of younger figures emerged at the close of the nineteenth century, exhibiting with the Minneapolis Art League and its successor in the 1910s, the Artists' League of Minneapolis. Many were women who would act as pioneers in other communities. ELISABETH CHANT, a figure and landscape painter, studied at the Minneapolis 2.30
School of Art at the end of the nineteenth century and then set up a studio in the city. She left about 1911 to work with Gill's Art Galleries in Springfield, Massachusetts, and then became the driving force in the art world of Wilmington, North Carolina, in 1922. In Minneapolis, Chant shared a studio with MARGARETHE HEISSER, at one time the most 3.59
noted professional artist of North Dakota. Swiss-born Henrietta Clopath, an Impressionist painter, was a student and disciple of the French artist Jean-François Raffaëlli; she taught at the University of Minnesota from 1895 until 1910, then settled in Tulsa, Oklahoma, in 1913 for the remainder of her career. Leila Grace Woodward painted peasant subjects in Grèz and Pont-Aven, France, and views of Venice. She was active in Minneapolis until about 1910, when she moved to Washington, D.C. The portraitist Grace McKinstry was active in Minneapolis from the turn of the century; Jean Mitchell Lawrence seems to have been the city's leading representative in the miniature-painting revival. Margaret

Gove Camfferman and her Dutch-born husband, Peter Camfferman, were younger artists who studied at the Minneapolis School of Art. Margaret Gove began exhibiting watercolor still lifes with the State Art Society in 1907, and during the first half of the following decade she and her husband were landscapists in the city. They eventually settled in Seattle, where they became important art teachers. Finally, DONNA SCHUSTER—who studied in Chicago and at the Boston Museum School with Edmund Tarbell and FRANK W. BENSON, and who later went abroad with WILLIAM MERRITT CHASE—lived in Howard Lake, west of Minneapolis, in the mid-1910s. She exhibited highly colored, strongly modeled figure paintings in local shows. Schuster later settled in Southern California, where she completely embraced the Impressionist aesthetic.

Minnesota's Scandinavian heritage was also apparent in **Duluth**. One of the earliest professionals to reside there was the Norwegian immigrant Peter Lund, who specialized in marine views along the shores of Lake Superior until he left for New York City in the 1890s. FEODOR VON LUERZER was a member of the Austrian nobility who studied in Vienna and came to this country in 1886 to work for William Wehner's American Panorama Company in Milwaukee. The association must have been extremely short-lived, however, for von Luerzer was in Cleveland a year later and in 1889 established himself in Duluth, where for two decades he specialized in broadly painted local landscapes, especially of the logging industry. Von Luerzer subsequently moved to Idaho.[12]

Duluth's most important painter was Swedish-born **David Ericson** (originally Eriksson). Young David arrived in Duluth at the age of four, in 1873. He was a self-taught artist who won a prize at the Minnesota State Fair in 1885 and two years later was able to go to New York City to study at the Art Students League. In 1900 Ericson went to Paris and studied with James McNeill Whistler. He returned to Duluth in 1902 but spent much of the ensuing period abroad. Ericson taught at the Albright Art School in Buffalo in 1906–7. Though his early works are rustic farming scenes, and many of his colorful pictures document his foreign travels, Ericson was a sensitive figure painter from the start. His best-known canvas, *Morning of Life*, depicts his young son adrift on calm waters, updating THOMAS COLE's famous pictorial metaphor in *The Voyage of Life*. Here, Whistlerian influences are successfully allied with careful but simplified academic rendering.[13] Finally it should be recalled that the young Max Weber, later such an important figure in the development of American modernism, was head of the drawing and manual-training department of the Minnesota State Normal School in Duluth from 1903 until he went to Europe in 1905. During these years Weber painted the local scenery; his first public showing consisted of four landscapes and still lifes included in the second annual traveling exhibition of the Minnesota State Art Society in 1905.

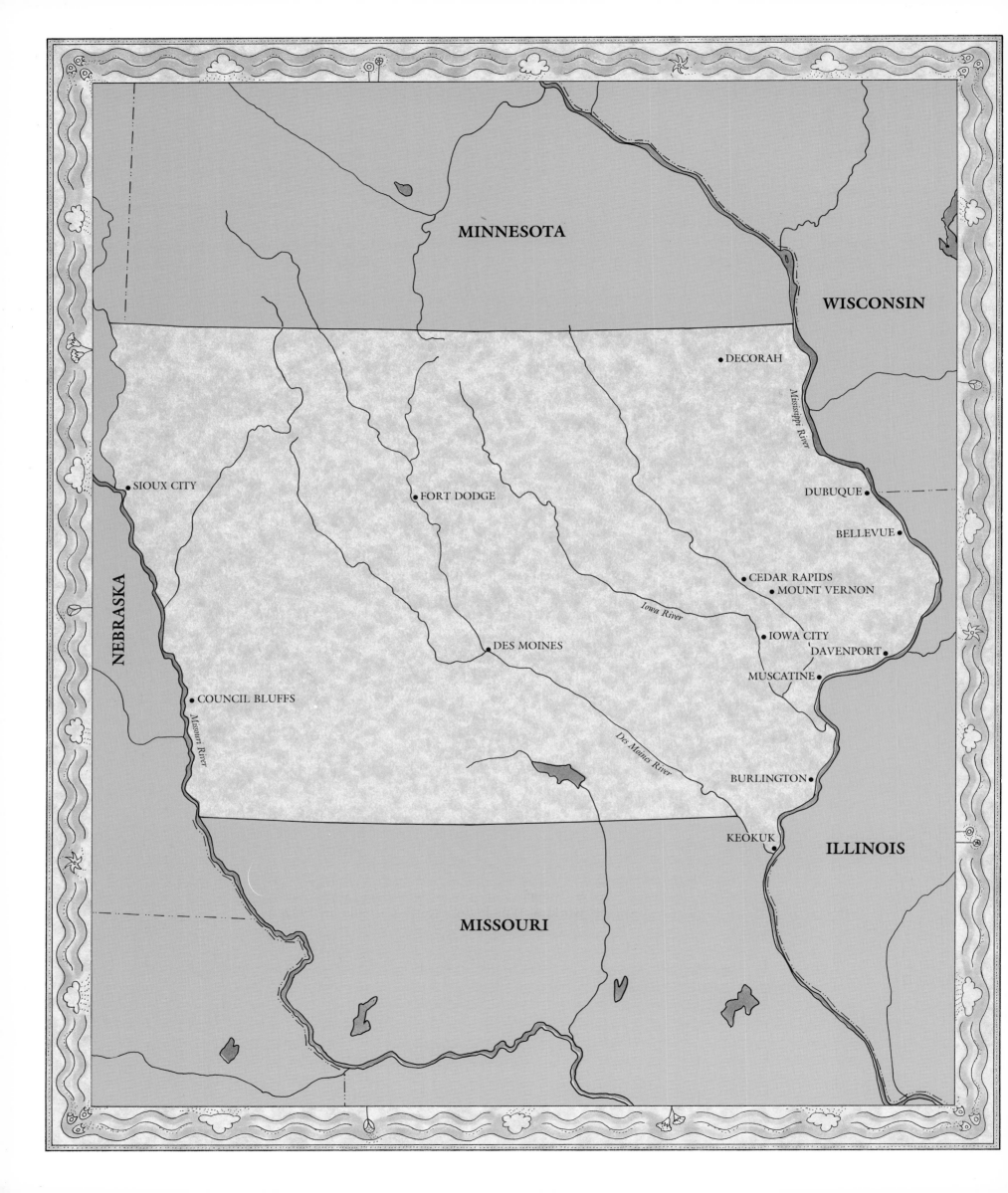

MINNESOTA

WISCONSIN

• DECORAH

Mississippi River

SIOUX CITY •

DUBUQUE •

• FORT DODGE

BELLEVUE •

• CEDAR RAPIDS
• MOUNT VERNON

Iowa River

NEBRASKA

• DES MOINES

• IOWA CITY
DAVENPORT •

MUSCATINE •

• COUNCIL BLUFFS

Missouri River

Des Moines River

BURLINGTON •

KEOKUK •

ILLINOIS

MISSOURI

IOWA

Iowa was primarily rural during most of the period covered in this survey, and while a number of well-known painters were born there, the lack of large urban centers inhibited the growth of a significant art establishment. Originally part of the Louisiana Purchase, what is now Iowa was next part of the Missouri Territory, then of Michigan, and then Wisconsin. A separate Iowa Territory, organized in 1838, included parts of Minnesota and the Dakotas. The state of Iowa, with Iowa City as its capital, was admitted to the Union in 1846; Des Moines replaced Iowa City in 1857.

3.17 The earliest artists to pass through Iowa were painters of Indians such as GEORGE CATLIN, who traveled along the state's eastern and western boundaries, the Mississippi 3.18 and Missouri rivers, respectively. The panoramists of the upper Mississippi, such as LEON POMAREDE and Henry Lewis, included scenes of many of the early Mississippi settlements, especially Dubuque but also Bellevue, Davenport, Muscatine, Burlington, Keokuk, and other towns perched on or below the picturesque bluffs.[1] The Swiss-born landscape painter and lithographer John Caspar Wild left Saint Louis to settle in Davenport in 1844; though he died only two years later, his time there was extremely productive. As part of a project he conceived to document the towns and forts of the upper Mississippi, Wild painted views of his new home community and of Dubuque and Muscatine, as well as Moline, Bloomington, and Galena in Illinois and forts Snelling and Armstrong, most of which were subsequently lithographed.[2]

The state's few resident painters in the second half of the nineteenth century were 3.12 widely scattered. One of the earliest, **George Simons**, lived in Council Bluffs, a Missouri River port in the far western part of Iowa. Council Bluffs (originally called Kanesville)

3.12 George Simons (1834–1917)
Council Bluffs, c. late 1860s
Oil on canvas, 29 x 59 in.
Council Bluffs Public Library,
Council Bluffs, Iowa

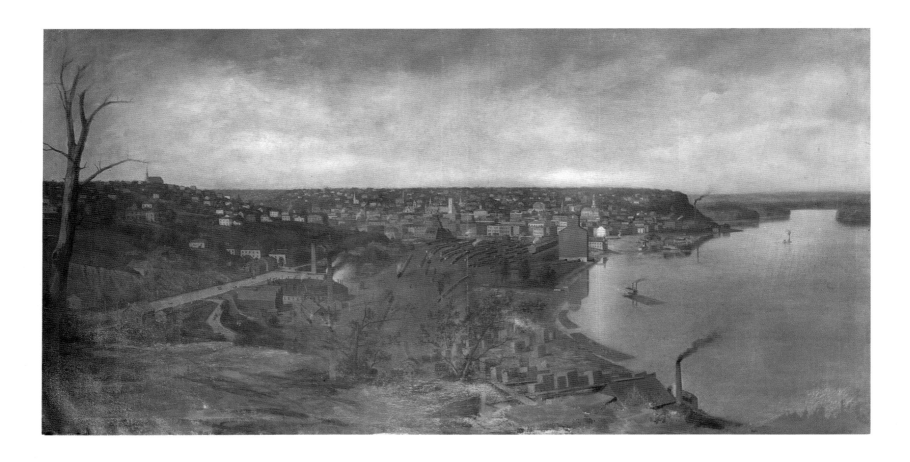

3.13 George Harvey (1835–1922)
View of Burlington, 1892
Oil on canvas,
59⅜ x 117¾ in.
Burlington Public Library,
Burlington, Iowa

developed rapidly as an important transportation hub, becoming an outfitting site for travelers to the California gold fields in 1849. In 1863 it was selected as the eastern terminus of the Union Pacific Railroad. Simons, a gunsmith and tinker by trade, painted primitive portraits and documented the community, to which he is said to have gone as early as 1849, initially as a cook on a railroad right-of-way survey. He also documented Sioux City and the new settlement of Omaha, Nebraska, across the river. Packet boats on the Missouri, Mormon encampments, and farm scenes are included in Simons's naïve but fascinating views of frontier life. In 1926 the Iowan artist Grant Wood enlarged a number of Simons's scenes for the Pioneer Room of the Hotel Chieftain in Council Bluffs.[3]

Isaac Augustus Wetherby was probably the state's earliest professional painter. Born in Providence, Rhode Island, Wetherby painted in Boston and nearby communities until he set up a daguerreotype studio in Iowa City in 1854. He soon moved to Rockford, Illinois, and then to Eureka, Iowa, settling permanently in Iowa City in 1859, where he had begun to paint portraits the year before. Though Wetherby maintained a photography studio, he also painted oil portraits into the 1880s.[4] David Gue, a lawyer and pharmacist in Fort Dodge, Iowa, turned to portraiture when he was past fifty; self-taught, he was best known for likenesses of Civil War leaders, such as Ulysses S. Grant, Abraham Lincoln, and Henry Ward Beecher, and of Iowa legislators, though it appears that he was living in the East when he painted them. The well-known portrait and genre painter George H. Yewell grew up in Iowa City; he went to New York City to study at the National Academy of Design between 1851 and 1854. Yewell returned to Iowa City for his only period of professional residence in Iowa, painting portraits, especially of babies and young children, from 1854 until 1856, when Judge Charles Mason financed a trip abroad for him to study with Thomas Couture. Yewell then lived in New York City, though he, too, painted portraits of numerous Iowa legislators.[5] The earliest professional landscape painter to reside in the state was **George Harvey**, the nephew of the more famous painter of the same name. The family settled in Burlington in 1850, and the younger Harvey, having studied with his uncle in Boston and with Thomas Hicks in New York City, lived and worked in Burlington for over fifty years, painting scenes of the Mississippi Valley. His most noted picture was an enormous view of Burlington commissioned by a group of 3.13

private citizens and shown in the Iowa Building at the World's Columbian Exposition in Chicago in 1893.[6]

3.3 Norwegian-born **Herbjörn Gausta** was active in Iowa. Having been a student at Luther College in Decorah in 1872, he left for Norway and, three years later, Munich. Gausta came back to this country in 1881, living in Chicago, Madison, Wisconsin, and La Crosse, Wisconsin, before returning to Decorah. He taught at his alma mater in 1886–

3.14 87 and then settled in Minneapolis. The best known of his early canvases, *The Lay Preacher*, represents a contemporary evangelical meeting. Probably first sketched in Telemark, Norway, it is based on the most famous early nineteenth-century Norwegian painting of historical genre, Adolph Tidemand's *Haugerne* (1848; National Gallery, Oslo).[7]

The earliest documented art exhibition to take place in Iowa was a show held in Davenport to celebrate the 1876 centennial. Though one section featured the work of ''Home Talent,'' the only artist with even a modest national reputation was Ida Burgess, later active in Champaign, Illinois, who exhibited a portrait. Two years later the Art Association of Davenport held its first loan exhibition, much of which was culled from the collection of William Penn Clarke, a prominent attorney, editor, and collector in Iowa City and an early patron of George H. Yewell. The principal local artist represented was

3.84 GEORGE W. PLATT, who exhibited a still life, a portrait, a figure study, and a Venetian scene. Platt had been born and brought up in Rochester, New York. After serving as a draftsman with John Wesley Powell's geological surveys of the West, he studied art at the Pennsylvania Academy of the Fine Arts, probably from 1871 until 1876, and then in Munich, also traveling to Italy. His parents moved to Muscatine, and by February 1878 Platt had settled in nearby Davenport or across the river in Rock Island, Illinois—he is listed as resident in both towns at the time. By 1882 Platt was painting still lifes in Chicago, and in the 1890s he was working in Denver.[8]

The most dynamic figure in the creation of an Iowan art community was **Charles Atherton Cumming**, a figure, portrait, and landscape painter from Illinois. After attending Cornell College in Mount Vernon, Iowa, Cumming studied at the Chicago Academy of

1.248 Design under LAWRENCE C. EARLE in 1878–79. He returned to Cornell College to teach in 1880 and then took leaves of absence in 1885 and 1889 to study at the Académie Julian

2.266 in Paris, where JOHN VANDERPOEL, on leave from the Art Institute of Chicago, was a fellow

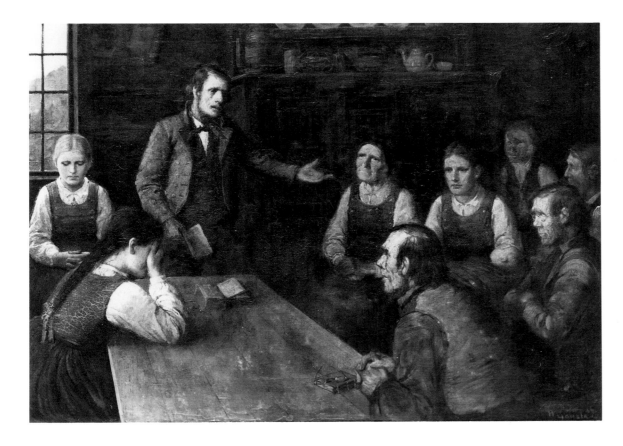

3.14 Herbjörn Gausta (1854–1924)
The Lay Preacher, 1884
Oil on canvas, 18 x 24 in.
Luther College Collection, on loan to Vesterheim, Norwegian-American Museum, Decorah, Iowa

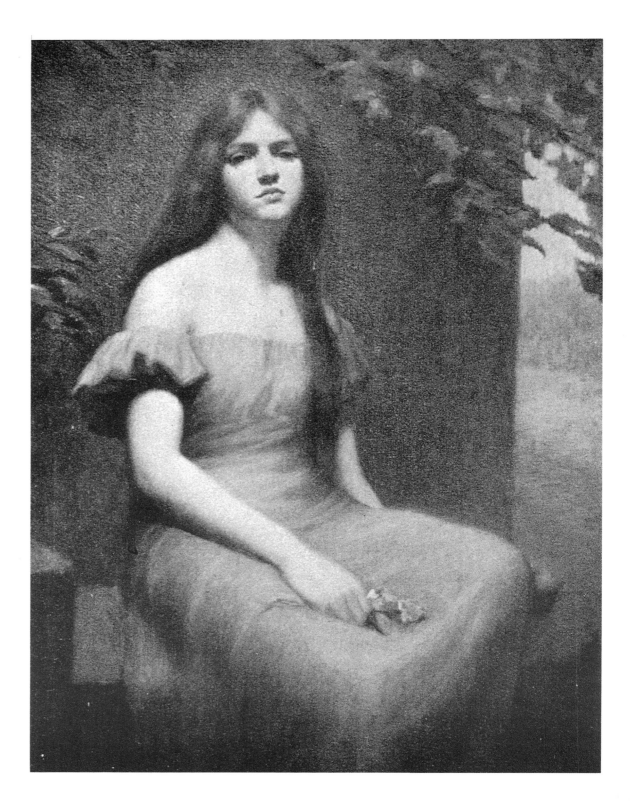

3.15 Charles Atherton Cumming
(1858–1932)
Neva, n.d.
Oil on canvas, 36 x 27 in.
Marea Schenk Dangremond

student. Cumming returned to Cornell and, in 1895, was hired by the Iowa Society of Fine Arts to take over the Des Moines Academy of Arts. The Academy, founded in 1891, was soon renamed the Cumming School of Art; it provided basic training for students going on to study in New York City, Boston, or Chicago. In 1909 Cumming began to teach at the University of Iowa in Iowa City, commuting from Des Moines. In his own painting he explored peasant subjects, particularly in Brittany, but he also painted portraits and idealized female figures, one of the finest of which is his lovely, sensitive *Neva*. His 3.15 solo show at the Des Moines Women's Club in 1902 was cited as the first public exhibition exclusively of the work of a Des Moines artist. Cumming painted a mural, *The Departure of the Indians from Fort Des Moines,* for the Polk County Courthouse in Des Moines; the other painters involved in this mural project included BERT GEER PHILLIPS, STEPHEN ARNOLD 3.109; 3.4 DOUGLAS VOLK, and Edward E. Simmons. Cumming was a much-admired instructor who

inspired his many students. Linn Culbertson and Harriet Macy, two prominent landscape painters, were students of his, both of whom exhibited work in the Northwestern Artists shows in Saint Paul during the late 1910s. With two other students they joined Cumming in founding the Iowa Art Guild, a graduate society of the Cumming School, in 1914. The guild held annual exhibitions and, in 1925, sponsored a reunion exhibition of work by alumni of the school.[9]

The work of Grant Wood was not included in the 1925 show, though he was surely Cumming's most famous student; he had studied with Cumming only sporadically for one year, 1911–12, at the university in Iowa City. Born on a farm near Anamosa, Wood moved in 1901 to Cedar Rapids, then a growing community; four years later an art association was formed there to operate a public gallery. Wood moved to Chicago in 1913, returning to Cedar Rapids three years later. He served in World War I and then taught in the public school system between 1919 and 1925, though this was punctuated by periods of travel and study abroad. Wood worked closely with his good friend Marvin Cone, with whom he had a joint exhibition at Killian's Department Store in Cedar Rapids in 1919; Wood had previously shown his work with the Northwestern Artists group in Saint Paul as early as 1916, as Cone had the following year. Wood's early easel paintings of the late 1910s—rural landscapes—are broadly brushed in an Impressionist vein, but in the 1920s the artist turned to industrial themes and mural work, developing the tight linear manner for which he is best known about 1927.[10] Marvin Cone, Wood's colleague, studied at the Art Institute of Chicago between 1914 and 1917, painting "cloud pictures"— landscapes with low horizons emphasizing sky and cloud formations that recall the work

1.125 of CHARLES HAROLD DAVIS of Mystic, Connecticut.[11]

IOWA

ILLINOIS

KANSAS

Mississippi River

• SAINT JOSEPH

• LIBERTY
KANSAS CITY • • LEXINGTON
• INDEPENDENCE
FRANKLIN
ARROW ROCK • ROCHEPORT
BOONVILLE • COLUMBIA

Missouri River

JEFFERSON CITY • HERMANN SAINT LOUIS •
NEW HAVEN

KIMMSWICK •

Meramec River

PILOT KNOB • • IRONTON
ARCADIA

• SPRINGFIELD

• JOPLIN

• OZARK UPLIFT

• BRANDSVILLE

OKLAHOMA

ARKANSAS

TENNESSEE

MISSOURI

Missouri was admitted to the Union in 1821, and **Saint Louis** was chartered as a city the next year, though settlement by the French had begun there in 1764. The city's growth was slow until Lieutenant William Clark joined Captain Meriwether Lewis in leading an expedition to find a route to the Pacific; they left Saint Louis in 1804, reaching the mouth of the Columbia River a year and a half later and returning in 1805. Clark was appointed governor of the Missouri Territory in 1813. From then on, Saint Louis's preeminence as a gateway to the West was assured, and its population tripled every ten years between 1800 and 1850.

Saint Louis became the cultural hub not only of Missouri but also of the entire Mississippi Valley. It was superseded as the paramount artistic center of the region only by Chicago toward the end of the century. A succession of developments and personalities directed attention to Saint Louis: the appearance of the earliest nationally recognized
3.24 ''western'' painter, GEORGE CALEB BINGHAM; the city's crucial position as a base for almost all of the midcentury panorama painters, who featured Saint Louis in their pictorial travelogues; and the development of the Saint Louis School of Fine Arts under the brilliant
3.30 HALSEY COOLEY IVES. Another factor was the merging of the area's early French legacy with German influences following the European revolutions of 1848 and the resulting emigrations. The French legacy, noticeable in the pre–Civil War years, was exemplified by the frequent movement of artists between Saint Louis and the other major French cultural outpost in America, New Orleans. Some of these artists expanded their activities to work in the geographic belt that extended westward along the Missouri River to Independence.

Much of Saint Louis's continuing success as a cultural center was due to its geographic position, midway in the Mississippi Valley at the confluence of the Missouri and near the mouth of the Ohio River. It is thus a gateway to all directions. This truism takes on greater meaning as one traces the movements of artists—not only the travels of
3.17 Indian artists such as GEORGE CATLIN but also the careers of painters of diverse subjects,
3.29 such as the landscapist JOSEPH RUSLING MEEKER. Almost all painters whose activities were not restricted to the Eastern Seaboard passed through Saint Louis. Some lingered for prolonged visits, others established a permanent residence. The city's preeminence was recognized by the Society of Western Artists in 1896, when Saint Louis was named one of its six centers; the city also became the organizational base for artists located farther west.

Elsewhere in the state, artistic concerns were sparser. Developments in Kansas City occurred much later and are only now beginning to be studied. And it was only in the 1910s and '20s that the wild beauty of the Ozarks began to attract considerable interest from landscape painters.

The earliest recorded resident professional artist in Saint Louis was the Frenchman François-Marie Guyol de Guiran, who painted portraits and miniatures there from 1812 until after 1820; he subsequently was recorded as a drawing teacher in New Orleans.
1.68 One of the first American-born professional painters to appear in the city was CHESTER HARDING in 1820, at the beginning of his career. Harding had arrived from the East with a letter of introduction to Governor William Clark, who helped him procure a studio and sat to him for a portrait (Missouri Historical Society, Saint Louis), the background of which was added by a local scene painter, John Duberman. This led to other commissions, and Harding also painted an image of an Osage Indian chief (location unknown) while in Saint Louis. It may have been Clark who advised Harding to go into the countryside to record the likeness of Daniel Boone, who had opened up what was then thought of as the West many decades earlier and who had settled in Missouri about 1799. This

historic picture (Massachusetts Historical Society, Boston)—executed in June 1820, shortly before Boone died—was the only life portrait done of him, though JOHN JAMES AUDUBON 2.67 had met Boone and later painted a memory likeness (Audubon Museum, Henderson, Kentucky). Due to the oppressive weather, Harding worked in a temporary studio in Franklin, some two hundred miles up the Missouri River from Saint Louis and about sixty miles from Boone's rural dwelling on Lieutre Island. In all, the untutored artist's sojourn of over a year seems to have been fairly successful; he was able to purchase land with the monies he obtained from his commissions.[1] Harding returned frequently to Saint Louis, as we shall see.

James Otto Lewis was in Saint Louis by the 1820s, though presumably not for long. Born in Philadelphia, Lewis had gone west with a theatrical company, but a falling out with his manager led him to offer his services as a miniature painter and engraver. A number of his engravings are known, most notably one made after the full-length portrait of Daniel Boone that Harding painted from his original life study. Sometime in 1822 or '23 Lewis moved to Detroit, where he painted his earliest Indian paintings, upon which his reputation is founded.[2]

The young Swiss-born **Peter Rindisbacher** moved from Gratiot's Grove, Wisconsin, 3.16 to Saint Louis late in 1829, remaining until his early death four years later. Rindisbacher achieved considerable national acclaim for the engravings published after his western, sporting, and Indian scenes that appeared in the new *American Turf Register and Sporting Magazine*. *Sioux Warrior Charging* was the first of these engravings, reproduced in October 1829; his work was presented through March 1832, bringing to the American public views of the untamed wilderness never before illustrated. One final picture was published posthumously in October 1840. These prints seem to have been made after drawings and paintings sent by the artist or by friends based at nearby Jefferson Barracks, whom he occasionally accompanied on excursions up the Missouri River. Rindisbacher also painted miniatures and drew crayon portraits during his years in Saint Louis.[3]

Most of the early painters of the American Indians passed through the city during the 1830s and '40s, but only **George Catlin** stayed for several years. Catlin was there in the spring of 1830 and made the city his base until 1836, painting an extensive view of 3.17 it and of the river steamboats in 1832 or '33. Many of Catlin's sketches of Indians and the western landscape were worked into paintings in Saint Louis, and in the fall of 1832 he also painted a number of portraits of Indians held prisoner in Jefferson Barracks. Rindisbacher's fellow Swiss, Karl Bodmer, was also in the city during this period, accompanying his patron, Prince Maximilian of Wied-Neuwied. They reached Saint Louis

3.16 Peter Rindisbacher
(1806–1834)
Assiniboin Hunting on Horseback, 1833
Watercolor on paper,
9¾ x 16⅛ in.
Amon Carter Museum, Fort Worth

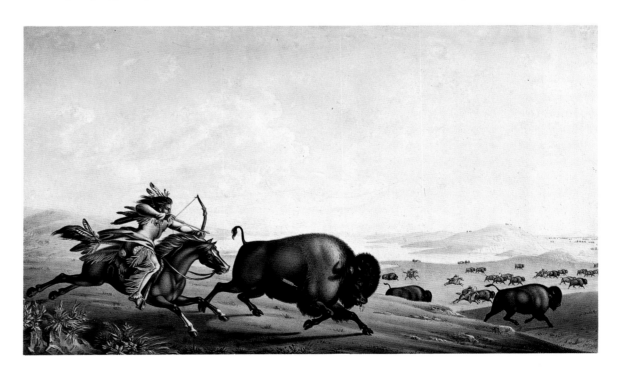

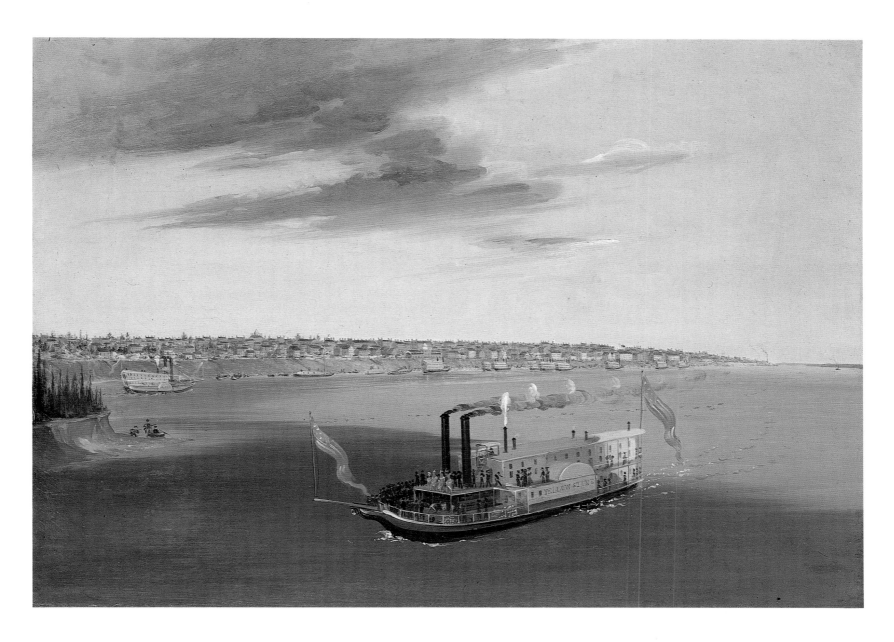

in March 1833 and remained for several weeks; Bodmer painted a number of Indian portraits and sketched the terrain. He probably met Rindisbacher, since Prince Maximilian acquired some of the latter's watercolors. ALFRED JACOB MILLER was in Saint Louis in 1837 on his way west. All of these artists received enormous assistance from William Clark, superintendent for Indian affairs, who also amassed a collection of Indian portraits, which was unfortunately dispersed after his death.

About the time that Catlin painted his view of Saint Louis, **Leon Pomarede** recorded the city from the opposite shore of the Mississippi. Pomarede, who had arrived to execute church decorations for the old Saint Louis Cathedral in 1832, also executed easel paintings of the building. By 1837 he was back in New Orleans, but six years later he had returned to Saint Louis, where he formed a decorative painting firm with a fellow artist, T. E. Courtenay. In 1848 Pomarede joined with Henry Lewis to produce his giant panorama of the Mississippi, but after a quarrel in June each went on to produce his own. Pomarede finished his with the assistance of the young CHARLES F. WIMAR and Courtenay. The last scenes to be completed constituted a trilogy: the city's appearance before the great fire of May 17, 1849; the fire itself; and the sad, blackened spectacle that resulted. Although the *Panorama of the Upper Mississippi* opened in Saint Louis on September 19, 1849, the artist continually added to it during the two months that it was on view. He then took it to New Orleans and to the East, where it was destroyed by a fire in 1850. Pomarede continued to paint diverse subjects in his Saint Louis studio, including dramatic scenes of Indian life in settings undoubtedly derived from his studies

3.17 George Catlin (1796–1872)
Saint Louis from the River Below, 1832–33
Oil on canvas, 19⅜ x 26⅞ in.
National Museum of American Art, Smithsonian Institution, Washington, D.C.; Gift of Mrs. Joseph Harrison, Jr.

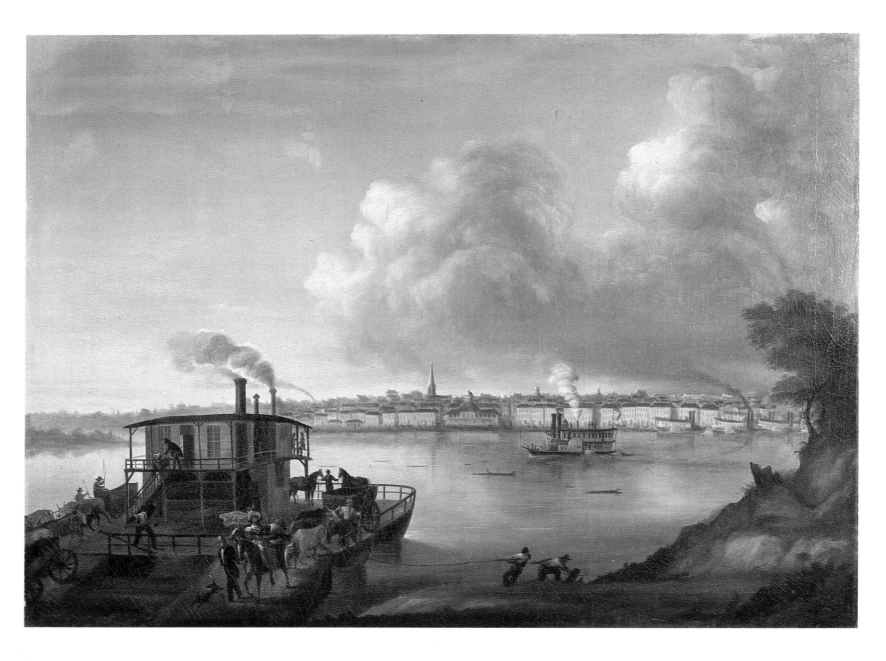

3.18 Leon Pomarede
(c. 1807/11–1892)
*View of Saint Louis from Illinois
Town*, 1835
Oil on canvas, 29⅛ x 39⅛ in.
The Saint Louis Art Museum;
From the collection of Arthur
Ziern, Jr.

for the panorama. His greatest efforts were reserved for decorative schemes for such buildings as the Mercantile Library in 1854, the Merchants Exchange Building in 1857, the hall at Saint Louis University in 1858, and various theaters and churches. He remained a vigorous artist throughout his life and died from a fall while painting in a church in Hannibal, Missouri, in 1892.[4]

All the Mississippi panoramas featured Saint Louis, of course, though not all the painters were resident there. The earliest, that of John Banvard, was completed and first shown in Louisville, Kentucky, in 1846. Since it depicted only the lower Mississippi, from Saint Louis to the gulf, it was a complement to Pomarede's. John Rowson Smith and Samuel Stockwell both produced Mississippi panoramas that appeared in 1848, though only Stockwell's was painted and exhibited in Saint Louis. A Boston-born scene painter, Stockwell had settled in Saint Louis about 1845; when his panorama venture failed financially, he returned to theater painting in 1852. Stockwell died on a trip to Savannah, Georgia, in 1854.[5] Smith had painted theater scenery in Saint Louis in 1836 and may have done his Mississippi sketches then, but he spent most of the 1840s in New York City doing scenic work for the stage; it is likely that his panorama first appeared in fashionable Saratoga Springs.

Pomarede's erstwhile collaborator, Henry Lewis, put his panorama on view on September 1, 1849; the two overlapped from the nineteenth through the twenty-sixth of that month, during which time the local citizenry had the opportunity to compare them.

Lewis's was hardly the first of the Mississippi panoramas, but it was the longest (and this was a field of painting in which length was a measure of achievement). English by birth, Lewis had arrived in Saint Louis in 1836; though a carpenter and cabinet maker, he had
2.251 set himself up as a landscape specialist by 1845, sharing a studio with the portraitist JAMES F. WILKINS. During the next few years the local newspapers noted Lewis's pictorial achievements, many of them based on sketching tours of the upper Mississippi in the
3.2 summers of 1846 and '47. During the latter journey he met SETH EASTMAN at Fort Snelling and offered him a partnership in his panorama venture. Eastman refused but sold a group of seventy-nine sketches to Lewis, who used them for his panorama, for illustrations in his book about the river, and possibly as inspiration for some of his oil compositions. After one more trip up the Mississippi in the summer of 1848, Lewis began to work on his panorama. His previously planned association with Stockwell was broken off, and the great work was created in Cincinnati with the assistance of some theatrical scene painters and financial help from the proprietor of the National Theatre, who became a part-owner of the resulting picture.

 In Cincinnati, Lewis exhibited the first part of his panorama, that devoted to the upper Mississippi, in May 1849 and the lower Mississippi section in August. After Saint Louis, Lewis took the panorama on tour through America and Canada. Late in 1851 he took it to England. The following spring he was in Holland and exhibited the panorama in Germany. By 1853 Lewis had settled in the artists' colony in Düsseldorf, joining such
3.183; 1.250, Americans as ALBERT BIERSTADT, Emanuel Leutze, and WORTHINGTON WHITTREDGE. He sold
2.168 his panorama in 1857 to a Dutch planter who transported it to Calcutta and Java. However, Lewis was not yet done with the Mississippi, for he had retained his original sketches and published *Das illustrierte Mississippithal* in Düsseldorf in twenty parts between 1854 and 1857, issuing the entire work as a single volume in 1858. In Düsseldorf, Lewis was a consular agent, vice consul, and commercial agent. Though he returned to Saint Louis only once, in 1881, he continued to paint Mississippi scenes based on his early sketches. He also served as host and cicerone to American artists visiting Düsseldorf,
2.109 including those with Saint Louis connections such as THOMAS ALLEN, James William Pattison, and Charles F. Wimar.[6]

 The Swiss-born landscapist John Caspar Wild, who settled in Saint Louis in 1839, was the first professional to devote himself to depicting the Mississippi Valley. Wild had come to this country by 1831 and had published views of Philadelphia and Cincinnati before settling in Saint Louis, where he remained until 1844. He published views of midwestern communities and forts and of the Mississippi Valley using Saint Louis as his base; in 1840 he published a series of eight views of that city. Wild put out his own *Valley of the Mississippi Illustrated* in 1840–42, preceding Lewis's more famous German publication by over a decade. Though Wild's original paintings for this work have not been located, his lithographs are the most significant early records of the appearance of the Saint Louis area. In 1844 Wild moved to Davenport, Iowa.[7]

 Naturally, a city of Saint Louis's size and dynamism quickly attracted portraitists to serve the populace. Some appear to have been portrait specialists, such as the little-known George Markham, while others were ambitious painters of history or genre subjects who found most of their commissions as portraitists. Markham is said to have arrived by 1825, and attractive but provincial likenesses by him are known from the early 1830s; he is listed in the city directories between 1836 and 1841. Probably the most notable eastern portraitist to visit and paint regularly in Saint Louis was Chester Harding, who had two children living in Saint Louis. Harding made winter visits in 1838, 1844, 1845, 1855, 1859, and 1865; his last portrait, of General William Tecumseh Sherman (Union League Club, New York), was begun there in the winter of 1865–66.

 James F. Wilkins was trained at the Royal Academy in London, where he exhibited portraits in 1835–36; he settled in Saint Louis as a portraitist in 1844, sharing a studio the next year with Henry Lewis. Wilkins is best known for a panorama of the overland route to California, which he exhibited in 1850–51; it was painted from sketches made the previous year. He apparently remained a peripatetic painter.[8]

Other early portraitists to work briefly in the city in the 1830s and '40s included Edward Dalton Marchant, Charles Soule, Jesse Atwood, and, in 1837, Daniel Steele and his wife, who was a professional miniaturist. In the mid-1840s such specialists began to settle more permanently. **Sarah Miriam Peale**, who was in Saint Louis in 1847, remained for over thirty years, rejoining her sisters, Margaretta and Anna, in her native Philadelphia only in 1878. An able still-life painter in the family tradition, Peale had also built a solid reputation in Baltimore during the 1820s and '30s as a portraitist in the manner of her cousin and mentor, REMBRANDT PEALE. She was the foremost professional woman portraitist of her time and certainly became the best-known woman artist in Saint Louis. While still residing in Baltimore in the early 1840s, Peale made numerous trips to Washington, D.C., painting likenesses of distinguished statesmen including senators Lewis F. Linn (location unknown) and Thomas Hart Benton of Missouri. In poor health, she was invited by Linn and others to settle in Saint Louis, where her work had preceded her. She appears to have been quite active there in portraiture, though she returned to still-life painting as well, winning prizes for her fruit and flower pictures in the Saint Louis Agricultural and Mechanical Association Fairs of the late 1850s and '60s.[9]

Though by midcentury still-life painting had begun to be appreciated (at least as attractive decoration) by collectors elsewhere, Saint Louis patrons and artists evinced little interest in the subject except for the work of Peale and **Hannah Brown Skeele**, who had

1.319

1.318

3.19

3.19 Sarah Miriam Peale
(1800–1885)
Thomas Hart Benton, 1842
Oil on canvas, 30 x 25 in.
Missouri Historical Society,
Saint Louis

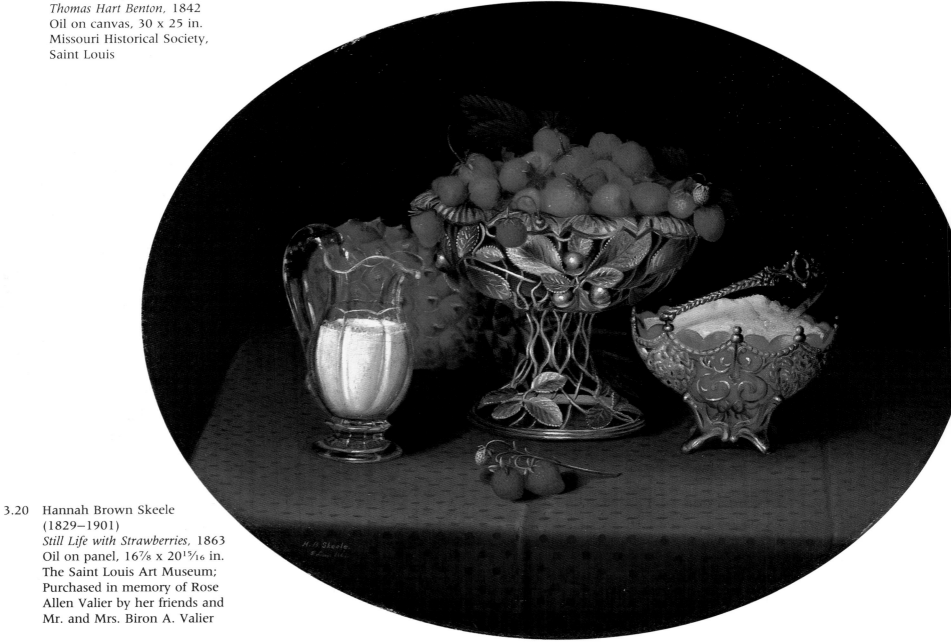

3.20 Hannah Brown Skeele
(1829–1901)
Still Life with Strawberries, 1863
Oil on panel, 16⅞ x 20¹⁵⁄₁₆ in.
The Saint Louis Art Museum;
Purchased in memory of Rose
Allen Valier by her friends and
Mr. and Mrs. Biron A. Valier

moved from Maine about 1858. Skeele may have been inspired, and perhaps even taught, by Peale; Skeele's luscious fruit arrangements such as *Still Life with Strawberries* may also reflect the influence of the Pennsylvania specialist John F. Francis, whose work was exhibited in Saint Louis in 1860. In 1871 Skeele returned to Maine and established herself in Portland, where she turned to portraiture.[10]

Manuel Joachim de França, a Portuguese artist born in Oporto or in Funchal, on Madeira, was in Saint Louis, probably in 1844. He had arrived in Philadelphia about 1830, remaining for twelve years or so. After several years in Harrisburg, Pennsylvania, he settled in Saint Louis, where he remained until his death in 1865. De França painted historical and religious works but was principally a Romantic portraitist, and a very successful one, working in a colorful, painterly manner, as can be seen in *Major William Christy and His Daughters*.[11]

Alfred S. Waugh, who settled in Saint Louis a year after de França, had worked earlier in Missouri, painting portraits in Jefferson City, Independence, and Lexington for about a year in 1845; his partner was John B. Tisdale, whom he had met in Mobile, Alabama, the previous year. Waugh, an Irish-born painter and sculptor, had studied in Dublin before arriving in Baltimore by 1833. He was active throughout the South, working in Raleigh, North Carolina; Pensacola, Florida; and Mobile before going to Missouri. In 1846 Waugh traveled to Santa Fe, New Mexico; after his return he painted portraits and miniatures in Boonville, Missouri, then settled in Saint Louis for the rest of his career. Waugh continued to paint and to sculpt portraits, and he was perhaps the first to write extensively on the fine arts in Missouri, publishing his essays in the *Western Journal* in 1848–49. His erstwhile partner, Tisdale, was active as a miniaturist in Lexington, Missouri, but after serving with the Missouri Mounted Volunteers in New Mexico and California, he returned to Mobile, where he appears to have given up painting.[12]

The 1850s brought a number of other capable portraitists to Saint Louis, including MARTIN JOHNSON HEADE, Ferdinand Thomas Lee Boyle, William F. Cogswell, and Alban Jasper Conant. Heade, at the time still devoted almost completely to portraiture, was there in 1851–52, painting the earliest fully professional likeness known by him, of an unknown man (private collection, Washington, D.C.). **Ferdinand Thomas Lee Boyle**, born in England, had been taken to Brooklyn as a boy; he studied in New York City with HENRY INMAN and at the National Academy of Design in the late 1830s. Though Boyle emerged in 1839 as a strong painter of historical and literary subjects, it was the success of his 1850 full-length portrait of the Reverend John Hughes (location unknown) that helped win him election to the National Academy and determined the nature of his future. In 1856 he settled in Saint Louis, where one of his first subjects was "Old Bullion," Senator Thomas Hart Benton, the great exponent of Manifest Destiny, who also had been painted by Sarah Miriam Peale. Boyle's painting reflects the vigor and alertness taught by Inman and contrasts with Peale's more easy-going and formulaic likeness. Boyle was active in local artistic activities, helping to found the Western Academy of Art and serving as vice president of the Saint Louis Academy of Design. His active role in the military during the Civil War cost him the support of his Confederate friends and patrons, and shortly thereafter he returned to Brooklyn for the remainder of his career.[13]

William F. Cogswell had a long and fascinating life. Though his primary profession was as a portraitist, he also specialized in genre subjects involving children. His most imposing work was the panorama he created of the gold rush and the trip through Panama to California, which described his own journey of 1850. Having lived for several years in Manhattan, by 1855 he had resettled there and in Brooklyn, but he was an active member of the Saint Louis art community in 1859. Subjects such as *The Schoolboy* and *The Schoolmaster* (locations unknown) are noted as having been exhibited by him in the late 1850s. The war may have impelled Cogswell to return briefly to Brooklyn in 1864, but he was active in Chicago the next year and may have spent time there earlier, while painting portraits in Wisconsin throughout the 1860s. By 1873 Cogswell had gone to California, where he remained for the rest of his life with the exception of trips to Hawaii in the 1870s and in 1890–92.

3.20

3.21

1.67, 2.69

1.229

3.22

3.21 Manuel Joachim de França (1808–1865)
Major William Christy and His Daughters, 1850
Oil on canvas, 48 x 43 in.
Missouri Historical Society, Saint Louis

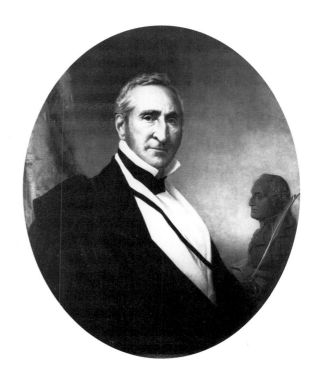

3.22 Ferdinand Thomas Lee Boyle (1820–1906)
Thomas Hart Benton, 1856
Oil on canvas, 36 x 30 in.
Missouri Historical Society, Saint Louis

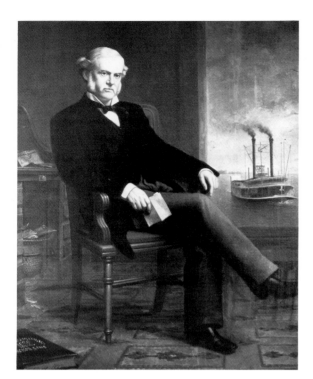

Alban Jasper Conant arrived in Saint Louis in 1857, just shortly after Boyle. He, too, received advice from Henry Inman, though not until 1845, near the end of Inman's life. Like Boyle, Conant was involved in founding the Western Academy of Art. Having traveled a good deal during the Civil War years, he found it profitable to return to Saint Louis soon after the war. He remained active there, exhibiting and painting portraits such as that of "Captain" John Scudder, who organized the Saint Louis–Vicksburg–New Orleans Packet Company. The Scudder portrait is compelling in its strong geometric framework and the pairing of the subject with one of his steam vessels at the right, but it does betray the photographic style that had succeeded the romantic, painterly aesthetic favored by earlier artists such as de França and Boyle. Conant also actively pursued the study of early Missouri archaeology. He moved to New York City a few years after this portrait was painted.[14]

3.23

Saint Louis's most famous portraitist at midcentury was also the most outstanding artist of its entire history, **George Caleb Bingham**. (Traditionally associated with that city, he actually lived elsewhere in the state for most of his career: in Jefferson City from 1844; in Columbia at the end of the decade; in Independence in 1855; sporadically in Jefferson City again, with a residence there from 1862 until 1865; in Independence; and, finally, in Kansas City from 1870 until his death.) Bingham's portraiture is, of course, overshadowed by his innovations in genre painting, and rightly so, but like most nineteenth-century figure painters, he made his living painting portraits. When only ten years old, Bingham assisted Chester Harding in his temporary studio in Franklin, Missouri. Harding's impact appears to have been fundamental, and a painting he did at the time remained with Bingham throughout his life.[15]

Bingham was born in Virginia. His family moved to Franklin, Missouri, in 1819, though after his father's death they lived on a farm in adjacent Arrow Rock, which remained the family homestead. While Bingham was apprenticed to a cabinetmaker in nearby Boonville, he had an encounter with an itinerant portraitist that rekindled the enthusiasm that must have evolved from his association with Harding. Significantly, one of his earliest efforts was a full-length hotel or tavern sign depicting Daniel Boone, probably based on James Otto Lewis's engraving and possibly on Bingham's memory of Harding's painting. Bingham adopted an itinerant career about 1833 and was working in such towns as Columbia, Liberty, and Saint Louis by 1835. In the winter of 1836–37 he was painting portraits in Natchez, Mississippi, and in 1838 he was in Philadelphia, viewing paintings at the Pennsylvania Academy of the Fine Arts and elsewhere. He may also have visited New York City and the National Academy of Design annual. During these years Bingham's art had developed from primitive beginnings toward increasingly sophisticated strategies of effective modeling and spatial illusion. He returned to Missouri late in 1838, but—following Harding's course—he first practiced extensively in the East, in Washington, D.C., in the autumn of 1840.

By the time Bingham returned from his prolonged stay in the East, he had developed a distinct, if rather undistinguished, professional style, creating haunting, austere likenesses that blossomed into occasional masterpieces, such as *John Cummings Edwards* (1844; Missouri Historical Society, Saint Louis) and *Dr. Benois Troost* (1859; Nelson-Atkins Museum of Art, Kansas City, Missouri). As Missouri's most distinguished native artist, he was called on to provide historical portraits, such as those of Thomas Jefferson and Henry Clay, for the Capitol in Jefferson City. But even before his Washington sojourn, he had begun to branch out into other genres, painting *Western Boatmen Ashore* (location unknown) in Philadelphia in 1838 and exhibiting it at the Apollo Gallery in New York City. In 1840 he sent genre, literary, and landscape subjects to the National Academy annual, and after he returned to Missouri, he began to specialize in subjects indigenous to the Mississippi valley: fur traders and trappers, flatboatmen, and individuals involved in political campaigns and elections on the civilized frontier. Other themes included squatters, farmers, and Indians and their captives. In addition to being carefully wrought compositions with strong, accurately drawn and painted figures, these works presented a national, yet exotic, range of subjects not depicted previously.

These paintings were destined primarily for an eastern audience, for Bingham's appearance as a genre painter coincided with the emergence of the art unions, the largest and most successful of which, the American Art-Union in New York City, was the successor to the Apollo Association (which had succeeded the Apollo Gallery), where Bingham had first exhibited. He sent his finest genre pictures to that group until its demise in 1852. The art unions purchased the works they accepted, thus offering a popular artist a degree of financial security, and as the works were distributed each year to subscribers around the country, the painter or sculptor was also guaranteed a wide reputation among art lovers. Bingham's popularity increased when several of his works were engraved by the American Art-Union for annual distribution to its entire membership, as happened with *The Jolly Flatboatmen* in 1847.

3.24

During its heyday in the late 1840s, the American Art-Union remained Bingham's primary outlet. He obviously favored the art-union concept, and the Philadelphia Art-Union and the Western Art-Union in Cincinnati also distributed his works, but to these he submitted fewer and often less significant canvases—landscapes and barnyard scenes. New York City offered him greater exposure and the opportunity to be compared with his most formidable eastern rival, WILLIAM SIDNEY MOUNT.

1.148

Even after the dissolution of the art unions, Bingham continued to produce genre paintings in Saint Louis, creating his most successful political pictures in the early 1850s.

3.24 George Caleb Bingham
(1811–1879)
The Jolly Flatboatmen, 1846
Oil on canvas, 38⅛ x 48½ in.
Private collection

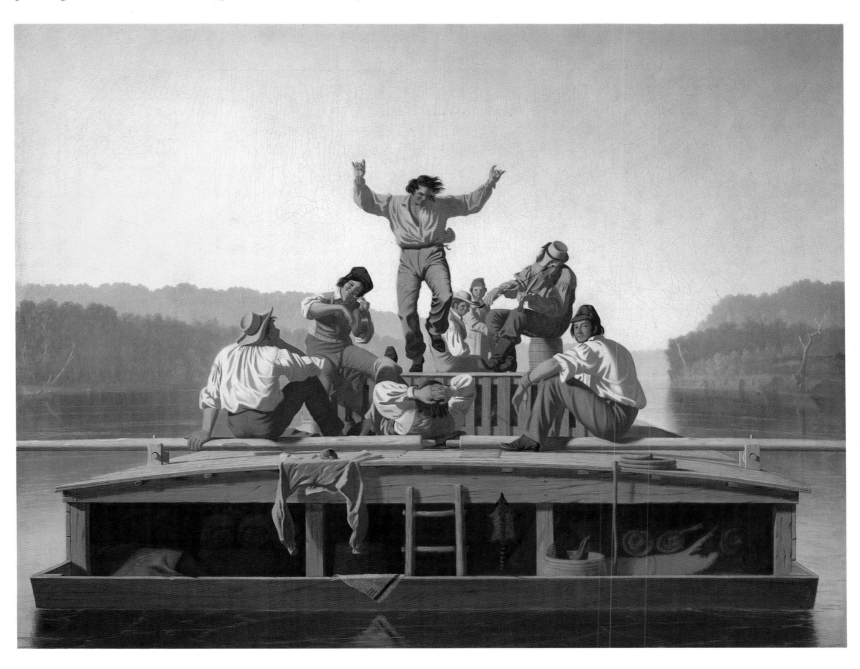

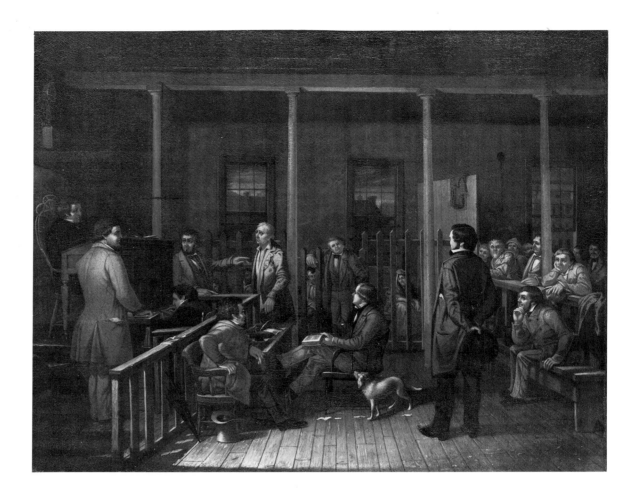

He had begun this series after his own defeat for the post of state representative in 1846; surely his creation of *The Stump Orator* (location unknown) the following year reflected his own increasing political ambitions. These election pictures, which climaxed with *The Country Election* (Saint Louis Art Museum and Boatmen's National Bank of Saint Louis), *Stump Speaking* (Boatmen's National Bank of Saint Louis), and *The Verdict of the People* (Boatmen's National Bank of Saint Louis), painted between 1851 and 1855, are far more complex than his previous works and attracted further recognition as engravings and lithographs. Bingham often repeated, with variations, some of the themes on which his earlier success had been built. He continued to produce portraits and landscapes, both of bucolic rural scenes and more dramatic western views. He occasionally attempted historical subject matter, most successfully with *The Emigration of Daniel Boone* (1851; Washington University, Saint Louis). Bingham's later years saw him increasingly involved with Missouri politics, though this does not appear to have interfered with his artistic activity. He was named professor at the newly established school of art at the University of Missouri in Columbia in 1877 and died two years later.[16]

Bingham does not appear to have developed a large coterie of students. The Virginia portraitist Henry James Brown is said to have studied with him in the 1840s, and one Charles Pinckney Stewart of Columbia went to Kansas City in 1870 to study with him, but he remained no more than two months. Probably the artist's best-known student was Ralph Davison Miller, who was born in Cincinnati and studied art there and in Kansas City with Bingham. In the late 1890s Miller settled in Los Angeles and became known as a painter of the scenery around Monterey, California, and in northern Arizona. Several Missouri genre painters appear to have been influenced directly by Bingham and his paintings, including James F. Wilkins and **William Josiah Brickey**. Wilkins's *Leaving the Old Homestead* (Missouri Historical Society, Saint Louis) strives for a pathos that Bingham successfully avoided. The contrasting solid stone homestead and Conestoga wagon marks this as a painting of the urban frontier, whether Saint Louis or elsewhere.

Brickey's slightly naïve *Missouri Courtroom* is more completely indebted to Bingham's relatively rare indoor genre pictures in its strong geometric foundation and concern with 3.25

political and legal processes. Brickey, a native Missourian, was born in Potosi and began painting portraits in 1841. In 1847 he spent two and a half months with Bingham in Arrow Rock, copying the latter's paintings; he then traveled throughout the state, settling in Saint Louis for several years in 1850 and sharing a studio with Alfred S. Waugh. Brickey valued his short time with Bingham tremendously. In ill health, he spent his last year, 1853, in Natchez, Mississippi, and New Orleans, where he died.

Still basically a frontier settlement, Saint Louis continued to attract painters of Indian life and western scenery. One of the most competent, **Charles Deas**, had grown up in Philadelphia and began his career as a painter of literary genre in New York City during the late 1830s. About this time he was inspired to go west and explore Indian subjects, no doubt spurred on by the achievements of earlier specialists, in particular George Catlin, whose Indian Gallery was on view in New York City in 1837–39. In 1840 Deas went to the Wisconsin Territory to visit a brother; he stayed at Prairie du Chien for most of 1841 and visited Fort Snelling. By the end of that year he had settled in Saint Louis, where he remained until the summer of 1847. In 1848 he tried unsuccessfully to finance an Indian gallery of his own.

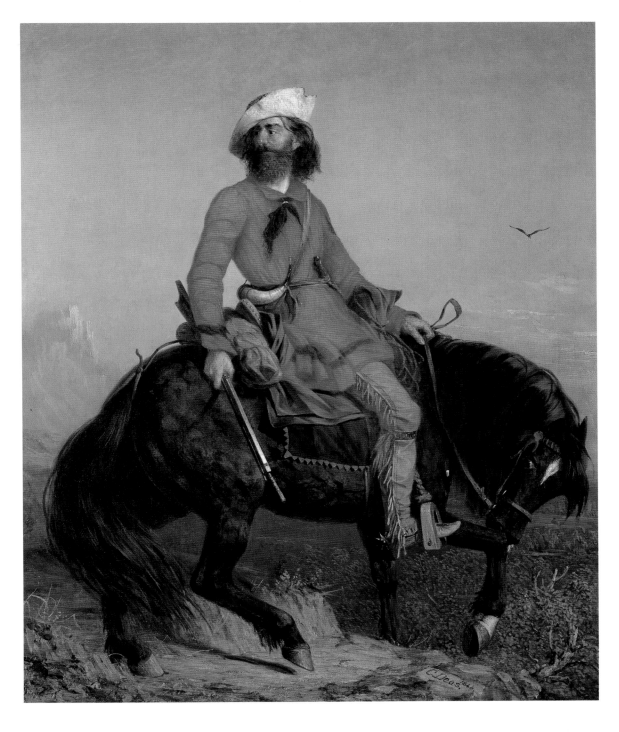

3.26 Charles Deas (1818–1867)
Long Jakes (The Rocky Mountain Man), 1844
Oil on canvas, 30 x 25 in.
Private collection

Deas's major works were painted during his six years in Missouri. His pictures of Indian life, unlike those of his predecessors, are carefully and academically rendered. He emphasized ethnographic specificity when rendering his Winnebago and Sioux subjects, depicting them playing ball or checkers. Deas also painted occasional portraits and landscapes as well as pictures of trappers, guides, and fur traders, which he exhibited locally and with the American Art-Union. There, his first major success was *Long Jakes* 3.26 *(The Rocky Mountain Man)*, which was acquired by the art union. In this imposing image the figure is seen from below as if dominating the mountainous wilderness, a wild yet refined man on the edge of civilization. The success of this and other pictures by Deas of French trappers and traders may, in fact, have inspired Bingham's major painting *Fur Traders Descending the Missouri* (1845; Metropolitan Museum of Art, New York). Deas's later pictures, such as his well-known *Death Struggle* (Shelburne Museum, Shelburne, Vermont) and *Prairie Fire* (Brooklyn Museum), present far more dangerous scenes than the assured calm of *Long Jakes*. Their instability and urgent frenzy almost surely reflect the artist's own increasingly unbalanced state of mind. In the summer of 1848 Deas, less than thirty years old, was committed to an asylum in New York City, where he had returned at the end of 1847.[17]

The finest Indian painter in Saint Louis in pre–Civil War days was Carl or **Charles F. Wimar**. Born and raised in Germany, Wimar settled in Saint Louis in 1843, before the great Germanic influx of the end of the decade. In 1845 he was apprenticed to Leon Pomarede, with whom he spent six years working on decorating commissions and assisting on Pomarede's Mississippi panorama. During their travels Wimar was inspired less by the extensive landscape than by the native inhabitants, and Pomarede urged him to pursue formal training in order to better depict them. For an ambitious American artist at midcentury, especially one born in Germany, this meant study in Düsseldorf, to which Wimar journeyed in 1852. He studied first at the Academy under Joseph Fay, who had painted the murals in the town hall in Elberfeld, Germany, and then under his compatriot Emanuel Leutze, one of the most famous history painters of the time. Even in Düsseldorf, Wimar became known as "the Indian painter." His formal training allowed him to combine academic structure, clearly delineated figures, and strong compositions to create more sophisticated works than those by earlier specialists in Indian subjects. The Düsseldorf tradition of history painting, often tendentious, influenced Wimar's representations of 3.27 Indians as both heroic and aggressive in their confrontations with white settlers or with the buffalo, their alter-image as a doomed race.

Wimar sent his pictures back to Saint Louis for sale before he himself returned in 1856. Certain themes, such as attacks on emigrant trains and buffalo hunts, appeared in a number of variations, some initiated in Germany and then reiterated in this country. Wimar made two extensive trips—in May 1858 and the summer of 1859—to the upper Missouri River country to study the Indians and to accumulate the necessary props for ethnographic authenticity. Though Indian painting remained his prime interest, he also painted numerous portraits and, in 1861, received a major public commission: the decoration of the Saint Louis Courthouse. These historical scenes, among the earliest such professional murals to be painted in this country, were created at the same time that Wimar's teacher Leutze was painting his monumental *Westward the Course of Empire Takes Its Way* in the House wing of the Capitol in Washington, D.C. Indeed, one of Wimar's four large panels bore the identical title (alternatively, *Westward the Star of Empire Takes Its Course)*, though he depicted a herd of grazing buffalo in Colorado driven westward by the arrival of emigrants, themselves fatigued by travel, rather than a panoramic tribute to western expansion, as did Leutze.[18]

Leutze, in fact, passed through Saint Louis in the summer of 1861 on his way to and from the West in order to record more authentically the Rocky Mountains for his giant mural. He visited his former student at the time, undoubtedly offering additional inspiration for the courthouse project. Wimar's study with Leutze and his solid professional training marked him as Saint Louis's most vaunted artist in the late 1850s, in some ways superseding George Caleb Bingham. This may have motivated Bingham himself to work

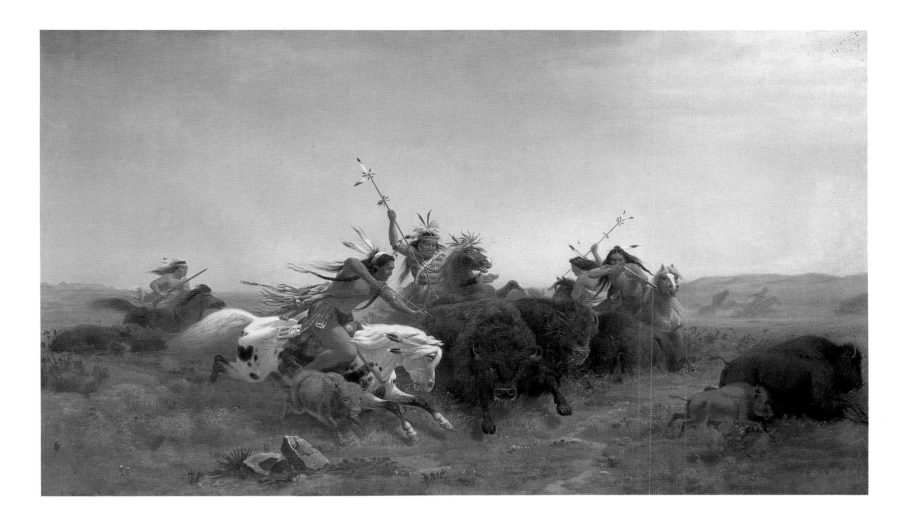

in Düsseldorf late in 1856. Another, less-known Saint Louis painter had a career similar to Wimar's. Matthew Hastings, who was born in Virginia, arrived in the city in 1840. After studying art at Saint Louis University, he too went to Düsseldorf, remaining for two years. Hastings returned to Saint Louis, establishing himself as a painter of black genre, portraits, and Indian subjects.[19]

History painting found few practitioners in Saint Louis at midcentury. Wimar undertook a series of paintings on the theme of Daniel Boone and his daughter's abduction by Indians. The city's earliest history painter—more a visitor than a resident—was the little-known German artist Johann Philip Gerke, who made his living painting portraits. Gerke was in Saint Louis in 1838 with his painting of Columbus on board ship—which had already been offered to Congress for consideration for the Capitol Rotunda—and other compositions. He painted a variety of esoteric historical subjects while in the city, from a depiction of blind Ullaf, king of Norway, and his daughter, who had been kidnapped by a Norwegian giant, to *Herrmann and Thusnelda* and *The Last Moments of Wallenstein* (locations unknown); the last was on public exhibition in the city as late as 1872.[20]

Even before Gerke's arrival the local citizenry had demonstrated a taste for pictorial spectacle. In 1831 a work supposedly by Jacques-Louis David, *Cain Meditating upon the Death of Abel,* was exhibited in the city, and in the fall of 1833 JAMES REID LAMBDIN, who recently had opened his museum in Louisville, Kentucky, put his original *Interior of a Nunnery* (location unknown) on view in Saint Louis. In 1834 *The Temptation* and *The Expulsion*, by an artist named LeBlanc, offered acceptable biblical nudity on a heroic scale, perhaps in competition with a pair of works on the same subject by Claude-Marie Dubufe, which were traveling around the country but seem not to have reached Saint Louis (LeBlanc's might have been copies). Although Dubufe's originals were destroyed by fire, probably in 1835, copies made in Baltimore by John Beale Bordley in the winter of 1833–34 appeared in Saint Louis in 1837, 1839, 1840, 1843, and 1850.

The Cincinnati painter Samuel Lee took his *Destruction of Sodom and Gomorrah* to

2.149

3.27 Charles F. Wimar
(1828–1862)
Buffalo Hunt, 1860
Oil on canvas, 35¼ x 60 in.
Washington University Gallery
of Art, Saint Louis; Gift of Dr.
William van Zandt, 1886

Saint Louis in 1835, and in 1840 the Irish-born itinerant Trevor Thomas Fowler presented the curious combination of Queen Victoria ascending her throne (a copy after Thomas Sully) and Venus reclining on her couch (supposedly an original) (locations unknown). In 1844 BENJAMIN WEST's *Death on a Pale Horse* (location unknown) appeared in town— most likely the version by William Dunlap or another copyist—followed by Rembrandt Peale's ever-popular *Court of Death* (1820; Detroit Institute of Arts) in 1847.

1.268

Art was included in the occasional museums that were set up in Saint Louis, though it usually played second fiddle to more exotic curiosities. William Clark's collection of Indian material was an exception in this regard. It is difficult to determine if he intended this as a public display, though he was certainly generous with access to his collection of Indian artifacts as early as 1816; his Indian picture collection existed by 1824. A traveling museum of wax figures and large paintings appeared in Saint Louis in 1819 and another in 1828. The next year a Saint Louis Museum was opened with a pictorial and sculptural component, and in 1830 Dr. N. St. Leger d'Happart opened another "universal" museum that included art; neither seems to have survived much longer than a year. Somewhat longer lasting was another Saint Louis Museum, opened in 1836 by Albert Koch, which featured panorama displays. In March 1841 John Banvard showed two early panoramas there, *Jerusalem* and *Venice* (locations unknown), and the following month he purchased a partnership in the museum with W. S. McPherson, who had bought it from Koch that January. Banvard quickly painted *Grand Panorama of Saint Louis* (location unknown), but he soon abandoned the museum business, supposedly due to bankruptcy. Nonetheless, this Saint Louis Museum continued to exist at least as late as 1859, when a catalog was issued of its sizable art collection, which included two landscapes by GEORGE CALEB BINGHAM.

3.24

While museums offered pictorial entertainments, they were generally peripheral to the professional art community. More important to the artists were opportunities for public exhibition. These began to occur with the shows of the Mechanics' Institute during the 1840s and the fairs of the Saint Louis Agricultural and Mechanical Society, which started in the next decade. An unsuccessful attempt was made to include an art gallery at the first fair in 1856, but nothing was submitted except some old master copies and a few good portraits by FERDINAND THOMAS LEE BOYLE. A significant display was introduced the following year, with works borrowed from private collections and presumably others submitted by local artists; this was the first art loan exhibition held in Saint Louis. Many of the works in the 1858 gallery were by amateurs, though a landscape by the now-expatriated Henry Lewis won a premium, and portraits were shown by Boyle, ALBAN JASPER CONANT, and MANUEL JOACHIM DE FRANÇA. In 1859 a large, dazzling painting show took place, with many examples by George Caleb Bingham and CHARLES F. WIMAR and premiums going to William F. Cogswell (for a portrait of Wimar), to Henry Lewis again, to Paulus Roetter (for landscapes), and to SARAH MIRIAM PEALE (for a melon still life). Roetter and Peale won premiums again in 1860, for landscape and portraiture, respectively, but that display was less varied and impressive than the previous year's.

3.22

3.23
3.21
3.27

1.319, 3.19

The reason for this decline was the establishment of a professional organization to which the local community gave wholehearted support. This was the Western Academy of Art, plans for which had been inaugurated at a meeting in Boyle's studio in December 1858. Originally envisaged were a sketch club; a school with primary, antique, and life classes; and regular exhibitions. The Sketch Club was soon formed, but despite local enthusiasm, the construction of a building and the acquisition of casts progressed slowly. Though institution of the school was repeatedly delayed, the first—and last—exhibition opened in 1860 with over four hundred works by the entire professional community and by nationally known and foreign artists. Lenders included local collectors as well as galleries in New York City, Philadelphia, and elsewhere, including Saint Louis's premier gallery, Pettes and Leathe. Though the show did not garner the expected receipts, a number of paintings were purchased (and others commissioned from local artists) to form a permanent gallery to serve the needs of students at the projected school. Like similar nascent organizations in Pittsburgh and elsewhere, the Academy, which was eagerly

looking forward to continuous operation of its school, became a casualty of the Civil War. The Agricultural and Mechanical Association Fairs also went into abeyance, to be revived only in 1867. Despite the city's North–South factionalism, a significant fair was assembled in support of the United States Sanitary Commission in 1864—the Mississippi Valley Sanitary Fair, which included an art gallery of over 350 works. A fair percentage of the canvases were by local artists: portraits by Boyle, Conant, and de França; Indian paintings by the departed CHARLES DEAS and the deceased Wimar; still lifes by HANNAH B. SKEELE; and landscapes by Lewis (now living in Düsseldorf) and by Bingham, whose only genre inclusion was *Chequer Players* (Detroit Institute of Arts).

3.26; 3.20

After the war the art displays at the Agricultural and Mechanical Association Fairs helped to fill the gap left by the demise of the Academy and by the fragmentation caused by national strife: the fairs provided an outlet for the local community through 1872. In 1867 and '68 Peale won premiums for fruit and flower paintings. Works by eastern artists were included as well as selections from Pettes and Leathe. The 1870 fair included a formidable display of American and European works; Skeele won prizes in both still-life and animal painting. Another dealer, George M. Harding, had appeared on the scene, featuring a collection of paintings by Saint Louis artists.

The galleries of the Saint Louis Mercantile Library were the other major exhibition facility available after the war. The library had built up a collection of paintings and sculpture even before the war and in 1859 had published a catalog of its holdings, which featured sculptures by Harriet Hosmer, who had acquired her anatomical training in Saint Louis. The collection also included European old masters and a few American ones, such as Peale's portrait of Thomas Hart Benton. By 1871, when another catalog was issued, the holdings were much increased and included portraits by nearly all of the city's present and earlier specialists—in particular, some of Bingham's most famous election and flatboat scenes. That year the library began to hold exhibitions. A number of paintings were for sale, but the greater parts of the shows of 1871 and '72 were loans from private collections.

One factor that emerges from a study of these shows is the immense popularity of the deceased Wimar. His work was exhibited in abundance and described enthusiastically. Bingham's work appeared, too, of course, but more sporadically and without garnering special attention. By 1870 many of the early local painters had died or moved. A new

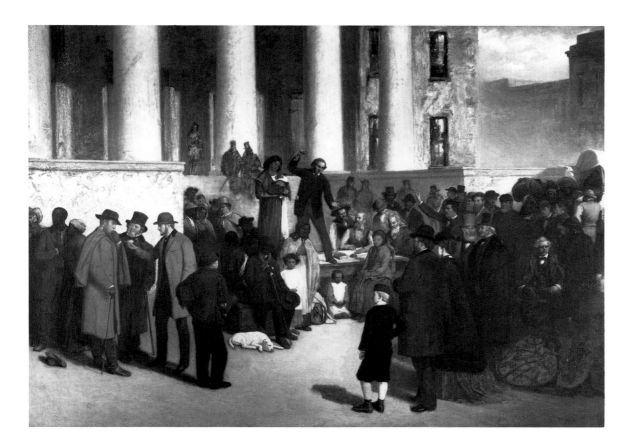

3.28 Thomas Satterwhite Noble (1835–1907)
The Last Sale of Slaves in Saint Louis, 1860
Oil on canvas, 60 x 84 in.
Missouri Historical Society, Saint Louis

generation had begun to emerge just before the war, undoubtedly encouraged by the association fairs and by the formation of the Western Academy of Art. One of the most talented of these was **Thomas Satterwhite Noble**. Born in Lexington, Kentucky, Noble studied with Thomas Couture in France from 1856 until 1859 and then set up a studio in Saint Louis, where his family had recently moved. Noble immediately joined the local art establishment, becoming a member of the Sketch Club; he won a premium for fruit painting at the Agricultural and Mechanical Association Fair in 1860 and contributed a number of figure paintings to the Western Academy of Art display that year. Soon after the beginning of the war, Noble joined the Confederate Army. In 1865 he reestablished himself in Saint Louis as a portrait painter, but a year later he was in New York City. In the winter of 1868–69 Noble accepted the professorship of the McMicken School of Design in Cincinnati. Saint Louis had not only been significant for Noble's professional maturation but also provided him with the subject of his first great success: *The Slave Mart*, begun and presumably completed in Saint Louis in 1866 and first shown at Pettes and Leathe. This picture, showing the sale of a slave girl on the auction block in front of the local courthouse and containing about seventy-five figures, won accolades throughout the country; after it was destroyed in the Chicago fire of 1871, Noble painted a replica entitled *The Last Sale of Slaves in Saint Louis*. The original was a harbinger of the best known of Noble's later compositions, all dealing with slavery: *John Brown Led to Execution* (New-York Historical Society), *Margaret Garner* (private collection), and *The Price of Blood* (Robert M. Hicklin Jr., Inc., Spartanburg, South Carolina).[21]

2.176

3.28

The other major figure painter to appear just prior to the Civil War was Louis Schultze. German-born, he began his studies in Berlin in the mid-1830s and continued them in Munich. The date of Schultze's arrival in this country is not known, but he seems to have gone to Saint Louis about 1855, first as an assistant to Manuel Joachim de França, and he appeared as an independent portrait painter in the local directories in 1859. Schultze was professor-elect at the school of the Western Academy of Art and stayed in the city even though the school never materialized. In addition to portraiture, he seems to have specialized in outdoor domestic genre scenes and depictions of blacks, but as the 1860s progressed he turned to landscape subjects and to watercolor, in which medium he was regarded as unsurpassed in the Midwest. His *Mother and Dead Christ* in Saint Joseph's Convent was regarded as his masterpiece. In his scenic work Schultze specialized in Missouri and southern Illinois views, which he also exhibited in New York City, and in scenes set in Switzerland, Bavaria, the Tyrol, and the West, indicative of his extensive travels. The last record of Schultze is his role in 1895 as vice president of the Art-Union Palette, a local association that sponsored the Historical Art Exhibition of Works by Saint Louis Artists of the Last 50 Years that same year. With thirty-nine oils and watercolors, Schultze was a major exhibitor.[22]

Landscape painting became the focus of interest among Saint Louis's artists just before the Civil War. Landscapist Paulus Roetter, an older German emigrant from Nuremberg, had studied in Munich and Düsseldorf. He came to this country to join an early utopian community in Dutzow, Missouri, and in 1845 he arrived in Saint Louis as an artist and pastor. Eleven years later Roetter became the first teacher of drawing at Washington University, a position he retained through 1861. It was not until the late 1850s that he emerged as a serious portrayer of romantic scenes set along the bluffs of the Mississippi. In addition to winning several premiums in the 1858 Agricultural and Mechanical Association Fair, Roetter was well represented at the 1864 Sanitary Fair by both local and German views. He served in the home guard during the war and by 1867 had become an associate of Louis Agassiz at Harvard University, though he returned to Saint Louis in 1884 for his last decade.[23]

Another even less-documented painter who disappeared from view after the Civil War was Henry Isaacs. Isaacs showed several works at the 1859 Association Fair and exhibited *Scene on the Upper Missouri* (location unknown) at the Western Academy of Art the next year. That he was considered to be especially promising is indicated in a report from Saint Louis to New York City's *Crayon* magazine in December 1859, which noted

3.29 Joseph Rusling Meeker
(1827–1889)
The Land of Evangeline, 1874
Oil on canvas, 33 x 45½ in.
The Saint Louis Art Museum;
Purchase: Funds given by Mrs.
W. P. Edgerton, by exchange

that "Mr. Isaacs, a young aspirant for artistic honors, is giving evidence of ability that needs but culture to give him a position."[24] Subsequently, Isaacs appears to have turned to a career as an architect.

The landscapist who replaced George Caleb Bingham and Charles F. Wimar as the best-known painter in Saint Louis for the next several decades was **Joseph Rusling Meeker**. Meeker had been born in Newark, New Jersey, grew up in Auburn, New York, and studied in New York City at the National Academy of Design in 1845. In 1848 he returned to Auburn for a year and then painted in Buffalo before settling in Louisville, Kentucky, where he was active from 1852 until 1857. There he undoubtedly would have met the young Thomas Satterwhite Noble, who would have sought out such a well-trained professional artist; Noble might even have received instruction from Meeker. They certainly would have renewed contact when Meeker settled in Saint Louis early in 1859 for the remainder of his career.

In his post–Civil War years Meeker traveled widely in search of picturesque scenery, painting in Minnesota, in the Wyoming Territory, along the New England coast, and locally along the Meramec River. His reputation is based on his haunting, luminous views of the bayou country in southern Louisiana, which he explored while serving with the Union Navy during the Civil War. While Meeker's earlier work extended the aesthetic of the Hudson River School, by 1869 he was concentrating on quiet, empty scenes of cypress and oak forests overgrown with Spanish moss, rising from placid waters. These compositions, infused with a hazy, silvery light, represent a regional version of Luminism, a resemblance accentuated by the extended horizontality of some of Meeker's canvases. In his vertical canvases Meeker focused greater botanical exactitude on the thick, sinuous tree trunks. Several of his most ambitious bayou scenes are infused with literary associations inspired by the Acadians, the French settlers from the Canadian Maritime provinces, a subject immortalized in Henry Wadsworth Longfellow's *Evangeline* (1847). Meeker's two

3.29 most ambitious works are probably *The Land of Evangeline* and *The Acadians of Atchafalaya* (Brooklyn Museum), both of the early 1870s. One of his most significant pupils, Augusta S. Bryant, was active as a delineator of Missouri scenes during the 1880s and one of the few women landscape painters of the time.

Immediately hailed as an outstanding talent in Saint Louis, Meeker was extremely

active in the art establishment. A member of the Western Academy of Art, he later was active in the Saint Louis Art Society, the Saint Louis Sketch Club (which he founded), and the Saint Louis Academy of Fine Arts. As a champion of the English artist J.M.W. Turner, Meeker wrote articles for the important periodical the *Western*. His work, promoted by the dealer George M. Harding and collected by the patron C. B. Carr, dominated the Agricultural and Mechanical Association Fairs in 1868 and '70.[25]

James William Pattison, having fought in the Civil War and returned home to nearby Alton, Illinois, in 1865, studied with Alban Jasper Conant in Saint Louis. Rejecting Conant's specialty of portraiture, Pattison became a landscapist. In 1868 he began to teach drawing at the Scientific School and at Mary Institute, both branches of Washington University, where Paulus Roetter had been the first drawing teacher; in 1872 Pattison was named the university's first professor of drawing. In the summer of 1869 he had taken a group of students to Colorado, and on the basis of sketches made on this trip he created a number of major western landscapes, including *Twin Lakes, Colorado* and *The Rocky Mountains* (locations unknown). In 1873 Pattison went to Düsseldorf, working privately with the former Academy instructor Albert Flamm, convinced that Düsseldorf surpassed both Munich and Paris for landscape work. Later Pattison studied and painted in France, then settled in Jacksonville, Illinois, and, finally, in Chicago.[26]

In Saint Louis, Pattison shared a studio with WILLIAM MERRITT CHASE, who was there late in 1870, fresh from his studies at the National Academy of Design in New York City. Earlier, in Indianapolis, Chase had begun to specialize in still-life painting, which he continued in New York. He brought this genre to a peak of technical perfection in Saint Louis, creating rich, complex fruit arrangements, which he exhibited in 1870 and '71 at the Agricultural and Mechanical Association Fairs and the Mercantile Library. So successful were these still lifes that a group of patrons offered to subsidize Chase's study abroad. These included a wealthy merchant, Samuel F. Dodd; the architect, connoisseur, and leading art critic William R. Hodges; and probably the most active local patron, Samuel Coale, who commissioned Chase to act as his art-buying agent. Partly on the advice of the artist JOHN MULVANY, recently returned from Munich and temporarily residing in Saint Louis, Chase departed for the Bavarian capital in 1872. Pattison was later to be one of many to write biographical accounts of his former studio-mate.[27]

About 1871 the old Insurance Exchange Building at the corner of Broadway and Olive Street became an important artistic center. Chase and Pattison had their studio there, Hodges had his office there, and Alban Jasper Conant, Joseph Rusling Meeker, and George Calder Eichbaum—a portraitist from Pittsburgh who settled in Saint Louis in 1859 for the rest of his long life—all had studios in the structure. Sharing Eichbaum's studio was Saint Louis–born THOMAS ALLEN, a former student at Washington University. One of the students who accompanied Pattison on his 1869 trip to Colorado, Allen was inspired to choose an artistic career. In 1871 he went to Düsseldorf, where he later linked up with his former teacher, also seeking instruction in Paris. Allen, who spent most of the late 1870s at the family homestead in Pittsfield, Massachusetts, is best known for the paintings he did in San Antonio, Texas, in 1878–79. He later settled in Boston as a painter of bucolic, Barbizon-style landscapes.[28]

The other members of this postwar generation were Harry Chase and JAMES REEVE STUART, the latter a portraitist from the South who had gone to Saint Louis in 1868, settling a few years later in Madison, Wisconsin. Stuart and Harry Chase, who shared a studio, had studied in Munich. Even then Chase had been drawn to marine painting, recording scenes on the Danish North Sea coast. After a brief time in Saint Louis he returned to Europe, working for two years in Paris and painting the French coast. He passed three years in Holland, chiefly in the Hague, studying with Hendrik Willem Mesdag. Chase became one of the major American proponents of the Hague School of Dutch "impressionists" before his return to Saint Louis in 1879. He remained for only a short time before moving to New Bedford, Massachusetts, and then to New York City.[29]

The young, ambitious artists who appeared in Saint Louis soon after the Civil War remained only a short while. What was to give the city a more permanent and more

1.146, 1.155

3.42

2.109

2.305

dynamic art establishment was the founding of institutions devoted to art education. Art had, of course, been taught there privately almost from the beginning. In 1809 Christopher Friederich Schewe opened a language school with other subjects, such as drawing, offered on demand. Later that same year Isaac Livres planned to open a drawing school, as did Ve Pescay in 1812. More concerted efforts were made after Saint Louis Academy, founded in 1818, was expanded into Saint Louis College in 1820, at which time the portrait and miniature painter François Guyol de Guiran was professor of writing and drawing before departing for New Orleans. The Art Hall, started in 1866, seems to have had indifferent success despite an effort at reorganization in 1868 as the Saint Louis Academy of Art.

The Munich-trained Conrad Diehl had grown up in the Saint Louis area, returning from Chicago when his studio was destroyed in the 1871 fire. He founded the Saint Louis School of Design, where some of his Chicago students joined him. The school flourished through 1879. A painter of portraits and historical and literary subjects, Diehl also taught in the public schools and planned (but never published) a textbook to revolutionize the teaching of art in America. An invitation to replace the deceased George Caleb Bingham at the University of Missouri led him to move to Columbia in 1879. Several other design schools were founded in the late 1870s in Saint Louis. One, begun in 1877, stressed the decorative and fine arts, with Louis Schultze and Paul Harney, recently returned from Munich, among its faculty, but no notice is found of it after 1878. Another institution, the Saint Louis School of Art and Design, also founded in 1877, stressed women's work in the arts but appears to have lasted only until 1879. Started by Mrs. John B. Henderson, it was modeled on the South Kensington School of Art and Design in London.[30]

The Saint Louis School of Fine Arts was founded in 1879 by **Halsey Cooley Ives**, the most significant figure in the local art world of the later nineteenth century. Having fought in the Civil War, he became a designer and decorator, settling in Saint Louis in 1874. That year he became an instructor at the O'Fallon Polytechnic School of Washington
2.137 University, establishing at the same time a free evening drawing school. CARL GUTHERZ from Memphis joined the school's faculty in 1875, and Ives went abroad for a year of study, returning as professor of art and art education. Ives, Gutherz, and the departed Pattison were the artists listed among the organizers of the Saint Louis Academy of Fine Arts, which was founded as an independent, professional school at the beginning of 1878. This Academy seems to have merged with the Saint Louis Museum and School of Fine Arts, headed by Ives in 1879 as a separate art department at Washington University. Two years later, with the patronage of Wayman Crow, the museum itself opened to the public. Ives remained devoted to both it and the school, although in 1892 he was called to Chicago to organize the art department of the World's Columbian Exposition. In 1904 he assumed the same duties for the Louisiana Purchase Exposition held in Saint Louis. When

3.30 Halsey Cooley Ives
(1847–1911)
Waste Lands, 1895
Oil on canvas, 8 x 15 in.
The Saint Louis Art Museum;
Gift of Charles Nagel, Sr.

the Saint Louis Art Museum was founded in 1906, Ives became its director, relinquishing his connection with the art school, which by then had become one of the most respected in the Midwest. Ives was a distinguished painter of moody, ''dreary'' landscapes, strongly painted in a Barbizon mode, such as *Waste Lands*, a prize winner at the Lewis and Clark Centennial Exposition in Portland, Oregon, in 1905, but his administrative duties precluded the creation of an extensive oeuvre.[31]

3.30

Carl Gutherz served on the faculty of the university and the School of Fine Arts until 1884, when disagreement with Ives led him to resign and return to Paris. Another distinguished artist who was an early member of the school's faculty was Paul Harney, who was born in New Orleans but grew up in Saint Louis. There he was an art student by 1870, sharing a studio with James Reeve Stuart and Harry Chase and becoming a private pupil of Alban Jasper Conant. Harney began to exhibit independently in 1873 and studied in Munich between 1874 and 1877, returning to teach at the School of Fine Arts from 1880 until 1885. At first a painter of foreign figural subjects, he became famous as a specialist in barnyard scenes. Harney remained in the Saint Louis area, starting an outdoor summer school in 1883 across the Mississippi River at Shurtleff College in Alton, Illinois; two years later he became head of a permanent art department there and also taught at Monticello College, remaining resident in Alton for the rest of his career. He returned to Saint Louis proper after 1912, soon after completing a series of portraits in New York City for Conant, then rapidly failing in health.[32] In the 1890s Harney turned to sculpture, having studied with Rupert Schmidt in San Francisco.

The most distinguished painter from the School of Fine Arts' first student body was Mary Fairchild, winner of the Wayman Crow medal for drawing in 1880 and a member of the faculty from 1882 until 1885. She then went to Paris to study, and there

3.31 John M. Tracy (1844–1892)
Botany, 1891
Oil on canvas, 16 x 24 in.
The Phelan Collection

2.115 she married the renowned sculptor Frederick William MacMonnies in 1888. FRANK M. REAUGH, who studied at the school in 1884, became the leading painter of his generation

3.240 in Dallas. And another alumnus, BENJAMIN CHAMBERS BROWN, became one of Southern California's most distinguished Impressionists.

One of the most impressive early achievements of the School of Fine Arts was *Palette Scrapings*, the student periodical published between January 1882 and January 1885. This was the earliest of the magazines produced by America's new professional art schools; *Art Student*, from the Boston Museum School, began publication in June 1882, probably inspired by *Palette Scrapings*. The Saint Louis magazine lasted longer than most of the similar publications that followed from Boston, Cleveland, Chicago, and Washington, D.C. Mary Fairchild edited *Palette Scrapings* for most of its three years of publication. Her drawings were reproduced in the magazine, as were those by a number of other promising students, including James M. Barnsley, John Hemming Fry, and Fred Lippelt. Fry married his fellow student Georgia Timken and became a member of the faculty from 1882 until 1894, interrupting his teaching to study in Paris. A figure painter, he was an apostle of latter-day classicism in the mode of Kenyon Cox and an outspoken opponent of modernism.[33] Lippelt and Canadian-born Barnsley, who was in Paris by the winter of 1883, were both landscapists who appear to have been among the first to record the beauty of the Ozark wilderness in the southern part of Missouri, around Arcadia, Pilot Knob, and Ironton. Lippelt studied at the School of Fine Arts for five years and then went to Paris; he returned to teach in 1887, but drowned two years later. Barnsley was painting and exhibiting in Saint Louis by 1888.

The early 1880s were an especially felicitous period for art publishing in Saint Louis. While no city other than New York was able to sustain such specialized journalism until Chicago entered the arena in the 1890s, Saint Louis did achieve brief success a decade earlier. Even before *Palette Scrapings* appeared, the short-lived but extremely informative *Art and Music* made its debut in September 1881, continuing into the following spring. After a hiatus, publication resumed in Chicago at the end of the year, before the magazine was absorbed into the *Illuminator*. William R. Hodges was one of the chief writers for *Art and Music*; he also wrote on art matters for the *Spectator*, a weekly publication in Saint Louis during the early 1880s with informative articles on the local scene.

During its short life *Art and Music* gave special attention to the activities of the monthly sketching receptions held by the Sketch Club; the results of those receptions usually were on view the following day at Harding's Gallery. The city's most important art organization at the time, the club numbered among its members almost all of the important local painters and sculptors, including **John M. Tracy**. Born in Rochester, Ohio, Tracy had studied in Chicago with Albert Leighton Rawson before going on to Paris in 1867. Tracy then settled in San Francisco, working primarily as a landscapist; when the depression of 1877 forced many of the artists there to seek patronage elsewhere, Tracy settled in Saint Louis in 1878. Though he first established himself as a portraitist, he soon

3.31 became known for his animal paintings—cattle pictures and sporting paintings of horses and hunting dogs, which established his reputation. About 1883 he moved to Greenwich, Connecticut, and by the end of the decade he had settled in New York City.[34]

3.180 Also in Saint Louis at this time was **William Lewis Marple**, a well-established landscape painter who had joined the California gold rush, becoming one of the principal and most successful artists in San Francisco, where he settled in 1866. In 1877 Marple, like Tracy, left that city; he went to New York City, but in 1879 he settled temporarily in Saint Louis, where he was founder and director of the Saint Louis Art Association. In the winter of 1880–81 Marple participated with Tracy and Joseph Rusling Meeker in a sale of paintings, the meager result of which led William R. Hodges to write a diatribe against local patrons, for withholding support from local artists, and against those artists, for producing too many works tailored to the marketplace.[35] While many of Marple's paintings seen in Saint Louis were views of California, he spent the summer of 1881 sketching in the Arcadia Valley of the Ozarks, where James M. Barnsley and Fred Lippelt had also

3.32 been working. Marple also painted local subjects, such as *Light Falls on the Wharf*, scenes

3.32 William Lewis Marple
(1827–1910)
Light Falls on the Wharf, n.d.
Oil on canvas, 13½ x 23½ in.
The Missouri Athletic Club,
Saint Louis

admired for their atmospheric poetry. He relocated in Aspen, Colorado, apparently abandoning art to devote himself to silver mining. His long-time associate in both painting and mining, HARVEY OTIS YOUNG, was resident in Saint Louis in 1881, exhibiting at the School of Fine Arts a recent Ute Indian scene along with a Fontainebleau landscape of a few years earlier, lent by a local patron. 3.88

George W. Chambers, a Saint Louis native, studied at the School of Fine Arts under Gutherz and then went to Paris in 1880 as a student of Jean-Léon Gérôme. He returned in 1885, taught at the school for two years, and then became involved in decorative work and stained glass.[36] Ernest Albert, who had been appointed scenic painter at Pope's Theatre in Saint Louis in 1880, remained until he moved to work at the Chicago Opera House in 1885. Albert was also a landscape painter of considerable ability. In 1895 Charles Holloway also left Saint Louis for Chicago, where he became known as a mural painter and designer of stained glass. Active in the Sketch Club, Holloway had taught at the School of Fine Arts in the late 1880s. William Henry Howe first studied drawing in Saint Louis and was a member of the Sketch Club, then went to Europe for twelve years in 1880, studying for two years in Düsseldorf and then with the animal specialist Otto de Thoren in Paris. In 1884 he exhibited a cattle picture in Saint Louis, which he gave as his home address, but when he returned to this country, he settled in Bronxville, New York, gaining a reputation as the nation's foremost cattle painter. Lizzie Sylvester was, in the early 1880s, one of the few women members of the Sketch Club; an early student at the School of Fine Arts, she went to New York City to study at the Art Students League.

Cassily Adams, an artist of some significance *without* a recorded affiliation with the Sketch Club, is best remembered for his *Custer's Last Fight,* completed in Saint Louis, probably in 1885, and destroyed in a fire in an army officers' club headquarters in Fort Bliss, Texas, in 1946. Adams had studied under Thomas Satterwhite Noble at the McMicken School in Cincinnati about 1870 and settled in Saint Louis about 1878 or '79, remaining until 1884 or '85, when he returned to Cincinnati. Adams painted his version of Custer's heroic battle for two associate members of the Saint Louis Art Club, who 3.33 planned to promote it for exhibition, stimulated by the success achieved by JOHN MULVANY 3.42 in Kansas City with a canvas of the same subject. When the proceeds proved to be disappointing, the owners sold Adams's picture to the keeper of a saloon at Eighth and Olive streets, and after the latter's death one of the chief creditors, the brewing firm of Anheuser-Busch, acquired the picture in lieu of payment. About 1895 the painting was presented to the Seventh Cavalry Regiment and was moved around a number of army forts until it wound up at Fort Bliss. Before the presentation Anheuser-Busch had had the picture copied and chromolithographed by the Milwaukee Lithographic and Engraving

3.34 Company; German-born **Otto Becker** made the copy and supervised the printing, with the result that his name is now attached to the image, of which 150,000 lithographs were produced. Cassily Adams, the painter of what may be the best-known image produced in Saint Louis during the late nineteenth century, is largely forgotten.[37]

Reflecting the developing cultural scene in the late 1870s, the Saint Louis Academy of Fine Arts was formed by prominent businessmen and artists such as Meeker to promote art through classes, receptions, and shows. Their aim—perhaps a bit premature—was to erect a building with exhibition space and to establish a permanent art gallery. Soon after, exhibitions of a scope and quality almost unparalleled in the Midwest did begin to occur. In 1881 the Museum and School of Fine Arts presented a loan show including work by Harry Chase, Carl Gutherz, William Lewis Marple, Louis Schultze, Charles F. Wimar, and others alongside that of leading European contemporaries. In 1883–84 the Saint Louis Exposition Building and Music Hall was constructed on Olive Street; in 1884 it began to host major annual exhibitions, which continued through 1901. The superintendents of the early shows were the art dealer Henry B. Pettes and, later, Andrew Redheffer, of Redheffer and Koch; Halsey Cooley Ives was on the committee of fine arts, thus ensuring high quality and good local representation. Many of the American exhibitors were former residents who had settled in the East, including John M. Tracy, Harry Chase, Thomas Allen, Carl Gutherz, and Mary Fairchild.

In 1888 the local art establishment was especially well represented in this annual, but in 1890 a drastic change was made that guaranteed greater international prestige at the expense of local artists. Subsequent exhibitions included small subgroupings of current and well-known schools, sometimes incorporating solo exhibits. The one held in 1890 had sections devoted to the Barbizon School, the Hispano-Roman School, and (in their first Saint Louis showing) the French Impressionists; there were also large presentations

ABOVE:
3.33 Cassily Adams (1843–1921)
Custer's Last Fight, 1885
Oil on wagon canvas, 15 × 25 ft.
Destroyed

BELOW:
3.34 Otto Becker (1854–1945)
Custer's Last Fight, 1896
Lithograph (first edition),
39 × 49½ in.
Anheuser-Busch Archives, Saint Louis

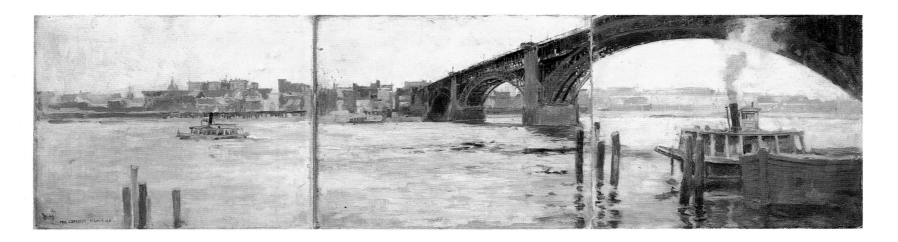

3.35 Paul Cornoyer (1864–1923)
*A View of Saint Louis:
A Triptych*, 1898
Oil on canvas on board,
12½ x 46⅞ in.
Courtesy of Christie's,
New York

of the work of William Merritt Chase and JOHN LA FARGE. In 1891 different national watercolor schools were grouped along with works by CHILDE HASSAM and a retrospective presentation—probably the first in the country—of the Hudson River School.

1.88

1.30, 1.154,

3.144

This policy was continued and enlarged in 1894, when Charles M. Kurtz assumed the art directorship of the Saint Louis expositions. Kurtz was a brilliant writer, organizer, and administrator who had studied at the National Academy of Design in 1877–78 and was editor of *Art Union* magazine in New York City in 1884 and of *National Academy Notes* from 1881 until 1889. From 1883 until 1886 he was director of the art department of the impressive Southern Expositions in Louisville, Kentucky, and in 1889 he became art editor of the *New York Daily Star*. In 1891 Kurtz became Halsey Cooley Ives's assistant chief for the department of fine arts at the World's Columbian Exposition, and he followed Ives back to Saint Louis in 1894. Together, these two men supported a golden age in the city's artistic life. After being appointed assistant director of fine arts for the United States Commission to the Paris International Exposition of 1900 and again as Ives's assistant chief in 1901 for the Louisiana Purchase Exposition of 1904, Kurtz became the first director of the new Albright Art Gallery in Buffalo in 1905.[38]

The first exposition show that Kurtz supervised, in 1894, emphasized French Impressionist and Dutch paintings, which were not new to Saint Louis, but in 1895 he introduced the Glasgow School to this country, one of his most impressive achievements. That same year, capitalizing on the popularity of the Scandinavian paintings shown at the Columbian Exposition, he introduced a large collection of contemporary Danish pictures; in 1896 he introduced the Munich Secession to America. The local establishment's participation in the annuals was also revitalized by Kurtz, who stressed "Americanism" in the shows of 1898 and '99. After he left, the final exposition show, of 1901, consisted solely of works owned in Saint Louis, some lent by local artists who were also well represented, but the international scope of the shows was no more.

Born in Saint Louis, Will Sparks followed the usual pattern of the neophytes of the 1880s, studying at the School of Fine Arts and in Paris. Sparks returned in 1886 and exhibited at the exposition of 1888, meeting Mark Twain, whose vivid descriptions of California induced him to settle that year in San Francisco, where he became one of the most prolific painters of the missions and of nocturnal scenes in the local adobes. Other, less-known professionals who appeared in the mid-1880s remained in Saint Louis. These included the still-life specialist John Tenfeld, the figure painter Edgar Julian Bissell, and Paris-trained David S. Diamant, noted for his portraits and scenes of foreign travel. English-trained Holmes Smith became an even more significant member of the community, arriving in 1884 as professor of drawing at Washington University and becoming involved in most of the local art organizations. Smith specialized in New England shore scenes, working in both oils and watercolors, and became one of the city's best-known specialists in the latter medium along with Charles Ault, who had moved to Cleveland by 1895.

John Douglas Patrick, a former student at the School of Fine Arts, returned to teach there in 1889, fresh from his triumph that year at the Paris International Exposition

with his powerful painting of a man and a horse, *Brutality* (Grayce Patrick Wray and Hazel Patrick Rickenbacher, Kansas City, Missouri). He remained for three years and then went to teach in Kansas City. In 1889 Patrick was joined by the peripatetic artist and Episcopal minister JOHANNES ADAM OERTEL, who taught until 1891. During his years in Saint Louis, Oertel produced only two major religious works: *Christ Known by His Breaking of Bread at Emmaus* (location unknown) and *Ezekiel's Vision of Restored Israel* (University of the South, Sewanee, Tennessee).[39] Another major figure painter to reside in Saint Louis by the end of the nineteenth century was Frederick Lincoln Stoddard from Quebec. Stoddard had studied at the School of Fine Arts in 1883–85 and, after instruction in Paris, returned in 1899 to teach there. He created decorative panels featuring idealized figures in harmonious, generalized landscapes and was a noted mural painter for churches and schools, most importantly for the City Hall. Later in his career Stoddard moved to Gloucester, Massachusetts.

By the later 1880s a landscape school was beginning to form in Saint Louis that would become the city's most distinctive artistic feature. Its members stressed poetic mood over topographical naturalism. Among them was Sylvester Annan, a Paris-trained painter of Tonal landscapes, and, more important, **Paul Cornoyer**. Born in Saint Louis, Cornoyer studied at the School of Fine Arts in 1881; he began his career exhibiting rustic scenes in a Barbizon mode in 1887 and in 1889 went to Paris for additional training. By the early 1890s he had turned to a more lyrical Tonal approach, applying this aesthetic to city scenes as well as to landscapes. Cornoyer had returned by 1894, painting a mural depicting the birth of Saint Louis for the Planter's Hotel. However, his activities during the next six years were not especially profitable, and few of his Saint Louis paintings are located. A notable exception is his triptych, *A View of Saint Louis*, its urban realism heightened by the strong diagonal thrust of the Eads Bridge. Opened in 1874, the bridge became the primary symbol of Saint Louis's urban modernity, functioning both as the physical gateway to the West and as a marvel of engineering comparable to the Brooklyn Bridge in New York City. Cornoyer was only one of Saint Louis's artists to celebrate the structure, the most notable and devoted of whom was FRANK NUDERSCHER.[40]

Having acquired work by Cornoyer (probably the Parisian scene shown at the Pennsylvania Academy of the Fine Arts annual in 1896–97), WILLIAM MERRITT CHASE encouraged him to move to New York City. This the Saint Louis painter did in 1899, becoming an early specialist in Tonal urban scenes such as his masterwork, *The Plaza after Rain*, acquired in 1910 by the new art museum in his native city.[41] German-born Gustav Wolff, a student of the School of Fine Arts, and especially of Cornoyer, followed his teacher as a specialist in Tonal landscapes. And Wolff, who remained a major landscapist in Saint Louis, was the teacher of Arthur Mitchell, also a delineator of poetic landscapes in the early twentieth century and a long-time resident of that city.[42]

Cornoyer's emphasis on Tonal aesthetics was undoubtedly supported by the emergence of **Edmund H. Wuerpel** as one of the major painters of Saint Louis. Unlike Cornoyer, Wuerpel remained a vital figure in the city for his entire career. Born in Clayton, outside Saint Louis, he attended the School of Fine Arts for two years beginning in 1886 and then went to Paris. There he met James McNeill Whistler while copying the latter's portrait of his mother in the Louvre. The ensuing friendship was the determining factor in Wuerpel's aesthetic development. In 1892 Wuerpel, who had been a protégé of HALSEY COOLEY IVES, was asked by the latter to accompany him to Spain to search for paintings for the World's Columbian Exposition. Two years later Ives invited Wuerpel to return to Saint Louis as instructor in the school's life class. When the museum and school split fifteen years later and Ives became director of the museum, Wuerpel was named director of the Art School. Wuerpel was a writer and an important figure in art education in Saint Louis. His history of art in the city, written in 1897, was published two years later; he also wrote a two-part reminiscence of Whistler.[43]

Whistler's aesthetics infuse the lovely, poetic landscapes, such as *An Evening Song*, that Wuerpel created and began to exhibit at the Saint Louis expositions in 1894. He also

3.36 Edmund H. Wuerpel
(1866–1958)
An Evening Song, c. 1894
Oil on Masonite,
25½ x 19½ in.
Washington University Gallery
of Art, Saint Louis; University
Purchase, Subscription Fund

2.135

3.35

3.40

1.146, 1.155

3.30

3.36

3.37 Frederick Oakes Sylvester
(1869–1915)
The River's Golden Dream,
1911–12
Oil on canvas, 40 x 30 in.
The Saint Louis Art Museum;
Museum purchase

adopted the philosophy of art for art's sake that Whistler espoused. Wuerpel's pictures were frequently referred to as "songs in paint" and their effects compared to those of musical harmonies. Wuerpel wrote for the catalog of his solo show at the Saint Louis Museum in 1912: "These paintings are not easel pictures meant to catch the passing eye. They are meant to decorate, to become a part of a room, just as the door or window or the furniture is a part of the room. They are meant to be LIVED with. And to return in quiet and reminiscent moods the interest which the observer may have in them."[44] In his landscapes Wuerpel aspired to a spiritual interpretation of nature that accorded with the Hegelian philosophy dominant in Saint Louis intellectual circles after the Civil War.

Among the many other landscapists who studied at the School of Fine Arts and then in Paris were Edward Morton Campbell and Louis Berneker. Campbell returned to teach at the school, beginning in 1889, and to paint lyrical Symbolist landscapes, while Berneker settled in New York City and painted extensively at Gloucester, Massachusetts. Both artists participated in the expositions in Saint Louis during the 1890s.

The third major landscapist to appear in the 1890s, and probably the most admired of the city's late nineteenth-century painters, was **Frederick Oakes Sylvester.** The short-lived Sylvester was born in Brockton, Massachusetts, and studied at the Massachusetts Normal School in Boston beginning in 1888. The normal schools were teacher-training institutions, and Sylvester began his career as acting director of the art department at Newcomb College in New Orleans, relieving ELLSWORTH WOODWARD, who was touring in 2.100 Europe. Sylvester began to paint the Mississippi River levees and continued working with this subject when he moved to Saint Louis in 1892 to teach at Central High School. In 1901 Sylvester became art director at Principia, a private school operated by Christian Scientists. The river remained his constant subject, although his mature work divides into three distinct periods. His earliest pictures exhibited in Saint Louis in the 1890s appear to have been gentle Tonal works, usually on a small scale. By the end of the decade he was painting dynamic, realistic scenes of the busy waterfront, bird's-eye views of ships at the wharves and of the adjoining industrial complexes, and, above all, Eads Bridge. In 1900 Sylvester exhibited twenty-five paintings of the bridge at the Saint Louis Exposition.

In the summer of 1902 the artist bought a house in the village of Elsah, a community perched on the bluffs across the river in Illinois, which many years later would be the site of the Principia College. Especially after a European interlude in 1906, the artist's Mississippi views became paeans to the river's beauty, emphasizing a harmony between color and light—often sparkling and crystal clear—and among water, unpopulated cliffs, broad terrain, and luminous, cloud-filled skies, as in *The River's Golden Dream.* Sylvester 3.37 was as poetic a landscapist as Wuerpel, but instead of generalizing, as the latter did, he detailed the beauty of nature. His pictorial devotion to the river extended to the murals he painted for Central High School in 1909; for the Noonday Club in 1910; and for Decatur High School, in Illinois, in 1911. That year Sylvester produced *The Great River,* a book of his poetry about the Mississippi illustrated with photographs of his own paintings. One of his pupils, Pamela Hammond, who followed her teacher as a landscape painter, began to exhibit in 1899 and became well known locally.[45]

For reasons yet to be explained, Saint Louis does not appear to have followed the lead of other midwestern cities, such as Chicago and Cincinnati, in fostering a strong coterie of professional women artists. In time, of course, such now-forgotten artists as Eugenia Ludwig and Augusta S. Bryant may become better known. For the moment, however, Mary Fairchild, who left the city only a few years after graduating from the School of Fine Arts, is the most renowned of the city's women painters. In the 1890s Carrie Blackman achieved prominence as a children's portraitist, later moving to Carmel, California. Lillian M. Brown became a noted delineator of the rural landscape in oils and pastels. Martha H. Hoke, who had begun her studies at the School of Fine Arts in 1880, was one of the earliest artists to participate in the turn-of-the-century miniature-painting revival, starting to show her work in 1892. Hoke first came to public attention when a sensational murder occurred at the Southern Hotel in 1885 and her father, an engraver who had patented a chalk plate method of newspaper illustration, called her out of art

class to sketch the scene. Her drawings, which appeared in a special edition of the *Post-Dispatch*, immediately established her reputation as a commercial artist, and with Brown, a fellow student, she opened a studio for newspaper and commercial illustration in connection with the Hoke Engraving Plate Company. Subsequently, Hoke gained fame for her miniatures and watercolors.[46]

Others who followed by the end of the decade included Emma Moreau; Katherine Starr, later active in Hollywood; and Agnes Thompson. Among the pastelists of the 1890s were Sophie Schuyler, one of the best known of this group, who specialized in Dutch genre; Alice Mary Beach; Mary F. Taulby; and Cornelia Maury from New Orleans, a specialist in depictions of children who also was active as an etcher into the 1930s and who had a solo show at the City Art Museum in 1916. All had studied in Paris, where all but Beach were pupils of Raphael Collin.

George Aid, Charles Frederick von Saltza, Carl Gustav Waldeck, and OSCAR E. BERNINGHAUS emerged as professional artists at the end of the century. Aid, a student at the School of Fine Arts and in Paris, first exhibited at the Saint Louis Exposition in 1898. The following year he went with his fellow student RICHARD MILLER to France, subsequently expatriating to San Remo in Italy while also working in Paris. His depictions of elegant women, often Oriental models, in kimonos in colorful interiors, related to the paintings by Miller and Frederick Frieseke. Aid also became known for his etchings of buildings and street scenes, first in Holland and then in France and Italy.[47]

Charles Frederick von Saltza was the principal Swedish artist to emigrate to Saint Louis. A student in Stockholm with Anders Zorn, Bruno Liljefors, and others who achieved prominence in their native land, von Saltza went on to study in Brussels and Paris, coming to America in 1891. After a brief stay in New York City, he was in Chicago, where he met Halsey Cooley Ives, who offered him a teaching post. Von Saltza taught at the School of Fine Arts beginning in 1892 and became a successful portrait painter, but he left in 1898 to be an instructor at the Art Institute of Chicago and, the following year, at Teacher's College of Columbia University in New York City.[48]

Born in Saint Charles, Missouri, Carl Gustav Waldeck first began to exhibit in Saint Louis in 1898. He went to Paris to study in 1893, returning to settle in Saint Louis four years later. Although Waldeck became known for his strong figure paintings, the best known being *The Blind Violinist* (location unknown), he established himself principally as one of the city's most noted portraitists, succeeding von Saltza. One of his most famous portraits was the *Countess d'Haussonville* (location unknown), painted when she visited the city in 1904 for the Louisiana Purchase Exposition. Waldeck also painted a number of the city's ''official'' mayoral portraits.[49]

Oscar E. Berninghaus began to exhibit professionally in 1899, after studying for three terms at the School of Fine Arts, beginning in 1894. That same year, when the Denver and Rio Grande Railroad commissioned him to paint watercolor sketches of the Southwest, Berninghaus became enamored of the Taos region. Until 1925, when he moved there permanently, he divided his time between Taos and his native Saint Louis, with its greater number of private and commercial patrons. Though almost all of the artist's known works are southwestern subjects, he was active in Saint Louis's artistic life, creating floats for the annual parade of the Saint Louis Veiled Prophet, and he was a member of the Society of Ozark Painters during the 1910s. In 1920 Berninghaus was commissioned to paint a series of five lunettes illustrating Missouri history for the new State Capitol in Jefferson City, which he executed in Taos. Along with those by other Saint Louis painters, his decorations were unveiled in January 1921. Through Berninghaus almost all the other members of the Taos Society of Artists—EANGER IRVING COUSE, WALTER UFER, BERT GEER PHILLIPS, ERNEST L. BLUMENSCHEIN, and WILLIAM HERBERT DUNTON—subsequently painted additional historical murals for the Missouri State Capitol.[50]

The most noted Saint Louis artist of his time was Richard Miller, who studied at the School of Fine Arts from 1893 until 1897 and began to exhibit at the expositions in 1895, showing landscapes through 1897. Two years later Miller went to Paris with George Aid to study at the Académie Julian. He turned to figure painting—at first, period subjects—

3.111

3.243

3.112, 3.142;
3.114; 3.109;
3.110; 3.113

but quickly moved on to dramatic contemporary scenes of Paris street and night life. Miller was in Saint Louis in 1901–2 to teach the life class at the School of Fine Arts but otherwise remained an expatriate for almost twenty years, painting and teaching in Paris and Giverny. There, with Frederick Frieseke, he became the principal exponent of second-generation Impressionism. Both artists specialized in monumental female figures painted indoors, often in their boudoirs, or outdoors in colorful gardens. When Miller returned to this country late in 1914, he settled first in Pasadena, California, and finally in Provincetown, Massachusetts. His ties with Missouri led to a commission for a series of lunettes and four large murals for the Missouri State Capitol, for which he also provided a design for a stained-glass window.[51]

In France, Miller was quite a famous teacher, and his reputation drew students there from Saint Louis. The best known of these was **Fred Greene Carpenter**, who returned to teach at the School of Fine Arts in 1904, remaining for almost fifty years. Carpenter's work reflects Miller's strong figures and jewellike palette, but canvases such as *Caprice*
3.38 also represent an advanced strain of modernism, with their dramatic patterning and disregard for the naturalism of the Giverny Impressionists. Another noted colorist of the early 1900s was Carpenter's student Mildred Bailey, whom he married in 1914.[52]

3.38 Fred Greene Carpenter
(1882–1965)
Caprice, 1926
Oil on canvas, 35 x 29 in.
The Saint Louis Art Museum;
Gift of the pupils of Frederick
Greene Carpenter, Saint Louis
School of Fine Arts

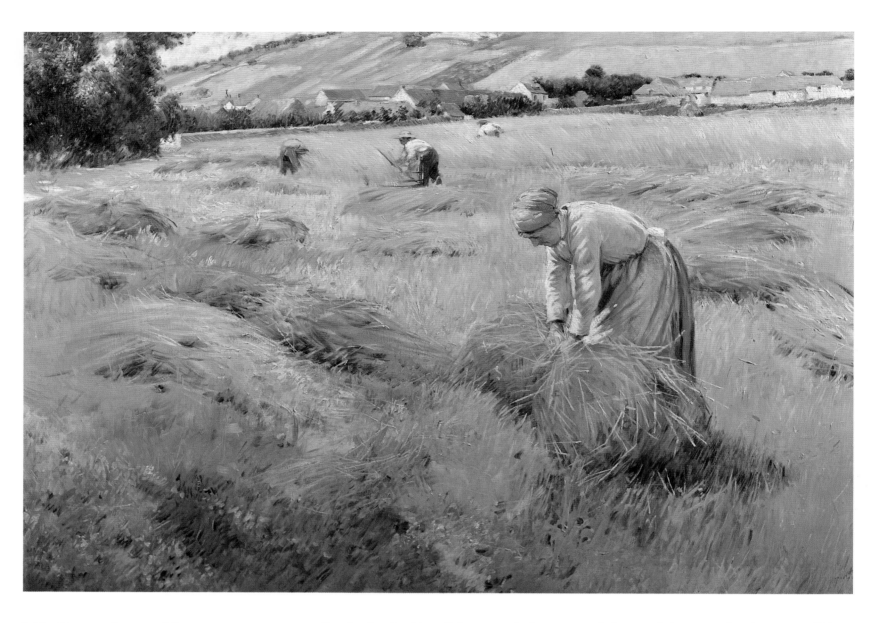

3.39 Dawson Dawson-Watson
(1864–1939)
Harvest Time, n.d.
Oil on canvas, 34 x 50¼ in.
Private collection; Courtesy of
Spanierman Gallery, New York

By the beginning of the twentieth century Saint Louis's strong landscape tradition, represented by the Tonalism of Edmund H. Wuerpel and by the vigorous urban realism of Frederick Oakes Sylvester, was further enriched by the influence of Impressionism. The earliest significant resident Impressionist, **Dawson Dawson-Watson**, was an English-born artist who enjoyed quite an odyssey before settling in the city. The son of an English illustrator, he grew up in the London artists' colony of Saint John's Wood, taking art instruction from the American expatriate Mark Fisher. Dawson-Watson went to Paris to study from 1886 until 1888 and then lived in Giverny among the American and Canadian artists who had "converted" to Impressionism under the influence of Claude Monet. Dawson-Watson's Giverny pictures reflect a combination of the strongly structured peasant subjects and the intense colorism and frequent emphasis on purple tones so often associated with that aesthetic.

In 1893 Dawson-Watson went to Boston and then settled in Hartford, Connecticut, for four years as director of the Hartford Art Society. After returning to England he came back across the Atlantic in 1901, painting in Quebec for two years and associating himself with LOVELL BIRGE HARRISON at the new Byrdcliffe artists' colony in Woodstock, New York, 1.174, 2.52 in 1903. The next year Dawson-Watson accepted an offer to teach at the Saint Louis School of Fine Arts, where he remained for eleven years; during the summers he frequently painted in New England. Dawson-Watson introduced Impressionism to Saint Louis in both his sun-filled landscapes and his strong, brightly colorful portraits, such as that of 3.39 the poet Bliss Carman (location unknown), with whom he was associated in making illustrations. During this period Dawson-Watson expanded his artistic range, becoming

involved in decorative and pageant work and craft production. In 1912 he opened the Dawson-Watson Summer School of Painting and Handicraft at Brandsville in the western Ozarks, but a few years later his home and all of his tools were destroyed in a fire. In 1917, 1920, and 1926 Dawson-Watson was in San Antonio; after winning the first annual Texas Wild Flower Painting Competition there in 1927, he established a studio there as well as in Saint Louis, specializing in colorful depictions of cactus flowers and bluebonnets.[53]

3.29

2.276

Dawson-Watson's summer school at Brandsville was accessible by the Frisco Railroad from both Saint Louis and Kansas City. The Ozarks were being explored by tourists and artists at this time, and, in fact, his school was sponsored by the Art Association of the Ozarks to increase interest in the region. Even in the early 1880s JOSEPH RUSLING MEEKER and other members of his Sketch Club such as Fred Lippelt and James M. Barnsley had recorded the wild and picturesque scenery of the region around Arcadia, Pilot Knob, and Ironton in the eastern Ozarks, south of Saint Louis. However it wasn't until the 1910s that the Ozarks became a major artists' colony. In the summer of 1912 CARL R. KRAFFT from Chicago painted in the western Ozarks, already made famous in Harold Bell Wright's novel, *Shepherd of the Hills* (1907). The following year Krafft organized the Society of Ozark Painters, which included Oscar E. Berninghaus, Carl Gustav Waldeck, and **Frank Nuderscher** from Saint Louis.

Nuderscher, one of the most active and important Saint Louis members of the society, was the most significant Impressionist painter to spend his whole career in Missouri. He studied at the School of Fine Arts and later in Provincetown, Massachusetts, with Richard Miller. Nuderscher opened his own summer school in Kimmswick, just south of Saint Louis; in the Ozarks he gravitated to the region around Arcadia, where he lived for several years in 1923 and which he served as mayor.

2.238

Nuderscher's Ozark landscapes glow with bright, broken (though not systematic) color and suggest a debt to the popular Indiana painter THEODORE CLEMENT STEELE, whose work, seen in the annual exhibitions of the Society of Western Artists, was extremely influential in the Midwest. Nuderscher also depicted Saint Louis in paintings of riverfront derelicts and views of the streets and Eads Bridge, which he featured in his mural commission of 1921 for the State Capitol, *Artery of Trade*. One of Nuderscher's best-known Saint Louis subjects is *Red Cross Drive*, with its Impressionistic buildings that recall the well-known Flag series of New York City scenes painted in 1917–18 by Childe Hassam.[54]

3.40

3.41

Another able painter of local Mississippi views was **Frederick Gray**, whose work exhibits the heightened colorism of Impressionism and the influence of Whistler's Nocturnes, as is evident in *Boys Bathing in the Mississippi River*. Whistler's impact is apparent in the monochromatic Tonal blueness, the choice of an evening subject, and the light reflections. Gray, a figure and landscape painter, had trained at the School of Fine Arts before going to Paris in 1894; he moved to Northern California in the early 1920s.

2.137

The city's most important artists' organization to arise in the late nineteenth century was the Saint Louis Artists' Guild, formed in 1886. Among its charter members were Halsey Cooley Ives, Holmes Smith, Paul Harney, John Hemming Fry, and CARL GUTHERZ (the last was in Europe at the time). The guild was first discussed at a meeting at the home of Joseph Rusling Meeker. The inclusion of women was a key issue, and when the guild was formed with male and female members drawn from the older Sketch Club, Meeker was not present to voice his objections. The guild would, in fact, later record its history as dating back to 1877, when the Sketch Club had been formed. While architects, musicians, and writers were included, the majority had to be painters and sculptors; spouses were eligible for associate membership, as were some patrons. The membership increased as neophytes such as Martha H. Hoke and Cornelia Maury, who were members of the Saint Louis Art Students League, became professionals. The guild began as a very relaxed organization, with occasional sketching, delivering of papers, and exhibitions. These activities became more regular when Ives offered the guild use of the basement of the old Museum of Fine Arts for meetings and of the galleries for exhibitions. By the mid-1890s these spaces were no longer available, and the guild led a nomadic life until land was bought and a building started in 1907.

The exhibition of Missouri artists' work organized by the guild under the direction of the sculptor George Julian Zolnay for the Missouri State Building at the Lewis and Clark Centennial Exposition was both an achievement and a disaster. The exposition was held in Portland, Oregon, in 1905, and Missouri's was the only state building to install a large, independent art gallery. Oils by Dawson Dawson-Watson, Halsey Cooley Ives, Richard Miller, Frederick Lincoln Stoddard, Frederick Oakes Sylvester, Carl Gustav Waldeck, Gustav Wolff, and Edmund H. Wuerpel were shown with George Aid's etchings and Cornelia Maury's pastels. Unfortunately, the building burned, and only a few of the pictures were saved.

The 1905 exposition was the successor of the Louisiana Purchase Exposition held the previous year in Saint Louis itself, in Forest Park. The art exhibition at the Louisiana Purchase Exposition included thousands of paintings by Americans and by artists from twenty-six foreign nations; a special section featured over five hundred Russian works, pictures from Eastern Europe, and a large Latin American selection. Halsey Cooley Ives was chief of the art exhibition, with Charles M. Kurtz as his assistant; Zolnay was superintendent of the sculpture division. Wuerpel chose paintings from the Midwest. The three most significant artists represented were Wuerpel himself, who showed four Tonal landscapes; Frederick Oakes Sylvester, who showed two Mississippi River scenes; and Richard Miller—the best represented—with five acclaimed portraits, figure pieces, and landscapes. Other local artists included were Edward Morton Campbell, with a Tonal, Symbolist landscape; George Eichbaum, Ruth Stirling Frost, Louis Mutrux, and Carl Gustav Waldeck, with portraits; Cornelia Maury, with two pastels of domestic subjects; Frederick Lincoln Stoddard, with a Symbolist decorative panel; and Gustav Wolff, with two Tonal landscapes, *Sunset* and *Winter* (locations unknown).

In 1895 the Saint Louis Association of Painters and Sculptors was organized as an annual exhibition society, with the galleries of the old Saint Louis Museum at its disposal. Wuerpel was chairman; other leading artists involved in organizing the shows included Edward Campbell, Paul Cornoyer, Martha Hoke, and Holmes Smith. The association appears to have lasted through 1897 and was succeeded by the Two-by-Four Society, an

exhibiting group organized in 1906 out of the male members of the Artists' Guild. (The name of the group referred to the maximum dimensions for exhibited paintings.) By their third annual the society was exhibiting at the Saint Louis Museum. When the museum moved into the permanent Fine Arts Building of the Louisiana Purchase Exposition in 1906, major annual exhibitions of work by American artists were inaugurated. These continued when the museum, still under Ives's directorship, separated from Washington University in 1909 and was renamed the City Art Museum of Saint Louis. The annuals, at first co-organized with the Buffalo Fine Arts Academy, where Charles M. Kurtz had gone as director in 1905, included the work of few local artists, whose work *was* included in the annual of the Society of Western Artists held at the museum. By 1915 the Saint Louis Art League had come into existence, holding exhibitions at the Artists' Guild.

Another educational enterprise was the establishment in 1910 of the People's University in University City, on the outskirts of Saint Louis. Conceived by Edward Gardner Lewis, a major publisher of popular magazines for women and the mayor of University City, the university was started to keep rural women in touch with urban culture. Underwritten by the American Woman's League, it offered free education to any woman who joined the league. Instruction was by correspondence except for especially talented students, who were invited to University City for personal instruction. Though short-lived, the university's Art Institute included a number of important artists on its faculty. JOHN VANDERPOEL, the most distinguished art instructor at the Art Institute of 2.266
Chicago, joined the People's University as the chief instructor in drawing and painting in 1910, one year before his death. He was succeeded by Ralph Chelsey Ott from Springfield, Missouri, who painted portraits there after studying at the School of Fine Arts; Ott subsequently went to Paris for additional instruction. He was one of the region's principal portraitists during the first three decades of the present century, painting the likenesses of eight Missouri governors.

Other than Saint Louis and Springfield, the other two Missouri cities with resident professional artists were **Columbia** and Kansas City. Columbia was the seat of the state university, and artists of some prominence were there as early as 1877, when GEORGE 3.24
CALEB BINGHAM was made professor of art. Bingham was replaced after his death by the portraitist Conrad Diehl from Saint Louis. Diehl appears to have been far more active as a teacher of, and lecturer on, art than Bingham had been, and several of his significant lectures were published.[55] Another able professional was the landscape painter ALFRED 1.79
VANCE CHURCHILL, who left Iowa College for an instructorship at Teacher's College in Columbia from 1897 until 1905, though his more exciting and original works of this period were harbor scenes painted during summers at the artists' colony at Gloucester, Massachusetts. Churchill painted landscapes in France in 1906 before teaching at Smith College in Northampton, Massachusetts.

Columbia's most distinctive painter was John Sites Ankeney, for twenty-eight years a member of the university's art department. A student of JOHN TWACHTMAN and WILLIAM 1.64, 1.120,
MERRITT CHASE, Ankeney went to Paris and then settled in the old town of Rocheport in 2.178; 1.146,
the Columbia area, where he became a painter of the Missouri River and its bluffs, as 1.155
FREDERICK OAKES SYLVESTER was of the Mississippi. Ankeney declared the most beautiful 3.37
views of the river to be the bold front of the Ozark Uplift, the stretch of bluff and plain that faces the river between New Haven and Hermann.[56]

Kansas City developed as a major urban center much later than Saint Louis. Independence, now a suburb of Kansas City, was the older settlement; established as a Mormon colony as early as 1831, it played an active role as a jumping-off point for California during the gold rush. George Caleb Bingham was the first significant artist to reside in Kansas City, settling there in 1870. The following year the annual Kansas City Industrial Exposition—later the Kansas City Industrial Exposition and Agricultural Fair Association—was begun. It always had an Art Hall, but except for Bingham's work, which dominated several of the annuals, and such popular items as John Rogers's domestic plaster groups, the work shown rarely rose above amateur status.

3.42 John Mulvany
(1844–1906)
Custer's Last Rally, 1881
Oil on canvas, 11 x 22 ft.
Photograph courtesy of Library
of Congress, Washington, D.C.

3.42 At the end of the 1870s **John Mulvany** was at work on *Custer's Last Rally*, surely the most famous painting done in Kansas City during the nineteenth century. The Irish-born Mulvany had studied in New York City at the National Academy of Design and then in Düsseldorf, Munich, and Antwerp, after which he worked in Saint Louis and Chicago. The great Chicago fire of 1871 caused him to become an itinerant in the Midwest during the 1870s. In the spring of 1879 he was in Cincinnati, and shortly thereafter he settled in Kansas City. The tragedy of Custer's battle inspired the artist to extensive on-site study, interviews with army officers, and visits to Sioux reservations over a two-year period until his twenty-foot extravaganza was completed. In April 1881 Mulvany began to tour his great work, taking it first to Boston, where he made various changes. He then exhibited the painting in New York City, where it was reviewed by no less a writer than Walt Whitman, who found it authentically American. Mulvany continued to exhibit his monumental composition for the rest of the decade, showing it in Louisville, Kentucky, and Chicago several times, and occasionally added other western paintings to his display. There were reports that the picture was to be sent to London and Paris, but this transatlantic crossing may never have been made. By 1884 Mulvany had left Kansas City and was in Detroit, though whether as a resident or touring his picture is not known. He later turned to portraiture and in 1906 drowned himself in the East River in New York City.[57]

 Late in 1884 a far more famous artist of western scenes settled in Kansas City: Frederic Remington. Born in upstate New York, Remington had taken his first trip west to Montana in the summer of 1881. After his father's death later that year he returned to become acquainted with frontier life. He ran a sheep ranch near Peabody, Kansas, and in the fall of 1884 set up a studio in Kansas City, where he also invested in a saloon. Remington began to paint and to sell his work through a gallery and art-supply store owned by William Findlay. It was Findlay who suggested that Remington become an illustrator, and the young artist left Kansas City in 1886 to study at the Art Students League in New York City.[58]

 In 1885 a sketch club was founded in Kansas City, the earliest artists' organization there, which two years later held its first exhibition. By then several trained professionals were in residence and became members of the club, including James L. Fitzgibbon, later a watercolor landscapist in Saint Louis; Emma Richardson Cherry, who had taught at the University of Nebraska from 1879 until 1881; Lillian Crawford from Cincinnati; Laurence
1.343 Brumidi, said to have studied in Rome and son of CONSTANTINO BRUMIDI, the mural decorator of the Capitol in Washington, D.C.; and the landscape painter John Franklin Stacey, who had studied in Paris before going to Kansas City in 1886. In 1887, too, a

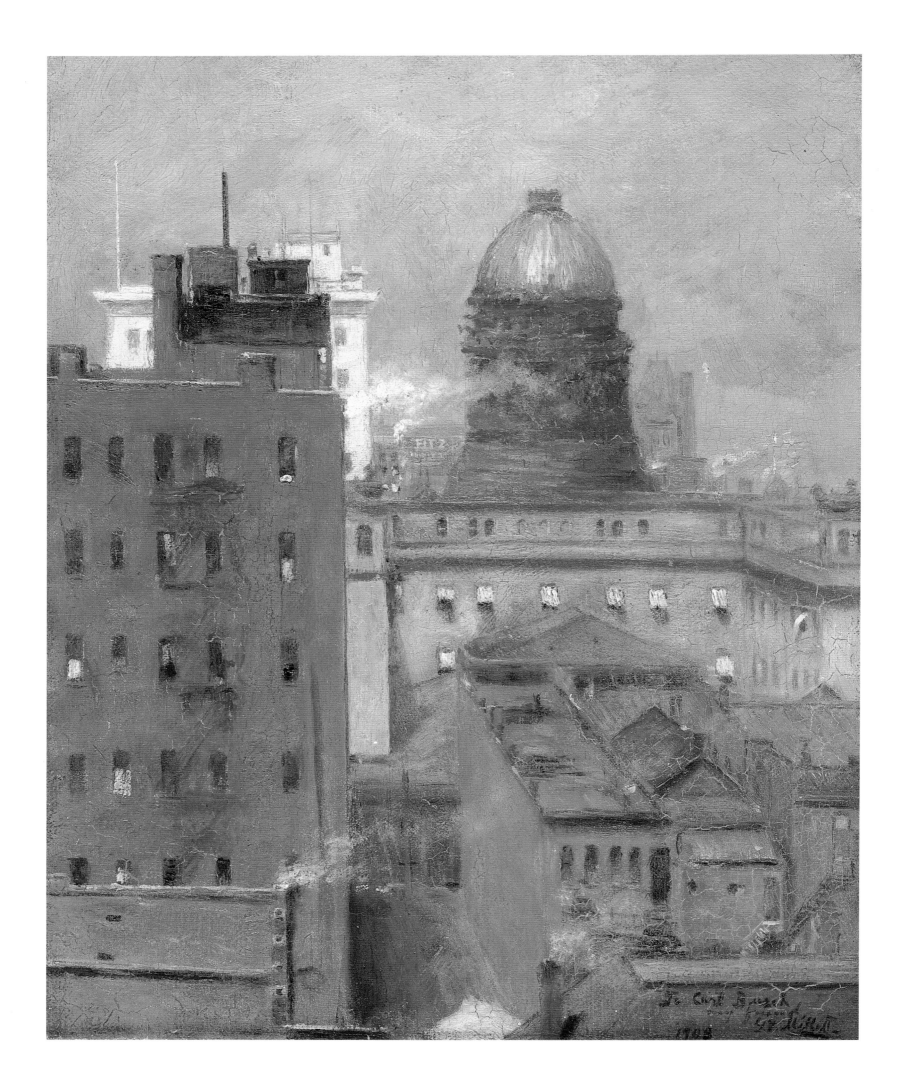

group of local businessmen raised the funds to start an art school and museum, the Kansas City Art Association and School of Design, which opened in January 1888, with Laurence Brumidi as director and Fitzgibbon and Crawford on the faculty. The young Ernest Lawson began his training there that year. Brumidi was succeeded by Stacey, who evolved into a painter of colorful Impressionist farm scenes; about 1890 he settled in Chicago. In 1892 the community was joined by the Paris-trained figure painter John Douglas Patrick, following his three-year teaching stint at the Saint Louis School of Fine Arts.

The two leading women artists to emerge in Kansas City during the 1890s were Helene De Launay, a specialist in Tonal nocturnal and winter scenes, and the short-lived Alice Murphy, a specialist in landscapes and figures painted outdoors, including Indian subjects. Murphy, who had studied at the Saint Louis School of Fine Arts and with William Merritt Chase in London during the summer of 1904, organized the drawing class at Manual Training High School in Kansas City in 1897. This was the first high school west of the Mississippi with a comprehensive curriculum in the arts. Under Murphy's guidance it developed into the largest high school art department in the West and one of the finest in the nation. Murphy herself was a talented delineator in oil, watercolor, and pastel of European peasant genre, especially Dutch figures in interiors, and foreign landscapes, especially exotic, sunny views of Italy and North Africa executed during a two-year sabbatical in 1902–4.[59]

2.137 **George Van Horn Millett**, a native of Kansas City, left in 1886 to study in Munich for four years, then spent a year in Paris. On his return to Kansas City in 1892 he opened an art school, the Western Art League, which was quickly absorbed into that of the Art Association. The latter was destroyed in a fire in 1893, and the depression of the following year brought a temporary end to organized art activity. Edmond A. Huppert, the Saint Louis painter of rural landscapes in oil and watercolor, was a pupil of CARL GUTHERZ and Paul Harney at the School of Fine Arts before studying in Munich and Paris. He started his own classes in Kansas City in 1894, later resigning to become superintendent of art in the public schools. In 1896 Millett, who had emerged as the major figure on the local art scene, started the Paint Club (reorganized in 1900 as the Art Club) to hold exhibitions of American paintings of national significance; these began in 1897 and continued until 1904. Millett's own paintings of the late nineteenth century are generally dark genre subjects, often sentimental depictions of children, but he gradually moved outdoors, passing through a Barbizon phase to a colorful aesthetic approaching Impressionism. This

3.43 is apparent both in his rural landscapes and in his sparkling *Downtown Kansas City*.

In 1897 William Rockhill Nelson, a former member of the Art Association, opened his own museum, the Western Gallery of Art, at first exhibiting only copies of old masters. In 1907 an art school was once again established, the Fine Arts Institute (later the Kansas City Art Institute), which quickly evolved into the leading teaching institution for the central Great Plains. John Douglas Patrick became one of its foremost instructors, and in 1908, while he was teaching there, the masterwork of his years in Paris, *Brutality* (1888; Grayce Patrick Wray and Hazel Patrick Rickenbacher, Kansas City, Missouri), was put on public exhibition in the city.[60]

Art leagues were instituted in other Missouri cities toward the end of the period under study, in Saint Joseph in 1914 and in Joplin in 1921. Nevertheless, Saint Louis and Kansas City remained the centers of culture in the state.

3.43 George Van Horn Millett
(1864–1952)
Downtown Kansas City, 1908
Oil on canvas, 14 x 11 in.
Mr. and Mrs. Whitney E. Kerr,
Kansas City, Missouri

NEBRASKA

MISSOURI

COLORADO

LEAVENWORTH

KANSAS CITY

TOPEKA

LAWRENCE

BALDWIN CITY

Kansas River

LINDSBORG

McPHERSON

Arkansas River

DODGE CITY

WICHITA

OKLAHOMA

KANSAS

3.44 Henry Worrall (1825–1902)
*The Kansas Exhibit,
Philadelphia,* 1877
Oil on canvas, 38½ x 58⅛ in.
Kansas State Historical
Society, Topeka

Established as a territory in 1854, Kansas was the site of bloody conflicts between pro- and antislavery groups during the 1850s; only at the beginning of 1861 was it admitted to the Union as a free state, with Topeka as its capital. That city, founded in 1854 by antislavery colonists, was an early railroad hub. Wichita, founded a decade later, developed into a cattle-shipping center in the early 1870s and became the state's largest urban entity. Lawrence, with origins similar to those of nearby Topeka, became the site of the state university in 1863. The strongest artistic developments took place in Lindsborg, in McPherson County in the center of the state, where Lutheran Bethany College was started in 1881. As in many other places in the Midwest, professional developments in Kansas were intricately tied to their support by institutions of higher education.

1.325 Indian painters such as Samuel Seymour, Karl Bodmer, ALFRED JACOB MILLER, and
3.17 GEORGE CATLIN passed through the northeastern edge of what is now Kansas, where Fort Leavenworth was situated. It was there that Catlin painted his earliest Indian portraits in the West, in 1830; he returned in 1832, painting many more. John Banvard, who included the Missouri River in his panorama, also passed through that corner of Kansas, but he did not portray its scenery. Later, with the increased pictorial exploration of the West that
3.183 began with ALBERT BIERSTADT in 1859, artists passed through Kansas and occasionally painted there; Bierstadt's great *Wolf River, Kansas* (Detroit Institute of Arts) was painted on the return from his first trip west.

The earliest professional artist to reside in Kansas was the portraitist **Henry Worrall**.

Born in Liverpool, England, Worrall went to **Topeka** in 1868, where he remained the rest of his life. He is best known for his extensive illustrations of Kansas and western life that appeared in *Harper's Weekly* and *Frank Leslie's Illustrated Newspaper*, in local periodicals, and in two historical volumes. As a painter he depicted distinguished Kansas judges, governors, and other leading citizens, but his most interesting works are those documenting aspects of Kansas life (all in the Kansas State Historical Society, Topeka): *The First House in Topeka*; *Buffalo Herd* of 1871, showing surveyors staking out the Atchison, Topeka and Santa Fe Railroad; an 1870 view of Topeka; and *The Kansas Exhibit, Philadelphia*, demonstrating local pride in the state's achievements and fecundity as exhibited at the Philadelphia Centennial in 1876. A large wooden carving of the Kansas state seal made by Worrall was exhibited at the centennial.[1]

3.44

A contemporary of Worrall was the landscapist HARRY LEARNED, who had gone to Lawrence in 1855 from his native Boston. Learned studied with Henry Chapman Ford in Chicago in 1869–70, returning to Lawrence, where he shared a studio with Peter Fishe Reed from Chicago for a while. Learned's paintings included local views and more spectacular scenery he had sketched farther west in the Rockies and in New Mexico. In 1874 he moved permanently to Colorado, settling first in Denver. Selden J. Woodman, born in Maine, decided to become an artist while living in Chicago in 1863. He went to Europe and studied with Thomas Couture and in 1871 settled in Topeka, where he lived for many years. Woodman is best known for his much-praised portrait of John Brown, based on descriptions and photographs (Kansas State Historical Society, Topeka).[2]

3.76

The earliest native professional Kansas painter was **George Melville Stone**, who was born near Topeka in 1858. A generation younger than Worrall, Stone took a year of instruction with George Edward Hopkins at the Art School of the Kansas State Art Association in Topeka, then studied in Paris from 1887 until 1891. In the latter year he returned to Topeka for the rest of his life. A leading turn-of-the-century portraitist, Stone was also a specialist in recording the local agricultural landscape, becoming known as the "Millet of the Prairie." In 1910, while rendering a likeness of the daughter of the proprietor of the Mission Inn in Riverside, California, he was engaged to do decorative painting there, though he had never before undertaken such work. Stone painted nine mission subjects, which were followed by other murals, for churches in Dodge City and Topeka. His most important murals were painted in 1920 in the governor's office in Topeka's State Capitol to memorialize prairie life: *The Spirit of Kansas* and *Kansas Pioneers*.[3]

3.45

The earliest art classes in the state were offered at Washburn College in Topeka under Minnie V. Otis and at Baker University in Baldwin City, both in 1865. After a lapse

3.45 George Melville Stone
(1858–1931)
Kansas Pioneers, 1920
Oil on canvas, 72 x 120 in.
Kansas State Historical Society,
Topeka

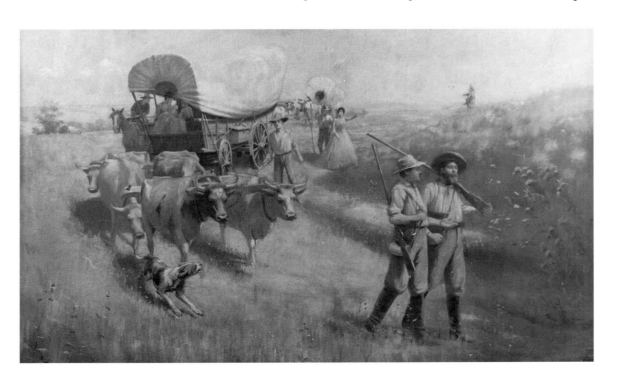

in the program, Frances Whittemore became director of the Art Department at Washburn College in 1893. She was largely responsible both for the organization of the Topeka Art Guild and for the creation in 1925 of the Mulvane Art Museum as a branch of Washburn University. The first professional schools were that of the Kansas State Art Association in Topeka (a patrons' group founded in 1883 under Edward Wilder, treasurer of the Santa Fe Railroad), which began in 1886, and the Leavenworth Art School, begun in 1891 under the sponsorship of the Leavenworth Art League. Munich-trained George Edward Hopkins, Worrall's first teacher at the Art Association school, was subsequently connected with the art department of Kansas University from 1891 until 1893. **William Alexander Griffith** taught at the university from 1899 until 1920, when he moved to Laguna Beach, California, joining BENJAMIN CHAMBERS BROWN, his classmate from his days in Saint Louis. Griffith, a native of Lawrence, Kansas, and a student at the Saint Louis School of Fine Arts and then in Paris, brought an Impressionist aesthetic to his interpretations of the Kansas landscape in oils and pastel.[4] Helen Francis Hodge, a pupil of both Hopkins and Stone who was born in Topeka, was noted for her marine paintings.[5]

3.46 William Alexander Griffith (1866–1940)
From the Hill, Lawrence, 1915
Oil on canvas, 21⅞ x 26 in.
Jane Griffith Stevens, Lawrence, Kansas

The two best-known Kansas artists of the early twentieth century were **John Noble** and Sven Birger Sandzén, who pursued radically different careers. Noble was born in Wichita and grew up on his father's sheep range, but his career was made outside the state, though he became known as "Wichita Bill" in later years. He studied in Cincinnati then was an itinerant for ten years before studying in Paris in 1903. When Noble returned in 1919 he became a mainstay of the artists' colony in Provincetown, Massachusetts. He did return to exhibit his work in Wichita in 1912 and 1920, inspiring the establishment of the Wichita Art Association. While Noble painted powerful, dramatic marines in France and on the New England coast, among his finest works is *The Big Herd*, as well as moonlit Kansas landscapes and other prairie scenes.[6] 3.47

Sven Birger Sandzén was the most influential—and one of the most original—artists in the history of Kansas. Born in Sweden, the son of a Lutheran minister, he studied from 1891 until 1893 at the school of the Artists' League in Stockholm under Anders Zorn and Richard Bergh, two outstanding Scandinavian painters. After instruction in Paris, Sandzén emigrated in 1894 to teach at Bethany College in **Lindsborg**, Kansas, where he remained until his death. In 1899 he organized the first American exhibition of Swedish-American art there, consisting of paintings by himself, his Lindsborg colleagues OLOF GRAFSTRÖM and Carl Lotave, and the local Swedish-American author and writer 2.293, 3.140
Gustav Malm; Sandzén also participated in the 1905 exhibition of the Swedish-American 3.160
Art Association in Chicago. At first a Tonal landscapist whose work reflected the manner of Scandinavian Romanticism, by the 1910s—shortly after his first trip to the Rockies in 1908—Sandzén had turned to Pointillism and then, about 1915, to an exciting, colorful style. He laid paint on his canvases in expressionist blocks of pigment with rich impasto, creating modernist work that combined Fauve color with the structural concerns of Paul Cézanne. While some of Sandzén's landscapes, such as *Creek at Moonrise*, depict Kansas 3.48
scenery, many were inspired by his western travels, particularly after he taught during

3.47 John Noble (1874–1934)
The Big Herd, 1927–28
Oil on canvas, 45⅛ x 48⅛ in.
Wichita Art Association;
Permanent collection

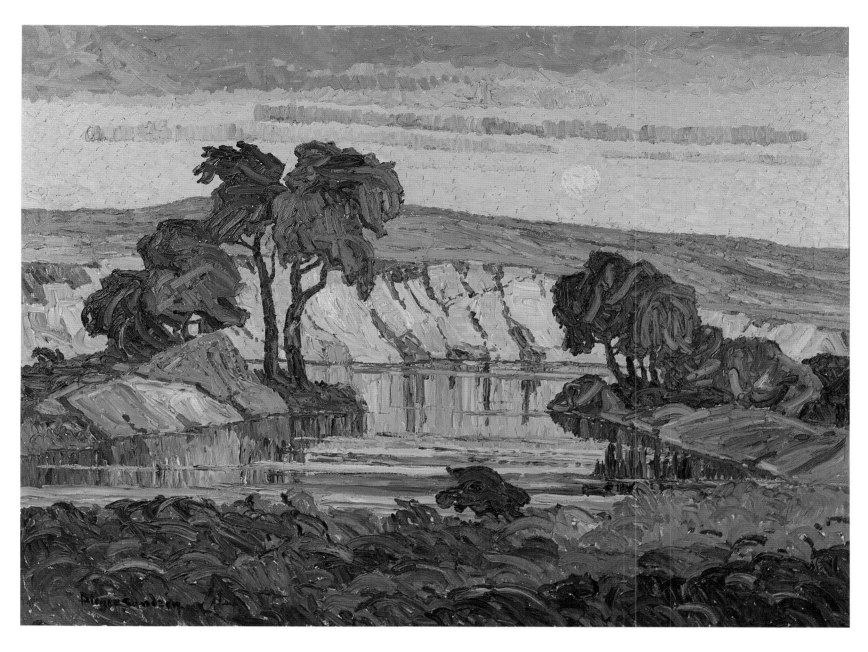

the summers of 1923 and '24 at Broadmoor Art Academy in Colorado Springs and in the summers of 1928, '29, and '30 at the State Agricultural College in Logan, Utah. He had a strong impact on the Logan art scene.[7]

Sandzén was a conscientious educator. At Bethany, where the teaching of art had begun in 1890 under Lucy Osgood and, later, Hannah and Marie Swensson and Addie Covell, he joined Grafström, who had arrived in 1893 and who went on to Augustana College in Rock Island, Illinois, in 1897. Grafström's place was taken by Carl Lotave, Sandzén's former student-colleague from Stockholm, a portraitist who remained two years before departing for Colorado Springs. Sandzén then became professor and department head, a post he held for forty-seven years. A tremendous number of his students spread the gospel of art through the Midwest, including the artists Mary Marsh Bruff and Signe Larson and several artist-teachers. The best known of the latter was Swedish-born Oscar Brousse Jacobson, who became director of the art department at the University of Oklahoma, succeeding the tragically short-lived Samuel Holmberg, also Swedish-born, who was another of Sandzén's most promising students. Sandzén built up the collection at Bethany College through acquisitions made at the annual exhibitions of the Smoky Hill Art Club, a group founded by the artist in 1913.[8] He also supported Carl Smalley, an art dealer in McPherson, Kansas, and, briefly, in Kansas City, by promoting annual exhibitions of local, national, and international art at McPherson High School, beginning in 1910. Sandzén and Smalley also encouraged art appreciation in the schools and at home.[9]

3.48 Sven Birger Sandzén
(1871–1954)
Creek at Moonrise, 1921
Oil on canvas, 60 x 80 in.
On loan to the Birger Sandzén
Memorial Gallery, Lindsborg,
Kansas, from the collection of
the Unified School District
#400, Lindsborg, Kansas

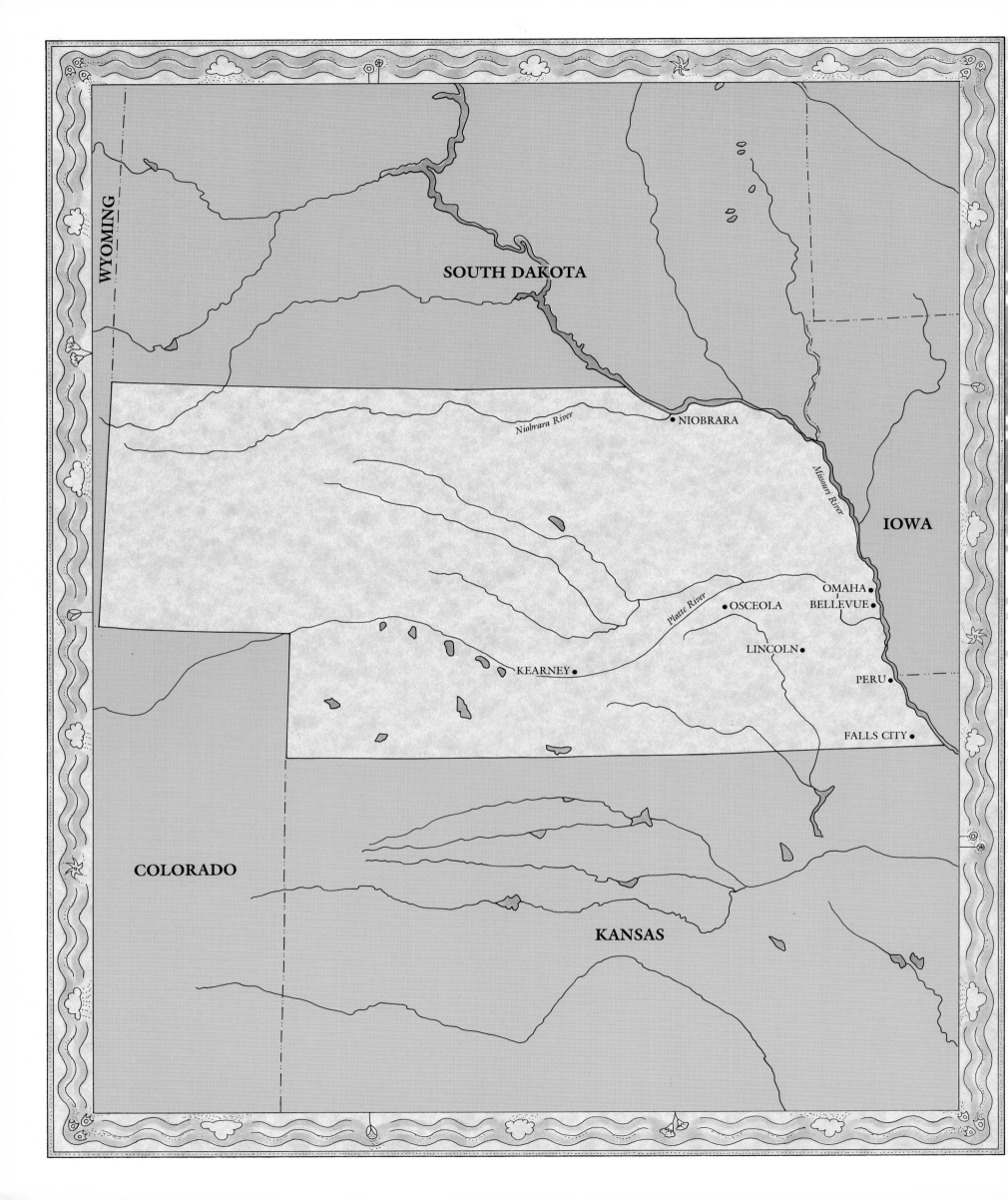

WYOMING

SOUTH DAKOTA

Niobrara River

● NIOBRARA

Missouri River

IOWA

OMAHA ●
BELLEVUE ●

Platte River

● OSCEOLA

LINCOLN ●

KEARNEY ●

PERU ●

FALLS CITY ●

COLORADO

KANSAS

NEBRASKA

Nebraska's early political and cultural history is similar to that of Kansas. Both were identified as separate territories in 1854, though Nebraska, originally much larger, lost some of its land to the Dakotas and Colorado in 1861 and entered the Union in 1867. Artistic activity was concentrated in one major urban center—**Omaha**, the territorial capital—and at the university in Lincoln, the state capital from 1867. The closeness of these two cities and their relative proximity to other major midwestern centers facilitated contact with the eastern art establishment. Thus, Omaha was able to mount two major international exhibitions at the end of the nineteenth century. The Nebraska Art Association had developed even earlier into one of the most active and successful of the many such organizations in the Midwest.

3.49 J. Laurie Wallace
(1864–1963)
William Jennings Bryan, 1902
Oil on canvas, 49 x 39½ in.
Nebraska State Historical
Society, Lincoln

3.17; 1.325
3.183; 1.250,
2.168

The first artistic visitors to Nebraska were, again, the Indian painters Karl Bodmer, GEORGE CATLIN, ALFRED JACOB MILLER, and Samuel Seymour. Later, eastern artists such as ALBERT BIERSTADT, in 1859 and 1863, and WORTHINGTON WHITTREDGE, in 1866, traveled through Nebraska and painted there on their way west, for the pony express passed through Fort Kearney in the center of the state and followed the Platte River. The state's largest settlement, Omaha, became a major railroad junction between Chicago and the West; the Union Pacific line was completed between there and San Francisco in 1869, again following the course of the Platte. Thereafter many artists made use of this mode of rapid transportation to the Rockies and beyond.

3.12

Nebraska's earliest quasi-resident painter was GEORGE SIMONS, who was settled in Council Bluffs, Iowa, as early as 1849. Simons painted Omaha and Bellevue, the oldest town in Nebraska, just south of Omaha. Stanislas Schmonski, from Schleswig-Holstein in what is now Germany, was the first resident painter, living in Bellevue about 1852. Schmonski settled there as a farmer but is also known to have been active as a surveyor and draftsman. His watercolors of the area are unsophisticated, not unlike those of Simons, his neighbor across the river.

Omaha had its first sketch classes in 1877, taught by a Mrs. Charles Catlin, and two years later the town held its first loan exhibition, of works owned locally. In 1881 the Social Art Club was established. With the Inter-State Fair and Exposition of 1886, Omaha enjoyed an art display of quality, with pictures sent by artists from Chicago and Milwaukee and almost a hundred European paintings (some of them major) lent by George W. Lininger, Omaha's premier art patron and director of the display. He traveled to Europe and the Near East several times during the 1880s, making purchases for his collection, which he opened to the public on Thursdays and Sundays, starting in 1881.

That same year Lininger helped to organize and became president of the Western Art Association in Omaha, offering his gallery for its first exhibition and showing the members' work. The association held annuals through 1892 and one in 1894. In 1891 it established the Omaha Academy of Fine Arts and invited one of Thomas Eakins's most promising students, Irish-born **J. Laurie Wallace**, to leave Chicago, where he had been painting and teaching for six years, to become director. Though both the association and the Academy were of limited duration, due to the panic of 1893, Wallace remained as Omaha's major portraitist. His first commission was for a likeness of Lininger (Joslyn Art Museum, Omaha), but his most famous and impressive work is the portrait of Lincoln,

3.49

Nebraska's, most famous son, William Jennings Bryan.[1] The first show of the Western Art Association consisted almost totally of work by Omaha painters, ranging from amateurs to professionals. Gradually artists from throughout the state and beyond began to exhibit, and the shows were enriched by loans from Chicago and elsewhere.

Fired by the success of the 1886 Inter-State Fair and Exposition, the Omaha Art Exhibition Association was formed in 1890 to surpass the earlier show by bringing together work by artists of national and international reputation. Among the Americans who were well represented in the 1890 show were Albert Bierstadt, ALEXIS J. FOURNIER from Minneapolis, and the expatriate Frederick Arthur Bridgman. The show attracted national attention when Carey Judson Warbington threw a chair through Adolphe-William Bouguereau's Salon nude *Le Printemps* (Joslyn Art Museum, Omaha), "to protect the virginity of women." This resulted in a protracted lawsuit; Warbington, who was judged insane and acquitted, later committed suicide. The painting was repaired in Paris by Bouguereau himself and, after its purchase by Lininger, returned to Omaha. The scandal caused the dissolution of the Omaha Art Exhibition Association.

 In 1898, to stimulate the failing economy, Omaha held the Trans-Mississippi Exposition, which had been inspired in 1895 by a passionate oration by William Jennings Bryan encouraging regional aspirations. Though overshadowed by the great fairs that took place in Chicago (1893), Buffalo (1901), and Saint Louis (1904), the Omaha exposition was a major international event. Mexico was represented by an official display, and ten other foreign nations were included with private exhibits. Lininger kept his private gallery open daily, and the exposition itself contained an international art exhibition of over eight hundred fifty works. Many midwestern painters showed their works, including Carl Lotave from Lindsborg, Kansas. Strangely, J. Laurie Wallace was not among the Nebraska exhibitors, though a number of other local artists did participate, including Ethel Evans, who had studied at the Philadelphia School of Design and the Art Students League in New York City before becoming supervisor of drawing in the Omaha schools. Evans was in Paris for instruction from 1895 until 1898, and she showed recent French scenes at the Trans-Mississippi Exposition. Also represented was the Omaha still-life painter Frances Miller Mumaugh, who had studied with WILLIAM MERRITT CHASE and was, like Evans, a former member of the Western Art Association; N. S. Holm from Lincoln; Alice Righter, also from Lincoln and a former instructor at the university, who showed a pastel portrait and some miniatures; and Katherine Willis from Omaha, a pupil of Wallace, who showed a local genre study. The predominance of professional women among this group is indicative of the important role they played in the artistic life of the state. Mumaugh was an important art teacher; one of her paintings, *Grapes* (location unknown), was in Lininger's collection.[2]

 The Trans-Mississippi Exposition was followed in 1899 by the Greater American Exposition, again with an impressive gallery of work by American and foreign artists; a number of paintings by the Omaha still-life specialists Albert Rothery and Ella Ittner were included. By 1906 a Society of Fine Arts had evolved, replacing the now-defunct Western Art Association. By 1910 the society had begun to hold annual exhibitions of work by nationally famous artists. Another artists' organization with local concerns was the Omaha Art Gild [*sic*], founded in 1912, of which J. Laurie Wallace was art director. Most of Omaha's leading painters were active in the Gild except Albert Rothery, who was the principal exhibitor in the first annual of the Omaha Sketch Club, in 1913; the club may have been started as a rival to the Gild.

 College and university instruction not only offered training to prospective professional artists but also provided a livelihood for a number of Nebraska's best-known painters, the majority of whom were women. Training received at the University of Nebraska, **Lincoln**, usually constituted only a beginning, however. Motivated pupils went on to professional art schools in Chicago, New York City, and, sometimes, abroad. Art instruction began at the university as early as 1877, six years after the institution was founded. At that time, even though art instruction was offered in the university catalogs and took place on campus, tuition was separate and the classes were not integrated into the regular university curriculum until 1897. The teacher from 1877 to 1879 was Frank Stadter (born Boris Harodinski), a Polish army deserter. Later instructors included Emma Richardson (later Emma Cherry), from 1879 until 1881, who studied in Chicago, New York City, and Paris and became active in Kansas City, Denver, San Antonio, and Houston;

Ada Seaman, in 1882–83; and Miss A. Davis, in 1883–84. These artists received no salaries but had the rent-free use of the school's studio. The pivotal figure of these early years was Sarah Wool Moore from Plattsburg, New York, who had studied at the Packer Collegiate Institute in Brooklyn, New York, in 1865 and in Vienna before going to the university in 1884. She remained until 1893 and has been credited with "the quickening

3.50 Cora Parker (1859–1944)
Candlelight, 1899
Oil on canvas, 38 × 24 in.
Sheldon Memorial Art Gallery,
University of Nebraska-
Lincoln; F. M. Hall Collection

and development of artistic taste and expression in Nebraska."[3] Moore was responsible for founding the Haydon Art Club in Lincoln in 1888, named after the once-prominent British history painter Benjamin Robert Haydon, whose art, ambition, and struggle epitomized dedication to the highest artistic principles. The club's goals were those of so many art associations founded in the late nineteenth century, especially in the Midwest: the study of art and the presentation of papers; the encouragement of art in the community and schools; the institution of exhibitions; the formation of a permanent collection; and the acquisition of a suitable museum building.

Enthusiasm was immediate, and the membership had increased to over a hundred by the fall of 1888. Late that year the club presented its first annual exhibition, consisting of a single monumental painting by the acclaimed Munich artist and former director of the Bavarian Royal Academy, Karl von Piloty: *The Wise and Foolish Virgins*, borrowed from the Metropolitan Museum of Art in New York City. Annual exhibitions have continued there ever since, though the depression of the early 1890s curtailed them somewhat, that of 1891 being borrowed primarily from the Western Art Association in Omaha. The association was a main source of the 1894 annual as well, but for the first time work by local painters was also shown, including **Cora Parker**, Alice Righter, and Henry Howard Bagg.

Cora Parker had succeeded Sarah Moore at the university in 1893 and remained until 1899, when she left for Greenwich, Connecticut, to take charge of the gallery of the Bruce Museum. Born in Kentucky, Parker had studied in Cincinnati and Paris as well as with William Merritt Chase. Her *Candlelight* is a perceptive study not only of subdued 3.50 illumination but also of reverie and melancholy. Many women students of Moore and Parker became professional artists, contributing to Nebraska's artistic life through their involvement with the Haydon Art Club. Alice Righter was a student of Moore's in 1886 and returned a decade later as an instructor and assistant to Parker, becoming a trustee and one of the first members of the Nebraska Art Association as well as a painter of miniatures and landscapes. ADA B. CALDWELL, a student of Moore, went on to the Art 3.56 Institute of Chicago and was South Dakota's major artist from 1898 until 1936. Marion Canfield Smith was born in Lincoln and studied at the university in 1893. After instruction in Philadelphia and elsewhere, she was appointed in 1905 to the faculty of the Nebraska Normal School at Kearney (later Kearney State Teachers College) and became known for her rural landscapes and her Indian subjects painted on trips to South Dakota. Alice Cleaver was a Parker student who also went to Chicago and Paris to study and then settled in Falls City, Nebraska, where she painted modern working women in France and America. Other students made their careers elsewhere, such as ELIZABETH TUTTLE HOLSMAN, 2.275 an important Impressionist landscape painter who settled in Chicago.

In 1897, while Parker was still its head, the School of Fine Arts was fully integrated into the university under the auspices of the Haydon Art Club, which assumed financial responsibility for it. On Parker's departure the university agreed to absorb the new department, while exhibitions and acquisitions continued to be financed by the club. Thus began a unique association, which was more firmly cemented in 1900, when the club voted to expand its operations and rename itself the Nebraska Art Association, with branches throughout the state. The connection between the association and the university has continued ever since. After the establishment of the association, and with the success of the art galleries featured at the international expositions in Buffalo in 1901 and Saint Louis in 1904, eastern artists were more amenable to sending work for exhibition to the Nebraska annuals, which became more national in scope.

Chicago-born **Sara Shewell Hayden** succeeded Parker as head of the art department in 1899, remaining until 1916. A portrait and figure painter, Hayden had studied in Chicago, in Paris, and in New York City with William Merritt Chase. Her best-known work is the evocative *Girl in Green*, for which one of her students, Mrs. H. C. Filley of 3.51 Lincoln, had posed. This meditative image has an aura of gentle mystery. Hayden emphasized the richly colored patterning of the dress, making it the dominant element in the manner of Hayden's contemporary John White Alexander. In 1913 Hayden was joined

in the department by Louise Mundy, a former student who specialized in watercolor still lifes. Among Hayden's other pupils was Elizabeth Dolan, a landscapist of note and a popular mural painter who created work for public buildings and private homes.[4]

Though the seemingly endless sweep of the Great Plains offered a challenge to the imagination and resources of landscape painters, few American artists were inspired by these visual stimuli. The state's earliest landscape specialist, **Henry Howard Bagg** from Illinois, went to Nebraska to teach at the State Normal School in Peru in 1895. In 1902 he taught art at Cotner College and in 1906 transferred to Nebraska Wesleyan University, both in Lincoln. Bagg also painted still lifes and religious works. Even in his scenic work, such as *Black Hills Landscape*, he preferred the more rugged, picturesque scenery of southwestern South Dakota to the flat expanse of his adopted state. Over the years Bagg provided western imagery for a number of calendar companies; he probably achieved his

3.52

RIGHT:
3.52 Henry Howard Bagg
(1854–1928)
Black Hills Landscape, 1920
Oil on canvas, 24 x 35 in.
Sheldon Memorial Art Gallery,
University of Nebraska-
Lincoln; Gift of Mrs. Wishart
in memory of Mrs. Bratt

BELOW:
3.53 Robert Fletcher Gilder
(1856–1940)
Shadow of the Bridge, n.d.
Oil on canvas, 23½ x 29½ in.
Joslyn Art Museum, Omaha

1.152, 1.254 greatest popular recognition when he shared with THOMAS MORAN the color illustration of Thomas D. Murphy's *Seven Wonderlands of the American West* (1925).

Twentieth-century Nebraska saw the arrival of a number of more modern landscape painters, including Clara Leland and the watercolorist Augusta Knight, who went to Omaha in 1909 and became director of art at the University of Omaha. The best known of these artists was **Robert Fletcher Gilder**. Before he went to Omaha in 1887, Gilder

1.257 studied painting under AUGUST WILL, the Jersey City painter of urban scenes who ran a school in New York City. Gilder was active as a journalist on the *Omaha World-Herald* for twenty-five years; he also achieved an international reputation in archaeology and was the staff archaeologist for the University of Nebraska. In addition, he painted vivid

3.53 Impressionist landscapes and urban scenes of great freedom, such as *Shadow of the Bridge*.

Other late nineteenth- and early twentieth-century artists in Omaha included James Knox O'Neill, Albert Rothery, and Augustus Dunbier. O'Neill was probably the earliest professional in Omaha, where he arrived in 1880; though he was primarily a portraitist, one of his most noteworthy works was a historical representation of the Battle of Wounded Knee. Albert Rothery was a student in his native Poughkeepsie, New York, of either the landscape painter Frederic Rondel or the still-life specialist Louis Rondel, and in New York City of A. Chatain, a pupil of Jean-Léon Gérôme. A figure and still-life painter, Rothery went to Omaha about 1888; George W. Lininger was one of his patrons and owned several of his fruit and flower paintings. Rothery exhibited with the Society of Western Artists in 1902, one of the few Nebraska painters to show with that significant midwestern organization. Augustus Dunbier was born in Osceola, Nebraska, and studied in Düsseldorf before going to Omaha in 1915 and setting himself up as a portrait painter and independent teacher. Dunbier painted a moving likeness of his colleague Robert Fletcher Gilder (1933; Nebraska Art Collection, Kearney State College); with Alice Cleaver and J. Laurie Wallace, the two participated in the annual exhibitions of work by northwestern artists held in Saint Paul from 1915.

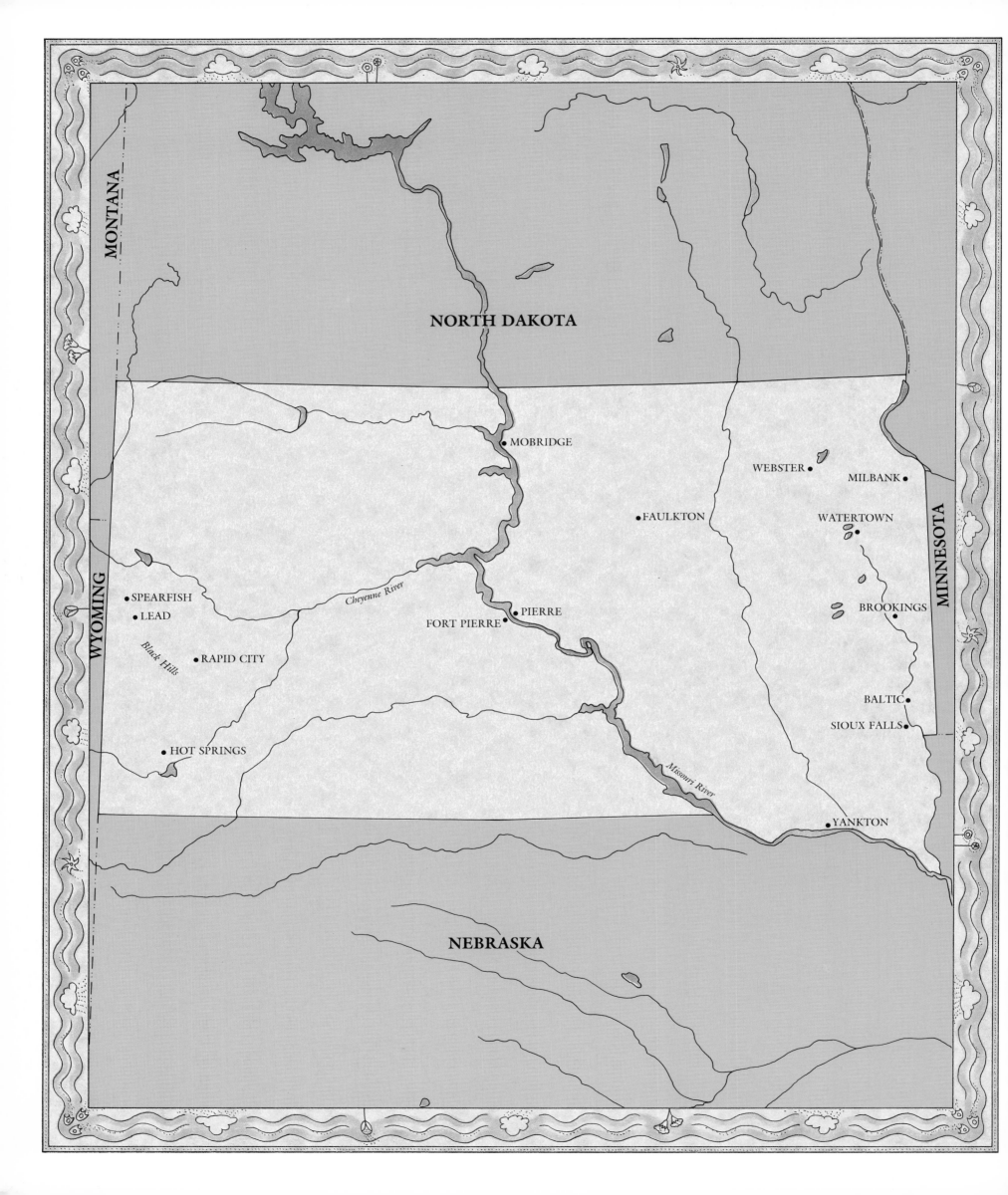

MONTANA

NORTH DAKOTA

WYOMING

MINNESOTA

• MOBRIDGE

WEBSTER • MILBANK •

• FAULKTON WATERTOWN •

SPEARFISH •
• LEAD Cheyenne River BROOKINGS •

Black Hills FORT PIERRE • PIERRE

• RAPID CITY

BALTIC •

• HOT SPRINGS SIOUX FALLS •

Missouri River

• YANKTON

NEBRASKA

SOUTH DAKOTA

The Dakota Territory was formed in 1861 out of land included in the Louisiana Purchase of 1803. Settlement was spurred in 1874 by the discovery of gold in the Black Hills, and in 1889 the territory was divided into the two states of South and North Dakota. South Dakota was, and remains, the more populous; the gold settlements were in the western part of the state, but the first territorial capital was Yankton, in the southeastern corner on the Missouri River. The earliest settlement, established in 1817, was the American Fur Company post at Fort Pierre, farther along the Missouri and opposite the present state capital of Pierre, which was founded as a railroad terminus in 1880.

The artistic histories of the Dakotas are remarkably diverse. Though both states attracted numerous visiting artists who sought Indian subjects or were on westward travels, South Dakota enjoyed a resident art establishment in various communities to a far greater extent than did its northern neighbor. This development postdated the Indian wars from the Sioux uprising of 1862 to the Battle of Wounded Knee in 1890. South Dakota scholars have documented the state's artistic history much more thoroughly than has been the case in North Dakota.

The earliest visitors to what is now South Dakota were, predictably, GEORGE CATLIN, Karl Bodmer, and the botanical naturalist Thomas Nuttall, who was in the area of Mobridge in 1811. Catlin was at Fort Pierre in 1832; JOHN JAMES AUDUBON, accompanied by Isaac Sprague, was there in 1843. By midcentury academically trained Indian painters appeared in the region, including CHARLES F. WIMAR, who traveled the upper Missouri in 1858, and William Jacob Hays in 1860. In the 1880s a number of the later Indian specialists appeared, such as HENRY F. FARNY from Cincinnati in 1881; RICHARD LORENZ, the best-known member of the German art colony to settle in Milwaukee in the late 1880s, found many of his subjects in the Dakotas. In the 1890s several other Indian painters, such as Edwin Deming, Frederic Remington, CHARLES SCHREYVOGEL, and De Cost Smith, were all active there.

Native and resident South Dakota artists tended to look toward Chicago and Minneapolis for inspiration and training. The state could boast no major urban art center of its own, nor even as large and aware a community as Omaha. **Yankton**, and later Brookings near the eastern boundary with Minnesota, housed the most vital clusters of artists in the late nineteenth and early twentieth centuries. Even there, no regular exhibition outlets existed. No Dakota painters appear ever to have exhibited in the annual shows of the Society of Western Artists. And though art was taught in the public schools and in some of the state's institutions of higher learning, there were no art schools.

The first professional resident painter was probably Isabelle Weeks, who was in Yankton as early as 1872, remaining for the rest of her life. Another painter there during these early decades was Lavina Bramble Vanderhule, who settled in 1875. Better known was Bohemian-born Louis Janousek, whose family emigrated to Niobrara, Nebraska, in 1869, where the young man opened a photography studio in 1885. Two years later Janousek worked at Rounds photographic studio in Yankton, in which city he remained until his death in 1934. He had studied with the portraitist Arthur J. Rupert at the Chicago Academy of Fine Arts in the early 1880s and maintained a double career as photographer and painter, though his specialty was landscape. Janousek showed work at the Northwestern Artists annual in Saint Paul in 1916.

The best-known nineteenth-century painter to reside in South Dakota was the once-renowned panoramist John Banvard, who retired in 1883 to the small community of Watertown, where his son was a prosperous attorney and loan and real-estate agent.

3.17
2.67
3.27
2.179; 2.162
1.256

There the aging artist wrote poetry and political tracts, lectured on his travels, and painted such works as *The Lord's Prayer*, donated to the local Trinity Episcopal Church. In 1886 the septagenarian Banvard began a massive diorama of the burning of Columbia, South Carolina, which he exhibited in Watertown and nearby communities.[1]

Grace Ann French, the earliest professional artist in the western part of the state, had studied at the School of Design in Lowell, Massachusetts, at Massachusetts Institute of Technology in Cambridge, and at the Boston Museum School before moving to Rapid City, in South Dakota's Black Hills, in 1885 for the rest of her long career. The Black Hills had been settled following the discovery of gold in 1874. In 1888 French began to teach at Black Hills College in Hot Springs, south of Rapid City (now located in Spearfish). Rapid City began to attract other professional women painters in the early twentieth century, including the landscapist Della Vik, who went to South Dakota in 1906 and was influenced by French and by Lillian B. Forde, who went to the town of Lead in 1900; Forde became the art instructor at the Spearfish Normal School in 1909. Forde also influenced the work of Mar Gretta Cocking, who had been teaching in the public school system in Rapid City from 1917 and who succeeded Forde at Spearfish in 1935, becoming director of the Black Hills Art Center there.[2] (The most notable artistic endeavor in the region, the carving of Mount Rushmore by Gutzon Borglum between 1927 and 1939, falls beyond the scope of this study.)

Two of the young state's most individual and interesting painters lived in quite isolated circumstances. **Charles Greener** resided in Faulkton, a small town in the north-central part of the state, from 1890 and studied first at the University of North Dakota in Grand Forks and then in Galesburg, Illinois; Boston; Cincinnati; and Minneapolis. He appears to have come into his own in the 1910s, exhibiting at the Northwestern Artists annual in Saint Paul in 1915. Greener specialized in painting the prairies, capturing their vast expanse in simplified contours and brilliant, glowing light, as in *Honkers at Sunrise*. While never achieving the painterly excitement of his Canadian contemporary Charles W. Jeffreys, Greener was perhaps this country's most devoted and noted interpreter of the distinctive character of the Great Plains.[3]

3.54

OPPOSITE:

3.54 Charles Greener (1870–1935)
Honkers at Sunrise, 1910
Oil on canvas, 23³⁄₁₆ x 17 in.
South Dakota Art
Museum, Brookings

ABOVE:

3.55 Myra Miller (1882–1961)
Hunter's Pride, c. 1912
Oil on canvas,
48⁵⁄₁₆ x 23⁷⁄₈ in.
South Dakota Art
Museum, Brookings

LEFT:

3.56 Ada B. Caldwell (1869–1937)
Near Colorado Springs, c. 1929
Oil on panel, 8³⁄₄ x 11¼ in.
South Dakota Art
Museum, Brookings

3.57 Harvey T. Dunn
(1884–1952)
The Prairie Is My Garden, c.
1925–51
Oil on canvas, 40 x 69⅞ in.
South Dakota Art
Museum, Brookings

Myra Miller lived in Buffalo Lake and in Webster, in the state's northeastern corner. Largely self-taught except for instruction from the Rogers sisters in Milbank, she was also a painter of western subjects, but as a still-life specialist, the most distinctive in South Dakota. Miller's paintings represent a late flowering of the trompe-l'oeil tradition initiated by William Michael Harnett's vertical cabin-door paintings. Such paintings as Miller's *Hunter's Pride* so resemble the works of Harnett's immediate follower, the peripatetic 3.55
RICHARD LA BARRE GOODWIN, that it is inconceivable that she was not familiar with them. 3.145
Coincidentally, his most famous such painting has a Dakota reference: *Theodore Roosevelt's Cabin Door* (location unknown; study at Vassar College Art Gallery, Poughkeepsie, New York), based on an exhibit at the Lewis and Clark Centennial Exposition in Portland, Oregon, in 1905 and painted shortly before Miller took up the theme, refers to Roosevelt's hunting cabin at Medora in western North Dakota.[4]

One of the most influential of all South Dakota artists was **Ada B. Caldwell**. Originally from Bryan, Ohio, Caldwell studied at the University of Nebraska and, having decided on an artistic career in 1893, went to the Art Institute of Chicago for five years, studying with JOHN VANDERPOEL. In 1898 Caldwell was recommended as an instructor to 2.266 Yankton College, but after a year there she transferred to South Dakota Agricultural College in **Brookings**, where she remained for the rest of her career. In addition to making etchings and woodblocks, Caldwell painted able landscapes that became increas- 3.56 ingly expressive and colorful as she sought additional training in New York City and, later, with SVEN BIRGER SANDZÉN at Broadmoor Art Academy in Colorado Springs, even as 3.48 she continued her own teaching.[5]

Caldwell's most noted pupil at Brookings was **Harvey T. Dunn**, a native South Dakotan born in Manchester, who studied at the agricultural college in 1901 and who always acknowledged the vistas Caldwell opened to him. Dunn went to Chicago and to Wilmington, Delaware, to work with HOWARD PYLE. His career as an illustrator, easel 1.309 painter, and muralist was based in the East, where he lived in Leonia and then Tenafly, New Jersey, and taught in New York City. However, Dunn spent his summers in South

3.57 Dakota, and his native state remained the inspiration for his finest works—inspirational scenes of prairie life and toil such as *The Prairie Is My Garden*. Such a painting convincingly projects a combination of the beauty and the hardships of pioneer life and a sense of the stalwart men and women Dunn wished to memorialize. He remains South Dakota's most honored painter; the State Art Museum in Brookings, which contains a large holding of his and Caldwell's works, faces Harvey Dunn Street.[6]

3.6 Neva Harding, from Rock Island, Illinois, was also a student of Caldwell's in Brookings, as was Gilbert Risvold from Baltic, South Dakota, who became one of the state's best-known native sculptors. Probably the most important painter to work in **Pierre**, the state capital, in the early twentieth century was the Minnesota portraitist NICHOLAS RICHARD BREWER, who painted likenesses of state legislators and other distinguished citizens in 1912–13. The most distinguished paintings in Pierre are the historical and allegorical murals executed in 1910 for the Capitol by the Chicago artist Charles Holloway and *The Spirit of the West* by the renowned New York muralist Edwin Blashfield.

The Rogers sisters, Anna and Laura, who were the teachers of Myra Miller, were among the more significant private art teachers in the state, living north of Brookings in **Milbank**. Nellie Voss, a painter of Impressionist landscapes, was the best-known artist there. **Sioux Falls**, the state's largest city and a major commercial center in the southeastern part of the state, began to attract professional artists only in the second decade of the twentieth century, when the Chicago-trained portraitist L. Lova Jones settled there in 1916; Henry Rezac, a painter of architectural decoration, arrived the following year.

CANADA

MONTANA

MINNESOTA

FORT UNION

Fort Berthold
Reservation

Fort Totten
Reservation

Red River of the North

GRAND FORKS

Sheyenne River

FORT CLARK

MEDORA

FARGO

MANDAN BISMARCK

Missouri River

FORT YATES

SOUTH DAKOTA

NORTH DAKOTA

3.17 North Dakota possesses a more meager artistic heritage from the period covered by this study. GEORGE CATLIN visited in 1832, making Fort Union his base of operations while he painted members of the Crow and Blackfoot tribes and participated in buffalo hunts. On his return voyage to Saint Louis, Catlin stayed at Fort Clark, adjacent to the Mandan village, where he produced some of his most powerful and best-known images of Indian life. Karl Bodmer painted in the same area, though he ventured farther along the upper
2.67 Missouri and into what is now Montana. In 1843 JOHN JAMES AUDUBON traveled the same route along the upper Missouri River.

3.27 At midcentury CHARLES F. WIMAR—in 1858—and William Jacob Hays—in 1860— were among the most prominent artists to visit the northern Dakota region, while in 1881
2.179 HENRY F. FARNY painted the Sioux at Fort Yates, in what is now south-central North Dakota. The most famous visitor of all was Thomas Eakins in 1887, whose *Cowboys in the Badlands* (private collection) of the following year is probably the most artistically noteworthy nineteenth-century image to memorialize the Dakota region.

There were few resident artists before 1920. One of the principal painters from before statehood in 1889 was **John Delbert Allen**, who lived in Mandan, just across the Missouri from the capital, Bismarck. Allen had worked as an aide to the governor of Colorado and in 1881 was a stenographer for the Northern Pacific Railroad in Mandan, where he opened a taxidermy shop the following year. He lived and painted among a collection of Indian artifacts and mounted birds, mammals, reptiles, and fish. He was a specialist in Indian landscapes, and he also was noted as a painter of game still lifes, such
3.58 as *Woodcocks*. Allen prepared hunting trophies for such notables as Theodore Roosevelt, who had a ranch and hunting cabin near Medora.

Allen was self-trained in both taxidermy and art. **Margarethe Heisser**, however, studied in her native Minneapolis, where she shared a studio with her long-time colleague
2.30 and friend, ELISABETH CHANT, and in New York City and Paris. After three years abroad Heisser maintained a portrait studio in Fargo, North Dakota, painting local notables and a series of likenesses of North Dakota Indians. In 1907 she spent the summer at the Fort
3.59 Berthold Reservation, where she painted the first three works in the series, including *Bad Brave*. The following year, on her way to Fort Totten Reservation, she became seriously ill and died in Grand Forks. Many of North Dakota's other leading artists of the earlier decades of this century were of Norwegian and Icelandic heritage: the portrait and landscape painter Gustav Gulliksen; landscapists Kristinn Armann and Emile Walters; and sculptors Einar Olstad and Ole Olsen, for example.

TOP:

3.58 John Delbert Allen
(1851–1947)
Woodcocks, 1878
Oil on canvas, 18 x 12 in.
State Historical Society of
North Dakota, Bismarck

BOTTOM:

3.59 Margarethe Heisser
(1871–1908)
Bad Brave, 1907
Oil on canvas, 32¼ x 23 in.
State Historical Society of
North Dakota, Bismarck

THE ROCKY MOUNTAIN WEST

"The West" brings to mind America's last frontier, a wild, unspoiled territory with an indigenous population and without urban settlements or cultural amenities. In fact, the West encompassed diverse traditions by the second half of the nineteenth century, especially after the discovery of gold in California and the rapid settlement of the northern part of that state. "The Rocky Mountain West" refers to the western interior, those states bordering on the Rocky Mountains: Montana, Idaho, Wyoming, Colorado, and Utah. Little attention was paid to this region in the literature devoted to cultural achievement at the turn of the century; it was considered no more than a travel corridor, particularly after the East and West coasts were linked by rail in 1869. The railroads themselves became major patrons of American artists in the early years of the twentieth century. They commissioned works to decorate the offices and the stations of the Atchison, Topeka and Santa Fe, the Great Northern, and the Northern Pacific railroads. Those paintings were usually, but not always, created by artists living in the West (especially the Southwest and the Northwest).

For the most part, eastern artists who traveled through the Rockies remained only a short time and, except possibly in Colorado, had little impact on the resident population, neither influencing artists there nor seeking local exposure and patronage. The market for the visitors' views of majestic western mountain scenery, sometimes peopled by Indians, was in the East.

Many eastern artists did eventually move west in search of a healthier climate or a pleasant environment for their old age: some sought the high, clear air of Colorado; others, the dry warmth of the Southwest; and still others, the temperate Southern California climate of Santa Barbara, Los Angeles, and San Diego. The few urban centers of the interior West did cultivate a full range of artistic endeavor, but such settlements were few in number for so vast a territory and resident artists lived and worked in relative isolation. Those painters and sculptors who were not strictly transient often devoted themselves to the same subjects and styles favored by the more famous artists who passed through the American West.

3.60 Charles Stewart Stobie
 (1845–1931)
 Young Ute, Indian Camp, 1915
 Detail of plate 3.72

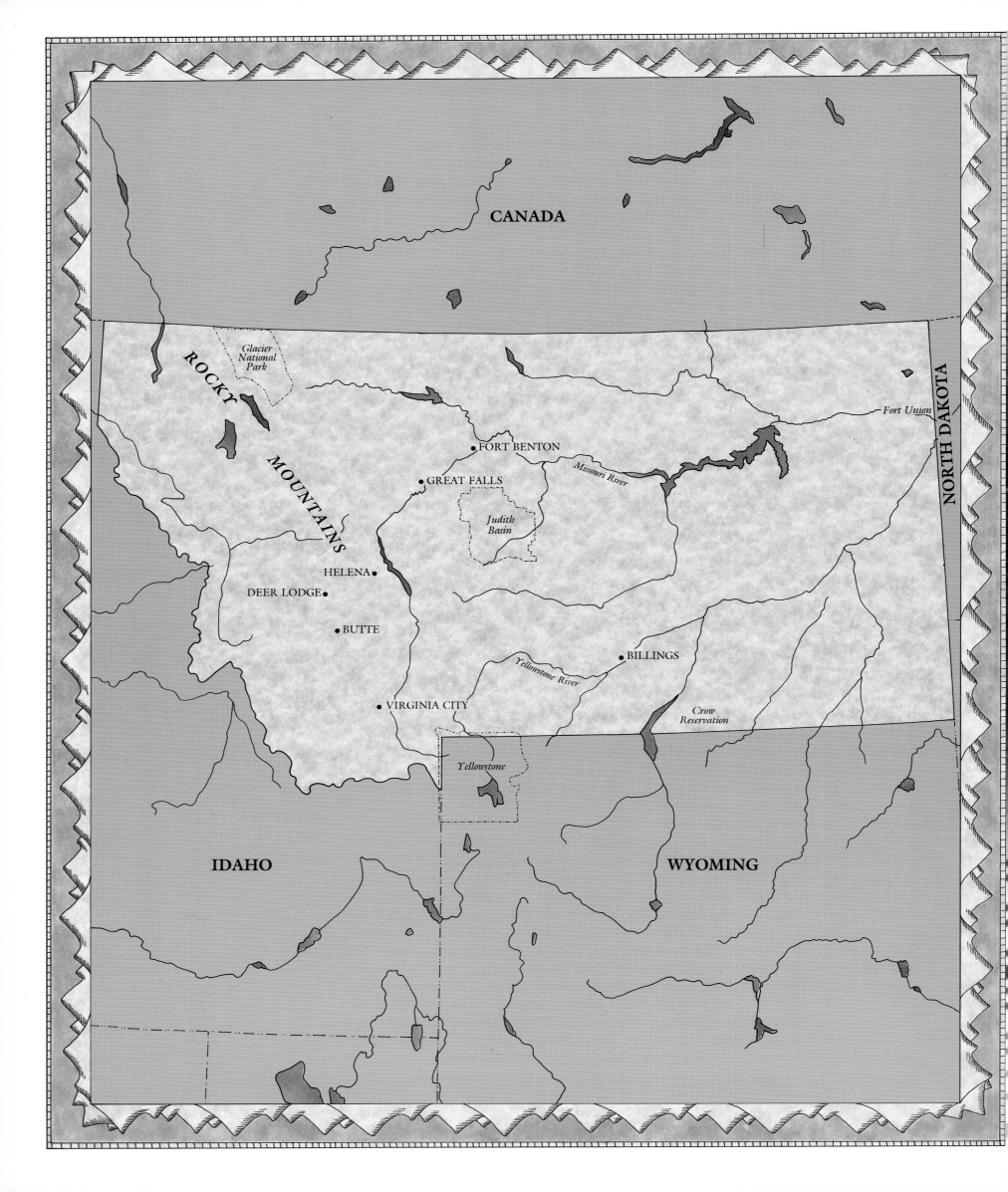

CANADA

NORTH DAKOTA

*Glacier
National
Park*

ROCKY

MOUNTAINS

● FORT BENTON

● GREAT FALLS

Missouri River

Fort Union

*Judith
Basin*

HELENA ●

DEER LODGE ●

● BUTTE

● BILLINGS

Yellowstone River

*Crow
Reservation*

● VIRGINIA CITY

Yellowstone

IDAHO

WYOMING

MONTANA

Swiss-born Karl Bodmer was the earliest artist to visit the region now identified as Montana, proceeding from Fort Union by keelboat along the upper Missouri River to Fort McKenzie in 1833.[1] Others followed, including Father Nicolas Point, a missionary artist who lacked Bodmer's academic skills. During the 1850s artists were hired by the United States government to sketch the terrain for railroad surveys. James Madison Alden, a Boston-born artist who had studied with Thomas Seir Cummings in New York City in 1853–54, was the topographical draftsman for the Northwest Boundary Commission from 1858 until 1860 and painted a series of spectacular watercolors of the region later established as Glacier National Park in Montana.[2] In the 1860s the region (which had become the Montana Territory in 1864) was visited by such painters as William de Montagne Cary, who traveled from Fort Union to Fort Benton. Two years later the peripatetic Danish artist Peter Peterson Tofft arrived, having gone to California during the gold rush and later turned his attention to art. The gold fields of Montana attracted Tofft to the Rockies, but his lack of success sent him back to art. His scenic paintings caught the attention of patrons in Virginia City, then the capital of the territory. Tofft also teamed up with Acting Governor Thomas F. Meagher to illustrate an article for *Harper's New Monthly Magazine*, "Rides through Montana," before moving to Helena and then leaving for the East and England.[3] In the fall of 1867 the draftsman-lithographer Alfred Edward Mathews, who had settled in Denver in the Colorado Territory, visited Montana, producing his *Pencil Sketches of Montana* the following year. In 1883 the Northern Pacific Railroad crossed the territory, and in 1889 Montana was admitted as a state to the Union.

Artists continued to visit Montana, though only a few settled there; many of those recorded as active in the early twentieth century were basically art educators in the public schools rather than professional painters. Frederic Remington's first trip west was to
1.26 Montana in the summer of 1881. That same year GEORGE DE FOREST BRUSH went to Wyoming with his brother, and in the fall he went to the Crow Reservation near Billings, an experience that was the source of many of Brush's Indian paintings of the 1880s. The previous summer **Charles Marion Russell** from Saint Louis had first visited the Montana Territory via the Union Pacific and Utah Northern railroads, continuing by stagecoach to Helena, which had become the territorial capital in 1875, and making his way to Judith Basin, which remained his base until he moved to Great Falls in 1893. From 1881 to 1888 Russell worked as a horse wrangler, and at the same time he began to paint local subjects. In 1886 his earliest oil painting, *Breaking Camp* (Amon Carter Museum, Fort Worth), was shown in the Saint Louis Exposition and Music Hall Association annual, Russell's first public exposure. Though self-taught, Russell made clear his awareness of the art of other Indian specialists; he was particularly indebted to Remington and to
3.27 CHARLES F. WIMAR, the Saint Louis Indian specialist who had died shortly before Russell was born. In 1887 a small watercolor (location unknown) depicting the tragic effects of freezing winter on the cattle herds brought more attention to Russell's abilities; the following year *Harper's Weekly* published an engraving after one of his paintings, and he began to achieve a national reputation.

In 1893, accompanying a beef train to Chicago, Russell visited the World's Columbian Exposition and then went on to see his parents in Saint Louis. There he met William Niedringhaus, a merchant with ranching interests in Montana, who commissioned several paintings from him; this allowed Russell to give up his life as a cowboy. Great Falls also provided patronage, particularly from Sid Willis, who opened the Mint Saloon

3.61 Charles Marion Russell
(1864–1926)
The Medicine Man, 1908
Oil on canvas, 30⅛ x 48⅛ in.
Amon Carter Museum,
Fort Worth

in 1898 and began to collect Russell's paintings to hang on its walls. Montana remained Russell's home for the rest of his illustrious career, and he became the state's most noted artist. In 1903 he had his first solo show in Saint Louis; in 1911 one was held in New York City at Folsom's Gallery. Russell's art, with its emphasis on fiercely active Indian and cowboy life set in the broad plains with the Rockies as a backdrop, became the model followed by most other Montana painters. Russell worked not only in oils and watercolor but also created bronze sculptural groups. He was tremendously prolific, and the quality of his output varies. Both his draftsmanship and his color can be crude and summary, but in his finest paintings, such as *The Medicine Man*, he combined his respect for the 3.61 dignity of the vanishing Indians with a technical sureness that reveals an awareness of sophisticated contemporary techniques.

Russell's paintings are generally based on his own experience, but he also portrayed imaginary and historical scenes and scenes taken from accounts by earlier mountain men, fur traders, and missionaries. He was especially attracted to the Lewis and Clark expedition, and his most ambitious work, painted in 1912, was *Lewis and Clark Meeting the Flatheads in Ross' Hole, September 4, 1805*, a mural for the House of Representatives in the Montana State Capitol in Helena.[4]

Russell's fame as Montana's foremost painter of cowboy and Indian subjects has tended to obscure the activity of a number of other very able professionals who shared his themes and achieved considerable reputations in their own time. One of these was **Edgar Samuel Paxson**, who arrived in the Montana Territory as a freight-wagon driver in 1877, just a year after the tragic battle at Little Big Horn. Paxson had grown up on the outskirts of Buffalo, New York, and had been impressed by the first significant American acquisition of the Buffalo Fine Arts Academy, ALBERT BIERSTADT's *Laramie Peak*. In Montana, 3.183

Paxson became an Indian scout and led the life of a frontiersman while developing his artistic abilities. He first resided at Deer Lodge then in 1880 established a studio in the growing metropolitan community of Butte, remaining for twenty-four years; one of his first positions there was as scenic artist at the Renshaw Opera House. Paxson painted Indian subjects, three of which were exhibited in the Montana Building at the World's Columbian Exposition, and he was involved in illustration for a sportsmen's journal, *American Field*. After a bout of malaria contracted in the Philippines after the Spanish-American War, he resumed work on a major historical canvas, *Custer's Last Stand*, the site of which he had visited and begun to research as early as 1877. Paxson completed the canvas, which contains over two hundred figures, in 1899, after which it was shown in Washington, D.C., and began to establish the artist's reputation.

3.62

Determined to be recognized as a professional painter, Paxson showed work at the Louisiana Purchase Exposition in Saint Louis in 1904 and at the Lewis and Clark Centennial Exposition in Portland, Oregon, in 1905. The following year he moved to Missoula. In 1911 he was commissioned to execute six historical murals for the State Capitol in Helena and the following year, eight murals about Montana's frontier history for the Missoula County Courthouse. But the artists's most frequent subjects were Indians—portrait heads and full-length (sometimes equestrian) figures and the buffalo hunt. He exhibited such work in the Northwestern Artists annuals in Saint Paul in 1915 and '16, one of the few Montana painters to participate. Among his white subjects were trappers, hunters, and prospectors but—unlike his friend and colleague Russell—seldom cowboys.[5]

Paxson may have met Russell in Montana in the early 1880s; they were certainly friends by 1891 and renewed their relationship in the early twentieth century. Paxson

3.62 Edgar Samuel Paxson
(1852–1919)
Custer's Last Stand, 1899
Oil on canvas, 70½ x 106½ in.
Buffalo Bill Historical Center,
Cody, Wyoming

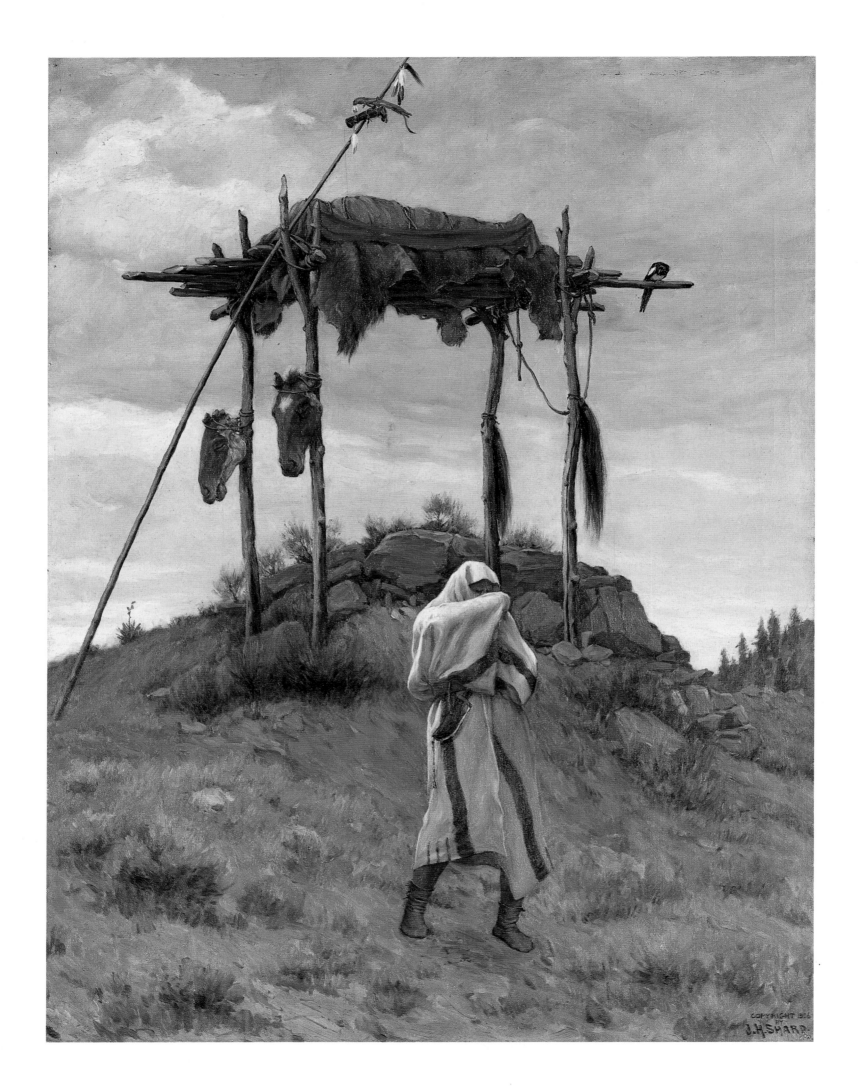

also was acquainted with **Joseph Henry Sharp**, the Cincinnati painter who was one of the first members of the artists' colony in Taos, New Mexico. Sharp began to visit the Crow Reservation in southern Montana in the summer of 1899. The artists De Cost Smith and Edward Deming had recorded the Crow Agency when they passed through in the early 1890s, and Russell was also a visitor. Sharp visited Russell in Great Falls in 1907. Frederic Remington, CHARLES SCHREYVOGEL, and the Wyoming artist BILL GOLLINGS were also at the agency. Having been commissioned by Phoebe Apperson Hearst (mother of William Randolph Hearst) in 1902 to execute scenes and portraits of Indian life, Sharp set up his headquarters at the Crow Agency, connected by rail with Chicago, Denver, and Billings. He wintered there from 1902 until 1910, abandoning his property after his wife's death in 1913. Some of Sharp's finest paintings are vivid, realistic renditions of reservation life—cold and somber scenes such as his moving record of a platform burial, *Voice of the Great Spirit*—which are distinct from his colorful renditions of southwestern Indian life. That Sharp considered himself very much a resident of the agency in Montana is verified by his identification as such in the annual of the Society of Western Artists between 1908 and 1912; before 1908 he listed himself as a Cincinnati painter and after 1912 as a Taos resident. Sharp also established an eastern reputation, exhibiting annually at Fishel, Adler and Schwartz in New York City from 1904 until 1910.[6]

Several professional landscapists who visited Montana during the territorial and early statehood years are still little known. CYRENNIUS HALL, originally from Blue Earth, Minnesota, settled in Chicago and was actively painting and exhibiting his views of Yellowstone in Helena and Butte in 1885.[7] Mary Cecil Wheeler, a member of the first graduating class at Helena High School in 1879, was a teacher and art supervisor in the Montana public schools for some forty years. She exhibited local views and French scenes in Denver. Ralph Earll DeCamp was born in Attica, New York, and after studying at the Pennsylvania Academy of the Fine Arts in 1881–82, he received a commission from the Northern Pacific Railroad in 1885 to paint in Yellowstone. The next year he went to Helena, attracted by its scenic possibilities, and remained for most of his career; he painted rugged mountain scenery and bucolic landscapes with cattle. In 1911 DeCamp joined his friends Russell and Paxson in creating murals for the State Capitol, and as DeCamp was a resident of the capital city, his studio became a meeting place for members of this coterie, who are believed to have painted a number of easel landscapes in concert.[8]

ABBY WILLIAMS HILL, from Tacoma, Washington, and JOHN FERY, resident in Milwaukee and Saint Paul, both painted dramatic scenery in Montana for the Great Northern Railroad, Hill between 1903 and 1905 and Fery from 1910 on. The offices and stations of the Great Northern and Northern Pacific railroads, with their paintings by Hill, Fery, and DeCamp, could rightly be called Montana's first art galleries.[9] This was particularly true since there was no art establishment as such in Montana during the years under consideration. Works of art were shown at the state fairs in Helena, and Russell and DeCamp together organized the Helena Sketch Club about 1890.

A later landscapist active professionally in Montana was Lee Hayes, from Butte, who exhibited with the Northwestern Artists in 1918. His primary profession was chief engineer for the Anaconda Copper Mining Company; as an artist, he was more famous as an etcher. In 1913 Winold Reiss came to this country from Germany, having studied in Munich, to paint the Indians; he created eighty-one pictures for the Great Northern Railroad, and forty-nine of his works were reproduced in Frank B. Lindeman's book *Blackfeet Indians* (1935). While painting portraits of the Blackfoot, Piegan, and Crow tribes, Reiss spent many summers teaching art at Glacier National Park and was probably the state's leading art teacher.[10] Only a visitor to Montana, but a very significant one, was the California artist MAYNARD DIXON, who was commissioned in 1917 by the Great Northern Railroad to create a group of paintings of the Blackfeet and of Glacier National Park. Twelve of those pictures were acquired for Glacier Lodge in the park.

One of the finest native American artists to paint in an academic manner and one of the first native American professionals to utilize his own people as his primary theme was **Lone Wolf**. He was born on the Blackfoot Reservation in Montana, the son of the

3.63 Joseph Henry Sharp
(1859–1953)
The Voice of the Great Spirit, 1906
Oil on canvas, 40 x 30⅛ in.
National Museum of American Art, Smithsonian Institution, Washington, D.C.; Bequest of Victor Justice Evans

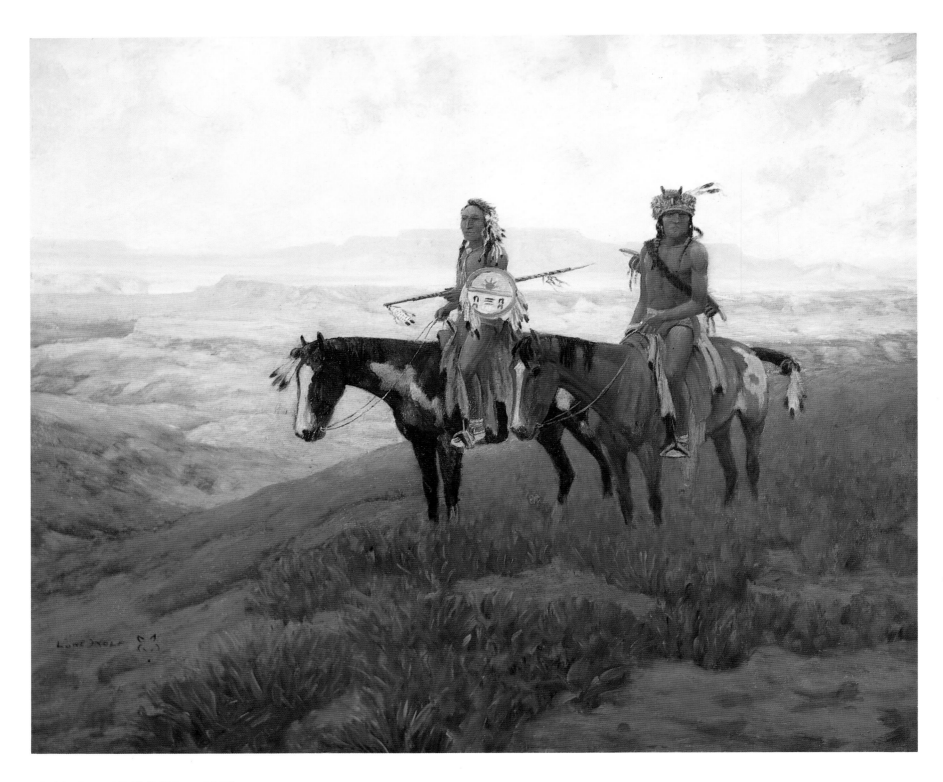

3.64 Lone Wolf (1882–c. 1965)
Scouts on the Watch, c. 1921
Oil on canvas, 19¼ x 23½ in.
The Phelan Collection

author James Willard Schultz and his Indian wife, Fine Shield Woman. As a youth Lone Wolf was taught by his grandfather to model animals in clay, to draw, and to paint on buckskin. After the death of Fine Shield Woman in 1903, Lone Wolf's father abandoned the Indian way of life and went to the West Coast. The following year Lone Wolf was advised to seek a change of climate for his health, and he subsequently spent winters in the Southwest and summers back in Montana, a seasonal migration that he continued through 1955. Lone Wolf painted his first watercolor of an Indian subject in 1904. Charles Schreyvogel, the Hoboken, New Jersey, painter of western scenes, gave Lone Wolf his first oil paintings, but it was THOMAS MORAN, whom Lone Wolf met at the Grand Canyon in 1909, who offered the neophyte the greatest inspiration and encouragement to pursue an artistic career.

1.152, 1.254

Lone Wolf was reunited with his father in Los Angeles in 1904, and following Moran's advice he entered the Art Students League in that city; he went on to school at the Art Institute of Chicago in 1914. Lone Wolf's first one-artist exhibition, held in Los Angeles in 1917, was greeted by enthusiastic reviews. He later established a summer studio at Saint Mary's Lake, Glacier Park, Montana, and another in the mountains of Arizona, where he spent the colder months. Among his closest professional associates were his fellow Montana artists Charles Marion Russell and Olaf Seltzer, and his paintings, like theirs, were devoted to the realistic portrayal of the American Indian, as in *Scouts on the Watch*.[11]

3.64

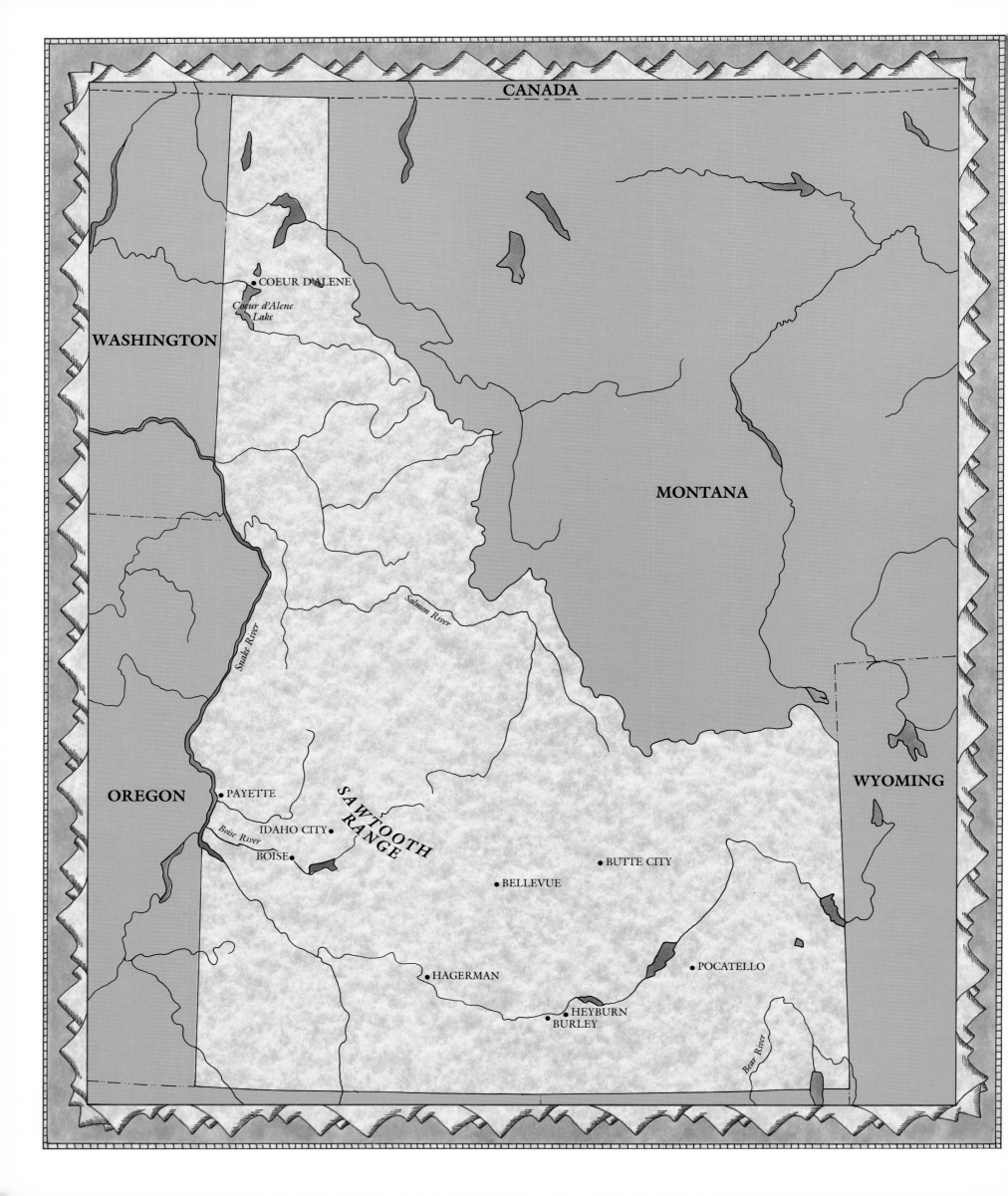

IDAHO

1.152, 1.254

Idaho, included in the Oregon Territory in 1848, became a separate territory in 1863 and was admitted to the Union as a state in 1890, with Boise its capital and largest city. Despite the discovery of gold in 1860, Idaho was sparsely populated throughout the period under consideration, and very few professional artists of consequence were active there. The earliest was probably Charles Ostner, a native of Austria, who arrived in 1862 during the gold rush and settled in Boise in 1869. In addition to his locally famous equestrian statue of George Washington, carved in 1869, Ostner painted portraits, mining scenes, and landscapes with animals.[1] The first professional painters appeared in the 1880s.

Artists visited Idaho, of course. THOMAS MORAN was one of the most active and famous, there for the first time in 1879. Probably the best-known artist to live in Idaho during the nineteenth century was **Mary Hallock Foote**, better known for her writing and illustration than for her paintings; indeed, she was one of the finest illustrators of her time in America. Mary Hallock was born in Milton-on-the-Hudson, New York, and educated in Poughkeepsie at the Female Collegiate Institute, where she took her first art lessons with Margaret Gordon in the early 1860s; later she studied with William Rimmer and William Linton at the Cooper Union School of Design for Women in New York City. One of the earliest works for which she provided illustrations was A. D. Richardson's *Beyond the Mississippi* (1867); she had thus done western scenes even before moving to the region in 1876, the year she married Arthur Foote, a mining engineer. They lived first in California and then moved to Leadville, Colorado, at the end of the 1870s. In 1882 Arthur Foote began an irrigation venture in Idaho, and two years later Mary joined him; they lived in **Boise** and then in Boise Cañon, ten miles away, where they remained until they moved to Grass Valley, California, in 1895.

Foote's western prose had begun to appear in 1878 in *Scribner's Monthly* (later *Century*), whose editor was Richard Watson Gilder, the husband of a classmate of Hallock at Cooper Union, the artist Helena de Kay Gilder. During her years in Idaho, Foote consolidated her reputation as an artist-author with ''Pictures of the Far West,'' a series

3.65 Mary Hallock Foote
(1847–1938)
Between the Desert and the Sown, 1895(?)
Wash drawing on paper,
6⅞ x 10 in.
Library of Congress,
Washington, D.C.

of Idaho scenes that appeared in *Century* in 1888–89, and with her novels and stories, many of which were set in Idaho, including *The Chosen Valley* (1892) and *Coeur d'Alene* (1894). Foote's illustrations and her drawings such as *Between the Desert and the Sown* 3.65 vividly capture the Idaho landscape and the conditions of frontier living.[2]

Though a small town, Boise was also home to several other artists, including Margaretta (Maggie) Brown, a painter of local genre. Originally from McConnellsville, Pennsylvania, Brown had settled in Idaho City from 1864 until 1882 and then lived in Boise until her death in 1897. She was married to a miner who had been attracted to Idaho City as the center of the territorial gold rush. Brown's best-known canvases were done there, including *Hydraulic Mining in the Boise Basin* (Idaho Historical Museum). She also painted murals—*Faith, Hope,* and *The Good Samaritan*—for the Good Templar's Hall in Idaho City.[3] A later painter in Boise was Eban Frank Gove, a specialist in rugged mountain scenery who lived in the capital in 1904–5, before moving to Payette.

Idaho's other, more professional, leading artists were both landscape painters. The earlier of these was Irish-born **Joseph Patrick McMeekin**, whose family came to America in 1872 and who settled on an island in the Snake River near Hagerman in the late 1880s. McMeekin was noted for his renderings of the distinctive lava canyons of southern Idaho and of scenery along the river, which flows through the southern part of the state, 3.66 carving awe-inspiring basalt cliffs. The artist exhibited paintings of Shoshone and Twin

Falls at the World's Columbian Exposition in 1893, won prizes at the Idaho Intermountain Fair in Boise in 1902, and showed work at the Lewis and Clark Centennial Exposition in Portland, Oregon, in 1905. In 1904 McMeekin opened a gallery—a combination art and photography studio—in Hagerman, then in 1910 moved to Napa, California, for the rest of his life.[4] A later artist, **George Schroeder**, was born in Chicago, where he engaged in sign painting; in 1885 he established a sign-painting business in Omaha that was successful throughout the far Midwest. In 1906 Schroeder settled in Heyburn, Idaho; six years later he moved to nearby **Burley**, also on the Snake River plain. (Burley had been home since 1895 to Celia May Southworth Beach, a painter of wildflowers and Rocky Mountain landscapes.) Schroeder studied with the New York City landscapist Theodore Pembrook and in Italy in 1914. Though he painted Italian scenes and American views, 3.67 Schroeder established his reputation as Idaho's leading landscape painter, utilizing his talents to popularize the scenery of his adopted state. He was noted for his views of the Sawtooth Range and Jackson Lake country, and among his achievements was the commission for scenes to adorn the Governor's Special, a train that toured the eastern states in the early 1910s to advertise the wonders of Idaho. Schroeder was the teacher of Selma Calhoun Barker, a painter of cowboys and other western subjects who was born in Butte City, Idaho, and lived in Bellevue.[5]

2.266 In Pocatello, in eastern Idaho, Minerva Kohlhepp set up a portrait studio in 1917, after extensive training at the Art Institute of Chicago—beginning in 1909, with JOHN VANDERPOEL as her major teacher—and at New York's Art Students League, in 1915, with Robert Henri. She married and changed her surname to Teichert that same year, when she also had an exhibition in Boise. A decade later, after her family moved to Cokeville, Wyoming, she emerged as one of the West's most ambitious women artists, painting monumental Indian subjects and works reflecting her Mormon beliefs.[6]

Coeur d'Alene, the one major urban community in far northern Idaho, became a mining center in 1882 with the discovery of silver and lead. A raw frontier settlement in its first decades, it had taken on a cultured veneer by 1909, when the Austrian-born landscape and genre painter **Feodor von Luerzer** left Duluth and settled there, joining family members who had established boat works on Lake Coeur d'Alene. Designating the town the "Lucerne of America" and entranced with the Northwest's unspoiled wilderness, 3.68 von Luerzer painted numerous idyllic scenes, such as *Camp on Lake Coeur d'Alene*. An added attraction was the proximity of Spokane, Washington, where by 1909 there was an active art community and a local branch of the Society of Washington Artists, with which von Luerzer exhibited.[7]

3.67 George Schroeder
(1865–1934)
The Sanctuary, 1921
Oil on canvas, 14½ x 9 in.
Mr. and Mrs. Frank Blanchard

3.68 Feodor von Luerzer
(1851–1913)
*Camp on Lake Coeur
d'Alene*, 1911
Oil on canvas, 24 x 38 in.
Braarud Fine Art, La Conner,
Washington

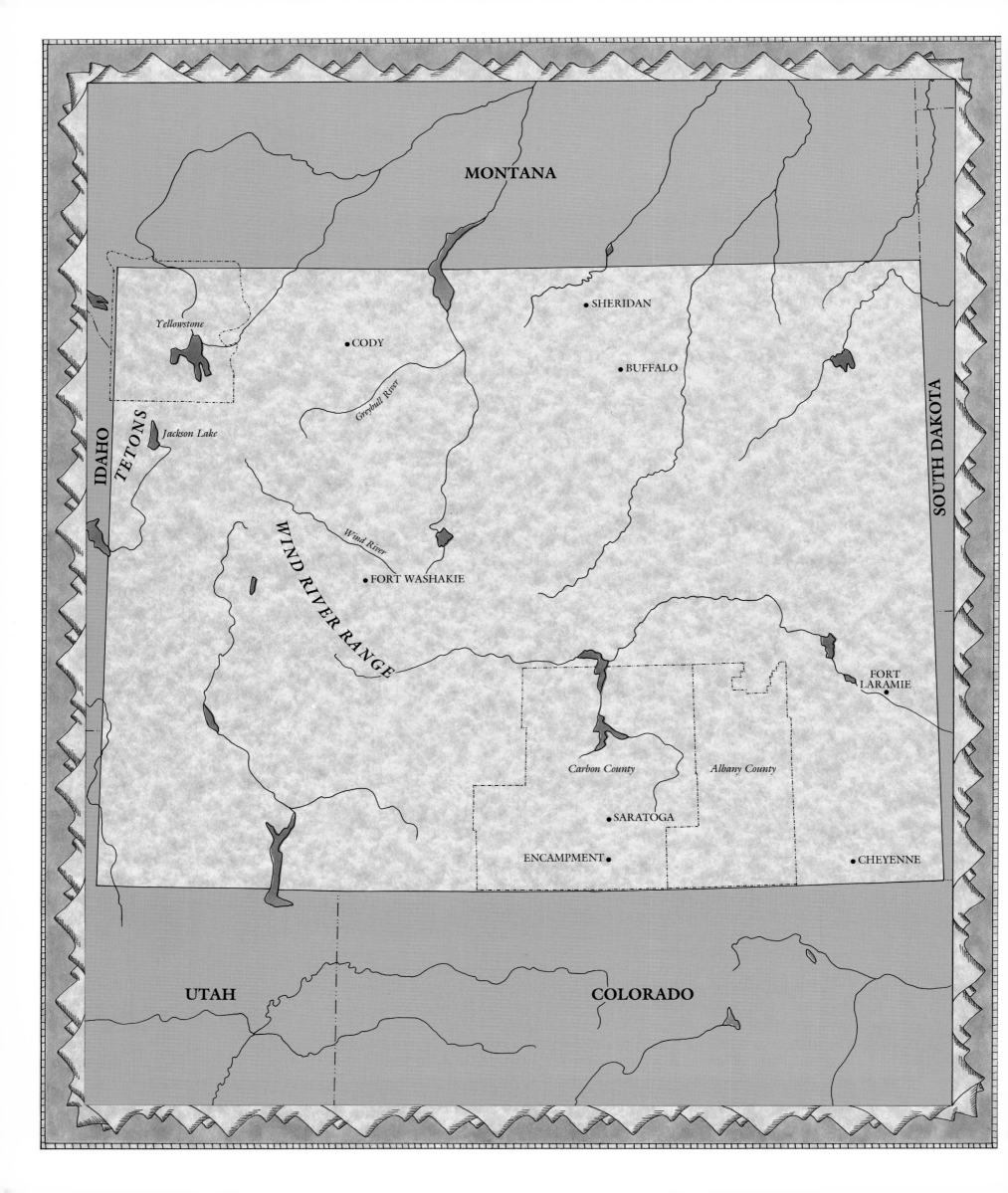

WYOMING

Wyoming was admitted to the Union as a state in 1890. Its sparse population and economy based on ranching and agriculture were not conducive to the support of an artist population; indeed, the local art establishment did not mount its first exhibition, at the University of Wyoming in Laramie, until 1932. But even though painters did not settle in the region, many were attracted by its Indian population and its spectacular scenery.

1.325 As early as 1837 ALFRED JACOB MILLER, the Indian painter from Baltimore, was there, accompanying the exploratory expedition of William Drummond Stewart, which proceeded through Fort Laramie as far as the Wind River Mountains.

3.183 ALBERT BIERSTADT painted Wyoming scenery inspired by his earliest trip west in 1859, which followed much the same route that Miller had taken. Subsequently, Bierstadt painted major works depicting the Wind River country in his New York City studio; his masterpiece of 1863, *The Rocky Mountains* (Metropolitan Museum of Art, New York), was based on his visit to Lander's, or Fremont, Peak. He was followed in the next decade by the Swiss artist Frank Buchser, who passed through Fort Laramie with General William Tecumseh Sherman in search of Indian subjects; by Chicago's HENRY ARTHUR ELKINS, who painted in the Tetons in 1868; and by Ralph Albert Blakelock, who was in the Wyoming Territory—at Cheyenne and Laramie and in the Wind River Valley—on the 1869 trip on which so many of his romantic canvases were based.[1]

2.255

That same year transcontinental rail travel became possible with the linkage of the Central and Union Pacific railroads. Many artists took advantage of this facility, which 1.250, 2.168 passed through Cheyenne, the territorial capital. Sanford Gifford and WORTHINGTON 1.152, 1.254 WHITTREDGE painted there in 1870, and Samuel Colman and THOMAS MORAN were in Wyoming in 1871. Moran sketched extensively at Yellowstone, which was established as the first national park the next year, and was in the territory numerous times later in the 1870s and in subsequent decades, including the summer of 1892, to gather materials for the 1893 World's Columbian Exposition in Chicago. The team of French-born illustrators, 3.190, 3.259 Paul Frenzeny and JULES TAVERNIER, who were working for *Harper's Weekly* on a sketching expedition across the continent, were in Fort Laramie early in 1874; the fort was the 1.26 subject of Tavernier's only known oil sketch executed on the trip. GEORGE DE FOREST BRUSH based many of his finest Indian paintings on his stay in Wyoming and Montana in 1881, camping at Fort Washakie among the Shoshone and Arapahoe before leaving for the 3.175 Crow Reservation in Montana. One of California's leading landscape painters, THOMAS 1.64, 1.120, HILL, painted at Yellowstone in 1884; eleven years later JOHN TWACHTMAN depicted 2.178 Yellowstone Falls and the Emerald Pool in an Impressionist mode. Other well-known Indian painters arrived in the area at the end of the nineteenth century and the beginning of the twentieth. Frederic Remington was at Yellowstone in 1893 and in Cody in 1899, 1902, 1908, 1910, 1911, and 1912. William Leigh sketched in the region around Yellowstone, the Tetons, and the High Rockies.

The only quasi-professional artist resident in Wyoming during the nineteenth century was Merrit Dana Houghton, who arrived in Laramie from Michigan in 1875. He also resided in Saratoga, Encampment, and Buffalo, producing pictorial records of mining, ranching, and logging operations that were commissioned by their owners in Albany and Carbon counties. Houghton also illustrated C. G. Coutant's *History of Wyoming* (1899) and a number of promotional booklets that appeared after the turn of the century. He moved to Spokane, Washington, in 1909.

The well-known French-trained figure and portrait painter Abraham Archibald

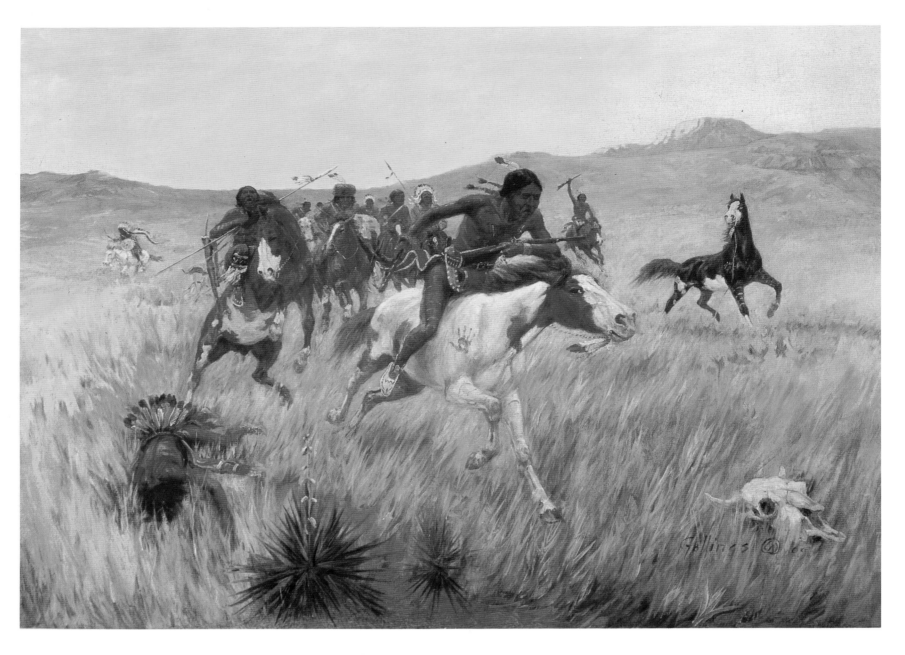

3.69 Bill Gollings (1878–1932)
Warfare on the Plains, 1909
Oil on canvas, 28 x 39 in.
The Anschutz Collection

Anderson, who was active in New York City and abroad, had a ranch on the Greybull River, having been appointed forest superintendent of the Yellowstone Forest Reserve by Theodore Roosevelt in 1902. Anderson does not appear to have painted extensively in Wyoming, although his experience at the adjoining Crow Reservation inspired *The Vanished Tribe* (1930; location unknown). "Buffalo Bill" Cody was directly responsible for the artistic career of Robert Farrington Elwell, whom he discovered in Boston sketching the cowboys and Indians at the former's Wild West Show about 1890. Elwell was invited to spend his summers at Cody's Wyoming ranch and became ranch manager in 1896. Maintaining that post for twenty-five years, he continued to sketch and paint, providing illustrations of horses and stagecoaches for a number of leading eastern magazines. Elwell's last years were spent in Phoenix.[2]

Wyoming's one resident professional artist of note during the early twentieth century was **Bill Gollings**. Gollings was born in the Rockies, in Pierce City in the Idaho Territory, but grew up in rural Michigan. Drawn back to the West, he began his career as a cowboy and cattle herder. Early inspired by Frederic Remington's illustrations, in 1903 Gollings acquired some oil paints and began to paint while living on a ranch. His early pictures were exhibited in a furniture store in Sheridan, Wyoming, where several were sold and others came to the attention of the Chicago art critic Marian White, who wrote about the young artist in 1905 and encouraged him to study in Chicago. He took instruction at the Chicago Academy of Fine Arts in the winter of 1905–6 and won a

scholarship for additional study there in 1907–8; he was back in the winter of 1912–13 and in 1918. In the winter of 1909 Gollings settled down to the life of a professional artist, building a studio in Sheridan, where he had begun to spend time in 1903. Like his friends and colleagues in Montana with whom he was often grouped—CHARLES MARION RUSSELL, EDGAR SAMUEL PAXSON, and JOSEPH HENRY SHARP (the last the greatest influence on Gollings's art)—Gollings was a specialist in painting Indians and cowboys, as can be seen in *Warfare on the Plains*. He found the subjects for his paintings primarily in Wyoming and Montana, and between 1915 and 1918 he provided the State Capitol in Cheyenne with a group of dramatic western scenes.[3]

3.61
3.62; 2.181,
3.63, 3.108
3.69

WYOMING

NEBRASKA

UTAH

KANSAS

OKLAHOMA

NEW MEXICO

Cache la Poudre River

● FORT COLLINS

● GREELEY

● ESTES PARK

South Platte River

● BOULDER

M
O
U
N
T
A
I
N
S

CENTRAL CITY ●

IDAHO SPRINGS ●

GEORGETOWN ●

GOLDEN ●

● DENVER

Colorado River

● GLENWOOD SPRINGS

● LEADVILLE

ASPEN ●

● TWIN LAKES

R
O
C
K
Y

MANITOU SPRINGS ●

Garden of the Gods

CRIPPLE CREEK ●

^
*Pikes
Peak*

● COLORADO SPRINGS

San Luis Creek

● CAÑON CITY

● PUEBLO

Arkansas River

● COLORADO CITY

COLORADO

Of all the Rocky Mountain states, it was Colorado that most closely followed the same patterns of artistic development as elsewhere in America. Denver and, to a lesser degree, Colorado Springs developed significant, sophisticated, and professional art communities. Colorado was a gateway to the Rockies, especially after completion of the transcontinental railroad in 1869, so that eastern painters frequently made Denver their base of operation. And while these individuals were seldom even part-time residents, their activities were reported in the local press and their impact felt by local artists.

Most of the eastern half of what is now Colorado was included in the Louisiana Purchase; the rest was yielded to the United States in 1848 at the conclusion of the war with Mexico. Colorado began to attract settlers when gold was discovered near Pikes Peak in 1858; the earliest community, Auraria, became part of the city of Denver in 1860. The following year Colorado was organized as a territory, entering the Union as a state in 1876, with Denver as its capital. The region had been explored as early as 1806, and the artist Samuel Seymour accompanied Stephen H. Long's expedition in 1820. Other artist-explorers followed, such as Richard Kern in 1853, though Colorado was not visited by any of the more famous early Indian painters. It was only with the appearance of

3.183 ALBERT BIERSTADT in 1863 that Colorado began to provide artistic subjects for painters of national significance—perhaps first, and most notably, Bierstadt's own *Storm in the Rocky Mountains* (1866; Brooklyn Museum), based on scenery sketched near Idaho Springs, thirty miles west of Denver.[1] Many others followed; most, like Bierstadt, were landscape

1.214 specialists. The New York City animal painter WILLIAM HOLBROOK BEARD accompanied the travel writer Bayard Taylor to Colorado in 1866, though Beard found little of interest in the West and did little painting. That same year there arrived a more enthusiastic contingent

2.257; 2.255 of Chicago artists, including JAMES FARRINGTON GOOKINS, HENRY ARTHUR ELKINS, and Henry Chapman Ford, the latter two of whom created panoramic western landscapes in Chicago in emulation of Bierstadt. Elkins, who made a specialty of Rocky Mountain scenery in the manner of Bierstadt, returned to Colorado in 1868, 1869, 1873, 1881, 1883, and

1.250, 2.168 1884, dying in Georgetown, Colorado, on his last visit. WORTHINGTON WHITTREDGE was in Denver and painted in Colorado in 1866, accompanying a tour of inspection under General John Pope on the way to New Mexico. Whittredge returned in 1870, this time by railroad, with his New York colleagues John Frederick Kensett and Sanford Gifford. It was Whittredge who produced the most numerous and memorable Colorado scenes along the Platte and Cache la Poudre rivers, substituting an emphasis on the vastness of the plains below the Rockies for Bierstadt's mountain spectacles. Ralph Albert Blakelock seems to have experienced and recorded the Rockies in the vicinity of Golden, Colorado, just west of Denver, for the first time in 1869, traveling around Boulder, Greeley, and Clear Creek Canyon. In that summer the young Saint Louis painter James William Pattison took a group of his students from Washington University to Colorado. One of these was

2.109 THOMAS ALLEN, who chose an artistic career on the basis of this journey; Pattison himself subsequently created a number of major Rocky Mountain canvases derived from studies made that season. Pattison's trip in 1869 may have spurred Saint Louis's leading landscape

3.29 specialist, JOSEPH RUSLING MEEKER, to travel to Colorado about 1870, where he painted Pikes Peak and the Platte River Cañon.

The first woman artist of note to visit and work in Colorado was Eliza Greatorex. Having trained as a landscapist in Paris, New York City, and Munich, in 1873 she went west with her artist-daughters, Kathleen and Eleanor, visiting Manitou, Pueblo, and Colorado Springs as well as Denver. In Colorado she prepared the drawings on which

her travel book, *Summer Etchings in Colorado* (1873), was based.[2] In 1873–74 the Paris-trained illustrators JULES TAVERNIER and Paul Frenzeny visited, and in 1874 THOMAS MORAN was first in Colorado, working around Colorado Springs and journeying to make sketches for *Mount of the Holy Cross* (Gene Autrey Western Heritage Museum, Los Angeles), completed in 1875 in his Newark, New Jersey, studio. Moran was in Colorado again in 1881; in 1892, when he had a major exhibition in Denver early the following year; and for numerous visits in the early 1900s.

3.190, 3.259; 1.152, 1.254

By the 1860s less-known professional artists were beginning to settle in the state, and an art community began to develop in **Denver**, ultimately taking on distinctive characteristics. For instance, Denver, almost alone among established turn-of-the-century art centers, appears to have offered little response to the miniature-painting revival. While portraits, genre paintings, and pastoral landscapes were, of course, painted by Colorado artists, the dominant themes of its resident painters were spectacular wilderness scenery and Indian and pioneer life. Denver was the only major nineteenth-century urban center where these subjects predominated and were related to common experience rather than exotic re-creations. (In Salt Lake City, even though the Wasatch Range was beautifully interpreted by leading landscapists in the late nineteenth century, the primary themes of earlier painters were portraiture, vernacular history, and genre, while the pastoral and agricultural landscape were stressed later.)

Though communities such as Pueblo and Colorado Springs early attracted both settlers and artist-visitors, Denver remained the primary art center. One J. Y. Glendinen was attracted there in 1859 by the gold rush; primarily a photographer, he also painted the earliest view of the community that year. John E. Dillingham's depictions of Colorado communities were lithographed in 1862–63. The earliest professional artist in Colorado

3.70 Mary Achey (1832–1886)
Nevadaville, n.d.
Oil on canvas, 13½ x 20½ in.
Colorado Historical Society,
Denver

3.71 John D. Howland
(1843–1914)
*Buffalo Encircling a Slain
Indian*, n.d.
Oil on canvas, 33½ x 45¼ in.
Denver Country Club

3.149 resided in the nearby communities of Nevadaville and Central City. This was **Mary Achey**, who had arrived in 1860 and who painted landscapes and views of such communities as
3.70 Nevadaville in a tight, linear style that captured a great deal of detail within a panoramic scope. Achey also drew the camps of the army's Colorado Volunteers in 1862. She remained in Colorado until the 1870s, and after some time in California's Napa Valley she moved to Aberdeen, Washington.

John D. Howland is generally considered Denver's earliest resident painter, arriving in his teens in 1858, lured by the discovery of gold. He served with the Colorado Volunteers in the Civil War and, after being mustered out of the army in 1864, went to Paris to study art for three years. On his return he was appointed secretary to the Indian Peace Commission while also working as an artist-illustrator for *Harper's Weekly* and *Frank Leslie's Illustrated Magazine*. Denver became Howland's permanent home, and he became an important figure there. He was a specialist in the painting of western animal
3.71 subjects, such as *Buffalo Encircling a Slain Indian*, which depicts a reversal of the buffalo hunt subject, that most common of all western themes, which Howland also recorded.[3]

Charles Stewart Stobie, who arrived in 1865, was actually painting in Denver earlier than Howland. He had been born in Baltimore, but at the close of the Civil War his family moved to Chicago, and the twenty-year-old Charles traveled to Denver. At this point he seems to have conceived of himself as a plainsman rather than an artist; in 1866 he was with the Ute Indians, even participating in their wars. A short time later he became a scout known as "Mountain Charlie." Stobie appears to have begun to paint by the late 1860s, creating portraits of Indian chiefs and scenes of Indian and cowboy life, such as
3.72 *Young Ute, Indian Camp;* in addition to their artistic merit, his works have ethnological importance. They are highly detailed and tightly painted with sharp outlines in a primitive but highly effective and often dramatic manner. Included among his frontier portrait subjects were such Indians as Sitting Bull and the famous scout Kit Carson, whom Stobie painted in 1868 (State Historical Society of Colorado, Denver). In 1875 the artist returned to Chicago, where he remained a specialist in Indian themes.[4]

Another artist to arrive in Denver in 1865 was Alfred Edward Mathews, brother of the successful New York City portraitist William T. Mathews. The English-born Mathews family settled in Rochester, Ohio, and from 1861 until 1864 Arthur served in the Civil

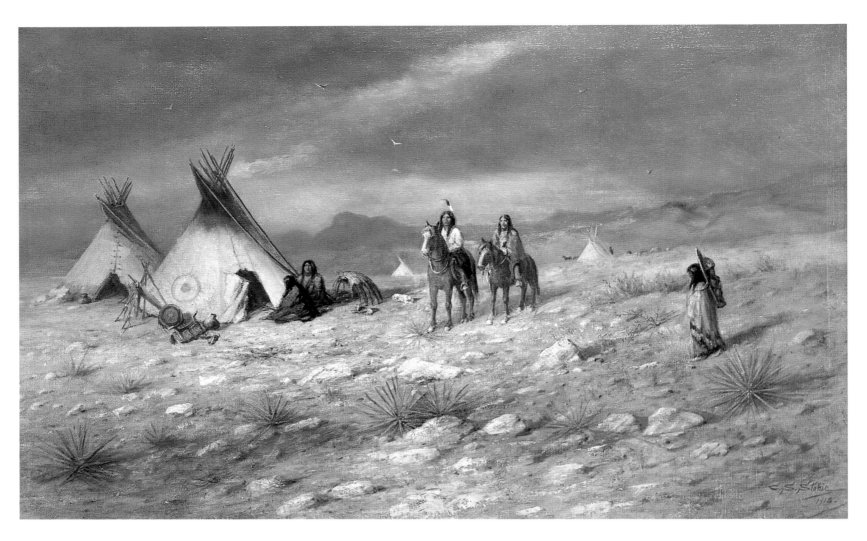

3.72　Charles Stewart Stobie
(1845–1931)
Young Ute, Indian Camp, 1915
Oil on canvas, 27 x 44 in.
Colorado Historical Society,
Denver

War. He drew and later lithographed battle scenes, and in 1864 he prepared a panorama of the southern campaign. A year later he traveled west, through the Nebraska Territory and into Colorado. Mathews was primarily a draftsman and lithographer, depicting Denver and other towns as well as the mining industry; he published some of these scenes in *Pencil Sketches of Colorado* (1866). Mathews spent the winters of 1866–67 and 1867–68 in the East, creating a panorama of Rocky Mountain scenery. He followed his Colorado volume with *Pencil Sketches of Montana* (1868); *Gems of Rocky Mountain Scenery* (1869), probably to celebrate the completion of the transcontinental railroad; and *Canyon City, Colorado, and Its Surroundings* (1870). Mathews remained resident in Colorado, acquiring land in Cañon City in 1869 and attempting to colonize the region for stock farming. This project failed, and in 1873 he was in Southern California, but he was resident in Denver again in 1874, dying there later that year.[5]

A greater degree of professionalism characterized Colorado art during the 1870s, especially with the arrival of a number of young eastern-trained painters, including a contingent from Buffalo. One of these was English-born **Hamilton Hamilton**, who arrived in Buffalo in 1872 and journeyed to Denver the following year. He visited Denver repeatedly for twenty years, though he was in France in 1878–79, studying in Paris and staying at the artists' colony of Pont-Aven in Brittany. In 1881 Hamilton moved to New York City. Later in his life he settled in Norwalk, Connecticut, and was a member of the Silvermine artists' colony. Hamilton's paintings done in the East generally present idyllic visions of lovely young women in reverie either indoors or out in the fields; they are often dual images based on his twin daughters, one of whom, Helen, was also a professional painter. In the West, Hamilton established himself as a painter of the local scenery, producing his first notable landscapes in 1875, such as *Valley of the Mountain* and *Laramie Peaks* (locations unknown); his *Pack Train of the Rio Grande* is faithful to the aesthetics and themes of the Rocky Mountain painters, both resident and visitor.[6]

3.73

It is likely that Hamilton was lured to Colorado by his Buffalo-born colleague **John Harrison Mills**, whom Hamilton would have met when he arrived in that city. Mills had begun to study art in Buffalo with John Jamison, a locally noted bank-note engraver, and then studied sculpture there with William Lautz. Mills studied oil painting with LARS GUSTAF SELLSTEDT and William Holbrook Beard and worked as a portraitist before serving in the Civil War. He returned to paint in Buffalo until 1872, when he went to Denver and Middle Park, Colorado, continuing to paint portraits but also working at figure, animal, hunting, and mountain landscape subjects. He also produced illustrations for *Scribner's Monthly* in 1878–79, including some in collaboration with MARY HALLOCK FOOTE;

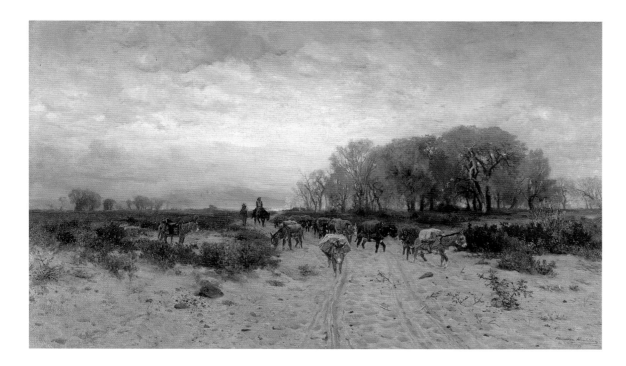

3.73 Hamilton Hamilton
(1847–1928)
Pack Train of the Rio Grande, n.d.
Oil on canvas, 36 x 62 in.
Stephen V. O'Meara,
Scottsdale, Arizona

3.74 John Harrison Mills
(1842–1916)
News from Home, 1882
Oil on canvas, 20 x 24 in.
Colorado Springs
Pioneers Museum

in 1873 he had worked for *Frank Leslie's Illustrated Newspaper*. In 1888 Mills worked on a two-part article, "The Heart of Colorado," for *Cosmopolitan*. His best-known western oils are figure pieces representative of pioneer life: *A Frontier Justice of the Peace* (location unknown) and *News from Home*. He remained in Colorado until 1885, when he settled in New York City.[7]

<div style="text-align: right">3.74</div>

Other artists who arrived in the 1870s included the landscapist **Howard Streight,** who moved from the Midwest to Denver in 1874, remaining until 1890, when he went on to California; he was fortunate to gain the patronage of the Kansas Pacific Railroad. Streight specialized in Rocky Mountain scenery painted in meticulous detail and often illuminated by glowing sunsets; his best-known work was *Cross on the Mountain* (location unknown). Streight also painted topical figural works, among them the companion mining scenes *The Discouraged Prospector* (possibly the work now identified as *Pikes Peak or Bust*) and *Struck It Rich* (location unknown).[8]

<div style="text-align: right">3.75</div>

Harry Learned was also in Denver in 1874, having earlier been in Colorado as a teenager, joining his father in the Pikes Peak gold rush. In 1869 Learned studied painting in Chicago with Henry Chapman Ford, who had previously painted landscapes in Colorado. Learned then returned to the family home in Lawrence, Kansas, as a professional artist, before moving to Denver about 1874; he worked for the Palace Theater and Greeley Opera House there as well as in other Colorado communities. Learned lived intermittently in Denver for over two decades, also residing in Boulder, Fort Collins, Golden, and Aspen

3.75 Howard Streight (1836–1912)
Pikes Peak or Bust, 1870
Oil on canvas, 18 x 24 in.
Colorado Historical Society,
Denver

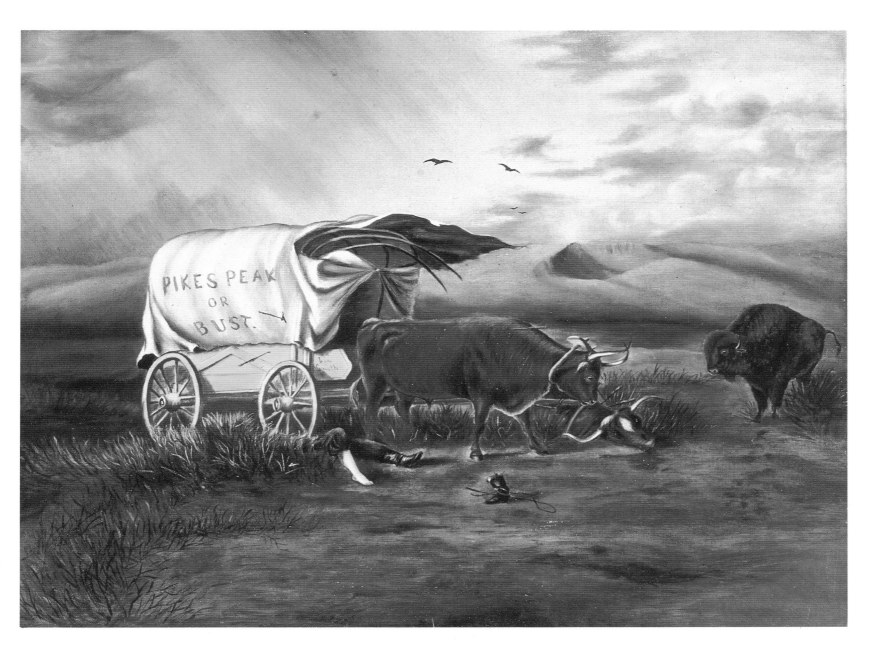

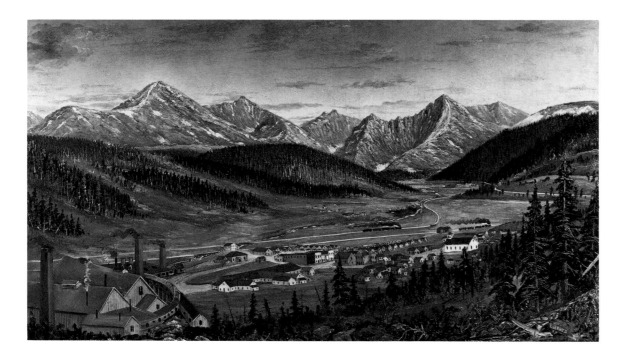

3.76 Harry Learned
(active c. 1874–1896)
Robinson, Colorado, 1887
Oil on canvas, 18⅛ x 30½ in.
Amon Carter Museum,
Fort Worth

3.77 Joseph Hitchens (1838–1893)
*Jerome Chaffee Introduces Miss
Columbia to Miss Colorado* (also
known as *Admission of Colorado
to the Union*), 1884
Oil on canvas, 96 x 132 in.
Colorado Historical Society,
Denver

3.76 and, most significantly, from 1884 until 1888 in the now-vanished town of Robinson,
west of Denver and north of Leadville, in the center of a mining district that was thriving
in the 1880s. Learned made a number of spectacular, if primitive, pictorial records of that
industry, with the mines set in vast valleys and painted in meticulous detail.

Colorado artists appear to have been singularly disdainful of historical subjects.
The most important exception in the nineteenth century was English-born **Joseph**
3.77 **Hitchens**'s *Jerome Chaffee Introduces Miss Columbia to Miss Colorado* (also known as *Admission
of Colorado to the Union*). But, like the majority of his Colorado contemporaries, Hitchens
was primarily a landscapist. In the 1880s he moved from Denver to Pueblo, becoming
that city's first resident professional artist and devoting himself to painting the scenery of
the San Luis and Arkansas river valleys.

More significant for the artistic life of Denver was **Helen Henderson Chain**, who
had previously lived in San Francisco. After marrying in 1871 Chain went to Denver and

3.78 Helen Henderson Chain
(1848–1892)
Royal Gorge, n.d.
Oil on canvas, 35¼ x 14½ in.
Colorado Historical Society

worked for the Chain and Hardy bookstore. In 1873 she met John Harrison Mills, who encouraged her to pursue an artistic career. She received some instruction from Hamilton Hamilton; a few years later she supposedly spent a winter in New York City as a pupil of GEORGE INNESS. Chain was a painter of rugged mountain landscapes on a grand scale, such as *Royal Gorge*, an unusual specialty at a time when women landscapists were rare, and those painting wilderness mountain scenery rarer still. Chain was also an important figure in Denver's nascent artistic life, starting a gallery in 1891, teaching, and opening her studio to students in 1877. Chain died in the wreck of the SS *Bokhara* in 1892.[9]

One of Chain's pupils, and ultimately a far better-known artist, was **Charles Partridge Adams**. He was born in Franklin, Massachusetts and, like a number of painters, went to Denver for health reasons in 1876, working as an engraver in the Chain and Hardy bookstore. Like Chain, Adams became a specialist in the painting of the Rocky Mountain landscape, securing passage on many of Colorado's railroads to explore the terrain and in 1905 building a summer studio in Estes Park that proved extremely profitable for sales of his mountain paintings. Adams also worked, as did Chain, in New Mexico and toward the end of his life settled in California. Like his teacher, Adams discarded the meticulous rendering of topography favored by such early landscapists as ALBERT BIERSTADT for broader, more impressionistic, and more subjective strategies.[10]

One of the most elusive of Denver's painters is **Alexis Comparet** (or Compera). Born in South Bend, Indiana, as a boy he moved to Colorado City; at about eighteen he went to Paris to study under Benjamin Constant. On his return to this country, he sought out the Rockies for reasons of health, living in Denver. There he was inspired by the mountain scenery, which he interpreted in soft, misty tones. Probably the high point of

1.41, 1.244, 2.68; 3.78

3.79

3.183

3.80

3.79 Charles Partridge Adams
(1858–1942)
Looking across South Park, 1897
Oil on canvas, 27¾ x 39½ in.
Private collection

3.80 Alexis Comparet (1856–1906)
Landscape, n.d.
Oil on canvas, 14½ x 17½ in.
Colorado Historical Society,
Denver

3.81 Richard Tallant (1853–1934)
Horseman, 1887
Oil on canvas, 14½ x 22 in.
Denver Art Museum, Bequest
of the Clyde Dawson Estate

Comparet's career was the adulation and patronage offered by Sarah Bernhardt when she visited him while her troupe was performing in Denver. Comparet died the year he moved to San Diego, at the age of fifty.[11]

 Richard Tallant was born in Zanesville, Ohio, and went to Colorado to work in the mining camps. After working in Denver and Salt Lake City in 1889–91, he settled in Estes Park. Many of Tallant's interpretations of the Rocky Mountain landscape were in watercolor, but he also painted quiet, pastoral views of central and southern Colorado around the turn of the century, venturing into the pueblo country of New Mexico in 1896. Denver's leading woman landscape painter at the end of the century was **Elizabeth Henrietta Bromwell**, who studied there and abroad. Her vivid, painterly *Landscape* demonstrates the movement away from emphasis on majestic scenery toward a recognition of pastoral pursuits, similar to the thematic preferences in neighboring Utah.

 One of the most talented and professional painters to work in Denver during the 1880s was English-born **Edwin Deakin**, who had come to this country in 1856 and settled in Chicago before moving to California in 1870. Primarily associated with San Francisco, Deakin visited Europe in 1878–80 and had a residence in Denver in 1882–83. There he was lionized as the finest artist who had ever visited the town, and he painted and exhibited many works. In addition to depicting the scenery along the Platte River,

3.81

3.82

3.193

3.82 Elizabeth Henrietta Bromwell
(1859–1946)
Landscape, n.d.
Oil on canvas, 14 x 18 in.
Colorado Historical Society,
Denver

3.83 Edwin Deakin (1838–1923)
Rose of Peru, 1882
Oil on canvas, 24 x 16 in.
Courtesy of Kennedy Galleries,
Inc., New York

OPPOSITE:
3.84 George W. Platt (1839–1899)
After the Hunt, 1893
Oil on canvas, 60 x 40 in.
Spanierman Gallery, New York

Deakin developed a number of English views, the most majestic being one of the interior of Westminster Abbey (location unknown), but the pictures that attracted the most consistent critical acclaim in Denver were his fruit pieces, especially his renderings of different varieties of grapes.

3.83

Given the penchant among Denver artists and patrons for western subject matter, it is not surprising that still lifes related to pioneer life found favor. The city's leading specialist was **George W. Platt**, one of the finest followers of William Michael Harnett.

Born in Rochester, New York, Platt had been a draftsman with John Wesley Powell's western expeditions before studying at the Pennsylvania Academy of the Fine Arts in the mid-1870s; he then went on to Munich. Platt was in Davenport and Muscatine, Iowa, in 1878, painting conventional fruit still lifes, figures, and interiors, and he was active as a professional painter in Chicago in the 1880s. In his later years there he must have been attracted to Harnett's trompe-l'oeil mode, which Platt himself took to Denver in the early 1890s. His pictures of hanging cowboy gear and stuffed animal heads are painted in monochromatic tones, but unlike the work of Harnett and most of his other followers, they have rich, painterly surfaces that somewhat negate their illusionistic intent.[12] In 1900, the year following Platt's death, his place was taken by that most peripatetic of Harnett's followers, RICHARD LA BARRE GOODWIN, who moved to Colorado Springs from Chicago. Goodwin remained only a few years, however, going to California in 1902. | 3.84 3.145

In the late nineteenth century there had also been more traditional still-life specialists in Colorado, women artists who specialized in floral subjects. These included Fanny Tarbell, some of whose pictures of roses and pansies were acquired by Louis Prang for chromolithographic reproduction and who later became a portraitist after studying with WILLIAM MERRITT CHASE. Harriet Hayden, a successful Chicago art teacher, arrived in Denver in 1888 and founded the Le Brun Art Club. Alice Stewart Hill of Colorado Springs was active in the state from 1874, specializing in local flora; her works were reproduced in Helen Hunt Jackson's *Procession of Flowers in Colorado* (1885). Most active of all was Elizabeth Spalding, a prolific painter of Impressionist watercolor floral studies and landscapes, who had gone from Erie, Pennsylvania, to Denver in 1874, when her father became Episcopal bishop. Spalding studied in New York City with a number of the nation's leading Impressionist painters, but it was probably Rhoda Holmes Nicholls, an important teacher of watercolor, who had the greatest impact on her. On Spalding's return to Denver she became an active figure in the Artists' Club, though she also exhibited back in Erie when the Art Club was formed there in 1898. | 1.146, 1.155

Colorado's first public art sale was held in Denver in the autumn of 1873. It included paintings by John Harrison Mills and Hamilton Hamilton that were based on sketches made during an expedition to the Upper Arkansas River and Twin Lakes. Art was included as early as 1882 in the National Mining and Industrial Exposition in a show set up by a committee headed by the mining tycoon and senator Horace W. Tabor and arranged by Mills; in the 1883 exposition, Charles Partridge Adams won a gold medal. The third annual, held in 1884, encompassed some seventy artists, most of them Colorado residents. All of Denver's leading artists showed work in these early exhibitions.

The state's earliest art organization, the Academy of Fine Arts Association of Colorado, was formed in Denver in 1876, when Mills interested other artists and professionals in meeting regularly to study and discuss art. This was augmented in 1880, when the Denver Sketch Club was formed, its name changed the following year either to the Kit Kat Club or the Colorado Art Association. This group came to include the best-known local figures, such as Howard Streight, Charles Stewart Stobie, John Harrison Mills, Harvey Otis Young, and Charles Partridge Adams. In 1883 Mills arranged with Tabor for the association to take over the fifth floor of the Tabor Grand Opera House as a studio building, becoming the city's first bohemian center and allowing for the institution of artists' receptions on Saturday afternoons. Edwin Deakin and Mills were among the first artists to move in. Lacking support, the association went out of existence before 1885, but in 1886 the Denver Art Club was formed, with John D. Howland as president. The club met an early demise the next year due to a schism within its membership. The Denver Paint and Clay Club was founded in 1889, with Young as its head. He organized a thoroughly professional public exhibition that year, with a strong representation of Denver's leading artists and several who were settled elsewhere, including Richard Tallant, then in Salt Lake City, and Edwin Deakin, in San Francisco. A large group of women artists were also involved, including Elizabeth Henrietta Bromwell, Helen Henderson Chain, and Emma Richardson Cherry. Also included in this pioneering exhibition was the White Mountain landscape specialist EDWARD HILL, who had gone to Denver for an | 1.23

3.85 William Henry Read
(1851–1935)
On the Plains, n.d.
Oil on canvas, 14 x 28⁹⁄₁₆ in.
Denver Art Museum

extended stay in 1888 and who was to settle there more permanently in his old age in 1900, after his wife's death.

The Paint and Clay Club, which also appears to have been of short duration, was followed in 1893 by the Artists' Club. Formed in Emma Richardson Cherry's studio, it held its first exhibitions in 1894 and 1895, even more impressive shows than the one held by the Paint and Clay Club. In this organization Adams and Young took the lead along with Cherry, an important landscape painter trained in Chicago, New York City, and Paris. She had already played a vital role in the growing art establishment in Kansas City and was to move to Houston in 1899 to do the same. The Artists' Club proved to be a long-lived organization, incorporating as the Denver Art Association in 1917 and as the Denver Art Museum in 1923.

The 1890s were a period of tremendous ferment in the art community. In 1890 the Le Brun Art Club was founded and in 1892, the Denver Art League. The Le Brun Art Club was organized in the studio of the painter and art teacher Harriet Hayden and operated a school for Denver women, professional and amateur; it modeled itself on the Palette Club of Chicago, to which Hayden had belonged. The Art League was active in presenting exhibitions of work by artists of national importance, including one of paintings by the expatriate Walter McEwen late in 1892 and a major show of over 260 examples of Thomas Moran's work in January 1893.

The Art League also attempted to expand the availability of professional teaching in Denver. Helen Henderson Chain taught in her studio from 1877, and John Harrison Mills's Academy of Fine Arts Association opened the Colorado Academy of Design in 1882, with twenty-seven pupils. Other teachers at that Academy included Adams, Comparet, Deakin, and Howland, but activities petered out with Mills's departure for the East in 1885. The Art League started a school in 1892 under the directorship of the
2.234 Indiana artist SAMUEL RICHARDS, with Adams and Hayden as instructors. Richards, perhaps the finest of the Munich-trained figure painters of his generation, had gone to Denver to restore his fast-failing health and succumbed the next year; the school itself was shut down due to the panic of 1893.

The Denver School of Fine Arts, operated at the University of Denver, had started in 1880 to offer courses with Ida de Steiguer; it expanded in 1892 under the supervision of the sculptor Preston Powers, son of the great Neoclassicist Hiram Powers and creator of *The Closing Era* (1898), which stands on the grounds of the State Capitol. George W. Platt also taught the painting of game and scenery at the university and instituted the earliest classes to paint from the nude. In 1890 English-born **William Henry Read** arrived in Denver, seeking better health, and five years later he started the Student's School of Art. In addition to his pedagogical efforts, Read was also of prime significance in city planning and as head of the Denver Art Commission. He was also a practicing artist, and

though not primarily concerned with painting the West, he did depict regional subjects, such as *On the Plains*. 3.85

Read numbered among his pupils several of Denver's leading younger painters. These included Elizabeth Spalding, noted for her watercolor landscapes, and **Allen Tupper True**, the state's leading muralist and probably its most noted early twentieth-century painter. True, who came from Colorado Springs, studied at the Corcoran School of Art in Washington, D.C., and with HOWARD PYLE between 1902 and 1908. He then became 1.309 an assistant of the great English muralist Frank Brangwyn, working on his murals for the Panama-Pacific International Exposition in San Francisco in 1915. True painted murals

3.86 Allen Tupper True
(1881–1955)
Packers Breaking Camp, 1925
Oil on canvas, 36¾ x 36⅞ in.
Denver Art Museum

in the Colorado State Capitol, in the capitol buildings in Wyoming and Missouri, and in the Colorado National Bank. In his easel work he followed the lead of Read and other

3.86 Colorado painters, depicting vanished pioneer life, as in *Packers Breaking Camp*.[13]

3.241 A number of talented painters arrived in Denver in the early years of the twentieth century; perhaps the most promising was JEAN MANNHEIM from Decatur, Illinois, who appeared in 1902, primarily as a painter of landscapes. After five years he left for Europe to work with Frank Brangwyn and in 1908 settled in Los Angeles, where he made his reputation as one of the leading California Impressionists. The etcher George Elbert Burr settled in Denver in 1906, having exhibited there in the city's first truly commercial gallery, newly founded by R. L. and Cyrus Boutwell.

Colorado Springs was the other community that began to attract painters early on, no less because of its proximity to mining activities than because of its natural splendor. The town is situated at the foot of Pikes Peak, near the spectacular rock formations known as the Garden of the Gods and the great springs of Manitou, which Eliza Greatorex drew and wrote about as early as 1873. English-born **Walter Paris**, the earliest resident artist in Colorado Springs, had preceded Greatorex there by a year, searching for a healthful climate. In England he had studied architecture, practicing there and in Bombay, India, before coming to this country. Paris remained in Colorado Springs for five years, moving to New York City in 1877, though he returned to Colorado in 1891, living in Colorado Springs and Denver before settling in Washington, D.C., about 1893–94. His work

3.87 Walter Paris (1842–1906)
Pikes Peak Avenue, Colorado Springs, with Second Antlers Hotel and Pikes Peak, 1892
Watercolor on paper,
10¼ x 14¼ in.
Private collection

3.88 Harvey Otis Young
(1840–1901)
Heart of the Rockies, 1899
Mixed media, primarily oil on
canvas, 30 x 40 in.
Pikes Peak Library District,
Colorado Springs; Fine
Arts Collection

consisted primarily of tightly painted, pale-hued watercolors in the British topographical tradition; they depict local scenery and towns such as Colorado Springs itself, Pueblo, Cripple Creek, and Glenwood Springs.

Harvey Otis Young became one of Colorado's principal painters. He grew up in Vermont and may have attended art school in Worcester, Massachusetts, and New York City before he sailed for California in the fall of 1859 and became a miner, an interest he never abandoned. It was only in 1866 in San Francisco that he began to devote his full attention to a professional artistic career. In 1870 Young made the first of six European trips, studying in Paris and painting in various artists' colonies in Germany and France while maintaining his studio primarily in San Francisco. He took his first sketching tours into Colorado in 1873–75 and produced a number of major Rocky Mountain and Platte River scenes. Young appeared in Manitou Springs in the summer of 1879, attracted more by the prospects of the Roaring Fork Mining District and his involvement with the Castle Rock Mining Corporation at Aspen than by the area's artistic glories. Though he first established a home at Manitou Springs, Young was residing in Denver by 1887, and in 1889 he was elected president of the newly formed Denver Paint and Clay Club. Though he continued to travel a great deal, he returned periodically to Denver, where he became a charter member of the Artists' Club in 1893 and established a full-time studio in 1896, maintaining it for three years. In 1899 he moved to Colorado Springs, continuing to paint prolifically until his death two years later.

Young was Colorado's most cosmopolitan nineteenth-century artist, one who absorbed the multiple currents, both native and international, to which he was exposed. ALBERT BIERSTADT and the Barbizon School influenced him, and in such works as *Heart of the Rockies*, an almost Tonal haze makes somewhat spectral the immensities that earlier artists would have delineated clearly. Despite his mining interests, Young played a major role in the artistic life of Colorado Springs and especially Denver, influencing other painters such as CHARLES PARTRIDGE ADAMS and ALEXIS COMPARET.[14]

3.183; 3.88

3.79; 3.80

Charles Craig, another of Colorado Springs's early resident painters, was urged to settle there by his fellow artist JOHN D. HOWLAND. Before studying at the Pennsylvania Academy of the Fine Arts in 1872–73, Craig had traveled the upper Missouri as far as Fort Benton, Montana, and spent four years in the West, living among the Indians. He arrived in Colorado in 1881 and opened a studio in Howbert's Opera House, becoming a painter primarily of Indian subjects. Works such as *On the Lookout*, tightly and literally painted and admired for their ethnological accuracy, derived from his experiences with the Ute tribes in southwestern Colorado. He kept an ongoing solo exhibition in the lobby of the Antlers Hotel, and many of his works were lost when the hotel burned in 1898.

3.71

3.89

Craig made an extensive trip among the Utes of Colorado in 1893, accompanied by his close colleague Frank Sauerwein, who had arrived in Denver in 1891 for reasons of health. Sauerwein had studied in Philadelphia at the School of Industrial Art and the Pennsylvania Academy of the Fine Arts and may later have taken instruction at the Art Institute of Chicago; he remained in Denver until he settled in Los Angeles in 1901. In 1898 Sauerwein visited Taos, New Mexico, and thereafter became a painter of Indian subjects, concentrating on the western wastelands and pueblos. A number of his pictures were purchased by the Santa Fe Railroad.[15]

Colorado Springs developed an art establishment independent of the activities in Denver. Craig and Walter Paris were joined by Thomas Parrish, brother of the better-

3.89 Charles Craig (1846–1931)
On the Lookout, 1900
Oil on canvas, 30 x 50 in.
Butler Institute of American
Art, Youngstown, Ohio

3.90 Anne Lodge Parrish
(active 1885–1900)
Anne Adams, 1885
Oil on canvas, 38 x 25 in.
Colorado Springs
Pioneers Museum

known STEPHEN WINDSOR PARRISH and uncle of Maxfield Parrish. Thomas Parrish was a 1.29 businessman, painter, and etcher who went to Colorado Springs about 1872 but returned to Philadelphia after the death of his wife. There he studied art and married Anne Lodge; together they returned to Colorado Springs, where they both taught art. Thomas Parrish's best-known works were his illustrations for *Colorado Springs, Its Climate, Scenery and Society* (1889) and *Legends of the Pikes Peak Region* (1892).

Of greater repute as an artist was **Anne Lodge Parrish**, who studied with Thomas Eakins in 1882–83. She became Colorado's outstanding figure and portrait painter of the late nineteenth century. Prior to her appearance in Colorado Springs, the town's leading portraitist had been W.H.M. Coxe, who was still active when Charles Craig arrived in 1881; Coxe subsequently moved to Texas, perhaps daunted by the competition offered by Parrish. Her portrait *Anne Adams* is a sensitive image, unflattering and objective yet 3.90 sympathetic in its interpretation of young womanhood, with the structural sureness of Parrish's Philadelphia mentor.

Others in the Colorado Springs artists' colony included Frank T. Lent, an architect turned Barbizon landscape painter who had studied with Bruce Crane. Lent lived in Jersey City and New York City in the early 1880s and was the editor of the important art periodical the *Studio* in 1882–83 before moving to Colorado by 1885. English-born William Bancroft studied art in Saint Louis in 1878 and, after painting with Joseph Hitchens in Pueblo, set up a sign-painting company in Colorado Springs in 1881. Bancroft painted mining camps and mountain landscapes; *The Miner's Last Dollar* (Myron Stratton Home, Colorado Springs) is one of a number of trompe-l'oeil still lifes that he painted in the manner of William Michael Harnett. Bancroft is also known for more broadly painted, colorful landscapes executed in his later years under the influence of Harvey Otis Young. Canadian-born Leslie Shelton, a landscapist, appeared in Colorado Springs in the 1890s; Swedish-born Carl Lotave, who had studied with Anders Zorn, arrived in 1899, having served as art instructor for two years at Bethany College in Lindsborg, Kansas. Lotave, an able figure and portrait painter, painted murals in a restaurant and private homes in Colorado Springs and created the scenes in the Indian Room of Denver's Savoy Hotel. He was also employed to record Indian life for the Smithsonian's Bureau of Ethnology, remaining in Colorado until 1910.

The earliest important art loan exhibition in Colorado Springs took place in 1888 to benefit the Bellevue Sanitarium. This show included old master paintings and works by nationally known and local artists—William Bancroft, Charles Craig, Frank T. Lent, Walter Paris, Anne and Thomas Parrish, and Harvey Otis Young. Lent and the Parrishes developed Colorado Springs's first art school the same year. A more important show was the First Art Exhibition, held by Colorado College in February 1900, on completion of Perkins Fine Arts Hall, which was devoted solely to local work. Swiss-born Louis Soutter, who had studied in Paris in 1895, was the most prolific exhibitor, showing portraits and decorative watercolors. Soutter, a cousin of the great architect Le Corbusier, had settled in Colorado Springs in 1897 and the following year was appointed head of the fine arts department at Colorado College; in 1899 he was sent abroad to investigate European teaching procedures, continuing his own studies at the Académie Julian. Having activated the program at Colorado College, he returned to Switzerland in 1903.[16]

Denver's Boutwell Gallery opened up a branch in Colorado Springs about 1911 under R. L. Boutwell, and in 1919 the Broadmoor Art Academy was founded there, with Boutwell as its first president. This developed into one of the most important summer teaching institutions in the West and, indeed, in the country, becoming even more significant after it became associated in 1926 with Colorado College. Though the Academy's later history is beyond the parameters of this study, it should be noted that JOHN F. CARLSON, 1.175 in landscape, and Robert Reid, in figure drawing and painting, were the first faculty members, in 1920. SVEN BIRGER SANDZÉN, Randall Davey, and Ernest Lawson also taught 3.48 at Broadmoor in the 1920s.

Shortly before World War I the Colorado Springs Art Society was formed and began to hold exhibitions that brought in works by nationally known artists to alternate

with shows of paintings by resident artists, Charles Craig being the best known among the latter. A school of specialists in the western landscape developed, including Marie Forbush, Eleanor Ormes, Katherine Smalley, and Henry Russell Wray. Anne Ritter painted both figure and landscape subjects; married to the painter and potter Artus Van Briggle, she also directed the Van Briggle Pottery Company after her husband's death in 1904.

1.146, 1.155 Alice Shinn, who had studied under WILLIAM MERRITT CHASE, became supervisor of drawing for the public schools in Colorado Springs and specialized in floral paintings in the Impressionist style, about which she also wrote.[17] Holding shows devoted to their own work in 1914 and '15, the community founded the Colorado Springs Art Club, with Wray as its first president. In a few years the club and the Art Society merged, bringing artists and patrons together.

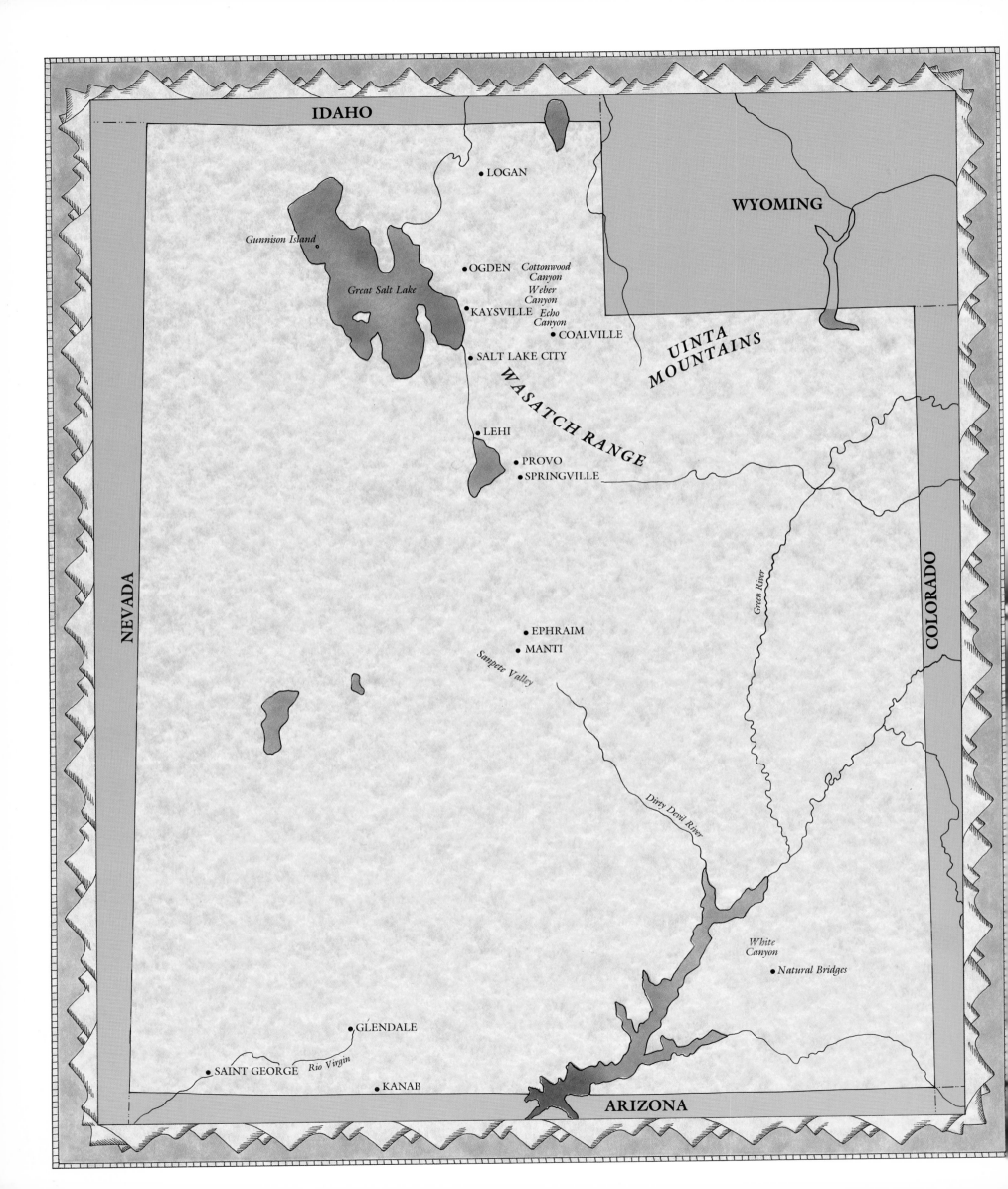

IDAHO

WYOMING

●LOGAN

Gunnison Island

Great Salt Lake

●OGDEN *Cottonwood*
 Canyon
 Weber
 Canyon

KAYSVILLE *Echo*
 Canyon
 ●COALVILLE

UINTA
MOUNTAINS

●SALT LAKE CITY

NEVADA

WASATCH RANGE

●LEHI

●PROVO
●SPRINGVILLE

Green River

COLORADO

●EPHRAIM

●MANTI

Sanpete Valley

Dirty Devil River

White
Canyon

●Natural Bridges

●GLENDALE

●SAINT GEORGE *Rio Virgin*

●KANAB

ARIZONA

UTAH

The nature and support of the arts in Salt Lake City was unique in this country. This was due to the singular role that the Mormon church played in cultural activities as it did in all other aspects of life. Most, though not all, of Utah's major artists during the period under consideration were Mormons. Brigham Young founded the first settlement in Utah at **Salt Lake City** in 1847, leading his followers from Illinois and Missouri even before the region was transferred from Mexico to the United States. In 1849 Salt Lake City, which remained the church's headquarters, became capital of the provisional Mormon state of Deseret, which was refused recognition by the national government. Instead, the Territory of Utah was organized in 1850 and Utah was admitted to the Union as a state in 1896. Relatively few visiting painters of landscapes and Indian subjects worked extensively in Utah, even though Salt Lake City became a departure point for overland travel to the California gold fields two years after its founding. The most significant visiting portraitist in the 1850s was Solomon Nunes Carvalho, a painter and daguerreotypist then resident in Baltimore who had been hired as the official photographer on John Charles Frémont's fifth and last western expedition. After the great hardships of that trip Carvalho spent time recuperating in Salt Lake City early in 1854, remaining to paint numerous portraits, including two of Brigham Young. Carvalho accompanied Young that spring on a peace mission among the Indian tribes in central Utah, where he painted portraits of tribal leaders; *Warka, Indian Chief* (Thomas Gilcrease Institute of American History and Art, Tulsa, Oklahoma) is one of his most incisive works. Subsequently, Carvalho followed Frémont to the expedition's destination in California, where he set up a portrait and daguerreotype studio in Los Angeles for a short while before returning home.[1]

The first transcontinental railroad intersected Ogden, north of Salt Lake City, when
3.183 the line opened in 1869. ALBERT BIERSTADT was probably the most prominent midcentury landscapist to pass through Salt Lake City—on his second trip west, in 1863; he was there again in 1881. Bierstadt's artistic strategies appear to have influenced the local landscapists, though not necessarily due to his brief visit. Ralph Albert Blakelock was in Ogden, Utah, in the Wasatch Range, and at the Great Salt Lake in 1869 and in the 1870s.
1.152, 1.254 Also active in the Wasatch Range were THOMAS MORAN, in 1873 and 1879; Gilbert Munger,
3.83, 3.193 a landscape painter from Saint Paul, who explored the West in 1869–71; and EDWIN
3.175; 3.179; DEAKIN, THOMAS HILL, and RANSOM HOLDREDGE, all from San Francisco. WILLIAM KEITH, also
3.178 from San Francisco, painted in Echo, Cottonwood, and Weber canyons in the winter of 1873–74. Moran also painted in southern Utah, near Kanab and in the valley of the Rio Virgin, in 1873, as well as at the Great Salt Lake, and he became acquainted with the
3.97 local landscapist, HENRY CULMER.

Only an occasional artist of national reputation settled in Salt Lake City for any length of time. Perhaps best known was the portrait and genre painter Enoch Wood Perry, who was in Salt Lake City in 1865–66 and received commissions from the Mormon church for a series of portraits of Brigham Young and the Quorum of the Twelve Apostles as well as for a full-length likeness of Young for the new City Hall, with an imaginary view of the yet-to-be-built Mormon Temple and Tabernacle in the distance.[2] Perry, who was not a Mormon, was sufficiently well patronized by the Mormon church and society to arouse resentment among local Mormon artists.

From the first the arts had been encouraged by the church, with Brigham Young exhorting missionaries to recruit painters for service. Such cultural concern and ultimate pride in artistic achievement, though often insufficiently supported by patronage, is

3.91 William Warner Major
(1804–1854)
Brigham Young and His Family,
1845–51
Oil on board, 28 x 36 in.
Museum of Church History
and Art, Salt Lake City

reflected in the abundant literature devoted to Utah art from the early 1880s until the present. The early settlers' agricultural economy was a stable one, a factor that supported the establishment of, and respect for, an art community.

The earliest professional Mormon artist to go to Salt Lake City was **William Warner Major** in 1848. Originally from Bristol, England, Major had converted to Mormonism and had come to this country in 1844, settling in Nauvoo, Illinois, until the church was forced to move two years later. Having been assigned by the Mormon leader William Richards to sketch views of the overland trip to Utah, Major remained for five years, painting the surrounding countryside as well as portraits of settlers and some of the indigenous Indians. His best-known work is a group likeness, *Brigham Young and His* 3.91 *Family*, in the tradition of the English conversation piece. After his stay in Utah, Major was recalled to Great Britain in 1853 and died the following year.[3] A naïve group likeness similar to his *Brigham Young and His Friends* (Museum of Church History and Art, Church of Jesus Christ of Latter-day Saints, Salt Lake City) was painted about 1864 by Sarah Ann Burbage Long, the earliest woman artist in Salt Lake City; she was a Mormon from England who began to advertise her artistic skills in 1854.

Four years after Major's departure, in 1857, the Dane **C.C.A. Christensen** arrived in Salt Lake City. Christensen had studied at the Royal Academy of Art in Copenhagen in the later 1840s and had converted to Mormonism in 1850. In 1853 he was on a missionary tour to Norway; following his arrival in Salt Lake City he moved to the Sanpete

Valley in central Utah, finally settling in Ephraim. Christensen resumed his artistic activities only in the 1860s, when he designed scenery for the Salt Lake Theatre (opened in 1862) and other theaters beginning in 1863. Later he created decorations and murals for Mormon temples throughout Utah, completing the earliest of these in 1881. Christensen's greatest pictorial achievement was the creation of a panorama depicting the history of the Mormon Church in America: twenty-three large historical paintings rolled in a sequence that, though naïve, forms a striking visual and instructive narrative. This work, begun in 1878 and completed over a number of years, was exhibited in predominantly Mormon communities throughout Utah and in Idaho, Wyoming, and Arizona. The first scene is now lost or destroyed; the rest belongs to Brigham Young University, Provo. This panorama is one of probably four with which Christensen celebrated the Mormon church; he also painted individual scenes of Mormon life in Utah. *Immigration of the Saints* is one of the largest and finest of his easel pictures, recording the arrival of an emigrant family in Salt Lake City in the 1860s and portraying with affection the communal bonding intrinsic to Mormon emigrant life. Christensen experienced additional missionary service between 1865 and 1868 in Norway, where he studied with the landscape painter Philip Barlag, and between 1887 and 1889 in Copenhagen. He died in Ephraim, Utah.[4]

3.92

Christensen's closest colleague, with whom he collaborated on temple decoration and the first of his panoramas in 1877–78, was **Danquart Anton** (Dan) **Weggeland**. Born in Christiana (now Oslo), Norway, Weggeland studied art in Stavanger and then at the Royal Academy in Copenhagen. After meeting Christensen in Stavanger, Weggeland converted to Mormonism. He performed missionary service in England, arriving in this country in 1861, at the start of the Civil War. Weggeland studied in New York City with Daniel Huntington and then traveled to Salt Lake City, arriving in the autumn of 1862. He worked for the Salt Lake Theatre from 1862 until 1873 and created a decoration for the Mormon temple in Bountiful, the earliest such mural in Utah; later he decorated the four major Mormon temples in Saint George, Logan, Manti, and Salt Lake City. Weggeland's most effective easel work consists of local genre subjects such as *The Skating Pond*.

3.93

Temple decoration was a singular activity among the artists of Utah; no other territory or state was thus religiously motivated and dominated. Two—one might even acknowledge three—generations of important artists were involved in temple decoration. Christensen, Weggeland, and others were followed by the French-trained group comprising

3.92 C.C.A. Christensen
(1831–1912)
Immigration of the Saints, 1878
Oil on canvas, 34⅛ x 50 in.
Daughters of the Utah
Pioneers Museum,
Salt Lake City

3.93 Danquart Anton Weggeland
(1827–1918)
The Skating Pond, 1870
Oil on canvas, 22 x 30 in.
Museum of Church History
and Art, Salt Lake City

EDWIN EVANS, JOHN B. FAIRBANKS, JOHN HAFEN, and LORUS PRATT. Later artists such as Minerva 3.102; 3.101;
Teichert were called on to touch up or restore some of the earlier work. The artists 3.99; 3.100
decorated three rooms in the temples: the Creation Room, where their work was meant
to project wonder at the vastness of God's creation and at the same time to suggest
disorganization; the Garden Room, intended to radiate peace and harmony; and the
World Room, intended to suggest forces of opposition and death, the world after humanity
had sinned.[5] Begun in 1883, the murals in the Logan Temple were painted by Weggeland,
the landscapist Reuben Kirkham, and William Armitage, a Scotsman who specialized in
animal subjects; Christensen may also have participated. The murals in the Manti Temple
probably were painted by Weggeland and Christensen later in the 1880s, but like most
of the early murals, they deteriorated. The murals for the great temple in Salt Lake City
were undertaken by a younger generation of painters together with Weggeland.

A third early figure and genre specialist was **George M. Ottinger**, a Pennsylvania
native who grew up in New York City. Though attracted to an artistic career, he went to
sea in 1850, returning to the East in 1853 to pursue painting in earnest. Ottinger began
to practice as a professional miniature painter in Lancaster, Pennsylvania, later in 1853;
he converted to Mormonism in the late 1850s and arrived in Salt Lake City in the summer
of 1861. He began to work almost immediately, creating scenery for the local theater and
forming a photography firm with Charles R. Savage, Utah's pioneer photographer, where
he tinted photographs. In 1872 Ottinger began to devote himself full-time to his art.
Despite technical inadequacies he was able to render effective portraits and figure subjects
as well as imaginative and historic works, including scenes from the Book of Mormon.
His intense vision was most compelling in his re-creations of Aztec life, in connection
with which he traveled to Latin America in the 1880s. These scenes, begun in 1867 with
The Last of the Aztecs, were predicated on a vision of pre-Hispanic life, which Ottinger 3.94
believed paralleled the Mormon experience, a subject on which he wrote and lectured as
well. Such works are unique in American art of the nineteenth century.[6]

About midcentury a group of landscape specialists, all born in England, joined the
Mormon art community. John Tullidge had studied with a decorative painter in his native
country before going to Utah in the early 1850s, following his conversion to Mormonism.
Continuing his decorative work, he also painted mountain scenery and seascapes from
memory. His brother, Edward Tullidge, was a prominent early writer on Utah art,

publishing *Tullidge's Quarterly Magazine*. Reuben Kirkham arrived in Salt Lake City in 1866 and moved to Logan in the 1880s. Initially, he found employment as a scenic artist for the local theater. The scenic work of both John Tullidge and Kirkham, while bordering on the naïve, represents the earliest stages of professional landscape work in the territory. Kirkham formed a friendship with the more proficient **Alfred Lambourne** that led to a coast-to-coast painting trip in the 1870s. On their return they created a panorama, *American Landscape*, which they toured throughout the territory. Near the end of his life Kirkham made another series of panorama paintings illustrating the Book of Mormon.

Lambourne was the first fully professional landscapist in Utah. Having arrived in Salt Lake City in 1866, he was soon working for the theater. Self-taught, he derived his inspiration from various styles current during the third quarter of the century. The meticulous details and jagged outlines in his landscapes suggest a kinship with the Düsseldorf aesthetic, perhaps through the work of Albert Bierstadt, with whom Lambourne painted when Bierstadt visited Salt Lake City in 1881. The exaggerated format of works such as *Cliffs at Promontory, Great Salt Lake, Utah* recalls the popular panoramas and the art of the Luminists such as MARTIN JOHNSON HEADE and John Frederick Kensett, with whom Lambourne shared a passion for clarity and stillness. Lambourne provided a pair

3.95
1.67, 2.69

BELOW:

3.94 George M. Ottinger
(1833–1917)
The Last of the Aztecs, 1867
Oil on canvas, 33 x 65 in.
Museum of Church History
and Art, Salt Lake City

BOTTOM:

3.95 Alfred Lambourne
(1850–1926)
Cliffs at Promontory, Great Salt Lake, Utah, 1883
Oil on canvas, 17 x 66 in.
Museum of Church History
and Art, Salt Lake City

3.96 George Beard (1854–1944)
Dead Horse Pass (formerly
known as *Mountain
Landscape*), 1923
Oil on canvas, 36½ x 28 in.
Russell Beard, Bountiful, Utah

of inspirational scenes for the new Salt Lake City Temple and others for the temples in Logan and Saint George. He was also a prolific writer; in addition to magazine articles on western scenery, he published fourteen books, including *Our Inland Sea* (1909), written while he painted on Gunnison Island in the Great Salt Lake.[7]

George Beard, another of Utah's pioneer artists, emigrated in 1868 with his family from Whaley Bridge, England, when he was thirteen years old. They settled in Coalville, east of Salt Lake City, where Beard spent his entire life, making a living as a merchant and becoming mayor in 1891. Beard had two other passions: art, which he had loved since boyhood, and wilderness scenery, which he explored from the 1880s on, especially in the Uinta Mountains of Utah and the Teton and Yellowstone regions of Wyoming. A self-taught artist, Beard was influenced by, and found encouragement in, the works of his colleagues Henry Culmer, Lambourne, George M. Ottinger, and Danquart Anton Weggeland, though his greatest inspiration was Thomas Moran. One other source should

be noted: the work of the photographer Charles R. Savage. Beard became an outstanding nature photographer in his own right, though not a commercial one. Today his inspiring painted views of the Uintas, Jackson Hole, and Yellowstone in Wyoming are admired equally with his photographs of similar scenes and the permanent family summer camp he had established by 1894 in the wilderness at Glendale on the upper Weber River.[8]

3.96

Henry Culmer arrived in Utah with his family in 1868, having converted to Mormonism. Like Lambourne, Culmer, who appears to have begun painting professionally about 1880, was devoted to the scientific study of natural phenomena, favoring exactitude in geology and botany; even more than his colleague, Culmer wrote as well as painted. Like the other early landscapists, Culmer sought initial instruction at home. It is possible that he studied at the University of Deseret (later the University of Utah) under Weggeland. Culmer took art lessons from Lambourne and Reuben Kirkham and possibly from JULIAN WALBRIDGE RIX either in New York City or on one of his visits to Monterey, California, which had had an early Mormon colony and about which Lambourne and Culmer both wrote, the former in 1889 and the latter in 1899.[9] Culmer painted the Great Salt Lake, though he viewed it in less beatific terms than Lambourne. He was more attracted to mountain scenery, traveling through the Wasatch Range in search of subjects. Culmer became nationally known for his paintings of the southern Utah desert and especially for his depictions of the first three great natural bridges discovered in southeastern Utah: the Edwin, the Caroline, and the Augusta Natural Bridge, the last considered the greatest such wonder in the world at the time. (The bridges were all renamed with Indian designations by the National Parks Service; the Augusta Bridge is now the Sipapu.) These were first surveyed in 1903 and information about them publicized the following year.

3.191

3.97

3.97 Henry Culmer (1854–1914)
Augusta Natural Bridge, c. 1910
Oil on canvas, 42 x 60 in.
Utah Arts Council, Salt Lake City; State Fine Arts Collection

Culmer agreed to head an expedition to White Canyon in 1905, to take measurements and photographs and to make descriptions of the bridges; at this time he made sketches on which his paintings were based. Culmer was active in the early national parks movement in Utah.[10]

Utah's earliest still-life specialist was the little-known Arthur Mitchell, again English-born, who arrived in 1866. Perhaps the most prominent visitor to set up a studio in Salt Lake City in the 1880s was also a still-life specialist: the exceptionally able fruit and landscape painter Edwin Deakin. In the late summer of 1883 Deakin was en route to his home in San Francisco from Denver, painting scenery in the vicinity of the Great Salt Lake.

During the 1860s attempts were made to organize the Mormon art community. This began with the founding in 1863 of the Deseret Academy of the Fine Arts in the old Salt Lake Theatre, with GEORGE M. OTTINGER as President and William V. Morris as vice president; Morris was a decorative painter and interior designer who had opened the first art-supply store in Salt Lake City in 1852. DANQUART ANTON WEGGELAND and John Tullidge taught drawing and painting at the Academy along with Ottinger. Though this school lasted only ten months, it was the earliest such institution in the American West. In the mid-1860s Ottinger, Charles R. Savage, and the visiting Enoch Wood Perry founded the Deseret Art Union, a lottery organization patterned after the defunct American Art-Union, but this too was of brief duration.

About 1869 the Deseret Agricultural and Manufacturing Society (later the Utah State Fair) began exhibiting and awarding medals for painting, the first opportunity for public recognition of professional local artists. Ottinger won six "best picture" awards in 1872 and in 1879 won a gold medal for history painting and a silver for landscape. Organizational activities ceased until the Salt Lake Art Association was founded in 1881, again with Ottinger as its driving force. The association was a forerunner of the Utah Art Institute and the Utah State Institute of Fine Arts, the latter a government agency for the exhibition of art, first in different cities in the state and then in annual juried shows in Salt Lake City. With the encouragement of Alice Merrill Horne, the state's first professional dealer and historian of local art, the Utah Art Bill was passed in 1899, establishing the Utah Art Institute and the "Alice Art Collection," a state assemblage of works by Utah artists acquired as purchase prize winners. Although the University of Deseret was founded in 1850, drawing may not have been offered until 1868–69, by Louis F. Monch, "Professor of German, Drawing and Penmanship." Weggeland served briefly as instructor of drawing in 1871–72. Ottinger became a professor at the university in 1885, succeeding William Armitage. A formalized department of fine arts was organized there in 1888–89 with Ottinger as principal, teaching freehand drawing and painting. It was Ottinger and Weggeland who provided the greatest inspiration for the painters who succeeded them and went on to more complete professional training toward the end of the century.

James T. Harwood was one of the finest (and the most completely studied). He was the only important Utah artist who was not a Mormon, his father having been excommunicated over the issue of polygamy. Harwood grew up in Evansville (now Lehi), south of Salt Lake City, and had a few lessons from Lambourne and Weggeland. He was familiar with the paintings of John Tullidge, who became his closest friend among the pioneer artists. Works by these painters and their local contemporaries were the only paintings Harwood saw. Realizing the need for additional training, in 1885 he went to San Francisco to study at the California School of Design with its director, the landscapist VIRGIL WILLIAMS; Harwood plunged himself into this professional environment. Returning to Utah after winning a gold medal for draftsmanship at the school, he settled in Salt Lake City, opening his own Salt Lake Art Academy in 1887 to teach the principles he had learned in San Francisco.

In 1888 Harwood joined his former fellow student GUY ROSE in Ogden, from which they made the transcontinental journey to New York City and then to Paris. Although Marie Gorlinski is said to have been the first Utah painter to study in France, in 1882, it was Harwood who introduced Utah painting into the international arena. He studied at

3.94

3.93

3.177

3.242

the Académie Julian and the Ecole des Beaux-Arts, remaining in Paris until 1892, except for a half year spent teaching in Salt Lake City in the winter of 1890–91. In 1892 Harwood became the first Utah artist to exhibit at the Paris Salon with his *Preparation for Dinner* (Utah Museum of Fine Arts, University of Utah, Salt Lake City), a work shown at the World's Columbian Exposition in Chicago in 1893.

Though it was a meticulously painted bunch of grapes that had won him admission to the California School of Design, and his rural landscapes that made his reputation in Utah, Harwood concentrated in Paris on figural subjects, visiting Brittany and painting peasants doing domestic chores indoors or working in the fields. He took his newly won facility back to Salt Lake City in 1892, painting portraits, domestic genre, and, later, important scenes of boyhood in oils and watercolor. His innovative work was in landscape, where he seized on the bright colorism and rich sunlight of Impressionism, applying them to the local landscape, as in *Dandelion Field*, or to scenes painted on his frequent trips to Europe. The dramatic Wasatch Range often forms a backdrop for Harwood's landscapes, but he concentrated not on grandeur but on painterly interpretations of the local and the familiar. Harwood was always a major exhibitor in local art shows, but public response was limited. His agnosticism undoubtedly engendered some reluctance among patrons, though he began a series on the life of Christ at the beginning of the twentieth century, culminating in 1922 in *Come Follow Me* (Museum of Church History and Art, Church of Jesus Christ of Latter-day Saints, Salt Lake City), in which Impressionist light becomes an emanation of the divine. Harwood's income and spirits were undoubtedly elevated when his landscape *Black Rock* (Museum of Church History and Art, Church of Jesus Christ of Latter-day Saints, Salt Lake City) won the first purchase prize of the newly instituted Utah Art Institute in December 1899. Harwood was the art instructor at the

3.98 James T. Harwood
(1860–1940)
Dandelion Field, 1913
Oil on canvas, 25½ x 40 in.
Museum of Church History
and Art, Salt Lake City

3.98

3.99 John Hafen (1856–1910)
Quaking Aspens, Aspen Grove, 1907
Oil on canvas, 63 x 33¾ in.
Springville Museum of Art,
Springville, Utah

Salt Lake City high school from 1898 and became head of the University of Utah art department in 1922, in addition to taking on private pupils. Harwood's first wife, Harriet Richards Harwood, had been his student in 1887 at the Salt Lake Art Academy, becoming the finest Utah still-life specialist at the turn of the century, known for her floral work.[11]

James T. Harwood was the forerunner of the four "French Mission" artists, a group of Utah painters sponsored by the church to pursue training in Paris; they were under contract to provide the Mormon temples—specifically, the great temple in Salt Lake City—with murals on their return. Edwin Evans, John B. Fairbanks, John Hafen, and Lorus Pratt made a strong impact on the history of Utah painting. Of these, **John Hafen** was the one who established a reputation outside the state. He and his family arrived from Switzerland in 1862 and lived in a number of small Utah communities before settling in Salt Lake City in 1868. He began to study art at Dr. Karl Maeser's twentieth-ward Academy and visited the studios of both Ottinger and Weggeland; he also met his future colleagues Pratt and Fairbanks, urging the latter toward an artistic career.

Finding little encouragement for their artistic efforts, the four young men entered the allied field of photography. In the late 1880s they were able to persuade church leaders of the need for modern murals for the new Salt Lake City Temple and for travel subsidies to ensure the proper training to produce them. Fairbanks, Hafen, and Pratt left for Paris in the summer of 1890; Evans joined them a few months later. After studying at the Académie Julian and independently in Paris with Arthur Mitchell (a young American painter of Barbizon-inspired landscapes from Saint Louis), Hafen returned to Salt Lake City in 1891 and then settled in Springville. He was primarily a landscapist who admired Jean-Baptiste-Camille Corot and GEORGE INNESS. Like Inness, whose art is embued with the spirit of Swedenborgian theology, Hafen viewed nature as an altar to the deity, to be portrayed with reverence. By donating a work, *A Mountain Stream*, to the local high school in 1903, Hafen initiated the Springville Art Project, which developed a major collection over the years, including forty-two of his own pictures; the collection, in turn, stimulated the institution in 1921 of the Springville Salon, a national, sometimes international, annual exhibition from which additions were made to the permanent collection. Hafen's *Quaking Aspens, Aspen Grove* is typical of his delicate aesthetic, related to Tonalism; a later work than *A Mountain Stream*, it is also touched with the more scintillating light of Impressionism. Though Hafen won purchase prizes at the Utah Art Institute shows of 1900 and 1903, and a first prize at the Utah State Fair in 1902, poverty always dogged him. He traveled widely in search of picturesque subjects, from Boston to Monterey. His last three years were spent mostly in the new artists' colony of Brown County, Indiana.[12]

Despite his deprivation Hafen always regarded his art and career as divinely inspired. Yet his commitment to the temple mural project was not as great as that of his colleagues. **Lorus Pratt** had studied at the University of Deseret with Weggeland and Ottinger and, on their advice, went to New York City for instruction in 1876, stopping off to visit the Centennial Exposition in Philadelphia. In 1879 Pratt was in England, returning to Salt Lake City as a teacher of English and an artist of portraits and occasional landscapes. He was able to go to Paris to study in 1890. In 1892 Pratt returned to fulfill his Salt Lake City Temple commission and to paint murals in the temples in Saint George, Logan, and Manti. Like Hafen, he led an unsung, impoverished life.

John B. Fairbanks was the progenitor of a dynasty of Utah artists. On his return from Paris in 1892 he fulfilled his temple commission and then traveled throughout the region and to South America, following in Ottinger's footsteps in an attempt to find proof of the stories contained in the Book of Mormon. Fairbanks settled in Provo for a while, teaching at Brigham Young University and in Ogden as the first supervisor of the arts in the public schools. He was the father and teacher of the painter J. Leo Fairbanks, who became the supervisor of drawing in the Salt Lake City public schools, and of one of Utah's leading sculptors, Avard Fairbanks. The latter fathered two sculptors, Justin and Ortho Fairbanks, as well as the art historian Jonathan Leo Fairbanks.

The most impressive pictures painted by Pratt and Fairbanks are those done in France and, subsequently, in Utah, depicting peasants and farmers working in the grain

1.41, 1.244, 2.68

3.99

3.100

3.100 Lorus Pratt (1855–1923)
 Haying Time, 1894
 Oil on canvas, 30 x 48 in.
 Utah State Historical Society
 History Museum,
 Salt Lake City

3.101 John B. Fairbanks
 (1855–1940)
 *Harvesting in Utah
 Valley*, 1925
 Oil on canvas, 34 x 38 in.
 Brigham Young University,
 Museum of Fine Arts
 Collection, Provo, Utah

fields and harvest landscapes. This was a theme shared by the art missionaries and also by James T. Harwood, who initiated the theme with *The Gleaners* (Museum of Church History and Art, Church of Jesus Christ of Latter-day Saints, Salt Lake City) and *Workers in a Field* (Springville Museum of Art, Springville, Utah), both painted in France in 1890. These splendid works, and others such as Pratt's *Haying Time* and Fairbanks's *Harvesting in Utah Valley*, descend from the peasant pictures of Jean-Francois Millet at midcentury, but the Utah painters invested the theme with new meaning. Instead of emphasizing the burden of toil, they emphasized God's beneficence, the bountifulness of the earth rewarding workers in the fields. These paintings embody a degree of modernity, too, allying sound figural and spatial construction, learned in the Parisian academies, with the brilliant light of contemporary Impressionism and, sometimes, painterly breadth.[13]

3.100; 3.101

 Edwin Evans, the fourth of the art missionaries, grew up in Lehi, Utah, as had

Harwood. Evans did not conceive of an artistic career until the late 1880s, spending a little time with Ottinger and Weggeland before joining the Paris mission. Having painted harvesting pictures in France and at home, he exhibited *Grain Fields* (Brigham Young University Museum of Fine Arts, Provo) in Chicago at the World's Columbian Exposition. On his return to Utah in 1892, Evans became the most successful member of the group, both in his easel paintings of rural life, such as the well-known *Calf,* and in murals painted in Utah (including some for the Veterans Administration Hospital in Salt Lake City) and in Cardston, Canada. He was a major organizer and teacher in the art world of Utah and head of the University of Utah art department for twenty years, beginning in 1899.[14]

The Salt Lake City Temple paintings, executed directly on plaster, were completed at the time of the temple's dedication in April 1893. Hafen, assisted by Evans, had painted the Garden Room; Pratt had helped with the foliage, and Weggeland painted most of the animals. The World Room murals were painted by Weggeland, Evans, and Fairbanks. It was not until 1915, however, that the murals in the Creation Room were painted, by a Norwegian artist, Fritjof Wibert.

Evans was the first president of the Society of Utah Artists, founded in 1893. Almost all the leading Utah artists except Hafen exhibited at the first exhibition, held in December 1893; Hafen, along with the still-life specialist Marie Gorlinski (then Marie Gorlinski Hughes), showed in the second annual of 1894. Other significant Utah painters who showed in the society's first exhibition included John Willard Clawson, Herman Haag, Rose Hartwell, and Mary Teasdel, all Paris-trained.

Clawson, a grandson of Brigham Young, had studied with George M. Ottinger at the University of Deseret before going to the National Academy of Design in New York City for three years in 1882. Inspired by Harwood and his future wife, Harriet Richards, Clawson went to France to study in 1889, remaining abroad for almost a decade. He returned to Utah for a few years before moving to California, finally settling in Utah in 1933. Primarily a portraitist, Clawson portrayed many prominent Utah citizens; he also exhibited recent Venetian scenes at the society's exhibition of 1893 and one such work

3.102 Edwin Evans (1860–1946)
The Calf, 1899
Oil on canvas, 29 x 34 in.
Brigham Young University,
Museum of Fine Arts
Collection, Provo, Utah

at the World's Columbian Exposition.[15] The German-born convert to Mormonism Herman Haag was one of Harwood's most talented pupils during the latter's interlude in his French studies in 1890–91 and accompanied his teacher back to Paris in the latter year as a fifth "art missionary." Having returned to Salt Lake City by 1893, Haag became an artist of great versatility, painting foreign scenes, picturesque figures, historical re-creations, and religious subjects. He was hired with Harwood by the art department of the University of Utah in 1894 but died within a year, just before his twenty-fourth birthday.

Probably the most prominent among Utah's women artists at the turn of the century was **Mary Teasdel**, the daughter of a successful merchant in Salt Lake City; she began studying art with Ottinger at the University of Deseret. Teasdel's father was unsupportive of her professional career, though she was able to study briefly with Harwood and had

1.26 one season with GEORGE DE FOREST BRUSH at the Art Students League in New York City in 1897. She finally studied in Paris in 1899, remaining for three years; her most important teacher, and a major influence on her art, was James McNeill Whistler. Teasdel was the first Utah woman to have a work accepted at the Paris Salon. A floral specialist in the early 1890s, she became a painter primarily of portraits and figural subjects after her

3.103 Parisian training, executing such works as the sympathetic, shadowy *Mother and Child*; she also painted Impressionist landscapes. Teasdel remained Utah's foremost woman artist until she moved to Los Angeles in the early 1920s.[16]

Teasdel was followed at the Paris Salon by Rose (Nina Rosabel) Hartwell, who had studied in Salt Lake City with Harwood and Clawson before going abroad for instruction in the early 1900s. Hartwell lived and worked in Paris and Giverny, France, for many

3.104 years. She was joined there by her fellow Utah painter **Myra Sawyer**, who was back in Salt Lake City by 1907, becoming an instructor of art at the University of Utah under Edwin Evans. Sawyer participated in the general exploration of Impressionism; her *Girl among the Hollyhocks* (location unknown) is not only painted in that style but also involves a theme favored by many American artists of the early twentieth century, notably those who had settled in Giverny, such as Frederick Frieseke. Sawyer was also proficient at miniature painting and as a watercolorist.

The Society of Utah Artists' exhibitions were well received, and a fair number of works were sold out of its early shows, albeit for tiny sums. With the formation of the Utah Art Institute in 1899, local artists had a second outlet for exhibition and the promise of purchase prizes. Friction between the society and the institute over the awarding of purchase prizes in 1903 led to a temporary separation of their exhibition activities the following year. The older native artists associated with the institute held their show in Ogden, and the foreign-trained painters dominated the society in Salt Lake City. Evans became president of the Utah Art Institute in 1904–6, effectively ensuring the supremacy of the younger, more modern Utah painters. The Utah State (formerly Territorial) Fairs continued, offering painters and sculptors a third public venue, from which a permanent collection was also formed. In addition to their high school and college classes, Evans, Hafen, and Harwood taught privately at their own Academy of Art in Salt Lake City, each with his own studio.

The activities of Harwood, the art missionaries, and the others who went to Paris to study in the 1890s and early twentieth century effectively liberated Utah art from its provincialism and even opened the way for experimentation with modernism. The career of **Alma Brockerman Wright** is a case in point. A close friend of Mahonri Young, one of Utah's outstanding sculptors, he first encountered art in George M. Ottinger's studio in Salt Lake City during the 1880s. Wright had formal training under Harwood and Herman Haag at the university and was an art instructor at Brigham Young College in Logan from 1899 until 1902. In the latter year Wright went to Paris to study, developing an energetic Whistlerian portrait style, which he took back in 1904 to Logan, where he was rehired

3.105 at the college. It was during this time there that Wright painted *Portrait of a Lady*, with its monochromatic color scheme and simple composition. In the next decade he frequently was engaged in mural work for Mormon temples as far away as Arizona, Canada, and Hawaii, and in 1916 for the Senate Chamber of the new State Capitol. By the 1920s

OPPOSITE:

3.103 Mary Teasdel (1863–1937)
Mother and Child, c. 1920
Oil on canvas, 31 x 25 in.
Utah Arts Council, Salt Lake
City; State Fine Arts Collection

ABOVE, TOP:

3.104 Myra Sawyer (c. 1866–1956)
*Portrait of the Artist or Her
Sister, Augusta,* c. 1914
Watercolor on ivory,
diameter: 3½ in.
Nyal W. and Donna Anderson,
Salt Lake City, Utah

ABOVE, BOTTOM:

3.105 Alma Brockerman Wright
(1875–1952)
Portrait of a Lady, 1908
Oil on canvas, 28 x 22 in.
Museum of Church History
and Art, Salt Lake City

3.106 Le Conte Stewart (b. 1891)
In the Beginning God Created
Heaven and the Earth, 1921
Oil on canvas, 108 x 65 in.
Museum of Church History
and Art, Salt Lake City

Wright had abandoned the dark tonalities of his early style for the flat patterning and high colorism of a latter-day Fauvism and had become associated with the so-called Logan School. Wright joined Harwood on the faculty of the University of Utah in 1931, succeeding him as head of the department the following year.

Wright's early career paralleled that of his close colleague the painter Lee Greene Richards. Also influenced by Ottinger, Richards went to Paris to study in 1901. He, too, returned to practice portrait painting in Utah and painted murals in the State Capitol in 1916. Richards became a member of the faculty of the University of Utah in 1938, on

Wright's retirement. Compared to Wright, Richards worked in a more bravura style consciously related to that of the English masters of the eighteenth century; while he clearly appreciated Whistler, he made freer use of the decorative qualities inherent in a carefully controlled colorism. Richards was to become Utah's most prolific portraitist, creating an oeuvre that included many likenesses of his fellow artists.[17]

While the first Utah painters to study in Paris underwent training in figure drawing and painting only to return to work primarily as landscapists, artists such as John Willard Clawson, Wright, and Richards retained their interest in the figure, devoting their abilities especially to portraiture. Before their return to Utah, a major commission for the likenesses of the Mormon General Authorities had been given to the visiting New York City artist George Henry Taggart. He had gone to Salt Lake City for reasons of health in 1900 and remained several years, the first significant artist from outside the state since Enoch Wood Perry, in the mid-1860s, and EDWIN DEAKIN, in 1883.

3.83, 3.193

Still, landscape appears to have been the theme that attracted the majority of Utah professionals, although patronage remained sparse. Lewis Ramsey, who studied with John B. Fairbanks and in New York City before going to Paris, started out as a sculptor then turned to painting—at first portraits and religious subjects. In midcareer he began to devote his talents to landscape, especially of the spectacular canyon country in northern Arizona and southern Utah, using a colorful, painterly approach. An artist who more fully represented the impact of modernism was Swiss-born (John) Henri Moser, who studied in Logan with Alma Brockerman Wright from 1906 until 1908. Moser went to Paris in 1909, quickly succumbing to the influence of Fauvism, whose impact is clear in the still lifes and Utah landscapes he painted following his return to Logan to teach in 1911. For almost two decades Moser led a peripatetic life in Utah, Idaho, and Texas, returning to Logan in 1929, a pioneer in expressionism and a pivotal influence on the local art scene.[18] SVEN BIRGER SANDZÉN, from Bethany College in Lindsborg, Kansas, spent the summers of 1928–30 teaching at the State Agricultural College in Logan, reinforcing the modernism that characterized the Logan School with which Moser was involved.

3.48

The simplification and rich colorism of modernism also influenced the art of Donald Beauregard, who studied at Brigham Young University in Provo in 1901 and at the University of Utah under Edwin Evans two years later, going to Paris in 1906. Beauregard returned to Utah to become supervisor of art for the Ogden public schools in 1908. A few years later he received a commission for a major series of murals depicting the life of Saint Francis and the settlement of the Americas, for the auditorium of the new Santa Fe Fine Arts Museum. He had completed only one or two of these before he died in 1914; the others, completed to his designs by the Santa Fe artists CARLOS VIERRA and Kenneth Chapman, remain in the museum's auditorium today.[19]

3.117

After Beauregard's death, probably the most promising and talented of the younger Utah painters was **Le Conte Stewart**. Stewart studied painting in Woodstock, New York, and New York City in 1913, returning to Utah the following year. He was engaged in temple decoration in Hawaii from 1917 until 1919, and in Cardston, Canada, until 1922, finally returning to Kaysville, Utah. Stewart painted additional temple murals in Mesa, Utah, in 1925, with Alma Brockerman Wright and Lee Greene Richards. Much of Stewart's subsequent career was spent in Ogden as head of the art program at the high school until he was appointed as head of the art department of the University of Utah in Salt Lake City. Stewart rejected modernism for a realist approach, at first depicting the pastoral landscape and then, during the Depression, focusing on solitary, sometimes abandoned farm buildings. These regionalist works are heirs to the legacy of Impressionism, as were the landscapes in Stewart's temple murals, in which pointillist paint application was put at the service of spiritual expression.[20]

3.106

THE SOUTHWEST

The painters considered here worked in what are now the states of New Mexico, Arizona, and Nevada. The first two entered the Union only in 1912, and the population in all three states was sparse before 1920. The art forms of the Indian and Hispanic inhabitants fall outside the purview of this study. Until the end of the nineteenth century the Southwest attracted primarily two groups of visiting painters: those who accompanied survey and military expeditions and those who explored unknown territory on their own, sometimes en route to the more settled communities on the Pacific coast.

3.107 Louis Akin (1868–1913)
El Tovar Hotel, Grand Canyon, 1907
Detail of plate 3.122

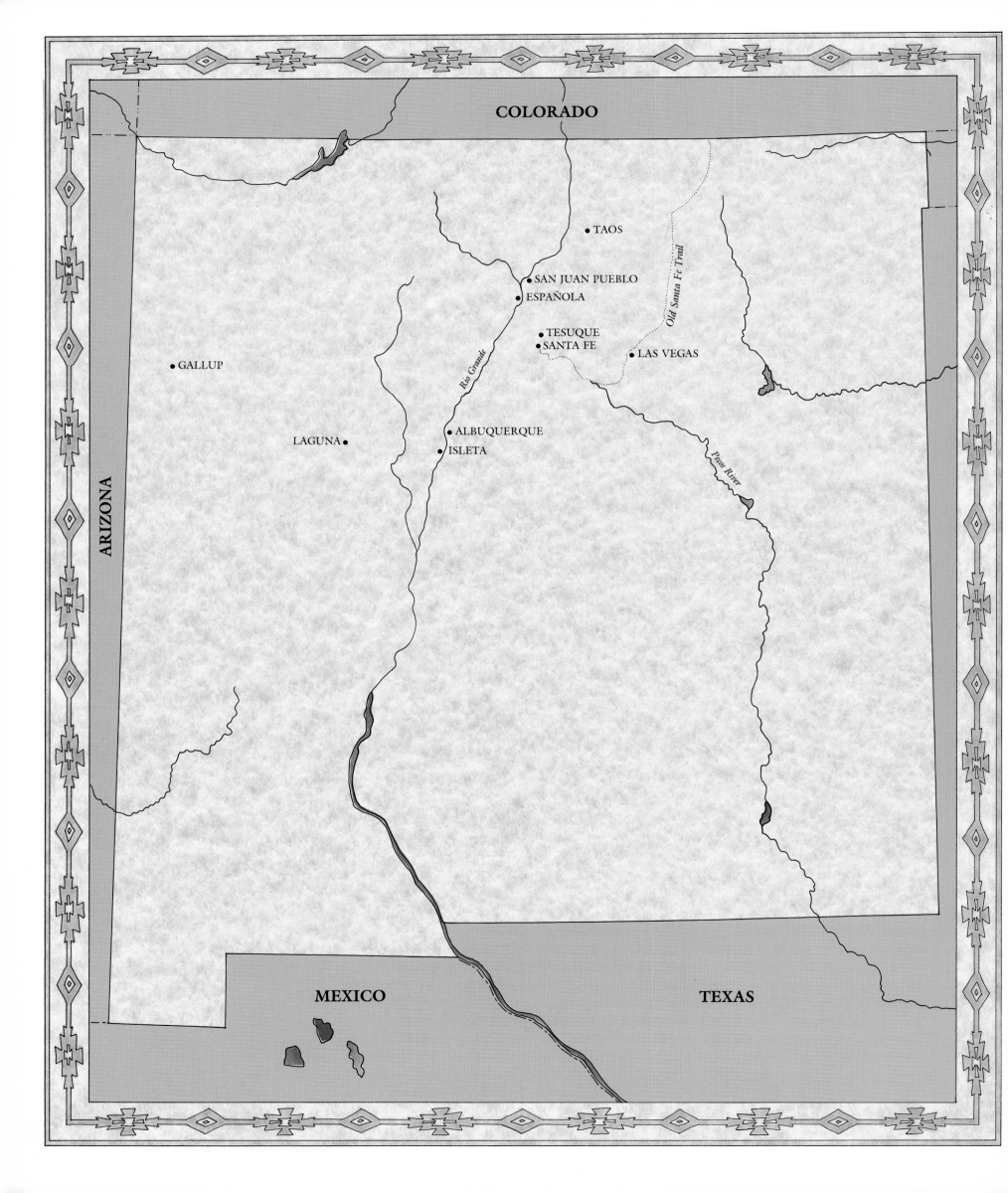

COLORADO

ARIZONA

• TAOS

• SAN JUAN PUEBLO
• ESPAÑOLA

Old Santa Fe Trail

• TESUQUE
• SANTA FE

• GALLUP

• LAS VEGAS

Rio Grande

LAGUNA •

• ALBUQUERQUE
• ISLETA

Pecos River

MEXICO

TEXAS

NEW MEXICO

New Mexico's Taos School may be the best-known regional art colony in the nation. And Santa Fe, New Mexico's capital, also developed its own pictorial tradition. Indeed, the term *southwestern painting* has come to refer specifically to art produced in Taos and Santa Fe. More has probably been written about New Mexican art as regional expression than about that of any other state, despite New Mexico's short history, its meager population, and its concentration in two relatively small communities.

Santa Fe, founded by the Spanish in 1609, was the principal center of trade with the United States at the time the region joined Mexico, in 1821. The town became the territorial capital in 1851, following the Mexican War, when the entire Southwest was ceded to the United States (except for the southern strip of the Gadsden Purchase, which was acquired two years later). Long before then, however, Santa Fe had been the terminus of the Old Santa Fe Trail, the route developed in the 1820s along which artists, among others, traveled to the Southwest. The trail began in Independence, Missouri, adjacent to Kansas City; reached the Arkansas River in mid-Kansas; and then either cut across to Santa Fe from Cimarron or proceeded along the river into Colorado and south to Santa Fe. The railroad was begun along the same route in 1868; the Atchison, Topeka and Santa Fe generally followed the Colorado branch of the old trail, though it did not reach Santa Fe until 1880. It became a tremendously successful route, and the railroad developed into a major patron of southwestern artists. Important connections also developed with the major midwestern cultural centers of Chicago and Saint Louis, which offered continuing support to their painters who moved to New Mexico.

2.206 JOHN MIX STANLEY may have made his first trip to New Mexico in 1845 with the entrepreneur Sumner Dickerman, his partner in the creation of a gallery of Indian paintings. After returning to Cincinnati to prepare finished paintings from field sketches and exhibiting them in Cincinnati and Louisville, Kentucky, Stanley went back to New Mexico in 1846, following the Old Santa Fe Trail and arriving there in August. The next month he moved on with General Stephen W. Kearny's military expedition, the Army of the West, to San Diego, California. Stanley's views from this trip of San Felipe and Valencia, New Mexico, are known today, as are lithographs of other, unlocated, works.[1]

The Missouri artist Alfred S. Waugh was also in Santa Fe in 1846. Early sketches and views of New Mexico by the army topographical engineer Lieutenant James W. Abert were published in 1848. The brothers Richard and Edward Kern recorded the region in 1849–51; and in 1853–54 the German artist Heinrich Balduin Möllhausen accompanied the Corps of Topographical Engineers under Amiel Weeks Whipple across New Mexico in the transcontinental-railroad survey of the thirty-fifth parallel.

Landscape painters began to visit in the following decade. New Mexico was
1.250, 2.168 WORTHINGTON WHITTREDGE's destination on his first trip west in 1866, when he accompanied General John Pope's tour of inspection; Whittredge made it to Santa Fe and Albuquerque.
3.80 The Denver landscape painter ALEXIS COMPARET was painting in New Mexico in 1879, and Peter Moran visited San Juan Pueblo the following year. Moran's watercolors of New Mexican pueblos, exhibited in New York City in 1881, were likened by critics to the exotic scenery of the Near East. Moran's most extensive trip to New Mexico occurred in 1881, when he accompanied Captain John Bourke to study the ethnological aspects of Pueblo Indian life, documented in Bourke's book *The Snake-Dance of the Moquis of Arizona*
1.152, 1.254 (1884). Peter's brother, THOMAS MORAN, was in New Mexico in 1881, when he visited Taos briefly, and he subsequently painted a small view of that pueblo (unfinished, location unknown). He also went to the San Juan and Laguna pueblos, both of which he depicted

in oil the following year: *The Pueblo Laguna, New Mexico* (Kimbell Art Museum, Fort Worth) and *The Pueblo of San Juan, New Mexico* (location unknown). Thomas returned in 1892, 1900, and several times in the following decade. The Indian painter CHARLES CRAIG visited Taos in 1881 on his way to Colorado Springs, where he was to settle; he returned to Santa Fe and Taos in 1883. The young Colin Campbell Cooper is said to have been in Taos before 1883.

3.89

In 1881 the future Impressionist WILLARD LEROY METCALF worked among the Zuni Indians in western New Mexico, providing illustrations for articles by Sylvester Baxter that appeared in *Harper's New Monthly Magazine* and *Century* the following year and in 1885. Metcalf returned in 1882 with the young anthropologist Frank Hamilton Cushing, whose three-part essay, "My Adventures in Zuni," illustrated by Metcalf and the Cincinnati Indian specialist HENRY F. FARNY, appeared in *Century* in 1882–83. Farny did not visit the Southwest himself but portrayed the Zunis who accompanied Cushing to Washington, D.C. Another Cincinnati artist, Joseph Henry Sharp, did travel to New Mexico in 1883, visiting Santa Fe before moving on to Tucson and the Pacific coast. Sharp may have inspired the visit three years later by his fellow Cincinnatians Charles T. Webber and Henry Mosler. The latter had commissions from H. H. Warner of Rochester for two Indian paintings, *The White Captive* and *Abandoned* (locations unknown), which he executed in Paris. Webber and Mosler traveled to New Mexico with Topeka's HENRY WORRALL, who had been there in 1879, when his illustrations appeared in *Harper's Weekly*.

1.40

2.179

3.44

Henry Rankin Poore, best known as a painter of farm animals, accompanied his Philadelphia teacher, Peter Moran, to the New Mexican pueblo country in 1881 and illustrated and published "A Harvest with Taos Indians" in the *Continent* in April 1883. Poore was in New Mexico again in 1890 as a government census taker, as was the Denver artist CHARLES PARTRIDGE ADAMS. Other painters who traveled to New Mexico in the last two decades of the century included French-trained LOVELL BIRGE HARRISON, who left Paris about 1883 to circumnavigate the globe and who stayed for a time in California and the Southwest. In ill health, Harrison did little painting but a good deal of illustration, and in May 1885 he wrote and illustrated an article for *Harper's New Monthly Magazine* about the town of Espanola. He settled there for a while but soon found the climate and the Indian way of life distasteful. The Cincinnati painter and illustrator Fernand Lungren was encouraged by his close association with Joseph Henry Sharp to go to New Mexico in 1892 on a trip sponsored by the Santa Fe Railroad. Thirty-eight paintings resulting from this visit were featured in the art section of the Saint Louis Exposition and Music Hall Association annual in 1893. Frederic Remington, who first arrived in New Mexico in 1886, returned repeatedly through 1907.

3.79
1.174, 2.52

Whether in Taos or Santa Fe, and whether visiting or resident, professional artists and their audiences and patrons were absorbed by three subjects. The first was the broad landscape, usually glowingly colorful, sometimes more dramatic. At times it was painted as a vast, empty stretch, at other times populated by Indians and ranchers, and at others with characteristic adobe and pueblo habitations. The second primary subject was Indian culture and the third, the succeeding Hispanic civilization. Some painters romanticized a mythic or long-gone culture, emphasizing native craftsmanship and ritual—the Indian dances, the Hispanic flagellants. Others pictorialized their concern with cultural interplay and the intrusion of the Anglos.

With one exception, none of the above-mentioned nineteenth-century artists became residents, though their fascination with the region is evident in the numerous return visits they made and in the plenitude of illustrations that fascinated their eastern audiences. That exception was **Joseph Henry Sharp** from Cincinnati, founder of the **Taos** School and the artist who was significant for the establishment of a resident art community in New Mexico. Sharp's origins were typical in that most members of the Taos School hailed not from the East but from the American heartland. Neither Sharp's paintings nor those by his colleagues were at all provincial, unlike work by members of other less integrated and less sophisticated regional groups across the country.

2.181, 3.63

3.108 Joseph Henry Sharp
(1859–1953)
The Stoic, 1914
Oil on canvas, 52½ x 61½ in.
Museum of New Mexico,
Santa Fe

The Taos painters, who began to come together at the end of the nineteenth century and consolidated into the Taos Society of Artists in 1915, were heir to a cosmopolitan, strongly professional tradition. They remained primarily figure painters, fully utilizing the training they had received in Munich and Paris. Impressionism, and even modernism, was often integrated with their basically academic strategies. They kept strong ties with the sophisticated midwestern urban centers and maintained connections with New York City through exhibitions, patronage, and membership in such prestigious organizations as the National Academy of Design (to which half the Taos Society of Artists belonged).

2.179 In 1881 Joseph Henry Sharp had a studio in the same Cincinnati building as HENRY F. FARNY, just when Farny was commencing his career as a specialist in western subjects. Sharp's own interest in Indians had been aroused when he was a child, but Farny attempted to discourage him from pursuing such subjects, recounting the hardships and dangers of western travel. Undaunted, Sharp first went to Santa Fe in 1883.

2.180 Following a trip to Europe in 1886 with his fellow Cincinnati painter JOHN HAUSER, who was also to devote himself to Indian subjects, Sharp returned to Cincinnati in 1889. He was the first member of the future Taos Society of Artists to go to New Mexico regularly, beginning in 1893, when he went there with Hauser, visiting the northern pueblos. The earliest masterwork to result from this visit was Sharp's *Harvest Dance*, which was immediately purchased by the Cincinnati Art Museum.

 Sharp went back to Paris for additional study in 1894–96, returning to Cincinnati the latter year. He spent the next several summers in Taos and the rest of the time in Cincinnati until 1899, when he went to the Crow Agency in Montana. This remained his pattern until 1902, when the patronage of Phoebe Apperson Hearst allowed Sharp to resign from his position at the Cincinnati Art Academy and to spend the falls and winters at his home at the Crow Agency and the summers among the pueblos near Taos. Only in 1908 did he purchase a house and studio in Taos, which he made his permanent residence after his wife's death in 1913 and a subsequent trip to Europe.

3.109 Bert Geer Phillips
(1868–1956)
The Elk Hunter, before 1912
Oil on canvas, 28 x 40 in.
The Anschutz Collection

Sharp's paintings of the Indians of the Crow Agency are remarkably different from those done in Taos. He was undoubtedly more moved by the romantic aura surrounding the disappearing northern tribes and their austere lives, and his interpretations were heightened by the bleakness of his winter residence with them. He viewed Taos as a more settled and enduring community, and his paintings done there are often sweeter and more colorful, reflecting the influence of Impressionism; he also painted occasional fulsome floral still lifes there. Yet, at their finest, his Taos pictures capture what he perceived as the native American's nobility, as in his dramatic and poignant *Stoic*.[2]

3.108

In Paris in 1895 Sharp became acquainted with **Bert Geer Phillips** and **Ernest L. Blumenschein**, two fellow students at the Académie Julian who were lured to Taos by Sharp's descriptions of it. Both were attracted to Indian subjects, Blumenschein having been a student in Cincinnati of Fernand Lungren, who had been in New Mexico in 1892. After Blumenschein and Phillips returned to this country—the former in 1896, the latter the following year—they set up a studio in New York City. Even there they pursued western subjects, hiring cowboys and Indians from Buffalo Bill's Wild West show as models. In the winter of 1897–98 Blumenschein spent some time in Colorado and New Mexico, and in the fall of 1898 the two artists went west. When they left Denver, their goal was Mexico, not New Mexico, but their wagon broke down near Taos and the two were so entranced by the area that they went no farther. Blumenschein did not make Taos his permanent home until 1919, but Phillips remained, the first of the Taos group to settle there, and it is therefore from 1898 that the Taos art colony "officially" dates.

Phillips, from Hudson, New York, had studied in New York City before going to

Paris in 1894. Once in Taos, he never veered from his enthusiasm for the region. He was instrumental in creating the Taos Forest Reserve, of which he was the first ranger. The world that Phillips constructed was admittedly an ideal one—unfettered archers, intrepid hunters, and music-making free spirits, integrated into his beloved landscape, especially the aspen forests. His renderings of the Hispanic population of Taos, though imbued with nostalgia or sorrow, were more realistic, often depicting older men and women.[3]

Born in Pittsburgh, Blumenschein grew up in Dayton, Ohio, and began his education, first in music and then in art, in Cincinnati, studying illustration at the Art Academy of Cincinnati with Lungren before going to New York City in 1892. Following

3.109

3.110 Ernest L. Blumenschein
(1874–1960)
The Peacemaker, 1913
Oil on canvas, 45 x 45 in.
The Anschutz Collection

his years in Paris he returned to New York City as an illustrator in 1896; the following winter he was commissioned by *McClure's* for a series of illustrations of Arizona and New Mexico. During the crucial visit to Taos the following year, Blumenschein became homesick for the East after only three months. In 1899 he returned to Paris for two years to renew his studies. He was back in this country in 1901–2, revisiting Taos before returning to Paris, this time remaining for nine years as a successful illustrator; while there he married Mary Shepard Greene, a successful Paris-trained painter.

When the Blumenscheins returned to this country in 1909, they settled in New York City, continuing to work as illustrators and teaching at Pratt Institute and the Art Students League. During each of ten successive summers, Ernest spent three months in Taos, and in 1919 an inheritance received by Mary enabled the family to move there permanently. Some of Ernest's early Taos paintings, such as *The Peacemaker*, are idealized 3.110
allegories of Indian life, but after he had settled there he recorded not only traditional mores but also the conflicts between cultures. Like his colleague Phillips, he depicted the Hispanic population with sensitivity. He was more receptive than many of his associates to Impressionism and modernism, especially Post-Impressionism, and his works of the 1920s and '30s, often set in panoramic landscapes, pulse with formal rhythms, intense coloration, and simplified, abstracted shapes.[4]

At the turn of the century more and more artists visited Taos. Frank Sauerwein from Denver arrived in 1898; the following year **Oscar E. Berninghaus** from Saint Louis appeared on the scene, remaining only a week, during which he met the now-resident Phillips. Like Sharp and Blumenschein, Berninghaus divided his professional years between his native city and the New Mexican pueblo he visited each summer. Though he acquired a house in Taos in 1919, he moved permanently only in 1925. Berninghaus, the only one of the early Taos artists not to have studied abroad, generally exhibited his southwestern scenes in Saint Louis. His connections there stood him and his colleagues in good stead, his major patronage deriving from the Busch family, owners of the Anheuser-Busch brewing company.

Berninghaus began his career as a commercial artist. His first visit to Taos occurred while he was on commission from the Denver and Rio Grande Railroad to prepare watercolor sketches for travel pamphlets. Only after his return to Saint Louis did he begin to work in oil and to apply himself with renewed seriousness to the career of a professional painter. In general, his paintings are more concerned than those of most of his Taos contemporaries with the unidealized, nonindividualized daily lives of the Indians in the area, perhaps reflecting the commercial origins of his art and his lack of academic training. They are sometimes set in the town, as in *Post Office, Taos, New Mexico*, and sometimes in 3.111
the panoramic landscape.[5]

The next of the Taos group to arrive was **Eanger Irving Couse**. Of all the artists 3.142
under consideration here, Couse immersed himself most deeply in the academic traditions he studied in Paris between 1886 and 1896. He interrupted his stay abroad only by a visit during 1891–92 to rural southern Washington, near Roosevelt, on the Columbia River, where he lived on the family cattle ranch of his new wife, the French-trained painter Virginia Walker. There, across from Arlington, Oregon, and near the Yakima and Klickitat Indians in Washington, Couse began to depict Indian subjects; he painted portraits during the winter in Portland. The intensity of his academic instruction probably explains his skill as a painter of ennobled Indians. For despite some repetition in his compositions— the near-naked crouching Indian in profile, for example, appears over and over again in his paintings—Couse was the most successful of all the Taos artists. The Atchison, Topeka and Santa Fe Railroad was his greatest patron, and his paintings found their way to national museums throughout the country.

Couse had had the advantage of early exposure to Indian life while growing up in Saginaw, Michigan, in close proximity to Chippewa Indians. He was one of the first students at the newly established Art Institute of Chicago in 1882, where ALICE KELLOGG 2.259
TYLER, PAULINE PALMER, and ADAM EMORY ALBRIGHT were among his fellow students. Couse 2.28; 2.268
studied at the National Academy of Design in New York City in 1883–85 before going to

ABOVE:

3.111 Oscar E. Berninghaus
(1874–1952)
*Post Office, Taos, New
Mexico,* 1915
Oil on canvas, 16 x 20 in.
Mr. and Mrs. Martin Kodner,
Gallery of the Masters,
Saint Louis

LEFT:

3.112 Eanger Irving Couse
(1866–1936)
Hopi Flute Dancers, n.d.
Oil on canvas, 50⅜ x 60 in.
Stark Museum of Art,
Orange, Texas

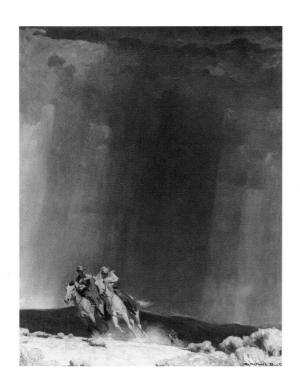

3.113 William Herbert Dunton
(1878–1936)
The Shower, c. 1914
Oil on canvas, 32 x 25 in.
The Anschutz Collection

Paris. There, in 1886, he met Ernest L. Blumenschein and Bert Geer Phillips and heard about Taos from Joseph Henry Sharp. During his summers in France, Couse painted typical peasant themes at Cernay-la-Ville; later, in 1893, he settled in the fishing village of Etaples. He also painted religious subjects, the most ambitious of which, done soon after his return to this country, was the sixteen-foot *Adoration of the Shepherds,* commissioned in 1899 by the Methodist Episcopal Church in Harrisburg, Pennsylvania, and painted for the most part in Mystic, Connecticut. After returning to this country in 1896 and staying at the Walker ranch for several years—where he again painted the Klickitat and Yakima Indians—Couse settled in New York City in 1898, subsequently teaching at the Art Students League. On his first visit to Taos in 1902 he found all the inspiration he needed, and he continued to return each summer, settling permanently in 1927. Couse depicted romanticized, intellectualized Indians stoically playing music; making baskets, pottery, or sculpture; cooking or weaving; or involved in courtship and dancing ceremonies, as in *Hopi Flute Dancers,* a work painted at the Hopi pueblos in Walpi, Arizona. Like his 3.112
French teacher, Adolphe-William Bouguereau, Couse specialized in idealized, nearly nude figures in his studio-oriented art; for this reason male Indians and children were his preferred models, while draped female figures occur only peripherally. The Hispanic and Anglo worlds are virtually absent from Couse's art, and his concern with the Taos landscape was minimal.[6]

The last member of the original Taos Society of Artists, **William Herbert** (Buck) **Dunton,** arrived a decade after Couse, in 1912, and immediately made the town his home. Born in Maine, Dunton moved west at eighteen, becoming a hunter, ranch hand, and cowboy in Montana. Inspired there by the career of CHARLES MARION RUSSELL, he 3.61
turned to commercial illustration, studying at the Cowles School in Boston about 1897 and returning west each summer. Dunton's ambition led him to New York City about 1903 to take instruction at the Art Students League, where one of his teachers, Ernest L. Blumenschein, suggested that he visit Taos. There, unlike his colleagues, Dunton was immediately attracted by the life and activity of the Anglo cowboy, as is apparent in *The* 3.113
Shower, and of the cowgirl, which became his almost exclusive subjects. Narrative remained a component of Dunton's art, a heritage from his involvement in illustration.[7]

The Taos Society of Artists, conceived in 1912, was originally an informal group that comprised Berninghaus, Blumenschein, Couse, Dunton, Phillips, and Sharp. It was organized officially in 1915, with Couse as president. Membership was based on proven professionalism and a minimum of three years' association with Taos; in 1917 a proviso was added that the exhibited work should depict the Southwest. The society's purpose was, above all, to seek exhibition outlets, which were not available in Taos itself. In 1915 the group held its first exhibition, in the Palace of the Governors in Santa Fe, and in 1917, when the Museum of New Mexico opened in the capital, it became a major showplace for work by New Mexico's artists. By that year the society had established a plan for two traveling exhibitions: one beginning in New York City and moving west to Santa Fe; the other starting in Santa Fe, traveling to California, and ending in Colorado Springs. Provision was made for adding members and associate members; eight associate members and five full members joined before the group voted to dissolve in 1927. In one sense the society had served its purpose by then, having introduced throughout the country the notion of a distinct southwestern art, and most of the artists had solid reputations. Once established and defined, however, Taos art no longer offered the excitement of its initial years.

Many of the society's associate members were primarily connected with Santa Fe: Robert Henri, elected in 1918; Randall Davey, B.J.O. Nordfeldt, and JOHN SLOAN, all 3.120
elected in 1921; and Gustav Baumann and SVEN BIRGER SANDZÉN, elected in 1922. Albert 3.48
Lorey Groll, a painter of luminous northern New Mexico and Arizona desert landscapes since 1905, was elected an associate in 1919. Julius Rolshoven, originally from Detroit, was an expatriate who had settled in Florence, returning to this country in 1915. Inspired by the examples of New Mexico architecture he saw that year at the Panama-California Exposition in San Diego, Rolshoven went to Taos and Santa Fe in 1916, staying for

several years. He was elected an associate in 1917 and an active member the following year, but returned to his expatriate life soon after the war. He was returned to associate status in the society in 1923.[8]

More important than the associates to the society's fortunes were the six artists who were elected to active membership from 1917 on: **Walter Ufer** and **Victor Higgins** in 1917; Julius Rolshoven, elevated to full membership in 1918; Catherine Carter Critcher and E. Martin Hennings in 1924; and Kenneth Miller Adams in 1926. Ufer and Higgins were particularly significant additions due to the quality and distinction of their work and to their Chicago backgrounds, which caused publicity and patronage to accrue to the society from that major cultural center.[9] The society's exhibitions may have received more favorable publicity there than anywhere else beyond New Mexico. Press notices for shows held in Chicago in the late 1910s were extremely favorable, though it was, not surprisingly, the work of the two "locals" that received the greatest attention. Both artists had been sponsored by Mayor Carter Harrison, a patron who urged Ufer and Higgins to join the Taos colony and devote their abilities to painting the Southwest.

Other factors contributed to Ufer's and Higgins's importance. More than their colleagues, they were concerned with formal issues. Ufer's preoccupation with light represents a late flowering of the "glare" aesthetic—an emphasis on brilliant effects of

3.114 Walter Ufer (1876–1936)
Indian Corn—Taos (also known as *Cornfield in Taos*), n.d.
Oil on canvas, 40 x 50 in.
Mr. and Mrs. John W. Mecom, Jr.

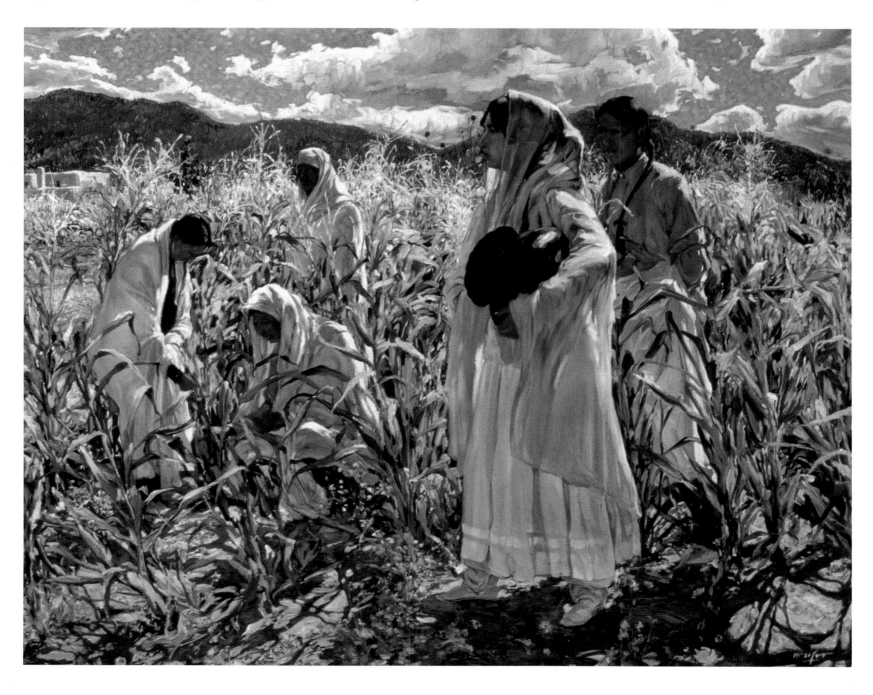

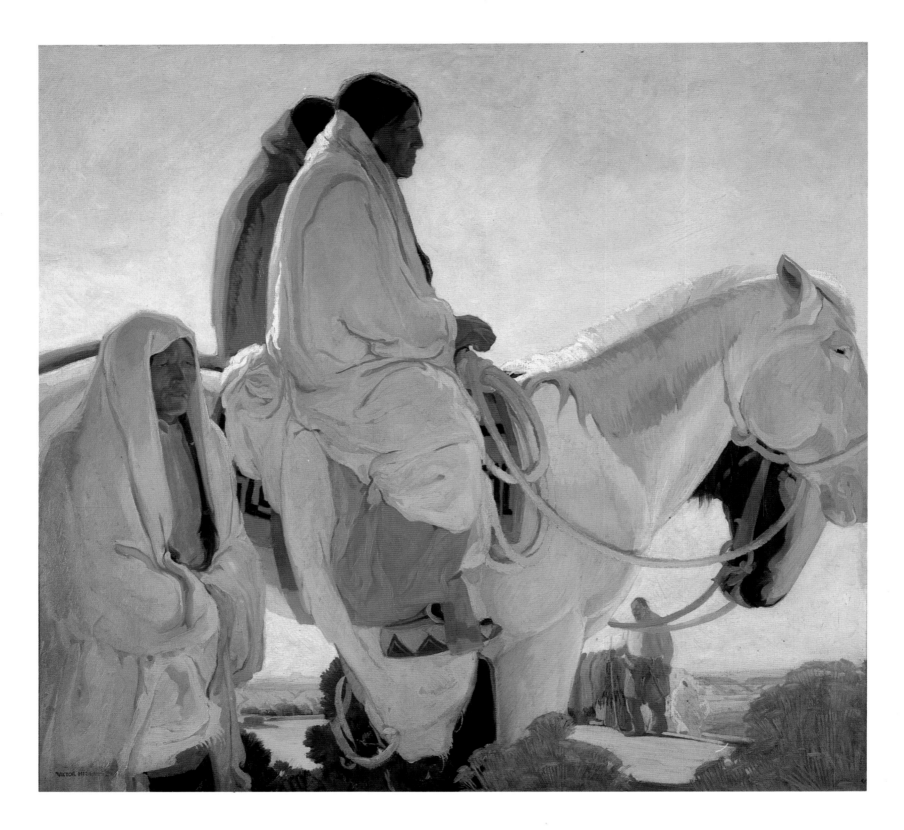

3.115 Victor Higgins
(1884–1949)
Fiesta Day, 1918
Oil on canvas, 52 x 56 in.
Butler Institute of American
Art, Youngstown, Ohio

light that reinforce rather than efface strong modeling and sharp outlines. Higgins's formal simplifications veered increasingly in the direction of various modernist strategies such as Cubism. Ufer, Higgins, and those who followed recognized the impact of Anglo culture on the native population. Instead of naturalistic descriptions, reconstructions, or idealizations of Indian life, they recognized in their paintings the cultural interactions characteristic of Taos. Picket fences and coal stoves replaced open aspen groves and adobe hearth fires. In Ufer's case this emphasis was urged on him by his patron Carter Harrison, who deplored the more traditional representations he had done on his first trip to New Mexico. Alone among the society's members, Ufer was also a political radical, a follower of Leon Trotsky and a member of the International Workers of the World, and he participated in a miner's strike in Gallup, New Mexico.

Ufer, born to German emigrant parents in Louisville, Kentucky, went to Europe in 1893 after visiting the World's Columbian Exposition in Chicago; he worked for a lithography firm in Hamburg and several years later studied at the Royal Academy in Dresden. He returned to Louisville in 1898 and in 1900 moved to Chicago, where he worked as an engraver while studying at John Francis Smith's Art Academy of Chicago, which was affiliated with the Académie Julian; he became an instructor at Smith's school in 1904. In 1911 Ufer went abroad for two years, studying in Munich. On his return the works he exhibited from his trip attracted the interest of Mayor Carter Harrison, who formed a syndicate to finance Ufer's travel on the Santa Fe Railroad to Taos in 1914. That year he worked in Isleta, San Juan, and Taos; in 1915, in San Juan and Taos; and from 1916 on, in Taos alone. From 1914 on, Ufer was a member of the Taos colony, though he spent winters in Chicago until 1920, and in New York City thereafter. Ufer's Taos works were hailed when they were exhibited in Chicago from 1916 on and in New York at the National Academy of Design in 1918. His *Indian Corn—Taos* (alternatively *Cornfield in Taos*) was illustrated in the Chicago periodical *Fine Arts Journal* and praised exuberantly when exhibited in the Taos Society's show in Chicago in the winter of 1917–18, held at the Carson Pirie Scott Galleries. *Indian Corn—Taos* exemplifies Ufer's distinct manner of depicting Indians—strong, solid, heavily robed figures engaged in agricultural pursuits, unlike Couse's near-naked primitives. Ufer's work is marked by swathes of brilliant golden light and strong shadows; unlike Couse, he painted outdoors. His interpretation of individual figures curiously but effectively contrasts implied noble bearing and heritage with the meniality of their tasks.[10]

3.114

Higgins, too, benefited from Carter Harrison's generous support. Born in Shelbyville, Indiana, Higgins had gone in 1899 to Chicago to study at the Art Institute and then at the Chicago Academy of Fine Arts, where he later became an instructor. In 1908 he studied in New York City and in 1910 went to Paris and Munich for three years, meeting Ufer in Europe. Higgins was back in New York City in time for the Armory Show, which greatly influenced him; his work, more than that of any other member of the Taos Society, reflected European modernism. The paintings he exhibited in Chicago in 1913 attracted the attention of Mayor Harrison, who sponsored Higgins's trip to New Mexico in 1914. The artist was attracted at once to the landscape of the Taos region, and in 1914 he became a resident, though he continued to make long visits to Chicago.

Like Joseph Henry Sharp, Higgins occasionally indulged in still-life, especially floral, painting, but he focused principally on the Pueblo Indians as his subjects, though formal experimentation became more and more significant to him. His earliest works done in Taos, such as *Fiesta Day*, feature strong, massive figures similar to those painted by Ufer, though they lack the latter's intense lighting and illustrate Higgins's interest in chromatic variations and simplified forms. His Indians are often depersonalized, reduced to simplified, carefully balanced masses, and painted broadly in rich colors. From the first, the New Mexico landscape assumed importance equal to that of the human activity in his art, and as time progressed the figures were often melded into the landscape as repeated areas of color. Geometric elements derived from Paul Cézanne played an increasingly major role.[11]

3.115

The society's six founders along with Ufer and Higgins—the "Ochos Pintores" as they were called by Kenneth Miller Adams, the last artist to join—received an important public commission in 1917, to execute the mural decoration of the new Missouri State Capitol in Jefferson City under the direction of Dr. John Pickard, an art professor at the University of Missouri. The choice was determined by a general antipathy to the allegorical decorations that had been done during the previous two decades in various public buildings and by the local connections of Oscar E. Berninghaus. A Saint Louis native, Berninghaus was known to such commission members as the collector William Bixby and the dealer Arthur Kocian of Noonan and Kocian Art Galleries. Berninghaus was the second artist who agreed to provide murals for the Capitol, signing up at the end of January 1920 to paint *The Attack on Saint Louis in 1780* and *The Surrender of the Miamis to General Dodge, 1814*; British muralist Frank Brangwyn had agreed to paint murals for the rotunda the previous November.

Berninghaus's murals were unveiled in January 1921 along with others by N. C. WYETH, Adolphe Blondheim, Herman T. Schladermundt, and Saint Louis's FRED GREENE CARPENTER. But more murals depicting Missouri's early history were required, and, since Indians would necessarily appear in some of them, Berninghaus was asked to suggest painters who dealt with that subject. He invited the commission to go to Taos the following summer to meet his colleagues there, and a contract was signed in the fall of 1923 with Blumenschein, Couse, Dunton, Higgins, Phillips, and Ufer—everyone in the society except Sharp, who did not participate, for unknown reasons. The paintings appear to have been undertaken and delivered rapidly, though it is not known if all the artists visited the site for the pictures they would paint in their Taos studios. Fittingly, John Pickard himself purchased a house in Taos three years after his initial visit.[12]

Carter Harrison also gave his support to a third Chicago painter to join the Taos colony, **E. Martin Hennings**. Hennings had grown up in Chicago and had attended the Art Institute. After a period in commercial art, he sought additional training, first at the Art Institute and then in Munich, where he renewed his Chicago-based friendship with Ufer and Higgins and studied under Walter Thor, previously Ufer's teacher in Munich, while seeking instruction from Franz von Stück. With the turmoil of World War I, Hennings returned to Chicago by 1915, and with the backing of Harrison and Oscar Mayer (founder of the meat-packing firm), he was sponsored for a season in Taos with the assurance that his New Mexico paintings would be purchased.

Though impressed by the potential subjects in Taos, Hennings returned to Chicago late in 1917 and explored other art colonies before deciding to settle in Taos in 1921. Like Ufer, he painted the contemporary and, to some degree, Anglicized Indian, but he focused, like Higgins, on the local landscape, interpreting it in a decorative, less analytical manner. Like Couse, Hennings was patronized by the Santa Fe Railroad.[13]

1.284
3.38

3.116

3.116 E. Martin Hennings
(1886–1956)
By the Stream, c. 1918–20
Oil on canvas, 36 x 40 in.
Private collection

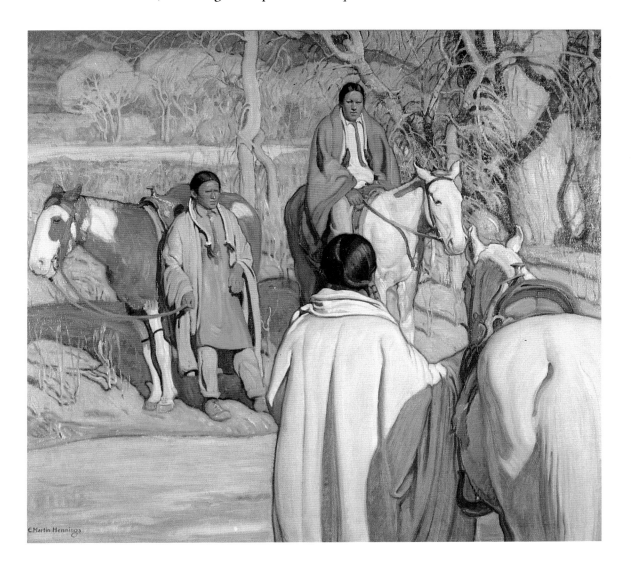

Catherine Carter Critcher, the Washington, D.C., portraitist and head of the Critcher School of Painting there from 1919 on, first arrived in Taos in 1920 and continued to summer there, becoming a member of the society in 1924, the only woman to do so. Portraiture continued to be her primary focus in New Mexico, particularly Indian and, occasionally, Mexican subjects. Kenneth Miller Adams, the last member admitted to the society, had been born in Topeka, Kansas, studying there with GEORGE MELVILLE STONE, moving to Chicago in 1916, and studying in New York City in 1919. Adams's exposure to the work and teaching of Andrew Dasburg encouraged him to investigate modernist strategies and led him to New Mexico, where Dasburg regularly spent part of each year in Santa Fe. Finding no suitable working facilities, Adams proceeded to Taos with an introduction from Dasburg to Ufer, who acted as a guide to the younger painter. Adams's early paintings, following the lead of most of the society's artists, were devoted to Indian subjects, but he later found his inspiration in the Hispanic community.[14]

3.45

There were, of course, artists in Taos during this period who were not associated with the society, including several professional artists who were married to society members. Virginia Walker Couse appears to have abandoned her art after marriage. Mary Shepard Greene, from Rhode Island, had had a successful art career in Paris for fifteen years before marrying Ernest L. Blumenschein in 1905. A figure painter and illustrator in New York, she joined her husband in Taos in 1919, thereafter turning to jewelry making.[15] Maurice Sterne had been lured to paint in Bali and the Far East before he went to New Mexico in 1916. That year he married the wealthy cultural maven Mabel Dodge, immediately leaving her behind when he took a "solitary" honeymoon in Santa Fe at the invitation of his fellow artist Paul Burlin. Dodge joined him at the end of the year but insisted on leaving for Taos; though the pueblo town was home to Sterne for only a year, Dodge remained there the rest of her life, surrounding herself with a coterie of avant-garde painters and writers and playing a vital role in establishing Taos as a major cultural center. Among the modernist painters she attracted were MARSDEN HARTLEY and Andrew Dasburg, both in Taos in 1918; both would be far more active and influential in Santa Fe, where Dasburg lived from 1921 until 1932, moving back to Taos in 1933. Hartley felt alienated from the closed society of Taos, though he was stimulated by the landscape, the Indians, and especially the *santos*, Mexican-American altarpieces that inspired a series of his paintings.

1.18

Although artists had visited **Santa Fe** earlier and more often than Taos in the nineteenth century, the town did not develop into an art center until the 1910s, and no group like the Taos Society of Artists ever evolved there. In the 1920s and '30s, however, more individually well-known painters visited Santa Fe, some regularly, taking inspiration from the town and the surrounding landscape. Unlike Taos, Santa Fe also attracted many long-time visitors due to its fame as a health resort. Inevitably, a rivalry developed between the state capital of Santa Fe and the smaller, more hermetic community of Taos.

A "Professor" George Stanley is known to have resided in Santa Fe for a while about 1896–98, painting scenes of Indian and Mexican life. **Carlos Vierra** may have been the first full-time artist-settler in Santa Fe, moving there for health reasons in 1904. Born in California, he first studied at the Mark Hopkins Institute in San Francisco under GOTTARDO F. P. PIAZZONI from 1898 until 1901; he then traveled to New York City to study art and begin a career as a cartoonist. Lung trouble led Vierra to Santa Fe, where he established himself as a painter of Indian, genre, and landscape subjects and as a photographer. When Edgar L. Hewett founded the School of American Archaeology— later the School of American Research—in Santa Fe in 1907, he encouraged artists to associate with the institution and offered them studio space. Vierra became involved in the restoration of the Palace of the Governors and the construction of the Fine Arts Museum. In 1909 the territorial legislature established the Museum of New Mexico in the Palace of the Governors, which housed the New Mexico Historical Society, the New Mexico Archaeological Society, and the Museum and School of American Archaeology, with Hewett as director.

3.210

3.117 Carlos Vierra (1876–1937)
Zia Mission, c. 1918
Oil on canvas, 28 x 36 in.
Museum of New Mexico,
Santa Fe

Artistic patronage and support began in earnest when Hewett's backer, the wealthy collector, land holder, and territorial senator Frank Springer, commissioned a series of murals depicting the early New Mexican cliff dwellers for the Museum of American Archaeology. The Colorado Springs painter Carl Lotave, who worked for the Smithsonian Institution's Bureau of Ethnology, received the job. Under the school's auspices, Vierra himself painted murals of Mayan architecture for the California Building (now the Museum of Man) at the 1915–16 Panama-California Exposition in San Diego and others depicting the history of the Franciscan order in the auditorium of Santa Fe's new Fine Arts Museum. He completed the latter series with a colleague, Kenneth Chapman, after the death of their original designer, the Utah painter Donald Beauregard, another protégé of Frank Springer. Beauregard's own completed panels had hung in the New Mexico State Building at the Panama-California Exposition, after which they were returned to Santa Fe. Vierra undertook the pictorial reconstruction of Spanish missions in a suite of sixteen architectural paintings including *Zia Mission*, and he also wrote perceptively about this genre of 3.117 indigenous architecture.[16] Chapman, who had gone to Las Vegas, New Mexico, in 1899 as a teacher and illustrator, settled in Santa Fe in 1909, achieving fame principally through his interest in, and promotion of, Indian pottery.[17]

Warren Rollins, who was in New Mexico before Vierra and Chapman, became known as the dean of the Santa Fe art colony. He had studied at the San Francisco Art Association's School of Design before beginning a career as an itinerant painter of the American Indian and the West. Though Rollins was in Taos as early as 1893, for many years he roamed the vast empty territories of Arizona and New Mexico, establishing a permanent home in Santa Fe only in 1917. He is said to have had the first solo show at the Palace of the Governors in 1910 and was the first president of the Santa Fe Art Club, teaching classes in the Palace about the same year.[18]

The next artist to settle in Santa Fe was **Gerald Cassidy**. Born in Covington, Kentucky, he had studied with FRANK DUVENECK in Cincinnati and then in New York City 2.177 before turning to a career in commercial art. In 1912 declining health took Cassidy to Santa Fe from Denver, where he had resided for several years. Through Hewett he was

3.118 Gerald Cassidy
(1869–1934)
Cui Bono?, c. 1913
Oil on canvas, 93½ x 48 in.
Museum of New Mexico,
Santa Fe

3.119 Sheldon Parsons
(1866–1943)
October in New Mexico, n.d.
Oil on canvas, 30 x 40 in.
Santa Fe Collection of
Southwestern Art, Chicago

commissioned to paint murals in the Indian Arts Building at the Panama-California Exposition. Subsequently, Cassidy turned to the depiction of Indian and desert life. His most famous easel painting is undoubtedly *Cui Bono?*, exhibited at the San Diego exposition. 3.118 The luminescence of the traditional village and the pure white robe of the Indian suggest, with telling irony, the attempt to maintain the dignity of the Indian's indigenous culture against the inevitable dominance of the Anglo intruders, including the artist himself. Cassidy also provided historical murals of the native Americans and the Spanish conquistadors for the Santa Fe Post Office.[19]

Sheldon Parsons, the capital's next resident artist, arrived in 1913, seeking better health after a successful career as a portraitist in New York City. Under the influence of the Southwest's brilliant light and exotic landscape, he turned to scenic art, adapting a quasi-Impressionist aesthetic in such works as *October in New Mexico*. In 1914 Parsons 3.119 became the art curator of the Museum of New Mexico.[20]

In 1913 the first signs of modernism appeared in Santa Fe, which, by the end of the decade, would witness a greater variety of artistic activity than Taos. Paul Burlin, who had come under the influence of Robert Henri and Alfred Stieglitz in New York City, went to Santa Fe after participating in the Armory Show of 1913. Burlin introduced Fauve color and expressionist distortion in his paintings of the New Mexican landscape and of Indian figures. Kept from traveling abroad by World War I, he built a house in Santa Fe in 1914 and continued to visit regularly through 1920; his pioneering modernism was early acknowledged by critics.[21]

The limitations of wartime travel were partially responsible for the influx, starting

in 1916, of a host of painters from Chicago, New York City, and even abroad. Robert Henri went to Santa Fe that year, encouraged to paint there by Edgar Hewett; he depicted Indians and Mexicans, as he had done earlier in San Diego. Henri returned in 1917 and on several occasions in the 1920s. He and Julius Rolshoven were followed in 1917 by Leon Kroll and George Bellows, both of whom were encouraged to visit by Henri. Dutch-born Henry Balink arrived from Taos in 1917 and painted a series of ethnologically valuable portraits of sixty-three tribal groups.[22] The delayed impression that the New Mexican landscape made on MARSDEN HARTLEY was revealed in scenes executed in New York City and Berlin in the 1920s, a series entitled Recollections of New Mexico that depicts intensely somber rolling vistas.

1.18

Also encouraged by Henri, **John Sloan** began to summer in Santa Fe in 1919 and returned regularly for thirty years; his studio was one formerly used by Henri and provided by the Museum of New Mexico. Of all the "resident-visitors," Sloan was probably the most transformed by his Santa Fe experience, gradually abandoning the harsh urban drama of his Ashcan School painting for the bright light and color of the Southwest. Many of his finest pictures from the ensuing decades, such as *Music in the Plaza*, depict genre scenes in the New Mexican capital, the broad desert landscape, and Indian ceremonies. Sloan, in turn, promoted New Mexico's art in the East and, more important, championed Indian painting and other tribal arts.[23]

3.120

On his first visit to Santa Fe, Sloan traveled with his close friend Randall Davey, one of Henri's most promising students; previously, Sloan and Davey had worked together in Gloucester, Massachusetts. Abandoning the vividly painted figural types favored by Henri, Davey had turned to portraiture and, after he moved to Santa Fe, to landscape. In the 1920s and later he would become known for his paintings of racetracks.[24] In 1919 Fremont Ellis, then teaching art in El Paso, Texas, settled in Santa Fe, continuing to paint the landscape for sixty-five years. Walter Mruk, who had been born in Buffalo, also arrived in 1919 and was joined in 1920 by his friend and fellow Buffalonian, also of Polish parentage, Jozef Bakos. Both had taken instruction at the Albright Art School and

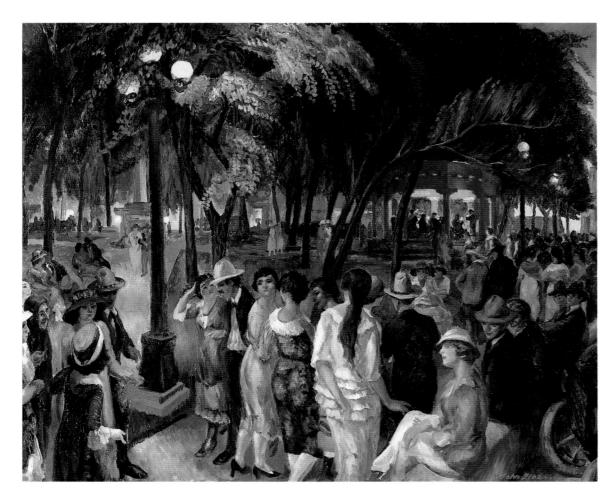

3.120 John Sloan (1871–1951)
Music in the Plaza, 1920
Oil on canvas, 26 x 32 in.
Museum of New Mexico,
Santa Fe

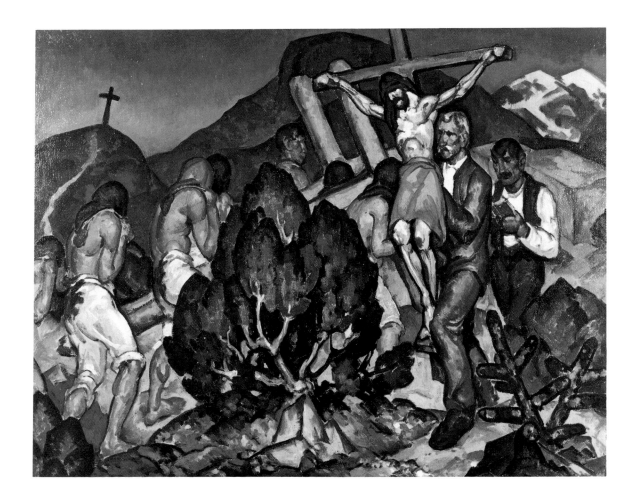

3.121 William Penhallow
Henderson (1877–1943)
*Holy Week in New Mexico
(Penitente Procession)*, 1919
Oil on panel, 32 x 40 in.
Museum of New Mexico,
Santa Fe

had gone to Colorado after completing their studies.[25] In 1920 Sloan's student William Howard Shuster began to summer in Santa Fe, partly for reasons of health. That year Willard Nash, a young student at the Fine Arts Academy in Detroit under John Palmer Wicker, went to Santa Fe to assemble material for a mural project; he returned in 1921 and remained for fifteen years. In 1921 Nash began to study with Andrew Dasburg.[26]

Also in 1921 Bakos, Ellis, Mruk, Nash, and Shuster formed their own exhibiting group, Los Cinco Pintores (a small-scale Santa Fe counterpart to the better-known Taos Society of Artists), circulating exhibitions through the Midwest and to the West Coast. Los Cinco Pintores was a relatively disparate group more modernist in approach than many of their colleagues in Santa Fe and, certainly, than the society members in Taos. The art of Nash, Bakos, and Mruk, for example, was imbued with the influence of Paul Cézanne. The majority of the paintings by these five artists, and by most of the other professionals in Santa Fe, were landscapes or views of the town; only Henri and Balink devoted themselves to the figure—usually Indian subjects. This preference distinguished the Santa Fe artists from the primarily figure-oriented painters in Taos. Los Cinco Pintores showed together only a few years, and then they were subsumed by the larger, more significant New Mexico Painters group, which was formed in Santa Fe in 1923. Even before that, the Santa Fe Art Club had been started, in 1920, representing a more traditional, yet more heterogeneous, membership, with Randall Davey as president and Sheldon Parsons as vice president.[27]

The influx of painters from Chicago included another painter patronized by Carter Harrison, **William Penhallow Henderson**, who moved to Santa Fe for reasons of health 2.285 in 1916. Henderson infused many of his scenes of Indian and Hispanic life, in both oil and pastel, with an expressive, rhythmic modernism that balances then-radical artistic strategies with scenes of traditional rituals, especially Indian dances and the ceremonies of the Hispanic flagellants, or *penitentes*. The latter subject also attracted members of Los 3.121 Cinco Pintores such as William Howard Shuster and Willard Nash.[28]

Henderson was followed to Santa Fe in 1918 by his former Chicago colleague

2.289 B.J.O. Nordfeldt, whom he induced to go to New Mexico after the latter's residence in Provincetown, Massachusetts, and who remained for two decades; Nordfeldt, too, applied an aesthetic heavily indebted to Cézanne to interpretations of the landscape and of Indian and Hispanic life, including the *penitentes*.[29] Nordfeldt, in turn, was joined in 1924 by his former Chicago student RAYMOND JONSON. On a visit two years earlier Jonson had been inspired by the New Mexican landscape to begin a series of abstracted Earth Rhythms. The Chicago contingent proved decisive for the development of modernism in New Mexico, especially after Jonson was appointed to the faculty of the University of New Mexico in Albuquerque in 1934.

2.117 The Santa Fe art colony had few active women professionals until the 1920s, when Dorothy Brett arrived with D. H. Lawrence in 1924 and, most significantly, GEORGIA O'KEEFFE, in 1929. The first important woman artist was Indiana-born Olive Rush, who began her career as an illustrator, studying in Washington, D.C., and New York and with

1.309 HOWARD PYLE in Wilmington, Delaware. She then turned to easel painting after studying in Paris in 1911 and 1913. The following year Rush made her first visit to Sante Fe, where she had one of her earliest exhibitions; she continued to visit during ensuing summers, finally purchasing a studio-home there in 1920. She remained active in the city for over forty years, becoming known for her mural decorations in the vestibule of the

2.189 public library and in the dining room of the La Fonda Hotel.[30] ALICE SCHILLE—the Columbus, Ohio, painter of colorful watercolors—visited Santa Fe in the summer of 1919 rather than making her usual excursion to Gloucester with John Sloan and Randall Davey; she returned in 1920, joining Rush, her schoolmate from the Art Students League.

Though the original concentration of the Museum of New Mexico was archaeological, works by territorial and, after 1912, state artists were shown in the Palace of the Governors; Santa Fe painters began to exhibit there as a group in August 1915, and the Taos Society held its first show in September of that year. In 1917, with the growing fame of the Taos group and the increasing attraction of Santa Fe to painters throughout the country, an art gallery, integral to the Museum of New Mexico, opened to the public in November, an exact copy of the New Mexico State Building at the 1915–16 Panama-California Exposition in San Diego.

In **Albuquerque**, the largest city in the state and home of the university since 1889, Joseph Imhof, a painter of native Americans from 1907 until 1912, and Theodore Van Soelen, a painter of Indian culture and ranching activities, were the principal artists. Van Soelen had moved to Albuquerque in 1916 for reasons of health after having studied at the Saint Paul Institute in Minnesota from 1908 until 1911 and at the Pennsylvania Academy of the Fine Arts; eventually he settled at Tesuque, outside Santa Fe.[31]

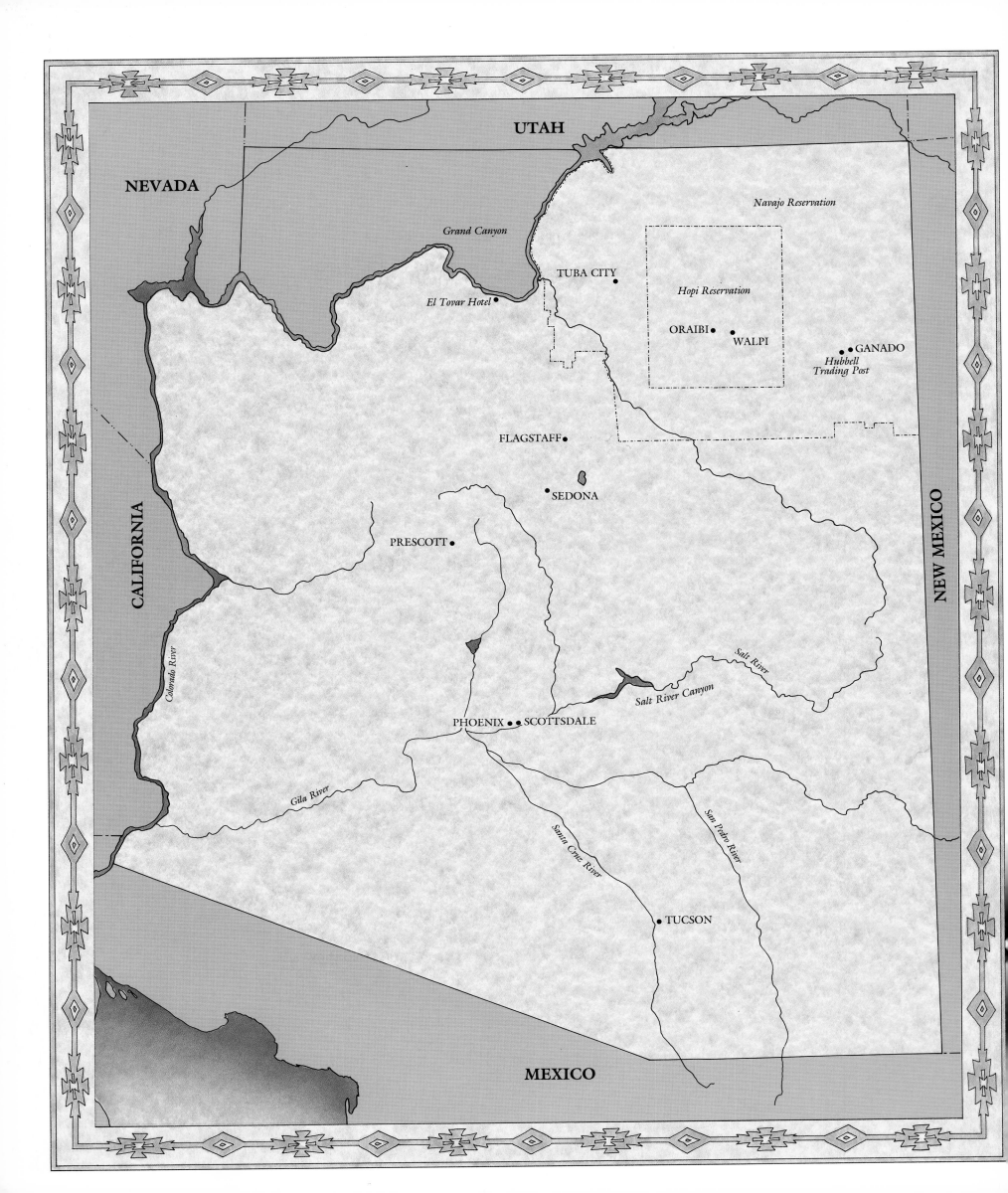

ARIZONA

2.206

3.88

Like New Mexico, Arizona was part of the land conquered by the Spanish and then incorporated into Mexico when that nation achieved independence in 1821. Arizona was organized as a separate territory in 1863 and was admitted into the Union as a state in 1912. Many of the artists who recorded the territory that became New Mexico also visited Arizona. For example, JOHN MIX STANLEY traveled through Arizona from Santa Fe to California in 1846, later enlarging his on-the-spot sketches into easel paintings. In Arizona, however, no central municipal base or art colony developed that was comparable to Taos or Santa Fe. It was the landscape itself, and primarily the northern region of the Grand Canyon, that lured artists, who were encouraged by the railroad to promote the territory to tourists. For the most part, there was no motivation, either on the part of the local population or the artists themselves, to become residents. Neither Tucson (the territorial capital from 1867 to 1877) nor Phoenix (a later capital of the territory and, from 1912, of the state) was close to the northern plateau and the Grand Canyon. The New England landscapist Henry Cheever Pratt did record scenes along the territory's southern border in 1851 as part of the Mexican Boundary Survey. He and Colorado's HARVEY OTIS YOUNG, who pursued his mining interests in southern Arizona, appear to have been the only two significant professional painters in that region in the nineteenth century.

The literature on the history of art in Arizona reflects these factors, being relatively scant and focusing on the artists who passed through. Heinrich Balduin Möllhausen was in Arizona and New Mexico in 1853, as part of Lieutenant Amiel Weeks Whipple's survey for a southern transcontinental railroad route, and in 1857 with Joseph Ives's survey of the Colorado River. The landscapist Vincent Colyer, a friend of John Frederick Kensett, acted as United States Indian commissioner in the late 1860s and early '70s, recording Indian subjects, landscapes, and pueblo villages, as well as plants, flowers, and other botanical specimens. Colyer exhibited a pueblo landscape in the art gallery of the Philadelphia Centennial in 1876.[1]

1.171

The exploration of the Colorado River attracted the first major influx of artists, and then tourists, to Arizona. In 1871 the young FREDERICK DELLENBAUGH went on Major John Wesley Powell's second trip down the river and through the Grand Canyon. Dellenbaugh would become a first-rate professional painter associated with the Cragsmoor art colony in New York State. His Arizona visit led him to publish two reminiscences, *The Romance of the Colorado River* (1902) and *A Canyon Voyage* (1908). Dellenbaugh returned to Arizona in 1875, in the winter of 1884–85—this time attracted by the Hopi Indian culture—and in 1907.[2] The crucial figure in the popularization of the Grand Canyon and, by extension,

1.152, 1.254

the spectacular scenery of northern Arizona was THOMAS MORAN, who accompanied Major Powell on his third exploratory trip there in 1873. In 1872 Moran had painted *The Grand Canyon of the Yellowstone* (based on an 1871 trip west with Dr. Ferdinand Hayden), which Congress had purchased for ten thousand dollars; subsequent to his journey with Powell, he painted and sold to Congress a pendant, the *Chasm of the Colorado*. The 1873 visit was only the first of Moran's numerous trips to Arizona, on the basis of which he produced countless views of the great natural wonder. His paintings induced the Santa Fe Railroad to sponsor other artists to visit and paint the Grand Canyon after the company had acquired the Atlantic and Pacific Railroad, which was completed through Arizona in 1882 and which specialized in tours to the Southwest. Other well-known landscapists soon followed and recorded the Grand Canyon, most notably William Henry Holmes in 1880 and Samuel Colman in 1882; their landscapes reflect Moran's luminous style and his combination of geological specificity with spectacular drama.

In 1892 Moran himself began to make almost yearly trips on the Santa Fe Railroad, which invited numerous other artists to make the journey to the Grand Canyon. Fernand Lungren made the trip in 1892 and again in 1903 (just after he had moved to Los Angeles) to paint the Hopi and Navajo Indians. In 1903 the railroad started to purchase paintings of the region, first acquiring a stagecoach scene, *San Francisco Peaks near Flagstaff* (1900; Santa Fe Railroad Collection of Southwestern Art, Chicago), by the Chicago-born and -trained landscape specialist Bertha Menzler Dressler. Reproductions of the railroad's paintings in calendars and pamphlets promoted tourism, as did the decoration of the Fred Harvey chain of hotels along the route. In 1908 the railroad purchased 107 works; by 1940 it owned over five hundred. Many of the artists were visitors from the Midwest and the East, such as William Leigh from New York City, who painted a view of the Grand Canyon for the railroad in exchange for transportation in 1907, and the Chicago Indian painter ELBRIDGE AYER BURBANK, from whom the railroad purchased several works in 1911. Burbank had been in Arizona as early as the winter of 1897–98, after executing his famous portrait of Geronimo at Fort Sill in present-day Oklahoma, and he made many other trips to the territory, painting Indian scenes and portraits.

2.264

The best-publicized artistic journey on the Santa Fe Railroad was that made by five eastern painters—Moran, ELLIOTT DAINGERFIELD, EDWARD POTTHAST, FREDERICK BALLARD WILLIAMS, and DeWitt Parshall, in November 1910 to paint views of the Grand Canyon, sponsored by the railroad and the American Lithographic Company. The resulting paintings, together with Grand Canyon views by Dressler, GEORGE INNESS, JR., George McCord, WILLIAM RITSCHEL, and JOSEPH HENRY SHARP, were exhibited at a number of institutions such as the Cincinnati Art Museum in 1912. Meeting with enthusiastic response and supported by the railroad, these artists organized the Society of Painters of the Far West (alternatively the Society of Men Who Paint the Far West), which enlisted other artists—such as ERNEST L. BLUMENSCHEIN and EANGER IRVING COUSE from Taos and GEORGE GARDNER SYMONS and WILLIAM WENDT from California—and held annual traveling shows for a number of years, beginning in 1911.[3]

2.29; 2.185; 1.251

1.245

3.221; 2.181; 3.63, 3.108

3.110

3.112, 3.142; 3.236; 3.235

The Santa Fe Railroad thus became a major patron of artists visiting Arizona, for whom the Hopi dances at Walpi may have been the single most significant Indian attraction. In 1897 Cornelia Cassedy Davis from Cincinnati was one of many artist-guests welcomed at Lorenzo Hubbell's Trading Post at Ganado, strategically situated on the Navajo Reservation and in proximity to that of the Hopi. Another was Swedish-born CARL OSCAR BORG from Santa Barbara, California, who spent much of his time painting in the Southwest. Hubbell promoted Indian arts and crafts at the same time that he patronized Anglo painters in Arizona, including Borg, Frederick Dellenbaugh, Elbridge Ayer Burbank, Louis Akin, and others. Gunnar Widforss, another Swede, was attracted to California in 1921 by the grandeur of Yosemite and, devoted to painting the West's national parks, he worked a great deal in Arizona, especially in the vicinity of the Grand Canyon.

3.225

California supplied many artist-visitors to Arizona. Another who came to paint the Grand Canyon at the invitation of the Santa Fe Railroad was JOHN BOND FRANCISCO, one of the earliest landscapists to reside in Los Angeles, who was in northern Arizona in 1906. A more famous artist who arrived even earlier was MAYNARD DIXON, who studied in San Francisco, beginning a career as an illustrator in 1893. Encouraged by Charles F. Lummis, the editor of *Land of Sunshine* magazine, Dixon was in Arizona as early as 1900 and in 1902, visiting Hubbell's Trading Post and painting the Navajo Indians with a commission from Hubbell. Dixon returned in 1904 and received his first major painting commission, for a series of western murals for the Southern Pacific Railroad depot in Tucson, in 1907. His losses in the San Francisco earthquake sent Dixon to New York City later that year to pursue his career in illustration; he returned to California in 1912, continuing to make short visits to Arizona and painting the landscape and scenes of Apache and Navajo life. Dixon settled in Tucson in 1939.[4] He and Fernand Lungren may have urged their young California colleague the landscapist FRANCIS JOHN McCOMAS to visit northern Arizona in 1909; McComas painted desert scenes throughout the next decade.

3.230

3.127

3.213

Frank Sauerwein, who had established himself in Denver in 1891, first visited the

Southwest two years later on a trip to the Ute Reservation in southern Utah; he was in Taos in 1898. Arizona, which he first visited in 1900, attracted him for the rest of his short life; he, too, was associated with Lorenzo Hubbell, and from Ganado went to the Hopi Reservation to paint Indian themes, including the popular subject of the Snake Dance. Though much of Sauerwein's last decade was spent in California, he continued to visit Arizona, New Mexico, and Denver regularly, exhibiting at the famous El Tovar Hotel at the rim of the Grand Canyon, which was run by the Santa Fe Railroad and which maintained a permanent art gallery.[5]

Perhaps the two best-known painters of the early twentieth century whose art is most associated with Arizona, though they were constantly on the move, are Warren Rollins and Albert Lorey Groll. Rollins, trained at the San Francisco School of Design, began his career as an itinerant sign painter in the West and was early associated with the artists of Taos and, more permanently, of Santa Fe. He spent much of his time roaming through northern Arizona among the Hopi and Navajo. Rollins was a painter of powerful Indian figural subjects and of the expansive desert landscape, which led the Santa Fe Railroad to build him a studio cabin at Paradise Point on the southern rim of the Grand Canyon. Albert Lorey Groll, more completely a landscape painter, first visited Arizona on holiday from New York City, meeting Lorenzo Hubbell in Ganado. Groll—a successful Munich-trained painter of Tonal landscapes and an admirer of GEORGE INNESS and HOMER MARTIN—was immediately attracted to the desert panoramas. He depicted reductive scenes emphasizing the seemingly limitless land and broad, cloud-filled skies. The horizons are low, allowing for a play of bright, light-filled cloud formations, a western equivalent of the sky pictures painted by CHARLES HAROLD DAVIS in Mystic, Connecticut. Though Groll was not an Arizona resident, his later career was based on the works he painted there.[6]

Though no community of resident artists grew up in Arizona in the period under consideration here, a handful of isolated professionals produced landscape and figure paintings of distinction. Probably the best known was the landscape specialist **Louis Akin**, originally from Oregon, who had studied with WILLIAM MERRITT CHASE in New York City and who was sent to Arizona by the Santa Fe Railroad in 1903 to paint the Hopi Indians. Akin remained with the Hopi at Oraibi for eighteen months, and later, in 1906, published an article sympathetic to their conflicts with the Anglo world, which had intruded into their civilization with the coming of the railroad. That same year he returned to Arizona, hoping to establish a colony of artists devoted to the Hopi; he settled in Flagstaff for the last seven years of his life. Akin's first paintings were of Hopi life, but after he returned to the West he turned to painting the landscape—the soaring mountains, immense canyons, and spectacular rock formations—in an almost surreally intense palette. His most spectacular painting, however, is a more straightforward one, a commissioned view of the new, luxurious El Tovar Hotel, complete with the Grand Canyon, a Hopi family,

1.41, 1.244,
2.68; 3.7

1.125

1.146, 1.155

3.122

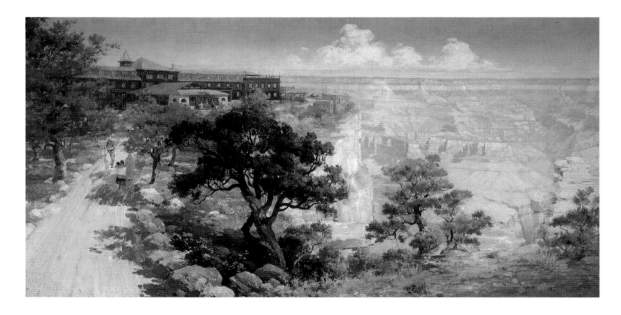

3.122 Louis Akin (1868–1913)
El Tovar Hotel, Grand Canyon, 1907
Oil on canvas, 25 x 50 in.
Santa Fe Collection of Southwestern Art, Chicago

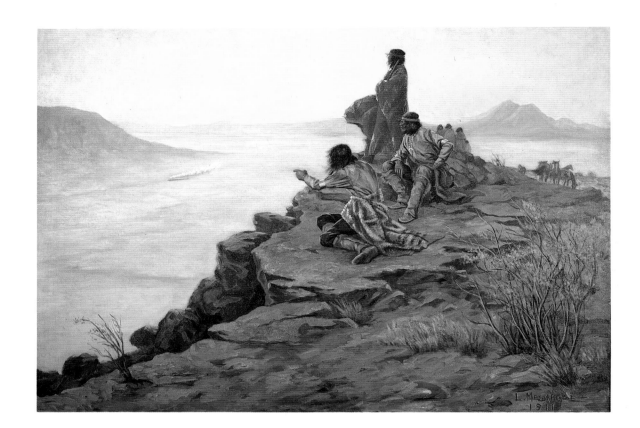

3.123 Lon Megargee (1883–1960)
Navajos Watching a Santa Fe Train, 1911
Oil on canvas, 31 x 42 in.
Santa Fe Collection of Southwestern Art, Chicago

3.124 Kate T. Cory (1861–1958)
Pueblo at Walpi, n.d.
Oil on canvas, 18 x 22 in.
Santa Fe Collection of Southwestern Art, Chicago

and a Mexican rider. With reproductions widely distributed by the Santa Fe Railroad and the Fred Harvey Company, Akin's panoramic rendering helped to promote both the hotel and tourism in the area.[7]

Lon Megargee from Philadelphia left home for the West in 1896, working as a cowboy, bronco buster, and exhibition roper in Arizona. He also developed a successful commercial art career and, in addition, executed oils of the cowboys and Indians he knew well. Megargee was associated with ranch rather than urban life, living variously in the Salt River Canyon and near Sedona. He was one of the artists well patronized by the Santa Fe Railroad between 1911 and 1953; one work he produced for the railroad is *Navajos* 3.123 *Watching a Santa Fe Train*. As one of the state's few resident artists, Megargee was commissioned to paint a series of fifteen large mural landscapes for the newly constructed Capitol when Arizona became a state in 1912.[8]

Megargee was probably the most popular and representative Arizona artist in the 1910s. His painting *The Elemental* was the first picture by a resident artist to be purchased for the Municipal Collection of Phoenix from the art exhibitions that were held at the Arizona State Fairs beginning in 1915. These appear to have been the first serial public art shows held in Arizona. In addition to selections by artists living in the state, they included works by a large contingent of California painters, and artists from that state frequently served as judges for the awards. Megargee appears to have been well represented in these shows and won numerous prizes for figure and landscape work.

One striking feature of the small band of early twentieth-century professional artists resident in Arizona is the number of women. The earliest was probably **Kate T. Cory**, who arrived in 1905. Born in Waukegan, Illinois, Cory went to New York City in 1879 to study at the Cooper Union and the Art Students League; her meeting with Louis Akin, just back from his initial stay among the Hopi, led her to rent a house at Oraibi, where she began her lifelong task of recording the Hopi tribe, as in *Pueblo at Walpi*. Cory remained 3.124 in Oraibi and Walpi until 1912, when she moved to Prescott, where she remained for the rest of her life. She, like most painters in the region, also recorded the Grand Canyon.[9]

Another painter of the Arizona Indian was Lillian Wilhelm Smith from New York City, who had studied at the National Academy of Design and the Art Students League. As Lillian Wilhelm she became an illustrator, and an assignment to do pictures for *The*

3.125 Jessie Benton Evans
(1866–1954)
Landscape, n.d.
Oil on canvas, 34 x 39½ in.
Royal Palms Inn, Phoenix

Rainbow Trail by her cousin, Zane Grey, led her to Arizona in 1913; its attraction was confirmed on her assignment to illustrate Grey's *Border Legion* (1916). She subsequently married a cowboy, Jesse Smith, and established a guest ranch–trading post in the Hopi architectural style at Tuba City, within the Navajo Reservation, and, later, another at Sedona. Smith painted both the Indians and such natural wonders as Arizona's Havasupai Canyon.[10] A number of Arizona women were more involved with landscape painting than with Indian subjects. Mary Russell Ferrell Colton, who studied in Philadelphia, first went west on her honeymoon in 1912. Fourteen years later, after frequent visits, Flagstaff became her home. In 1928 she and her husband established the Museum of Northern Arizona in Flagstaff, with Mary as director. She was a noted painter of landscapes and of the Hopi and Navajo Indians, whose crafts she encouraged.

 Jessie Benton Evans was purely a landscapist. A native of Ohio, she attended the
1.49 Art Institute of Chicago, then studied in Europe and with CHARLES W. HAWTHORNE in Provincetown, Massachusetts. Illness forced Evans to move to Arizona, where she and her husband established a permanent home in Scottsdale. She became known for her
3.125 idyllic Impressionist views of the Salt River Valley desert country and other Arizona landscapes, and some of her works were acquired by the Santa Fe Railroad. Critics in the 1920s compared Evans's landscapes with those painted in the northern part of the state by Albert Lorey Groll, finding her scenes less forbidding. Residing near Phoenix, Evans was one of the first nationally known painters to be active there.[11]

 In Tucson in the early twentieth century, probably the most established painter
3.189 was the landscapist MARIUS DAHLGREN, originally from Denmark, who had lived in Oakland, California, before moving in 1905 to Arizona. There he painted the local landscape and frescoes in Saint Augustine's Cathedral in Tucson.

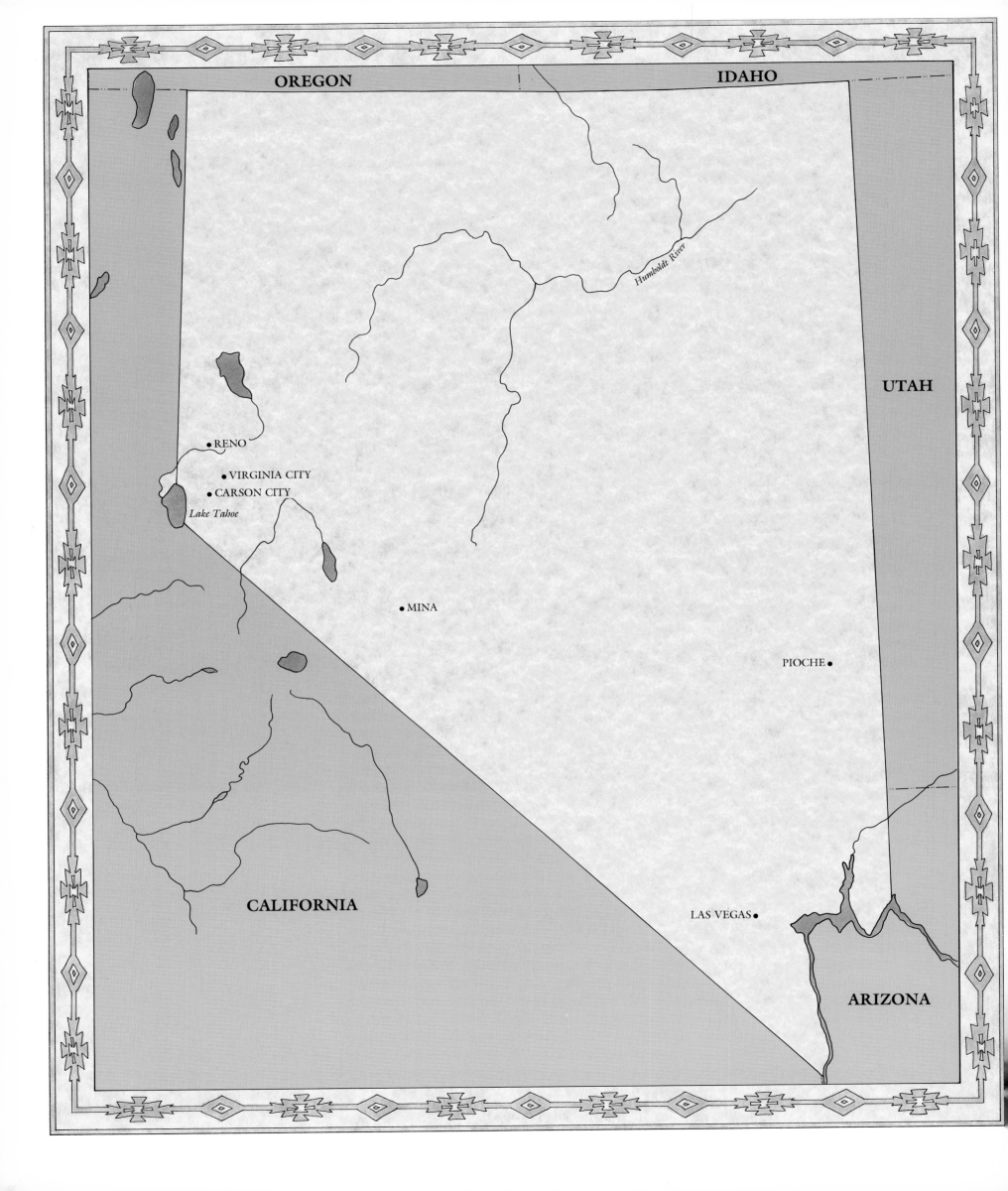

OREGON

IDAHO

UTAH

Humboldt River

• RENO

• VIRGINIA CITY

• CARSON CITY

Lake Tahoe

• MINA

PIOCHE •

CALIFORNIA

LAS VEGAS •

ARIZONA

NEVADA

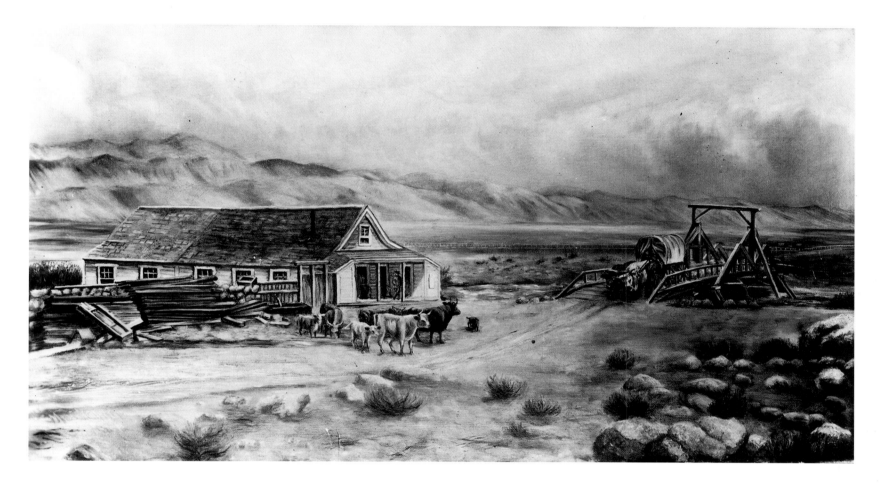

3.126 Cyrinus B. McClellan
(1827–1883)
Reno Twenty Years Ago, 1882
Oil on canvas, 36 x 48 in.
Reno-Sparks Convention and
Visitors Authority, Lake
Mansion, Reno, Nevada

Nevada was part of the territory ceded by Mexico to the United States in 1848 and was initially the western section of the Utah Territory. The earliest settlement in Nevada was established by Mormons in 1851. The area's population increased with the discovery in 1859 of silver at Virginia City, the site of the Comstock Lode; Nevada became a separate territory in 1861 and was admitted as a state in 1864. The population centers were Virginia City; nearby Carson City, which became the territorial and state capital; and Reno, which developed after the arrival of the Union Pacific Railroad in 1868 and where the University of Nevada was founded in 1874. When the silver bonanza began to peter out in the early 1880s, Virginia City became a ghost town. Las Vegas, in the southeastern part of the state, though occupied by Mormons as early as 1855, became a population center and tourist resort only in the twentieth century.

The Hungarian-born portraitist Paul Petrovits had worked in New York City before living in San Francisco in 1874–75 and in Los Angeles in 1876; by the end of that year he was sailing for Chile. Beginning in 1878 he was painting portraits in still-booming Virginia City, becoming especially noted for his renderings of children. In 1881 Petrovits was executed in Australia for the murder of his young wife.

With the coming of the railroad many artists passed through Nevada, but few chose to remain for any length of time. The greater part of the state was desert, inhospitable and without pictorial interest. Nonetheless, a few well-known landscape painters did visit
1.152, 1.254 briefly, most notably Ralph Albert Blakelock, about 1869–70, and especially THOMAS MORAN in 1879. The most commonly portrayed natural site was Lake Tahoe, just west of

175

3.127 Maynard Dixon (1875–1946)
Washoe Wickiup, 1919
Oil on canvas, 14¾ x 17 in.
A. P. Hays, Arizona West
Galleries, Inc., Scottsdale,
Arizona

Carson City on the border between Nevada and California, which was visited and painted by almost all the landscape specialists resident in San Francisco.

Nevada's one nineteenth-century painter of interest was **Cyrinus B. McClellan,** who was born in Pennsylvania and went to California in the mid-1850s. He is said to have studied with a prominent San Francisco still-life specialist—possibly SAMUEL MARSDEN BROOKES—before settling in Virginia City in 1868. McClellan worked as a sign painter for merchants and saloon keepers and created fantastic murals inside saloons as well; he also painted portraits and, later, the local landscape and historical works. With the depression in the mines in the early 1880s, he moved to Reno, where he died in 1883. One of his best-known paintings is a historical re-creation, *Reno Twenty Years Ago,* painted in a tight, nearly primitive manner—a fascinating document of the foundation of the community and the interaction between the Indian and the Anglo.[1]

The early twentieth century saw the arrival of a few other professional artists in the state. These included Arthur V. Buel, primarily a cartoonist, who was in Reno and

2.296, 3.181

3.126

other Nevada towns from 1905 until 1911, after which he moved to Sacramento, California; his caricatures were published in the local newspapers. Boyd Moore was another newspaper illustrator and cartoonist in Nevada during the 1910s, and Jo G. Martin, a student at the Art Institute of Chicago, was a painter, printmaker, and illustrator, especially of equestrian subjects, who lived in Pioche. Danish-born Fred Maxwell, who worked in Mina from about 1920, was a prospector-turned-painter who produced engaging primitive landscapes.

3.127 Probably the most significant later visitor was the San Francisco painter of western scenes **Maynard Dixon**, who traveled and painted in Nevada in 1901 and 1905. He first painted a Nevada subject in 1915, followed by three more in 1919. His highly coloristic *Washoe Wickiup*, painted near Carson City in October 1919, reflects the influences of Impressionism and Post-Impressionism, which he would abandon in the 1920s for a more realistic and ultimately Cubist-realist style. He returned to painting Nevada subjects in 1921 and produced over fifty of them in 1927–28.[2]

E. S. Denny.
Feb. '44.

THE
PACIFIC

The Pacific as defined here is a vast and varied region that encompasses Oregon and Washington (the states often identified as the Northwest) plus California and the last two states to enter the Union: Alaska and Hawaii. British survey expeditions—notably James Cook's third and last voyage to the Pacific—reached the coast of Oregon in 1778 and proceeded northward, where the expedition artist John Webber made numerous drawings. During the next decade New England merchant ships involved in the China trade sought shelter, supplies, and trade with the Indians along the coast. The interior of the region now known as Oregon and Washington was first explored by Captains Meriwether Lewis and William Clark, whose expedition established the United States' claim to the Oregon Territory and opened the region to trade and settlement. The route that Lewis and Clark established—the Oregon Trail—began in Saint Louis and followed the Missouri River over the Rocky Mountains, continuing along the Columbia River, the latitudinal boundary between Oregon and Washington. Settlement began at the mouth of the Columbia, where Lewis and Clark established Fort Clatsop in 1805; John Jacob Astor founded Astoria, a fur trading post, there in 1811.

It was several decades before urban communities began to develop. A boundary dispute between Spain and England left the entire Northwest beyond Spanish control and under joint occupancy of the United States and England from 1818. American pioneers continued to arrive, with an emigration society established in 1831 and missionary work among the Cayuse, Nez Percé, and Flathead Indians beginning five years later. By the mid-1840s settlers numbered in the thousands. The United States, seeking to retain a deep-water port at Puget Sound, agreed to recognize the forty-ninth parallel as its northern border with Canada all the way to the coast. In exchange, the British Hudson Bay Company, which had established its headquarters at Fort Vancouver, across the Columbia River in what is now Washington, moved its main depot to Vancouver Island.

Coastal survey draftsmen arrived early on. George Davidson was an amateur artist from Charlestown, Massachusetts, who served as painter on board the *Columbia* from 1790 until 1793, recording the second of its voyages to the Orient and the Pacific Northwest under Captain Robert Gray; a number of Davidson's sketches of the Washington and Canadian coasts are known.[1] Far more famous and significant was the United States Exploring Expedition under Lieutenant Charles Wilkes, which left Boston in 1838, rounded Cape Horn, and proceeded to Tahiti and the Samoan and Fiji islands. The expedition wintered in Hawaii in 1840–41 and proceeded in the spring to the Northwest coast, arriving at the Columbia River. Field trips were taken inland, and surveys were made as far north as the Fraser River in Canada and as far south as San Francisco. Two official artists were attached to the expedition, Joseph Drayton and Alfred Agate. Drayton, a former Philadelphia engraver, accompanied a group that traveled up the Columbia to Walla Walla, down the Willamette Valley in Oregon, and to the Whitman mission at Waiilatpu, making crude but significant drawings of Indian life. Agate, a far better-trained artist from New York City, had studied (along with his brother, Frederick) with Thomas Seir Cummings and possibly in the school of John Rubens Smith before enrolling at the National Academy of Design. On the Exploring Expedition he was assigned to the overland

survey from the Columbia River to San Francisco. Agate's and Drayton's drawings were reproduced in the 1856 *Narrative* of the expedition. The health of both was seriously impaired by the voyage, and Agate died in 1846, four years after returning to New York City. The expedition's report confirmed the desirability of an American port in the Puget Sound region, reinforcing the demand for American control of the Oregon Territory.[2]

The British also assigned artists to military reconnaissance tours while the territory was still in dispute. Henry J. Warre was there in 1845–46, later producing *Sketches in North America and the Oregon Territory* (London, 1848). The most extensive pictorial record of the region was made by the Canadian artist Paul Kane in 1846–47. Kane recorded sights such as Mount Saint Helens, the Indian tribes, and nascent settlements such as Oregon City in the Willamette Valley, which Warre had also depicted. Itinerant painters later came to paint portraits and to record the spectacular landscape. Resident painters were few until the last decades of the nineteenth century. Only in 1914 did the Seattle Fine Arts Society establish its Artists of the Pacific Northwest annuals. Ironically, this occurred just a year before the similarly named Northwestern Artists annuals were instituted in Saint Paul, in the *old* Northwest.

The art of no territory or state has been the subject of more patronage and study than that of California. And while regional chauvinism was seldom a primary motivating factor in other parts of the country, in California artistic growth has been reported since the 1860s with unabating pride, and artists have often been patronized in part because they *were* local celebrities. This has been due to a number of factors, including the inevitable competitiveness between the two coasts and, to a lesser degree, between Northern and Southern California; the recognition that the arts developed very quickly in California; and the perception that the leading California masters produced works of sufficient quality to be compared favorably with those by their better-known, because *nationally* known, eastern counterparts. California painters were not provincial. The national trends reflected in their work were adopted in the course of the artists' sophisticated training and professional experience, not absorbed from itinerants or minor figures. This was especially true during the formative years in San Francisco, where outstanding painters such as THOMAS HILL, WILLIAM KEITH, and SAMUEL MARSDEN BROOKES were backed up by a professional art community. Any fears about provincialism were eased when Keith and Hill, for example, took studios in New England and were rewarded with a favorable response from eastern critics.

3.175; 3.178;
2.296, 3.181

A cultural establishment developed earlier and differently in Northern than in Southern California, even though many artists traveled back and forth, and some even changed residences from one to the other. Thus, portraiture was still a major art form when San Francisco's community originated but was no longer as important later in the century when Los Angeles developed its art community. Tonalism and Symbolism were strong in the North, while Southern California artists subscribed wholeheartedly to Impressionism. Whereas something is known about artists who were active in the Sacramento Valley, the central coast east to Fresno remains terra incognita in terms of its art, and far Northern California figures only as a source of spectacular scenery for the artists from San Francisco and elsewhere.

One sign of California's artistic richness is the extent of the local painters' travels throughout the Northwest, the Rocky Mountains, Arizona, and New Mexico. At the same time, eastern painters appeared frequently in California, seeking to sell work (and thus compete with the local artists) but also enlivening the scene, particularly after the completion of the transcontinental railroad in 1869. When they and their midwestern colleagues went to San Francisco, Los Angeles, and San Diego, they often remained for significant periods of time—some for their lifetimes. These interrelationships among regional centers other than the Northeast fulcra deserve more study.

A number of Hawaii's most able professional artists arrived from San Francisco, having been resident there. The state has a considerable tradition of Western-style professional painting, in addition to its native one, and also merits further research.

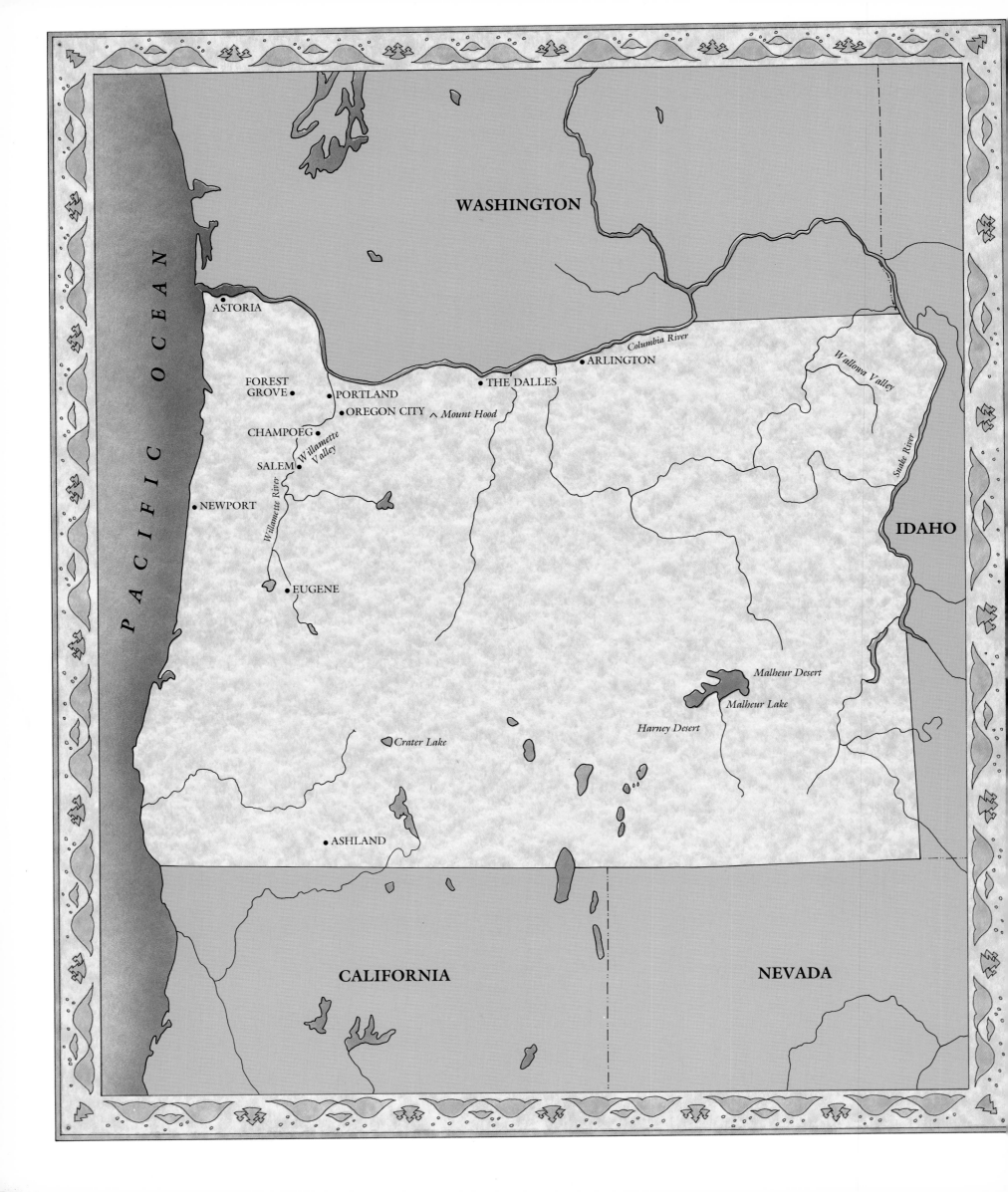

PACIFIC OCEAN

WASHINGTON

IDAHO

CALIFORNIA

NEVADA

ASTORIA

FOREST
GROVE

PORTLAND

OREGON CITY

CHAMPOEG

SALEM

NEWPORT

EUGENE

ASHLAND

THE DALLES

ARLINGTON

Columbia River

Mount Hood

Willamette River

Willamette Valley

Crater Lake

Malheur Desert

Malheur Lake

Harney Desert

Wallowa Valley

Snake River

OREGON

The earliest settlement in the Oregon Territory was founded by a Methodist missionary in the Willamette Valley in 1834. Two years later Dr. Marcus Whitman began to establish Presbyterian missions among the Indians in eastern Oregon, and in 1841 Catholic missionaries followed. An early pictorial document of this activity, *The Protestant Ladder* (1844; Oregon Historical Society, Portland) was painted for the Indians' instruction by a missionary, Eliza Spalding, in response to charts made by Catholic missionaries to illustrate their own "Road to Heaven." During the 1840s immigrants concentrated in the Willamette Valley from Salem to Oregon City, just south of present-day Portland. In 1849 Oregon City became the first capital of the Oregon Territory, succeeded two years later by Salem, which remained the capital when Oregon became a state in 1859. In 1853 the northern half of the territory had been organized as the Washington Territory, but artistic activity along the Columbia River and at Vancouver (known as Fort Vancouver until 1857) will be considered here in relationship to Oregon and its principal urban center, Portland.

2.206 The earliest professional artist to work among the settlers in Oregon was JOHN MIX STANLEY, who, after leaving General Stephen W. Kearny's Army of the West in San Diego, moved north to San Francisco, then arrived in Oregon City in 1847. Stanley remained in the territory for over a year, painting portraits for his livelihood and Indians for his gallery, traveling into what is now Washington beyond present-day Spokane, and narrowly avoiding being killed by Cayuse Indians in the Marcus Whitman massacre late in the year. Stanley and a group of survivors were taken to Fort Vancouver at the beginning of 1848; he soon crossed the Columbia River to Portland, returning to Oregon City for six more months. In addition to more portraits Stanley painted several landscapes, including one of Mount Hood (Oregon Historical Society), a subject he would later paint in enlarged form several times, and one of Oregon City (Amon Carter Museum, Fort Worth). He also painted scenes of the Cayuse—portraits of tribal leaders and the Whitman massacre. Stanley was in the Northwest again in 1853, attached to a Pacific Railroad survey; his ultimate goal was Puget Sound in the newly established Washington Territory. He traveled south to Fort Vancouver, from which he departed for San Francisco, eventually crossing the Isthmus of Panama and journeying east again.[1]

In 1849 the United States Mounted Rifle Regiment took possession of the new army post at Fort Vancouver, establishing one of a series of such posts along the Oregon Trail to the newly secured Oregon Territory. One of the regiment's members was **William Henry Tappan**, formerly of Boston. His career is not securely documented, but he seems to have been the region's earliest resident professional artist. Tappan apparently remained for over two decades, helping to lay out the town of Saint Helen's in Washington in 1851 and in 1854 designing and engraving the seal of the Washington Territory, where he served on the first territorial council, having settled in Clark County. Tappan painted local

3.130 scenery, such as the stark *Methodist Mission at the Dalles*, and participated in the Oregon State Fair held in Salem in 1862, where one of his works was awarded a "first premium." He returned to his native Manchester, Massachusetts, in 1876.[2]

The Philadelphia artist William Birch McMurtrie was attached to the United States Navy's Pacific coastal survey, which studied the northwestern coast in 1850. McMurtrie prepared watercolors of the Columbia River region. In 1854 he was joined by the Boston-area artist James Madison Alden, who served under him; though McMurtrie was listed as "Official Artist," Alden was actually the better trained. Alden had joined the navy to become part of the coastal survey, having studied cartographic drawing in Washington, D.C., and, in 1853–54, having studied under Thomas Seir Cummings in New York City.

3.130 William Henry Tappan
(1821–1907)
*Methodist Mission at the
Dalles*, 1849
Oil on composition board,
11 x 15¼ in.
Oregon Historical Society,
Portland

Both artists were based in San Francisco while on assignment to explore the United States–Canadian boundary. They made numerous watercolors on trips to Oregon over the next several years—of Fort Vancouver, Astoria, the falls of the Willamette, and the Columbia River, before departing for the East, McMurtrie in 1859 and Alden in 1861.[3]

Danish-born Peter Peterson Tofft arrived in California during the gold rush in 1850 but after a year he turned to artistic pursuits. By 1852 he was working in the Oregon Territory; he was active throughout the Northwest and the northern Rockies until 1867. Major eastern landscape painters did not explore Oregon until the following decade. ALBERT BIERSTADT, on his second trip west in 1863, traveled to California and up the Sacramento River into Oregon. He followed the Willamette River, reaching Portland and exploring the Columbia River up to the Dalles. There he made studies for the first of his several magnificent paintings of Mount Hood, all executed the following year. Bierstadt returned to paint Mount Hood in 1889.

3.183

Mount Hood was the primary attraction for landscapists who followed Bierstadt. R. Swain Gifford was in California and Oregon in the late summer of 1869 to record the scenery for three articles in William Cullen Bryant's *Picturesque America*, published serially beginning in 1872. One of these articles featured the landscape "up and down the Columbia"—views, including one of Mount Hood, that Gifford worked into major oil paintings.[4] Oregon scenery proved an irresistible subject for the growing school of California landscape painters. One of the first was FREDERIC BUTMAN, who had settled in San Francisco in 1857; his renditions of Mount Hood, painted in the 1860s, were exhibited often and praised extensively, both in San Francisco and New York City. In 1868 the young WILLIAM KEITH was hired by the Oregon Navigation and Railroad Company to paint in the Northwest, and that summer he traveled as far as Vancouver. The following winter he developed his sketches into paintings of the Columbia River and also made a large oil of *Mount Hood* (Brooklyn Museum), which he had climbed during his journey. That painting is one of Keith's first masterworks, executed in the tight, detailed, panoramic manner popularized by Bierstadt. In 1881 Keith returned to Mount Hood and went again in 1888 with the famous naturalist John Muir. In the late 1860s Gilbert Munger, from Saint Paul, spent part of three or more years painting in the West and visited Oregon, where he depicted Mount Hood, probably in 1872. So did the San Francisco artist THOMAS HILL, by

3.173

3.178

3.175

1874, and the artist-teacher RAYMOND DABB YELLAND, by 1883. WILLIAM BRADFORD, the eastern specialist in arctic scenes, maintained a studio in San Francisco between 1879 and 1882, and sometime during that period he, too, visited Oregon and painted Mount Hood (Free Public Library, New Bedford, Massachusetts).

Bierstadt and the other artist-visitors used **Portland** as their base of operations. Settled in 1845 and strategically situated at the head of the Willamette River and on the Columbia, across from Vancouver, Portland soon became the state's major urban community. Although Portland does not appear to have become the permanent residence of significant professional portraitists, a number of able artists did work there. Perhaps the earliest after Stanley was **Cyrennius Hall**, a young painter from Minnesota. Hall made the trip over the Oregon Trail in 1853–54, when he seems to have been active primarily as a painter of western scenery. He is said to have been in California in the late 1850s and to have spent about five years in South America during the 1860s; he seems to have been in Portland again in the late 1860s. After a brief return to New York City and Westminster, Ontario, Hall went abroad for three years, studying in Munich and returning to this country in 1870. He was active in New York City in the early 1870s and then moved to Chicago, which was his base of operations for the remainder of his career, though he continued to be peripatetic. Hall's best-known likeness, that of Chief Joseph, leader of the Nez Percé Indians, was painted in 1878, after the chief had been taken prisoner by the army. When his tribe's reservation lands were occupied during the Idaho gold rush of 1877, Chief Joseph attempted to lead his people to Canada from the Wallowa Valley in Oregon but was captured and held prisoner in Fort Leavenworth, Kansas. Although not painted in the Northwest, Hall's work has special significance for the region, as the Nez Percé Indians originally inhabited a large section of central Idaho, northeastern Oregon, and southeastern Washington. After his release Chief Joseph and his tribe were sent to the Colville Reservation in north–central Washington, but he made periodic trips to the Portland area and was well known there. While in Kansas, Hall may have been inspired to paint his impressive full-length posthumous portrait of Andrew H. Reeder (Kansas State Historical Society, Topeka), that state's first territorial governor. About 1880 Hall appears to have been in Kansas City and then went back to Portland, continuing his activity as a portrait painter.[5] Chief Joseph was later portrayed in the Northwest by the Chicago Indian painter ELBRIDGE AYER BURBANK, who visited Portland in 1899 and who referred to the chief in his autobiography as "My Greatest Indian."[6]

As Portland developed, visiting portraitists arrived from the thriving art community in San Francisco, seeking additional patronage. One of these, William F. Cogswell, had been active in Louisville, Kentucky, and Saint Louis in the 1850s and then in Chicago, Madison, and Janesville, Wisconsin, through 1871; he settled in San Francisco in 1872 or '73. From there he made numerous trips to Portland, probably as early as 1875, and to the Hawaiian Islands, for portrait commissions.

The German-born portrait and still-life painter PETER BAUMGRAS left Washington, D.C., about 1871 and proceeded to San Francisco via the Isthmus of Panama. During the 1870s he, too, painted portraits in Portland, which he had visited by the summer of 1873, before taking a teaching position at the University of Illinois in 1877. A longer residency in Portland was maintained by the English-born portraitist **Horace Duesbury**, who was there from 1879; his portrait *Catherine Hawthorne* was painted there in 1884. Duesbury had studied and painted in Australia before emigrating in 1876 to San Francisco, to which he had returned by 1886 for the rest of his career. Probably Portland's first professional figure painter, Duesbury was represented in the art gallery at the 1879 Portland Mechanics' Fair both by portraits and by such genre paintings as *Thinking of Home* and *The Lovers* (locations unknown); he showed a portrait and a still life at the 1883 fair. Duesbury appears not to have been in residence by the time of the 1885 show. A French portraitist, L. E. Jardon, was successful as a portrait painter in Portland during the late 1880s; his work in the stark, realistic manner of the French academic master Léon Bonnat was praised in the local press. In the early twentieth century one of the city's leading portraitists was Lillie O'Ryan Klein from Quebec, who had studied in New York City with WILLIAM

3.131 Cyrennius Hall (1840–1904)
Chief Joseph (Hinmaton-Yalaktit), 1878
Oil on canvas, 22¼ x 18 in.
The National Portrait Gallery,
Smithsonian Institution,
Washington, D.C.

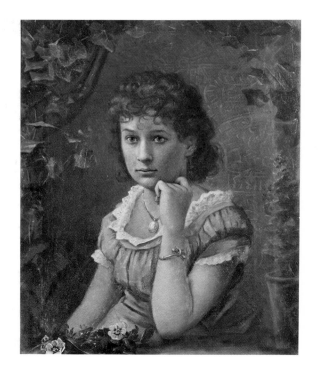

3.132 Horace Duesbury
(1851–1904)
Catherine Hawthorne, 1884
Oil on canvas, 27 x 22 in.
Oregon Historical Society,
Portland

3.133 Cleveland Rockwell
(1837–1907)
Smoky Sunrise, Astoria Harbor,
1882
Oil on canvas, 20 x 34 in.
Braarud Fine Art, La Conner,
Washington

MERRITT CHASE and GEORGE DE FOREST BRUSH and in Boston at the Cowles School with 1.26
Dennis Miller Bunker. In 1900 Klein moved to San Francisco, but after the earthquake
of 1906 she settled in Portland, winning a gold medal at the Alaska-Yukon-Pacific
Exposition in Seattle in 1909 and showing at the 1915 Panama-Pacific International
Exposition in San Francisco. She was known for both portraits-in-large and miniatures.[7]

The dominant theme in Oregon painting was landscape. In addition to attracting
visiting landscapists, Oregon, especially Portland, gradually supported a group of local
professionals who specialized in painting the state's scenery. One of the earliest, and one
of the finest of the city's nineteenth-century resident artists, was **Cleveland Rockwell**.
Rockwell spent his youth in Cleveland and studied in New York City, taking a course in
design with Thomas Seir Cummings and working toward a degree in mechanical
engineering. Like William Birch McMurtrie and James Madison Alden before him,
Rockwell was attached to the coastal survey, arriving in 1868 as chief of the Coast and
Geodetic Survey after serving in the Civil War and then charting the Magdalena River for
the Colombian government. Rockwell's primary duty in Oregon was charting the mouth
of the Columbia River, but he also painted and exhibited views of the local landscape
(including Mount Hood), living in Albina, now part of Portland, from 1880. His finest
paintings are views of the river and harbor of Astoria, where he was first assigned. Works 3.133
such as his several impressive scenes of Astoria's harbor, painted both in oil and watercolor,
combine scientific accuracy with light and color that suggest a West Coast variant of
Luminism. Rockwell was active in the local art community and greatly appreciated during
his own time.[8]

William S. Parrott, a landscape painter of considerable merit, established himself
in Portland in 1867. Parrott made a specialty of painting Mount Hood; he exhibited one 3.134
version in the Portland Mechanics' Institute art gallery in 1879. Like other Portland artists
he painted Washington State's most famous landscape attractions, such as Mount Rainier
and Mount Saint Helens; his *Mount Rainier* (location unknown), nine feet long, was
reported in 1873 as the largest picture painted in Oregon up to that time. Parrott became
known as well for his depictions of southern Oregon, especially Crater Lake, and achieved
a national reputation. He maintained a studio in Portland for two decades.[9]

In contrast, Howard Campion, active as a landscapist in Portland from 1874,
remained little known. Campion had painted in Sacramento, California, in 1870–71
before settling in San Francisco, primarily as a portraitist. In Portland he painted the
scenery, as in *Saint Peter's Dome, Columbia River* (Oregon Historical Society, Portland).
Another local artist, **Clyde Cook**, won a premium for a drawing at the Oregon State Fair

ABOVE:

3.134 William S. Parrott
(1844–1933)
Mount Hood, 1885(?)
Oil on canvas, 20 x 26 in.
The Portland Art Museum,
Oregon Art Institute; Gift of
Miss Mary Woodworth

LEFT:

3.135 Clyde Cook (1860–1933)
*Blockhouse and the Upper
Cascades*, 1879
Oil on canvas,
25½ x 41¼ in.
Oregon Historical Society,
Portland

3.136 Eliza Rosanna Barchus
(1857–1959)
Mount Hood, 1905
Oil on canvas, 40 x 60 in.
Joseph M. Erdelac, Cleveland

in 1865—at the age of five!—and naturally was encouraged to pursue an artistic career. In 1879, the year before he went to Munich for five years of study, Cook painted *Blockhouse* 3.135 *and the Upper Cascades*, perhaps the same work exhibited at the Portland Mechanics' Institute art gallery that year. On his return he settled in Portland, continuing to specialize in landscape; he taught at Pacific University at Forest Grove and, subsequently, in his native Salem, where he took up residence again in 1888.

The imagery of Mount Hood is particularly identified with Oregon's leading nineteenth-century woman painter, **Eliza Rosanna Barchus**. Born in Salt Lake City, Barchus went to Portland about 1880. Shortly thereafter she began taking art lessons from William S. Parrott and started a professional career in 1885. Barchus was known for her paintings of all of Oregon's scenic wonders, but Mount Hood was her specialty. 3.136 Her views of the mountain won medals at the local mechanics' fairs, at the Lewis and Clark Centennial Exposition in Portland in 1905, and in New York City at the 1890 autumn exhibition of the National Academy of Design. Although there was a commercial aspect to the outpouring of her sometimes repetitious views of Mount Hood—she even copyrighted postcards of the subject—Barchus was a true professional. She traveled through the West, painting subjects such as Yellowstone and Yosemite, and to Alaska, dying in Portland at the age of 102.[10]

In addition to Rockwell and Barchus, **James Everett Stuart** was probably the best-known nineteenth-century artist to have a Portland studio, but his stay was relatively brief. Stuart grew up in the Sacramento Valley and studied under VIRGIL WILLIAMS and 3.177 Raymond Dabb Yelland at the San Francisco School of Design during the 1870s. Stuart had a studio in Ashland, in the southern part of the state, in the early 1880s and then settled in the fall of 1881 in Portland, where he remained until moving to New York City, probably in 1886. Although he was an especially active exhibitor in the art gallery of the Portland Mechanics' Fair of 1883, he was absent from the 1885 show. Stuart was reported in 1891 to be returning to Portland, but settled instead in Chicago for twenty years. In 1912 he returned to San Francisco for the rest of his life. Stuart's work suggests the influence of Yelland and Albert Bierstadt, although his interpretations of the local landscape are more painterly, as can be seen in *Indian Camp near Celilo*. Predictably, numerous views 3.137 of Mount Hood are also known by him.[11]

GRAFTON TYLER BROWN, a little-known painter of sensitive landscapes, worked in the 3.150 detailed yet panoramic manner of his Oregon colleagues. Brown, the West's earliest black

artist, was born in Harrisburg, Pennsylvania, and was active as a lithographer in San Francisco from 1861. In 1869 he moved to Victoria, British Columbia, taking part in a Canadian government geological survey in 1882. He had an exhibition in Victoria the following year and then traveled extensively in western Washington, staying in Tacoma; by the mid-1880s he was residing in Portland. By the early 1890s Brown had settled in Saint Paul, Minnesota, for the rest of his career, but no works from this period are known.[12] **Christian Eisele**, another able landscape painter, worked in Oregon at the end of the century. Eisele, who appears also to have been active in Colorado and Utah, is

3.139 Nels Hagerup (1864–1922)
Front Street, Portland, 1895
Oil on canvas, 22½ x 31 in.
Oregon Historical Society,
Portland

3.138

3.139

2.293, 3.160

3.140

OPPOSITE, TOP:
3.140 Olof Grafström (1855–1933)
View of Portland, Oregon, 1890
Oil on canvas, 47 x 75⅞ in.
The Fine Arts Museums of
San Francisco; Museum
Collection

OPPOSITE, BOTTOM:
3.141 Edward L. Espey
(1860?–1889)
*Repose—Brittany Burial
Ground,* c. 1885
Oil on canvas,
43¼ x 78¼ in.
Multnomah County Library,
Portland, Oregon

known for his renderings of local scenery, such as *View of the Dalles, Mount Hood, and Mount Saint Helens in the Distance.* The German-born Eisele adopted the panoramic format favored by many western landscape painters and applied it to city views; another example is his detailed *Logan, Utah* (Museum of Church History and Art, Church of Jesus Christ of Latter-day Saints, Salt Lake City), painted in 1892. The following year Eisele was commissioned by the World's Fair Commission of Utah to send a large painting of Salt Lake City (location unknown) to the World's Columbian Exposition in Chicago.

There was a significant Scandinavian presence in Portland toward the end of the nineteenth century. Norwegian-born **Nels Hagerup** was active for over a decade beginning in 1882. After studying in Christiana (now Oslo), Berlin, and Copenhagen, he sailed to Portland as a merchant seaman and became instructor of drawing at the Bishop Scott Academy; he also taught for a short time at Pacific University in Forest Grove. Hagerup's *Front Street, Portland* shows the Monnastes and Davis Foundry and is based on an 1850s photograph. After his Oregon residence the artist worked in San Francisco as a coastal and marine painter for almost three decades.[13] A more talented artist who remained for a shorter time was **Olof Grafström.** Portland was Grafström's destination after his arrival in New York City in 1886 following four years of training at the Academy of Fine Arts in Stockholm. His first patrons in Portland were members of the Swedish community, but he soon extended his reputation by painting frescoes on the walls of a fashionable saloon, where—the authorities decreed—his nude allegories had to be covered with veils. Grafström exhibited both Swedish and northwestern landscapes in Portland. His most spectacular known Oregon scene is *View of Portland, Oregon,* in which the panoramic format traditional to western landscape is combined with a celebration of the growth of a metropolis, seen expanding beyond the still-virgin wilderness in the foreground. This work was painted in 1890, the year Grafström left for Spokane, hoping perhaps to find a more receptive market. He spent much of his later career turning out altarpieces for Lutheran churches throughout the West and Midwest; one such painting, *Christ in Gethsemene,* remains in Bethany Lutheran Church in Warren, Oregon.[14]

A new cosmopolitan note was struck on the Portland art scene by **Edward L. Espey,** considered one of Oregon's most promising painters in the 1880s, who went to France for his training. Though Espey had begun his career painting the Columbia River

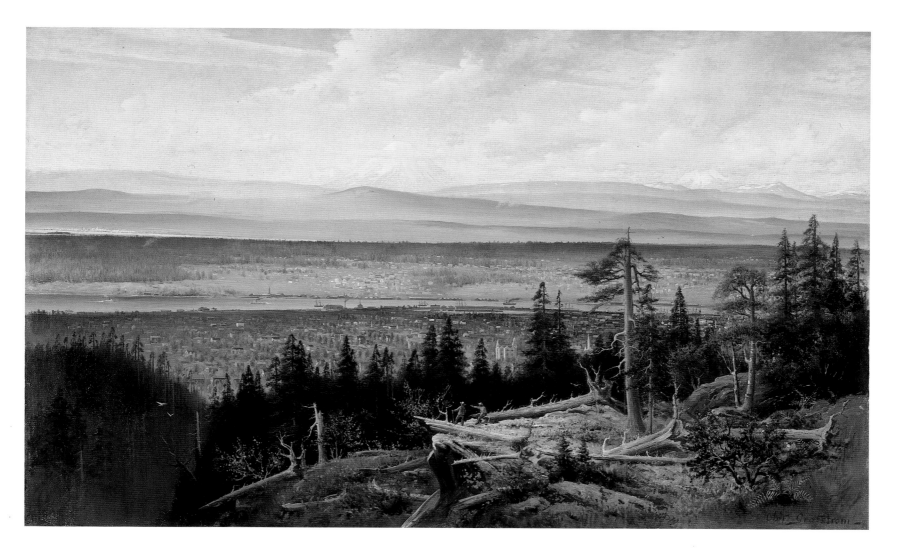

about 1880, his finest works were done while he was studying in France and painting at Concarneau in Brittany. In such pictures as his recording of sailors' graves, *Repose—Brittany Burial Ground*, Espey abandoned the grandioseness characteristic of earlier Oregon painting for a soulful interpretation of an intimate scene, adopting a Whistlerian Tonalism. This work, exhibited in the Paris Salon in 1885, was one of the first purchases made by the Portland Library Association the following year. Espey's career was cut tragically short, for he died before he was thirty, but his posthumous fame remained great enough that a group of his Breton scenes was shown at the Minnesota State Art Society in 1910, and he was the one deceased artist whose work was lent to Oregon's display at the Panama-Pacific International Exposition in San Francisco in 1915.

3.141

Espey's death occurred at just the moment when the local art community was evolving into a full-fledged cultural establishment, of which he was recognized as an important part. Local exhibitions had occurred beginning in the early 1860s as part of the Oregon state fairs held in Salem and sponsored by the State Agricultural Society; these were succeeded by the more serious and professional fine arts exhibitions at the Portland Mechanics' Fairs, established in 1879. Male artists such as Clyde Cook, William S. Parrott, and Cleveland Rockwell, and a number of women artists such as Eliza Rosanna Barchus participated in these shows, which also brought work by foreign and other American (especially California) artists to Portland. These shows were followed by the North Pacific (later Portland) Industrial Expositions, beginning in 1889, in which works by artists of national significance were accorded the place of honor. Not until 1893 were Oregon artists encouraged to submit their own work and promised equal treatment in the hanging of the exhibition.

Meanwhile, local artists had begun to organize on their own. Elbridge Willis Moore arrived in Portland from Augusta, Maine, where he had practiced portraiture and photography, and his Portland studio became a meeting place for the city's artists as well as one of the Northwest's finest galleries. Moore was active in forming the community's first art organization, the short-lived Portland Art Club, started in 1885. The club's all-male membership included Cook, Espey, Moore, Rockwell, Grafton Tyler Brown, James Everett Stuart, Henry Epting, and James Tilden Pickett, the painter-lithographer son of a Haida Indian princess. Epting and Pickett, like Espey, had died by the end of the decade. The Art Club appears to have been reborn as the Sketch Club, which was founded in 1891 as an active painting and sketching group with many architect members, holding exhibitions in the late 1890s. At first restricted to male artists, it was renamed the Portland Sketch Club after opening its doors to the growing number of women professionals about 1899. It included several artists who would become community leaders in the early twentieth century, especially Harry Wentz and Anna Belle Crocker, who were among the most active exhibitors. In 1906 the club was reorganized as the Oregon Art Student's League, but lasted only a few more years.

The most important development of the 1890s was the founding of the Portland Art Association in 1892. The purpose of this patron-directed group was the cultural enrichment of the community through the establishment of a permanent art collection and a gallery suitable to house it. Toward that end a collection of casts was installed in the public library in 1895, with Henrietta Failing as curator; the association occupied its own building in 1905 and began a regionally renowned art school in 1909. (The Portland Art Association sponsored the Oregon Art Association, with Cleveland Rockwell as president; this group began to hold annual exhibitions in 1896.) The Portland Art Association, which evolved into the Portland Art Museum, aspired to present a national program, giving considerable attention to photography, architecture, and the applied arts. In 1911 the Portland Art Museum held its first invitational show of work by Oregon artists, in 1912 the Portland Art Association held the First Annual Exhibition of Artists of Portland and Vicinity, and in 1913 it began the annual series Artists of the Pacific Coast. Among the major local artists included were Clara J. Stephens and Harry Wentz, who received their first solo exhibitions at the museum in 1913 and 1914, respectively.

The presiding figure in the Portland art community at this time was Colonel Charles

Erskine Scott Wood, who had been trained at West Point and led a number of Indian campaigns in the Northwest in the late 1870s. He then obtained a law degree at Columbia University in New York City. Wood returned to practice successfully in Portland, where he specialized in maritime law and land development. He was also a writer of prose and poetry, an amateur painter of no little talent, and a friend and patron to many artists— both well-known national figures such as Albert Pinkham Ryder, JULIAN ALDEN WEIR, Childe Hassam, and the sculptor Olin Warner, and local artists.[15] Wood's own landscape style is marked by a modified Impressionism, probably influenced by Hassam, Weir, and other artists he admired. Wood's patronage led other local families, such as the Corbetts and the Ladds, to support the arts and the Art Association. Mrs. William S. Ladd donated the funds in 1903 for the association's own structure, and Henry Corbett presented the site; the building opened in 1905 as the Portland Art Museum.

In the years before and after the turn of the century the most significant artists in Portland were visitors who returned regularly. In the 1890s the finest of these was **Eanger Irving Couse**. His marriage to Virginia Walker, a native of Washington State, took him to the Northwest in 1891–92. During the summers he painted the Yakima and Klickitat Indians; during the winters he painted portraits in Portland. Couse was the only artist-lender to the important Art Loan Exhibition in Portland in January 1892; other lenders included members of the Ladd, Corbett, and Failing families and Colonel Wood. Couse lent both French and Indian scenes, and others added portraits that he had recently painted. The Couses returned to France in 1892; once back in America, they spent the greater part of 1896–98 in the Northwest. Couse's Indian pictures from this period, painted on both sides of the Columbia River near Arlington, Oregon, constitute some of his finest

1.119

3.112

3.142 Eanger Irving Couse
(1866–1936)
The Card Player, c. 1897
Oil on canvas, 31 x 45 in.
Location unknown

3.143 Frank Vincent DuMond
(1865–1951)
*Sketch of Table Rock near
Medford*, 1901
Oil on canvas, 27 x 29½ in.
The Portland Art Museum,
Portland, Oregon

renderings of native Americans. Works such as his hauntingly tragic *Card Player* combine 3.142
dramatic austerity with superb academic form and are more intense than his later
romanticized Indian scenes done in Taos, for which he is better known. In October 1904
the Portland Art Association held an exhibition of Couse's work, including many of his
depictions of the Klickitats.[16]

 Another artist connected with Oregon by marriage was **Frank Vincent DuMond**
from Rochester, New York. Well trained in Paris, DuMond emerged as a painter of both
strong religious pictures with Symbolist overtones and bright, quasi-Impressionist land-
scapes. In 1892 he began a long career as a teacher at New York's Art Students League,
taking the league's summer school to Old Lyme, Connecticut, in 1902 and remaining
there as a summer, and then full-time, resident after the school moved to Woodstock,
New York. In 1895 DuMond married a former league student, Helen Xavier of Portland;
a decade later he was appointed director of the department of fine arts for the Lewis and
Clark Centennial Exposition in Portland.

 DuMond's exposition appointment allowed him and his wife to make an extended
visit to her native town and gave him an opportunity to consolidate his position as a
"visiting native son." They had been there in 1899 on their return from an extended stay
in Europe after their wedding, when DuMond taught a summer class for the Sketch Club;
two years later he painted *Sketch of Table Rock near Medford*, which was a gift in 1913 3.143
from fifty-two subscribers to the Portland Art Museum. During the summer of 1905
DuMond taught a class for the Portland Art Association; he returned in 1908 to fulfill a
number of important portrait commissions. In the exposition's art display he emphasized
Impressionism, including a sizable selection of paintings by Edouard Manet, Claude
Monet, Camille Pissarro, Pierre-Auguste Renoir, and Alfred Sisley and by Mary Cassatt,

Childe Hassam, Ernest Lawson, Theodore Robinson, and Julian Alden Weir.[17]

1.30, 1.154 Impressionism had, in fact, arrived in Portland the year before, when **Childe Hassam**, especially well represented at the Lewis and Clark Centennial Exposition, made the first of two visits to Portland, at the request of Colonel Wood. The invitation was not only social; Wood wanted him to paint a mural series in his library. Hassam provided paintings of nude bathers and coastal landscapes, combining classical themes with Impressionist light and color. In 1904 Hassam also painted portraits, landscapes, and still lifes, some of which were purchased by other Portland collectors. On his return trip in 1908, Hassam, with Wood, visited the Harney and Malheur deserts in eastern Oregon, from which trip emerged a series of enchanting, spacious, light-filled landscapes in a

3.144 patterned, Post-Impressionist manner, such as *Golden Afternoon*. Another of these, *Afternoon Sky, Harney Desert*, was the Portland Art Museum's earliest purchase, subscribed to by friends of the institution. The results of this painting trip constituted a Hassam exhibition that was held at the museum in November 1908; a number of works from this show were acquired locally.[18]

 One other artist-visitor who remained a little longer acquired his limited fame as a result of his stay there. In 1904 a hunting cabin owned by Theodore Roosevelt, situated in the Little Missouri Badlands of North Dakota and known as the Maltese Cross Cabin, was dismantled and shipped in its entirety to the Louisiana Purchase Exposition in Saint Louis and then to the Lewis and Clark Centennial Exposition in Portland the next year. It was there that **Richard La Barre Goodwin** (inspired by William Michael Harnett's *After the Hunt* [Fine Arts Museums of San Francisco]) copied the cabin's door—which was not

3.145 unlike a multitude of other doors he had recorded—for his most celebrated work, *Theodore Roosevelt's Cabin Door*. Goodwin, who had worked in Syracuse, New York; Washington, D.C.; Chicago; Colorado Springs; Los Angeles; and San Francisco, remained in Portland for two years. He then returned east with his celebrated painting, living in Rochester, New York, in 1908 and dying two years later in Orange, New Jersey. The Maltese Cross Cabin was hardly less itinerant, moving on for display in Fargo and Bismarck, North Dakota, before coming to rest in Medora in that state.[19]

 A few years after Goodwin departed, a quasi-amateur arrived who found inspiration

LEFT:

3.144 Childe Hassam (1859–1935)
Golden Afternoon, 1908
Oil on canvas, 30 1/16 x 40 3/8 in.
The Metropolitan Museum of Art,
New York; Rogers Fund, 1911

ABOVE:

3.145 Richard La Barre Goodwin
(1840–1910)
Theodore Roosevelt's Cabin Door, n.d.
Oil on canvas, 25 1/4 x 19 1/2 in.
The Vassar College Art
Gallery, Poughkeepsie, New
York; Purchase: The Suzette
Morton Davidson Fund

3.146 Harry Wentz (1876–1965)
Wind Blown Coast, 1914
Oil on board, 21½ x 27½ in.
Washington State University
Museum of Art, Pullman

3.147 Anna Belle Crocker
(1867–1961)
Self-Portrait, n.d.
Oil on wood, 19 x 13¾ in.
The Portland Art Museum,
Oregon Art Institute; Loan of
Crocker Trust

in Oregon's early history. Canadian-born Theodore Gegoux spent most of his mature years in Watertown, New York, where, after taking some training in France, he turned from mercantile to artistic pursuits, painting portraits of eminent figures including Governor Roswell Flower and members of the state's supreme court. In 1909 failing health took him to Portland, where he painted landscapes and flower pieces and began a retrospective series of portraits of the city's first twenty-four mayors. Gegoux's masterpiece was his eleven-foot-long *Birth of Civil Government in Portland* (Champoeg Memorial State Park, Saint Paul, Oregon), created between 1915 and 1920, which reconstructed the moment on May 2, 1843, when Oregon was declared a part of the United States by a local vote of fifty-two to fifty. This had occurred at Champoeg, south of Portland in the Willamette Valley, where the aged Gegoux became caretaker of the Champoeg Memorial House. In 1924 he took his painting on an exhibition tour through the state, leaving two years later to join his family in California.[20]

Despite the encouragement given by local collectors to more modern approaches, turn-of-the-century painters in Portland tended to work in a conservative Tonal style. Landscape remained the primary mode of expression. Many leading practitioners from that period are even less known today than their predecessors. These include two women artists: Jennie E. Wright, who arrived from Chicago in 1890 and depicted mountain scenery, especially Mount Hood, and more lyrically interpreted informal scenes; and German-born Francesca Grothjean, who grew up in Portland and studied under Edward L. Espey before going to Paris. Both women were active into the present century.[21]

By far the best-known Oregon landscapist of this period is **Harry Wentz**, who was born in the Dalles. Wentz had studied in New York City at the Art Students League and was already a member of the Portland Sketch Club in 1899, exhibiting woodland scenes. In the early years of the twentieth century he taught at the Oregon Art Students League; a year after the founding of the Portland Museum Art School in 1909, he became its principal instructor. Wentz, who specialized in paintings of Oregon scenery, some traditionally rugged and majestic, was at his most effective in his low-key coastal and dune pictures, with their suggestions of windblown landscape in the strong diagonal

3.146

silhouettes of hillsides and the simplified shapes of bending trees. Among the contemporaries he most admired were his fellow Tonalists in San Francisco, GOTTARDO F. P. PIAZZONI, GIUSEPPE CADENASSO, and ARTHUR F. MATHEWS. Wentz also painted notable urban scenes, both industrial subjects and views of Portland's Chinatown.

When Wentz joined the faculty of the museum's art school, the museum's curator was **Anna Belle Crocker**, Henrietta Failing's successor, who remained until 1936. Crocker's professionalism is clear in her *Self-Portrait*; she also painted figure pieces, landscapes, and still lifes. A member of the Sketch Club, Crocker had studied with Frank Vincent DuMond during his visit in the summer of 1899; she went to New York City to study at the Art Students League in 1904. Two other prominent women artists were Kate Cameron Simmons, the first teacher at the museum's art school in 1909, and Clara J. Stephens, a former member of the Sketch Club who also studied with DuMond. Stephens specialized in landscapes and colorful Venetian scenes; she later became head of the art department at the Portland Academy. Clyde Leon Keller was a Salem-born landscapist who had the distinction of being patronized by President Herbert Hoover, who acquired *The Old Swimmin' Hole*, and President Franklin Roosevelt, who acquired *Site of the Bonneville Dam* (locations unknown).

With Wentz on its faculty, the art school became prominent just as Crocker was guiding the museum into the realm of modernism; Marcel Duchamp's *Nude Descending a Staircase* (1912; Philadelphia Museum of Art) was exhibited in Portland in 1914. There was, of course, conservative opposition among local artists, who, in 1912, formed the Society of Oregon Artists. Some of the society's members seem to have disassociated themselves from the museum's annual shows of local work following the initial exhibition that year of the Portland and Vicinity annual.[22]

Painters from outside Oregon continued to be attracted to the beauties of its scenery. Indiana's leading landscape painter, THEODORE CLEMENT STEELE, traveled west in July 1902, partly to console himself after the death of his wife. Finding little to inspire him in the Cascade Mountains, Steele painted on the Oregon coast at Newport and Nye Creek Beach, producing a series of rugged, colorful Impressionist works.[23]

Oregon's major urban communities other than Portland appear not to have produced outstanding artistic talents, although many exhibitors in the Oregon Building at the Panama-Pacific International Exposition in San Francisco in 1915 were from Eugene. In 1921 Portland-born Maude Kerns—who painted in a nonobjective manner—went to Eugene to teach at the university. Oregon's outstanding professional painter outside Portland was **Myra Albert Wiggins**, who was born in **Salem** to a pioneer family in the Willamette Valley. Wiggins won a premium at the Oregon State Fair in 1886; art had always been a feature of these annual fairs, which had been held in Salem since 1860 and at which the artists were almost always women from that city. Wiggins studied with Clyde Cook in Salem in 1888–89 and in 1891 went to study at the Art Students League in New York City as a pupil of William Merritt Chase. She painted portraits and taught art in Salem from 1892, soon turning to landscape. Wiggins's later specialties were still lifes—often contrasting fragile blooms with copper and ceramic vessels—and figure paintings inspired by Dutch pictures and utilizing Dutch costumes and accessories, such as her often-reproduced *Morning Blessing*, painted in Salem in 1899 and depicting her only daughter. Wiggins became increasingly interested in photography after she moved to Washington in 1907, first to Toppenish in the Yakima Valley and, in 1932, to Seattle.[24]

3.210
3.212; 3.207

3.147

2.238

3.148

3.148 Myra Albert Wiggins
(1869–1956)
A Morning Blessing, 1899
Oil on canvas, 20 x 18 in.
Mr. and Mrs. Robert H. Benz,
Yakima, Washington

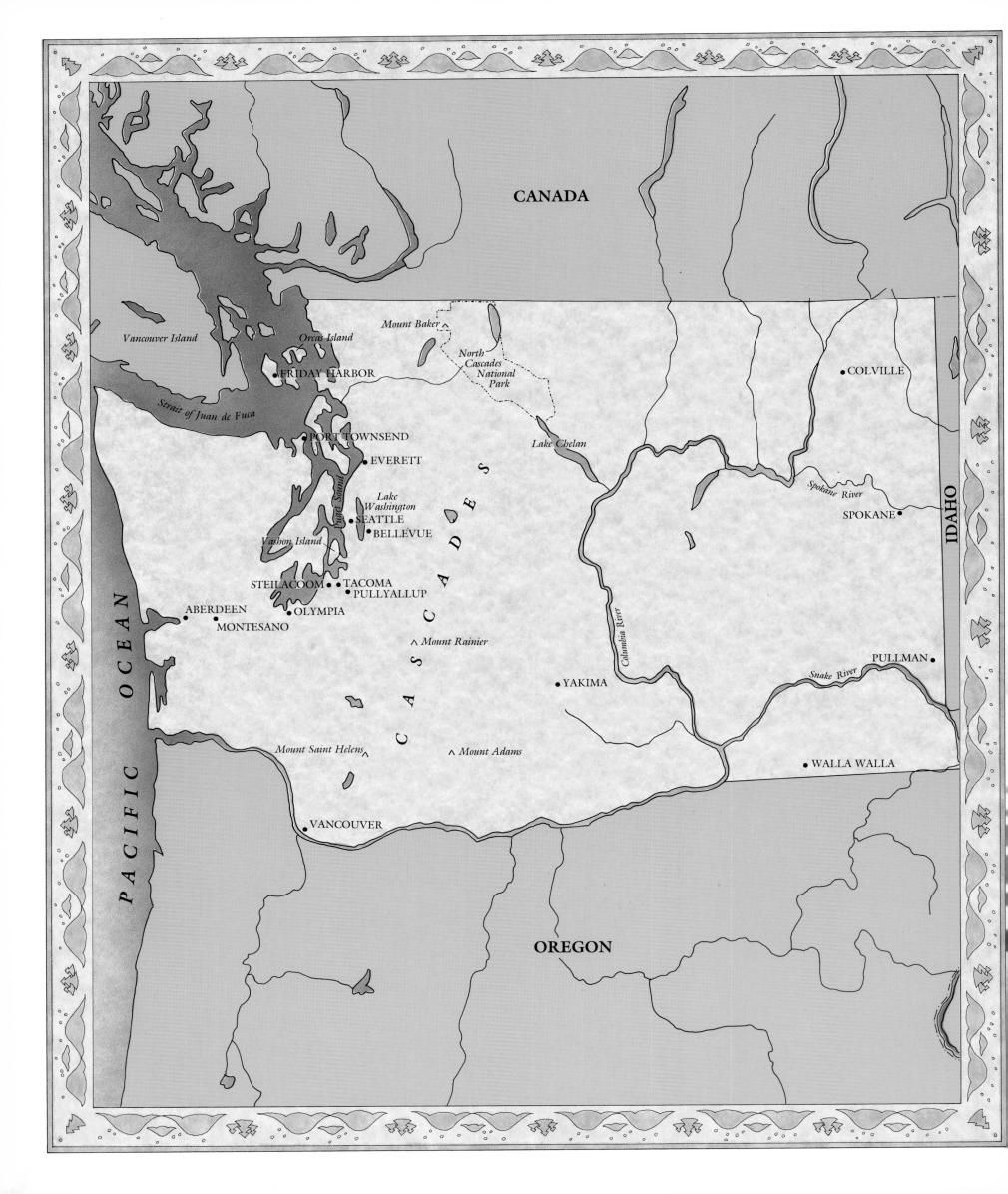

CANADA

Vancouver Island

Orcas Island

Mount Baker ∧

North
Cascades
National
Park

• COLVILLE

• FRIDAY HARBOR

Strait of Juan de Fuca

Lake Chelan

• PORT TOWNSEND

• EVERETT

Spokane River

Puget Sound

Lake
Washington

• SEATTLE

SPOKANE •

Vashon Island

• BELLEVUE

STEILACOOM • • TACOMA
• PULLYALLUP

ABERDEEN
• • OLYMPIA

Columbia River

• MONTESANO

∧ *Mount Rainier*

PULLMAN •

Snake River

• YAKIMA

Mount Saint Helens ∧

∧ *Mount Adams*

C A S C A D E S

• WALLA WALLA

PACIFIC OCEAN

IDAHO

• VANCOUVER

OREGON

WASHINGTON

The early history of art in Washington State inevitably parallels that of Oregon, since the area was part of the Oregon Country, jointly occupied by the United States and Great Britain until 1846, and integral to the Oregon Territory until a separate Washington Territory was formed in 1853. Lewis and Clark's first attempt at an outpost at the mouth of the Columbia River was on the north (Washington) side, which, due to its marshy terrain, was soon abandoned for Fort Clatsop on the south. Artists assigned to the early coastal surveys, often working from bases on the west coast of Vancouver Island, explored the Washington coast, especially Puget Sound and the Strait of Juan de Fuca. These included draftsmen such as George Davidson of the *Columbia* in 1792 and, later, Joseph Drayton and Alfred Agate of the United States Exploring Expedition in 1841, which explored the coast and the Columbia River as far as Walla Walla.

Later coastal artists such as William Birch McMurtrie, James Madison Alden, and
3.133 CLEVELAND ROCKWELL were active along the coast and up the Columbia River. A group of McMurtrie's watercolors of Washington from 1850 have survived. Alden's first visit to Puget Sound, in 1854, resulted in a number of drawings and watercolors, including one of Port Townsend (Dr. and Mrs. Franz Stenzel, Portland, Oregon); McMurtrie is presumed to have participated in this voyage, but no depictions of the Northwest from that year are known by him. Alden and McMurtrie returned the following year and in 1857, when Alden did renderings of communities on the sound. Most of Rockwell's scenes were confined to the shores of the Columbia River and views of Mounts Saint Helens and Rainier, but drawings and paintings of Washington survive from a trip to Alaska in 1884.

The great peaks of Mount Baker in the north and Mount Saint Helens, Mount Adams, and Mount Rainier in the south attracted both eastern and California landscape painters, though fewer of these visitors appear to have been active in the Washington
3.183 Territory than in the Oregon Territory. ALBERT BIERSTADT painted these mountains either during his second trip west in 1863 or during his longer residence in California between
3.178 1871 and 1874; he was back in 1889 making sketches of Mount Rainier. In 1868 WILLIAM KEITH was in Vancouver, Washington, across the Columbia from Portland—a common
3.173 destination for artists painting the scenery along the river. FREDERIC BUTMAN, the early California landscape painter, painted Mount Saint Helens in the late 1860s, and Keith was in the Washington Territory again in 1881 and returned in 1888 with the naturalist John Muir, painting Mount Rainier. Oregon artists, too, visited Washington, especially
3.137; 3.130 the prolific JAMES EVERETT STUART. WILLIAM HENRY TAPPAN, one of the earliest artists working in Oregon, ultimately settled in the Washington Territory, living in Clark County (the county seat of which is Vancouver) and joining the first territorial governor, Isaac Ingalls Stevens, at the historic Walla Walla Council in 1855.

In 1869 Vincent Colyer, who was with the United States Indian Commission on his way to Alaska, traveled the Columbia River and stayed at Fort Walla Walla; he later worked up his sketches from that trip into oil paintings shown in New York City during the following decade. R. Swain Gifford depicted Mount Rainier from the Columbia River during his 1869 trip to make illustrations for William Cullen Bryant's *Picturesque America* (published serially, from 1872). Although Bryant's article mentions the view of the mountain from Puget Sound, there are no pictorial records to show that Gifford actually ventured into the Washington Territory. Sanford Gifford, whose inactivity during an 1874 visit to Oregon is puzzling—he seems to have been more concerned with salmon fishing than with landscape painting—made studies on his return from Alaska of Mounts Baker, Saint Helens, and Rainier, the last of which he worked up into a masterful rendition

(Gerald Peters Gallery, Santa Fe, New Mexico) the following year, perhaps the finest Washington landscape painted in the nineteenth century.

The primary settlements in the newly established Washington Territory, other than those on the Columbia River, centered on Puget Sound. The earliest was Fort Nisqually, established by the Hudson Bay Company in 1833, which was overshadowed by Olympia in 1845 (it became the territorial capital in 1853), by Seattle in 1851, and by Tacoma in 1868. James Madison Alden drew Olympia in 1857. The landscape painter Gilbert Munger apparently was headed for the Puget Sound region in 1872, while Sanford Gifford appears to have made Tacoma his base during his brief stay in Washington in 1874.

Since the Washington Territory attracted permanent settlers and witnessed the founding of lasting townships even later than Oregon, the history of the resident art community is necessarily more compressed. As in Oregon, few early portraitists worked in the nascent urban centers. Two factors distinguished the art community that emerged in Washington in the late nineteenth century. One was the role of the railroad, which not only helped to determine which communities would emerge as the state's cultural centers but also enabled the local economies to thrive, which in turn yielded money for patronage. The transcontinental railroads commissioned talented artists to paint the glorious scenery along their routes, much of it lying within Washington's boundaries. The other factor was the importance assumed by women artists. This was true not only of their roles in organizing institutions such as art societies, schools, and museums (a role increasingly played by women throughout the country)—but also of their activity as professional artists. **Mary Achey**, probably Washington's first woman painter, is a case in point. A native of Scotland, Achey was active in Nevadaville, Colorado, which she painted in vivid, detailed renderings. She left Colorado in the early 1870s, finally settling in Aberdeen, Washington, in 1880. Her best-known Washington painting, a view of nearby Montesano, is said to be historically accurate in every respect.

Olympia, which became the state's capital in 1889, appears to have attracted few professional artists during the period under consideration here. EDWARD LANGE—a painter of charming, detailed delineations of Long Island, New York—moved to Olympia when it became the state capital, possibly hired by the railroad to advertise the region's attractions. There he concentrated his activities on commercial work—local views for newspapers, mining and lumber concerns, and realty companies.[1]

3.70

3.149

1.150

3.149 Mary Achey (1832–1886)
Montesano, Washington Territory, 1883
Oil on canvas,
18½ x 26½ in.
Washington State Historical Society, Tacoma

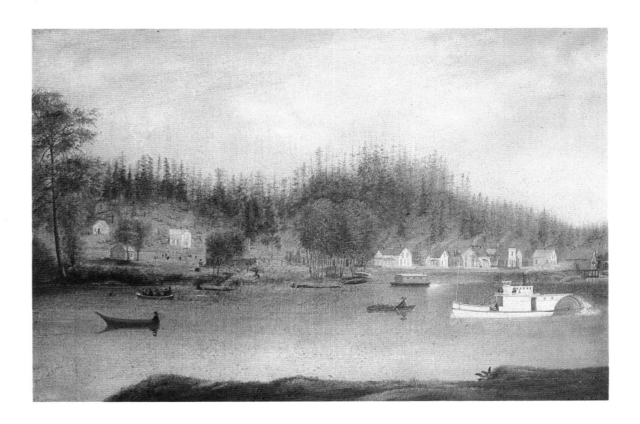

3.150 Grafton Tyler Brown
(1841–1918)
Mount Tacoma from Lake Washington, 1884
Oil on canvas, 16 x 26 in.
Washington State Capital Museum, Olympia

3.150 With the coming of the Northern Pacific Railroad—which was completed from Bismarck, North Dakota, through Portland to Tacoma in 1883—**Tacoma** became the earliest established cultural center in Washington. Virginia-born Frederick Taylor had settled there in 1875, after living in Yakima and Portland. Taylor ran a logging camp, worked for the railroad, and started a soda works and a steam laundry, becoming city comptroller in 1890. He then moved to Steilacoom, Washington. Making numerous painting trips with his pupil and colleague John Anderson, Taylor was one of literally dozens of artists to record Mount Rainier. Another was the black painter and lithographer **Grafton Tyler Brown**, who was based in Tacoma about 1884, after leaving Victoria, British Columbia, and before settling in Portland in 1886 for a number of years. Among Brown's finest works are several views of Mount Rainier painted in 1885 in a colorful but topographical manner comparable to that of his contemporaries in Oregon and California. Brown's last twenty-five years were spent in Saint Paul, Minnesota, as a draftsman in the city's civil engineering department; he appears to have given up his artistic career.[2]

Fred W. Southworth, from Ontario, Canada, was another early Tacoma specialist in landscape and forest scenery. One of the state's outstanding painters was **Abby Williams Hill**, who settled in Tacoma in 1889, the year Washington was granted statehood. She

2.258
1.146, 1.155 was born in Grinnell, Iowa, and studied with HENRY FENTON SPREAD in 1882 at the newly established Art Institute of Chicago and, in 1888, with WILLIAM MERRITT CHASE at the Art Students League in New York City. Hill sketched at the family's summer camp on Vashon Island in Puget Sound and specialized in landscapes of rugged mountain scenery, commissioned by the state. She subsequently received railroad commissions for paintings that would publicize the Northwest and thus bring both visitors and settlers into the region. Her first commission came in 1903 from the Great Northern Railroad (with its terminus in Tacoma), for paintings in the Cascades and around Lake Chelan; these pictures were then exhibited at the Tacoma Library. In 1904 and again in 1905 and 1906, she was hired by the Northern Pacific Railroad—first commissioned for a series of paintings of Mount Rainier and the Monte Cristo Mountains as well as other sites in Idaho and Montana, and then for a group of depictions of Yellowstone National Park to advertise

3.159 the railroad's Yellowstone Park Line. (Hill and JOHN FERY are the two Washington painters who appear to have profited the most from railroad patronage.) Hill ranged over the

3.151 entire Northwest for subjects, and though later in date, her views such as *Cabinet Gorge, Idaho* and renderings of Yellowstone are worthy successors of the Rocky Mountain

3.183; 1.152, landscapes of ALBERT BIERSTADT and THOMAS MORAN, whose style she emulated successfully.
1.254 Hill's work for the railroads was shown at the Louisiana Purchase Exposition in Saint

3.151 Abby Williams Hill
(1861–1943)
Cabinet Gorge, Idaho, 1904
Oil on canvas, 38 x 28 in.
The University of Puget
Sound, Tacoma, Washington;
Permanent collection

Louis in 1904 and at the Lewis and Clark Centennial Exposition in Portland in 1905; her paintings also won gold medals at the Alaska-Yukon-Pacific Exposition in Seattle in 1909. Producing panoramic landscapes for the Northern Pacific in 1904 brought her into contact with the native American population, and Hill began to concentrate on portraits painted on the reservations of the Sioux, Flathead, Nez Percé, and Yakima Indians. After moving to Southern California in 1910 and settling in Laguna Beach, California, in 1913, she painted a series of landscapes of the national parks. Many of her paintings are preserved in Tacoma, in the collection of the University of Puget Sound.[3]

Tacoma benefited from the benevolence of Clinton P. Ferry, a major collector who established the Ferry Museum in the local courthouse in 1893; this was later incorporated into the Washington State Historical Society Museum (founded 1890), whose first curator was the landscape, figure, and portrait painter **William Henry Gilstrap**. Born in Illinois, 3.152

he had studied with HENRY ARTHUR ELKINS, Henry Fenton Spread, and DANIEL FOLGER BIGELOW in Chicago and had exhibited professionally in the Midwest. After a trip to the Rocky Mountains in 1886, Gilstrap taught in Bloomington, Illinois, and was one of the first trustees of the Bloomington Art Association, which he helped found in 1888. In 1889 he went west again, painting and teaching in Omaha and then settling in Tacoma in 1890. With works such as *The Cobbler's Shop* (location unknown), depicting a pioneer workman at his trade, Gilstrap may have been the earliest northwestern painter to garner recognition outside the region.[4]

The Tacoma Art League was established in the late 1880s under the leadership of Julia Slaughter; it survived until 1897 but appears to have held only one exhibition. Slaughter was the head of the picture committee of the Art Loan Exhibition, which opened in March 1891 at the Public Library, almost surely one of the area's earliest significant exhibitions. Included were works by the prominent Philadelphia-related landscapists WILLIAM TROST RICHARDS and Frederick DeBourg Richards and a version of WILLIAM MORRIS HUNT's sculpture of horses, preparatory to his murals in the State Capitol

3.152 William Henry Gilstrap
(1849–1914)
Peter Whitmer, 1884
Oil on canvas, 27 x 22 in.
McLean County Historical
Society, Bloomington, Illinois

in Albany, New York. Among local artists represented were Abby Williams Hill; Slaughter herself, who showed a group of watercolors; Richard Max Meyer (who operated a photographic studio and taught art classes in Tacoma before moving to Portland); and Henry Holt, one of the earliest dealers in the Puget Sound region and an active landscape watercolorist. The most exotic elements of the show were scenes and still lifes distinctive to Hawaii, lent by Mrs. W. C. Merritt—some by herself and some by the resident Hawaiian artist CHARLES FURNEAUX. 3.257

A broader range of styles and of nationally known artists was included in the industrial expositions held in Tacoma in 1891 and 1892, ranging from the meticulous genre of EDWARD LAMSON HENRY and the traditional panoramic scenery of Albert Bierstadt 1.170 to the Tonalism of the brothers Alexander and LOVELL BIRGE HARRISON and the newly 1.174, 2.52 imported Impressionism of JOHN TWACHTMAN and CHILDE HASSAM. Members of the Tacoma 1.64, 1.120, Art League were represented, including Slaughter and the young San Francisco–trained 2.178; 1.30, Warren Rollins, a future specialist in Indian subjects; listed as "Professor" in the exhibition 1.154, catalog, he resided in Tacoma in 1891. The league languished but was revived in 1908, 3.144 after which it presented frequent exhibitions and worked to create a permanent collection. In 1900 Gilstrap and Slaughter appear to have been instrumental in founding the short-lived Tacoma Sketch Club, which met in the Ferry Museum.

Among Tacoma's leading painters in the early twentieth century was the English-born landscapist Thomas C. Harmer, who had studied with LEWIS HENRY MEAKIN in 2.186 Cincinnati and MATHIAS J. ALTEN in Grand Rapids, Michigan. George Heuston, who had 2.221 studied in Chicago and Saint Paul, went to Tacoma in 1908, settling in as a painter, printmaker, and cartoonist; he also instructed the life classes at the University of Puget Sound and established his own Heuston Art Classes, where he taught privately beginning in 1918. Alice Engley Beek, a watercolorist from Providence, Rhode Island, had studied there at Mary Wheeler's School and at the Rhode Island School of Design with the watercolor specialist SYDNEY R. BURLEIGH. Beek became a prominent landscape painter and 1.95 a teacher at the Annie Wright Seminary in Tacoma. One of her students there was Ruby Blackwell, who became a specialist in floral watercolors.

Seattle early surpassed Tacoma as a center of wealth and culture. Though devastated by a fire in 1889, Seattle quickly rebounded. In 1893 the railroad baron James J. Hill, who was also a major patron of the arts, completed the Great Northern line from Saint Paul to Puget Sound. Four years later Seattle became the jumping-off point for miners who sought their fortunes in the Alaska gold rush. Even before this, artists had begun to appear, including the mysterious English-born B. J. Harnett, who had been in San Francisco earlier and who, in 1889, painted a fascinating view of Seattle during the great fire (Museum of History and Industry, Seattle).

The majority of Seattle's early artists were women. Sarah Cheney Willoughby, possibly the first, was born in Lowell, Massachusetts, and arrived in Seattle in 1862 to teach art at the new Territorial University of Washington. Finding no art students, she gave instruction in music instead, and the following year moved to Port Townsend to teach. In 1877 Willoughby's husband was appointed Indian agent for the Macah and Quinault Indian reservations; Sarah's sketches of Indian utensils, weapons, and clothing made during the ensuing decade have been praised for their ethnological significance.[5] Minnie Sparling offered the first actual art class at the university to eight students in 1878; she also was commissioned to paint portraits of past territorial governors, which were hung in the State Capitol.

Emily Inez Denny, supposedly the first white girl born in Seattle, was a member of the Territorial University's first class, in 1863. A display of drawings by Willoughby inspired her to pursue an artistic career, and she took her first drawing lessons locally from a Mrs. Parsons in 1871. In 1876 Denny began to work in color with Thomas Alexander Harrison during his brief visit from San Francisco to the Northwest; she later received instruction and encouragement from Harriet Foster Beecher. Denny's landscapes—such as *Panoramic View of the Olympic Mountains*, which is the artist's first large-scale 3.153

work—record in an unsentimental, naturalist mode the rugged scenery of Washington, Denny's principal theme.[6]

Harriet Foster Beecher was another of Seattle's pioneer artists. Born in Indiana, she went west in 1875 to study at the San Francisco School of Design. In 1881 Beecher set up what was reputedly Seattle's first artist's studio. Active as a painter and teacher, she gave instruction at the Territorial University in 1882–83, and although she moved to Port Townsend in 1883, she continued to inspire students; 36 of the 150 paintings in the Washington State Building at the World's Columbian Exposition in Chicago in 1893 were by Beecher and her students. Beecher's own work was more diversified than Denny's; she painted Puget Sound coastal scenes (some with Indians), floral still lifes, genre pictures, and portraits. Among her best-known likenesses are several sympathetic renderings of
3.154 Ezra Meeker, a famous Washington pioneer and the first mayor of the town of Puyallup. The one reproduced here was painted in Seattle in 1914, a decade after Beecher and her family moved back to Seattle, where she became a mainstay of the art community and a charter member of the Society of Seattle Artists. Beecher served on the West Coast Advisory Committee for the Panama-Pacific International Exposition of 1915 in San Francisco, where the Meeker portrait was shown.

Beecher was succeeded at the Territorial University by Kate Almond and, from 1888 until 1895, by Claire Gatch; after her tenure the art department was discontinued for almost two decades. Jessie Elliott, from Baraboo, Wisconsin, studied in San Francisco before moving to Seattle, where she opened an art school in the late 1880s. Seattle was receptive to the turn-of-the-century miniature-painting revival, in which the outstanding local figure was **Ella Shepard Bush** from Galesburg, Illinois (who also painted full-size portraits). Bush, who was in Seattle by 1887, had studied in Washington, D.C., at the Corcoran School of Art and in New York City at the Art Students League. She became a major force in Seattle, organizing the Conservatory of the Arts in 1890. Her associate in this school was Scottish-born Jessie Fisken, who arrived in 1888 and became a well-known craftswoman and painter of miniatures and children's portraits. In 1894 Bush started the Seattle Art School, modeled after the Art Students League, which existed until she moved to Sierra Madre, California, in 1915. In 1904 she became the first president of the Society of Seattle Artists. Bush's ability as a miniature painter is clear in such strong

3.153 Emily Inez Denny (1853–1918)
Panoramic View of the Olympic Mountains, 1894
Oil on canvas, 30 x 59¾ in.
Museum of History and Industry, Seattle; Gift of Victor Denny

3.154 Harriet Foster Beecher (1854–1915)
Ezra Meeker with Book, 1914
Oil on canvas, 28¹/₁₆ x 24¹/₁₆ in.
Museum of History and Industry, Seattle; Gift of Mrs. H. W. Beecher

portraits as *Lillian Bell Whittlesey;* she was a member of several regional miniature-painters' societies, such as those in California and Pennsylvania.[7]

Another important Washington miniaturist, who worked in a more delicate mode, was Gertrude Willison, who studied under Beecher in her native Port Townsend and later in San Francisco and the East. Willison maintained a studio in San Francisco early in the present century but moved to Seattle in 1906, sharing space with the photographer Adelaide Hanscom.[8] A third well-known miniaturist, Clare Shepard Shisler, studied painting with Bush, with Carlotta Blaurock Venatta (formerly a Chicagoan and a pupil of James McNeill Whistler and Charles Lasar in Paris), and with Lillian Annin Pettingill. (Pettingill—who was a student of IRVING RAMSEY WILES in her native Le Roy, New York, before moving to Seattle in 1904—was the first Seattle art teacher to offer classes from living models.) Shisler won a medal at the Alaska-Yukon-Pacific Exposition in Seattle in 1909 and shared a studio with the well-known photographer Imogen Cunningham, of whom she painted a miniature (location unknown) that was exhibited at the Society of Seattle Artists in 1912 and with whom she held a joint exhibition in their studio the following year. Indeed, many of Shisler's most commended miniatures depict such Seattle friends and colleagues as Cunningham, Kathleen Houlahan, and Jessie Fisken. Shisler moved to San Francisco in 1914 and to Pasadena, California, about 1920.[9] Other noted miniaturists included Alice Carter Foresman, active between 1916 and 1920, and Gertrude Little, who opened the Little–Mitchell studios with her former pupil Margaret Mitchell in 1915; Little moved to Los Angeles in 1923. Many of these painters, such as Shepard, Mitchell, and Little, were pupils of Ella Shepard Bush. Miniature painting was sufficiently practiced and patronized that local exhibitions had distinct categories and prizes for it.

Another woman portraitist of note, Mary G. Allen, also painted landscapes. Rowena Alcorn and Lily Hardwick were both known for their portrait documentation of Northwest Indians, akin to that of ABBY WILLIAMS HILL in Tacoma. By far the best known of the younger women in Seattle in the early twentieth century was **Kathleen Houlahan.** Born in Winnipeg, Canada, she spent her youth in California, moving to Seattle in 1902. Houlahan was a prize student of Robert Henri in New York City, and, like Henri, imbued her sitters with vivacity and character, creating both portraits and character studies. Houlahan was known for her colorful, spontaneous likenesses of children, but her best-known work is *Ezra Meeker,* "captured" in a single three-hour sitting and exhibited at the Panama-Pacific International Exposition in San Francisco in 1915. A landscape and still-life painter of considerable ability, Houlahan showed eighteen works in the Panama-California Exposition in San Diego that year.[10]

Foremost among Seattle's prominent male artists of the early twentieth century were **Paul Morgan Gustin**, Edgar Forkner, and Eustace Paul Ziegler. Gustin, the youngest of the trio, was the first to arrive, in 1906; born in Vancouver, Washington, he grew up in Denver, where JEAN MANNHEIM was one of his teachers. Gustin established himself as Seattle's leading landscapist in oils of the period. His chief subjects were Mount Rainier and the wilderness of British Columbia and Vancouver and Nootka islands. Among his most noteworthy works is a series of views around Jarvis Inlet on Nootka, done for his patron, Frank Pratt; *Nootka Island* is a vivid portrayal of the rugged scene, made more dramatic by the patterning of the swirling waters. Gustin won later acclaim for his murals of Seattle history done in 1926 for Roosevelt High School and for those on Northwest history in the Northwest Room of the Suzzallo Library at the University of Washington. A significant teacher, Gustin became director of the newly instituted Seattle Fine Arts School in 1916 and taught during the 1920s at the University of Washington.[11]

Edgar Forkner, primarily a watercolor painter with a thorough control of his medium, was Seattle's leading specialist in that medium. He had made a reputation for himself in his native Richmond, Indiana, and then in Chicago; in 1911 he began to visit the Seattle area, attracted by the scenery. In 1914 he settled there permanently. Forkner specialized in Seattle harbor views and scenes of virgin wilderness, intimate rather than panoramic. He gained renown for his flower pieces as well, and he was an important teacher of the next generation of professional artists, including Olympia Barker, Theodore

3.155

1.156

3.151

3.156

3.241

3.157

3.158

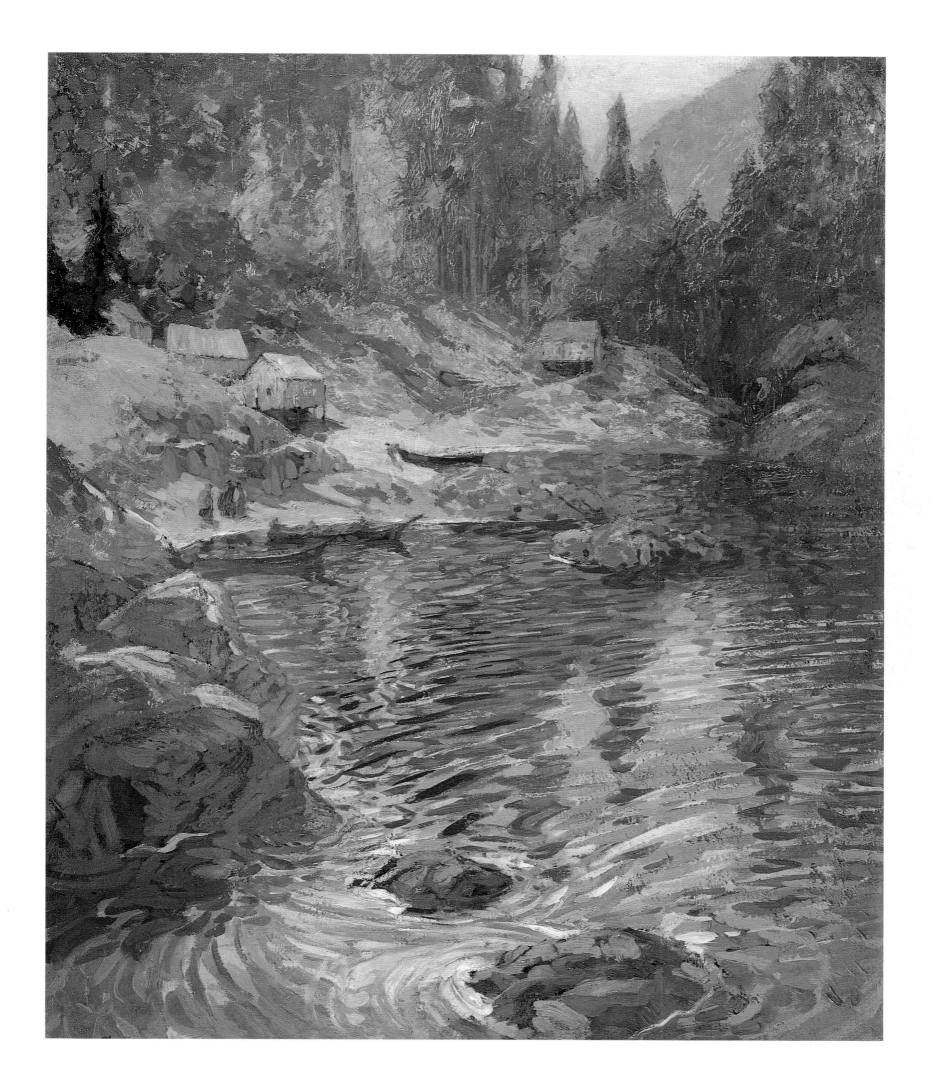

3.158 Edgar Forkner (1867–1945)
Pines, n.d.
Watercolor on paper,
22¹⁄₁₆ x 17⁵⁄₁₆ in.
Henry Art Gallery, University
of Washington, Seattle;
Horace C. Henry Collection

Eggers, Anita Elvidge, Ethel Ernesti, Leon Hammond, and Elizabeth Warhanik, who also studied with Gustin.

EUSTACE PAUL ZIEGLER, born and trained as a painter in Detroit, is known for the works he created in Alaska over many decades. Based in Seattle in the 1920s, having moved his residence there in 1924, he was active as a teacher. Even while resident in Alaska, he had painted a series of murals for the Seattle offices of the Alaska Steamship Company, subsequently receiving commissions for the Post-Intelligencer Building and the Olympic Hotel. Among the artists who visited Seattle on the way to Alaska was the Indian painter JOSEPH HENRY SHARP, still based in Cincinnati, who went to Alaska in 1900, spending about a month in the late spring in Seattle. Such visitors were not particularly active in the city, however.

3.163

2.181, 3.63, 3.108

Early in the present century Seattle was enriched by emigrants from Australia, Europe, and Asia. Julius Ullman from Bavaria, who had studied in Karlsruhe and Munich, became an able landscape and waterfront painter in Seattle. Yasushi Tanaka arrived from

Tokyo in 1905 to study with India-born Fokko Tadama; Tanaka remained until 1920, when he went to Paris, achieving considerable acclaim. He was given a major exhibition of landscapes and figure paintings by the Seattle Fine Arts Society on his departure. Although he apparently explored the wilder scenery of the Cascades and Vancouver Island, his primarily Tonal twilight landscapes were generalized and intimate, often with figures and with gentle Symbolist overtones.[12] Tanaka was the best known of a sizable group of Japanese artists who worked in Seattle.

Although the landscapist **John Fery** did not become a Washington resident until 1929, at the end of his career, his art focused on the state and was seen and enjoyed by a wider public than that of Gustin or Forkner. Fery was born in Austria and trained in Vienna, Düsseldorf, and Munich before coming to the United States. His home bases before 1929 were Saint Paul and Milwaukee. In his travels in the Rockies, Fery met members of the Hill family, who had developed the Northern Pacific Railroad, and they hired him to paint monumental scenes advertising the beauties of the region through which the railroad passed. He ultimately produced over three hundred works, which 3.159 hung in ticket offices and stations and in hotels and lodges serviced by the line. His *Mount Index in the Cascades* is one of the finest, depicting a train passing through the great mountain range—soaring peaks and industrial progress coexisting in harmony. One of Fery's best-known paintings, *Seattle Waterfront with Indian Canoes* (Museum of History and Industry, Seattle), illustrates a motif prominent in the work of local artists and juxtaposes native society with an urban culture. The subject suggests that this work was painted during one of what must have been numerous stays in Seattle, long before the artist moved to Orcas Island, Washington, in 1929. That same year a fire destroyed his studio with all of his paintings and sketches. Fery subsequently moved to Everett, where he died five years later.[13]

By about 1920 a new generation of artists was settling in Seattle, painters who would help to develop an indigenous form of early modernism. One of these was Australian-born Ambrose Patterson, who had studied in Paris, traveled to Canada and

3.159 John Fery (1859–1934)
Mount Index in the Cascades,
c. 1910–30
Oil on canvas, 47 x 83 in.
Burlington Resources, Seattle

New York City, and returned to Australia before recrossing the Pacific, working in Hawaii in 1915–17 and settling in Seattle in 1918. The following year he joined the staff of the University of Washington (formerly Territorial University), where he established the School of Painting and Design in 1919. Patterson's earliest Seattle works, such as *Duckabush River* (Seattle Art Museum), continued the naturalistic tradition established by Gustin and Forkner, but his later paintings are more in harmony with the spiritual modernism of Morris Graves, Mark Tobey, and Kenneth Callahan.[14]

Art exhibitions appear to have begun in Seattle with the Loan Art Exhibition for the Benefit of Women's House, held in 1891. This was followed in 1904 by a major exhibition and sale of fine, industrial, and decorative arts sponsored by the Woman's Century Club. The art community did not organize regular shows until the Society of Seattle Artists was formed in that year; their first annual took place in 1905. In 1907 the society adopted a semiannual exhibition schedule. Their third annual was called the First Annual Spring Exhibition and the fourth annual, the First Annual Fall Exhibition. The eleven original charter members were all women, including Harriet Foster Beecher, Ella Shepard Bush, Jessie Fisken, and Lillian Annin Pettingill. In the first annual Fall Exhibition, Paul Morgan Gustin was the only male artist to show a sizable group of works, along with a single entry by one Clifton Faron. Gustin appears to have remained the only active male participant in the society's shows until Edgar Forkner joined him in 1912. After that, other male painters were included, such as Alan Lee and John Butler. Butler was a graduate of the University of Washington who had studied with Ella Shepard Bush and Carlotta Blaurock Venatta before going abroad in 1910 to study in Munich and Paris. Returning to Seattle in 1913, he joined the summer class held by WILLIAM MERRITT CHASE in Carmel, California, the next year. Butler, who painted French and Italian scenes and garden pictures in an Impressionist manner, was active in Seattle's artistic life, noted for his staging and painted decorations for pageants, pantomimes, and the festivals mounted by the Fine Arts Society. He joined the Ambulance Corps after the United States entered World War I and went to France, leaving behind his most ambitious work, an unfinished mural of the *Holy Grail* (location unknown). Butler spent much of his subsequent career in France, returning temporarily to teach at the University of Washington in 1923–25 and to direct the school at the summer art colony at Friday Harbor.[15]

The Seattle Fine Arts Society, organized in 1908, was less closely tied to the art community than the Society of Seattle Artists. The new society began to hold exhibitions the year of its founding; one of the first major shows was a display of work by the nationally famous JOHN LA FARGE in 1909. Though at first it supported the activities of the Society of Seattle Artists, the Fine Arts Society finally overshadowed it, holding an exhibition of work by Seattle artists in the summer of 1915. Included were paintings by Harriet Foster Beecher, John Butler, Alice Carter Foresman, Edgar Forkner, Paul Morgan Gustin, Kathleen Houlahan, Gertrude Little, Margaret Mitchell, and the printmaker Roi Partridge, and his wife, Imogen Cunningham. As part of its first festival, in the spring of 1914, the society had instituted its Artists of the Pacific Northwest annuals (not to be confused with the Northwestern Artists annuals started in Saint Paul the following year). Open to artists of Washington, Oregon, Idaho, and Montana, and drawing most of its exhibitors from Seattle, Tacoma, and Portland, this series became the most important in the region. The Fine Arts Society formed the nucleus of the present-day Seattle Art Museum after joining with the Washington State Art Association in 1917.

The Washington State Art Association was founded in 1906, primarily to prepare for the international exposition held in 1909, the Alaska-Yukon-Pacific Exposition, Seattle's answer to Portland's Lewis and Clark Centennial Exposition four years earlier. The art gallery of the 1909 exposition included a selection of old masters and recent French art, both academic and Impressionist pictures lent by the French gallery Durand-Ruel; American Impressionism was also well represented. Major private collectors from Portland, such as Charles Erskine Scott Wood, lent to the gallery, as did collectors from Seattle, including Charles Frye and Fred Sanders, the latter probably the city's earliest major collector. California provided a separate gallery of art in its pavilion. The work of northwestern

1.146, 1.155

1.88

painters could be seen in the Washington State Pavilion and in the Women's Building. After the exposition the Washington State Art Association devoted itself to building a collection and constructing a museum.

In the early twentieth century Seattle provided facilities for art education beyond the long-established Seattle Art School presided over by Ella Shepard Bush. The university's art classes, discontinued in 1895, were revived in 1912 and incorporated into the College of Fine Arts, where Agnes Birkman was one of the earliest teachers. Private art schools, too, began to flourish, including the Arcade School of Mrs. George R. Davis in 1904, Martha K. Sumbardo's School of Fine Arts in 1916, and the art school of Fokko Tadama (who was born in India to Dutch parents)—a genre and portrait painter, trained in the Netherlands, who was a long-time resident of Seattle. Sumbardo was born in Hamburg, Germany, and painted in Florence before settling in Washington in 1908; her studio, where she specialized in portraiture and miniatures, contained large copies of old-master paintings. In 1908 SYDNEY LAURENCE, shortly to become Alaska's most noted artist, was one of the founders of the Western Academy of Beaux Arts in Seattle, an arts and crafts school that soon moved across Lake Washington to Bellevue, where an art colony was developed on the order of the Roycroft community in East Aurora, New York. By then, the major artists involved were Alfred T. Renfro, Frank Calvert, and the sculptor Finn Frolich. Calvert and Renfro established homes in the village, but Frolich, who became involved in the organization of the Alaska-Yukon-Pacific Exposition, moved to California in 1909. With his departure the Beaux Arts community appears to have evaporated.[16]

Margaret Gove Camfferman and her Dutch-born husband, Peter Camfferman, had studied in Minneapolis and in the mid-1910s settled in Seattle, where they became important teachers. In 1937 they both became members of an informal association of progressive artists, the Group of Twelve, along with Kenneth Callahan, Morris Graves, and Ambrose Patterson. Most innovative was the Cornish School of Allied Arts, founded in 1914 by Nellie Centennial Cornish. The Cornish School taught—and still teaches today—the visual arts in conjunction with music and dance; Mark Tobey went to Seattle to teach there in 1922.[17]

Professional artistry was scarce in the rest of Washington within the time covered by this survey. Searching for material for his Indian Gallery in 1847, JOHN MIX STANLEY had followed the Columbia River as far as Fort Walla Walla and then headed north, reaching the region of present-day Spokane in the autumn. Indian portraits by him are known from this period. Stanley accompanied the Pacific Railroad Survey along the nation's northern boundary in 1853–54. The survey began in Saint Paul, passed through North Dakota, Montana, and Idaho, and entered Washington near Fort Colville before moving down the Columbia and arriving at Fort Vancouver. This time Stanley made extensive use of the daguerreotype in addition to sketching in watercolor.[18]

Accompanying the survey as a United States army enlisted man was German-born Gustavus Sohon, who had come to this country in 1842 and joined the army a decade later. Sohon drew a remarkable group of incisive, individualized pencil portraits of Flathead and Pen d'Oreille Indians in 1853–54. He accompanied Governor Isaac Ingalls Stevens to the 1855 Walla Walla Council, which concluded the ceding of sixty thousand square miles of Indian land and the establishment of reservations for the Walla Walla, Cayuse, Umatilla, Yakima, and Nez Percé tribes. Sohon recorded both individual Indians and ceremonial activities there. He remained in the field, much of the time in the Washington Territory, through 1862 and worked on illustrations for the *Report on the Construction of a Military Road from Fort Walla Walla to Fort Benton* (1863); subsequently, he settled in San Francisco and in Washington, D.C.[19]

The town of Walla Walla, founded in 1856, grew up around the fort, but little artistic activity is recorded there. Yakima seems to have enjoyed professional artistic activity only when Blanche Helen McLane arrived there to teach, probably in the 1920s. The small town of **Pullman**, in the far southeastern part of Washington, near the Idaho border, became home to Washington State University in 1890. A number of professional

3.160 Olof Grafström (1855–1933)
A Reindeer Scene in Lapland,
c. 1886–87
Oil on canvas, 61 x 96 in.
Augustana College,
Centennial Hall Gallery and
Permanent Art Collection,
Rock Island, Illinois

artists were connected with that institution, including the landscape painter William T. McDermitt, from Illinois, and, from Indiana, Worth Griffin, who had studied in Indianapolis, Chicago, and New York City and who arrived in Pullman in 1925.

The major urban center in eastern Washington, **Spokane**, was not settled until 1872. Incorporated as the village of Spokane Falls in 1881, it was destroyed by fire in 1889, the same year as the devastating fire in Seattle. The San Francisco painter WILLIAM KEITH had visited the year before. The community was rebuilt quickly, and the still rough frontier city of Spokane was incorporated in 1891, with a fast-growing economy based on cattle, wheat, and silver and lead mining. In 1890 the North-Western Industrial Exposition had been held there, with an art gallery containing almost a hundred works by artists from all over the country—well-known painters such as J. G. Brown, Frank Millet, and the brothers JAMES M. and WILLIAM HART, and up-and-coming painters such as Frederic Remington. In addition, almost 150 works were lent by local painters, mostly women; some undoubtedly were amateurs, though one, Mrs. Thomas Gamble, is listed as a professional in the 1889 city directory. Among other works shown was a group of five very large paintings by the Cook brothers, including an eight-foot panorama of Spokane and two four-foot scenes depicting the destruction wrought by the recent fire; William R. Cook is also listed as an artist in the 1889 city directory.

The last paintings listed in the exposition's catalog were done by the most recent artist to arrive in Spokane and the most professional, the Swede **Olof Grafström**, who showed two works that had won prizes in Portland. One of these, *A Reindeer Scene in Lapland,* was a reminiscence of his native land painted soon after his arrival in this country. A mammoth work—eight feet long—its panoramic format was justified by the broad sweep of wilderness it depicted. Grafström's masterwork translated easily into the pictorial language of the American Northwest; the reindeer paraphrase the ubiquitous

3.178

1.180; 1.181

2.293, 3.140
3.160

3.183　American deer, symbolic of wilderness in many works by ALBERT BIERSTADT and others, and the hunters' tent could be mistaken for Indian wigwams. Though less accomplished than his gigantic landscape, Grafström's most notorious work from his stay in Spokane was his nine-foot copy (Eastern Washington State Historical Society, Spokane) of Adolphe-William Bouguereau's *Nymphs and Satyr* (Sterling and Francine Clarke Art Institute, Williamstown, Massachusetts), which hung in the saloon of the infamous "Dutch" Jake Goetz. Still in search of a receptive audience, Grafström moved to San Francisco at the end of 1891, turning there to the painting of altarpieces for Lutheran churches, which became a staple of his oeuvre.[20]

　　　　The Spokane Art League grew out of a meeting held in 1892 to coordinate Washington's contribution to the Women's Building at the World's Columbian Exposition. Julia Slaughter of the Tacoma Art League presided over the meeting, urging local women to form their own organization to stimulate the arts. The following year the Tacoma Art League established the Spokane Art League School, using local teachers. While visiting his brother, the painter Eugen Lingenfelder from Munich took charge of the classes; he was followed by Anna Louise Thorne, before she moved to Detroit, finally settling in her native Toledo, Ohio; and then by May von Gilsa from Chicago. Some stability was achieved when Helen Rhodes took over in 1903. The Spokane Art League sponsored exhibitions of work by members, students, and eastern artists. In 1906 an alternative establishment was founded, the Barnard School of Music and Art, which seems to have had only a short life.

　　　　Among other painters in Spokane after the turn of the century were W. Thomas Smith, an English artist who provided large portraits of the local elite, and the landscapist
3.68　FEODOR VON LUERZER, who had worked as a painter of views and logging scenes in Duluth,
3.159　Minnesota, and who was a friend of JOHN FERY. Von Luerzer settled in Coeur d'Alene, Idaho, in 1909, maintaining a studio in nearby Spokane until 1912 and specializing in depictions of the Cascade Range. Ethel Webling, also English, was in the city for a number of years, from about 1907 or earlier, as was Mary McKechnie, from Girard, Kansas, later; these were Spokane's principal participants in the miniature-painting revival. During the 1920s one of the leading artists in Spokane was Esther Partridge, who painted in a variety of media. Having grown up in Union City, Pennsylvania, she had studied at the Art Institute of Chicago's summer school in Saugatuck, Michigan, and in San Francisco and Los Angeles.

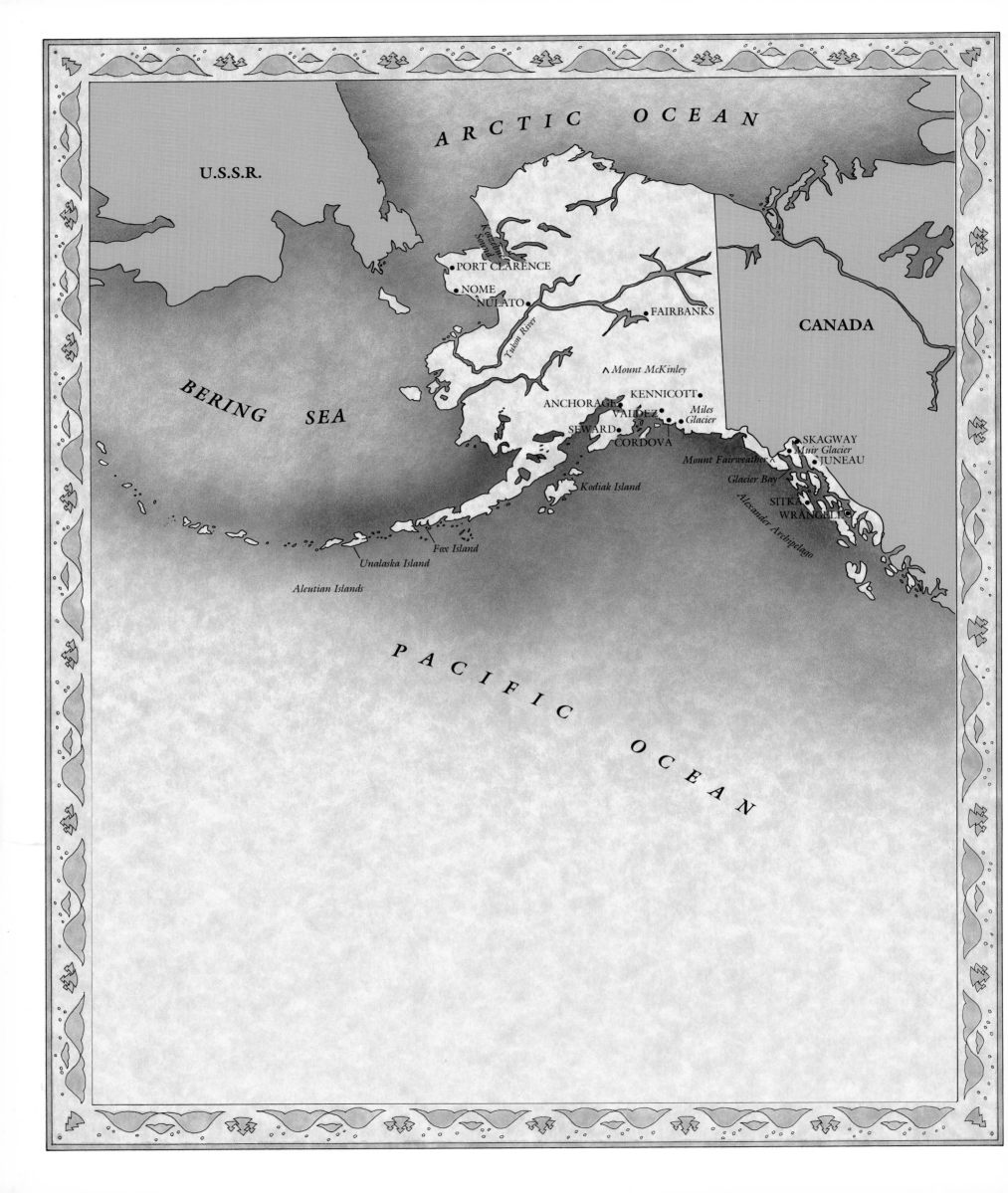

ARCTIC OCEAN

U.S.S.R.

CANADA

Kotzebue Sound

● PORT CLARENCE

● NOME

NULATO ●

● FAIRBANKS

Yukon River

BERING SEA

∧ *Mount McKinley*

KENNICOTT ●

ANCHORAGE ●

VALDEZ ● *Miles Glacier*

SEWARD ●

CORDOVA ●

● SKAGWAY

Mount Fairweather ∧ *Muir Glacier*

● JUNEAU

Glacier Bay

Kodiak Island

SITKA

Alexander Archipelago

WRANGELL ●

Fox Island

Unalaska Island

Aleutian Islands

PACIFIC OCEAN

ALASKA

Alaska was discovered by Russian explorers, who made their first permanent settlement on Kodiak Island in 1792. Subsequently, the area was frequented by British and Russian expeditions and by fur traders of the Hudson Bay Company; it was taken over in 1799 by a monopoly of the Russian-American Fur Company, which was managed by Aleksandr Baranov, who founded Sitka (originally New Archangel). At first Alaska's chief town, Sitka remained the capital after Russia ceded ownership of Alaska to the United States in 1867. The region was organized by the American government in 1884, received territorial status in 1912, and became a state in 1959. Gold discoveries in the Klondike region of Canada at the turn of the century brought prospectors to Alaska, most of them reaching the region by way of Seattle.

Painters before the gold rush confined themselves to the coastal settlements. This group included the early explorer-artists who accompanied government expeditions; landscape painters attracted by the remote and spectacular scenery; and residents. The earliest artists of the first category were British and Russian. James Cook's last expedition to the Pacific, begun in 1776, reached the Northwest coast early in 1778; he subsequently investigated the Aleutian Islands before returning to Hawaii, where he met his death. Among the draftsmen and amateurs with Cook who recorded Alaskan views were William Ellis, who depicted native life on the island of Unalaska, and the trained draftsman John Webber. The finest and most interesting of the later British expedition artists was William Smyth, assigned to the HMS *Blossom* under Captain Frederick Beechey to assist the Franklin Expedition searching for the Northwest Passage. The *Blossom* reached Kotzebue Sound in 1826 and, after wintering in Hawaii and California, returned the following year. Smyth's drawings and watercolors, some of which were engraved in Beechey's *Narrative* of the voyage, published in 1831, are fascinating, well-drawn documents of Inuit activity along the far northern Arctic coast and of the peril of expedition life.[1]

German-born Georg Heinrich von Langsdorff accompanied the first Russian expedition to circumnavigate the globe, making watercolors in Alaska in 1805–6 of native life and of the harbors and landscape of Unalaska Island; he also witnessed the resettlement of New Archangel, which had been destroyed by Tlingit Indians two years earlier.[2] The most famous Russian explorer-artist, Louis Choris, accompanied Commander Otto von Kotzebue on the *Rurik* to the Bering Sea between 1815 and 1818; Choris's drawings and watercolors of Indian life and likenesses done in 1816–17 were reproduced as lithographs in his *Voyage pittoresque autour du monde* (1822).[3]

Mikhail Tikhanov was the artist appointed to accompany the round-the-world voyage of the *Kamchatka*, which left Saint Petersburg in 1817 and arrived in Alaska the following year. Nineteen Alaskan paintings by Tikhanov are known, including depictions of the natives of the Aleutian Islands, Kodiak Island, and Sitka, as well as a portrait of Aleksandr Baranov. Pavel Mikhailov was assigned to accompany the round-the-world expedition of M. N. Staniukovich on the sloop *Moller*; he made drawings and watercolors of Inuits and views of Sitka's harbor in 1827.[4] The last of the great Russian scientific expeditions was made on the *Seniavin* under Feodor Litke; it left Russia in the summer of 1826 with two artists on board, Friedrich Heinrich von Kittlitz, assigned as "natural historian," and Aleksandr Postels. Specialists in botanical, ornithological, and mineralogical depiction, they were two of the most professional artists of the Russian expeditions. The lithographs done after von Kittlitz's views of New Archangel are the most competent and comprehensive early views of Alaska's major settlement.[5]

Once the United States took possession of Alaska, professional artists journeyed

there in more or less official capacities, for relatively brief periods. Chief among them was Vincent Colyer, a much-traveled landscape painter and close friend of John Frederick Kensett. After the Civil War, Colyer served as secretary to the board of United States Indian commissioners, first in the Southwest and, in 1869, in Alaska. While on duty Colyer made sketches of Alaskan and Northwest scenery, some of which he enlarged into exhibition pictures, which he showed in New York City in the 1870s. In Alaska, Colyer traveled to Wrangell and Sitka, painting views of both; presumably he also went to Kodiak. Paintings of more distant subjects, including the Aleutian Islands of Unalaska and Belcovsky, are known by him.[6]

Henry Wood Elliott from Cleveland, previously secretary to Joseph Henry of the Smithsonian Institution, was the official artist for Ferdinand Vandiver Hayden's United States Geological Survey of 1869–71. Elliott had visited Alaska and was in Sitka in 1866 in connection with the ultimately abandoned attempt to lay a Russian-American telegraph line across the Bering Strait. (The Englishman Frederick Whymper was also a member of the Russian-American Telegraph Exploring Expedition as early as 1865, working in and around Nulato, on the Yukon River, and along the Anadyr River in Siberia. Whymper subsequently was active as a painter in and around San Francisco and published his *Travel and Adventure in the Territory of Alaska* in 1869.) On the basis of his experience with the Hayden expedition, Elliott was appointed assistant treasury agent for the remote Pribilof Islands, to supervise the Alaska Commercial Company's management of the fur seal herd there. He arrived early in 1872 and based himself on the Island of Saint Paul until the summer of 1873. Elliott returned to the Pribilofs in 1874, also visiting the Aleutians as far as Attu; the field sketches that he made of the landscape, Inuit life, and, especially, the seals he later translated into finished watercolors, mostly about 1890–91. Elliott spent most of his later life in Cleveland, until he moved to Seattle in 1926; during these years he studied and wrote about seals, ultimately becoming instrumental in drawing up a treaty for their protection.[7]

The last of the great exploratory expeditions of the nineteenth century took place in 1899. Sponsored by Edward Harriman and the Washington Academy of Science, it traveled as far as the Seward Peninsula and up to the Arctic Circle, resulting in the two-volume publication *Harriman Alaska Expedition* (1901). Accompanying the expedition was Louis Agassiz Fuertes, who later painted Alaskan fauna, and R. Swain Gifford and FREDERICK DELLENBAUGH, whose paintings are reproduced in the book. This was the last of 1.171 the aging Gifford's extensive travels; views of Sitka, of Port Clarence, near Nome, and of Kachemack Bay are known by him. Dellenbaugh, better known for his travels in the Southwest and his activities with the Cragsmoor, New York, art colony, recorded Muir Glacier, with John Muir's isolated cabin surrounded by a vast, icy panorama.[8]

Despite the distances and hardships involved, it was not long after the United States occupied Alaska that American landscape painters began to visit. What is surprising is the relative paucity of pictorial results. Sanford Gifford appears to have traveled as far as Sitka on his trip to the Northwest in 1874. In the spring of 1884 Portland's CLEVELAND 3.133
ROCKWELL painted watercolors of Sitka and Juneau (founded in 1880) and a series of glacial landscapes. Probably the best-known nineteenth-century Alaskan painting is ALBERT 3.183
BIERSTADT's *Wreck of the "Ancon," Loring Bay, Alaska* (Museum of Fine Arts, Boston). In 1889 the artist made a trip across Canada on the newly completed Canadian Pacific Railroad and then sailed north from Victoria. This stunning work—with the remote, abandoned vessel isolated in motionless water and surrounded by a low fog—is a personal, very atypical example of Bierstadt's painting.

JOSEPH HENRY SHARP from Cincinnati traveled to Seattle and to Skagway, Alaska, in 2.181, 3.63,
1900, sketching Indian chiefs. Inspired by the Alaskan voyages and subsequent published 3.108
reports by his friend and traveling companion the famed naturalist John Muir, WILLIAM 3.178
KEITH of San Francisco visited in 1886, painting Sitka, Davidson Glacier, Glacier Bay, and Mount Fairweather. In 1887 he exhibited the results at the Bohemian Club in San Francisco, advertising the show as *Dreams of Alaska*. That same year Keith's colleague and sometime rival, THOMAS HILL, was commissioned by Muir to paint *Muir Glacier, Alaska* 3.175

(Oakland Museum, Oakland, California), depicting the meeting of travelers from San Francisco with Inuit against a backdrop of towering green-blue-purple ice shafts, perhaps the most spectacular Alaskan landscape painted in the nineteenth century.

3.137 JAMES EVERETT STUART was probably the most prolific painter of Alaskan scenes (including mountains, bays, and villages) in the late 1800s, noted there as early as 1891.

3.97 HENRY CULMER, one of Utah's landscape painters, was commissioned in 1911 to paint a series of views for the Alaska Steamship Company. He sailed from Seattle to Cordova, the terminus for the Copper River Railroad, then continued by rail to Kennicott and the Bonanza Mine, the richest of the copper discoveries; the Childs and Miles glaciers were Culmer's ultimate goal. He later was hailed as the first professional painter to penetrate the interior of the territory.[9]

The New York–based painter and decorator Lockwood de Forest visited Alaska in the summer of 1912 and painted coastal and glacier landscapes in which he attempted

3.136 to capture the region's cold and mists. In 1913 ELIZA ROSANNA BARCHUS from Portland visited Skagway, where she taught a painting class and hiked to the glaciers to gather material for such paintings as *Muir Glacier* and *Mount Saint Elias* (locations unknown).

3.161 Rockwell Kent (1882–1971)
To the Universe, c. 1918–19
Oil on canvas, 34¼ x 28 in.
Private collection, New York

Rockwell Kent traveled to remote Fox Island, Alaska, in 1918, remaining through the winter for almost a year. Kent created a group of major Alaskan pictures, including both extremely simplified, barren scenes with glowing light and more personal, symbolic figural pieces, such as *To the Universe*, the latter testimony to his admiration for William Blake. Two years later Kent had a major show of these paintings and published a book, *Wilderness: A Journal of Quiet Adventure in Alaska* (1920).[10]

1.16

3.161

The majority of visiting artists did not venture far into the Alaskan territory, primarily visiting those communities farthest south along the Alexander Archipelago or on the mainland opposite, such as Sitka, Wrangell, and Skagway. Those painters who might be termed resident or, at least, prolonged visitors, occasionally ventured farther. The earliest of these is also one of the least known: Walter B. Styles, who was in Sitka as early as 1880, originally having come as a miner and having remained as a missionary. Styles appears to have had some academic training; his records of life among the Tlingit Indians avoid the stereotypes of the early explorer-artists. Styles showed the Indians as individuals fishing and digging for shellfish, carefully documenting their costumes, boats, and houses within the pictorial structure of genre painting in the tradition of WILLIAM SIDNEY MOUNT.

1.148

Better known is **Theodore J. Richardson**, who grew up in Red Wing, Minnesota, and lived in Minneapolis, where he was supervisor of drawing in the public schools from 1880 until 1893. From 1884 on, Richardson spent twenty-four summers in Alaska, and while he traveled to California and painted the missions there, his career is primarily associated with the North. Richardson first went to Alaska when a friend offered to pay his passage, and he was assured of patronage for the sketches he would make there. His specialty was landscape, at first in watercolor and later in oils, in which he became proficient after studying in France for six years, beginning in 1896. Richardson also found pastel congenial to the recording of Alaskan scenes. On his return to this country he again spent every summer from 1903 through 1914 (the year of his death) in Alaska, painting along the beach and harbor at Sitka and

3.162

3.162 Theodore J. Richardson
(1855–1914)
Sitka, Alaska, n.d.
Watercolor on paper,
15½ x 25½ in.
Braarud Fine Art, La Conner,
Washington

recording glaciers. These views are interspersed with signs of Indian life—totem poles and canoes—rendered among the snow and ice, rock and water, air and mist that are unique to the region.[11]

Leonard M. Davis first arrived in 1898, a painter from Massachusetts who had trained in New York City at the Art Students League from 1884 until 1889 and then had spent the next six years studying in Paris. Davis, a latter-day itinerant, made many trips to Alaska and specialized in scenes of the region, though he also painted the Canadian Rockies and some of the national parks; 127 of his Alaskan views were shown at the Panama-Pacific International Exposition in San Francisco in 1915. Though primarily a landscapist who specialized in panoramic, austere, unpopulated views, Davis also painted portraits in Alaska and taught and lectured on art; in addition, he was active in gold mining. He finally settled in Southern California about 1930.

Eustace Paul Ziegler, born in Detroit, studied at the Detroit Museum of Art School under Ida Marie Perrault, FRANCIS PETRUS PAULUS, and JOSEPH W. GIES, three of the city's leading painters. In January 1909, restless and single, Ziegler accepted a position to manage the Red Dragon, an Episcopal mission dedicated to Saint George in Cordova, a principal port of access to the Kennicott copper mines in the Alaskan interior. Ziegler presided over the combination church, hostel, and town center, painting religious scenes on the walls and holding services while acting as a missionary along the railroad line to the mines. In 1914 the need for a permanent church in Cordova became apparent. Ziegler went east to Connecticut to prepare for his ordination. On Easter Sunday 1919, Saint George's Church in Cordova, adjacent to the Red Dragon, was consecrated, with Ziegler's *Descent from the Cross* hanging over the altar. At this time Ziegler also painted a *Nativity* and a *Crucifixion* for Saint Stephen's Mission in Fort Yukon, which are still on view there. He painted a variety of Alaskan subjects as well, including Indians, Inuit, and his counterparts in the Eastern Orthodox faith; Indian villages; and landscapes of glaciers and the ubiquitous Mount McKinley, which he referred to as his "studio."

In 1920–21 Ziegler went east once again, studying at the Yale University School of Art and with GERRIT A. BENEKER in Provincetown, Massachusetts. In 1911 his work had come to the attention of E. T. Stannard, president of the Alaska Steamship Company in Seattle, who acquired a mountain landscape from the artist at the time; soon after Ziegler's return to Alaska in 1921, he agreed to paint murals in the company's offices. Ziegler settled permanently in Seattle in 1924, becoming a full-time professional painter, and he was soon recognized as a leading figure in the local art community. Even though no longer a full-time resident of Alaska, Ziegler returned there almost every summer to sketch, and many of his finished works done in his Seattle studio were based on his Alaskan experiences.[12]

Alaska's most renowned resident artist was **Sydney Laurence**. Though he is best known for his Alaskan scenes, especially his endless repetitions of views of Mount McKinley, Laurence's earlier paintings done abroad were proficient and beautiful. Born in Brooklyn, he studied with the marine painter Edward Moran in New York City in the late 1880s, moving to Paris in 1889. Like many of his contemporaries, he journeyed to Venice and North Africa; by 1894 he had established himself in the major English art colony at Saint Ives in Cornwall. Laurence seems to have been in New York City in 1898, though much of this period was spent as a roving reporter making sketches and taking photographs while covering international conflicts for American and British journals. England remained his home until 1902.

On his return to the United States that year, Laurence headed for Alaska, arriving in Juneau in 1903, spurred on by the lure of gold. In 1904 he was prospecting in Valdez, and gold mining remained his preoccupation until late in 1912. While in Valdez recuperating from an accident, he heard about the grandeur of Mount McKinley (the highest peak in North America) and about plans being made to climb it. Financed by friends to travel there and paint the mountain, Laurence quickly boarded a steamer leaving for Seward, where he acquired a sled and dogs for the trip three hundred miles farther north. By the end of the summer of 1913 Laurence had produced forty oil sketches

2.215; 2.212

3.163

1.51, 2.199

3.163 Eustace Paul Ziegler
(1882–1969)
Russian Priest, 1918
Watercolor on paper,
9 x 7¼ in.
Anchorage Museum of
History and Art

and returned to Valdez, where he rented quarters and began an eight-foot canvas, later entitled *Top of the Continent*, completed in 1914 (private collection, Philadelphia), the first of perhaps hundreds of his views of Mount McKinley. At the same time he painted another, very different large canvas depicting the intimate, dramatic encounter of man

3.164 and wild predator, *The Trapper*, set in the snow-covered forests of the northern wilderness. Both paintings were subsequently exhibited at the Smithsonian Institution in Washington, D.C., giving Laurence national exposure. Meanwhile, he had opened a photography shop in Valdez to earn a living while continuing to paint, moving later to the site of a new town planned as the headquarters of the Alaska Railroad connecting Seward with Fairbanks. As this town developed into the substantial community of Anchorage, Laurence's reputation grew with it, so that, by 1920, he was able to establish a studio in the new Anchorage Hotel and dedicate himself to his painting. In 1925 Laurence was advised to seek a warmer climate for his health, and he moved to Los Angeles but continued to make frequent trips to Alaska.[13]

Though he was never a resident of the state (living in Tacoma, Washington; Banff, Alberta; and Santa Barbara, California), one other artist should be mentioned in connection with Mount McKinley: the mountaineer, explorer, and prolific writer Belmore Browne, who is best known for his book *The Conquest of Mt. McKinley* (1913). Browne was in Alaska at age eight, in 1888, and from 1906 on he made numerous attempts to scale the great peak, almost reaching the top in 1912. Trained at the New York School of Art with

1.146, 1.155 WILLIAM MERRITT CHASE and then in Paris, Browne became an illustrator in 1902 and started painting professionally in 1913, creating numerous depictions of the great mountain and of the landscape and the wildlife of Alaska. He was also active in establishing Mount McKinley National Park.[14]

3.164 Sydney Laurence (1865–1940)
The Trapper, 1914
Oil on canvas, 74¾ x 55 in.
Anchorage Museum of
History and Art

OREGON

NEVADA

PACIFIC OCEAN

^ *Mount Shasta*

• EUREKA

• UKIAH

Russian River

• FORT ROSS

Sacramento River

• MARYSVILLE

Lake Tahoe

• COLOMA
• PLACERVILLE
• SACRAMENTO

Marin County
Mount Tamalpais ^
SAUSALITO •
SAN FRANCISCO •
Farallon Islands

BERKELEY
• PIEDMONT
• OAKLAND
ALAMEDA

• STOCKTON

SIERRA

• SONORA
Tuolumne County *Yosemite*

NEVADA

• WAWONA
• MARIPOSA GROVE

PALO ALTO • • MOUNTAIN VIEW

• SAN JOSE

SARATOGA •

San Joaquin River

MOUNTAINS

SANTA CRUZ • • APTOS
• WATSONVILLE

PACIFIC GROVE • • MONTEREY
PEBBLE BEACH • • CARMEL
San Carlos Borromeo Mission

Salinas River

Death Valley

SOUTHERN CALIFORNIA

NORTHERN CALIFORNIA

In Northern California, as in the areas farther north along the Pacific coast, the earliest art is associated with the exploring expeditions from Europe. Though these arrived in California as early as 1542, artists were not attached to them until much later. By the late eighteenth century Monterey, settled in 1770 through the founding of a Franciscan mission, had become the military, political, and social center of Spanish California. It became the capital of the Spanish province in 1774, retaining that position under Mexico, and was the site of the first California constitutional convention in 1849, following the ceding of the territory to the United States in 1848. The name of the Yerba Buena pueblo, founded by Father Junipero Serra in 1777, was changed to San Francisco after the conclusion of the war with Mexico.

The first artist known to have worked in California was the Frenchman Gaspard Duché de Vancy, who in 1786 recorded the visit of the circumnavigational expedition under Jean-François Galup de Lapérouse to the San Carlos Borromeo Mission in Carmel Valley. In 1791 a Spanish expedition of similar intent, led by Alejandro Malaspina, called at Monterey; on board were two artists, Tomás de Suría from Mexico City and José Cardero, a self-taught artist-sailor whose tightly defined views of life in Monterey delineate the appearance and early activities at California's first settlement.[1]

The following year an English expedition under George Vancouver stopped at San Francisco and Monterey; the artists John Sykes and Harry Humphrys produced views of the latter community and of the surrounding landscape. The Russians arrived in 1806. Georg Heinrich von Langsdorff—who voyaged from Sitka, Alaska, under Count Nicolai Rezanov—executed the earliest-known view of the Spanish settlement of San Francisco and traveled inland as far as the San José Mission; an English translation of his narrative was published in 1926. The most talented of all these expedition artists was the Russian Louis Choris, who went to San Francisco on the *Rurik* under Otto von Kotzebue in 1816. He produced the largest known body of work: watercolors of the Spanish fort, of the natives, and of the wildlife, which were later reproduced in lithographs accompanying the two books that Choris wrote describing his travels.[2]

California became a province of Mexico after the latter won independence from Spain in 1822, and coastal ports thereafter became more open to trade. Numerous amateur artists from various countries accompanied exploratory and trading missions to California. When the British ship HMS *Blossom*, under Captain Frederick Beechey, arrived in Monterey in 1827, on board was the expedition artist William Smyth and the captain's brother, Midshipman Richard Beechey, who had inherited considerable talent from his father, the noted portraitist Sir William Beechey. Young Beechey produced picturesque pastorals that could be mistaken for English country views, except for the native costumes. Smyth, who worked in a topographical manner, was one of the first to record the most important symbols of Spanish heritage, the missions. The missions also attracted other amateur artists during the next few years. The German trader Ferdinand Deppe traveled on business from Mexico City to California at least six times between 1828 and 1836, painting accurate views of the Santa Barbara and San Gabriel missions. François-Edmond Pâris, a French naturalist-artist, recorded the San Carlos Borromeo Mission in Carmel Valley in 1839.

The earliest professional American artists in California arrived on the Pacific coast

3.165 Samuel Stillman Osgood (1808–1885)
General John A. Sutter, 1849
Oil on canvas, 29⅛ x 23¾ in.
The Fine Arts Museums of
San Francisco; Museum purchase

in 1841 with the United States Exploring Expedition under Lieutenant Charles Wilkes and were primarily active in the Oregon Territory and on the Columbia River. When one of their vessels, the *Peacock,* was lost, the stranded members made their way overland to San Francisco. One of these, Alfred Agate, thus recorded Mount Shasta and the upper Sacramento River. In the previous decade American settlers had begun to infiltrate California. One of these was John Augustus Sutter, who landed at San Francisco Bay in 1839 and founded a colony on the site of what is now Sacramento, becoming a Mexican citizen in 1841. Gold was discovered on his land at Coloma in the foothills of the Sierra Nevada in January 1848, leading to the greatest of the gold rushes. California was admitted to the Union as a state in 1850; four years later the capital was located permanently at Sacramento. Though that city remained the state's political hub and an important trading market, it was eclipsed early on by wealthy **San Francisco**, where an art community started to develop soon after the discovery of gold.

Almost all of the earliest painters to arrive in Northern California were lured by gold. The one exception appears to have been the Italian portraitist Leonardo Barbieri, who is believed to have arrived in 1849, after painting and teaching in Argentina and Bolivia. He worked his way south from San Francisco to San Diego, then went back to San Francisco and Monterey during the ensuing years before going to Mexico and Peru.[3] A host of amateur and professional artists left fascinating, if naïve, impressions of the early gold rush. Many—such as William McIlvaine from Philadelphia and George Victor Cooper, who had studied with Samuel F. B. Morse in New York—stayed for only a short time. McIlvaine must have been one of the earliest to arrive, for he had already painted California scenes by late 1849 and exhibited California landscapes and mining scenes at the academies in Philadelphia and New York City. Most of the other early artist-prospectors, such as Cooper, arrived in 1849; he published *California Illustrated* in 1852.

Mining themes were irresistible to San Francisco's early painters, and their depictions of the city's principal occupation attracted immediate public interest both in the East and elsewhere in the West. E. Hall Martin from Cincinnati began his career painting portraits in his native city and then continued his trade in Mexico in 1841; six years later he was exhibiting genre, landscape, and marine subjects at the Western Art-Union in Cincinnati. In 1849 he joined the gold rush, setting up a studio-residence the next year in Sacramento, where he painted a trilogy on the subject of Mountain Jack, two parts of which are known today (*Prospector,* private collection; *Mountain Jack and a Wandering Miner,* Oakland Museum). Martin died the following year at the age of thirty-three.[4] In 1849 the New York City marine specialist George Holbrook Baker (supposedly a student at the National Academy of Design, though registration records do not confirm this) also joined the gold rush, but he soon abandoned this profitless course to open a store in Sacramento. Returning to an artistic career and becoming a pioneer illustrator and printmaker, Baker moved to San Francisco after the great Sacramento flood of 1862.

Most Americans could not rush off to California, but California could come to them. Late in 1848 the Philadelphia landscape painter RUSSELL SMITH created a panorama 1.286 based on William McIlvaine's sketches of California and Mexican scenery, which the latter published in book form in 1850. Many artist-prospectors returned to painting to capitalize on the panorama vogue, which was then at its peak; panoramas of California rated second in public enthusiasm only to those of Mississippi. In 1850 the Swiss painter Paul Emmert, who had unsuccessfully joined the gold rush, exhibited a panorama of that subject in Brooklyn, New York, and then returned to California, where he painted another panorama, shown in San Francisco in 1852; the following year he left for Hawaii. William F. Cogswell, another New York City painter, joined the gold rush, returning to paint the now-unlocated *Panorama of the Gold Rush and Panama* (almost all of these artists had to travel across the Isthmus of Panama to reach the Pacific coast), which was on exhibit in New York City in 1851. Cogswell, who was residing in Saint Louis by 1859 and who lived in Chicago in the 1860s, returned to San Francisco as a well-established portraitist in 1873. English-born and -trained JAMES F. WILKINS, who went to Saint Louis from New 2.251 Orleans in the mid-1840s, traveled to California in 1849; back in Saint Louis in 1850–

51 he exhibited a panorama (location unknown) of the overland route based on the sketches he had made.

Thomas Almond Ayres went to California from the East in 1849 and sketched a large group of landscapes that were worked up by the painter Thomas A. Smith into a panoramic series of forty-six canvases. Exhibited in San Francisco in 1854 as *California on Canvas,* these included scenes from the Golden Gate to the Sierra Nevada. Two years later a panorama (location unknown) was put together, probably by Smith, based on Ayres's sketches and drawings of Yosemite; it was shown in Sacramento. Ayres was probably the earliest artist to go to Yosemite, in 1855, having been invited by the Englishman James Mason Hutchings, a 49er-turned-writer-and-publisher, who was planning an illustrated magazine. Hutchings published *The Yo-Semite Falls,* a lithograph based on an Ayres drawing, in 1855, and four engravings after Ayres's work appeared in the first issue of *Hutchings' California Magazine* in July 1856. In 1857 Ayres took his Yosemite paintings to be exhibited in New York City; the following year he drowned on his way back to San Francisco.[5]

With a growing population, a stabilizing society, and quickly amassed wealth, San Francisco soon demanded portrait likenesses. That demand was almost immediately filled. The earliest specialist to arrive was **Samuel Stillman Osgood**, who abandoned a moderately successful New York City career for the California gold fields in 1849. Having decided to follow his original profession in San Francisco, he stopped at Sutter's Fort in the Sacramento Valley to sketch John Augustus Sutter himself. Osgood completed the painting in San Francisco and took it to be engraved by the Philadelphia printmaker John Sartain. Osgood returned to San Francisco early in 1852, his fame from the popular likeness of Sutter preceding him, but he remained only until the end of 1853, when he journeyed east again. Vermont-born Stephen William Shaw arrived in San Francisco with the gold rush but after a few months moved to Sacramento, where Edwin Bryant Crocker, one of the builders of the Central Pacific Railroad, became his patron. By 1852 Shaw had settled in San Francisco, where he remained an active portraitist until the end of the century.

Better known was **William Smith Jewett** (often confused with the New York City

3.165

3.166 William Smith Jewett (1812–1873)
The Promised Land—The Grayson Family, 1850
Oil on canvas, 50⅞ x 65 in.
Courtesy of Berry-Hill Galleries, New York

3.167 Thomas Story Officer
(1810–1859)
Lydia Rollinson, 1853
Oil on canvas,
dimensions unknown
Location unknown

portrait painter William Jewett, the partner of Samuel Waldo in the firm of Waldo and Jewett). Also from New York City, William Smith Jewett exhibited in the 1830s and '40s at the National Academy of Design and the American Art-Union, heading for the California gold mines in 1849. Soon disillusioned, he opened portrait studios in 1850—both in Sacramento, where he remained until 1855, and in San Francisco, where he stayed thereafter until returning to New York City in 1869. Though his reputation was established primarily in portraiture (he painted many of early California's leading citizens), Jewett also painted landscapes and genre subjects. His most famous picture, *The Promised Land—* 3.166 *The Grayson Family,* a depiction of the noted artist-naturalist Andrew Jackson Grayson, his wife, and his son, brings all three themes into play. This work was painted from on-the-spot sketches made when Jewett and Grayson traveled to the crest of the Sierra Nevada, from which the latter's family had first seen the Sacramento Valley in 1846. Unlike Osgood's straightforward, naturalistic portrayal of Sutter, Jewett's image went beyond mere likeness, establishing a strong familial bond and depicting his sitters in an awe-inspiring landscape, a truly new world in which the Graysons were both pioneers and overseers. The painting has been referred to both as the starting point of California art and as a representation of the progress of civilization westward.[6]

Like Osgood and Jewett, **Thomas Story Officer** arrived in San Francisco as a fully trained, practicing artist, a student of Thomas Sully who had worked in New York City. From there he moved to Mexico and Australia before returning to the United States. He opened a portrait studio in San Francisco in 1855, attracted by the wealth the gold rush had engendered. Officer achieved little success even though he was an able painter of sophisticated likenesses, such as *Lydia Rollinson,* and was praised as a colorist. He was 3.167 also a talented miniature painter—perhaps the leading practitioner in San Francisco at the time of this no longer popular art form. Although he allied himself with the photographer George B. Johnson, whose work he colored, and exhibited portraits and miniatures at the Mechanics' Institute fairs in the late 1850s, Officer died impoverished at the end of the decade.[7]

More significant than the portraitists were the artists who imported "high art" to California. First and foremost among these was **Charles Christian Nahl.** Born into a family of artists in Kassel, Germany, Nahl trained there and in Dresden before moving to Paris in 1846, where he was a student or assistant of Horace Vernet, a prominent academician. Nahl may also have studied with another famous French academic painter, Vernet's son-in-law, Paul Delaroche. In 1849 Nahl's family went to the United States, remaining briefly in New York City, where work by Nahl was acquired and exhibited at the American Art-Union; the Nahls arrived in California in 1851. They resided in Sacramento after the inevitable fling at gold mining and then, following the great fire in that city, settled in San Francisco the next year. During his first decade there Nahl was recognized principally as an expert illustrator, but by the early 1860s he had been acknowledged as California's premier painter, and in 1869 he gained the patronage of Edwin Bryant Crocker, one of whose associates in the building of the Central Pacific Railroad, Leland Stanford, was also a patron of Nahl.

Nahl's significance for the development of art in Northern California is twofold. First, the respect accorded his academic training enabled him to give credibility to a multitude of Californian subjects—portraits and especially genre scenes documenting the lives of the miners and vaqueros (he also favored anachronistic classical themes and Oriental fantasies). Second, by the late 1860s he had attracted the attention of members of San Francisco society, who desired to complement their extravagantly furnished mansions with "tasteful" works of art. These early patrons recognized in Nahl's pictures a formal approach that coincided with that of the academic European art being acquired by themselves and their eastern equivalents. (Crocker's European collection, for example, consisted primarily of paintings by contemporary artists in Dresden and Munich.)

Nahl concentrated on figural themes, but he was notable for painting an almost bewildering variety of subjects. His rare fruit paintings are lusciously rendered, his animal representations pay reasonably successful homage to those of Jean-Léon Gérôme and

others, and his landscapes are topographically convincing, including his well-known *Fire in San Francisco Harbor* (1856; Fireman's Fund American Insurance Companies, San Francisco). With Thomas Hill and Gideon Jacques Denny, Nahl painted scenes of life on the Isthmus of Panama on the restaurant walls of the old San Francisco hostelry the Rail Road House; these were considered by a later artist, CHARLES DORMON ROBINSON, as unexcelled for "truth, color or design."[8]

3.186

Nahl's figural pieces are ambitious and mind-boggling in their diversity. His portraits are sharply drawn, tremendously detailed, and exuberant in their coloration; no wonder that Samuel Stillman Osgood retreated to the East and that Thomas Story Officer died penniless, for neither could match the brilliance of Nahl's canvases. As early as 1837, at the age of nineteen, he had successfully rendered a large *Finding of Moses* (Bernd Brand, Bremerhaven, Germany); during his residence in Sacramento he painted several religious subjects for a local church. He had early painted historical subjects in Kassel, such as *Wallenstein and Seni* (1846; Embassy of Federal Republic of Germany, Rome), so there were precedents for his large *South Idaho Treaty* (1866; Thomas Gilcrease Institute of American History and Art, Tulsa, Oklahoma), which includes a multitude of figures. Nahl's first commission from Edwin Bryant Crocker was a pair of vigorous equestrian chase paintings: the Orientalist *Love Chase* of 1869 and the allegorical *Patriotic Race* (1870; Crocker Art Museum, Sacramento). These and other major works reflect Nahl's indebtedness to Vernet, himself admired by American critics and collectors. The pair was followed by the most ambitious commission of Nahl's career, the three-part series *The Romans and the Sabines* (Crocker Art Museum, Sacramento), painted in 1870–71 for Crocker—*retardataire* if titillating canvases that pay homage to and mock their source, the great rendering of that

3.168 Charles Christian Nahl
(1818–1878)
Sunday Morning in the Mines, 1872
Oil on canvas, 72 x 108 in.
Crocker Art Museum,
Sacramento, California

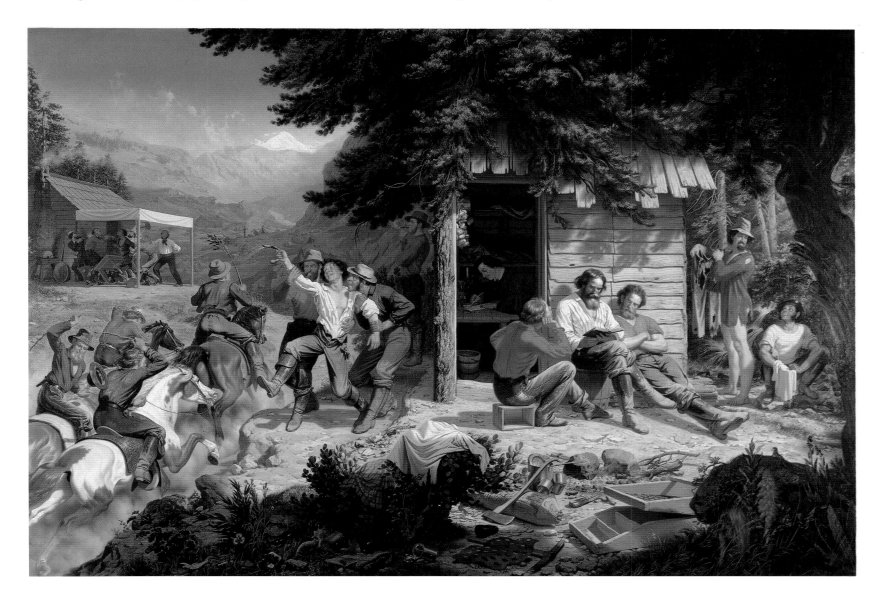

subject by the French Neoclassicist Jacques-Louis David (Louvre, Paris).

Today Nahl's masterpieces are considered to be his unique California genre paintings. Having begun to render prospecting and mining scenes as early as 1851–52, he never lost interest in these subjects. In addition to his illustrations, he painted *Miners in the Sierras* (about 1851; Fred Heilbron collection) for August Heilbron of Sacramento, and *Saturday Night at the Mines* (1856; Stanford University Museum of Art). His paintings of the vaqueros date from the 1860s, when he also explored the legend of the notorious bandit Joaquin Murietta. Nahl's masterworks are three paintings from the early 1870s: *Sunday Morning in the Mines; The Fandango* (1873; Crocker Art Museum, Sacramento); and *Sunday* 3.168 *Morning in Monterey* (1874; Santa Barbara Museum of Art). The first two, commissioned by Crocker, illustrate two aspects of California life: an all-male gathering contrasting temperate and uncontrolled behavior, and an examination of wayward and controlled passion. The pictures are unified in their composition (each contrasting enclosed and limitless vistas) and in their emphasis on dance and horsemanship. These are also characteristics of *Sunday Morning in Monterey,* the largest of Nahl's works, which was acquired by another major collector, Captain J. L. Best.[9]

Nahl's half-brother, Arthur, who had similar training, was a landscape, portrait, and animal painter but became known for his commercial work and photography. Arthur's son, Perham Nahl, became an important artist and a major educator in the Bay Area in the early twentieth century. Accompanying the Nahl family to California was August Wenderoth, also from Kassel and also a student of Vernet's, who worked primarily as a daguerreotypist; his genre paintings in oils are stylistically similar to those by Charles Christian Nahl. Given his association with Vernet, it is not surprising that Wenderoth favored equestrian subjects. In 1856, when he married Laura Nahl, half-sister of Charles and Arthur, the couple moved to Philadelphia.

Charles Christian Nahl's early illustrations of California mining life provided inspiration for similar scenes painted by the New York landscape and genre painter **Alburtus Del Orient Browere**. Browere moved in 1845–46 to Catskill, New York, the 1.164 home of Thomas Cole, where he began to specialize in landscape painting under the dual influence of the setting and of America's leading master of the genre. Browere's residence there was punctuated by two extended trips to California in the 1850s, which yielded a relatively large number of paintings that are important elements of California's early pictorial history. In 1852 Browere went to San Francisco via Cape Horn, apparently motivated by the lure of prospecting for gold. Nevertheless, he continued to paint; his *Lone Prospector* (1853; private collection) was based on a Charles Christian Nahl lithograph of the previous year. During the next several years Browere painted numerous other California scenes—pure landscapes, such as his 1854 *View of Stockton* (Oakland Museum), and mining scenes at Placerville. Despite their disproportioned, grotesque figures he succeeded in the latter in integrating authentically rendered activities with convincing topography. Family tradition has it that the red-shirted figure that frequently appears in Browere's California paintings—for instance, the kneeling prospector in the foreground of *The Mines of Placerville*—is the artist himself. 3.169

Having returned east in 1856 via the Isthmus of Panama, Browere went back to California in 1858 by the same route, remaining for three years. Fewer landscapes (though some of his most impressive ones) and genre scenes are known from this second extended stay. The landscapes detail the tropical scenery he observed while crossing the isthmus, perhaps inspired by FREDERIC EDWIN CHURCH's recently exhibited tropical views, a subject 1.103, 1.166 also investigated, though on a less panoramic scale, by Charles Christian Nahl in 1867. Browere remained in Catskill after his return in 1861, though it is likely that he continued to paint California subjects based on earlier sketches.[10]

Another California painter known for his mining scenes is French-born **Ernest Narjot**, both of whose parents were artists. Narjot enjoyed formal instruction in Paris before joining the gold rush in 1849. After three unsuccessful years as a miner, he moved to Sonora, Mexico, where he mined and continued to paint along the Arizona–Mexico border. His artistic residence in San Francisco commenced in 1865, when conditions for

ABOVE:

3.169 Alburtus Del Orient Browere (1814–1887)
The Mines of Placerville, 1855
Oil on canvas, 26 x 36 in.
National Cowboy Hall of
Fame Collection,
Oklahoma City

LEFT:

3.170 Ernest Narjot (1826–1898)
Gold Rush Camp (Miners—A Moment at Rest), 1882
Oil on canvas, 40¼ x 50¼ in.
The Los Angeles Athletic
Club Art Collection

exhibition and patronage had become more attractive. Narjot painted portraits, landscapes, murals, and scenes of emigration west in addition to mining subjects, his retrospective

3.170 *Gold Rush Camp (Miners—A Moment at Rest)* being his most impressive work. Instead of the furious activity and moralistic implications of Charles Christian Nahl's *Sunday Morning in the Mines* of a decade earlier, Narjot offered a naturalistic presentation of the leisurely, even boring, life of miners, who are shown smoking, playing cards, and reading the *Alta California*. Narjot was also one of the earliest (as well as one of the finest) painters of San Francisco's Chinatown.[11]

One other significant genre specialist, Enoch Wood Perry, arrived in San Francisco in the early 1860s. With the start of the Civil War the burgeoning city of San Francisco appeared especially attractive to Perry, who arrived there in 1862 from New Orleans. A number of sentimental but attractive genre pieces by him are known from this period, including the companion paintings *Grandfather and Boy* and *Grandmother and Girl* (private collections), featuring the contrast and affection between youth and old age, a subject that interested Perry throughout his career. Inspired by the magnificence of California

3.183 scenery and by the work of ALBERT BIERSTADT, who first arrived in San Francisco in 1863 and whom he accompanied to Yosemite, Perry became interested in landscape. Perry departed for Hawaii in 1864, and though he must have passed through San Francisco briefly on his return, his next known stop was Salt Lake City.[12]

Bierstadt's first visit, in 1863, directed the attention of artists and the general public to the magnificent scenery of the Sierra Nevada and of Yosemite,[13] but much of early California landscape painting depicts tropical rather than mountainous scenery, especially works by artists who arrived via Cape Horn or Panama before 1869, when the transcontinental railroad was completed. The earliest professional landscape specialist in San Francisco was probably **Norton Bush**, from Rochester, New York, who had studied

1.159 with JASPER F. CROPSEY in New York City. Although it has been said that Bush was encouraged by Frederic Edwin Church to specialize in tropical views, Bush arrived in San Francisco in 1853, the same year that Church made his first trip to South America. Instead, Bush's fascination with the tropics must have been fueled by his own journey to the Pacific (which took him across the jungles of Nicaragua rather than via Panama) and by

3.171 his patrons' enthusiasm for the exoticism of such luminous, colorful works as *Jungle Scene, Sunset*, which may have reminded them of their own travels. Once Church's tropical paintings began to win plaudits in the mid-1850s, Bush's work won acclaim as the closest California equivalent. Bush became the most prolific and successful California painter of "tropicals." Commissioned by the major patrons William C. Ralston and Henry Meiggs, respectively, he made trips to Panama in 1868 and to South America in 1875 in search of subjects. Turning to marine subjects in his later years, Bush spent 1871–72 in New York City and maintained a studio in Sacramento for a few years.

California's other highly regarded specialist in "tropicals" was **Fortunato Arriola**, a Mexican painter who had arrived in San Francisco by 1858; thereafter he may have remained in the city or returned to Mexico, but he definitely had established a permanent studio in San Francisco by 1862. The first work Arriola painted in this country was a tropical sunset, which he sold for a good price, and he continued to compose such

3.172 pictures, some quite fanciful, from memory and to paint portraits. He taught privately,
3.198 his most renowned pupil being TOBY EDWARD ROSENTHAL, in 1862; Rosenthal became one of the outstanding expatriate artists in Munich. Arriola's works reflect the smooth surfaces and glowing atmosphere of Luminism, a result either of influence by eastern painters or of the artist's instinctive response to his subjects. In 1871 Arriola went to New York City, hoping to gain greater recognition, and the next year he exhibited two Mexican scenes at the National Academy of Design, where Bush had shown *Lake Nicaragua* (location unknown) the previous year. Arriola drowned en route to San Francisco later in 1872.[14]

Bush and Arriola also painted local views, which became the paramount theme in California art. An obscure Frenchman, Antoine Claveau, probably painted the earliest oil paintings of Yosemite, winning a premium for such work at the fourth annual Agricultural Fair in Stockton in 1857. That same year he was painting a Yosemite panorama, which

OPPOSITE, TOP:
3.171 Norton Bush (1834–1894)
Jungle Scene, Sunset, n.d.
Oil on canvas, 20 x 30 in.
The Oakland Museum,
Oakland, California; Gift of
George and Lydia Clark

OPPOSITE, BOTTOM:
3.172 Fortunato Arriola
(1827–1872)
Tropics, c. 1865
Oil on canvas, 18 x 30½ in.
Mr. and Mrs. Irving Loubé,
Piedmont, California

3.173 Frederic Butman
(1820–1871)
Mount Shasta, 1864
Oil on canvas,
33¾ x 59¾ in.
University Art Museum,
University of California at
Berkeley; Gift of
Sarah P. Walsworth

was on view at the San Francisco Musical Hall at the end of 1858. Claveau remained active in San Francisco until 1872. **Frederic Butman**, who arrived from Maine in 1857, was the earliest specialist in Northern California mountainscapes to become well known, traveling throughout the region and into Oregon to paint along the Columbia River. Butman's work, such as *Mount Shasta*, simply but carefully focuses on the towering majesty of the great mountains, which rise out of a light-toned atmospheric haze in spectral grandeur, while painterly, yet detailed, foreground elements lend an air of authenticity. Himself inspired by artists such as Bierstadt, Butman influenced a number of later, and ultimately more sophisticated and famous, California painters. He went to New York City in 1866, setting up a temporary studio and auctioning a hundred of his western landscapes before going to Europe; having returned to San Francisco in 1869, he died two years later on a visit to his native town of Gardiner, Maine.[15]

 Gideon Jacques Denny was the earliest San Francisco specialist in marines, a natural theme for painters and patrons given the city's magnificent harbor and the commercial activity of ships of all kinds and nationalities. Denny was born in Wilmington, Delaware, and early worked as a sailor on boats in the Chesapeake Bay before joining the gold rush in 1849. After two years he turned to an artistic career, seeking training in Milwaukee from Samuel Marsden Brookes, then active as a portrait and landscape painter. In 1858 Denny returned to San Francisco, where his teacher joined him four years later. Denny specialized in painting clipper ships and shipwreck scenes influenced by the great English artist J.M.W. Turner.

 By the end of the 1860s San Francisco's society and economy had begun to stabilize, and this is reflected in the careers of both the city's early artists and a remarkable group of younger landscape painters. One of the most significant—indeed, one of California's greatest nineteenth-century painters—was **Thomas Hill**. Born in England, Hill had come to this country at fifteen with his family, which had settled in Taunton, Massachusetts. The young man started as a carriage painter and decorator, and in 1853 began to study at the Pennsylvania Academy of the Fine Arts. The following year he inaugurated his career as a professional landscapist, painting in the White Mountains of New Hampshire. Hill lived in the Boston area until concern for his health led him to travel overland to San Francisco in 1861. The following year he made his first trip to Yosemite with his young colleagues Virgil Williams and William Keith.

 Hill remained in San Francisco until 1866, when he exhibited one of his Yosemite paintings at the National Academy of Design in New York City and went to Paris to study with the German painter Paul Meyerheim. On his return in 1867 he lived in Boston, gaining acclaim with a ten-foot Yosemite painting (location unknown) shown there the

3.173

3.174

following year. His first great panoramic work, this was chromolithographed by Louis Prang. Ill health sent Hill back to San Francisco in 1871. The 1870s constituted the most successful period of his career; he gained the patronage of the brothers Charles and Edwin Bryant Crocker and was active in San Francisco's Bohemian Club and the newly formed Art Association. In 1875 Hill became a partner in one of the city's leading galleries, the shop of Joseph Roos, formerly of Snow and Roos. The following year Hill bought out the business, renaming it Thomas Hill and Co., but the depression at the end of the decade forced him to sell the gallery to Snow and Company. His most ambitious work, the famous historical picture *Driving the Last Spike* (California State Railroad Museum, Sacramento), was originally suggested by Governor Leland Stanford, president of the Central Pacific Railroad, but it was later turned down by Stanford, a bitter blow from which Hill never recovered.

In 1883 Hill built a studio in Yosemite Valley, and though it was demolished in a windstorm the following year, he returned frequently to paint in the region. In the summer of 1886 he established himself at Wawona, twenty-five miles south of Yosemite, near the Mariposa Grove of sequoia redwoods. Hill also worked at Yellowstone, and in 1887 he went to Alaska, commissioned by John Muir to paint Muir Glacier. More than almost any other of the scores of artists who visited and painted Yosemite, Hill is associated with the great valley, its magnificent cliffs, towering redwoods, and many famous waterfalls. Ruskinian in spirit but vigorous in technique, his style became increasingly sketchy, a painterly approach associated with Barbizon formal strategies. He has been accused of turning out high-quality potboilers for tourists. To some degree this is true, but his finest pictures, particularly his vast early masterworks—such as *Yo-Semite Valley* (1868; location unknown); *Great Canyon of the Sierras—Yosemite* (1871; Crocker Art Museum, Sacramento) (both painted in Boston); and *Yosemite Valley*—are unique in the grandeur they convey. 3.175 No other artist captured the spectacular vistas of the region while so accurately portraying its natural history.[16]

In 1862 another English-born painter, **Juan Buckingham Wandesforde**, appeared in San Francisco, having studied with the celebrated watercolorist John Varley. After arriving in this country in the early 1850s, Wandesforde had lived in New York City, where he painted portraits and landscapes and taught CORNELIA ADELE STRONG FASSETT; he 1.347 then went to Montreal. Once in San Francisco, Wandesforde established himself first as a portraitist and then as a painter of the Sierra Nevada and of "tropicals." Known for his 3.176 oils and watercolors, he was active in the art community in the 1860s and '70s.[17]

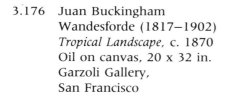

3.176 Juan Buckingham Wandesforde (1817–1902) *Tropical Landscape*, c. 1870 Oil on canvas, 20 x 32 in. Garzoli Gallery, San Francisco

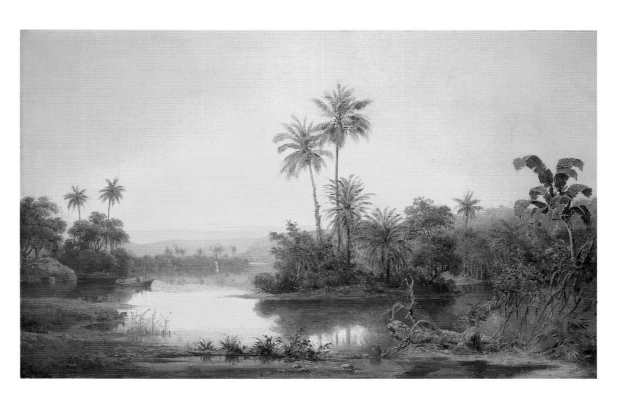

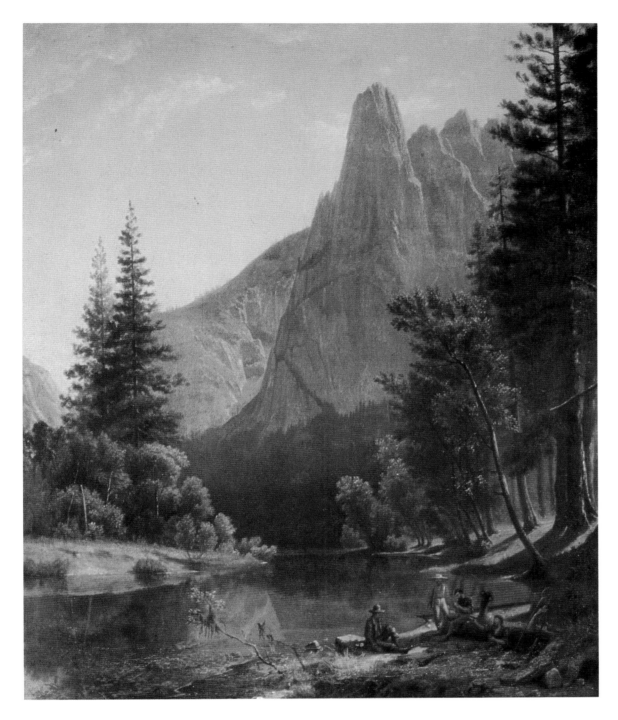

3.177 Virgil Williams
(1830–1886)
Along the Mariposa Trail, 1863
Oil on canvas,
41½ x 35½ in.
California Historical Society,
San Francisco

In 1863 Albert Bierstadt arrived in California, the most significant early artist-visitor from the East. This trip took the artist through Nebraska, Colorado, Wyoming, Utah, and Nevada to San Francisco. From there he traveled up the Sacramento River into Oregon, along the Columbia River, and down to Yosemite before returning to New York City via the Isthmus of Panama. The Yosemite trip was made with Enoch Wood Perry and Virgil Williams (who had been there with Thomas Hill the previous year). Bierstadt's transcontinental traveling companion, Fitz Hugh Ludlow, published an article in the *Atlantic Monthly* about this visit in June 1864. Throughout the rest of the 1860s Bierstadt based an extended series of magnificent paintings of Yosemite on the sketches he made at the time, most notably the fifteen-foot *Domes of Yosemite* (Saint Johnsbury Atheneum and Art Gallery, Saint Johnsbury, Vermont), painted in 1867 for LeGrand Lockwood of Norwalk, Connecticut. He became a resident of San Francisco on his return in the early 1870s, when his impact on the local art community was more direct and sustained.

Hill's companions on his first Yosemite trip, William Keith and **Virgil Williams**, became tremendously significant landscape painters in California. Virgil Williams had

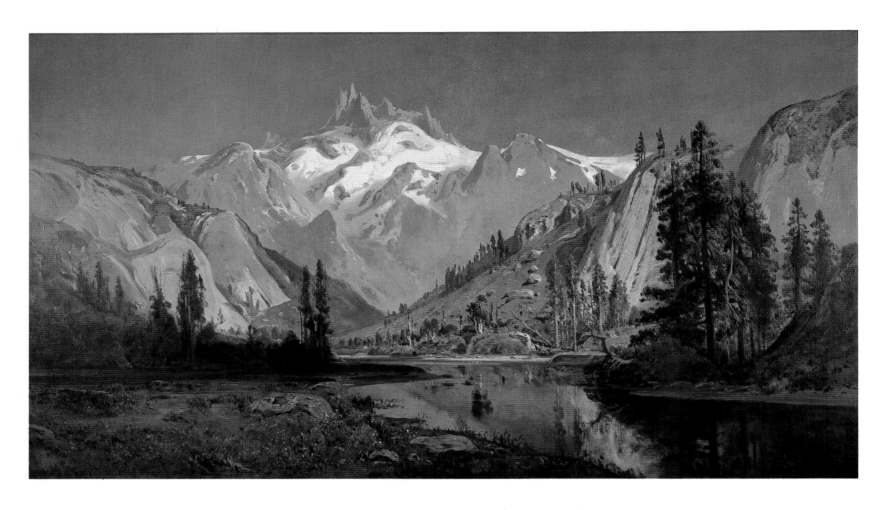

3.178 William Keith (1838–1911)
*Headwaters of the San Joaquin
River*, 1878
Oil on canvas, 40 x 72 in.
The Oakland Museum,
Oakland, California; Gift of
the Keith Art Association

studied with Daniel Huntington in New York City and then spent the years between 1853
and 1860 in Rome, working with the well-known American expatriate William Page,
whose daughter he married. On his return Williams settled in Boston, where he was
visited by Robert Woodward, whom he had met in Florence and who had purchased
from Williams some copies of old master paintings. Woodward pressed Williams to go to
San Francisco and to design and install an art gallery for him. Williams went to California
in 1862 and worked for Woodward, whose San Francisco gallery was incorporated in
1866 as Woodward's Gardens, a park featuring amusements, a zoo, and an aquarium;
the gallery itself showed works by Bierstadt (whom Williams knew from Italy) and other
painters and sculptors, in addition to the copies and original landscapes by Williams.
Following his trip to Yosemite in 1862, Williams continued to paint scenes in that area
as well as the Sonoma Valley and elsewhere in Northern California, working in a
naturalistic style akin to that of the Hudson River School. Failing to achieve commercial
success, he returned to Boston in 1866, settling permanently in San Francisco only in
1871. In 1874 he was hired as the first director of the newly formed School of Design of
the San Francisco Art Association and until his death in 1886 had a tremendous influence
on a generation of students from all over the West. Williams's landscapes consist of Italian
views, based on observations made during his long residence abroad, and California
scenes, such as *Along the Mariposa Trail*.[18] 3.177

Scottish-born **William Keith** had emigrated as a youth, in 1850 settling in New
York City, where he trained as an engraver and worked for Harper Brothers. In 1859 he
arrived in San Francisco and established his own engraving business. Keith began to study
painting with Samuel Marsden Brookes in 1863. Engraving remained his principal
occupation until 1868, when he turned to oil painting, although he had already begun
to work professionally in watercolor. Keith's major breakthrough as a painter was a
commission from the Oregon Navigation and Railroad Company in 1868 to paint the
scenery of the Pacific Northwest. In 1869 he went to Düsseldorf, where he studied with
Albert Flamm and was influenced by Andreas Achenbach, returning to this country two

years later. Keith spent much of 1871 in Damariscotta, Maine, with his wife's family. At
3.194 the end of the year he took a studio in Boston, which he shared with WILLIAM HAHN, a
German-born genre painter he had met in Düsseldorf. Like Hill, Keith made a tremendous
impression in Boston with his views of Yosemite. In May 1872 Keith and Hahn left
Boston for San Francisco.

No sooner was Keith back in California than he headed to Yosemite. From studies
made there he began his painting of Mount Lyell, *The Crown of the Sierra* (location
unknown), the first of his "epics"—panoramic views done in obvious competition with
Hill and Bierstadt. In Yosemite in 1872 Keith met John Muir, who championed his art
and encouraged the painter to take a topographical approach even in his later, more
subjective work. *The Crown of the Sierra* was succeeded by six- to ten-foot canvases almost
3.178 every year during the 1870s, including *Headwaters of the San Joaquin River,* which celebrates
the almost unbelievable natural glory of the West. By the end of the decade Keith was
getting restless; he painted in Maine and New Hampshire for the summer and early fall
in 1880, and the contemporaneous critical responses to the resulting works he took back
to San Francisco suggest the influence of new, broadly painted, more harmonious strategies
encountered in the East.

In 1883 Keith traveled to Munich, which had displaced Düsseldorf as the center
for artistic study in Germany. He was undoubtedly pointed in that direction by such San
Francisco artists as Toby Edward Rosenthal, who had become a successful Munich
3.199 expatriate, and THEODORE WORES, who had returned from there in 1881, taking a studio
in San Francisco adjacent to Keith's. In Munich, Keith was influenced by other American
2.299 expatriates—CARL VON MARR from Milwaukee in figure painting and J. Frank Currier in
landscape. By the time he returned to San Francisco in 1885, his art had changed
profoundly, focusing on more modestly scaled and quietly poetic scenes of oak groves,
still pools, and fields filled with cattle. His new work was influenced by the Barbizon
painters and by his desire to infuse his work with spiritual content related to his belief in
Swedenborgianism. Thus, he was allied with the East's leading landscape painter of the
1.41, 1.244, period, GEORGE INNESS, who visited California for the first time in 1891, spending time
2.68 with Keith in San Francisco, Monterey, and Yosemite; his visit culminated in a joint
exhibition of their work in San Francisco that June.

The 1890s were years of consolidation and security for Keith. In 1893 he had a
solo show at the Macbeth Gallery in New York City, where he was greeted as a "new"
artist inspired by Inness; that year he also visited the World's Columbian Exposition in
Chicago, stopping off to see Inness in Montclair, New Jersey, before traveling to Spain.
Keith went to Holland in 1899 to study the works of Rembrandt. His paintings of the
early twentieth century became dark and moody, taking on an old master appearance in
opposition to the rising tide of Impressionism. In 1903 he was commissioned by the Saint
Francis Hotel in San Francisco to paint two murals of California, one an eleven-foot view
of Mount Tamalpais, the other a smaller evening scene with an oak tree, more in keeping
with his then-current concerns; both were destroyed in the earthquake and fire of 1906.
Keith remained active after that disaster, one of the last—and among the greatest—of
America's Barbizon artists.[19]

Among the other outstanding landscape painters who were active in San Francisco
3.88 at this time were Ransom Holdredge, William Lewis Marple, and HARVEY OTIS YOUNG. New
York–born **Ransom Holdredge** went to San Francisco in 1858, working as a marine
draftsman; during the 1860s he turned to painting and was exhibiting California scenes
by 1869. Holdredge's paintings—like early works by Keith, with whom he was favorably
compared—are panoramic mountain landscapes. In the mid-1870s Holdredge is said to
have studied in France for several years and adopted broader, more dramatic formal
strategies. Holdredge later traveled extensively in the Northwest, living among the Indians,
3.179 and many of his later paintings are landscapes with aboriginal subjects, such as *Sioux
Encampment in the Rockies.*

3.32 **William Lewis Marple** and Harvey Otis Young were, for a short while, the leading
painters of California scenery in San Francisco after Frederic Butman, Virgil Williams,

3.179 Ransom Holdredge
(1836–1899)
*Sioux Encampment in the
Rockies*, c. 1880
Oil on canvas, 42 x 69 in.
The Phelan Collection

RIGHT:
3.180 William Lewis Marple
(1827–1910)
*Mount Tamalpais from Napa
Slough*, 1869
Oil on canvas, 20 x 32 in.
California Historical Society,
San Francisco

and Thomas Hill left for the East in 1866. They were both attracted by the lure of gold; Marple, considerably older, arrived in 1849, and Young, a decade later. Both retained dual interests in art and mining. Marple was one of literally hundreds of San Francisco painters to be inspired by Mount Tamalpais across the Golden Gate. He was active in the local art community, attracting, in 1872, the patronage of Solomon Gump, owner of one

3.180

of the city's first commercial galleries. Despite his financial success Marple went east in 1877, first living in New York City and then, in 1879–81, in Saint Louis, returning to mine silver with Young in Aspen, Colorado, in 1881.

Young, also a successful landscapist in San Francisco in the late 1860s, painted scenes from Mount Shasta to Yosemite until he moved to New York City in 1871. From there he made six trips abroad, spending the summer of 1875 with the American contingent in Munich and 1877 at Grèz in France with Alexander and LOVELL BIRGE HARRISON; in 1878 he studied in Paris. Young was also in San Francisco exhibiting work during these years, and he painted in the Rockies in 1873 and '74. In 1879 he moved permanently to Colorado, living in Manitou Springs and pioneering in silver mining in Aspen; he became one of Colorado's leading painters.[20]

While landscape was the strongest thematic tradition in California, the state was also home to a succession of able still-life specialists. One first-rate artist who joined the San Francisco community in the 1860s was **Samuel Marsden Brookes**, who soon became a nationally famous still-life painter. Having been active in Chicago and Milwaukee, in 1862 he followed the lure not of gold but of patronage to California, perhaps encouraged by his former pupil Gideon Jacques Denny, with whom Brookes shared a studio for many years. The young William Keith studied with Brookes the year after he arrived from Milwaukee. Though at first his production consisted primarily of portraiture, Brookes's aim was to specialize in still lifes, which he painted and occasionally sold. Although he made a comfortable living, with a monthly income of about three hundred dollars in the 1860s, it was not until the prosperous 1870s that he gained the patronage of leading collectors and the acclaim of the public and critics. In 1872 Edwin Bryant Crocker bought a large kitchen piece that Brookes had painted in 1862, a depiction of vegetables, a turkey, dead game, and fish lying on and hanging against an assertive stone wall and ledge (Crocker Art Museum, Sacramento). Mrs. Mark Hopkins purchased a brilliant study of a live peacock (destroyed in the San Francisco fire and earthquake of 1906) in 1880, voluntarily doubling the thousand-dollar price she had originally agreed to pay. Brookes's paintings of living birds, fish, and animals are a fascinating feature of his oeuvre, but it was in the realm of still life that the artist reigned supreme. These fall, for the most part, into three categories: lovely Victorian arrangements of flowers and bric-a-brac, sharply defined and brightly colored, akin to those painted at roughly the same time by ROBERT SPEAR DUNNING in Fall River, Massachusetts; depictions of hanging fruit—peaches and especially grapes—glistening against illusionistic stonework; and renderings of fish.

Though they lost their popularity in the twentieth century, fish paintings were fashionable and well patronized in America from the 1860s on, acquired by sportsmen and collectors on both coasts. None could equal Brookes's ability to capture the essence of shiny scales in microscopic detail and the myriad tints amid silvery grays, especially of the salmon he so often painted as hanging trophies. Even his fellow artists such as Hill and Bierstadt acknowledged his supremacy in this subject.[21] EDWIN DEAKIN, best known for his paintings of the California missions, became a close friend and disciple of Brookes, emulating his hanging bunches of grapes; Brookes's accentuated stonework backgrounds are even more emphasized in the hands of a specialist in architectural painting.

The San Francisco art community had crystalized sufficiently by the mid-1860s that organizations began to be established for exhibiting and selling works of art. Paintings had been included in the annual state fairs, which began in 1854, but these were held elsewhere: in San Jose in 1856, in Stockton in 1857, in Marysville in 1858, and in Sacramento from then on. In 1857 the Mechanics' Institute in San Francisco began its industrial expositions, which incorporated art galleries. During the Civil War the Ladies' Christian Commission Fair included an art gallery organized by the painter WILLIAM SMITH JEWETT, though the fair seems not to have been comparable to those held in support of the Sanitary Commission in the East and Midwest. Commercial galleries appeared in the 1860s—most notably that of Snow and Roos, founded in 1867. In 1865 SAMUEL MARSDEN BROOKES spearheaded the founding of the California Art Union, a subscription and lottery

3.181 Samuel Marsden Brookes
(1816–1892)
Steelhead Salmon, 1885
Oil on wood, 40 x 30 in.
The Oakland Museum,
Oakland, California;
Kahn Collection

organization undoubtedly patterned after the auctions that he had established in Milwaukee with his partner, Thomas Stevenson. The most ambitious work acquired by the art union was THOMAS HILL's *Trial Scene from the Merchant of Venice* (location unknown), an unusual 3.175 subject based on performances of the Shakespearean drama by Charles Kean. Photographic copies of Hill's picture were offered to all subscribers, but this promise was not kept, and it has been suggested that the $700 payment to the artist was at least partly responsible for the organization's quick demise. Brookes managed the subsequent San Francisco Artists' Union, another lottery-subscription organization, founded at the end of 1868 and made up of eighteen local professional artists. This, too, appears to have lasted only a year and may not have held any exhibitions.

No specialized art magazines were published in San Francisco during the nineteenth

century, with the exception of the short-lived *California Art Gallery,* which appeared for five months early in 1873. Works by California artists did appear in Hutchings' *Illustrated California Magazine* from 1856, and in July 1868 the *Overland Monthly* began publication, with extensive coverage of art, primarily in San Francisco itself. The city benefited from the sympathetic criticism of Benjamin Parke Avery (brother of the well-known New York art dealer Samuel P. Avery), who had gone to San Francisco during the gold rush. Avery became a noted, empathetic writer whose articles appeared in the *Overland Monthly* and in the New York periodical the *Aldine,* and he was also an important patron.[22]

Until the 1870s would-be artists in San Francisco had to rely on private instruction in the studios of established painters. One of the most successful was the Irish-born, Italian-trained Joseph Harrington, a figure painter who set up a local studio in 1870 and painted some of the same themes of California life as CHARLES CHRISTIAN NAHL. Primarily noted as a painter of altarpieces for Catholic churches, Harrington had among his students GIUSEPPE CADENASSO, HENRY RASCHEN, and THEODORE WORES.

The San Francisco Art Association was initiated at a gathering of artists at the home of JUAN BUCKINGHAM WANDESFORDE in 1871. A long-lasting, active, and successful exhibition organization, it presented semiannual shows until the depression at the end of the decade. In 1880 JULES TAVERNIER, then vice president of the association's board of directors, called for the formation of the Artists' Union, through which the association held regular auctions of members' work. Tavernier was also responsible for the institution of the Artists' Fund Society, patterned after organizations in New York City and Philadelphia, to help support the widows and heirs of indigent deceased members. And in 1884 the Palette Club was started by Tavernier and CHARLES DORMON ROBINSON (who served successively as its president), in response to complaints about the inclusion of too many potboilers in the association's exhibitions; this group held two annuals before reuniting with the parent organization, which patrons had continued to favor.

In 1874 the association had founded the California School of Design, with VIRGIL WILLIAMS as its director. One of his students, a deaf-mute artist named Theophilus d'Estrella, kept a useful record of Williams's teaching methods and aesthetic concerns. D'Estrella later became a noted teacher of deaf art students such as GRANVILLE REDMOND at the Institution for the Deaf, Dumb and Blind in Berkeley.[23] In the beginning Williams and his assistants oversaw all instruction, but in 1890 specialized classes began to be supervised by individual instructors. By 1897 ARTHUR F. MATHEWS was teaching the life class and Amédée Joullin was supervising still life; RAYMOND DABB YELLAND, the class in perspective and sketching; and Harry Fonda, the costume class. The sculptor Douglas Tilden offered modeling. All of these artists except Yelland had been students at the school.

The association and school had no fixed site until they were offered the Mark Hopkins mansion on Nob Hill; they moved into it in 1893, and the school, renamed the Mark Hopkins Institute of Art, became affiliated with the University of California. The most successful and prominent art school in the West for many decades, the school naturally attracted many students from San Francisco and the surrounding region, such as Theodore Wores, but young aspirants came from all over the West. JAMES T. HARWOOD, from Evansville, Utah, enrolled in 1885 and later became one of Utah's finest painters. Harwood's closest companion at the school, with whom he subsequently traveled to Europe, was GUY ROSE from Southern California; even as the Los Angeles area developed a cultural complex of its own, the lack of a formal art school brought many young painters to San Francisco for training.

Among the school's early matriculants, it was perhaps Alexander Harrison who rose to greatest prominence. Having joined the United States Coastal Survey as a draftsman, he arrived in San Francisco about 1876 and soon entered the school, winning a gold medal in 1878. The following year Harrison left to live in Europe, where he achieved international fame, especially for his Tonal marines.

Perhaps the most prolific of Virgil Williams's early students at the school was JAMES EVERETT STUART, a descendant of the great portraitist GILBERT STUART. In 1860, at the age of eight, the boy traveled with his family across the Isthmus of Panama, then settled on

3.168

3.212; 3.201;

3.199

3.176

3.190, 3.259

3.186

3.177

3.234

3.207

3.185

3.98

3.242

3.137

1.83

a ranch in the Sacramento River Valley. About ten years later Stuart had his first art lessons with the painter and photographer David Woods in Sacramento and then studied at the School of Design. Stuart painted in Ashland and Portland, Oregon, then moved to New York City in 1886 and to Chicago in 1891; he also traveled extensively throughout the Northwest, Alaska, and Mexico. In 1912 he returned to San Francisco, where he remained for almost thirty years and is said to have painted over five thousand works, mostly landscapes, including a series of mission views.

The Mark Hopkins Institute of Art was completely destroyed in 1906 but it was rebuilt on the same site the following year, changing its name to the San Francisco Institute of Art. A decade later it was renamed the California School of Fine Arts (and in 1961 was renamed, yet again, the San Francisco Art Institute).[24]

Related to the founding and expansion of the San Francisco Art Association was the establishment in 1872 of the Bohemian Club, a cultural fraternal organization that exists to this day. The Bohemian Club was a Pacific coast counterpart to the Sketch Club founded earlier in New York City, which survives today as the Century Association. Both clubs brought together artists, writers, journalists, and amateurs; both sponsored exhibitions and developed important permanent collections; and both remained staunchly all male. In the case of the Bohemian Club, journalists rather than artists sparked its formation, though among its original twenty-four charter members were the English-born painter and mining engineer Frederick Whymper, then in the editorial department of the *Alta California* newspaper, and Hiram Bloomer, a young landscape painter who had studied privately with Virgil Williams and Thomas Hill. In 1874 Bloomer went to Paris to study with Carolus-Duran and then worked in England, returning to San Francisco in 1892, when he became active once again in the Bohemian Club. He was one of the San Francisco landscapists who preferred informal, pastoral subjects rendered in a Barbizon-related mode. Bloomer also worked with Charles Dormon Robinson on an enormous panorama of Yosemite.[25]

The club's major social events were the Jinks, celebrations on the last Saturday evening of every month, each organized by one of the members, designated the ''Sire,'' who was chosen by the Jinks Committee. These evenings showcased oratorical, elocutionary, poetic, musical, and artistic contributions from other members. Gradually, other forms of Jinks developed, including Low Jinks, which followed dinner after the High Jinks entertainment and often comprised a more extemporaneous burlesque on the preceding High Jinks. In 1878 the club begun to hold open-air Midsummer Jinks in the country, which soon took on the ebullience of the in-town festivities.

Not surprisingly, most of the written and musical inventions of the club have long disappeared, but some of the artistic contributions, known as Cartoons, survive in the club's collection. These Cartoons were drawn or painted to illustrate the topic of a specific evening and are frequently striking pictures, highly finished and well framed. Though not cartoons in the comic sense, they occasionally involve caricature. Almost all the significant male painters of San Francisco were members of the club, and most of them contributed Jinks Cartoons at one time or another. Jules Tavernier was especially associated with their creation early in the club's history, and Theodore Wores, somewhat later.[26]

San Francisco's wealthy collectors emulated their eastern counterparts in acquiring works by European old masters and contemporary academicians, but regional favoritism led them to patronize local artists as well. With an art establishment thus firmly in place, the city became a mecca for painters for about a decade. Some from the East appear to have had more influence and to have stayed longer. In 1869 R. Swain Gifford was in San Francisco on commission for William Cullen Bryant's *Picturesque America* (published serially beginning in 1872); two of Gifford's three sets of illustrations were entitled ''The Coast of California'' and ''Northern California.'' On commission to illustrate the section on Yosemite (which he also wrote) for the same publication, James David Smillie arrived in 1871, accompanied by his younger brother, the artist George Henry Smillie. In 1872 THOMAS MORAN made a hurried trip to illustrate scenes along the Central and Union Pacific railroads for the piece entitled ''On the Plains and the Sierras'': views of spectacular rock

1.152, 1.254

formations in Utah, of the peaks of the Sierra Nevada, and of Donner and Tahoe lakes, ending in Oakland, after which the artist headed for Yosemite. Moran was familiar with the scenery there, having illustrated an article, "The Big Trees and Yosemite," for *Scribner's Monthly* the previous January, but those were done from photographs. The cool grandeur of Yosemite did not impress Moran, though he did find renewed inspiration during a return visit in 1904.

2.48 **John Ross Key**, who appeared in San Francisco in 1869, became very much a part of the local establishment despite his short stay. By December 1870 he had returned to Baltimore, where he exhibited a large number of California scenes, and then spent most of that decade in Boston. In California, Key traveled extensively, to Yosemite and to Lake Tahoe, and held several exhibitions in San Francisco in 1870. Some of his many
3.182 views of Lake Tahoe are among the finest depictions ever made of that lovely spot on the Nevada border. Key captured the lake's breadth and tranquility in views that are very different from the imposing mountains and vast panoramas that characterize California landscape of the period.[27] In their quiet harmonies and elongated horizontal formats, his paintings of 1869–71 reiterate the Luminist aesthetic, but the only artist traditionally
1.67, 2.69 associated with the Luminist movement who traveled to California was MARTIN JOHNSON HEADE. He appears not to have been terribly impressed by the experience, since only one California work, *Seal Rocks at San Francisco* (Oakland Museum), is located; but he did participate in the 1875 exhibition at the San Francisco Art Association.

In 1870 Thomas Hewes Hinckley, the Boston animal painter, was on the Mendocino coast seeking out deer and elk to paint. About that time Gilbert Munger established a studio in San Francisco, which he maintained for a number of years. The completion of the transcontinental railroad enabled him to move across the country in six days. From 1869 on, he spent summers on the West Coast and the remainder of the year in his studios in New York City or Saint Paul. In the fall of 1876 he showed depictions of the Wasatch Range in Utah and a much-praised *Glimpse of the Pacific* (location unknown), which was subsequently exhibited throughout the East. Munger followed these with pictures of mountain scenery, first Mount Tamalpais and then, in 1872, the far Northwest. He spent two seasons in Yosemite, receiving commissions from a party of Englishmen he met there, who encouraged him to move to London, which he did in 1877.[28]

3.182 John Ross Key (1837–1920)
 Lake Tahoe, 1871
 Oil on canvas, 20 x 40 in.
 Alfred C. Harrison, Jr.

3.183 Albert Bierstadt (1830–1902)
Seal Rocks,
San Francisco, 1872
Oil on canvas, 37 x 58⅝ in.
Private collection

Albert Bierstadt was back in San Francisco in the summer of 1871, spending time with Collis Huntington and selling paintings to Leland Stanford, both immensely powerful and wealthy railroad magnates and art patrons. Bierstadt participated in the newly formed Art Association, which made him its first honorary member. He returned east briefly in the autumn but was back in San Francisco by January 1872 and remained for almost two years. The daily press and the short-lived *California Art Gallery* magazine of 1873 kept close watch on his activities. Much of his time was spent making sketches in Yosemite and at Mount Whitney while also working on a ten-foot *Donner Lake from the Summit* (New-York Historical Society), completed in 1873 for Collis Huntington, which depicted the most challenging natural barrier that had been conquered in the completion of the Central Pacific Railroad. In the spring of 1872 Bierstadt sketched the sea lions on the Farallon Islands in the Pacific, twenty miles off the San Francisco coast—the same subject Martin Johnson Heade was to paint three years later—and the seals on the Seal Rocks opposite San Francisco's Cliff House. These depictions of the strange, lubricious mammals cavorting in their habitat constitute some of the most spectacular and unusual pictures of the artist's career. Bierstadt faithfully captured the diverse natural details: the rock structure eroded into fantastic shapes, the corrugated surface of the water, the translucent yet powerful waves. He painted at least four major pictures of these subjects, one of which, *Seal Rocks, San Francisco,* was acquired by the New York merchant prince and collector 3.183
Alexander T. Stewart. In the fall of 1873 the artist returned to New York City, having vitalized the San Francisco art community.[29]

Other eastern painters visited California during Bierstadt's second sojourn. PETER 1.344
BAUMGRAS, from Washington, D.C., was there by 1872, presumably having taken the old route across Panama, since he exhibited Panamanian and Mexican subjects at the Art

Association in 1872 and '73. Although he did sketch in Yosemite and although his largest, most significant landscape was of the canyon there, Baumgras was one of the few visiting painters during the period who was not attracted primarily by the state's scenery; he continued to paint and exhibit his staples of portraiture and still life. In 1873–74 LEMUEL M. WILES from New York traveled through Panama to California and painted in Yosemite; he appears to have been most interested in the missions. Wiles was one of the few visitors to spend time in Southern California, in San Diego. In 1874 and again in 1875 the pioneer Indiana landscapist GEORGE WINTER also visited the state.

1.208

2.225

Two of the most distinguished painters to go to San Francisco in the 1870s also arrived in 1875, and both remained for the rest of their lives. The peripatetic Danish landscape painter Ferdinand Richardt, who had come to this country in 1855, was known for his series of views of Niagara, displayed at the Niagara Gallery in New York in 1856 and '57. Richardt apparently returned to Europe in the early 1860s but was in San Francisco in the mid-1870s, continuing to paint Niagara views. He soon was attracted to Yosemite, especially its waterfalls. In the late 1870s he joined the new art colony in Monterey, painting more intimate views as well as the standard vistas.

Richardt lived in California for twenty years; the British-born marine painter **James Hamilton**, who arrived from Philadelphia in 1875, was not so fortunate. Having planned a trip around the world, Hamilton got no farther than San Francisco, where the beauty and activity of the harbor and surging Pacific were irresistible attractions. The limpid illumination and rapid execution of paintings such as his *Shipping on the Golden Gate* had no equal in the city during the mid-1870s. By the time Hamilton died early in 1878, he was so much a part of the local art world that his funeral was held at the Art Association; his colleagues acted as pallbearers, and students from the School of Design arranged the room and casket.[30]

3.184

The last major eastern painter to arrive in San Francisco in the 1870s was also a marine specialist but of a very different sort. WILLIAM BRADFORD, who had begun his career in New Bedford, Massachusetts, traveled extensively in the 1870s, and in 1879 he arrived in San Francisco. He is said to have maintained a studio there for seven years, though he was back in New York City by 1883. Bradford continued to turn out the arctic views he had begun to execute in 1861—he worked not only from sketches but also from his own superb photographs—while also exploring and painting the Yosemite and Mariposa valleys and the Sierra Nevada; he traveled as far as Mount Hood in Oregon.[31]

1.47

A whole group of landscape specialists came on the scene in San Francisco in 1874–75. One of the finest of these was English-born **Raymond Dabb Yelland**. Yelland

3.184 James Hamilton
(1819–1878)
Shipping on the Golden Gate, 1875
Oil on canvas on cardboard, 30 x 50 in.
The Oakland Museum, Oakland, California; Kahn Collection

3.185 Raymond Dabb Yelland (1848–1900)
The Golden Gate (Looking In), 1880
Oil on canvas, 40 x 72 in.
Garzoli Gallery, San Rafael, California

had grown up in New York City, studying at the National Academy of Design from 1868 until 1872. In 1874 he sailed around Cape Horn to San Francisco to take the position of art instructor at Mills College in Oakland. Joining the thriving art community, he became noted for his coastal scenes at sunset, such as *The Golden Gate (Looking In)*, which contrast broad stretches of sensitively painted, luminous green water with glowing, crumbly, rust-colored rock formations; these compositions are similar to those painted in a modified Luminist tradition by Alfred Thompson Bricher back East. Many of Yelland's paintings were done around San Francisco or across the bay, though he visited Jules Tavernier in Monterey in 1878 and spent the summers of 1880 and 1881 in Oregon. In 1877 Yelland assumed the assistant directorship at the School of Design, and after a trip abroad in 1886–88 for further study he was appointed director. As such, he had considerable influence on younger San Francisco artists.[32] 3.185

 A major landscapist who returned to the city in 1874 was **Charles Dormon Robinson**. Born in Maine, he grew up in San Francisco, and the daily activity on the bay made a lasting impression on him. In 1860 Robinson won a diploma for the best marine drawing in the juvenile department of the Mechanics' Institute exhibition. The following year his family returned to the East. Robinson studied in Boston with the portraitist Joseph Ames and the landscape painter Samuel Griggs and received advice and instruction from GEORGE INNESS, Albert Bierstadt, and various marine painters—William Bradford, 1.41, 1.244, Mauritz De Haas, and James Hamilton—which helped him decide the initial direction of 2.68 his art. Hamilton appears to have been the most influential, for when Robinson exhibited with the Art Association in 1875, he showed a copy after one of Hamilton's best-known pictures; the two undoubtedly renewed their acquaintance in California. Robinson's marines, such as *San Francisco Bay*, are naturalistic works with some of Hamilton's 3.186 romantic drama and with sunrise and sunset light predominant.

 Robinson made his first trip to Yosemite in 1880, setting up a studio where he spent the next ten summers; though forced to leave after a controversy with the State Board of Yosemite Commissioners, he continued to work in the Sierra Nevada for fourteen

more seasons, establishing himself as a leading interpreter of the area. Robinson was instrumental in the park's nationalization. In 1883 he conceived of a giant panorama of Yosemite as the only way to allow the public to appreciate its beauty and vastness, but a lack of capital forestalled his plan until 1892, when wealthy backers agreed to finance the project. Exhibited in San Francisco in 1893, the panorama measured 50 by 380 feet. It was shipped to Paris at the time of the 1900 world's fair, but there were no facilities for its exhibition, and so, deeply in debt, the artist cut it up and sold it for canvas to finance his trip home. Robinson published a detailed article about the panorama's inspiration and progress, having written previously about the redwood forests. Robinson painted his Yosemite pictures in the manner of the Hudson River School.[33]

Something of Robinson's devotion to Yosemite was passed on to the Norwegian emigrant Christian Jorgensen, who had been "discovered" by Virgil Williams and who became the first free student at the School of Design. After painting in and around San Francisco and Oakland, Jorgensen spent his first summer in Yosemite in 1898. Two years later he built a permanent studio there, which was open to the public and became a tourist attraction, embellished with an extensive garden; Jorgensen maintained the studio through 1917.[34]

Harry Cassie Best, who was born in Ontario, Canada, turned to art after seeing Mount Hood while traveling as part of a musical band in 1887. In 1895 Best and his brother, Arthur, settled in San Francisco, where Arthur and his artist-wife, Alice Leveque Best, established the Best Art School in 1897. Three years later Harry went to Yosemite, where he met Anne Ripley from Southern California; they were married at the foot of Bridalveil fall in 1901 and built a studio there the following year. Best turned out views of Yosemite in a blurred style that eliminated surface features and suggested atmospheric haze. His daughter married the photographer Ansel Adams in 1928, and his studio building survived as the Ansel Adams Gallery.[35]

A near-contemporary of Robinson, **William Coulter**, was probably the most successful of San Francisco's marine artists. Born in Ireland, Coulter spent seven years at sea, informing himself thoroughly about the structure of the ships on which he sailed.

3.186 Charles Dormon Robinson (1847–1933)
San Francisco Bay, n.d.
Oil on canvas, 22⅛ x 28 in.
The Oakland Museum, Oakland, California;
Kahn Collection

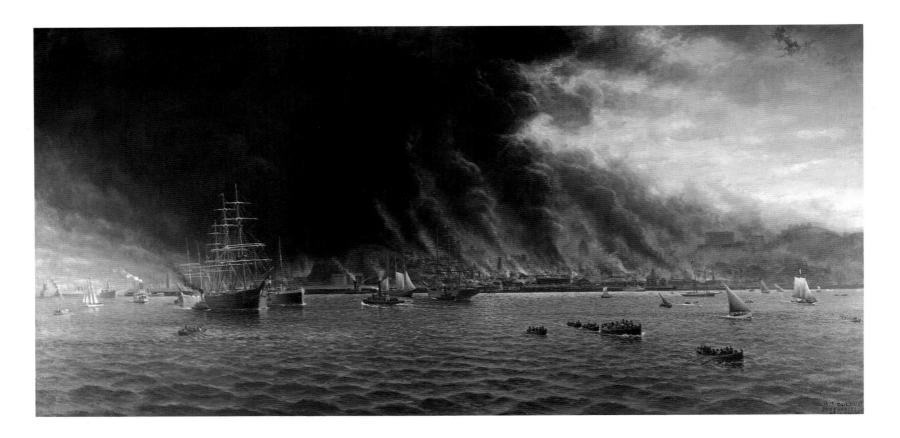

3.187 William Coulter (1849–1936)
San Francisco Fire, 1906
Oil on canvas, 60 x 120½ in.
Hirschl and Adler Galleries,
Inc., New York

Reaching San Francisco in 1869, he worked as a sailmaker and, exercising his natural gift for drawing, in 1874 he began to exhibit with the Art Association and the Mechanics' Institute. Originally self-taught, Coulter enhanced his skills by studying in Europe for three years, beginning in 1876. Having begun his career, as did most marine specialists, as a ship portraitist, he subsequently chronicled all phases of shipping on San Francisco Bay. A singular variation on this activity resulted from a seven-month visit to Hawaii in 1882, when he painted thirty large panels. He put them on public display in quasi-panoramic form as *Palette and Pen in King Kalakaua's Kingdom:* views of the islands' coastal regions and volcanoes rolled across a theater stage, accompanied by narration and music.

Coulter's proficiency in marine painting was later embodied in the most important undertaking of his career, the commission for five eighteen-foot murals of maritime life painted between 1909 and 1920 for the assembly room of the Merchants Exchange Building; a sixth panel was done by NELS HAGERUP, a prolific marine and coastal painter 3.139
in Portland, Oregon. Coulter's most spectacular easel painting, unusual for an artist who otherwise stressed the harmony and vitality of commercial shipping, was his ten-foot-long *San Francisco Fire,* painted in 1906 from studies made from his home across the 3.187
Golden Gate in Sausalito. The panoply of ships and boats steaming, sailing, and rowing across the bay; the inky blackness of the smoke; and the volcanic glow of fire reflected in the water conjure up an infernal—and all too real—vision.[36] San Francisco's marine tradition was continued into the twentieth century by Charles Henry Grant, who was born in the Great Lakes port of Oswego, New York, home to earlier maritime specialists such as JAMES GALE TYLER. In 1912 Grant moved to San Francisco, specializing in the 1.193
depiction of sailing vessels on stormy seas and in ship portraiture and the recording of fleets. One of his outstanding storm scenes is *At the Mercy of Neptune* (location unknown); among the latter category he took special pride in *The Atlantic Fleet Entering the Golden Gate, May 6, 1908* (Bohemian Club, San Francisco). In 1926 Grant was made official artist to the United States Navy on its visit to Australia.[37]

San Francisco's art community developed too late to be greatly influenced by the traditions of Düsseldorf. The one significant exception was the Prussian-born emigrant **Carl von Perbandt**, who had studied at the Düsseldorf Academy and then gone to New York City in 1870, though he may have been back in Düsseldorf by 1876. The following

year he moved to San Francisco, painting frequently at Monterey and living for a while in the backwoods of Sonoma County and among the Pomo Indians near Fort Ross, north of San Francisco. The influence of Düsseldorf is evident in his *Pomo Indians Camped at Fort Ross*. Von Perbandt returned to Germany at the beginning of the present century.

3.188

Another German landscapist who arrived in 1877 was Frederick Schafer, who probably traveled via the Isthmus of Panama with a stop at Mazatlán, Mexico. During the 1880s Schafer ranged all over the Northwest and the Rockies, painting panoramic mountain landscapes, though in a broader style and with more vivid colors than his compatriot. The 1880s appear to have been the high point of Schafer's career, though even then he had to supplement his income with commissions for theater scenery. Meyer Strauss, a third German emigrant artist, had come to this country in 1848 and spent over twenty-five years as a scene painter in the Midwest and South before settling in San Francisco in 1873. Strauss continued in his chosen line of work until 1877, when he began to devote himself full-time to easel painting. The Bay Area, Marin County, Monterey, and Yosemite were his preferred subjects, though he also painted still lifes and scenes in San Francisco's Chinatown.

Among other notable European-born landscapists to emerge during the 1870s were **Marius Dahlgren** (or Dahlgreen; the double *e* was dropped shortly after he arrived in the United States), and his older brother Carl Christian Dahlgren. Both had studied in their native Denmark and emigrated in 1872, living in Salt Lake City until moving to San Francisco in 1878. Both painted the local landscape, and Marius also sketched in the Northwest and Alaska in 1888–89. Carl, who painted a noteworthy series of San Francisco street scenes in the wake of the earthquake and fire of 1906, remained active in California for his whole life; Marius stayed there until 1902, when he moved to Tucson, Arizona. Another European emigrant was Belgian-born Henry Cleenewerck, who traveled to California via Cuba about 1879. He remained until at least 1903, painting in the Bay Area and at Yosemite.

3.189

3.259

A leader among the arrivals in the mid-1870s was the French landscapist **Jules Tavernier**. Trained in Paris, he had begun his career as a correspondent during the Franco-Prussian War and then worked as an illustrator for the *London Graphic*. Tavernier probably came to America at the end of 1871, becoming an illustrator for *Harper's Weekly* and the *Aldine*. In 1873 he began to work for *Harper's* in collaboration with the little-known Paul Frenzeny; later that year the magazine sent them west to document a cross-country trip. They arrived in San Francisco in 1874, and Tavernier immediately became active in the

3.188 Carl von Perbandt
(1832–1911)
Pomo Indians Camped at Fort Ross, 1886
Oil on canvas, 54 x 84 in.
The Oakland Museum,
Oakland, California;
Kahn Collection

3.189 Marius Dahlgren
(1844–1920)
View from Goat Island, San Francisco Bay, 1887
Oil on canvas, 30½ x 50 in.
The Oakland Museum,
Oakland, California;
Kahn Collection

3.190 Jules Tavernier (1844–1889)
Artist's Reverie, 1876
Oil on canvas, 24 x 50¼ in.
California Historic
State Capitol Commission;
Collection of Oscar and
Trudy Lemer

Art Association and Bohemian Club, moving into the latter's premises; late the following year he took a studio in Monterey, which marked the beginning of the art colony there. With its unspoiled setting, Monterey was ideal for Tavernier, removed from the expensive, cacophonous city and yet still accessible to it. Other artists were drawn to Monterey by his presence and shared his studio: the landscapists HARVEY OTIS YOUNG, Raymond Dabb Yelland, Carl von Perbandt, and Julian Walbridge Rix and the figure and portrait specialist JOSEPH STRONG. Tavernier returned to San Francisco at the end of 1878, becoming a force for change at the Art Association. He appears to have become less active as a landscape painter and to have devoted more time to his better-received narrative pictures, especially of Indian subjects. Hounded by creditors, he left for Hawaii in 1884, becoming the islands' most significant painter during the next half-decade.

3.88

3.203, 3.258

Tavernier's landscapes depicting groves and large rock formations in Monterey often were painted in a "French" (i.e., modified Barbizon) mode that puzzled critics familiar with the objective manner of William Keith and Thomas Hill. Indeed, Tavernier may be credited with introducing this more romantic, subjective aesthetic into California painting, though its reception was mixed. One of his most notable works, *Artist's Reverie* is an intimate picture with figural shapes and faces emerging from the campfire smoke, the rocks, and the clouds. Though a fantasy, the work relies on objective documentation

3.190

for its pictorial premise, combining detailed narrative with broader effects in the dramatic landscape.[38]

Tavernier's adaptation of Barbizon strategies to the Monterey landscape may have influenced work created there by other painters, which occasionally projects this same quality, unlike their interpretations of landscapes elsewhere in California. **Julian Walbridge Rix** appears to have been influenced by Tavernier, and some of his work suggests the impact of Barbizon. Having gone to San Francisco from Vermont at the age of fifteen, Rix studied briefly with Virgil Williams at the School of Design. His closest associates in the 1870s were Tavernier and Amédée Joullin, and Rix followed the former to Monterey.

3.191 Many of Rix's California works are characterized by deep shadows, gray skies, and dark trees, often depicted at twilight. When Tavernier returned to San Francisco in 1879, Rix not only joined him but shared his studio. With the declining market, however, he moved to Paterson, New Jersey, in 1881, at the suggestion of the wealthy collector William Ryle, who had visited San Francisco in 1880. Rix continued to show work in San Francisco, provided illustrations in 1888 for *Picturesque California,* and returned in 1901 to paint at Monterey and Santa Barbara.[39]

Besides William Keith, the principal California landscape painter to ascribe whole-heartedly to the precepts of Barbizon at the end of the nineteenth century was **Thaddeus Welch**. Born in Indiana, Welch grew up in Oregon and then went to California in 1866, where he studied privately with Virgil Williams. In 1874 he went to the Royal Academy

2.177 in Munich, joining the group of young Americans that revolved around FRANK DUVENECK
1.64, 1.120, and forming a close friendship with JOHN TWACHTMAN. In 1875 Welch joined the colony
2.178 of artists working outdoors at Polling, Germany, going there with Walter Shirlaw and Harvey Otis Young. About 1879 Welch moved to Paris and first experienced the influence of the Barbizon masters Jean-Baptiste-Camille Corot and Charles-Francois Daubigny. Returning to this country in 1881, he painted professionally in New York City, Philadelphia, and Chicago, and then went to Australia. Although in San Francisco for a while in 1889, Welch did not settle in the region until 1894. Living in Marin County, he began to paint

3.192 informal rural scenes of humanity at one with nature. In such works as *A Cottage in the Marin County Hills* the artist substituted bucolic quiet for the traditional grandiosity of California landscape interpretations, which he himself had occasionally essayed in the 1870s and '80s. When his health deteriorated, Welch sought the milder climate of Santa Barbara in 1905.[40]

3.83 A final artist with European connections, **Edwin Deakin**, established a reputation based on renderings of the California missions. Born in England, Deakin came to this country in 1856, settling in Chicago at the age of eighteen and starting to paint in 1869.

3.191 Julian Walbridge Rix (1850–1903)
Landscape (Twilight Scene with Stream and Redwood Trees), n.d.
Oil on canvas, 83½ x 46½ in.
The Oakland Museum,
Oakland, California; Bequest
of Dr. Cecil E. Nixon

3.192 Thaddeus Welch (1844–1919)
A Cottage in the Marin County Hills, n.d.
Oil on canvas, 20 x 36 in.
The Oakland Museum, Oakland,
California; Bequest of Ida D. Graham

The following year he moved to San Francisco. His work of the 1870s consisted of standard California scenery and landscapes painted elsewhere in a contemplative mode admired by contemporary critics. Deakin also painted picturesque scenes of English abbeys and castles, continuing to do so after his first trip to Europe in 1878–80. The missions became his primary theme despite the fact that several of them had been destroyed and he had to work from sketches or photographs. The buildings themselves range from simple, long arcaded structures to majestic churches such as that of San Carlos Borromeo in Carmel, which Deakin rendered silhouetted against the sky, emphasizing the strongly patterned and textured stucco and brickwork. In addition to single paintings, he produced at least three sets of all twenty-one missions, in both oils and watercolor, between 1870 and 1898. Deakin was not the first to depict these subjects—William Keith had sketched them all in 1883, painting some of them; Henry Chapman Ford had published etchings of the entire group in 1883; Oriana Day, a Boston-born painter of Spanish colonial life, had painted all twenty-one between 1867 and 1884; and Christian Jorgensen produced eighty watercolor studies and a complete set of oils, primarily in 1904–5. But it was Deakin who turned the state's attention to the missions as artistic as well as historical monuments and thus aroused interest in their restoration.

In 1882–83 Deakin visited Denver and Salt Lake City, in both of which cities he

3.193

3.193 Edwin Deakin (1838–1923)
The Mission of San Carlos Borromeo de Carmelo, 1895
Oil on canvas, 50 x 60 in.
Seaver Center for Western History Research, Natural History Museum of Los Angeles County

was lionized. After the earthquake of 1906 he painted a series of views of San Francisco in flames, suddenly finding the picturesque in his own backyard. He was much admired for his many still lifes, especially of grapes painted against architectural backgrounds in a mode similar to the patterned, crumbling stucco in his depictions of the missions.[41]

Professional figure painters were active in San Francisco in the 1860s and '70s. One of the earliest, Benoni Irwin, was a Canadian-born portrait and genre painter who studied in New York City at the National Academy of Design from 1864 until 1867, when he began exhibiting portraits. Irwin was in Toronto in 1868–69, and in 1870 he visited California, settling there for five years in 1872. Thus, he was in San Francisco and Oakland during the growth of the art community, in which he participated. Active primarily as a portraitist, Irwin painted a wide variety of figural works—sentimental pieces such as *The Little Artist* and *The Little Orphan* (locations unknown), scenes from *Don Quixote*, and Orientalist subjects. In 1877 he left San Francisco, probably for Paris, where he studied with Carolus-Duran; in the early 1880s he was in New York City, an Associate of the National Academy and an active exhibitor and painter of many of the Academy's diploma portraits, including that of Frederic Remington.

San Francisco's foremost genre specialist of the 1870s was German-born **William Hahn**, who studied at the Dresden Academy under Düsseldorf-trained Julius Hübner and,
3.178 in 1854, at the Academy in Düsseldorf itself; he met WILLIAM KEITH when the latter was in Düsseldorf in 1869. In 1871 Hahn emigrated to this country, having exhibited in San Francisco, Saint Louis, New York City, and Boston, where he settled. He was joined by Keith at the end of the year, and the two artists shared a studio. Keith took Hahn to San Francisco in 1872, and by 1876 the German emigrant was living at the Bohemian Club and was president of the Art Association.

Hahn traveled throughout Northern California in search of picturesque subjects

3.194 William Hahn (1829–1887)
Market Scene, Sansome Street, San Francisco, 1872
Oil on canvas, 60 x 96 in.
Crocker Art Museum, Sacramento, California

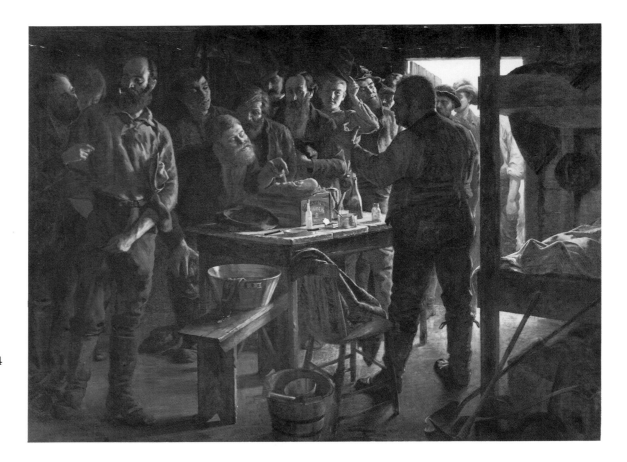

3.195 Oscar Kunath (1830–1909)
The Luck of Roaring Camp, 1884
Oil on canvas, 42¼ x 55⅜ in.
The Fine Arts Museums of
San Francisco; Gift of Mrs.
Annette Taussig in memory
of her husband, Louis Taussig

typical of the state. The panoramic vistas in his paintings of Yosemite serve as a foil for well-dressed visitors, and his works are fascinating documents of the growth of tourism, facilitated by the transcontinental railroad and by official promotion of the region. Hahn also painted rural workers and animals against well-rendered landscapes, such as vaqueros herding cattle in Monterey. His perceptive, unsentimental renderings of childhood include such subjects as children at their lessons, sleigh-riding, and sneaking into the circus.

Hahn's most renowned works, *Market Scene, Sansome Street, San Francisco* and 3.194
Sacramento Railroad Station (Fine Arts Museums of San Francisco), exhibited in 1874, are deftly handled, sprawling urban scenes containing diverse figures, abundant still-life details, and specific renderings of buildings, all situated in careful perspective. The former composition, which must have been created to demonstrate Hahn's Düsseldorf-inspired abilities in complex genre, was a success; it was displayed at Snow and Roos's gallery and purchased by Edwin Bryant Crocker. The latter work is a quieter and more disciplined scene, incorporating the railroad as a symbol of modernity. Hahn moved to New York Ctiy for a year in 1878, painting a related view of that city's Union Square (Hudson River Museum, Yonkers, New York). He was back in San Francisco late in 1879 and married in 1882; later that year he and his bride went abroad, living first in London and then, in 1885, returning to Dresden, where Hahn died unexpectedly in 1887, forestalling an anticipated return to San Francisco.[42]

Oscar Kunath, born in Dresden and first trained in Germany, came to this country at the age of thirty in 1860, living in Philadelphia and, by 1868, in New York City. There he became involved with a German-oriented artists' organization, the Palette. In 1873 Kunath moved to San Francisco but the following year returned to Munich to study for two years, as many art students from California were doing at that time. After another sojourn in Philadelphia, Kunath was in San Francisco in 1878. He taught at the School of Design and established himself as a figure and portrait painter, working for such families as the Stanfords and the Crockers. His best-known works re-create the earlier days of mining and prospecting. One of the finest is *The Luck of Roaring Camp,* based on the short 3.195 story of the same title which had appeared in the *Overland Monthly* in August 1868, the first piece of fiction by San Francisco's earliest literary master, Bret Harte.

The painter most associated with painting California's vaqueros was English-born **James Walker.** Walker grew up in Albany, New York, and in the early 1840s was in charge of the department of drawing at the Mexican Military College at Tampico; he resided in Mexico until the outbreak of the Mexican War. After escaping from that country he became an interpreter for General Winfield Scott and began to make a reputation as a painter of battle scenes while living in New York City. Walker went to Washington, D.C., in the late 1850s to paint *The Battle of Chapultepec*, commissioned in 1857 for the United States Capitol; he also painted Civil War battle scenes. In the early 1870s Walker moved to San Francisco, where he concentrated on the lives of the Mexican population in Northern California, especially the ornately garbed vaqueros on the cattle ranches, as
3.196 in *Vaqueros in a Horse Corral.* Walker may have moved frequently between California and New York City, for he had a studio in the East in 1875 and spent time in New York City in 1878 on his way to Europe. He returned to California in 1884 and died at his brother's home in Watsonville in 1889.[43]

During the 1870s San Francisco had its representatives of the grand manner. **Domenico Tojetti**, who came to exemplify this phase of art, was a well-traveled, highly experienced artist when he arrived in San Francisco in 1871. Born in Rome, he had studied with Vincenzo Camuccini, the foremost Roman advocate of Neoclassicism. Having received papal commissions and been decorated by the kings of Naples and Bavaria, in 1867 Tojetti accepted the directorship of the Guatemala Academy of Fine Arts. Wanting to escape the oppressive climate there, he moved to San Francisco, where he taught portraiture at the School of Design in the late 1870s. In addition to painting portraits, Tojetti created altarpieces for Catholic churches and mythological frescoes for private homes, many of which were destroyed in the earthquake and fire of 1906. His best-
3.197 known surviving work is the allegorical *Progress of America,* in which Raphaelesque figures follow a symbolic America in an eagle-decorated chariot over the Rockies with winged

3.196 James Walker (1819–1889)
Vaqueros in a Horse Corral, 1877
Oil on canvas, 20 x 36 in.
The Thomas Gilcrease
Institute of American History
and Art, Tulsa, Oklahoma

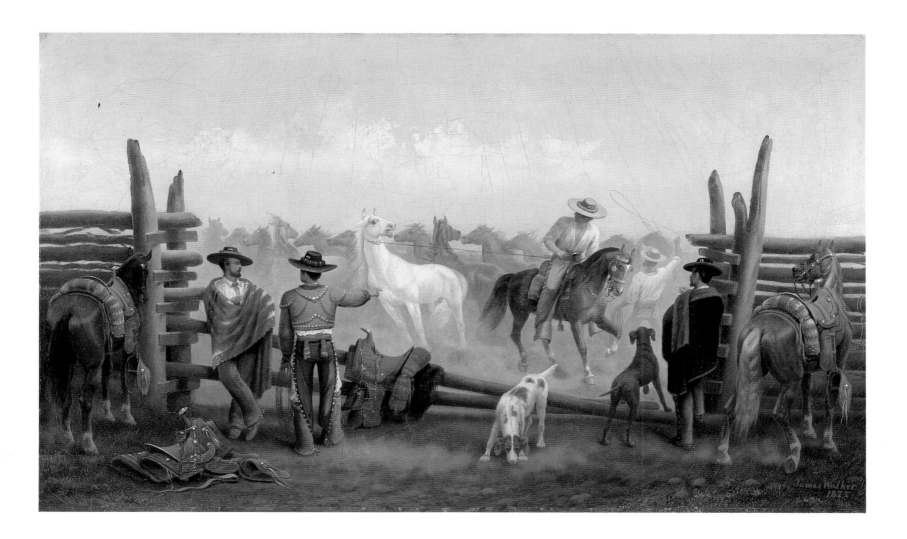

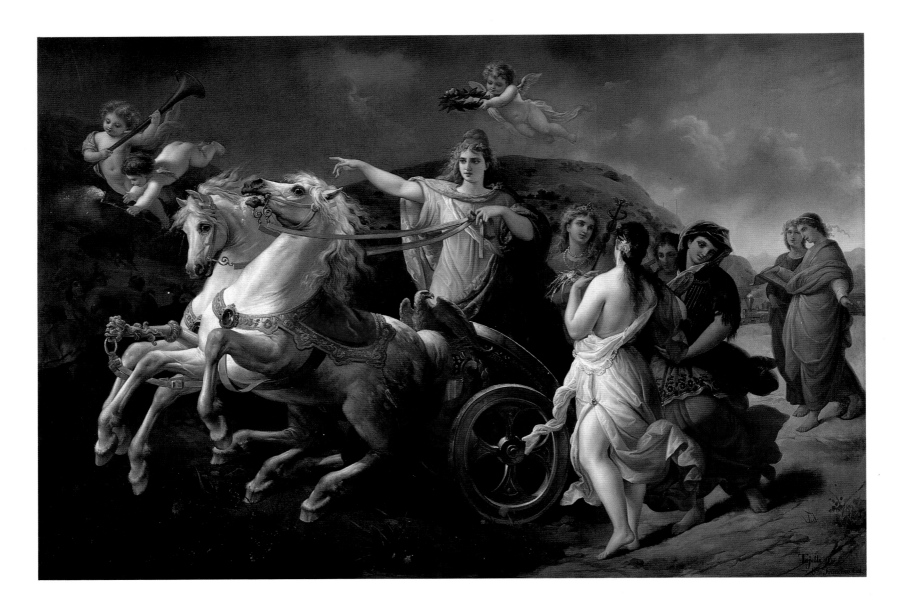

3.197 Domenico Tojetti (1806–1892)
The Progress of America, 1875
Oil on canvas, 71½ x 102 in.
The Oakland Museum,
Oakland, California;
Kahn Collection

putti flying overhead, while in the distance Indians and buffalo flee into oblivion. Tojetti's sons, Eduardo and Virgilio, studied with their father and followed in his profession, Eduardo remaining in San Francisco and Virgilio settling in New York City about 1881 and seeking training with Jean-Léon Gérôme in Paris about 1887.[44]

In addition to his allegories, Tojetti's most noted work of his early years in San Francisco was *Elaine* (private collection, San Francisco), a monumental literary subject from Tennyson's *Idylls of the King.* This controversial painting was commissioned by a leading patron, Tiburcio Parrott, in 1876. Parrott had previously commissioned the same subject from San Francisco's most renowned figure painter of the period, **Toby Edward Rosenthal,** but Rosenthal then sold the work for a higher price to another San Francisco collector, and Parrott turned to Tojetti for an alternative version, having already secured from him several portraits and *Francesca da Rimini* (location unknown), after Dante. This became, in a sense, the battle of the *Elaine*s, with Rosenthal's exhibited at the Snow and May gallery in 1875 and Tojetti's shown there the following year. The rivalry was even noted in the New York City press.[45]

The controversy became a rivalry between two schools of painting, a *retardataire* manner and a more contemporary one, though both may seem conservative today. Rosenthal was a major proponent of the Munich Academy. His *Elaine* is perhaps his most moving work; the expired heroine glows radiantly as she glides on her barge through the darkened landscape. Tojetti's depiction of the "Lily Maid of Astolat," in contrast, was commended for its rich costume and elaborate black velvet canopy—more matters of surface than of substance. Tojetti's picture was regarded as a true illustration of Tennyson's verse, while Rosenthal's was seen as an independent interpretation.

3.198

Rosenthal had been preceded in Munich by David Dalhoff Neal, from Lowell, Massachusetts, who began his climb to fame and fortune soon after his arrival in San Francisco in 1857 at the age of nineteen. His drawings attracted the attention of a wood engraver, who gave him employment. Neal received encouragement and painting instruction from CHARLES CHRISTIAN NAHL, and his desire for formal European study was gratified when a patron, S. P. Dewey, financed his voyage in 1861 to Munich, where he studied under Karl von Piloty. Although Neal lived the rest of his life in Munich, he painted portraits of many distinguished California citizens, including members of the Crocker and Hopkins families and the mining engineer Adolph Sutro.[46]

Having been born in Prussia and raised in San Francisco, Rosenthal studied with FORTUNATO ARRIOLA, who urged him to continue his instruction abroad. In 1865 Rosenthal went to Munich, where he, too, became a pupil of Piloty and stayed on. More than his compatriot, however, Rosenthal remained a San Francisco artist; he was acclaimed in the local press and enthusiastically supported by patrons there. Rosenthal reinforced that identification with prolonged visits in 1871–72, when Parrott gave him the commission for *Elaine*, and in 1879–80. *Elaine* was shown in Berlin and Boston before it arrived in San Francisco; it was then exhibited there and at the Philadelphia Centennial in 1876. When the picture was stolen on the morning of the final day of its showing at the Snow and May gallery—April 2, 1875—it caused national distress and tremendous publicity before its recovery forty-eight hours later. After being restretched the work was put back on view at the gallery, from April 7th until the 10th. The entrance fees to the gallery alone provided a handsome donation by the picture's owner to various public institutions and to the distressed family of the deceased Arriola, Rosenthal's teacher.[47]

Rosenthal continued to receive orders from wealthy Americans while in Munich. On his 1879–80 visit to San Francisco he was commissioned to paint a scene from Sir Walter Scott's *Marmion*, resulting in *The Trial of Constance of Beverly* (1883; formerly Betty Knight and Scott King Smith), a more melodramatic painting than *Elaine*. The two are Rosenthal's best-known paintings today. He later painted more lachrymose genre scenes and satirical pictures of the clergy similar to those by the popular Munich artist Eduard Grützner. More brightly colored than *Elaine*, these are extremely detailed. Both Neal and Rosenthal worked in a traditional academic style, neither having been influenced by the sketchy, bravura brushwork and strong chiaroscuro introduced in Munich in the following decade by Wilhelm Leibl and explored by such Americans as FRANK DUVENECK and WILLIAM MERRITT CHASE.[48] In 1871, on his first visit home, Rosenthal had accepted the young

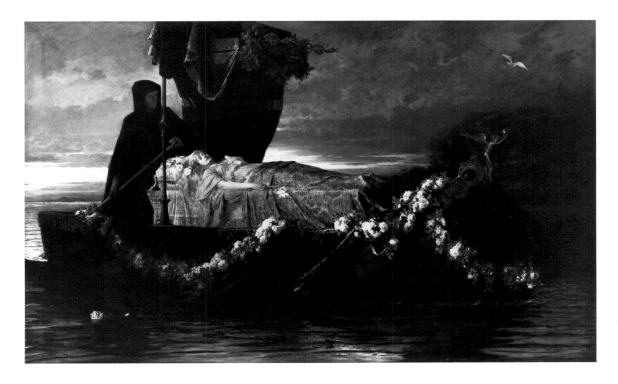

3.198 Toby Edward Rosenthal
(1848–1917)
Elaine, 1874
Oil on canvas, 38⅝ x 62½ in.
The Art Institute of Chicago;
Gift of Mrs. Maurice
Rosenfeld, 1917

London-born Reginald Birch as a student; Birch subsequently joined the older artist in Munich and later worked as an illustrator in New York City.

Theodore Wores, one of the earliest native-born San Francisco artists, began his training with Joseph Harrington in the early 1870s and was one of the first to enroll at the School of Design in 1874. The following year several of his drawings were sent to Rosenthal in Munich, who urged Wores to come for instruction. Wores studied with Rosenthal and at the Royal Academy before becoming one of the Duveneck Boys, following Frank Duveneck to Venice, where he met Whistler. Wores's earliest major works consist of dark, dramatic interiors and historical illustrations, such as *Juliet in the Friar's Cell* (1880; private collection, Norway).

Wores returned to San Francisco in 1881, hailed as a second Toby Rosenthal. Inspired by the vogue for exotic subjects, he found his own version in Chinatown, becoming known as the pioneer in the matter-of-fact delineation of life there.[49] In these works, many of which were destroyed in the disaster of 1906, Wores concentrated on typical Chinese costumes, customs, occupations, and pastimes; his *Chinese Fishmonger* (1881; National Museum of American Art, Washington, D.C.) retains the vigorous brushwork and bold chiaroscuro of his Munich years, but he was soon overtaken by the literally colorful nature of his subject: *New Year's Day in San Francisco's Chinatown* is a vivid, Impressionistic depiction, though the forms remain carefully delineated. Wores published a story about the New Year's celebration that includes a description of such a scene, and he also provided illustrations for several other articles on Chinatown.[50]

3.199

Inspired by Whistler's enthusiasm for the Far East, in 1885 Wores made his first trip, of almost three years, to Japan. Just as his paintings of the Oriental world in San Francisco had established his reputation locally, so his on-the-spot Japanese works, encompassing a variety of genre themes, established him internationally; they were shown in San Francisco, New York City, Boston, Chicago, and London after his return in 1887. In 1892 Wores went back to Japan to replenish his stock of subjects, continuing to paint them once he was reestablished in San Francisco in 1892. Between 1888 and 1901 Wores published nearly a dozen articles about Japanese life, artists, flower arranging, and especially gardens, which he often painted.

Wores remained an inveterate traveler, going to Hawaii and Samoa to paint in 1901–2 and to southern Spain in 1903, where his art took on increasingly Impressionistic qualities. In the Bay Area he favored brightly colored dune landscapes spotted with contrasting purple lupin and yellow-orange poppies, a motif favored in the early decades of the present century by such artists as GRANVILLE REDMOND, JOHN MARSHALL GAMBLE, and William F. Jackson. After 1902 Wores confined his traveling to North America, painting Indian subjects in Calgary, Canada, in 1913 and going to Arizona and New Mexico to record the Pueblo Indians in 1915–17. In the 1920s he remodeled an abandoned church in Saratoga, California, and there painted more formal garden scenes and flowering orchards in the high-key palette of Impressionism. Wores was an influential teacher in San Francisco; he gave private lessons soon after his return from Munich, including a class offered to a dozen Chinese art students, and he was the first instructor at the newly formed San Francisco Art Students League in 1884, teaching life and portrait classes and offering a sketch class. In 1907 he was named dean of the San Francisco Art Institute, the former School of Design, a position he held for six years.[51]

3.234; 3.224

By the 1880s Chinatown had become one of the most popular genre subjects. Illustrations by JULES TAVERNIER and Paul Frenzeny appeared in *Harper's Weekly* in 1874. William Hahn may have been the first painter to record the quarter, for he exhibited a Chinese street scene at Snow and Roos's gallery in 1872. The little-known Richard J. Bush also painted Chinatown in the 1870s. EDWIN DEAKIN painted extensively there in the late 1880s as an architectural specialist, concentrating on the streets and alleys. The New Haven–born Charles Albert Rogers, little-remembered today, went to San Francisco in 1877 as a portrait and landscape painter, and later turned to views of Chinatown in oil and watercolor; after his loss of 150 paintings, mostly San Francisco scenes, in the disaster of 1906, he moved to Los Angeles.

3.190, 3.259

3.83, 3.193

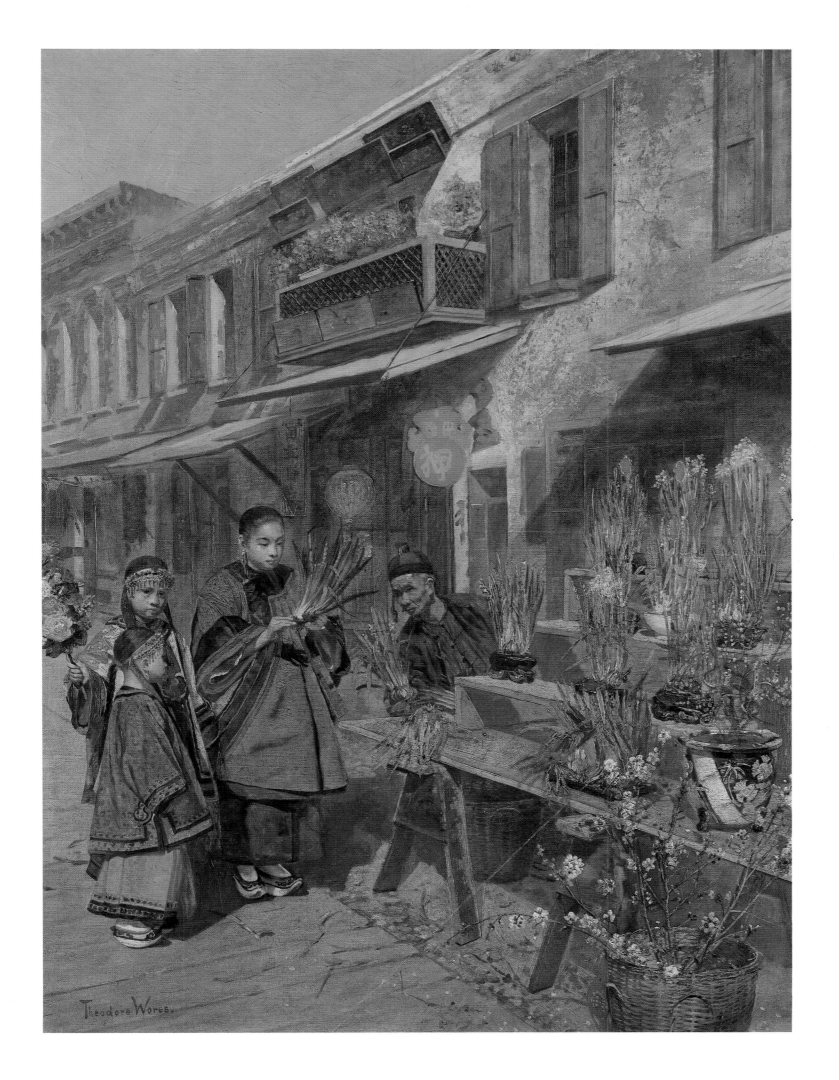

NORTHERN CALIFORNIA 259

Though far less prominent today than Wores, Amédée Joullin, also a San Francisco native, became known for his Chinatown scenes. Having studied at the School of Design and with Jules Tavernier, Joullin went to Paris for two years of additional study, returning in 1887 to become an instructor at the school for a decade. He began painting Chinatown subjects in 1888, and his *Interior of a Joss House* of 1891 (location unknown) was acclaimed as the finest Chinese character picture ever done by a local artist. In 1892 Joullin turned his attention to the Southwest Indians, which remained his primary subject.[52]

One other late nineteenth-century painter who trained in Munich and made a specialty of Chinatown views was **Henry Alexander**, another early native-born professional. Alexander studied with Virgil Williams at the School of Design and, encouraged by Rosenthal, went to Munich about 1875 or '76 and stayed for six or seven years. Alexander went to New York City for about a year and was back in his native town at the end of 1883, remaining until 1887; he then returned to New York City but made subsequent visits to California. He spent the last years of his short life in New York City, ending as a suicide.

Alexander was San Francisco's most representative proponent of the later Munich mode, which developed at the Academy there from the late 1870s on. This style emulated the precisionism and near-monochromatic tones of the Dutch "Little Masters" of the seventeenth century. Alexander's painting was similar to that of his better-known eastern counterpart, Charles Frederick Ulrich, a fellow student and close friend in Munich who urged his colleague's initial stay in New York City (and whose works are equally rare). Alexander applied this style to his colorful Chinatown interiors, with their sumptuous, exotic furnishings, and to his better-known genre paintings of homes and workrooms, which display fantastic amounts of still-life paraphernalia. These include well-appointed wealthy interiors, laboratories, taxidermy shops, and the shoemaker's store in *The Lost Genius.* Here the elderly craftsman's humble vocation is contrasted with his recreational devotion to playing the violin, his dark workshop opening out to the street and his abundant geraniums reaching, symbolically, for the sunlight. The compositional emphasis on the broad windowpanes revealing silvery gray light is a Germanic motif adopted by many American artists of the period. In 1906 Alexander's family assembled a collection of his work for a memorial exhibition, which was destroyed in the earthquake and fire.[53]

3.200

3.200 Henry Alexander (1862–1895)
The Lost Genius, n.d.
Oil on canvas, 21¾ x 29⅞ in.
University Art Museum,
University of California at
Berkeley; Bequest of
Hannah N. Haviland

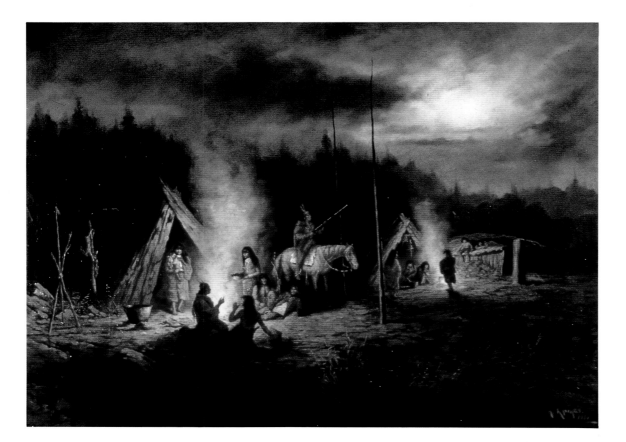

3.201 Henry Raschen (1854–1937)
*Indian Camp near Fort Ross,
California*, c. 1885
Oil on canvas, 30¼ x 40 in.
Location unknown

The mid-1870s were the high point of the California presence in Munich. Alexander began to go to Polling, Germany, to paint in the autumn of 1876, returning there numerous times. In the spring of 1878 he was there with his fellow San Franciscan **Henry Raschen**. Raschen appended a drawing of an Indian head to his signature in the guest book of the Polling inn, a harbinger of his role as one of San Francisco's leading specialists in the depiction of the native American. Born in Germany, Raschen and his family emigrated to California in 1868, living for their first year at Fort Ross. Raschen grew up in San Francisco, studying with Joseph Harrington and entering the School of Design when it first opened. Like Wores, he went to Munich in 1875 and stayed for eight years, becoming close to Thaddeus Welch; he returned to San Francisco as a portrait painter but made frequent trips north, often with the landscapist Carl von Perbandt. While the latter painted the landscape at Fort Ross, Raschen depicted the Pomo Indians there, adopting a painterly realist style, devoid of romanticization. In 1886 he was a sketch artist with the army in southern Arizona in pursuit of the Apache chief, Geronimo; after the latter was captured Raschen painted several portraits of him as well as depictions of the Arizona Indians. The artist was in Munich from 1890 until 1894 spending time in Etzenhausen, near the artists' colony at Dachau, painting peasant figures and interiors; otherwise he remained a Bay Area artist, moving to Alameda and Oakland across the bay from San Francisco after the 1906 earthquake.[54]

3.201

Raschen was the first San Francisco artist to be fully committed to Indian themes. He was soon followed by many other painters, including a number who achieved considerable acclaim. Warren Rollins studied at the School of Design for three years beginning in 1878, in 1884 becoming assistant director. His subsequent career, until he moved to Santa Fe in the 1910s, is confusing due to his wanderings throughout the West in search primarily of Indian subjects and due also to the contradictory information recorded by historians. In 1887 he has been said either to have left for study in Boston and New York City, returning to San Francisco, or to have moved to San Diego; in fact, he appears to have begun a nomadic life, traveling throughout the Pacific Northwest, becoming resident in Tacoma by 1891. From there he began to investigate the Crow in Montana and to travel through the Southwest, concentrating on the Hopi tribe in Arizona. Rollins is said to have been in Taos, New Mexico, as early as 1893 and to have visited

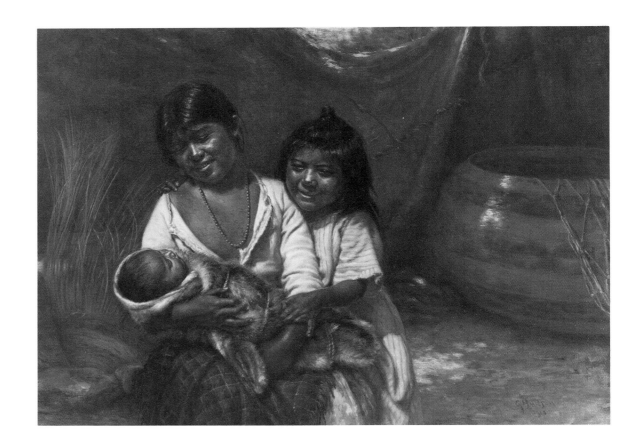

3.202 Grace Carpenter Hudson
(1865–1937)
Ka-ma-ko-ya (Found in the Brush), 1904
Oil on canvas, 23½ x 33 in.
The Los Angeles Athletic Club Art Collection

Arizona in 1900; he was resident in Oakland by 1906. In 1910 he made Pasadena, in Southern California, his base of operations. For all practical purposes he remained a Southwest painter, relocating to Santa Fe in 1917, while the Santa Fe Railroad built a studio for him on the rim of the Grand Canyon.

Entering the School of Design a year later than Rollins, **Grace Carpenter Hudson** likewise became a specialist in Indian subjects but remained a California painter. Born north of San Francisco in Ukiah, on the Russian River, she returned there in 1884 after completing her studies, opening a studio in 1889 and giving lessons. The following year she married the newly arrived Dr. John Hudson. In their home, marked by a totem pole out front, Hudson began to paint genre scenes of the Pomo Indians in the area, especially children and infants, and after her *Little Mendocino* (California Historical Society, San Francisco) became a sensation at the World's Columbian Exposition of 1893, she specialized almost completely in that subject. The principal exception was a series of paintings of the Pawnees in Oklahoma, commissioned by the Field Museum in Chicago in 1904. Hudson's works are undeniably authentic in their details of Northern California Indian life. After her husband gave up his medical practice to devote his career to the Pomo Indians, compiling a Pomo dictionary and collecting baskets and other artifacts for the Field Museum, such basketry became prominent in Hudson's pictures. In her own time Hudson was criticized for her choice of "unworthy" subjects; today her interpretations, even the best-known and most often-reproduced pictures such as *Little Mendocino* and *Ka-ma-ko-ya (Found in the Brush)*, may be faulted for their purposeful cuteness and sentimentality.[55] 3.202

MAYNARD DIXON, a preeminent later specialist in western subjects, painted the Hopis 3.127
and Apaches of the Southwest and the Blackfoot Indians of Montana, the latter on commission for the Great Northern Railroad in 1917. Dixon's early reputation was based more on his illustration work than on his painting; later he depicted cowboys and Spanish-Americans in addition to pure landscapes of those regions and, in the 1930s, powerful social realist themes. Dixon had been born on a ranch near Fresno, California; his family moved to Alameda in 1893. Abandoning formal classwork under ARTHUR F. MATHEWS at 3.207
the Mark Hopkins Institute of Art after only three months, Dixon began illustrating for *Overland Monthly*. He started to paint seriously in oils about 1902, and his first major commission consisted of a series of murals of western subjects painted for the Tucson

depot of the Southern Pacific Railroad in 1907. Later that year he moved to New York City, continuing as an illustrator and only turning fully to easel painting and mural work on his return to California in 1912, when he settled in Los Angeles.[56]

Among the figure painters active in San Francisco in the late nineteenth century there was a large contingent of portraitists ready to serve an ever-growing clientele. Albert Jenks grew up and studied in Chicago, painting portraits there from 1863 until 1871; after practicing in Detroit in 1873 he settled in San Francisco in 1875, moving to Los Angeles in 1886. Several of the major San Francisco portraitists were Munich-trained.

3.258 Probably the most interesting was **Joseph Strong**, who grew up in Oakland and was encouraged by the visiting Toby Edward Rosenthal in 1871. Strong subsequently painted the portrait of the mayor of Oakland, which so impressed the local citizenry that they raised funds for him to study in Munich, where he arrived with Reginald Birch in 1872. There he was a pupil at the Academy but was also close to Frank Duveneck and his circle; a large portrait of Duveneck was subsequently featured in Strong's San Francisco studio. Strong returned to California in 1877, joining Jules Tavernier in Monterey and returning with him to San Francisco. In 1879 Strong married Isobel Osbourne, whom he met in Monterey. She, too, was an artist and one of the early students at the School of Design, as was her mother, Fanny Osbourne, who married Robert Louis Stevenson in

3.203 San Francisco in 1880. Strong painted a full-length, almost hieratic likeness of Isobel Osbourne in the Monterey groves in 1879. Despite receiving many portrait commissions, the Strongs moved to Hawaii for six years in 1882, initially to paint landscapes for John D. Spreckels. They later joined the Stevensons in Samoa, where the latter had settled after their marriage, and Strong painted on other Pacific islands as well. After the Strongs were divorced in Hawaii, Joseph Strong returned to San Francisco in 1895, dying there in 1899. In his later years he was especially known for his scenes done in the Pacific.[57]

The portraitist Orrin Peck, who was in Munich in the early 1880s, then went to California, where he eventually became artistic director for William Randolph Hearst at the Hearst's Northern California ranch and painted portraits for the Hearst family. Peck returned to Munich for some time and worked in Paris, holding his first exhibition in 1901 in New York City at M. Knoedler and Co., where his earlier pictures of Hearst and his mother, the noted art patron Phoebe Apperson Hearst, were the most striking.[58] Joseph Greenbaum, who grew up in San Francisco, went to study in Munich and Paris after working at the School of Design. After his return he also had socially prominent patrons. Following the 1906 earthquake he moved to Los Angeles, teaching at the Art Students League there in 1908 and painting the Southwest desert.

3.132 The English-born portraitist HORACE DUESBURY emigrated to San Francisco in 1876 and worked in Portland, Oregon, from 1880 until 1886, subsequently returning to San Francisco. Frederick Yates, also an Englishman, arrived in 1886, after having studied in Paris. He was a popular portrait painter in San Francisco and taught at the newly formed Art Students League, where he introduced life drawing before a coeducational class. Having met the marchioness of Downshire on a trip to England, he was introduced into London society and returned to his native land in 1900.[59]

At the end of the century the most significant portrait painter to settle in San Francisco was Paris-trained John Willard Clawson, who had grown up in Salt Lake City and was a major figure in the Mormon art world. Clawson had established his professional credentials in Utah in 1885 after studying at the National Academy of Design in New York City. Having traveled to Paris, he then moved to San Francisco, painting over two hundred fifty portraits of prominent citizens including Collis Huntington. Clawson worked in a bravura manner that flattered his sitters; he was referred to as the John Singer Sargent of the West. Wiped out by the earthquake of 1906, Clawson moved to Los Angeles, then returned to New York City three years later, dividing his activity between the East and West coasts and Utah, where he settled permanently in 1934.

The last major male portraitist to settle in San Francisco before 1920 was Herman Gustave Herkomer. Born in Cleveland, Herkomer had studied with his more famous cousin, Hubert von Herkomer, in London and then in Munich and Paris. Herman Gustave

3.203 Joseph Strong (1852–1899)
Isobel Osbourne at
Monterey, n.d.
Oil on canvas, 24¼ x 13 in.
Garzoli Gallery, San Rafael,
California

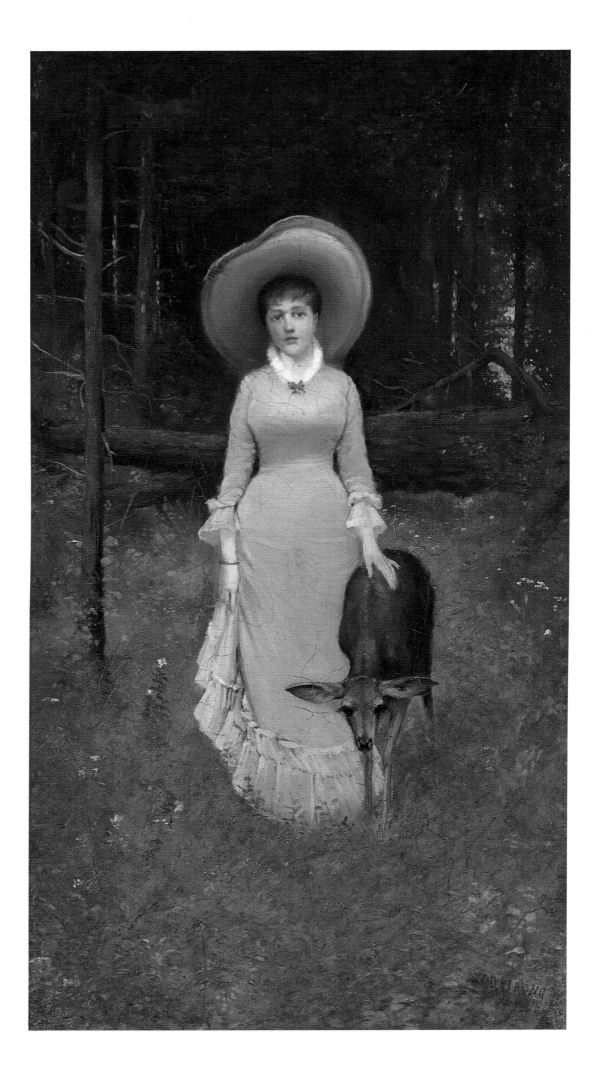

Herkomer became a well-established society portraitist in Europe, residing in London for over thirty years before he arrived in San Francisco about the time of the 1915 Panama-Pacific International Exposition, where he exhibited his work as an American artist. Herkomer remained in San Francisco and later settled in Auburn, California.

The earliest successful woman portraitist in San Francisco was Mary Curtis Richardson. Her father had joined the gold rush in 1849, and she grew up in San Francisco, where he established himself as a professional engraver. She received lessons from him and then went to New York City in 1866 to study wood engraving and drawing at the Cooper Union School of Design for Women, returning to San Francisco in 1868 to open a wood-engraving business. When the School of Design opened in 1874, Richardson was one of the first students; she returned to New York City to study at the Art Students League in the mid-1880s. Settling in San Francisco, she painted portraits and images of mothers and children, becoming identified as the "Mary Cassatt of the Pacific Slope."[60]

Evelyn Almond Withrow established an international reputation for her portraiture. Born in Santa Clara, California, she studied in San Francisco at the School of Design before going abroad in 1881. Withrow spent four years in Munich; though the Academy did not accept women, she studied privately with the Greek painter Georges Jacobides and had four years of instruction from the American expatriate J. Frank Currier before going to Paris. In the late 1890s Withrow settled in London, where her successful studio became a salon for artists and writers. She painted fashionable celebrity portraits, continuing in that vein when she returned to San Francisco early in the present century, remaining until 1926. Withrow was allied with the Symbolists, creating allegorical figural works drawn from haunting elderly models.[61]

Julie Heyneman, a San Francisco native, studied at the School of Design and received instruction and advice from John Singer Sargent in London in 1892, returning to California later that year. Her portraiture was well received and, like Clawson's, was likened to that of John Singer Sargent. Heyneman taught at her alma mater, renamed the Mark Hopkins Institute of Art, and at the Art Students League, where she recognized the talent of the future sculptor Arthur Putnam, whose biography she wrote in 1934. San Francisco–born Caroline Rixford was a student at the Mark Hopkins Institute and went to Paris, studying at the Académie Julian and with Whistler; she, too, became a successful portraitist in her native city.

Though few San Francisco artists were stimulated by the turn-of-the-century miniature revival, Rosa Hooper, another native, represented the movement, studying in Paris and Dresden. Returning to San Francisco, she moved to Palo Alto, California, and then to New York City. Another miniaturist, Lillie O'Ryan Klein, studied in New York City at the Cooper Union, going to San Francisco about 1900. A few years later she was commended as the city's only miniature painter of renown. After 1906 she moved to Portland, Oregon.[62]

The unusual dearth of professional women artists in the early decades of San Francisco's cultural history contrasts with their abundance at the turn of the century. One contributing factor may have been the circumstances under which the city had been founded, in the aftermath of the gold rush. Whereas many of the city's early male artists were disappointed prospectors, some of whom had had some training in art, the women who migrated there were seldom able to consider that career as an alternative.

Mary Benton and A[nnie?] T. Oakes are usually considered the earliest professional women artists in the city. Both were Boston-born landscape painters who arrived in San Francisco about 1855; both exhibited at the Mechanics' Institute Fair in 1857. Oakes had returned east by 1865, where she was an active exhibitor at the National Academy of Design for two decades, but Benton remained, teaching in the public schools. The representation of women artists increased dramatically over the years in the exhibitions at the Mechanics' Institute Fairs, and the San Francisco Art Association was showing work by women from its earliest exhibition in 1872, when Elizabeth Keith (the first wife of William Keith) displayed still lifes. With the opening of the coeducational School of Design, women could gain the training necessary to establish themselves professionally

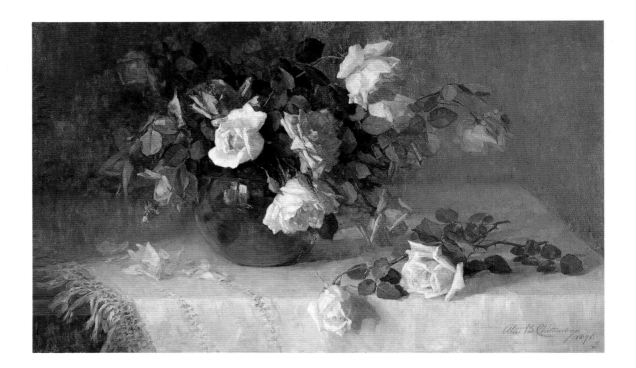

3.204 Alice Brown Chittenden
(1860–1934)
Roses, 1898
Oil on canvas, 25 x 40 in.
Petersen Galleries, Beverly
Hills, California

and compete with their male counterparts. Over three-quarters of the first class in 1874 were women.

Probably the earliest woman landscapist of repute to emerge from the school was Calthea Campbell Vivian, who also studied in Paris. A specialist in California landscapes and views of the missions, Vivian worked in a modified Impressionist manner. She was a significant teacher and the first head of the drawing department at San Jose Normal School. Bertha Stringer Lee, a later landscapist, studied at the Mark Hopkins Institute as well as privately with William Keith in 1885 and painted in the Bay Area and at Monterey.

In the late nineteenth century many women artists concentrated on still life, particularly floral pictures, subjects requiring no anatomical study. This changed gradually, both with the availability of life classes to women at the School of Design and at the Art Students League and with the prevailing emphasis on landscape subjects. In the Mechanics' Institute Fair of 1857, Mary Benton's pupil, a Miss A. E. Sandford, won a certificate of merit for a floral still life. Marianne Mathieu may have been the earliest professional woman still-life specialist in the city. A resident from the 1860s on, she painted watercolors of flowers, fruit, and vegetables and became particularly noted for her depictions of California wildflowers. One of the finest still-life artists, **Alice Brown Chittenden**, went to San Francisco in the 1870s and began studying at the School of Design with VIRGIL WILLIAMS in 1877. Two decades later she became a teacher there, an affiliation she maintained for more than forty years. The rich colorism and effusiveness of *Roses*, stressing the flowers' loveliness and fragility in a horizontal format suggesting Oriental influence, is similar to, and more sensitive than, comparable work by Chittenden's Philadelphia contemporary Milne Ramsey. Another woman still-life painter of note who studied with Williams in the 1880s was Sarah Bender, later Sarah De Wolfe, many of whose floral pictures were lost in the fire of 1906.

3.177

3.204

In 1887 the women students of the School of Design founded a summer sketch club with headquarters in Aptos and then in Pacific Grove, where they enjoyed the guidance of Emil Carlsen.[63] Two years previously an all-women's exhibition had been organized in San Francisco, one of the earliest such shows held in this country. Chittenden's work figured strongly among the many flower paintings, as did animal pictures by Matilda Lotz, an expatriate in Paris who had studied at the School of Design and with Keith.

The luminescence enveloping Chittenden's roses was due to new aesthetic influences in the realm of still life. Perhaps the most important painter of the 1880s was **Emil Carlsen**. He was the most significant American exponent of the so-called Chardin revival, which had begun in France as early as the 1840s, a reawakening of interest in the

beautifully arranged, atmospheric, and harmonious still lifes, often of kitchen subjects, painted in eighteenth-century France by Jean-Baptiste-Siméon Chardin. Carlsen went to teach at and direct the School of Design in 1887, a year after Virgil Williams's death, and though he remained in the city for only four years, he had a notable impact. A Dane and brother of the director of the Danish Royal Academy, Carlsen had started teaching at the newly established Chicago Academy of Design two years after arriving in America in 1872. He returned to study in Paris for a short while in 1875, establishing himself in Boston and New York City and gaining a significant reputation as a still-life specialist. In 1884 he was in Paris, supporting himself for two years by painting floral still lifes on commission for the New York City dealer Theron J. Blakeslee; wearying of the incessant demand for exuberant pictures of yellow roses, he accepted the position in San Francisco.

Chardin was the principal object of Carlsen's study during his years in Paris. In San Francisco, Carlsen continued his steady rise to fame based on his application of Chardin's approach to various still-life themes: large paintings of dead game laid out on a table, utilizing strong chiaroscuro in basically neutral tones; kitchen pictures of vegetables, copper pots, and the like; and more elegant objets d'art. The chronology of Carlsen's attention to these subjects awaits scholarly study. Neutral harmonies and a combination of balance and diversity inform his large *Still Life* of 1891, one of his last pictures painted

3.205

3.205 Emil Carlsen (1853–1932)
Still Life, 1891
Oil on canvas, 35 x 43 in.
The Oakland Museum, Oakland, California; Gift of Mrs. Sol Upsher

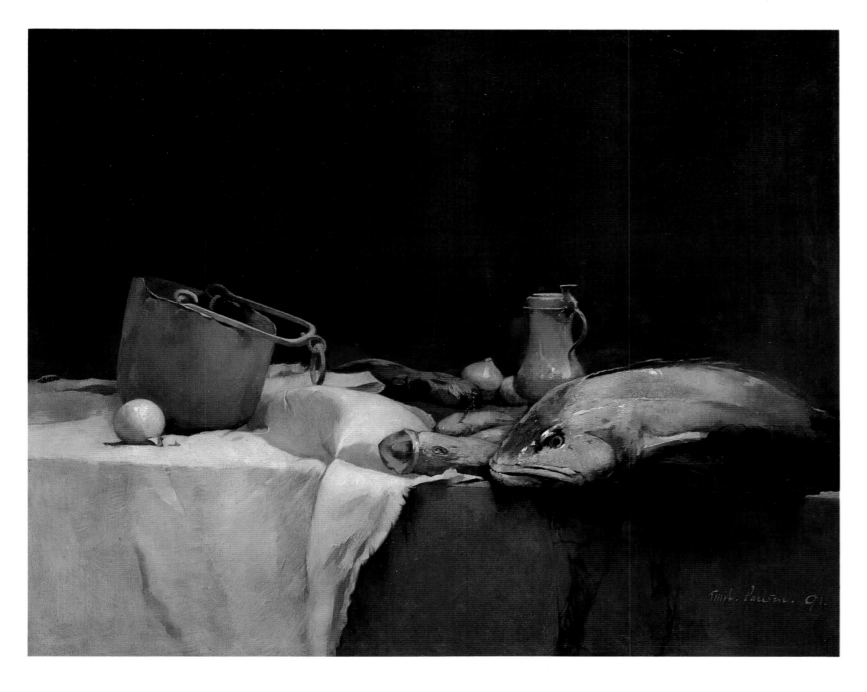

in San Francisco; this kitchen theme and the related dead-game paintings appear to be the subjects he emphasized there; they were favorably noted in the local press.

Carlsen remained at the School of Design for only a year, succeeded by RAYMOND DABB YELLAND. After a visit to the East in 1889, Carlsen returned to San Francisco and expressed his dismay at the management of the school, its dependence on subsidy, and the full-time demands made on the instructors' time. Though he himself then taught at the rival Art Students League, his criticisms were the basis for a reorganization of the School of Design in 1890 under Arthur F. Mathews. Carlsen also engaged in portraiture and decorated the home of William H. Crocker. On his return to New York City in 1891 Carlsen joined the cosmopolitan art world there; by 1921 Arthur Edwin Bye, in the first book to study American still-life painting, lauded him as "unquestionably the most accomplished master of still-life painting in America."[64] Among the students Carlsen most influenced in San Francisco were GUY ROSE and Genève Rixford Sargeant; the latter went on to study with William Merritt Chase in New York and became a painter of stylized figures in a Post-Impressionist mode; both Rose and she later were active in Southern California. Sargeant, one of the original members of the Sketch Club and a painter of figures and outdoor scenes, was in Northern California about 1910, and she remained active in San Francisco.[65]

Carlsen's game still lifes avoid the illusionism brought to the theme by William Michael Harnett and his followers. One of these, the much-traveled RICHARD LA BARRE GOODWIN, was a resident of San Francisco, among many other cities. Goodwin went there about 1902, having enjoyed considerable patronage while he was in Washington, D.C., in 1890–93 from the Hearsts and the Stanfords, who acquired examples of his vertical cabin-door paintings—pictorial references to hunting lodges and sporting activities. Goodwin remained in San Francisco for four years, but the disaster of 1906 sent him to Portland, Oregon, after most of his California work was lost.[66]

Carlsen's criticisms of the School of Design suggest the revitalization of the art scene in San Francisco as the depressed market of the 1880s picked up in the '90s. The school's principal competitor, the Art Students League, was structured after its New York City namesake and the French academies, where instructors supervised students by visiting one or two days a week. This appealed to many leading artists such as Carlsen, Arthur F. Mathews, and Theodore Wores, all of whom taught there. The league occupied several premises, including, at one time, the old Supreme Court House. Several professionals, such as William Keith, not only taught privately but also established schools of their own. The portraitist Frederick Yates associated his classes with those of the league in the mid-1880s. Another English-born portraitist, John Herbert Partington, who had emigrated to Oakland in 1889, established the Partington Art School three years later with his son Richard, emphasizing the teaching of illustration and continuing until the 1906 earthquake. Perhaps the most noted private school of the period was the Best Art School, which existed from 1897 until 1920.

At the 1893 World's Columbian Exposition in Chicago, California was the only state with its own gallery, which included works by many women painters. A large number of San Francisco's important male artists also showed, including THOMAS HILL, with two landscapes, a triptych of giant redwoods, *Muir Glacier, Alaska* (Oakland Museum), and *Driving the Last Spike* (California State Railroad Museum, Sacramento). Keith was strongly represented, scenes of Chinatown were shown by Amédée Joullin and ERNEST NARJOT, and so were Japanese pictures by Theodore Wores. Deceased masters represented included SAMUEL MARSDEN BROOKES, William Hahn, CHARLES CHRISTIAN NAHL, Jules Tavernier, and Virgil Williams.

The California Midwinter Exposition opened in San Francisco in January 1894; ten countries contributed to the art gallery, where French Impressionism was introduced to California, with pictures by Claude Monet, Camille Pissarro, Pierre-Auguste Renoir, and Alfred Sisley. (A Monet painting and a Pissarro drawing had been on view in a loan show in 1891, and single works by all four were lent to a benefit exhibition for the Hahnemann Hospital in 1893, all pictures from the collection of Mr. and Mrs. William

3.185

3.242

3.145

3.175

3.170

2.296, 3.181;
3.168

H. Crocker.) Courbet and the Barbizon School also were represented, but almost all of the French academic masters were absent. A separate section for California painters included a division featuring work by eight deceased artists: both Arthur and Charles Christian Nahl, Brookes, Hahn, Tavernier, Williams, Fortunato Arriola, and GIDEON JACQUES DENNY. Otherwise the American section was not outstanding. The Nahl family lent a selection of old masters accumulated in Europe, which they had put on public exhibit several days each week, beginning in 1884—this had constituted the first "museum" in San Francisco.

3.174

Other exhibitions available to San Francisco artists included shows at the Art Students League, which began in the mid-1880s, and shows held by the Bohemian Club, which began in 1891 and were sporadic at first, the second exhibition taking place in 1894. Until works by Alice Brown Chittenden and Maren Froelich, a student and then instructor at the School of Design, were admitted in 1898, the club constituted an all-male venue. The Sketch Club began semiannual all-women shows in the early 1890s. Artistic matters continued to receive extensive coverage in the local press, in the *Overland Monthly,* and in the *Californian* in the 1880s and the *Wave* in the 1890s.

French-derived cosmopolitanism dominated the San Francisco art world by the 1890s. The impact of Paris was first felt in earnest in 1881, with the appearance of Harry Humphrey Moore. A deaf-mute New York City–born artist, Moore had painted portraits in San Francisco in 1864–65 before becoming a student of Jean-Léon Gérôme in 1866. After working in Spain and Morocco, Moore returned to this country in 1875; his Gérôme-inspired Orientalist *Almeh, a Dream of the Alhambra* (location unknown) was triumphantly exhibited at Snow and May's gallery in 1877. Four years later the artist returned to reside in the city—where he was active on the local scene and with the Bohemian Club—before going to Japan and then settling permanently in Europe. Presumably he knew THEODORE WORES, who was in Japan at the same time.[67] The impact of French training was likewise clear during the brief visit of GEORGE DE FOREST BRUSH in the summer of 1881. Brush had returned to this country the year before, having also studied with Gérôme, beginning in 1873. More significant than his own presence was the exhibition in one of the city's galleries of his large figure piece *Miggles* (Chrysler Museum, Norfolk, Virginia), begun in Paris and completed in New York City. The subject, derived from a western story by Bret Harte, illustrated the results of modern French academic training.

3.199

1.26

In the 1880s increasing numbers of San Francisco artists, such as **Jules Pagès**, began to seek training in Paris after preliminary study at the School of Design. Pagès, who became one of the city's outstanding figure painters, was the son of an engraver who had settled there in 1857. The young man apprenticed under his father and in 1888 went to Paris. He returned to work as an illustrator for several newspapers and in 1902 returned to Paris to teach night classes at the Académie Julian. He remained that city's most famous expatriate for almost forty years, returning to America at the beginning of World War II. Pagès made numerous visits to his native city, however, painting views of it and subjects in Chinatown, including a large *Reconstruction in San Francisco after Fire and Earthquake of 1906* (Oakland Museum); he had a major exhibition at the Rabjohn and Morcom Gallery in 1914. Pagès worked extensively in Paris, among the villages of Brittany, and in Bruges, Belgium, and Toledo, Spain, and he was equally proficient at landscapes, cityscapes, and figural work. All are combined in his monumental *Sur les Quais, Paris,* a brilliant example of French naturalism; Pagès later produced more sketchy and highly colored paintings, allying himself with the American Impressionists in France.[68]

3.206

The city's most influential artist at the turn of the century, **Arthur F. Mathews,** was a stylistic innovator and a forceful leader of the art community. The California Decorative style he introduced was one of the most individual regional manifestations in America's history. Mathews's domination of the San Francisco art community through his art, his numerous followers, his teaching, and in publications was strong enough to engender resentment, but it lasted, more or less intact, through the Panama-Pacific International Exposition of 1915.

3.206 Jules Pagès (1867–1946)
Sur les Quais, Paris, n.d.
Oil on canvas, 64 x 84 in.
Private collection

Mathews had received his first instruction in 1867 in high school in Oakland (where he was brought up), from Helen Tanner Brodt, one of California's earliest women painters. In 1875 he apprenticed as an architectural draftsman under his father, his most noted accomplishment in this area being a grandiose design executed in 1879 for the Washington Monument, which was praised but not constructed. In 1881 Mathews turned to design and illustration for a local lithography company and then went to Paris to spend four years at the Académie Julian, returning in 1889. He taught at the Art Students League and was appointed assistant to RAYMOND DABB YELLAND, who had taken over as 3.185 director of the School of Design; Mathews himself was later to hold that position from 1890 until 1906.

In 1896 Mathews painted his most notable historical composition, *Discovery of the Bay of San Francisco by Portola* (formerly San Francisco Art Institute), which won a major award at the Art Association. By then he had begun to turn from traditional narrative motifs, including classical anecdote and peasant genre, to generalized and allegorical subjects allied to Symbolism but eschewing its more perverse and enigmatic themes. Mathews employed attractive women to represent his abstractions, which are vaguely Grecian in costume and concept and are executed in a low-key, flat, decorative mode. Their most important antecedent was the work of the French painter and muralist Pierre

Puvis de Chavannes. Puvis de Chavannes had tremendous influence throughout Western Europe and America, creating works in which traditional illusionism was replaced by abstract design and strong chiaroscuro gave way to simply patterned shapes in harmonious tones. Though Mathews's decorative colorism and emphasis on firmly delineated, sinuous outlines were derived from Puvis de Chavannes and allied him with Art Nouveau, they also had antecedents in James McNeill Whistler's paintings. All of these qualities are superbly realized in *Masque of Pandora*. Beyond his own undeniable mastery, Mathews's achievement lay in his propagation of this combination of Symbolist and Tonal aesthetics and his slowing the invasion of Impressionism into Northern California.

3.207

3.207 Arthur F. Mathews
(1860–1945)
Masque of Pandora, c. 1914
Oil on canvas, 67 x 63 in.
The Oakland Museum,
Oakland, California; Gift of
Concours d'Antiques,
Art Guild

Private patronage for Mathews's Symbolist pictures was greatest in the 1890s. He was also eager to undertake decorative commissions, receiving his first one for a mural frieze for the home of Horace L. Hill in San Francisco in 1896. He decorated other Bay Area homes and painted murals for the Oakland library and that of the Mechanics' Institute in San Francisco, the latter destroyed in 1906 and replaced by Mathews in 1917. Mural commissions received after 1906 were for public buildings, including the Lane Hospital Medical Library, the Children's Hospital in San Francisco, and—perhaps most important—twelve panels for the State Capitol in Sacramento, designed in 1914. Though his studio at the Mark Hopkins Institute also was destroyed in 1906, Mathews remained committed to the city and designed a new building, completed that same year, which housed his studio and that of WILLIAM KEITH. Under Mathews's administration the *Mark Hopkins Institute Review of Art* had begun erratic publication as a "quarterly" that appeared in nine issues between 1899 and 1904. After the fire he turned to journalism once more. Beginning in September 1906 Mathews published *Philopolis*, the earliest long-lasting art magazine in the West, which continued through September 1916 and served to promulgate his aesthetic philosophy. By that time the artist had become involved in the Arts and Crafts movement. The Philopolis Press published books designed by Mathews and his wife, Lucia Kleinhans Mathews, and their furniture shop produced furniture, frames, and other objects in wood. (The frame for *Masque of Pandora* was made there, although not originally for that picture.) The press continued to 1918 and the shop, to 1920.

In 1907 Mathews became one of the founding members of the Del Monte Art Gallery in Monterey; turning increasingly to landscape painting, he found inspiration in the dunes and pine groves there and in the Bay Area. These works are less stylized than his figure paintings but still are related to Tonalism. It was, in fact, in the realm of landscape that Mathews's decorative style had its greatest impact. Most of his figurative easel work remained unsold.

As a member of the international jury of awards at the Panama-Pacific International Exposition, Mathews was the dominant California artist, sharing an exhibition gallery with his one-time student FRANCIS JOHN McCOMAS. Mathews also painted a mural, *The Victorious Spirit* (presumed destroyed), for the Palace of Education. After the 1915 exposition he continued to be active executing murals and easel works for the next several decades, including decorations for the Supreme Court chambers and the Saint Francis Hotel in San Francisco, but he was replaced as leader of the art community by artists more in tune with Impressionism and Post-Impressionism, though no single individual commanded the allegiance that Mathews had won.[69]

The artist most in sympathy and most closely associated with Mathews and his work was Lucia Kleinhans Mathews, who married Mathews in 1894. She grew up in San Francisco and enrolled in the Mark Hopkins Institute in 1893, then had further instruction from Whistler at the Académie Carmen in Paris in 1899, when she and her husband were abroad. Involved in the Philopolis Press and the furniture shop beginning in 1906, Lucia Mathews was also an active painter; she helped to re-establish the Sketch Club after the earthquake, when its annual shows were opened to both men and women. Unlike her husband, she avoided allegorical themes and mural painting and tended to work on a more intimate scale, laying paint on more freely. Early in the twentieth century she turned to watercolor, often in the depiction of landscapes and still lifes.

Two other outstanding women artists associated with the California Decorative style were **Anne Bremer** and Rowena Meeks Abdy. Bremer studied under EMIL CARLSEN and Arthur F. Mathews at the School of Design and later went to Paris. Her early work is in the manner of Mathews's figurative allegories, but after working in Paris she painted outdoor scenes, sometimes of figures in gardens and among flowering trees, in an Impressionist manner not unlike that of Hugh Breckenridge of Philadelphia. Also a noted poet, Bremer was honored through sculptural monuments, publications, a scholarship, and a memorial library established at the California School of Fine Arts by her cousin, Albert Bender, the foremost San Francisco patron of contemporary art at the time, who also championed such native sons as JOSEPH RAPHAEL.[70] Rowena Meeks Abdy, a younger

3.178

3.213

3.205

3.208

3.214

3.208 Anne Bremer (?–1923)
 Girls under Blossoming Trees, n.d.
 Oil on canvas, 30½ × 25½ in.
 Mills College Collection,
 Oakland, California

artist, studied under Mathews at the Mark Hopkins Institute of Art just after 1900. Her landscapes of old Spanish buildings are broadly painted and descriptive; her contemporary scenes of the bay and her pure landscapes are patterned and stylized in the manner of Mathews, even occasionally utilizing gold leaf.[71]

An artist who studied at the Mark Hopkins Institute during Mathews's directorship and who seems to have been motivated by his preference for abstract pictorial concepts was Perham Nahl, son of the pioneer artist Arthur Nahl. The younger Nahl is best known as an educator, teaching at the University of California at Berkeley from 1912 until 1929, but he was also an able painter of symbolic figural themes such as the powerful and very individual *Morpheus* (Dr. Perham C. Nahl, Evanston, Illinois) and *Despair* (location unknown). Most of Arthur F. Mathews's better-known students and followers adopted Whistlerian Tonalism but applied themselves principally to landscape work. **Charles Rollo Peters**, who did not study with Mathews, and **Gottardo F. P. Piazzoni**, who did, were principally painters of landscapes, which they occasionally infused with a more mystical vision. Peters was a native of San Francisco, born into a wealthy pioneer family there.

3.190, 3.259 He first studied under JULES TAVERNIER and then moved on to the School of Design with

VIRGIL WILLIAMS and Christian Jorgensen before going to Paris in 1886 for more training. 3.177
There he was encouraged by the expatriate Alexander Harrison before returning to San
Francisco in 1889. Peters was back in France the next year, residing in Brittany; he finally
returned to a successful California career in 1895. He divided his time between San
Francisco and the home he built in 1900 in Monterey, which became one of the focal
points of the art colony there. Referred to by critics as a "Tonist," Peters specialized in
Whistlerian nocturnes—glowing, moody paintings of California adobe architecture in a
rich blue-black palette. Whistler himself is said to have remarked that Peters was the only
artist besides himself who could paint nocturnes successfully. Primarily a landscapist,
Peters also painted more mystical nocturnal works peopled with generalized figures, such
as *Visitation*.[72] 3.209

 Gottardo F. P. Piazzoni was probably the most significant of Mathews's students
and the one whose work most closely followed that of his teacher, though, ironically, it
was Piazzoni who organized the earliest reaction against Mathews's dominance. Born in
Switzerland, Piazzoni went to California in his teens, studying with Mathews and Raymond
Dabb Yelland at the School of Design in 1891–93. He went to study in Paris with Jean-
Léon Gérôme, returning to San Francisco in 1898. Like all of Mathews's students Piazzoni
was involved in pure landscape painting. These as well as his figurative representations
often embody abstract concepts such as Silence and Eternity. In *Lux Eterna* a religious 3.210
aura surrounds the simple figure kneeling before a generalized landscape. In all of his
works Piazzoni adopted the reductive strategies and muted palette of Tonalism. He also
followed Mathews's lead in his involvement in mural painting, from his first major
commission, for the First National Bank in 1908, to his major achievement, ten large
paintings for the grand staircase of the San Francisco Public Library, painted in 1929–31.

3.209 Charles Rollo Peters
 (1862–1928)
 Visitation, n.d.
 Oil on canvas on Masonite,
 18½ x 30¼ in.
 The Oakland Museum,
 Oakland, California;
 Kahn Collection

In both his easel and his mural works Piazzoni veered much further toward formal abstraction than Mathews, formulating his own stripped-down approach. In this sense Piazzoni was a precursor of modernism in Northern California. Reacting against the academicism of the Mark Hopkins Institute, he inspired the formation of the California Society of Artists in 1902. This group of progressive young painters and sculptors who resented Mathews's domination of the institute's shows held their own exhibition that year, but the society was short-lived, buried in the disaster of 1906. Piazzoni remained a convinced supporter of modernism, championing the Futurists when their work was shown at the Panama-Pacific International Exposition in 1915, and he was one of the two artist-organizers of the Exhibition of Contemporary French Art in the civic auditorium in 1923. From 1919 to 1935 he taught at the California School of Fine Arts, the successor to the Mark Hopkins Institute.[73]

3.127 Among the other young secessionists involved with the California Society of Artists were several of Mathews's other students, including MAYNARD DIXON and **Xavier Martínez**. Martínez, born in Guadalajara, Mexico, moved to San Francisco when his stepfather became consul general there. He enrolled in the School of Design, and two years later he went to Paris, joining Piazzoni in Gérôme's atelier; he was influenced directly by Whistler, reinforcing the training he had received under Mathews. Martínez returned to San Francisco in 1901 and, after the earthquake, moved across the bay to the hills of Piedmont. He became active with Peters and others in the Monterey art colony and in the founding of the Del Monte Art Gallery. In 1908 he commenced a long teaching career in Berkeley at the California School of Arts and Crafts, which later moved to Oakland and which was one of the principal Bay Area alternatives in the early twentieth century to the California School of Fine Arts; Martínez's responsibilities involved numerous summer terms on the Monterey Peninsula.

 Martínez painted simplified, poetic landscapes that retained descriptive references to their sources and poetic figural works, all in the Tonal aesthetic. Touches of bright color were added here and there, and harmonious effects of light were employed to unify 3.211 these scenes. Martínez's *Afternoon in Piedmont* immediately identifies its source in Whistler's great painting of his mother but transposes that composition into the depiction of his wife, a lovely young woman in the shadowy interior of their home, with the hilly countryside and the bay seen outside the partially curtained window.[74]

 One of Mathews's most talented pupils, **Giuseppe Cadenasso** from Italy, went to California in 1863. He began his studies in San Francisco with Joseph Harrington, later entering the Mark Hopkins Institute. Unlike most of Mathews's students, Cadenasso did

ABOVE, LEFT:
3.210 Gottardo F. P. Piazzoni (1872–1945) *Lux Eterna*, 1914 Oil on canvas, 41¾ x 60¹/₁₆ in. The Fine Arts Museums of San Francisco; Gift in memory of Ethel A. Voorsanger by her friends, through the Patrons of Art and Music

ABOVE, RIGHT:
3.211 Xavier Martínez (1869–1943) *Afternoon in Piedmont*, c. 1911 Oil on canvas, 36 x 36 in. The Oakland Museum, Oakland, California; Gift of Dr. William S. Porter

3.212 Giuseppe Cadenasso
 (1854–1918)
 By the Pool, n.d.
 Oil on canvas,
 25 x 30 in.
 Garzoli Gallery,
 San Rafael, California

3.213 Francis John McComas
 (1875–1938)
 Monterey Twilight, 1902
 Watercolor on paper,
 25 x 34 in.
 The Delman Collection

not go on to Paris. He established himself on Russian Hill and then across the bay, specializing in painting soft, monochromatic scenes of the marshes and eucalyptus groves, 3.212 which earned him the designation the "Corot of America." In typical works such as *By the Pool*, Cadenasso favored vague shadows and misty atmosphere to achieve a sense of poetic mystery; he preferred dawn and twilight effects, working in both oils and pastel, the latter an ideal medium to convey the fleeting effects of light. From 1902 on, Cadenasso was head of the art department of Mills College in Oakland.[75]

Among other students at the School of Design during Mathews's early years was English-born Arthur Atkins. In 1896 Atkins began to exhibit his low-key, tawny pictures of the foothills of Piedmont, where he resided. He died three years later, and his work is extremely rare, decimated by losses in a studio fire in the 1890s and the disaster of 1906.[76] Mathews's influence is acknowledged in the work of his student and continuing admirer **Francis John McComas**, originally from Tasmania, who studied in Sydney, Australia, before going to San Francisco in 1898. McComas studied at the Mark Hopkins Institute with Mathews the following year, going on to Paris and then returning to San Francisco late in 1901. He remained an inveterate traveler, settling in Carmel in 1912. Known 3.213 especially for his decorative scenes among the cypress trees at Monterey and for his paintings of Southwest Indians done in 1909–10, McComas was an outstanding Tonalist watercolor specialist, creating broad, flat forms in warm monochrome.[77]

Among the leading Tonal landscape painters in the Bay Area who did not study with Mathews was Will Sparks, who had been a student of John Fry and Paul Harney at the School of Fine Arts in Saint Louis. Having traveled to Paris, Sparks went to California in 1888 on the recommendation of Mark Twain. He worked as a newspaper illustrator in Fresno and Stockton before settling in San Francisco in 1891. Much of Sparks's painting was done in Monterey, where he was one of the founders of the Del Monte Art Gallery and where he specialized in nocturnal adobe scenes similar to those by Charles Rollo Peters. Sparks's most memorable achievement, completed in 1919, was his series of depictions of the missions; he also painted buildings in the old mining towns.[78] Bruce Porter, a multitalented native of San Francisco, painted murals, worked in stained glass, and designed the city's Robert Louis Stevenson monument. Porter's paintings have Tonal qualities similar to those of Piazzoni's work. German-born Eugen Neuhaus went to San Francisco in 1904, and for over forty years, beginning in 1908, he was the head of the art department at the University of California at Berkeley and the foremost art historian on the West Coast. Also an active landscape painter, he is best known today as a prolific writer, having written books on the Panama-Pacific International Exposition and on William Keith as well as one of the first modern textbooks on American art, *The History and Ideals of American Art* (1931), which is still the only such study to give California artists their due. Though he ultimately subscribed to Impressionism, Neuhaus long upheld the primacy of Tonalism, which he espoused in *Painters, Pictures and the People*, published in 1918 by Philopolis Press, with Mathews's painting *Art and Nature* as the frontispiece.[79]

The dominance of Tonalism and late Barbizon strategies in San Francisco during the early years of the twentieth century contrasts with the prevalence of Impressionist-oriented work in most other large urban centers throughout the country at the time. Although Ethel Crocker had a significant collection of works by Claude Monet, Camille Pissarro, Eugène Boudin, Edgar Degas, and Pierre-Auguste Renoir, they were hung in her basement; the main rooms of her San Francisco home were decorated with works by Mathews and artists of the earlier California landscape school along with French Barbizon and academic pictures and one by Pierre Puvis de Chavannes.[80] Even the early showing in San Francisco of a single Monet (*Sunlight Effect on the Riviera*) at the Art Loan Exhibition 1.41, 1.244, of Foreign Masters of March 1891 was overshadowed by a Monterey painting by GEORGE 2.68 INNESS that hung nearby. Indeed, Inness's much-heralded visit to San Francisco that year reaffirmed the commitment to Barbizon and Tonalist precepts. No American Impres-1.30, 1.154, sionist of national repute painted actively in Northern California until 1914, when CHILDE .144; 1.146, HASSAM was in Marin County and Carmel and WILLIAM MERRITT CHASE taught at the art 1.155 school in Carmel.

3.214 Joseph Raphael (1872–1950)
The Town Crier and His Family, n.d.
Oil on canvas, 78 x 64⅝ in.
The Fine Arts Museums of San Francisco; Gift of Honorable Raphael Weill

Impressionism finally arrived in full force, especially in its American interpretation, at the Panama-Pacific International Exposition in 1915. The fair was meant to prove both the city's resurgence after the devastation of 1906 and its cultural maturity; the event's aesthetic message of architectural harmony and the integration of all the arts was an assertion of the principles espoused by Arthur F. Mathews. Mathews himself shared a gallery with his student Francis John McComas, and William Keith had one to himself, as did the Impressionists Hassam, Chase, Twachtman, Edmund Tarbell, and EDWARD WILLIS REDFIELD; regional representatives ranged from KATE FREEMAN CLARK of Mississippi to the Old Lyme, Connecticut, painters and numerous artists of the Indiana Hoosier school. There was a substantial showing of the expatriates working in Giverny, France, and many artists from Los Angeles and San Diego exhibited. Examples of work by the French masters included Degas, Pissarro, Renoir, and Alfred Sisley, a wall of Monet's work, and paintings by the then-popular Swedish Impressionists. Hassam and Robert Reid, another American Impressionist, were involved in the mural decoration at the exposition, with Reid painting the dome of the rotunda of the Palace of Fine Arts and Hassam joining Mathews in embellishing the Court of Palms.

San Francisco artists were well represented at the Palace of Fine Arts, including some who followed Mathews's lead, such as Gottardo F. P. Piazzoni and Lucia Kleinhans Mathews; there was, in fact, a strong representation of San Francisco's women artists, including Mary Curtis Richardson, Maren Froelich, Calthea Campbell Vivian, Rosa Hooper, and Anne Bremer. Three outstanding Northern California Impressionists—Joseph Raphael, Euphemia Charlton Fortune, and Armin Carl Hansen—were silver medalists; ironically, all had been students of Mathews.

Joseph Raphael, a San Francisco native, became a student of Mathews at the Mark Hopkins Institute and went to study in Paris in 1903. He remained in Europe, living in the art colony in Laren, the Netherlands, and, about 1912, moving to Ukkel, a suburb of Brussels. With Jules Pagès in Paris, Raphael became one of San Francisco's most famous early twentieth-century expatriates. He continued to exhibit and to find much of his patronage there, recognized early on as a favorite son. He finally returned in 1939, at the outbreak of World War II.

Raphael is noted for his scenes of gardens and fields of flowers, painted in broken strokes of impasto and a vivid chromatic range. Abstract design elements and overall expressive effects carried his art into the realm of Post-Impressionism, and these works have been the basis of the recent revival of his reputation. He turned quite suddenly to this mode about 1912, after revisiting San Francisco in 1910, in connection with a solo exhibition at the San Francisco Institute of Art, and after moving to Belgium. His earlier maturation was marked by dark pictures of Dutch peasant genre; by about 1905 he had begun to produce monumental figural paintings—both single figures and complex groups in a powerful, dramatically lit naturalist mode with Symbolist overtones. The most elaborate of these are *La Fête du Bourgmestre* (San Francisco Art Institute), depicting the Laren burgomaster N. W. van den Broek, and *The Town Crier and His Family*. The former's successful exhibition in Paris had immediate reverberations in San Francisco, where it was presented to the Art Association in 1911. The latter was shown at the Art Association in 1906, having already been purchased by the merchant and art patron Raphael Weill. After being exhibited at the Bohemian Club in 1908, it was presented by Weill to the Memorial Museum in Golden Gate Park, the city's earliest public museum.[81]

Having served as the Fine Arts Building at the 1894 California Midwinter Exposition, the building in Golden Gate Park was established as a museum by M. H. de Young, publisher of the *San Francisco Chronicle*, and opened in 1895. De Young subsequently began accumulating a large number of acquisitions for the museum, not only paintings and sculpture but also decorative arts, artifacts from American Indian and South Pacific cultures, and almost anything else, from birds' eggs to thumbscrews. As the collections outgrew the space, a new building was completed in 1919 and an addition made two years later. A second public museum was donated to the city by Alma Spreckels, wife of the sugar magnate Adolph Spreckels, who was a fierce rival of de Young's. Mrs. Spreckels

3.215 Euphemia Charlton Fortune
(1885–1969)
Monterey Bay, 1916
Oil on canvas, 30 x 40 in.
The Oakland Museum,
Oakland, California

had been greatly impressed by the replica of the Parisian Palais de la Légion d'Honneur that had served as the French pavilion for the Panama-Pacific International Exposition, and she offered to construct a permanent version of it for an art museum focused on European art; it opened in 1924. After Alma Spreckels's death in 1968 a merger of the two museums was begun and finally ratified in 1972; the institution is now known as the Fine Arts Museums of San Francisco.

Euphemia Charlton Fortune remained closer to home than Raphael, and her art is more closely identified with Northern California. Born in Sausalito, across the Golden Gate from San Francisco, Fortune studied art in Great Britain, returning to this country in 1905. She studied with Mathews at the Mark Hopkins Institute and, after the earthquake, studied in New York City at the Art Students League, where she got to know William Merritt Chase. Though Fortune began her career as a portrait painter, she early turned to landscape, dividing her time between San Francisco and Monterey, where she was a significant presence and from which she took many of her subjects. Her mission pictures, landscapes, and harbor scenes on the Monterey Peninsula are among the earliest examples of local Impressionist-oriented painting, done in broad but blocky brushstrokes of bright color, as in *Monterey Bay.* In 1921 Fortune began a six-year residence in London. On her return she founded the Monterey Guild in 1928, which designed tabernacles, candlesticks, altar cloths, and hangings; in the 1930s Fortune abandoned easel painting for church decoration.[82]

3.215

Fortune's presence on the Monterey Peninsula in the 1910s is indicative of the increasing popularity of Impressionism among the painters there. The looseness of that community encouraged experimentation with modern aesthetics that might have been regarded with hostility in San Francisco. This more adventurous direction was reinforced in 1914, when Fortune suggested that Chase be invited to hold a summer class for the Arts and Crafts Club in Carmel, just south of Monterey. The club had been formed in 1905 and had begun to hold classes in the early 1910s. Chase's emphasis on painting outdoors in a vigorous manner and on the primacy of color over form encouraged an Impressionist orientation in the colony generally. Chase himself was productive in his Monterey studio, painting fish still lifes and local landscapes and working in monotype. This was his last formal teaching appointment, but he returned to California the next year as a member of the International Jury of Award for the Panama-Pacific International Exposition.[83]

Armin Carl Hansen became a noted teacher and Impressionist painter in Northern California. Born in San Francisco, he, too, studied at the Mark Hopkins Institute under Mathews, between 1903 and 1906, and then went to Stuttgart, Germany, for two more years of instruction. Hansen remained abroad until 1912, mostly on the Belgian coast at Nieuwpoort, after which he returned to San Francisco. A year later he settled in Monterey, where he remained for most of his career. Teaching privately at first, Hansen began to instruct summer classes in Monterey in 1918, for the California School of Fine Arts (previously the Mark Hopkins Institute). Like Chase before him, Hansen stressed outdoor landscape painting, concentrating on vivid, dramatic marines, such as *Salmon Trawlers*. His renderings of local Italian, Portuguese, and Mexican fisherfolk often document more dynamic activities than most Impressionist scenes. Hansen usually eschewed the broken color of Impressionism for broadly handled paint and intense color contrasts.[84]

Rinaldo Cuneo was born in San Francisco and, after three years in the United States Navy during the Spanish-American War, returned to his native city and studied at

3.216

3.216 Armin Carl Hansen
(1886–1957)
Salmon Trawlers, n.d.
Oil on canvas, 47 x 53 in.
Mrs. Justin Dart

3.217 Frank Van Sloun
(1879–1938)
The Critics, c. 1920
Oil on canvas, 22 x 28 in.
The Delman Collection,
San Francisco

the Mark Hopkins Institute under Mathews and Gottardo F. P. Piazzoni. In 1911 he went to London and Paris. On his return Cuneo painted marine subjects along the waterfront and Impressionist views in Marin County and the Sierra Nevada, sometimes with an emphasis on decorative patterning that allies him with Post-Impressionism.[85]

If Impressionism did not fare particularly well in San Francisco during the early twentieth century, neither did other more contemporary movements. There was little reflection of the urban realism of New York's Ashcan School, San Francisco's principal exponent of such concerns probably being **Frank Van Sloun** from the Midwest. Van Sloun had studied in New York City at the Art Students League and, most important, with Robert Henri, with whom he founded the Society of Independent Artists. Van Sloun settled in San Francisco in 1911, teaching at the California School of Fine Arts in 1917 and then starting a private school; he joined the faculty at the University of California at Berkeley in 1926. Van Sloun was noted for his contemporary, raw, hearty figure pieces and urban scenes, such as *The Critics*. In *Greed* (1914, location unknown), a rare excursion into allegory, he portrayed a naked family hanging from the cross of economic and industrial avarice against a backdrop of factories. Van Sloun's fame may have been due more to his etchings and monotypes than to his oil paintings; in fact, his greatest

3.217

importance lay in his teaching. He brought Henri's aesthetic, "art for life's sake," to the Bay Area and was admired for his pedagogical flexibility.[86]

Van Sloun's teaching at the California School of Fine Arts in 1917, though brief, was symptomatic of the changes occurring there. Theodore Wores had taken Mathews's place after 1906, remaining as director until 1914. Wores was succeeded by a former student of Mathews, Pedro Lemos, who had taught etching and decorative design at the school and who wrote several books on printmaking and applied arts. In 1917 Lee Fritz Randolph replaced Lemos, who, in 1919, became director of the art museum at Stanford University. Many of the academic instructors left with Lemos; Piazzoni, with more avant-garde sympathies, remained to teach painting. Randolph, a Paris-trained artist more open to new ideas, continued as director for twenty-five years.

Although the works of the Italian Futurists appeared in the Panama-Pacific International Exposition, Fauvism, Expressionism, and Cubism remained all but unknown in the Bay Area until the 1920s and even later. The catalog of the First Exhibition of Painting and Sculpture by California Artists—almost all *Northern* California artists—at the Golden Gate Park Memorial Museum in 1915 presented a comprehensive survey of leading painters and sculptors, in which Barbizon, Tonal, and Aesthetic styles seem to have dominated. Advanced aesthetic issues were addressed more vigorously in the Museum Loan Exhibition of Work by the California Group of Contemporary American Artists, held in January 1919 in the Palace of Fine Arts, under the sponsorship of the San Francisco Art Association.

The position most supportive of modernism was taken in Oakland by **William Henry Clapp**, who became the acting director of the Oakland Art Gallery in 1918 and was named director the following year. Canadian by birth, Clapp had grown up in Oakland but returned to Montreal, where he studied at the school of the Montreal Art Association before going to Paris for four years of instruction in 1904. He returned to the Bay Area in 1917, teaching a life-drawing class at the California School of Arts and Crafts in Berkeley before joining the staff of the Oakland gallery, which had been founded the previous year. In Canada, Clapp had rebelled against the academic system with fellow iconoclasts Maurice Cullen and Clarence Gagnon, and in Paris he had become devoted to the work of Monet and his fellow Impressionists. Clapp's own mature painting represents the most complete realization of Impressionist formal strategies in Northern California; his subjects were often casual activities in the bright outdoors, as in his best-known picture, *Bird-Nesting*, probably painted in Montreal about 1908–9. Clapp remained active as an artist after he assumed his duties in Oakland, though they did curtail his activity. His innovative exhibition policy of bringing to the Bay Area contemporary American and European art—including the first American museum presentation, in 1926, of the Blue Four (Alexej Jawlensky, Wassily Kandinsky, Paul Klee, and Lyonel Feininger)—is beyond the scope of this study.

Clapp's most important role was as a member and sponsor of the Society of Six, the most significant group of avant-garde painters in the Bay Area. The group was recognized when Clapp began to present their annual shows in 1923, continuing through 1928. The members—Clapp himself, Selden Connor Gile, August Gay, Maurice Logan, Louis Siegriest, and Bernard von Eichman—were identified as the Society of Six within a month of their first group showing in March 1923. Gile, Logan, and Gay, like Clapp, were practicing professionals by the late 1910s. Though the majority of works by all six display the rich, raw colors of Post-Impressionism and Fauvism, they identified the Impressionists as their inspiration. **Selden Connor Gile**, the oldest and the group's leader, had settled in Oakland in 1905. About 1910 he met August Gay, with whom he lived intermittently for the next decade; they were later joined by Logan and the teenaged Siegriest and von Eichman. About 1916 Gile moved into Chow House on Chabot Road, which became the group's unofficial headquarters; in 1917 he met Clapp.

All but Clapp visited the Panama-Pacific International Exposition; the paintings they saw had the greatest impact on Gile and Gay and, through them, on Siegriest and von Eichman; Logan, trained at the San Francisco School of Art, remained indebted to

3.218

earlier masters. Siegriest and von Eichman studied with Van Sloun, who had previously been one of Logan's teachers; Gile also may have taken instruction with him. By the late 1910s color had emerged as the dominant component of the group's art. With the exception of Clapp, who was regarded as old-fashioned in his allegiance to doctrinaire Impressionism, they applied color in broad, intense strokes juxtaposing large, bold masses of hue. The strong light of midday was preferred by Gile and his colleagues, as in the former's *Sausalito*. Their paintings were small and their subjects casual, corresponding in their ramshackle roughness to the gutsy paint application. In 1919 Gay moved to Monterey, thus forming a link between the two most advanced groups of artists in Northern California.[87]

Though small, the art community in **Monterey** and the surrounding towns on the peninsula is worthy of independent consideration. The earliest resident artist was the Boston landscape and portrait painter John Christopher Gore, who after graduating from West Point, went to Europe, studying and working in Florence between 1829 and 1832. Gore was active in Boston until he moved to Monterey in 1852 due to the poor health of his son; he purchased a ranch of almost five thousand acres and remained until 1861. Serious artistic activity began in Monterey in the mid-1870s, with the establishment there of JULES TAVERNIER and the artists he drew to his orbit. Northern California artists thenceforth made regular pilgrimages to the peninsula. In the next decade it attracted the students of

3.219

.190, 3.259

OPPOSITE:
3.218 William Henry Clapp
(1879–1954)
Bird-Nesting, c. 1908–9
Oil on canvas,
36½ x 28¾ in.
The Oakland Museum,
Oakland, California; Gift of
Mr. and Mrs. Donn Schroder

ABOVE:
3.219 Selden Connor Gile
(1877–1947)
Sausalito, 1915
Oil on canvas,
12¹/₁₆ x 16¹/₁₆ in.
Daniel and Virginia
Mardesich

the School of Design, under the guidance of EMIL CARLSEN, during the summers. In the period between Tavernier's stay and the establishment of a permanent artists' colony at the beginning of the twentieth century, visiting painters from America's interior helped to popularize Monterey's charms in picture and print, including several of Utah's outstanding landscape specialists, such as ALFRED LAMBOURNE in the late 1880s and HENRY CULMER a decade later.[88]

<div style="text-align: right">3.205</div>

<div style="text-align: right">3.95; 3.97</div>

After the earthquake of 1906 a fully developed art community began to form, although some prominent painters, such as CHARLES ROLLO PETERS, had already settled there in 1900. Monterey offered refuge, either as a cultural commune within easy reach of the rebuilt metropolis or as an active summer colony to visit. Some of San Francisco's artists had already established summer homes in Monterey or nearby Pacific Grove and moved into them after their in-town studios were devastated. Carmel-by-the-Sea, on the south side of the peninsula, had been established as a bohemian mecca in 1903, and a suburb of tents housing the fleeing artists sprang up there.

<div style="text-align: right">3.209</div>

Monterey's closest counterpart among eastern art colonies was probably Provincetown, Massachusetts, which developed at roughly the same time. The most important difference between them is that the growth of Provincetown depended on the art schools formed there, whereas Monterey's greatest initial attraction, beyond its natural splendor, was the Del Monte Art Gallery established in the hotel of the same name in 1907. It was founded by some of San Francisco's leading painters, including WILLIAM KEITH, ARTHUR F. MATHEWS, and the majority of the latter's best-known students. The gallery originally took up the slack caused by the commercial devastation of San Francisco, but it remained significant as an outlet for a wide variety of contemporary styles, while the San Francisco Art Association's shows remained devoted to the Tonal and California Decorative styles of the pre-earthquake years. The Del Monte exhibitions, restricted to California artists, were strictly juried to maintain a high level of quality and were financially remunerative.

<div style="text-align: right">3.178; 3.207</div>

In addition to Charles Rollo Peters and, later, EUPHEMIA CHARLTON FORTUNE, ARMIN CARL HANSEN, and August Gay, other well-known painters associated with Monterey included Charles Dickman, one of the gallery's founders, after whom a street was named in Monterey. The German-born Dickman grew up in this country, moving to San Francisco in 1882; he studied at the School of Design and in Paris for five years from 1896 and painted fisherfolk in Etaples. Returning to San Francisco and settling in Monterey in 1901, he specialized in paintings of cypress groves and fishermen at sea, becoming known as "California's Painter of Sunshine." Dickman participated in a two-man show that also contained nocturnal adobe scenes by Charles Rollo Peters and was known as the "gold and blue show."[89]

<div style="text-align: right">3.215; 3.216</div>

Monterey became the home of California's two finest specialists in watercolor landscapes, FRANCIS JOHN McCOMAS and **Percy Gray**. Born in San Francisco, Gray came from a long line of Scottish and English painters, all of whom, including his uncles, William John, Alfred, and Henry Gray, were professionals who specialized in watercolor. The Australian gold rush lured Percy Gray's father from England in 1852; fifteen years later he settled with his family in California. Young Percy, one of ten children, was the only one to follow an artistic career, entering the California School of Design in 1886 and studying under Emil Carlsen. Gray began in the early 1890s to work as a newspaper illustrator, continuing to do so when he settled in New York City in 1895, where he remained for over a decade.

<div style="text-align: right">3.213</div>

Gray returned to Alameda to report on the 1906 earthquake, but once back in the city he turned seriously to painting, exhibiting watercolors of the California landscape from 1910. Though he and McComas were contemporaries, the two approached the medium in diametrically opposite manners. Gray eschewed the flat, bold, reductive, and decorative manner that McComas had inherited from Arthur F. Mathews, preferring detailed formal description and rich atmospheric effects. Primarily a studio painter, Gray was capable of a variety of techniques, from quickly applied wet washes to an almost stippled approach. He aimed for a lyrical poetry based on the English watercolor tradition from which he had sprung, only occasionally affecting a more modern stance. He traveled

to and painted the favored California subjects, including Yosemite and Lake Tahoe, and took excursions to Oregon, Washington, and Arizona, returning repeatedly to a few themes. One was the eucalyptus groves of Northern California; another was the rocky seacoast. Gray joined THEODORE WORES and others in luxuriating in the intense color provided by fields of California wildflowers. His favorite theme probably was Mount Tamalpais, across the bay from San Francisco, which he painted throughout his career, beginning as early as 1887. In 1923 Gray joined the art colony in Monterey, where he had painted on visits, remaining for fifteen years before settling in Marin County in 1938.[90]

Clark Hobart grew up in California and studied at the Mark Hopkins Institute and in New York City and Paris. He settled in Monterey about 1911–12, remaining for approximately five years; in 1916 he moved to San Francisco. Hobart's paintings of the dunes and the Pacific utilize the brilliant color of Impressionism laid on in strong planes of contrasting hues, so that structure is as important as color, a Post-Impressionist strategy derived from Paul Cézanne, as noted by critics of the time. Hobart, who denied any allegiance to Impressionism, also was known for his portraits, figure, and monotypes.[91]

The nearby community of **Pacific Grove** hosted its own colony of artists. The English-born watercolorist John Ivey was active on the peninsula from 1902 until 1907 as head of the art department of the Pacific Grove Chautauqua Assembly. One of the community's principal painters was Bruce Nelson, a Californian who had studied in New

3.199
3.220

3.220 Percy Gray (1869–1952)
 Mount Tamalpais, n.d.
 Watercolor on paper,
 15½ x 20 in.
 The Cleland and Katherine
 Whitton Collection

York City at the Art Students League and with LOVELL BIRGE HARRISON and JOHN F. CARLSON in Woodstock. He returned to California in 1912 and the following year settled in Pacific Grove. For the rest of the decade Nelson painted coastal scenes and Santa Clara Valley landscapes in an increasingly colorful Impressionist palette but with strong, blocky brushwork reminiscent of Carlson's approach. Nelson is believed to have moved to New York City in the 1920s.

1.174, 2.52; 1.175

The Monterey Peninsula, like its Cape Cod counterpart, became known for the variety of summer instruction available there, especially in **Carmel**. XAVIER MARTÍNEZ began offering summer classes in Carmel soon after the founding of the Del Monte Art Gallery. Carmel became the headquarters for the area's most noted summer classes when the Arts and Crafts Club, formed in 1905, started its summer school in the early 1910s. The most important guest instructor from the East was, of course, WILLIAM MERRITT CHASE; George Bellows visited in the summer of 1917. Among the most prominent local painters who taught at the school were WILLIAM POSEY SILVA and Mary DeNeale Morgan. By the time he moved to Carmel in 1913; Silva had already established a reputation in his native Georgia; Chattanooga, Tennessee; and Washington, D.C., as a landscapist working in a modified Impressionist manner. Finding Carmel to be ''the land of promise,'' he devoted himself to painting the cypresses, eucalypti, dunes, and coasts in a vigorous manner.[92]

3.211

1.146, 1.155

2.138

Morgan, one of the Bay Area's leading women artists, was born in San Francisco and studied with VIRGIL WILLIAMS, Emil Carlsen, and Amédée Joullin at the School of Design. Morgan first visited Carmel in 1903, and after the death in 1909 of the local watercolorist Sydney Yard (the first noted artist to build a home there), she acquired his studio and became involved with the Arts and Crafts Club. It was Morgan who, at Euphemia Charlton Fortune's suggestion, invited Chase to teach in Carmel, where she herself was an instructor. Morgan's best-known paintings depict the windswept coastal cypresses in a colorful, painterly manner.[93] Jane Gallatin Powers from Sacramento arrived in Carmel in 1903 and remodeled an old log cabin into a studio near Pebble Beach. Another woman landscape painter, Mary Amanda Lewis, was among Chase's students in 1914 and was much influenced by him. A painter of themes similar to those of Morgan and Silva and a proponent of comparable formal strategies was Irish-born John O'Shea. He came to this country in the late 1890s and, after training in New York City, settled in California, first in the south, in 1913, and then in Carmel, in 1917.[94]

3.177

Probably the most eminent American painter to relocate to Carmel was **William Ritschel**. Born in Germany, Ritschel studied in Munich before emigrating to this country in 1895. He worked in the East until he settled in Carmel in 1911 for the rest of his life. Stylistically, his work resembles that of Armin Carl Hansen—highly colored and broadly painted in an Impressionist-related mode—and, like Hansen, Ritschel was renowned for his coastal pictures and marines. Human activities are far less significant in his paintings; he focused, as WINSLOW HOMER had done before him, on the forces of nature, as in *Rocks and Breakers, California*.[95]

1.12

3.221

Few Northern California painters of note resided beyond the San Francisco area and the Monterey Peninsula. Frederick William Billing was an exception, a painter in the older naturalistic style who favored coastal scenes and Yosemite, combining detailed realism with an emphasis on panoramic grandeur. German-born, Billing came to this country about 1856, studying with the German-American landscapist Johann Carmiencke in New York City. In ill health, Billing moved to Salt Lake City in 1879, becoming friendly with THOMAS MORAN, by whom he was influenced, and specializing in landscapes of the Tetons, Wasatch Range, and Yellowstone. About 1889 Billing settled in **Santa Cruz**, California, where he remained until his death twenty-five years later.[96] Frank L. Heath, a generation younger than Billing, grew up in Santa Cruz and after studying in San Francisco at the School of Design and painting there professionally for eleven years, he returned as a specialist of airy, painterly coastal scenes. With his students and colleagues Heath established the Jolly Daubers, a group of painters who worked outdoors, shortly after the turn of the century. This was the forerunner of the Santa Cruz Art League, which the artist founded

1.152, 1.254

3.221 William Ritschel (1864–1949)
*Rocks and Breakers,
California,* 1913
Oil on canvas, 50 x 60³⁄₁₆ in.
The Pennsylvania Academy
of the Fine Arts, Philadelphia;
Joseph E. Temple Fund

in 1919 with his former student, the Santa Cruz landscapist Margaret Rogers, who had settled there in 1905.

Astley D. M. Cooper was a colorful figure who settled in 1883 in **San Jose**, a busy commercial center that was the first civil community in California and that had been the state capital from December 1849 to January 1852. The Third Annual State Agricultural Fair had taken place there in 1856, when CHARLES CHRISTIAN NAHL won a premium in oil painting. Cooper, born in Saint Louis, was inspired by the work of GEORGE CATLIN. In the 1830s Cooper's grandfather—Major Benjamin O'Fallon of that city, who was a nephew of the explorer William Clark—had commissioned Catlin to paint a series of thirty-five Indian subjects. Cooper arrived in San Francisco in 1882, and after settling in San Jose a year later he built an Egyptian-style studio and made a reputation with his cowboy, Indian, and buffalo subjects. In fact, he essayed a wide variety of themes and painted large-scale decorations for local saloons and hotels. His several vividly realistic buffalo-head still lifes seem to project into the viewer's space. Serving as San Jose's portrait painter, he was patronized by such notables as Mrs. Leland Stanford, who also purchased a number of his buffalo and Indian pictures. One of his most unusual and spectacular pictures—a testament to wealth and to philanthropy—was the precisionist recording in 1898 of Mrs. Stanford's jewelry, commissioned to record her possessions before they were sold for the benefit of the Stanford University Library. The artist's habitual inebriation seems actually to have contributed to the lifelike sparkle he achieved in this "still life."[97]

Contemporary with Cooper in the region was HOWARD STREIGHT, an artist from Ohio who had painted meticulously detailed, glowing Rocky Mountain scenery after settling in Denver in the early 1870s; there he was fortunate to enjoy the patronage of the Kansas Pacific Railroad. About 1890 Streight settled on a ranch near Mountain View, California, just northwest of San Jose, where he continued to paint landscapes. The aforementioned Calthea Campbell Vivian, who was also a landscape painter, was the first head of the drawing department at the San Jose Normal School until 1917 and one of the region's leading women artists.

3.168
3.17

3.222

3.75

3.222 Astley D. M. Cooper
(1856–1924)
The Buffalo Head, n.d.
Oil on canvas, 40 x 36 in.
Buffalo Bill Historical Center,
Cody, Wyoming

Occasionally, an artist of note lived in a small, isolated town, as did the landscape painter Benjamin Willard Sears. Sears grew up in San Francisco, his father having gone to California in 1852 to prospect in the vicinity of Sonora. Sears based himself in that community after he left San Francisco in 1878, working as a sketch artist for the United States Coastal Survey, his duties taking him all over Northern California. Sears had painted many coastal scenes in San Francisco during the 1870s, but once he settled in Sonora he concentrated on landscapes of the Sierra Nevada, Yosemite, and Tuolumne County.[98]

Sacramento, the state capital from 1854, was the scene of activity on the part of many visiting or briefly resident artists, but long-term resident painters seem to have been few and little studied. Probably the city's two best-known artists were William F. Jackson and Mary Amanda Lewis. Jackson's family moved from Iowa in 1862, and the young man later studied at the School of Design in San Francisco with VIRGIL WILLIAMS and 3.177 Benoni Irwin, then established a studio in Sacramento. When the E. B. Crocker Art Gallery opened there in 1885, he assumed the position of curator and was allowed to keep a studio in the gallery. When funds were donated to establish an art school, Jackson took on its directorship as well. An innovative teacher, he introduced plein-air painting into the curriculum. Jackson is best known for his dashingly painted pictures of brilliant orange poppy fields, a popular motif in California at the beginning of the twentieth century. Mary Amanda Lewis, one of Jackson's most accomplished pupils, studied with

1.146, 1.155 WILLIAM MERRITT CHASE in Carmel in 1914; she was a specialist in spontaneous, informal outdoor scenes painted in an Impressionist mode and was active for a while in Monterey; an accomplished cellist, she played for five seasons at the Del Monte Hotel there.

3.202 Artistic activities beyond Marin and Sonora counties are undocumented, except for the occasional visits of landscapists to paint Mount Shasta and the singular activity of GRACE CARPENTER HUDSON in Ukiah. Eureka, the largest coastal community in that region, was settled in 1850, but few artists are known to have been active there. Perhaps the best-documented is Charles Theller Wilson, who was born in San Francisco and studied

3.190, 3.259 with JULES TAVERNIER. He remained in San Francisco until 1900, when he moved to Eureka. Wilson, who made extensive sketching trips throughout Latin America, is best remembered for his paintings of the California redwoods.

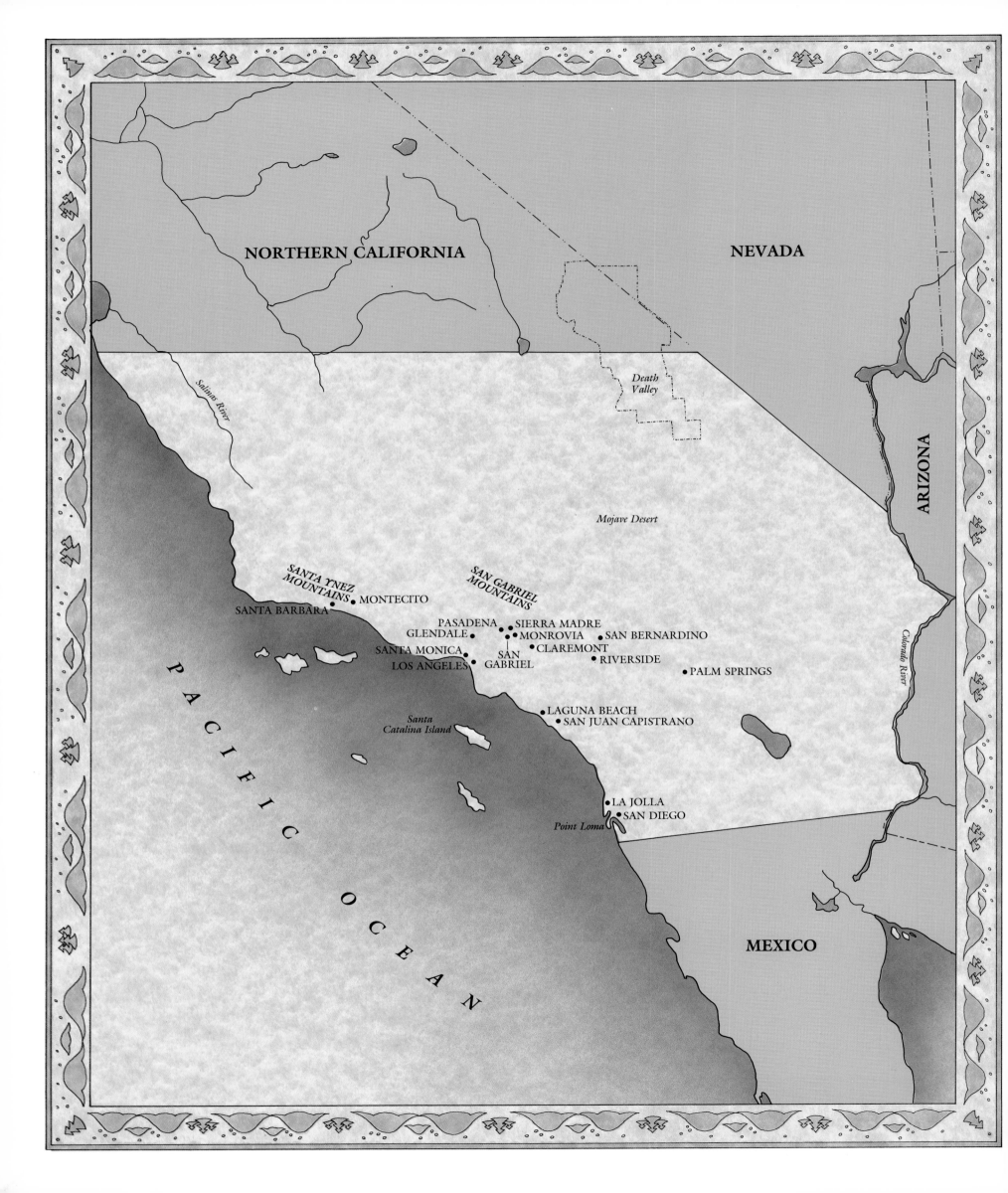

SOUTHERN CALIFORNIA

The aesthetics that had informed early painting in the Bay Area were no longer viable by the time a professional art establishment began to develop in Southern California. While San Francisco's well-entrenched patron class was traditional in its outlook, Southern California was more receptive to modernism. The area's warm climate attracted artists from bleaker American cities, either directly or after stints in Europe, where some of them were exposed to Impressionism. Inspired by what they had seen of modernism, they sought an environment that would nurture the exploration of related aesthetic strategies without hindrance from tradition. Whereas artists of both North and South were deeply involved with landscape painting, neither Los Angeles nor San Diego inspired a wealth of figural representations equivalent to the Chinatown and waterfront scenes painted in San Francisco. That city's geographic concentration encouraged its painters to congregate in artists' quarters that had no equivalent in decentralized Los Angeles. Laguna Beach, the rural retreat for painters of the latter city, developed only in the final years covered by this study.[1] Though Los Angeles had developed into Southern California's primary cultural center by 1920, both Santa Barbara to the north and San Diego to the south had independent artistic establishments and histories. All three began to attract painters about 1880, though it was a decade or more before true art communities began to flourish.

Founded in the eighteenth century, **Santa Barbara** was established as a city in 1850, about the same time as San Francisco. That same year the Italian portraitist Leonardo Barbieri, who is believed to have arrived in California in 1849, was painting in Santa Barbara on his way back up to San Francisco from San Diego. One of his best-known California likenesses is that of the Franciscan José Gonzales Rubio, painted for the Santa Barbara mission in 1850 as a tribute by the local populace to Father Rubio, who was appointed vicar general of the diocese that year.[2] Probably the earliest professional painter to live in Santa Barbara was the landscape specialist Henry Chapman Ford, one of the most distinguished members of the Chicago art community, who went to California to improve his ill health. Having settled in Santa Barbara in 1875, he began to create drawings, watercolors, oils, and prints of the California missions, completed in 1880–81, which he published as etchings in 1883; these were exhibited a decade later at the World's

3.83, 3.193 Columbian Exposition in Chicago. Like those of EDWIN DEAKIN in San Francisco, Ford's pictures were instrumental in the preservation of the missions.[3]

2.188 An artist of equal caliber, EDWARD EDMONDSON, joined Ford in November 1880. A major portrait and still-life painter from Dayton, Ohio, Edmondson also went to Southern California in search of better health. His quest was not successful, and after two years he moved to San Francisco and, in 1883, to Santa Rosa, dying early the following year. During his years in Santa Barbara, Edmondson turned to landscape, painting detailed coastal scenes and views of the mission there. He continued to paint still lifes, producing close-up studies of the sharply detailed, brightly colored foliage and fruit of the distinctive California pepper tree.[4]

Edmondson's talent was recognized in Santa Barbara by February 1881, when the community held its enormous Art Loan Exhibition in the Odd Fellows' Building, the first

major public exhibition presented in Southern California. It was sponsored by the Santa Barbara Improvement Association, which had been formed to benefit social and intellectual life in the city and to raise funds for public works. Despite its title, the show of almost fifteen hundred items consisted primarily of bric-a-brac, decorative objects, curios, and books. There were two art sections, however. One consisted of pictures by local artists, presumably mostly amateurs except Ford, who exhibited a pair of landscapes of Southern and Northern California, and Edmondson, who showed a still life of snipe (locations unknown). Another section displayed works owned by local citizens, in which more of Ford's pictures were on view; other American artists whose works were shown included HENRY INMAN and the midwestern painter Peter Fishe Reed.

1.229

About 1891 Paris-trained LOVELL BIRGE HARRISON settled in Santa Barbara, having 1.174, 2.52 left Europe for extensive travels in the Orient and the Pacific and a stay among the Pueblo Indians in Espanola, New Mexico. Harrison, too, was plagued by ill-health, and though he is said to have been active in California, that phase of his career is scantily recorded. The year after his wife's death in 1895, he moved to Plymouth, Massachusetts. Southern California's first significant painter, **Alexander Harmer**, who was destined to become the leader of the local art community, also arrived in the early 1890s. Harmer had served in the army in California during the 1870s and then studied at the Pennsylvania Academy of the Fine Arts under Thomas Eakins in 1880. Having re-enlisted in the army, he participated in the Apache wars in the Southwest and then began painting, exhibiting, and illustrating Indian subjects in the East. Once settled in Santa Barbara, and encouraged by Charles F. Lummis, the publisher of *Land of Sunshine* magazine and a major preservationist of Indian and Hispanic culture, Harmer turned to genre scenes of early Mexican life in California, painting them with great fidelity to detail. Harmer also dealt with contemporary traditions, including the elaborate flower festival established in 1891 during a visit from President Benjamin Harrison. Such a fête, which imitated the carnival of Nice in France, was natural to so lush a region and was revived on the visit of the Grand Fleet of the North Pacific in the spring of 1908. Flowers were scattered for several miles as the parade of sailors and officers was accompanied by members of the old Spanish

3.223 Alexander Harmer
(1856–1925)
Battle of the Flowers, Fleet Festival, 1908
Oil on canvas, 20 x 36 in.
Santa Barbara Historical Society, Santa Barbara, California

families in traditional costume. The ceremonies were recorded in one of Harmer's most elaborate works, *Battle of the Flowers, Fleet Festival*.[5]

3.223

 By the first decade of the twentieth century Santa Barbara had become established as an art center. The town, shielded from inclement weather by the Santa Ynez Mountains, had been attracting tourists since the 1870s, but it was the completion of the Southern Pacific Railroad in 1901, a coastal route connecting Los Angeles and San Francisco, that

3.192

started a tidal wave of tourists and retirees. The landscapist THADDEUS WELCH, who worked in a Barbizon tradition, settled in Santa Barbara in 1905, again for reasons of health, continuing to paint Marin County scenes from sketches made previously. John N. Marble and Robert Leicester (also known as Rob Wagner) were active as portraitists, the latter remaining for several years, beginning in 1906. Toward the end of that year the artist-illustrator Fernand Lungren arrived from Los Angeles, where he had resided since 1903. Lungren, who had grown up in Toledo, Ohio, had made western subjects his specialty since his first trip to New Mexico in 1892. He became a mainstay of the growing art community in Santa Barbara, and he and Wagner were put in charge of the artistic arrangements for the 1908 Fleet Festival. Lungren became known for his landscapes of the Rockies and the Southwest but established his greatest reputation for his depictions of the Mojave Desert and Death Valley. Indeed, he became *the* foremost desert painter of the early decades of the century, depicting this subject under varying conditions of light and at different times of day, reveling in the vivid coloration he observed. Many of the finest of these pictures remained in his own collection and were bequeathed to the University of California at Santa Barbara; Lungren's large assembly of Indian relics was donated to the local natural history museum.[6]

3.224 John Marshall Gamble (1863–1957)
Pink Buckeyes and Santa Barbara Mountains, c. 1920
Oil on board, 21 x 30 in.
California Historical Society, San Francisco

3.225 Carl Oscar Borg (1879–1947)
Dance at Walpi, 1918
Oil on canvas, 25 x 30 in.
The Los Angeles Athletic
Club Art Collection

Another arrival in 1906 was **John Marshall Gamble**, whose move resulted from the San Francisco earthquake. Born in Morristown, New Jersey, Gamble had grown up in New Zealand, going to San Francisco in 1883 and studying at the School of Design with VIRGIL WILLIAMS and EMIL CARLSEN. He opened a studio there after additional instruction in Paris, but it was destroyed in the 1906 disaster. Gamble was one of the state's most successful landscape painters and one of several who devoted themselves to depicting broad vistas filled with colorful wildflowers in a soft, painterly manner emphasizing the chromatic range of golden poppies, pink buckeye, and purple lupine, often against a mountain backdrop. His quasi-Impressionist work descends from the poppy fields of Claude Monet and their American counterpart, the Appledore pictures of CHILDE HASSAM.[7]

3.177; 3.205

3.224

1.30, 1.154; 3.144

Indian specialists also were present in Santa Barbara. **Carl Oscar Borg** first visited in 1908, purchasing property in the town eight years later and settling there in 1918. Born in Sweden, Borg had worked as a seaman before studying art in London and emigrating to the United States in 1901. Arriving in Los Angeles in 1903, he soon began to exhibit his paintings, which attracted the attention of the notable art patron Phoebe Apperson Hearst. Her support enabled him to travel extensively in Europe, after which he moved to Santa Barbara. The town offered a comfortable retreat with easy access to Indian country, and Borg lived there for six years while painting western and desert landscapes, cowboy scenes, and the Hopi and Navajo of Arizona, first visiting the desert there in the spring of 1916. Borg painted colorful, peaceful Indian subjects, reflecting the respect for their culture that he had absorbed from Charles F. Lummis, whom he had met in Los Angeles. The emphasis in many of Borg's pictures, such as *Dance at Walpi,* is on the monumental structure of the pueblos, which seem to enshrine an entire culture; in others diminutive figures are contrasted with vast landscape panoramas and cloud-filled skies. Borg wrote of "these great solitudes, these limitless horizons, this wilderness of color and form . . . marked by an Arcadian simplicity, by a dignity and reserve." Following his Santa Barbara sojourn, he spent a decade and a half traveling, which

3.225

included three trips to his native country, where he was forced to remain during World War II. He succeeded in selling his Indian paintings to collectors in Sweden, where he and his art remain celebrated.[8]

Borg was a mainstay of the Santa Barbara art community, as he had been in Los Angeles. He was a friend of Harmer and Gamble and especially close to his fellow painter of western life, **Edward Borein**. A California native and also a collector of Indian artifacts, Borein settled in Santa Barbara in 1921. After a career as a cowhand on local ranches and elsewhere in Southern California, he developed into a successful illustrator in the Bay Area. Inspired by the work of Frederic Remington and CHARLES MARION RUSSELL as well as by his own early experiences, Borein turned to oil and watercolor painting and the etching of cowboy, Indian, and California ranch life. He executed these works in his pueblolike home in Santa Barbara, where he remained for the rest of his career. The cowboy—and its Mexican counterpart, the vaquero—constitute his most successful subject, as in his romantic *Night Rider*, probably painted in Montana and influenced by similar compositions by Remington.[9]

Borein and Borg were both close to THOMAS MORAN, the veteran painter of western landscapes, who settled in Santa Barbara in 1916 for the last decade of his life; among Moran's finest late pictures are scenes on the California coast.[10] Borg painted Moran's portrait (location unknown) in Santa Barbara, as did the portraitist and marine specialist HOWARD RUSSELL BUTLER, who was resident there in the early 1920s (there are two versions of Butler's portrait, in the National Portrait Gallery, Washington, D.C., and the Guild Hall Museum, East Hampton, New York). Moran and Butler had been summer residents in East Hampton, New York, and both maintained studios on both coasts for a while before offering their allegiance totally to Santa Barbara, Moran giving up his East Hampton studio in 1922. The Paris-trained landscape painter DeWitt Parshall, best known for his views of the Grand Canyon, went to Santa Barbara in 1917, remaining until his death four decades later. Another veteran landscapist, Lockwood de Forest, built a house in Santa Barbara in 1915; after wintering there for a number of years he moved from New

3.226 Edward Borein (1872–1945)
The Night Rider, n.d.
Oil on canvas, 20¼ x 24 in.
Glenbow Museum,
Calgary, Canada

3.227 William Joseph McCloskey
(1859–1941)
Apples, 1896
Oil on canvas, 11 x 24 in.
H. J. Dengler

York permanently in 1922. The New York portrait painters and muralists Albert and Adele Herter, who had founded Herter Looms, which manufactured handwoven textiles and tapestries, had established a home in Santa Barbara by 1917. Albert Herter later painted murals in the Saint Francis Hotel in San Francisco and the public library in Los Angeles, which were considered among the finest wall paintings in the state. Adele Herter painted stylized cactus murals in homes in Montecito, a community adjoining Santa Barbara.[11]

The art community was further enriched by the presence of Colin Campbell Cooper, who settled in Santa Barbara in 1921. Cooper, who became dean of painting at the Santa Barbara School of the Arts, turned from his critically acclaimed, sparkling, coloristic scenes of New York City to Impressionist views of California gardens.[12] The school, which became one of the most important in Southern California, was founded at Fernand Lundgren's urging in 1920, under the sponsorship of the Community Arts Association of Santa Barbara. Albert Herter taught the life class, Borg instructed in landscape, and Lungren was in charge of illustration; Cooper subsequently taught outdoor painting. Despite its national reputation, the school did not survive the depression, one of its last activities being a memorial show of Lungren's work in 1933.

A striking factor in the evolution of Santa Barbara's community of artists in the 1910s and early 1920s was its relationship to the enclave that had earlier developed in East Hampton, New York. Moran, Parshall, Butler, and the Herters had all worked there; de Forest had kept a studio at nearby Montauk. All found in Santa Barbara a more relaxed atmosphere in which to work year-round. This also was an attraction for painters such as Alexander Harmer and Carl Oscar Borg, who had been active in Los Angeles but who preferred the easier life in the smaller town to the increasingly urbanized conditions of Southern California's fast-growing metropolis.

Los Angeles, which had been a Spanish settlement and which was incorporated as a city in 1850, started expanding in the 1880s as a result of the residential real-estate boom and the development of the region's agriculture. Prior to this a few painters had been active in Los Angeles, including two topographical expedition artists, the Spanish-Portuguese artist Solomon Nuñes Carvalho and German-born Heinrich Balduin Möllhausen, both in 1854. Both Carvalho and Möllhausen painted Indian likenesses, and Carvalho operated a daguerreotype gallery and held an exhibition of his portraits in Los Angeles. The city's first resident painter was French-born Henri-Joseph Penélon from Lyons, who

also arrived in the early 1850s and remained for about twenty-five years, working principally as the city's earliest photographer. Penélon painted oil portraits and religious works, mostly during his initial years in the city.[13] Mrs. C. P. Bradfield, a specialist in wildflower painting, arrived in 1874 and became an active art teacher; she was appointed principal of drawing for the public schools at the end of the decade.

3.236 A number of painters, such as Elmer Wachtel in 1882 and GEORGE GARDNER SYMONS in 1884, visited Los Angeles at the beginning of their careers and later returned to reside there. **William Joseph McCloskey** and **Alberta Binford McCloskey**, who arrived in 1884, can be considered the first professional artists to settle in Los Angeles, though their residence was sporadic. William Joseph McCloskey had studied under Thomas Eakins at the Pennsylvania Academy of the Fine Arts in Philadelphia from 1877 until 1880; Alberta

1.146, 1.155 Binford had been a student of WILLIAM MERRITT CHASE in New York. In Los Angeles they were active as portraitists; they also painted in Denver, where they had been married about 1883; in New York City during the later 1880s, where they both exhibited frequently; and in Paris, London, Leeds, and Manchester in the 1890s. Both are reported to have

3.228 Alberta Binford McCloskey
(1863–1911)
*The Artist's Daughter,
Eleanor,* 1892
Watercolor on paper,
20 x 16 in.
Bowers Museum, Santa Ana,
California; Gift of Mrs.
Eleanor Russell

been pupils of Jean-Léon Gérôme in Paris, and although this would otherwise seem unlikely, Gérôme did give them a certificate of commendation in 1893, noting that they had been recommended to him by his former pupil, Eakins. Having been in Los Angeles until 1886–87, the McCloskeys had returned there by 1894–95, maintaining dual studios there and in New York City. After they separated about 1900, William remained in Los Angeles into the 1920s as official portrait painter to the American Legion, before moving to Ashland, Oregon, in the middle of that decade. Alberta settled in England in 1907. In addition to their incisive, if literal, portraits, which they appear to have painted in tandem and signed jointly, William Joseph McCloskey is renowned for his still lifes, especially pictures of citrus wrapped in meticulous thin tissues, laid out on glowing red-brown mahogany supports, and of other fruits juxtaposed with crinkly papers, such as *Apples*. 3.227
While these can be dated to his years in New York City, he surely must have painted such works in California as well. In addition to lavish fruit arrangements, Alberta Binford McCloskey painted flowers lying on surfaces similar to those depicted by her husband. She was also an able watercolorist of attractive, detailed genre subjects, primarily depicting 3.228
members of her family, a theme investigated by her husband in oils.[14]

Many other women artists worked in Los Angeles during the 1880s, including Edith White, who had studied in San Francisco and who was in Los Angeles as early as 1882; Helen Coan, who was active from 1887, having been a student at New York's Art Students League; and Fanny Duvall, also a league student, who arrived in Los Angeles a year after Coan. All three painted still lifes. Coan and Duvall exhibited such works in the art gallery of the California Building at the World's Columbian Exposition in Chicago in 1893, as did several other less-known women, including Margaret Ashmead and Julia Briggs Painter. White was commended for her paintings of roses, and Duvall became noted for pictures of chrysanthemums. Duvall went to Paris in 1900 for instruction and was one of many California women to study with Whistler at the Académie Carmen; from then on Paris was her second home.

In 1885 ALEXANDER HARMER went to Los Angeles for several years. Since he and 3.223
William Joseph McCloskey had studied together at the Pennsylvania Academy of the Fine Arts in 1880, McCloskey may have encouraged Harmer's move five years later. In 1885, too, Gutzon Borglum, then a painter of western scenes, settled in Los Angeles after studying at the California School of Design in San Francisco. Borglum later made his reputation as a sculptor in the East, following his study in Paris in 1890. Just before he left Los Angeles he was the leading spirit of one of the first local art organizations, the Los Angeles Art Club, which met in his studio for sketching and criticism. Still primarily a painter, Borglum returned to Los Angeles for a few years beginning in 1893, before finally leaving in 1896.[15]

The year 1885 also took Charles F. Lummis to California. Lummis, though not an artist, had a strong influence on the careers of numerous Southern California painters such as Borglum and Alexander Harmer. A pioneer in the preservation of the Indian, Spanish, and Mexican heritage of the Southwest, Lummis settled in the Garvanza district of eastern Los Angeles and in 1896 took over the editorship of *Land of Sunshine*, which featured articles on California and southwestern art. The so-called Garvanza circle came to include artists such as Fernand Lungren of Santa Barbara, CARL OSCAR BORG, MAYNARD 3.225; 3.127
DIXON, William Lees Judson, Hanson Duvall Puthuff, Granville Redmond, Elmer Wachtel, Julia Bracken, and William Wendt; art museum personnel, critics, and writers such as Everett Carroll Maxwell and Antony Anderson; authors such as Mary Austin, Joaquin Miller, and Idah Strobridge; naturalists such as John Muir; and patrons such as Phoebe Apperson Hearst—all inspired by Lummis's belief in a southwestern cultural imperative arising out of the Indian tradition. Lummis founded the Southwest Museum in Los Angeles in 1907, dedicated to the preservation of the native heritage.

The earliest professional artists to remain at length in Los Angeles included, in 1886, Albert Jenks, a painter of naturalistic portraits, who had begun painting in Aurora, Illinois, after the Civil War and then moved to Chicago, Denver, and San Francisco. The Providence, Rhode Island, artist **Charles Walter Stetson** first visited Pasadena in 1889, 1.94

enchanted by the climate and the landscape. In that environment he started to investigate landscape and floral subjects, themes to which he returned when he went back to Pasadena in 1895 for five years, following an interlude in Rhode Island. During this longer residence he explored imaginative motifs in landscape and figural work, including the sensuous nude in biblical guise, as in the monumental *Susannah and the Elders* (formerly Bowater Gallery, Los Angeles), and in allegorical and classical, sometimes Dionysiac, clusters of dancing, nubile young women. The latter are often set in moody, provocative
3.229 nocturnal landscapes. Stetson's pure landscapes—such as *An Easter Offering*, an endless field of glowing green and white calla lilies—project a haunting mysticism, combining Whistlerian aesthetics with fin-de-siècle Symbolism. Stetson's Southern California painting
3.207 probably comes closest to the approach of ARTHUR F. MATHEWS and his circle in San Francisco, though Stetson's art is more erotic and individual, relying on rich, painterly effects and eschewing the flat, linear approach that Mathews had derived from Pierre Puvis de Chavannes. In 1900 Stetson returned to New England, then two years later he expatriated to Rome.[16]

Los Angeles's first landscape painter of note, **John Bond Francisco**, was active in the mid-1880s before going to Europe for three years of art and music training in Berlin, Munich, and, in 1887, Paris. Returning to Los Angeles about 1892, he pursued dual

3.229 Charles Walter Stetson
(1858–1911)
An Easter Offering, 1896
Oil on canvas, 40⅛ x 50¼ in.
Spencer Museum of Art,
University of Kansas,
Lawrence

RIGHT:

3.230　John Bond Francisco
(1863–1931)
Cherry Canyon, c. 1915
Oil on canvas, 35 x 51 in.
The Los Angeles Athletic
Club Art Collection

OPPOSITE, TOP:

3.231　Elmer Wachtel (1864–1929)
Valley Afternoon, c. 1910
Oil on canvas, 18 x 24 in.
Private collection

OPPOSITE, BOTTOM:

3.232　Marion Kavanagh Wachtel
(1876–1954)
*Summer Afternoon, Santa
Monica*, c. 1916
Watercolor on paper, 16 x 20 in.
Private collection

professional roles, helping to form the Los Angeles Symphony Orchestra in 1897 and teaching art and music. Francisco's renderings of the California hills and deserts combine the informality of the Barbizon mode with a Munich-derived dramatic chiaroscuro, as in *Cherry Canyon*; his later pictures reflect the impact of the brighter palette of Impressionism. 　3.230 Francisco's significance lies not only in the undisputed quality of his art but also in his pioneering role in determining that the landscape would dominate Southern California painting. He helped to identify the region's basic landscape aesthetic, with its gentle, informal rhythms unlike the spectacular scenery dominating the work of early Bay Area artists. In 1906 Francisco was commissioned by the Santa Fe Railroad to paint a series of scenes of the Grand Canyon to be used to promote the region and the railroad.[17]

One of Francisco's pupils was **Elmer Wachtel**. Wachtel, who had grown up in Illinois, went to California in 1882 to join his brother, who had married the sister of the neophyte artist GUY ROSE and was managing the large Rose ranch in San Gabriel. Wachtel, 　3.242 a violinist with the Los Angeles Philharmonic, began to draw and paint and in 1900 went to study in New York City and London. In 1901 he settled in Los Angeles, establishing himself as a leading landscape painter. In 1904 he married his pupil **Marion Kavanaugh** (who later dropped the *u* from her maiden name), who had been sent from San Francisco to study with him by her previous teacher, WILLIAM KEITH. 　3.178

The Wachtels, who lived in the Arroyo Seco in South Pasadena, became Southern California's premier artistic couple, painting direct, poetic renderings of local scenery, as in Elmer Wachtel's *Valley Afternoon*, still heir to the tradition established by John Bond 　3.231 Francisco. Both Wachtels gradually adopted a brighter chromatic range and began to simplify forms, embracing a Post-Impressionist love of patterning. They painted coastal scenery and subjects in the Sierra Nevada, but utilized this aesthetic particularly in their interpretation of sycamore trees and eucalyptus groves. At their best in such works as Marion Kavanagh Wachtel's watercolor *Summer Afternoon, Santa Monica*, these pictures 　3.232 are lovely and evocative, Southern Californian in both subject and style.[18] She was probably the region's leading watercolor specialist, though that medium had been the forte of the early landscape painter and teacher John Ivey, who had settled in Los Angeles in 1887. Ivey, who published a watercolor landscape manual in the city in 1891, moved later in that decade to San Francisco and, in 1902, settled in Pacific Grove on the Monterey Peninsula. His last years were spent in Seattle.

The most significant watercolor specialist to arrive in Los Angeles in the late

nineteenth century was the city's first major still-life painter, **Paul de Longpré**, probably the first Southern California painter to establish a national reputation. De Longpré was born in Lyons, France, long a center of flower painting due to the textile-design industry centered there. Having studied in Paris with the academicians Léon Bonnat and Jean-Léon Gérôme and having exhibited at the Salon in the late 1870s, de Longpré was well known in France before he settled in New York City in 1890. There he established himself as a painter of flowers, often drawn from summer trips into the New Jersey countryside, and as a commercial window decorator, holding well-received annual exhibitions at the American Art Galleries from 1896 until 1898 as well as in Boston—at the Williams and Everett Galleries—in 1896, and at the Milwaukee Industrial Exposition in 1898.

De Longpré moved to Los Angeles in 1898, seeking a comfortable environment in which he could paint an abundance of flowers; he continued to send work to New York City for exhibitions at such galleries as M. Knoedler and Co. In Hollywood he built himself a palatial home, which became a tourist attraction; its focus was a three-acre garden featuring four thousand rose bushes, from which he took many of his subjects. 3.233 De Longpré favored luxuriant roses, as in *Roses La France and Jack Noses with Clematis on a Lattice Work, No. 36*, or masses of wildflowers colorfully and freely painted in broad washes; both types are often silhouetted against the sky. His floral paintings earned him the cognomen "Le Roi des Fleurs."[19] Susie Dando, who went to California in 1903, trained with de Longpré and became a specialist in floral watercolors.

Flowers also became a specialty of **Granville Redmond**, who likewise settled in Los Angeles in 1898. Redmond was a deaf-mute artist who had studied from 1879 until 1890 at the Institution for the Deaf, Dumb and Blind in Berkeley, where he was taught 3.177 by Theophilus d'Estrella, the deaf-mute pupil of VIRGIL WILLIAMS. Redmond later studied at the California School of Design in San Francisco, with Arthur F. Mathews and Amédée Joullin, and in Paris, supported by a stipend from the Berkeley institution. On his return to California in 1898 Redmond took up residence in Los Angeles, painting moody Tonal landscapes, scenes of farmers and their animals, and nocturnes similar to those by John Bond Francisco and many of the scenic painters in Northern California. Redmond sought subjects throughout the state's coastal regions, often summering in Monterey County,

OPPOSITE:
3.233 Paul de Longpré
Paul de Longpré
(1855–1911)
Roses La France and Jack Noses with Clematis on a Lattice Work, No. 36, 1900
Watercolor on paper,
27¼ x 14¾ in.
Nancy Dustin Wall Moure

3.234 Granville Redmond
(1871–1935)
Silver and Gold, n.d.
Oil on canvas, 30 x 40 in.
Laguna Art Museum, Laguna Beach, California; Gift of Mr. and Mrs. J. G. Redmond, 1975

where he settled in 1908. Two years later he moved to San Mateo, becoming a member of San Francisco's art establishment, but he continued to exhibit in Los Angeles and to associate with that city's artists.

About the time he moved north Redmond turned to rendering highly colorful wildflowers—the purple lupine and, especially, the state flower, the golden California poppy—in sweeping terrain.[20] He adopted a colorism and brushwork linked to Impres- 3.234 sionism, though motivated more by his subject than by aesthetic theory. In 1909 West Coast critics noted his use of pointillism and likened his art to that of Claude Monet and Camille Pissarro. Though Redmond recognized the public's preference for his brightly colored poppy pictures, he preferred to paint darker, more poetic scenes. At the time of his return north, Los Angeles critics bemoaned his loss, but Redmond was back in Southern California in 1918. His late career is notable for the advantages he drew from his handicap; he helped Charlie Chaplin perfect his pantomime technique for silent movies and appeared in several of that great actor's films.[21]

The 1890s saw the beginning of an influx to Los Angeles of artists from Chicago, though they did not become a permanent presence until the first decade of the twentieth century. One of the first was English-born William Lees Judson, who had grown up in Brooklyn and in London, Ontario. After serving in the Civil War and spending ten years on a farm in Ontario, he studied painting in New York City and, from 1878 until 1881, in Paris. In 1890 Judson moved to Chicago, three years later settling in Los Angeles, where he was inspired by Charles F. Lummis. From 1896 until his death Judson was associated with the art department of the University of Southern California, which he rebuilt in 1901 as the College of Fine Arts, a branch of the university in the Garvanza district. Judson's favorite subjects were from this region of the Arroyo Seco—richly colored, glowing landscapes informed by Impressionism—but he also painted throughout the Southwest and in Europe. Intrigued by California's heritage, Judson painted the missions and majestic scenes of Indian craftsmen as well. He extended the range of the Garvanza circle's interests to embrace the crafts movement that developed in the Arroyo Seco and founded the Judson Studios for stained glass.[22]

3.235 William Wendt (1865–1946)
 Sunny Slopes, 1912
 Oil on canvas, 40 x 50 in.
 The Fieldstone Company,
 Newport Beach, California

3.236 George Gardner Symons
(1861–1930)
*Southern California
Beach*, 1925
Oil on canvas, 25 x 30 in.
James D. Zidell

One of the finest Chicago-trained painters to go to Los Angeles was German-born **William Wendt**, who had studied briefly at the Art Institute and who had made his debut as a promising local landscape painter in 1893. The following year he made the first of a number of trips to Southern California, returning there in 1896 with his close friend and former fellow art student, George Gardner Symons. Wendt returned to the Midwest, but Symons is said to have established a studio just south of Laguna Beach at the time, though other reports suggest a later date of 1902. In 1898 the two went to England, painting at the artists' colony at Saint Ives in Cornwall. Wendt was in Chicago in October 1899 and had an exhibition of his work the following month. Prior to his permanent residency in Los Angeles, he spent numerous winters in California, which he found eminently paintable. During those years he was establishing a growing reputation in the more sophisticated city of Chicago, where he found critical acclaim and patronage. Wendt participated in many Chicago exhibitions and enjoyed numerous solo shows at the Art Institute from 1900 on and, after his marriage to the young sculptor Julia Bracken, two-person shows of his painting and her sculpture. Julia Bracken Wendt—formerly an assistant to Lorado Taft in Chicago and the designer of the sculpture for the Women's Building at the World's Columbian Exposition—became the foremost sculptor in Los Angeles after her marriage. The Wendts' joint exhibitions continued in Chicago after they moved to Los Angeles, though they also had shows at the Museum of History, Science, and Art in Exposition Park in Los Angeles from 1917 on.

By the time William Wendt had settled in the city in 1906, he had adopted typical Impressionist strategies. Within a decade he abandoned this aesthetic for a more powerful one, utilizing broader, bolder brushwork with a palette limited primarily to greens and brown, as in such works as *Sunny Slopes* and *The Crags* (Jason Schoen, on loan to the Oakland Museum). Wendt enjoyed painting the large, rolling hills in the clarity of midday light, sometimes humanized with roadways and habitations but almost never inhabited by figures. The large scale of most of Wendt's landscapes is significant, for the forms they

3.235

depict are also monumental in their own way. His rugged interpretation was integrated by other California landscape painters into a more orthodox Impressionist approach and seems to have constituted a distinct regional variation. Wendt built a studio at Laguna Beach in 1918 and moved there permanently in the 1920s.[23]

Chicago-born **George Gardner Symons** also began his training at the Art Institute and studied in Munich, Paris, and London before establishing himself in Southern California and building a studio, perhaps in 1896, possibly as late as 1902, just south of Laguna Beach. This was Symons's primary base, though he was amazingly peripatetic, and much of his work was done in the East and in Cornwall, England. His best-known paintings are New England winter scenes, which have been likened in subject and manner to the work of EDWARD WILLIS REDFIELD and the Pennsylvania Impressionists, centered in the New Hope region. A more orthodox Impressionist approach characterizes Symons's landscapes painted on the coast and beaches of Southern California.[24]

1.280

3.236

Another Chicago-trained artist who arrived in Southern California early in the present century was **Hanson Duvall Puthuff**. Born in Missouri, Puthuff went in 1889, at the age of eighteen, to the Art School of the University of Denver and then studied at the Chicago Academy of Fine Arts, arriving in Los Angeles in 1903 to work as a commercial artist and become a significant teacher of private classes. In addition to his lyrical landscapes, often painted along the coast south of Los Angeles, in the foothills of the San Gabriel Mountains, and among the desert buttes of the Southwest, Puthuff was responsible for the backgrounds of the habitat groups at the Los Angeles County Museum of History, Science, and Art, and for a diorama painted for the Santa Fe Railroad. Stylistically, his work is akin to Wendt's, though with a wider chromatic spectrum.[25]

3.237

In addition to his own artistic achievements Puthuff was an activist in the art community, and he was partly responsible for the formation of the two most important artists' organizations of the period, the California Art Club and the Art Students League of Los Angeles. The community had first come together with the establishment of the Los Angeles School of Art and Design in 1887 by Louise Garden MacLeod, a London-born and -trained artist and teacher. The school, which continued until 1919, became the recipient of a scholarship to the Académie Julian in 1910. The year after the school was founded, the Ruskin Art Club was established, a ladies' self-study group devoted to the arts which, by 1901, had begun to sponsor annual exhibitions in Los Angeles. About 1890 the Los Angeles Art Club was established in Gutzon Borglum's studio and, more

3.237 Hanson Duvall Puthuff (1875–1972)
Topanga in Spring (California Landscape), n.d.
Oil on canvas, 24 x 36 in.
Joseph L. Moure

important, the Sketch Club was organized in conjunction with MacLeod's school, formally constituted as the Art Association about 1892. The association offered lectures and exhibitions at MacLeod's school until 1894, when the Los Angeles Chamber of Commerce offered it exhibition space. Among the artists who showed at the Chamber of Commerce

3.185 were John Bond Francisco, William Lees Judson, Guy Rose, Elmer Wachtel, RAYMOND DABB YELLAND from San Francisco, and other professionals. Though the Art Club appears not to have long survived Borglum's departure for Europe, two years after he returned he was involved with founding the Society of Fine Arts of Southern California, which also exhibited at the Chamber of Commerce. The Art Association appears to have been the more advanced of the two groups, with the society championing more traditional aesthetics. The latter group may have disbanded after Borglum's final departure from Southern California in 1896.

In 1899 the Blanchard Museum and Art Building was opened, housing artists' studios and a gallery and becoming the center for the city's art community for over a decade. By the 1900s a social organization, the all-male Painter's Club, had been established. Renamed the California Art Club in 1909, it thereafter functioned primarily as an exhibiting agency, becoming the most important artists' organization in Southern California; its social activities were continued by the Los Angeles Sketch Club, started in 1911. The shows of the Art Club were held at the Hotel Ivins and then at the Los Angeles County Museum of History, Science, and Art, when that institution was completed in 1913, the goal of a project instituted in 1909 as the Fine Arts League. Headed for a long time by William Wendt, the Art Club was a traditional one. Though its annual exhibitions were terminated in 1938, the group is still active. In reaction to the club's conservativeness, the Women Painters of California was formed in 1909 but held only a single exhibition.

The Los Angeles County Museum of History, Science, and Art, which was also a conservative institution in its early decades, was nevertheless cooperative with local artists. From its earliest exhibitions of contemporary American art, beginning in 1913, Southern California painters were shown in abundance along with artists of national prominence; interestingly, in the inaugural exhibition that November the only American painters whose works were displayed in the section entitled "Old Master and Deceased Artists" were

1.41, 1.244, GEORGE INNESS and William Keith. Solo exhibitions of California painters were plentiful
2.68 from the start, and in 1920 the museum instituted the annual Exhibition of Painters and Sculptors of Southern California.

Hanson Duvall Puthuff had introduced study from the nude in private classes in 1903, and in 1906 these were transferred to the Blanchard Building and took the name of the Art Students League of Los Angeles. The portraitist Joseph Greenbaum was subsequently added to the faculty, and the league later moved to the Stickney Memorial Building in Pasadena. In the early years of this century the league was the most liberal

3.249 school in Los Angeles, and from it issued a number of the city's early modernists—REX
3.250 SLINKARD, Bert Cressey, Val Costello, and STANTON MACDONALD-WRIGHT.

In the early twentieth century Los Angeles benefited from the existence of a critical establishment in the local press that was seldom equaled elsewhere in the country. Though undeniably chauvinistic, these writers were also perceptive. They maintained individual aesthetic stances and did not champion advanced artistic tendencies, but they did mix with the resident painters and sculptors and followed their progress closely. They included Norwegian-born Antony Anderson, who was the art critic for the *Los Angeles Times* for twenty years after the paper instituted a weekly art-review section in 1906; Everett Carroll Maxwell, the art editor of *Graphic* magazine from 1910 until 1915, who had acted as curator of the Blanchard Building's gallery and subsequently became the first art curator of the new museum in 1913; Mabel Urmy Seares, a prolific writer for *California Southland* and for many East Coast periodicals; and English-born Arthur Millier, who took over the *Times* position from Anderson and remained for over thirty years. Attempts to found independent art journals in the city were more short-lived. *California Arts* was published briefly in 1907; *Arroyo Craftsmen*, proceeding from the Arroyo Guild at the College of Arts and Crafts in Garvanza, appears to have existed for only the October 1909 issue; *Pacific*

3.238 Alice Emilie Ludovici
(1872–1957)
Portrait of a Woman, c. 1895
Watercolor on ivory,
3⅛ x 2⅝ in.
Private collection

Arts and Crafts News was published in 1911; and *Western Art!* lasted half a year in 1914 and was restarted as *Western Art* in 1916, though with no more success. Only *For Art's Sake*, begun in 1923, enjoyed a significant run.

An extremely active organization of artists founded in the early twentieth century was the California Society of Miniature Painters, the West Coast reflection of the revival of this art form across the country. This group, formed in 1912, became one of the most active of the regional miniaturists' societies. Although a relative latecomer, it included a large contingent of active artists and, like similar organizations elsewhere, was made up almost exclusively of women, many of whom had been active as miniaturists long before the society was formed. One of the earliest and finest of these was **Alice Emilie Ludovici**, 3.238 who was born in Dresden, Germany, and studied with her father, a portrait painter who came to this country about 1873, before she returned to Europe for instruction. The Ludovicis were living in Los Angeles by 1894, when Alice probably began her career, and they subsequently located in Pasadena. Among other notable miniaturists who appeared somewhat later was Canadian-born Laura Mitchell, who moved from Prince Edward Island to Los Angeles in 1909 and began teaching miniature painting in 1911; it was Mitchell who organized the society the following year. A few years later Los Angeles miniature specialists received an infusion of talent when some of the finest Seattle specialists moved to Southern California. In 1915 Seattle's most noted professional, ELLA 3.155 SHEPARD BUSH, went to Sierra Madre, and Clare Shepard Shisler settled in nearby Pasadena a few years later. The Pasadena area, in fact, became a center for miniature painting, with not only Alice Emilie Ludovici and her sister, Frieda, painting there but also Clara Force, one of Erie, Pennsylvania's, most noted painters, who moved to Southern California in the mid-1920s. Bush's presence undoubtedly attracted several of her most talented students: Alice Carter Foresman, who arrived about 1920, and Gertrude Little, who had studied in Seattle and New York City before moving to Los Angeles in 1923, became two of the city's most prominent miniature specialists.

Los Angeles also had a full contingent of competent, if undistinguished, oil portraitists-in-large. A number were refugees from the 1906 devastation in San Francisco; among the most notable of these was Joseph Greenbaum. The Paris-trained Utah artist John Willard Clawson worked in San Francisco until 1906, after which he moved to Los Angeles, remaining as a successful portraitist for three years; he was back again in 1919, continuing his residence until 1933. After studying in Paris in the early years of this century, Robert Leicester (also known as Rob Wagner) returned to his native Detroit as a portraitist in 1904, but in 1906–8 he was active in Santa Barbara, settling later in Los Angeles.[26] Probably the most distinctive portrait specialist during the first two decades of the twentieth century was Max Wieczorek. German-born and with a Polish background, Wieczorek had studied at the academies in Karlsruhe and Weimar before coming to this country in 1893. In addition to painting and exhibiting landscapes in oil in Europe, Wieczorek was active for Tiffany in New York City as a designer of stained glass before going to Los Angeles in 1908. There he established a reputation for his portraits in charcoal and colored chalk. His likenesses assert his subjects' status and often include their names in block print across the background. Sophisticated in the manner of the then-popular Spanish artist Ignacio Zuloaga and often depicting prominent, fashionable women, they were chic rather than profound.[27]

Among other figure painters working in the Los Angeles area who occasionally did portraits were the numerous Indian specialists. Neighboring Pasadena, especially, was a base of operation for several such artists, who spent much of their time in the field. These included Frank Sauerwein, Carl Oscar Borg, Warren Rollins, and JOSEPH HENRY 2.181, 3.63, SHARP, who established a Pasadena studio in 1910, though he did not work there for 3.108 prolonged periods until late in life. Maynard Dixon lived in Los Angeles in 1912–13 while painting murals depicting American Indians for the mansion of Anita Baldwin McClaughry in Sierra Madre. The best-known long-time resident Indian painter in Los Angeles was Kathryn Woodman Leighton, whose finest works are her colorful, strongly modeled portraits of individual Blackfoot Indians. Leighton settled in the city in 1910. After

studying art she painted desert landscapes with wildflowers and the landscape in Glacier
3.61 National Park. After 1918 Leighton concentrated on Indian portraiture. In 1926 CHARLES
MARION RUSSELL introduced her to the Blackfoot, and Leighton received a commission
from the Great Northern Railway for portraits of twenty-two tribal elders.[28] An artist with
2.201 a completely unrelated figural specialty was EDMUND H. OSTHAUS, the Toledo, Ohio, painter
of sporting pictures. Beginning in 1911 he maintained a winter studio in Los Angeles for
several years and returned during the 1920s.

The style adopted by almost all of the leading Los Angeles–area artists in the early
3.233 twentieth century was Impressionism. The most talented successor to PAUL DE LONGPRÉ as
a master of the floral genre was the Impressionist **Franz Bischoff**, whose pictures make
a fascinating contrast with those by the older artist. Both reveled in their exuberant motifs,
but Bischoff constructed almost explosive compositions in oil rather than de Longpré's
preferred watercolor medium. Bischoff's richly colored and thickly painted flowers have
a vivid surface quality. He preferred large, expanding blossoms, often chrysanthemums
3.239 and peonies, and even when he depicted de Longpré's favorite bloom, as in *Roses*, he
featured large, majestic flowers spilling over onto a support and backed by a decorative,
highly colored, vaguely Oriental background.

3.239 Franz Bischoff (1864–1929)
Roses, n.d.
Oil on canvas, 40 x 50 in.
Fleischer Museum,
Scottsdale, Arizona

Born in Bohemia, then part of Austria, Bischoff early followed the strong craft tradition of that land, studying design, watercolor, and ceramic decoration. He went to New York City in 1885, working as a decorator in a china factory, and later continued his work in ceramic and glass decoration in Pittsburgh, in Fostoria, Ohio, and in Detroit. Having visited California in 1900, Bischoff moved there in 1906, first to San Francisco and then to Los Angeles, where he took a studio in the Blanchard Museum and Art Building and then moved permanently to the Arroyo Seco in South Pasadena. By then he was turning to easel work. Though first and foremost a flower painter, he also responded to the local landscape, and his work became brighter and bolder as he painted among the Pasadena hills and along the coast as far north as the Monterey Peninsula.[29]

Most of the Los Angeles painters opted for an orthodox Impressionism characterized by bright colorism, the elimination of most neutral notes, the use of broken brushwork, and a concern with sunlight, all applied to a transcriptive, if summary, rendering of the subject. Among the nationally known eastern models, the work of CHILDE HASSAM might best exemplify this approach, and indeed, Hassam was the most significant eastern Impressionist to visit, though he went to Southern California only in 1927. A large group of American Impressionist works that had been shown at the Panama-Pacific International Exposition in San Francisco in 1915 was lent to the Museum of History, Science, and Art in Los Angeles in the fall of the following year. The preeminence of the approach was affirmed by Antony Anderson when he reviewed the spring exhibition held by the California Art Club in 1917.[30]

<div style="text-align: right">1.30, 1.154,
3.144</div>

Recently voted president of that club was the Los Angeles painter whose work most closely resembled that of Hassam, **Benjamin Chambers Brown**. Having trained at the Saint Louis School of Fine Arts at Washington University, Brown studied in Paris and then settled in Pasadena in 1896, devoting himself to glorifying the Southern California landscape in both painting and etching. His subjects ranged from the wildflower fields at the foot of the Sierra Nevada to the sparkling coastline. The local critic Mabel Urmy Seares and the nationally reputed art writer William Howe Downes both used his work to illustrate their writings. Brown's *Joyous Garden* embodies his vivid Impressionism and the generally affirmative interpretation characteristic of this school of Southern California landscape painters.[31]

<div style="text-align: right">3.240</div>

An important factor in the dissemination of Impressionism was the Pasadena School of Art, which opened in 1912 in the Stickney Memorial Building; it was often referred to as the Stickney School of Art. Possibly affiliated with the Art Students League of Los Angeles, which also was housed in the Stickney Memorial Building, it was the first of a series of new, influential art schools to appear in the area over a ten-year period, providing serious alternatives to the Los Angeles School of Art and Design, which closed in 1919. The Stickney School was followed early in 1919 by the Otis Art Institute, set up in The Bivouac, the former home of Harrison Gray Otis, the founder of the *Los Angeles Times*, who donated the building to Los Angeles County for the advancement of art in the West. The county established the Art Institute as an affiliate of the Museum of History, Science, and Art, and it opened in 1918. One of the early instructors was Nelbert Murphy Chouinard from Minnesota, who had gone to Pasadena in 1909 and taught for the craftsman Ernest Batchelder at the Batchelder School of Design. After spending two years with the Otis Art Institute, Chouinard started her own Chouinard School of Art in 1921 to accommodate the overflow from Otis. Her school quickly grew into one of the area's major institutions.[32]

The first administrator of the Stickney School was Roman-born Raffaello Montalboddi, who had been a studio assistant of Carolus-Duran in Paris. He was succeeded by Channel Pickering Townsley, a painter of floral landscapes, who had managed WILLIAM MERRITT CHASE's Shinnecock School on Long Island in New York. Townsley took over in 1914, remaining until he went to direct the newly formed Otis Art Institute four years later. The principal painting instructor during the early years of the Stickney School was **Jean Mannheim**. Born in Germany, Mannheim had studied in Paris in 1882–84 then settled in Chicago in 1885. A decade later he spent seven years in Decatur, Illinois, before

<div style="text-align: right">1.146, 1.155</div>

going to Denver in 1902. In Illinois, Mannheim appears to have been primarily involved with portraiture, though he painted landscapes around Decatur, and they became his main interest in Colorado. In 1907 Mannheim returned to Europe to study with the British muralist Frank Brangwyn. A year later Mannheim settled in the Arroyo Seco in South Pasadena. He adopted Impressionist strategies but remained essentially concerned with the figure, sometimes outdoors and sometimes in domestic genre scenes, such as 3.241 *Ironing Day*. In this work the artist's concern is as much with vibrant colorism and the effect of light passing through the translucent curtains and dresses as it is with the mundane chores of the group itself.[33]

In the mid-1910s two outstanding Impressionist painters were associated with the Stickney School: **Guy Rose** and Richard Miller. A native Californian who is often considered the state's finest Impressionist, Rose was born in San Gabriel, the son of a large landholder and former senator. Seeking professional art instruction, he went to San 3.177; 3.205 Francisco to study under VIRGIL WILLIAMS and EMIL CARLSEN at the California School of 3.98 Design and then went abroad with his close friend and colleague, the Utah artist JAMES T. HARWOOD. After several years of Parisian training Rose produced a series of monumental figural pieces that were shown at the Salon, ranging from peasant genre to exotic fantasies influenced by Symbolism. By 1890 Rose had begun to associate with the young American Impressionists in Giverny and had started investigating their aesthetics. He returned to Los Angeles a number of times in the early 1890s, holding a solo show in 1891 and

3.240 Benjamin Chambers Brown
(1865–1942)
Joyous Garden, n.d.
Oil on canvas, 30 x 40 in.
Private collection

exhibiting and lecturing with the Art Association connected with the School of Art and Design in 1894–95. In 1894 he succumbed to an attack of lead poisoning while in Greece, thus becoming incapacitated for easel work. Rose became a teacher and illustrator in New York City but was in France again in 1899. Five years later he acquired a cottage in Giverny, becoming an important figure among the second generation of Americans working there, including many midwestern painters. Like them he worked outdoors, often concentrating on figures in wooded and garden settings and in boats on the Epte River. Rose achieved acclaim in this country as one of the Giverny Group. In 1912 he returned to the United States, working for two years in New York and, in 1914, settling in Pasadena, where he became associated with the Stickney School, of which he subsequently became director. During the next seven years he painted controlled Impressionist renderings of the California landscape, often traveling to the Monterey Peninsula for subjects, as in *Carmel Shore*. By 1921, when he was partially crippled by another attack of lead poisoning, he was well recognized locally for his outstanding achievements.[34]

 Richard Miller's stay in Southern California lasted only two years, from 1916 until 1918, but as an artist who had garnered international acclaim as second only to Frederick Frieseke among the Americans in Giverny and as a teacher (in both Paris and Giverny)

3.242

3.241 Jean Mannheim
 (1861–1945)
 Ironing Day, 1910
 Oil on canvas, 39 x 34 in.
 Godfrey Edwards and Rotha
 Jean Palmer

3.242 Guy Rose (1867–1925)
Carmel Shore, c. 1915
Oil on canvas, 23½ x 28½ in.
The Rose Family Collection

of considerable renown, he likely made a significant impact on the local scene; Mabel Urmy Seares wrote that "his influence at a critical moment in California's art was potent and widespread." World War I made Miller's residence in France inadvisable, and after returning to this country late in 1914 he was invited to consult and give criticism at the Stickney School, through the intervention of his former Giverny colleague Guy Rose. Miller had trained at the Saint Louis School and then had gone to Paris. While in the Los Angeles area he continued to paint his characteristically monumental female figures in garden settings that sparkle in dappled sunlight; these constitute some of his finest pictures.

3.243 Many of them, such as *Day Dreams* (*Girl with Guitar*), were painted in a favorite setting, the extensive formal garden and studio of Mrs. Adelbert Fenyes, a student at the Stickney School. Miller went east after 1918 and eventually became associated with the art colony in Provincetown, Massachusetts.[35]

3.244 Miller's influence seems clear in **William Vincent Cahill**'s rather decorative *Thoughts of the Sea*, which depicts a large-scale, attractive, contemplative female figure, placed close to the picture plane. Cahill had studied first in New York City and then at the Museum

1.15 School in Boston with Edmund Tarbell and FRANK W. BENSON before settling in Southern California in 1914. There he opened the School for Illustration and Painting while continuing primarily as a figure painter. In 1917 Cahill sold his school to John Francis Smith, who had, since 1896, run the successful Art Academy of Chicago. Cahill remained in the region for a relatively short time, first in Los Angeles and then in Laguna Beach, where *Thoughts of the Sea*, with its ocean background, was painted. During this period he was associated with the region's emerging modernists. In 1920 Cahill moved to San Francisco and, two years later, to Chicago, where he died in 1924.[36]

Probably the finest woman among the Los Angeles–area Impressionists was **Donna Schuster**, like Cahill a pupil of Tarbell and Benson in Boston. Schuster then studied with William Merritt Chase on a painting trip to Belgium in 1912 and in Carmel during the summer of 1914. She had settled in Los Angeles the previous year. Her commitment to Impressionism was confirmed by the work she saw at the Panama-Pacific International

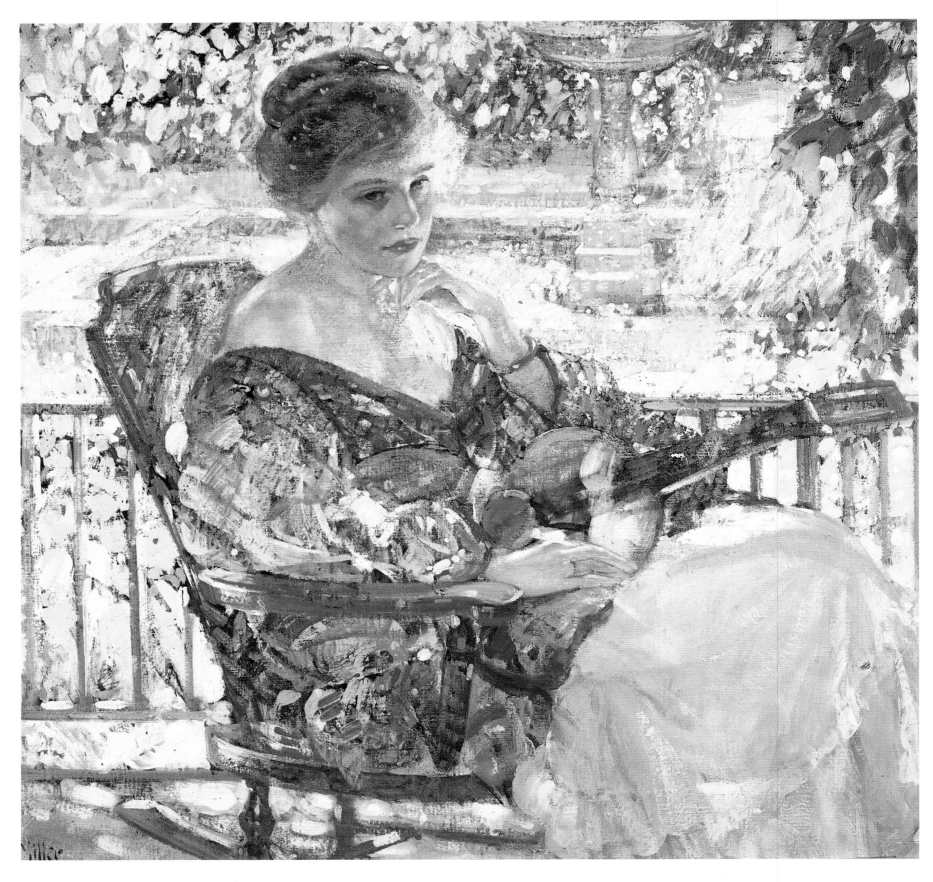

3.243 Richard Miller (1875–1943)
Day Dreams (Girl with Guitar), n.d.
Oil on canvas, 34 x 36 in.
Sheldon Memorial Art Gallery, University of Nebraska-Lincoln;
F. M. Hall Collection

Exposition in San Francisco in 1915. Schuster, too, painted figures close up, usually women in decorative informal garments, a popular motif of the period; these tend to be academic, for all their high coloration. She was most clearly an Impressionist in such outdoor paintings as *On the Veranda,* in which relaxed figures are depicted in porch and garden settings in bright sunlight, displaying the artist's preference for a colorful palette contrasting yellow-greens and purples applied in individual strokes. Schuster became a significant instructor at the Otis Art Institute beginning in 1923, and during her later

3.245

years she moved in the direction of a more high-key modernism, expressed in her Water Lilies series, painted in admiration of the late work of Monet and influenced by Cézanne and by Stanton Macdonald-Wright, with whom she began to study about 1928.[37]

2.271 The last major Impressionist to settle in the Los Angeles area within the period covered by this survey was **Alson Skinner Clark**. He exemplifies the migration to Los Angeles of painters from Chicago, where he was born. Clark studied at the Art Institute of Chicago before going to study with William Merritt Chase in New York City and at

3.244 William Vincent Cahill (1867–1924) *Thoughts of the Sea*, 1919 Oil on canvas, 40 x 39⅝ in. Mr. and Mrs. Gerald D. Gallop

3.245 Donna Schuster (1883–1953)
On the Veranda, 1917
Oil on canvas, 30 x 30 in.
Redfern Gallery, Laguna
Beach, California

Shinnecock, and then to Paris. A constant traveler, Clark was painting in Chicago in the early 1900s, having adopted a vigorous, dramatic realism akin to that of New York's Ashcan School. Experience in Giverny exposed him to Impressionism. By 1911 Clark had adopted this mode in bright, colorful landscapes of the hills overlooking the Seine River. Clark's most notable pictures of the 1910s were a series of paintings made in 1913 of the scenery of Panama and the construction of the Panama Canal, a subject for which he and Jonas Lie (in painting) and Joseph Pennell (in lithograph and etching) became especially noted. Eighteen of Clark's canal pictures were exhibited at the Panama-Pacific International Exposition in 1915 and in Chicago the following year.

In 1919 Clark settled in Pasadena, two years later assuming a position at the Stickney School, where his friend Guy Rose had become director. When Rose had to abandon that position at the end of the year due to ill health, Clark replaced him. Clark continued this association for a number of years, teaching a painting class, though in 1924 the miniaturist Mary Coleman Allen, who had settled in Pasadena in 1921, was serving as director. During these years Clark abandoned his peripatetic life to some degree, devoting himself to regional subjects except for several trips to Mexico and a visit to Europe in 1936. Much of his work of the 1920s consists of brightly colored landscapes and beach scenes, sparkling in warm sunlight and with a low, unbroken horizon above which the brilliant blue sky dominates the pictorial structure. Attracted by old architecture, he also painted the missions, just as he had recorded Catfish Row in Charleston, South Carolina, in 1917. Clark was also an able figure painter; the painting of his wife, *Medora* 3.246

on the Terrace, was one of the first works created after his arrival in Los Angeles. It exemplifies the transference of the Giverny Group's aesthetic concerns to his new environment.

In the mid-1920s Clark took on several monumental mural commissions. In 1926 he completed a series of seven scenes from the early history of California for the foyer of the newly built Carthay Circle Theater in Los Angeles. This was followed, in 1928, by a commission from the Pasadena First Trust and Savings Bank for four sixteen-foot-high representations of contemporary California industry—oil drilling, workers in a citrus grove, shipping, and the thriving motion-picture business. Soon after these were unveiled at the beginning of 1929, Clark was asked to paint a series of eight life-size figural murals for the dining room of the new California Club building in Los Angeles.[38]

"Eucalyptus School" was the derisive term coined by critics in the late 1920s to describe the repetitive, decorative, stylized landscapes by a group of Southern California artists, of which ELMER WACHTEL and MARION KAVANAGH WACHTEL were the finest.[39] The term refers to the predominance of these trees (transplanted from Australia in the late nineteenth century) as a motif, particularly between 1915 and 1930. There was no "school" as such, though such pictures do have an overall sameness, reinforced by the absence of figures or even any suggestion of human activity. Some artists particularly identified with the depiction of eucalyptus are: HANSON DUVALL PUTHUFF; Jean Mannheim;

3.231; 3.232

3.237

3.246 Alson Skinner Clark
(1876–1949)
Medora on the Terrace
(originally titled *Late Afternoon Siesta*), 1920
Oil on canvas, 36 x 46 in.
Private collection

3.247 Paul Lauritz (1889–1975)
California Mountains, c. 1920
Oil on canvas, 34 x 40 in.
The Phelan Collection

the New York–trained Dana Bartlett, who settled in Los Angeles in 1915 and taught at the Chouinard School; Edgar Alwin Payne; and ANNA ALTHEA HILLS. The other artist most 3.251 involved with this theme was Norwegian-born **Paul Lauritz**, who emigrated to Canada and then moved to Portland, Oregon, working as a commercial artist. Gold lured him to Alaska in 1915, where he was encouraged in his painting by SYDNEY LAURENCE; in 1919 3.164 Lauritz arrived in Los Angeles. He investigated the Sierra Nevada, the desert, and the 3.247 coast from Laguna Beach to the Monterey Peninsula in his work, but the eucalyptus groves predominate. Like Bartlett, he taught at the Chouinard School.[40]

An alternative aesthetic explored by other Southern California painters and associated first with WILLIAM WENDT suggests inspiration from the work of Paul Cézanne. 3.235 It features a sense of structure and solidity often expressed in the application of slab- or bricklike blocks of earth-colored paint. Jack Wilkinson Smith had studied at the Art Institute of Chicago and had been inspired in that city by the painting of Wendt and GEORGE GARDNER SYMONS. Smith started his career in Chicago as a scene painter, eventually 3.236 traveling to California and Oregon and settling in Southern California. His structural concerns were both directed at, and abetted by, his preferred subjects—the rocky coastline and later the Sierra Nevada. While early critics commended him as a colorist, encomiums

were bestowed later for his organization of mass and his handling of elemental forces. Smith was a primary mover in the organization of the Biltmore Galeria Real, or Salon, in 1923, a new exhibition and sales outlet initially devoted to western art.[41]

The most renowned mountain painter of the period was another Chicago artist, **Edgar Alwin Payne**. Payne first visited California in 1909, spending time in Laguna Beach and summering there during the 1910s; he continued to paint murals and easel pictures in the East and Midwest before settling in Southern California in 1917. His most extensive commission during this period was for a vast series of decorative works for the Congress Hotel in Chicago that same year; they were actually painted in Glendale, California, with the assistance of several artist friends, including Jack Wilkinson Smith. In 1912 Payne had married Elsie Palmer, herself a painter who had studied at the Best

3.207 Art School in San Francisco and who worked in the decorative figural mode of ARTHUR F. MATHEWS, later turning to stylized landscape painting. In 1918 Payne renovated a studio at Laguna Beach, where the interchange with fellow resident artists such as Smith and Wendt must have influenced him. Payne was attracted to the Sierra Nevada, creating monumental renderings in which he laid on his paint in broad, bold swaths. Though this

3.248 approach is allied to that of Wendt, almost a generation older, a work such as *Shadow*

3.248 Edgar Alwin Payne
(1883–1947)
*Shadow Slope, Inyo County,
California, near Bishop,* 1919
Oil on canvas, 36 x 46 in.
DeRu's Fine Arts, Bellflower,
California

Slope, Inyo County, California, near Bishop stresses majesty rather than the poetry implicit in the older artist's paeans to the California landscape. During the 1920s Payne's pictures of the Sierra Nevada and those painted on trips abroad and in the Southwest took on higher color, a response to the prevalent Impressionism.[42]

Many landscape painters who resided in the Los Angeles area sought their subjects on the Monterey Peninsula. An earlier painter, Ralph Davison Miller, spurned the local eucalyptus and sycamore groves for the cypresses of Monterey, though he was also attracted to the desert scenery of northern Arizona. Born in Cincinnati, Miller studied art there and in Kansas City with GEORGE CALEB BINGHAM, settling permanently in California about 1898. He lived in Los Angeles, turning from still-life subjects to landscape about 1906. Unlike most of his contemporaries, he remained committed to studio, rather than outdoor, painting. His very individual manner was synthetic, dramatic, and spiritual. In 1924 Miller moved to Carmel.[43]

3.24

The proximity of Los Angeles to the Mojave Desert attracted a whole group of scenic painters to investigate this motif, yielding results very different from those who painted the Sierra Nevada, the foothills, or the more decorative landscapes at Laguna Beach. In addition to the difficult conditions under which the desert works were painted, the artists faced special visual challenges in recording the intensity of sunlight, the almost surreal colors, and the vast expanse, often with few or no spatial markers. A number of painters established reputations almost solely on the basis of their desert pictures. German-born Carl Eytel came to this country in 1885 and, after arriving in Los Angeles in 1898, built a shack in Palm Springs to give himself direct access to the desert country, though he also drew and painted the pueblos and Indians of northern Arizona.[44] In 1913 Frederick Melville DuMond, the Paris-trained brother of the better-known FRANK VINCENT DUMOND, established his home in Monrovia, just east of Pasadena, and a ranch in the Mojave Desert, having previously painted among the Arizona mesas.[45] Shortly before World War I, James Swinnerton, who was recuperating from tuberculosis in Palm Springs, became so infatuated with the desert that he devoted himself to depicting it, ranging all over the Southwest while making his home in Palo Alto, with a studio in Los Angeles.[46] One of the finest of the Los Angeles desert painters was Conrad Buff, who was born in Switzerland and studied in Munich. Buff came to America in 1905 and to Los Angeles the following year, turning to desert scenes in the late 1910s. He depicted the eerie magnificence he observed in the desert's vast, airless emptiness, using strong color to delineate the broken bluffs and buttes, devoid of vegetation.[47]

3.143

Los Angeles's receptivity to modernism in the second decade of the twentieth century is clear in the work of several artists. Among the landscapists Clarence Hinkle carried high coloration and expressive brushwork much further than the Impressionists or Wendt and Payne, working in a pointillist manner and, later, in a Cézannesque mode, at Laguna Beach and among the inland mountains. Hinkle, who grew up on a ranch outside Sacramento, studied with William F. Jackson at the E. B. Crocker Art Gallery before going to the Mark Hopkins Institute in San Francisco to work under Arthur F. Mathews, to the New York Art Students League to study with JOHN TWACHTMAN, and to the Pennsylvania Academy of the Fine Arts in Philadelphia. His exposure to European modernism came first-hand as the result of a traveling fellowship from the Academy, after which he returned to New York City and, in 1912, to San Francisco. Five years later Hinkle moved to Los Angeles, teaching at the Los Angeles School of Art and Design; in 1921 he became the first painting instructor at the Chouinard Art School.[48]

1.64, 1.120, 2.178

Probably the earliest Los Angeles painter to work in a distinct, strongly modernist mode was the tragically short-lived **Rex Slinkard**. Born in Indiana, he studied in Los Angeles, at the College of Fine Arts of the University of Southern California and at the Art Students League, and then in New York City, in 1908–10, with Robert Henri. He returned to teach at and direct the Los Angeles League for three years, becoming recognized as the city's most progressive figure in the arts. In the next several years Slinkard began to produce mystical figural works embodying his concept of Everyman, such as *Ring Idols*, drawn totally from his imagination. These compositions won him the admiration of such

3.249

3.249 Rex Slinkard (1887–1918)
Ring Idols, c. 1915–16
Oil on canvas, 29½ x 33½ in.
Stanford University Museum
of Art, Stanford, California;
Estate of Florence Williams

1.18 fellow artists as MARSDEN HARTLEY, who recognized a kindred spirit and who wrote movingly
to him in his unpublished "Letters to the Dead." Slinkard's personal art, developed under
the influence of Chinese painting and early Renaissance and modern European masters,
was likened to that of William Blake, Odilon Redon, and the American Arthur B. Davies.
After being discharged from the United States Army in which he served in World War I,
Slinkard died in the influenza epidemic of 1918 at the age of thirty-one.[49]

 Though he acknowledged his debt to Henri and adopted the older artist's approach
in his teaching at the Los Angeles League, Slinkard rejected Henri's methodology and his
emphasis on art for life's sake. The leading exponent of Henri's aesthetics in Los Angeles
3.217 was Henrietta Shore, who assumed a unique role equivalent to that of FRANK VAN SLOUN
in San Francisco. Shore was born and grew up in Toronto, where she first studied, going
to New York City in 1900 and studying at the New York School of Art and with Henri
in 1902 before going abroad. She resided in Los Angeles from 1913 until 1920, a painter
of vivid contemporary figures like those by her mentor and of scenes of everyday life
painted in dramatic combinations of blacks, grays, and whites or more coloristically; all
are very painterly. She returned to New York City in 1920, working with a more abstract
orientation, but maintained her California connections. She went back to Los Angeles in
1923 and settled permanently in Carmel in 1930.[50]

 Shore was a member of the Modern Art Society, the first organization formed (in
1916) for the purpose of fostering modern art in Los Angeles; other members included
Bert and Meta Cressey, Helena Dunlap, Edgar Keller, and Karl Yens. The group held two
exhibitions, in 1917 and 1918. In 1919 some members of the society, calling themselves
the California Progressive Group, showed their work at the Lafayette Tea Room; included
were Shore, Dunlap, William Vincent Cahill, Caroline Bowles, and Edouard Vysekal and
his future wife, Luvena Buchanan. Only in the 1920s did more modernist artists become
prominent. In 1921 the Group of Eight was organized, including Clarence Hinkle, Donna

3.250　Stanton Macdonald-Wright
(1890–1973)
Canyon Synchromy (Orange),
c. 1919–20
Oil on canvas, 24⅛ x 24⅛ in.
University Art Museum,
University of Minnesota,
Minneapolis; Gift of Ione and
Hudson Walker

Schuster, and the Vysekals; their exhibitions continued through 1928. More significant for the cause of modernism was the formation of the Group of Independents, espousing Cubism and Expressionism, which held an exhibition in 1923. **Stanton Macdonald-Wright**, who wrote the foreword to the catalog, was a member of the Modern Art Workers, organized in 1925, a group that included many of the Modern Art Society's founders such as Shore, Dunlap, Yens, and the Vysekals.

Macdonald-Wright was the outstanding modernist in Southern California in the final years covered by this survey. Born in Virginia, he spent his teens in Santa Monica, California, and studied first with Joseph Greenbaum and then at the Art Students League of Los Angeles. In 1907 he left to seek instruction in Paris. Between 1911 and 1913 he and his colleague Morgan Russell evolved the aesthetic of Synchromism, in which

Cubism's geometric fragmentation and reorganization of form were reinterpreted as swirling fragments of color in dynamic arrangements. At the height of the movement Macdonald-Wright insisted on the primacy of abstraction, but after 1916 he reverted to interpreting the human form, still lifes, and landscapes employing Synchromist strategies.

3.250 Macdonald-Wright painted in this vein for some years after he returned to California in 1919, settling in Santa Monica and exhibiting Synchromies with the Modern Art Workers as late as 1926; a number of his Santa Monica Canyon Synchromies offer a fascinating contrast with the Impressionist landscape aesthetic prevalent in Los Angeles at the time. Macdonald-Wright was director of the Art Students League from 1922 until 1930; there one of his students was Nick Brigante, a leader of the next generation of Southern California modernists. Gradually, Macdonald-Wright adopted a calligraphic landscape mode derived from his study of Oriental philosophy and Chinese painting. Beginning in 1953 he returned to a more opaque version of Synchromism informed by rhythmic patterns of Oriental inspiration.[51]

3.236 The Los Angeles area's major art colony developed at **Laguna Beach**, on the coast forty miles south. Artists had begun painting there as early as the 1890s, when GEORGE GARDNER SYMONS established his studio just to the south. Laguna was popularized by Norman St. Clair, an English-born watercolorist from Pasadena who began working there regularly in 1906, dying at an early age six years later.[52] By the 1910s a full-scale community of painters had begun to locate at Laguna Beach, almost all of them landscape specialists who were attracted by the scenery.

Frank Cuprien had studied art in New York City and in Germany and, after teaching for five years at Baylor University in Texas, settled on Catalina Island in 1912. The following year he erected a studio in Laguna Beach, where he became a well-known 3.248; 3.235 marine specialist. EDGAR ALWIN PAYNE built a studio there in 1918, the year WILLIAM WENDT established a studio, as did German-born Karl Yens, who had settled in Los Angeles and 3.151 then Pasadena about a decade earlier. The Tacoma, Washington, landscapist ABBY WILLIAMS HILL had moved to Laguna in 1909 for her husband's health. A most significant member of the art community, **Anna Althea Hills**, had grown up in the Midwest and studied in New York City and Paris. Hills settled in Laguna Beach in 1912, painting colorful 3.251 Impressionist landscapes such as *Montezuma's Head*. By the 1920s she had become one of the leading practitioners of the decorative Post-Impressionist style that dominated the approach of numerous artists in Laguna.[53]

Unlike many of the compact art colonies on the northeastern coast, the studios of the Laguna Beach artists were strung out along two miles of shoreline. To facilitate social and professional interchange, the Laguna Beach Art Association was organized in August 1918, primarily by Payne and Hills. Payne was the first president, then Hills occupied that position for six years during the 1920s. In July 1918 the first exhibition of work by local artists had been held at an art center in a building that had served as town hall, and in 1928 a new gallery was built, due largely to Hills's efforts. During the 1920s many 3.46 other talented professionals joined the colony, including WILLIAM ALEXANDER GRIFFITH and Joseph Kleitsch. Griffith, head of the art department at the University of Kansas and that state's foremost Impressionist, had begun summering in Laguna in 1918 with his Saint 3.240 Louis classmate BENJAMIN CHAMBERS BROWN. In 1920 Griffith decided to retire to California. Hungarian-born Joseph Kleitsch also arrived in 1920; formerly a portrait and figure painter in Chicago and in Mexico, he turned to plein-air views and casual village scenes in Laguna Beach itself. In addition, he continued to paint figural works until his early death in 1931.[54]

Several communities inland from Los Angeles enjoyed notable professional activity in the early years of the twentieth century. This was true of **Claremont**, the site of Pomona College, where Louise Garden MacLeod (who had founded the Los Angeles School of Art and Design in 1887) had begun to teach painting and sketching in 1893. MacLeod visited Claremont only once a week, and when the need for an art program at the college grew, **Hannah Tempest Jenkins** was appointed professor of art and design

3.251 Anna Althea Hills
(1882–1930)
Montezuma's Head, n.d.
Oil on canvas, 30 x 40 in.
Maxwell Galleries, San
Francisco

and director of Pomona's School of Art and Design in 1905. Born in Philadelphia, Jenkins had studied there at the Spring Garden Institute and the Pennsylvania Academy of the Fine Arts before going to Paris and Japan for further instruction. She went to Pomona from the Mansfield, Pennsylvania, State Normal School, where she had been head of the art department. Jenkins's *Still Life*, with its rich, painterly treatment of dramatic but unlovely kitchen motifs, bears a kinship to the work of Charles Schuch, the leading late nineteenth-century Munich master of that genre; this stylistic heritage undoubtedly was passed down to Jenkins by WILLIAM MERRITT CHASE, one of her teachers at the Pennsylvania Academy. Though she exhibited a still life (location unknown) at the Alaska-Yukon-Pacific Exposition in Seattle in 1909, Jenkins was primarily a landscapist, one of her favorite painting grounds being Laguna Beach. She was not only a vital artist and a much-admired teacher at Pomona but immediately founded on her arrival the still-active Rembrandt Club, consisting of students and faculty concerned with the promotion of the arts through lectures and exhibitions.

In **Riverside** artistic life centered on the Mission Inn, a luxury hotel that housed a sizable art collection as well as the Spanish Arts Society of California and visiting and resident artists. Among these the principal figure was **Hovsep Pushman**. An Armenian, Pushman had studied at the Imperial School of Fine Arts in Constantinople (Istanbul) before emigrating to this country in 1900. He became a citizen while studying in Chicago

3.252

1.146, 1.155

at John Francis Smith's Art Academy of Chicago, where he won an Académie Julian prize in 1903. Pushman went to Paris to study, returning to Chicago in 1914 and taking a studio at the Mission Inn in Riverside two years later. He remained in Riverside for four years (though for at least some of that period he kept his Chicago studio), achieving acclaim for his colorful, direct figural paintings, often of exotic types, including sensual female subjects, in a manner related to the contemporaneous work by Max Wieczorek in Los Angeles. The Los Angeles art critic Antony Anderson was a primary booster of Pushman's reputation. Many of the Near Eastern figures in his pictures are backed by decorative hangings and accompanied by colorful, luxurious Oriental bric-a-brac; he also painted such objects separately, in sensitive still lifes similar to those by EMIL CARLSEN and Harry Watrous. These works, inspired by the carefully composed, subtly atmospheric still lifes of the French artist Jean-Baptiste-Siméon Chardin, are today most highly appreciated. Pushman left Riverside in 1919 to join the New York City art community.[55] Other painters continued to be attracted there, including the Norwegian-American artist Martin Borgord, who spent his last seven years, from 1928 on, residing at the Mission Inn.

San Diego, on the coast far to the south of Los Angeles, was the third major California community with an art history of its own. Its site had been discovered by the Spanish in 1542, and a base for exploration and a mission were set up in 1769. Deemed the finest harbor on the California coast outside San Francisco, San Diego was included in the territorial concessions at the cessation of the Mexican War, having been captured by United States forces in 1846. The city was incorporated, like Los Angeles and San Francisco, in 1850, though it was much smaller than they. Even before that, artists had appeared there, most notably JOHN MIX STANLEY. Accompanying the Army of the West, he had arrived in 1846 and sketched *Old Town San Diego* (location unknown) before moving north. Stanley, in fact, was the most professional painter to visit the city for four decades.

Subsequent visitors applied their talents to views of the growing town, to the mission, and to portraiture. H.M.T. Powell, a teacher from Greenville, Illinois, was in town in 1849 on his way to the gold rush; while in San Diego he sold drawings, including one of the mission. Leonardo Barbieri, who had painted portraits in Monterey, Santa Barbara, and Los Angeles, was active in San Diego in the 1850s. In 1851 the professional New England landscapist Henry Cheever Pratt accompanied the Bartlett surveying

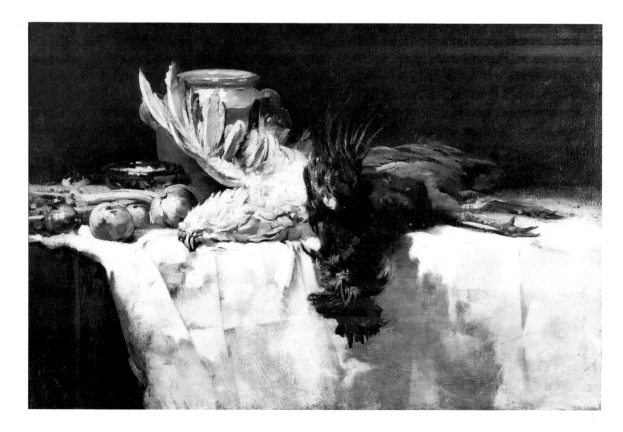

3.252 Hannah Tempest Jenkins
(1865–1927)
Still Life, n.d.
Oil on canvas, 32 × 46 in.
David and Heidi Loeb

3.253 Hovsep Pushman
(1877–1956)
Alice Richardson, c. 1920
Oil on board, 32 x 22⅞ in.
Riverside Art Museum,
Riverside, California

expedition for the new southwestern national boundary. He drew the mission and put his canvases on view in his hotel-studio, the earliest art exhibition known to have been held in the town. Pratt is reported to have exhibited portraits of Indians and of local gentlemen. Heinrich Balduin Möllhausen, traveling with the Pacific Railroad surveys during the 1850s, made probably the finest early record of the mission in 1854. Other visitors included the San Francisco artist Henry Miller, who arrived in 1856 as the first of many to systematically record the missions. That same year William Birch McMurtrie of the Pacific Coastal Survey Expedition made several drawings of San Diego.

Like these artists, English-born Alfred Edward Mathews was no more than a transient. He spent the winter of 1872–73 in Southern California, visiting San Diego as well as Los Angeles and San Bernardino and publishing a San Diego landscape among others from this journey. In the winter of 1873–74 the eastern landscapist LEMUEL M. WILES 1.208 also visited and painted in California—at Yosemite and at the missions as far south as

San Diego, where he spent several months in the spring of 1874. By the 1870s, in fact, the city's cultural life had begun to coalesce; the Philharmonic Society was founded in 1872 and a free reading room was established the following year. By 1873 the population had risen considerably in expectation of expansion based on the extension of the Texas and Pacific Railroad, but with the depression that year, the railroad was abandoned.

In 1885 San Diego was finally connected to the Santa Fe Railroad. Two years later rail service was initiated between Los Angeles and the southern city. This brought not only an increased population and a real estate boom but also the opening up of a tourist trade with the construction of the Hotel del Coronado in 1887. San Diego was promoted as a major resort for health and pleasure, attracting artists, among others, as visitors and residents. In 1882 the portrait painter Emma M. Chapin had relocated from western New York State and had become San Diego's first resident artist, taking likenesses of the local inhabitants and teaching painting. In 1885 William Thurston Black, formerly active in Detroit, settled in San Diego, almost immediately enjoying the patronage of the city's premier developer, Alonzo Horton. Black was active for a decade and may have painted portraits elsewhere in Southern California, such as Riverside. He died in 1895. Chapin continued to be active into the first decade of the twentieth century. The most distinguished visiting artist in the '80s was Henry Chapman Ford, the Chicago painter who had relocated in Santa Barbara and who visited San Diego in 1883 in connection with his pictorial survey of the missions.

After studying at the California School of Design in San Francisco and maintaining a studio there, Frank L. Heath traveled through the country searching for picturesque landscape subjects. He was painting in San Diego during the winter of 1886–87, before he returned to reside permanently in Santa Cruz, where he had grown up. The earliest
1.215 distinguished artist to reside in San Diego, AMMI FARNHAM, arrived about 1888–89. Farnham, a notable figure painter and teacher in the dynamic art community in Buffalo, became the first of a series of painters to migrate from that city to San Diego. These artists and others from even farther north, in eastern Canada, came in search of a more salubrious environment. Trained in Munich, Farnham contributed artistic sophistication to the nascent art world of San Diego, where he worked as a portrait and figure painter, later producing peasant genre subjects as well as landscapes. Until at least 1904 he maintained close ties with Buffalo, where he kept a studio and exhibited many Southern California landscapes in 1900, including views of the missions from Santa Barbara to San Juan Capistrano. Farnham was active in San Diego into the early 1920s.[56]

Until the turn of the century visiting artists were concerned with topographical renderings, whereas the few native talents were devoted mostly to figural work and portraiture. San Diego was subsequently home to several women involved with the miniature-painting revival. Four of these—Mary Belle Williams, Sarah Elizabeth Truax, Martha Jones, and Marie-Marguerite Frechette—established considerable reputations, though they were all latecomers to the scene. Williams and Truax, the earliest, both exhibited with the California Society of Miniature Painters in the 1910s. Williams was also a floral artist; Truax was active in local art organizations, teaching drawing at the San Diego Fine Arts Gallery from 1925 until 1929, and she was an officer in the San Diego Art Guild for two decades, beginning in 1917. Born in Iowa, Jones had studied at
2.266 the Art Institute of Chicago with JOHN VANDERPOEL and in Paris; she was in San Diego by the early 1920s. The younger Ottawa-born Frechette studied in her native Canada, in New York City, and in Paris and was active in San Diego by 1923.

By the end of the nineteenth century artists in San Diego, as elsewhere in California, were turning toward landscape as their principal theme. A. H. Slade, a Toronto photographer, maintained a studio in San Diego from 1887 until at least 1891, painting realistic depictions of San Diego Bay and the surrounding area; he may have been the city's first resident landscape painter. The most famous of all nineteenth-century landscapists to
1.41, 1.244, appear was GEORGE INNESS, who stayed at the Hotel del Coronado for two weeks in 1891
2.68 and then made his way to San Francisco; there is no indication that he painted in San
3.75 Diego. The Denver landscape painter HOWARD STREIGHT, who had settled on a ranch at

Mountain View, in northern California, about 1890, was in San Diego in 1895, exhibiting a monumental landscape of Mount Shasta (location unknown).

San Diego's earliest prominent landscape painter was **Charles Arthur Fries**, who settled there in 1897. Formerly an artist in Cincinnati—where he had studied at the McMicken School and been a classmate and neophyte colleague of such future notables as Robert Blum, Kenyon Cox, HENRY F. FARNY, and JOHN TWACHTMAN—Fries became a graphic artist and was associated with Farny in illustrating the McGuffey Readers. Fries had moved to Waitsfield, Vermont, in 1890 before going to California, a move inspired by the exhortations of Charles F. Lummis and by the fragile health of his wife. Among Fries's earliest paintings created in his new, permanent home were several views of downtown San Diego and the vicinity painted in 1898. The irony of his career is that his best-known painting, and certainly one of his finest, is a rare, though not unique, figural piece painted two years earlier. This is *Too Late*, a reminiscence of Fries's six-month stay with his family in the abandoned mission of San Juan Capistrano on their way to San Diego, when his child fell ill. The touching scene—juxtaposing the prone, distraught mother with the upright figure of the unavailing medical man—is a monument to the late nineteenth-century tradition of social realism prevalent in England. More specifically, it is a small but eloquent reflection of the most famous of all such pictures of that period, Sir Luke Fildes's *Doctor* (1891; Tate Gallery, London), popular the world over and especially in America through reproduction. (Fildes's picture recalled the death of his son Philip in 1877; Fries's daughter, Alice, recovered.) Fries's many landscapes of the rugged inland terrain and desert country are strong, expansive, dramatically lit realist scenes, his earthen colors enlivened by vigorous brushwork and twisting, irregular surfaces. The finest examples celebrate vastness and solitude, although he also painted the eucalyptus groves in San Diego's Balboa Park.[57]

In the early years of the twentieth century the three most significant events in the city's artistic life were the appearance of Anna and Albert Valentien in 1908; the emergence of a vital community associated with the Theosophical group established at Point Loma; and the Panama-California Exposition of 1915–16. Valentien had received his early training with THOMAS SATTERWHITE NOBLE at the McMicken School (renamed the Cincinnati Fine Arts Academy), where Fries had also studied. Joining the newly established Rookwood Potteries in 1881, Valentien met his future wife, the pottery decorator Anna Marie

2.179; 1.64, 1.120, 2.178

3.254

2.176, 3.28

3.254 Charles Arthur Fries
(1854–1940)
Too Late, 1896
Oil on canvas, 25⅛ x 35⅛ in.
The Corcoran Gallery of Art,
Washington, D.C.; Gift of
Alice Fries King, in memory
of her father, 1967

Bookprinter (originally Buchdrucker), who also was continuing her sculptural studies at the Academy. Albert Valentien became head of the Rookwood firm, while Anna pursued her sculpture. On a trip to Europe she persuaded him to paint the local wildflowers. His continued interest in this subject led them to visit Anna's brother in San Diego in 1903, and an exhibition of his California wildflower pictures was held at the State Normal School in San Diego that September.

Having moved permanently to San Diego in 1908, the Valentiens started a short-lived art-pottery firm two years later. Anna Valentien became a major teacher and producer of crafts while continuing her sculptural work. Her husband spent most of his remaining years in San Diego on a vast project commissioned by Ellen Browning Scripps of La Jolla, recording the wildflowers of California on eleven hundred sheets for publication. Scripps's refusal to publish the work due to the great expense was a devastating blow to Valentien. The fifty-two portfolios, each containing fifty illustrations, were deposited with the San Diego Museum of Natural History.[58]

The sculpture, furniture, and painting of **Reginald Machell** were integral to the

3.255 Reginald Machell
(1854–1927)
The Path, c. 1895
Oil and gesso on canvas,
89 x 74 in.
The Theosophical Society,
Pasadena, California

work fostered by the Art School at Point Loma, a product of the Theosophical movement, which had set up headquarters at the end of a long peninsula jutting out into the Pacific. Theosophy, a movement that brought together Eastern and Western theological concepts, had been founded by Helena Blavatsky in 1875. During the next half-century it attracted many artists, who found sources in the work of the European Symbolists and, at Point Loma, developed aesthetic strategies related to Art Nouveau. Katherine Tingley established the Universal Brotherhood and Theosophical Society at Point Loma in 1897, which came to be known as Lomaland. Lomaland attracted a number of English artists such as Machell, who had been introduced to Theosophy by Blavatsky herself and who regarded artistic language as symbolic of spiritual ideas. The school Tingley established, known as the Râja Yoga Academy, taught art in a traditional manner, from drawing after casts to sculptural modeling and study in oil, pastel, and watercolor, with landscape work done outdoors on the Lomaland property.

Though many artists were associated with Lomaland, the communal nature of the enterprise effaced individual personality to some degree. The group was somewhat shielded from the outside, and this kept many of the painters, sculptors, and craftspeople from becoming better known. About twenty artists were associated with the Point Loma Theosophists, but only a few left a notable mark and most of those were landscapists, with the exception of Machell. He settled at Point Loma in 1900, involved with the decoration of Lomaland buildings and the carving of furniture, screens, and frames in an Art Nouveau style. He had been an active book illustrator in England and continued in this vein in Lomaland. Machell's most complex Theosophical symbolism informs his twelve-foot-high sculptured doors for the Temple of Peace and his painting *The Path*, 3.255 which describes the course the human soul must pass to attain full consciousness. *The Path*, painted in England, was on constant view to offer inspiration at Lomaland, and it was reproduced as the cover illustration for *The Theosophical Path*, the movement's periodical published at Point Loma.

English-born and -trained Charles James Ryan also arrived at Point Loma in 1900. While he continued to produce landscapes, he was an active teacher of other subjects at the Râja Yoga Academy, especially astronomy. Another English-born landscapist was Leonard Lester, whose family moved to Canada in 1889 and eventually to the United States, where he studied art in New York City and Philadelphia; he later pursued instruction in Germany from 1900 until 1902. From 1906 on, Lester lived in various California communities; he visited Point Loma in 1907 then spent the next decade involved with Theosophical communities in Cuba. He returned to Point Loma in 1916, painting delicate landscapes there.

The community's best-known woman artist was Edith White, a floral specialist. Born in the Midwest, White had studied at the California School of Design in San Francisco and then opened a studio in Los Angeles in 1882. In 1893 she took a studio in Pasadena, exhibiting with the Art Association at the Chamber of Commerce the following year, when she was especially commended for a large picture of roses. White joined the Pasadena Lodge of the Theosophical Society in 1897 and moved to Point Loma in 1902, becoming the principal art instructor at the Râja Yoga Academy. Like most of her colleagues a painter of landscapes, White often included colorful growing flowers in her compositions.[59] Grace Betts, another painter of note, came from a large, well-known Chicago family of painters and had studied at the Art Institute at the beginning of the twentieth century; she arrived in Point Loma in 1904.

The Theosophical movement's most eloquent pictorial and literary exponent, though not a member of the Lomaland community, was **Maurice Braun**. The finest of San Diego's landscapists, Braun established a well-deserved national reputation. He was born in Hungary and emigrated with his family to New York City in 1881. In 1897 the young man began three years of study at the National Academy of Design, spending an additional year with WILLIAM MERRITT CHASE. He had established himself as a portrait and figure 1.146, 1.155 painter in New York City before he moved to San Diego in 1910.

Braun had embraced Theosophy in New York City and was ready to become a

member of the Lomaland community, but Katherine Tingley encouraged him to remain committed to his art and gave him studio space in the Isis Theater building in downtown San Diego. From then on, Braun produced expansive Impressionist landscapes of California. Primarily a studio rather than a plein-air painter, he often used a patterned, stylized approach, repeating shapes and contours, and utilizing an unreal golden palette. Many of his pictures are infused with a gentle mysticism. For Braun the scintillating vibrations of Impressionism were consistent with the vibrations of the universe that were a hallmark of Theosophical thought. Sometimes, especially in his earlier works, such as *A Morning Idyl*, presented by Braun to Katherine Tingley, the painter populated his stylized landscapes with dancing figures whose gestures and movements echo the forms of the swaying, stylized trees. Braun himself noted: "Landscape should not be taken too literally. It is what we visualize and the interpretation we give the phantasy of our mind that counts."[60] The artist remained devoted to San Diego and to the Southern California landscape, though between 1922 and 1924 he investigated the artists' colonies at Silvermine and Old Lyme, Connecticut. In his later years he turned increasingly to still life.[61]

3.256

3.256 Maurice Braun (1877–1941)
A Morning Idyl, 1914
Oil on canvas, 36 x 42 in.
The Theosophical Society,
Pasadena, California

In 1904 the San Diego Art Association was incorporated; Charles Arthur Fries was one of the founders. The association appears to have ceased functioning by 1915, when the San Diego Art Guild was established with many of the same members, remaining a more active group. Among the guild's presidents during its first decade were Braun, Fries, and Albert Valentien. Six years after the association was formed, a local Art Students League was established, but this may have become identified with the San Diego Academy of Art, the city's earliest art school, which was founded in 1910 by Maurice Braun. Braun was joined later by the sculptor and painter Marco Zim of Los Angeles, who taught there only briefly. Braun's most significant pupil, Alfred R. Mitchell, studied with him in 1913 and shared his Theosophical interests. Mitchell had been in Mina, Nevada, during the gold rush, settling in San Diego in 1908. At his teacher's suggestion Mitchell went to study at the Pennsylvania Academy of the Fine Arts in Philadelphia in 1916. Exposed there to the art of DANIEL GARBER and others among the New Hope Impressionists, he became a particular admirer of the work of the leader of that group, EDWARD WILLIS REDFIELD. Though essentially a realist, Mitchell adopted their clear light and strong outlines while retaining the variegated colors that dominated the painting of Braun and most Southern California landscapists. Mitchell returned to San Diego in the early 1920s and was president of the San Diego Art Guild in 1922–23; he also helped to found the La Jolla Art Association in 1918 and exhibited there regularly.[62]

1.281
1.280

Other professional landscapists in San Diego during the 1910s included Aime Baxter Titus, also a portrait and figure painter, who had arrived by 1914, having studied in New York City and San Francisco, and Rowena Meeks Abdy from Northern California, who was in San Diego from 1917 until 1920, when she returned to San Francisco. Titus was a member of the newly formed, long-lasting San Diego Art Guild; he taught an outdoor painting class in the summer of 1916.

As early as 1910 plans were being made for an elaborate exposition in San Diego—to complement the fair to be held in San Francisco in 1915—to commemorate the opening of the Panama Canal. This evolved into the Panama-California Exposition, under the direction of Edgar L. Hewett of the School of American Archaeology and head of the Museum of New Mexico, both in Santa Fe. Held in Balboa Park, the fair became known for its emphasis on the heritage of the Southwest, both Indian and Spanish Colonial. In the Southern California Building there was an art display chosen by the California Art Club. It included landscapes by almost all of the leading Los Angeles–area artists and paintings by less traditional individuals such as Max Wieczorek and Henrietta Shore along with examples by Braun, figure work by Titus, and paintings by Ammi Farnham, Charles Arthur Fries, and Albert Valentien.[63] The exposition also incorporated a separate art gallery, albeit a modest one, for modern art. This was the result of efforts by Alice Klauber, a leading native-born San Diego patron and a painter of Impressionist landscapes and waterfront scenes who had studied in New York City with William Merritt Chase and Robert Henri and in Spain with Henri in 1908. Henri and Klauber had continued a collegial relationship, and in 1914 she invited him to San Diego to plan the art gallery. Early that summer Henri established a temporary home in La Jolla.

Henri, the city's most important artist-visitor in the 1910s, painted a number of vivid, richly colored figural works, based on Mexican, Chinese-American, and Indian models, which were shown in September at the Museum of History, Science, and Art in Los Angeles and, later, in Cincinnati and at the Macbeth Gallery in New York City. Henri introduced a modern aesthetic to San Diego in his own work and in that shown at the exposition, though it would be a long time before avant-garde European art made an impression there.[64] Indeed, the fair's art gallery was dominated by the Ashcan School, bringing together works by all of the painters except Arthur B. Davies and Everett Shinn who had shown at the historic exhibition of the Eight at the Macbeth Gallery in 1908: William Glackens, Ernest Lawson, George Luks, Maurice Prendergast, JOHN SLOAN, and Henri himself. Painters who shared their urban-realist aesthetic, such as George Bellows and Guy Pène du Bois, were also represented. Also on view were Impressionist pictures by CHILDE HASSAM, Indian paintings by JOSEPH HENRY SHARP, and a single mystical figure

3.120

1.30, 1.154,

piece (*Gods at Play*, location unknown) by Carl Sprinchorn, a former Henri student and manager of the Robert Henri School of Art; this work was painted in the manner of Sprinchorn's close friend, the Los Angeles artist REX SLINKARD. When the decision was made to continue the exposition into 1916, a traveling exhibition of old master paintings was substituted for Henri's display. Many of the artists who showed works in the Southern California Building substituted other examples; pictures by artists not originally represented, such as BENJAMIN CHAMBERS BROWN, Kathryn Woodman Leighton, and GUY ROSE, were added.[65] It is difficult to assess the local impact of the exposition in general or of Henri's art show in particular.

In the 1920s the art community coalesced with the establishment in 1926 of the San Diego Fine Arts Society, of which Alice Klauber was one of the founders and Aime Baxter Titus was a director. That year the society took over the operation of the Fine Arts Gallery of San Diego in Balboa Park. The Art Guild moved into the gallery with the society but maintained a separate identity.[66] The San Diego Academy of Fine Arts, also in Balboa Park, was founded in 1921 under the direction of Eugene and Pauline De Vol, with Maurice Braun instructing—presumably a more permanent re-creation of Braun's earlier Academy of Art, which appears to have continued into the late 1910s. Eugene De Vol and his wife, the former Pauline Hamill, had both been students at Carl Werntz's Chicago Academy of Fine Arts, of which De Vol had become assistant director; after his death in 1929, his wife took over as director at the San Diego Academy, which continued until the United States Navy appropriated the park buildings after Pearl Harbor.[67]

Following the early lead of Ammi Farnham, a new infusion of painters from Buffalo invigorated the art community. CHARLES REIFFEL arrived in 1925 and Otto Schneider at about the same time; both remained for the rest of their lives. Reiffel and Schneider created dynamic landscapes, with exuberant brushwork and color, painted throughout the Southwest; Schneider taught at the Academy of Fine Arts from 1925 until his death.[68] With Braun, Fries, and Mitchell, the sculptors Donal Hord and James Tank Porter, and a number of younger artists, these painters formed the Associated Artists of San Diego in June 1929, two months later changing their name to Contemporary Artists of San Diego, representing the strong professional community that had developed in the city.[69]

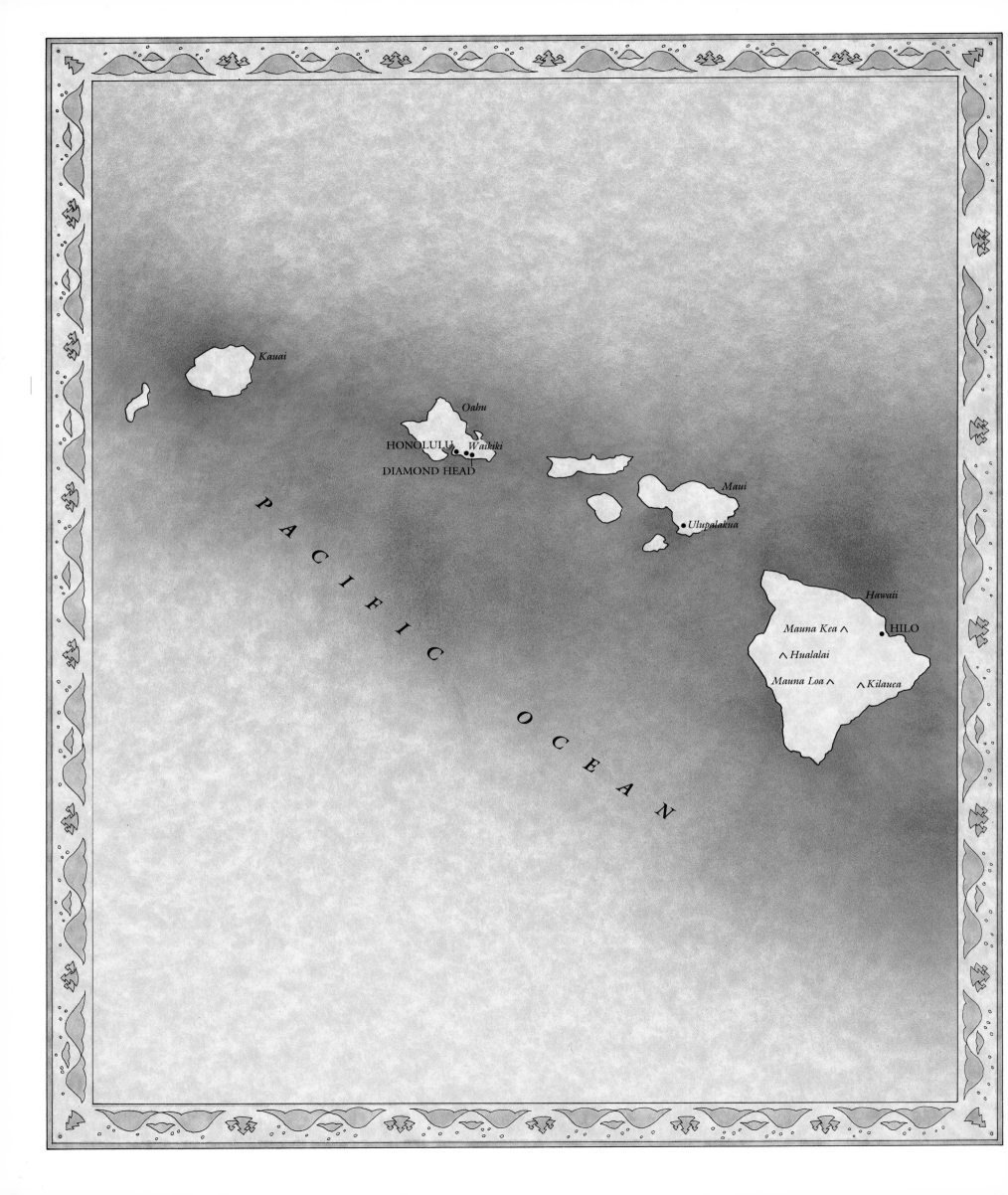

Kauai

Oahu

HONOLULU Waikiki

DIAMOND HEAD

Maui

Ulupalakua

Hawaii

Mauna Kea ∧ • HILO

∧ Hualalai

Mauna Loa ∧ ∧ Kilauea

P A C I F I C O C E A N

HAWAII

Hawaii was annexed by the United States in 1898 and became a territory two years later; it was admitted as the fiftieth state in 1959. Inhabited by Polynesians, the islands were first visited by Europeans when Captain James Cook arrived in 1778. They were united into a single kingdom by Kamehameha I early in the nineteenth century. In 1820 Christian missionaries from America began to visit the islands, and Hawaii came increasingly under America's influence, originally as an important trading station for New England whalers. After the deposition of Queen Liliuokalani in 1893 and the establishment of a republic, annexation was requested and, at first, refused. The islands' eventual incorporation resulted from the expansion of United States sovereignty in the Pacific under the policy of Manifest Destiny, a result of the war with Spain in 1898, when the Philippine Islands also were annexed. Unlike the Philippines and Puerto Rico, the Hawaiian Islands had been Americanized long before annexation in economic, political, social, and cultural ways.

Five successive periods of artistic activity in the western tradition can be distinguished in the period of Hawaiian history surveyed here. First, draftsmen connected with the exploratory expeditions of the late eighteenth and early nineteenth centuries made their appearance. Next, several well-trained American painters visited, starting in the 1840s. In the 1880s professional painters settled in Hawaii, and a small art community emerged. A new generation, including Hawaiian-born artists, began to appear at the end of the nineteenth century. Finally, a number of well-trained American painters took up residence on the islands early in the present century.

The English landscape artist John Webber, who was attached to Cook's expedition in the Pacific, recorded the appearance of the islands and its inhabitants in 1778, introducing some fanciful elements of the European rococo style. After the expedition returned to England in 1790, Webber was retained by the admiralty to supervise the engravings that accompanied the published journal of the voyage; on the basis of his work he was elected a Royal Academician.[1] A Neoclassical severity informs the images produced by Moscow-trained Louis Choris, the Russian artist who accompanied the 1816 Russian imperial expedition under Admiral Otto von Kotzebue, which visited the islands at the time of Kamehameha I. Even more clearly Neoclassical are the images created by Jacques Arago, a participant in the French expedition under Louis de Freycinet that circumnavigated the globe between 1817 and 1820; these range from scenes of execution to the baptism of the Hawaiian prime minister on board the French ship *L'Uranie*, documenting one of the earliest inroads of Christianity into the islands.

The most famous, though by no means the first, American expedition to visit Hawaii was the United States Exploring Expedition under Lieutenant Charles Wilkes, which wintered there in 1840–41. Joseph Drayton and Alfred Agate were the two official expedition artists, and Titian Peale had been taken on as a naturalist. Agate painted a watercolor portrait of King Kamehameha III and drew and painted numerous scenes of natives in characteristic settings. It is Peale's scientific observations, collecting, and pictorial achievements that are best known, however. These include delineations of the islands' fauna and documentation of the spectacular landscape; Peale became the first of a series of artists to give special attention to the awesome beauty of the smoldering volcanoes. The expedition visited all of the islands, including the largest and youngest, Hawaii, which is dominated by four still-active volcanic mountains: Mauna Kea, Hualalai, Mauna Loa, and Kilauea. Based for three months at the island's main settlement of Hilo (a mission station founded in 1824), the expedition made extensive studies of the latter two peaks, and Peale painted a series of spectacular renderings of Kilauea, including a nocturnal

view. After visiting the northwest coast of the mainland, the expedition returned briefly to Honolulu in November 1841 before proceeding across the Pacific.[2]

Peale was not the first artist to record the volcanoes. In 1825 the English ship HMS *Blonde* went to Hilo to return the bodies of Kamehameha II and his queen, who had died in London the previous year. Robert Dampier was the artist and draftsman aboard, and in addition to scenes around Honolulu and of the royal mausoleum, he made many drawings of Hawaii's scenery, including the earliest rendering of Kilauea, which was used as the frontispiece for the official narrative of the journey, published in 1826. Kilauea would become the most pictorialized feature of the islands over the next century.

Thus, by midcentury the artistic lure of the islands had been established. Honolulu, on the island of Oahu, had become the capital of the kingdom in 1820, while Hilo served as the gateway to the more spectacular scenery on the larger, lusher island of Hawaii. The earliest professional artist to visit and work on the islands was JOHN MIX STANLEY, who arrived in Honolulu in August 1848 and remained for over a year. The purpose of his journey is unrecorded, but he was active as a portraitist, recording the likenesses of wealthy merchants and of the royal family, including Kamehameha III and his wife. Stanley sailed from Honolulu to Hilo to paint a now-unlocated volcano picture. He also painted portraits for the Benjamin Pitman family, the wealthiest citizens of Hilo.[3]

2.206

The earliest resident artist in Hawaii was the Swiss painter Paul Emmert, who arrived in 1853 from California, where he had earlier joined the gold rush in 1849; he had then returned to New York City, where he painted a panorama of mining activities. Emmert remained in Hawaii until his death in 1867. His work there is limited primarily to black-and-white scenes—a series of six lithographs of Honolulu, published in 1854, and india ink landscapes from the island of Hawaii. The English-born portraitist and lithographer George Burgess had settled in San Francisco after joining the gold rush. He spent twenty years traveling back and forth between there and the home and shop of his brother, a Honolulu merchant and coffee-shop owner. In 1857 he produced prints of Honolulu and Diamond Head and also that year exhibited what are said to have been the earliest Hawaiian scenes to be shown in this country, at the first San Francisco Mechanics' Institute Fair.

An artist who had already achieved considerable renown when he arrived in Hawaii from San Francisco in 1864 was Enoch Wood Perry. Perry remained almost a year, painting portraits and lush landscapes: volcanoes, coastal scenes at Diamond Head, and plantation views. The last were commissioned by James Makee, who owned and operated a large sugar mill and cattle ranch in Ulupalakua on Maui, a productive, self-sustaining village that Perry depicted several times. His are among the earliest known paintings of Hawaiian scenery by a professional landscapist. Perry also painted portraits for the Makee family and, probably through their influence, was commissioned to take the likeness of King Kamehameha V and to paint from photographs two posthumous portraits of his predecessor and his deceased son.[4]

The next significant artist to arrive was the portraitist William F. Cogswell, who had painted in Chicago and Wisconsin and who had settled in San Francisco in 1873. Cogswell went to Hawaii in 1878 to paint portraits of King David Kalakaua and Princess Liliuokalani (Bernice P. Bishop Museum, Honolulu); in May 1879 he painted Samuel G. Wilder, the minister of the interior (location unknown), and, from photographs, the likenesses of Kalakaua's predecessors, Kamehameha IV and V (Bernice P. Bishop Museum, Honolulu). In the 1890s Cogswell appears to have made several return trips to Hawaii, in 1892 portraying Samuel P. Dole (location unknown), who became the first president of the Hawaiian Republic and then territorial governor. Though only a visiting artist, Cogswell was a very active one and, in a sense, he was the precursor of the professionals, mostly from San Francisco, who became residents in the following decade.

Two of these appeared in 1880. Margaret Girvin Gillin was the earliest professional woman artist in Hawaii, a Canadian who had studied in France and, in 1869, moved to California, painting portraits in San Francisco. On her arrival in Honolulu in 1880 she established herself in that specialty and also became the islands' first still-life specialist,

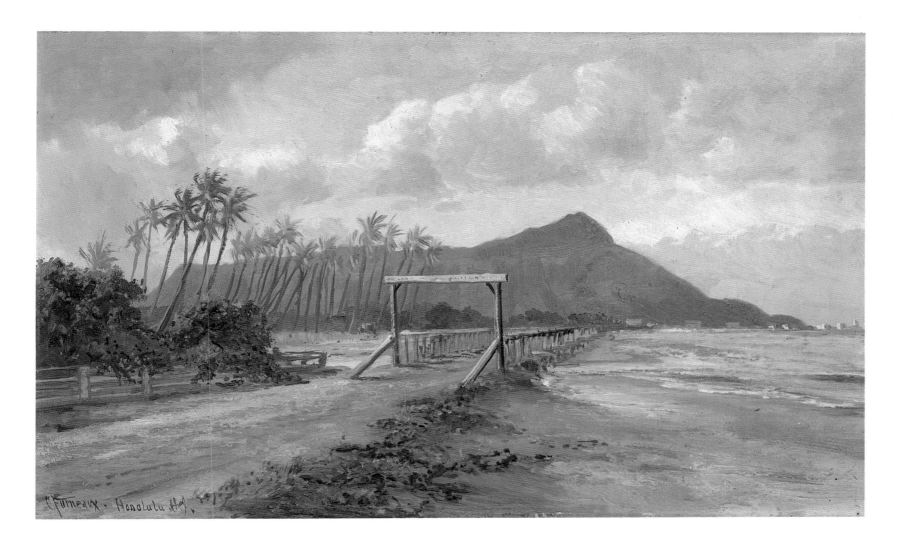

best known for her renderings of native fruits—mangoes, mountain apples, avocados, and breadfruit. Later Gillin went to Hilo and painted on the island of Hawaii before returning to California.

Settling on the islands the same year was **Charles Furneaux**, who remained for the rest of his long career. He was a landscape specialist and the earliest of Hawaii's resident volcano painters. Living in Honolulu, he made an expedition to the summit of Mauna Loa and was present in November 1880 when the volcano erupted and discharged a lava flow that almost reached Hilo during the next nine months. Furneaux recorded the flow in forty field sketches, which he exhibited in his Honolulu studio in 1882; he also painted numerous views of neighboring Kilauea. His landscapes were not always

3.257 devoted to the spectacular, as his romantic view of Diamond Head illustrates. He was also involved in portraiture, including royal commissions, and painted still lifes as well, particularly of island flowers. In addition, Furneaux was an early teacher in Hawaii, offering drawing instruction at the Iolani and Punahou public schools. After the 1880s he turned to photography, eventually abandoning painting; in 1888 he was appointed American consular agent and moved permanently to Hilo. From 1894 on he devoted himself to raising coffee and bananas at his country home on Hawaii.[5]

3.203 Furneaux was followed two years later by **Joseph Strong** from San Francisco, who initially was sent to Hawaii by John D. Spreckels (owner of extensive sugar plantations and of the Oceanic Steamship Company) to paint Hawaiian scenes for the company's San Francisco office. While Strong had been primarily a portraitist in California and continued in that vein in Honolulu, on the islands he also painted landscape and native genre

3.258 subjects, especially after visits to Samoa and other Polynesian islands. His *Hawaiian Canoe, Waikiki* is typical of the beach scenes at Diamond Head and Waikiki that became one of his specialties. Strong's most monumental production was a panoramic view of Honolulu Bay (1886, location unknown). Later in the 1880s he turned to volcano paintings,

3.257 Charles Furneaux (1835–1913)
View of Diamond Head,
c. 1880–85
Oil on panel, 11¹³⁄₁₆ x 20 in.
Mount Holyoke College Art Museum, South Hadley, Massachusetts; Gift of the Alumnae Association of Hawaii, 1885

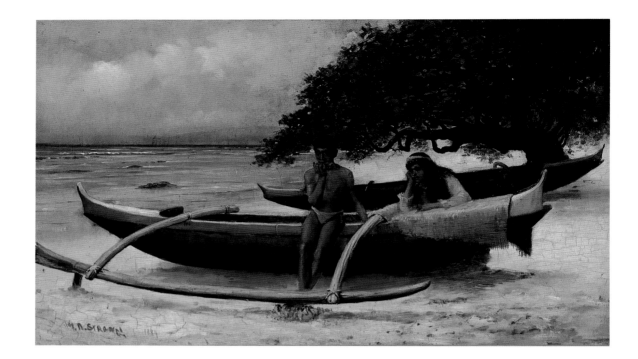

3.258 Joseph Strong (1852–1899)
Hawaiian Canoe, Waikiki,
c. 1884
Oil on canvas, 14 x 24 in.
Mr. and Mrs. Don R.
Severson, Honolulu

becoming known for his rendering of lava formations. After 1888 he appears to have spent increasing time in Samoa, the Gilbert Islands, and Sydney, Australia; he took an extensive exhibition of South Sea island material to the World's Columbian Exposition in Chicago in 1893 and the California Midwinter Exposition in San Francisco in 1894, remaining in the latter city until his death.[6]

Strong was joined in Honolulu at the end of 1884 by his close friend and associate from San Francisco, **Jules Tavernier**, who may have gone because he received commissions 3.190 from Spreckels; certainly Strong's presence was a lure. Before Tavernier died in Hawaii five years later he had emerged as the most influential painter there in the nineteenth century, becoming the most renowned master of volcano painting and specializing in the 3.259 vivid vermilion glow of Kilauea's fiery lava at night. His volcano pictures, of which he is said to have painted about a hundred, were acquired largely by tourists. Though repetitious in subject and form, at their finest they conjure up a demonic realm in vivid, painterly terms. Tavernier's volcano paintings popularized Hawaii on the mainland and became pictorial messengers of good will in diplomatic circles, presented to Western European heads of state. While the more spectacular are oil paintings, the artist was equally proficient in, and as well known for, his pastels. In 1886 Tavernier completed a ninety-foot panorama of Kilauea (location unknown), which he placed on exhibition in Hilo in October and in Honolulu in December, after which it was sent to San Francisco; this was intended as only a preliminary version of a much larger panorama on which he worked from 1887 until his death. Many of Tavernier's easel paintings of Kilauea are panoramic in format— exceedingly wide in relation to their height—a shape similar to that of earlier Luminist paintings by MARTIN JOHNSON HEADE, Sanford Gifford, and others. 1.67, 2.69

Tavernier's art was not totally devoted to scenes of the terrifying sublime. Within a year after his arrival he had toured the big island of Hawaii, Kauai, and Maui, where the Spreckels's sugar plantations were located. In September 1885 he moved to Hilo to work on sketches for an elaborately illustrated but never-published travel book about the islands; he remained there to paint until the end of the following year. Tavernier maintained a studio in Hilo, which was his preferred base of operation, and its environs provided the subjects for many of his pictures, though he frequently returned to Honolulu to exhibit his work. In 1888 it was noted that as Tavernier turned away from volcanic subjects Strong was increasingly taking over that theme.[7]

English-born C. Robert Barnfield went to the islands in the 1880s for reasons of health and died there, leaving landscapes and still lifes painted in watercolor; he was Hawaii's earliest professional specialist in that medium. By the 1880s Honolulu painters

were enjoying the facilities of the King Brothers art-supply store, where pictures were occasionally exhibited; otherwise, paintings were displayed in the Hawaiian Hotel and in the artists' own studios. The attraction their work held for the public and for tourists led the local newspaper, the *Pacific Commercial Advertiser*, to devote much attention to them.

3.187 During the last several decades of the century, visiting painters of note reinforced the local community. The well-known marine painter WILLIAM COULTER spent seven months in Hawaii in 1882, returning to San Francisco to exhibit *Palette and Pen in King Kalakaua's Kingdom*, thirty large panels in a panoramic manner presented to descriptive and musical

1.88 accompaniment. JOHN LA FARGE, traveling in the Pacific with Henry Adams, arrived in Honolulu in late August 1890 and stayed on the islands for a month, making watercolor studies of the scenery. His main goal was the island of Hawaii, where he spent three days at the Kilauea Volcano House, painting watercolors of the volcano. Afterward he went to Hilo, where he met Charles Furneaux, and across Mauna Loa, before returning to Oahu en route to Samoa.[8]

 In 1891 Walter Burridge from Chicago arrived in Hawaii. The result of his visit was the largest painting ever done of Hawaii. That same year Burridge, a specialist in scenic design, had established the decorative firm of Albert, Grover and Burridge with

2.262 OLIVER DENNETT GROVER and Ernest Albert; they acquired a sizable studio in Chicago early in 1892. There Burridge enlarged the sketches he had made of Kilauea for the immense *Cyclorama of Kilauea* (location unknown), commissioned by the newly formed Cyclorama Company to be displayed at the World's Columbian Exposition in 1893. Ironically, this pictorial entertainment was later attributed to Jules Tavernier, who had not lived to complete his own immense panorama of the subject.[9]

3.199 Two later artists from San Francisco were Alphonse Sondag and THEODORE WORES. French-born Sondag had grown up in California and studied in Paris in the early 1890s, returning to San Francisco in 1896 and continuing his studies at the Mark Hopkins Institute of Art. At the turn of the century Sondag lived in Honolulu for a number of years, painting scenes of the islands; he later returned to California. Wores, though only a visitor, was an important one. He had visited Honolulu briefly in 1892, on his second journey to Japan, and in the spring of 1901 he returned to the islands. Wores was unusual in being attracted there primarily to paint the native inhabitants rather than the landscape, though he did create some views of scenery and garden subjects. Wores was disappointed to find the inhabitants Europeanized and went to Samoa in search of more exotic subjects, as Joseph Strong and Robert Louis Stevenson had done. On his return to Honolulu, however, Wores was able to locate models that pleased him, and he held an exhibition there of over a hundred works. The most popular of these was *The Lei Maker* (1902; Honolulu Academy of Arts), a much-reproduced painting that has achieved iconic status

3.259 Jules Tavernier (1844–1889)
Hilo, Hawaii, March 1886
Oil on canvas, 20¼ x 58⅜ in.
Dr. George and Mary Jo
Newton

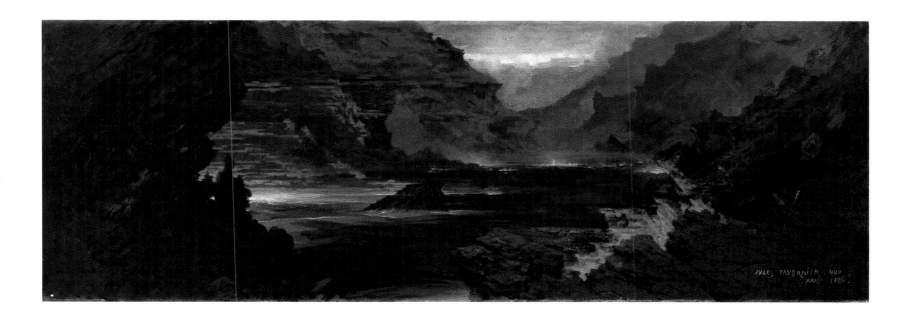

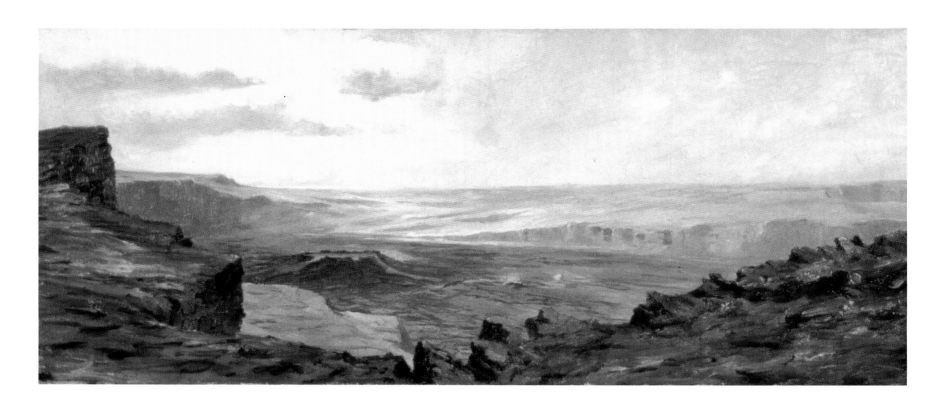

3.260 David Howard Hitchcock
 (1861–1943)
 Kilauea, c. 1896
 Oil on canvas, 33⅝ x 59⅞ in.
 Bishop Museum, Honolulu

as the most famous of all Hawaiian figural images, exhibited to great acclaim in San Francisco and New York.[10]

Wores exhibited with the first of Hawaii's art organizations, the Kilohana Art League, which was formed in 1894, at the time of the establishment of the short-lived Republic of Hawaii. The league's guiding spirit was Augusta Graham, daughter of the conductor of the Royal Hawaiian Band, who was a wood-carver and pyrographer—burning designs into panels of distinctive Hawaiian woods. The sculptor Allen Hutchinson was also involved in founding the league. The league's first exhibition, held the same year, took place at the King Brothers art-supply store, and semiannual shows continued until the organization's demise in 1913. Visiting artists from the mainland, usually from San Francisco, were given receptions and offered exhibitions at the league; these included the portraitist Frederick Yates in 1897; Wores, on a return visit in 1910; and Evelyn Almond Withrow in 1912. A reception was held for William Coulter in 1913, which was one of the group's final undertakings before its activities were taken over in 1917 by the Society of Hawaiian Artists.

The most active member of the league, and long its president, was **David Howard Hitchcock**, the best known of Hawaii's early artists and arguably the finest. Hitchcock was also the first native-born Hawaiian painter of significance, though he had been preceded by a number of talented amateurs, such as Joseph Nawahi, a lawyer, editor, and legislator who painted tiny but charming landscapes. Hitchcock was one of several pupils of Jules Tavernier—the short-lived John H. Robinson was another—and much of his work reveals the impact of that artist. Born and raised in Hilo, Hitchcock studied drawing at the Punahou School, and after attending Oberlin College in Ohio, he spent 1885–86 at the California School of Design in San Francisco. On his return he became a student of Tavernier in Hilo and Honolulu; he accompanied that artist and Joseph Strong to Kilauea to watch them paint.

Having gone to Paris for further instruction in 1890, Hitchcock was in Hawaii again in 1893, identified as "our island painter." He settled more or less permanently in Honolulu, though he made frequent trips to Hilo and eventually painted all the islands. A founder of the Kilohana Art League, he was also its chief exhibitor. Among his early works are many volcano paintings, such as *Kilauea,* continuing the specialty of his mentor. 3.260 Even in his many scenes painted elsewhere on the islands, he preferred attenuated horizontal formats. These panoramic strategies were put to good use in 1912, when he

3.261 Lionel Walden (1861–1933)
Volcano, n.d.
Oil on canvas, 22¾ x 35¾ in.
Honolulu Academy of Arts;
Gift of Mrs. Charles M.
Cooke, 1927

painted his fifteen-foot *Hanalei Bay* (location unknown), which was shown as part of Hawaii's exhibit at the Panama-California Exposition in San Diego in 1915–16. In 1917 Hitchcock worked on a series of thirty-foot diorama paintings that were featured in the Pan-Pacific Carnival held that year in Honolulu. Though he maintained a firm grasp on form and design, his work is characterized by a greater spontaneity of touch and coloristic breadth than that of Tavernier. By the early years of this century Hitchcock stood alone as Hawaii's outstanding resident professional artist. He taught a number of students privately, and in 1902 he began teaching art at the Punahou School, which he resumed in 1905 after two years spent in New York City in search of a wider public.[11]

3.261 Hitchcock worked on the Pan-Pacific Carnival dioramas with **Lionel Walden**, who arrived in Hawaii in 1911 and immediately was recognized as the other major professional in the community. Walden, born in Norwich, Connecticut, had studied in Paris with Carolus-Duran and was a long-time expatriate there, establishing himself as a noted marine and harbor specialist. His monumental seascapes found a ready market in Hawaii, and the islands served his interests well. Yet he, too, joined the tradition of volcano painting. He and Hitchcock were good friends and maintained an amicable rivalry; Walden was a more able figure painter. In addition to the dioramas, their mutual endeavors included murals for a theater, for the telephone company, and for a new ship of the Inter-Island Steam Navigation Company in the early 1920s. Walden began to divide his time between Hawaii and France after the mid-1920s, dying in the latter country in 1933.

Other prominent painters in Hawaii in the early twentieth century included William Twigg-Smith, Otto Wix, Kimo Wilder, Charles William Bartlett, and George and Lillie Gay Torrey. Twigg-Smith, a landscape specialist, was born in New Zealand and first visited Hawaii on his way to study at the Art Institute of Chicago. He returned to Honolulu in 1914 and worked with Hitchcock and Walden on the carnival dioramas in 1917; in his easel work he was involved with volcano subjects but also painted gardens and sugarcane fields. German-born Wix was a landscape painter who specialized in watercolor, favoring landscapes featuring the islands' luxuriant vegetation. Wilder (a native Hawaiian), English-born Bartlett, and George Torrey were Hawaii's leading portraitists of the period. Torrey also painted other figural subjects, including modern allegories; his wife, Lillie Gay Torrey, was the territory's leading floral specialist.

Notes

The Far Midwest

Minnesota

1. Grace Lee Nute, "Peter Rindisbacher, Artist," *Minnesota History* 14 (September 1933): 283–87.
2. John Francis McDermott, *Seth Eastman: Pictorial Historian of the Indian* (Norman: University of Oklahoma Press, 1961), pp. 16–62.
3. John Francis McDermott, "J. C. Wild, Western Painter and Lithographer," *Ohio State Archaeological and Historical Quarterly* 60 (April 1951): 111–25.
4. Frank Blackwell Mayer, *With Pen and Pencil on the Frontier in 1851*, ed. Bertha L. Heilbron (Saint Paul: Minnesota Historical Society, 1932); Jean Jepson Page, "Frank Blackwell Mayer, Painter of the Minnesota Indian," *Minnesota History* 46 (Summer 1978): 66–74.
5. John Francis McDermott, *The Lost Panoramas of the Mississippi* (Chicago: University of Chicago Press, 1958). See also T. E. C[ourtenay], *A Guide to Pomarede's Original Panorama of the Mississippi River, from the Mouth of the Ohio River, to the Falls of St. Anthony* (Saint Louis, 1850).
6. Marion J. Nelson, "Herbjorn Gausta, Norwegian-American Painter," in Harald S. Naess and Sigmund Skard, eds., *Americana Norvegica*, vol. 3 (Oslo-Bergen-Tromsö: Universitetsforlaget, 1971), pp. 105–40.
7. Douglas Volk, "Beauty and Its Relationship to the Handicrafts and the Machine," *Artist* 29 (April 1901): xiii–xviii.
8. The definitive study on Alexis J. Fournier is Rena Neumann Coen, *In the Mainstream: The Art of Alexis Jean Fournier* (Saint Cloud, Minn.: North Star Press, 1985). See also: E. J. Rose, "Alexis J. Fournier," *Brush and Pencil* 4 (August 1899): 243–47; "Alexis J. Fournier—Minnesota Painter of Exceeding Versatility," *Fine Arts Journal* 14 (March 1903): 82–87; Minnesota Historical Society, *Alexis Jean Fournier: The Last American Barbizon*, essay by Rena Neumann Coen (Saint Paul, 1985).
9. Nicholas R. Brewer, *Trails of a Paintbrush* (Boston: Christopher, 1938), specifically p. 201.
10. "W.H.N.," "Alexander Grinager: An Appreciation," *International Studio* 52 (May 1914): xxiv–xxv.
11. "Robert Koehler and Art in Minneapolis," *Art Interchange* 44 (February 1900): 36; Charlotte Whitcomb, "Robert Koehler, Painter," *Brush and Pencil* 9 (December 1901): 144–53; Peter C. Merrill, "Robert Koehler, German-American Artist in Minneapolis," *Hennepin County History* 47 (Summer 1988): 20–27; and Koehler's own "Chapters from a Student's Life," *Minneapolis Society of Fine Arts Bulletin* 1–2 (September 1906–Midsummer 1907).
12. Feodora L. Montgomery, *My Father Feodor von Luerzer* (Coeur d'Alene, Idaho[?]: Privately printed, 1973[?].
13. William G. Boyce, *David Ericson* (Duluth: University of Minnesota, 1963).

Iowa

1. "The River Towns of Henry Lewis," *Iowan* 5 (February–March 1957): 13–15, 43.
2. H. Sander's sketch of John Caspar Wild's life in Franc B. Wilkie, *Davenport Past and Present* (Davenport, Iowa, 1858), pp. 307–10; John Francis McDermott, "J. C. Wild, Western Painter and Lithographer," *Ohio State Archaeological and Historical Quarterly* 60 (April 1951): 111–25.
3. Joslyn Art Museum, *George Simons—Painter, Poet, Pioneer*, in special commemorative thirtieth anniversary bulletin, essay by Mildred Goosman (Omaha, 1961); Goosman, "George Simons: Frontier Artist," pp. 19–20, 51; "The Paintings of George Simons," pp. 21–24; "The Sketches of George Simons," pp. 25–32, 52, all in *Iowan* 10 (Summer 1962).
4. H. Maxson Holloway, "Isaac Augustus Wetherby (1819–1904) and His Account Books," *New-York Historical Society Quarterly* 25 (April 1941): 55–72.
5. Mildred W. Pelzer, "George H. Yewell," *Palimpsest* 11 (November 1930): 483–98; Oneita Fisher, "The Journals of George Henry Yewell," *Books at Iowa* 5 (November 1966): 3–10; Fisher, "George Henry Yewell, Early Iowa Artist," *Iowan* 15 (Winter 1966–67): 40–43, 52. See also George H. Yewell, "Reminiscences of Charles Mason," *Annals of Iowa* 5 (October 1901): 160–76; (January 1902): 250–71.
6. Marion Latour, "George Harvey, Painter and Burlington Pioneer," *Burlington Hawk-Eye*, September 5, 1920, p. 1.
7. Marion J. Nelson, "Herbjorn Gausta, Norwegian-American Painter," in Harald S. Naess and Sigmund Skard, eds., *Americana Norvegica*, vol. 3 (Oslo-Bergen-Tromsö: Universitetsforlaget, 1971), pp. 105–40.
8. Alfred Frankenstein, *After the Hunt* (Berkeley and Los Angeles: University of California Press, 1969), pp. 128–31.
9. Bess Ferguson, *Charles Atherton Cumming: Iowa's Pioneer Artist-Educator* (Des Moines: Iowa Art Guild, 1972).
10. Darrell Garwood, *Artist in Iowa: A Life of Grant Wood* (New York: Norton, 1944), pp. 13–70; Hazel E. Brown, *Grant Wood and Marvin Cone, Artists of an Era* (Ames: Iowa State University Press, 1972), pp. 3–27; Wanda M. Corn, *Grant Wood: The Regionalist Vision* (New Haven, Conn.: Yale University Press, 1983), pp. 1–35; James Dennis, *Grant Wood* (Columbia: University of Missouri Press, 1986), pp. 17–38.
11. Brown, *Grant Wood and Marvin Cone* (see n. 10); Cedar Rapids Art Center, *Marvin Cone: A Retrospective Exhibition* (Cedar Rapids, Iowa, 1980); Joseph S. Czestochowski, *Marvin D. Cone: An American Tradition* (New York: Dutton, 1985).

Missouri

1. Chester Harding, *My Egotistography* (Cambridge, Mass., 1866), pp. 34–41; Roy T. King, "Portraits of Daniel Boone," *Missouri Historical Review* 33 (January 1939): 171–83; John Francis McDermott, "How Goes the Harding Fever?" *Missouri Historical Society Bulletin* 8 (October 1951): 53–59; Leah Lipton, "Chester Harding and the Life Portrait of Daniel Boone," *American Art Journal* 16 (Summer 1984): 4–19; Clifford Amyx, "The Authentic Image of Daniel Boone," *Missouri Historical Review* 82 (January 1988): 153–64.
2. John Francis McDermott, "Indian Portraits: The First Published Collection," *Antiques* 51 (May 1947): 320–22.
3. Alvin M. Josephy, Jr., *The Artist Was a Young Man: The Life Story of Peter Rindisbacher* (Fort Worth: Amon Carter Museum, 1970), pp. 72–80.
4. John Francis McDermott, "Leon Pomarede, 'Our Parisian Knight of the Easel,'" *Bulletin of the City Art Museum of Saint Louis* 34 (Winter 1949): 8–18; McDermott, "Portrait of the Father of

Waters: Léon Pomarède's Panorama of the Mississippi," *Bulletin of the Institut Français of Washington* 2 (December 1952): 46–58; Joseph Earl Arrington, "Leon D. Pomarede's Original Panorama of the Mississippi River," *Missouri Historical Society Bulletin* 9 (April 1953): 261–73.

5. Joseph Earl Arrington, "The Story of Stockwell's Panorama," *Minnesota History* 33 (Autumn 1953): 284–90.

6. Henry Lewis, *The Valley of the Mississippi Illustrated*, ed. Bertha L. Heilbron (Saint Paul: Minnesota Historical Society, 1967), originally published as *Das Illustrierte Mississippithal* (Düsseldorf, 1854). See also: "W.R.H." [Wm. R. Hodges], "Art," *Spectator*, November 19, 1881, p. 176; Mona N. Squires, "Henry Lewis and His Mammoth Panorama of the Mississippi River," *Missouri Historical Review* 27 (April 1933): 244–56; Heilbron, *Making a Motion Picture in 1848: Henry Lewis' Journal of a Canoe Voyage from the Falls of St. Anthony to St. Louis* (Saint Paul: Minnesota Historical Society, 1936); Heilbron, "Lewis' 'Mississippithal' in English," *Minnesota History* 32 (December 1951): 202–13; John Francis McDermott, "Henry Lewis and His Views of Western Scenery," *Antiques*, April 1952, pp. 332–35; Joseph Earl Arrington, "Henry Lewis' Moving Panorama of the Mississippi River," *Louisiana History* 6 (Summer 1965): 239–72; Marie L. Schmitz, "Henry Lewis: Panorama Maker," *Gateway Heritage* 3 (Winter 1982–83): 36–48.

7. John Francis McDermott, "J. C. Wild, Western Painter and Lithographer," *Ohio State Archaeological and Historical Quarterly* 60 (April 1951): 111–25; McDermott, "Some Rare Western Prints by J. C. Wild," *Antiques* 77 (November 1957): 452–53.

8. "Oil Paintings by James F. Wilkins, an Important Heritage Fund Acquisition," *Missouri Historical Society Bulletin* 18 (April 1961): 267–74.

9. "What the Mails Bring: Reminiscences of a Lady Artist," *New-York Times*, November 30, 1877; *Missouri Republican*, November 26, 1877, and July 9, 1878; Peale Museum, *Miss Sara Miriam Peale, 1800–1885: Portraits and Still Life*, essay by John Mahey (Baltimore, 1967).

10. Martha Gandy Fales, "Hannah B. Skeele, Maine Artist," *Antiques* 121 (April 1982): 915–21.

11. Karen McCoskey Goering, "Manuel de França: St. Louis Portrait Painter," *Gateway Heritage* 3 (Winter 1982–83): 30–35.

12. John Francis McDermott, ed., *Travels in Search of the Elephant: The Wanderings of Alfred S. Waugh, Artist, in Louisiana, Missouri, and Santa Fe, in 1845–1846* (Saint Louis: Missouri Historical Society, 1951).

13. "Our Artists and Their Works, No. 1," *Brooklyn Monthly* 1 (November 1877): 1–2; Gabriel Harrison, "The Fine Arts in Brooklyn," in Henry R. Stiles, ed., *History of Kings County, Including the City of Brooklyn, New York* (New York, 1884), pp. 1147–48.

14. "Venerable Painter," *Art Interchange* 52 (April 1903): 84–85, discusses only Alban Jasper Conant's later career.

15. Lipton, "Chester Harding" (see n. 1), pp. 9–10, on Chester Harding's influence on George Caleb Bingham.

16. The bibliography for George Caleb Bingham is enormous. The definitive study of his life and art is E. Maurice Bloch, *George Caleb Bingham* (Berkeley and Los Angeles: University of California Press, 1967).

17. Carol Clark, "Charles Deas," in *American Frontier Life: Early Western Paintings and Prints* (New York: Abbeville Press, 1987), pp. 51–77. See also: [Henry T. Tuckerman], "Our Artists, No. V: Deas," *Godey's Lady's Book* 33 (December 1846): 250–53; Tuckerman, *Book of the Artists: American Artist Life* (New York, 1867), pp. 424–29; John Francis McDermott, "Charles Deas: Painter of the Frontier," *Art Quarterly* 13 (Autumn 1950): 293–311; McDermott, "Charles Deas' Portrait of a Mountain Man: A Mystery in Western Art," *Gateway Heritage* 1 (Spring 1981): 2–9.

18. William Tod Helmuth, *Arts in St. Louis* (Saint Louis, 1864), pp. 36–48; "Karl Ferdinand Weimer [*sic*]," *Deutsche Pionier* 13 (July 1881): 130–38; William R. Hodges, "Charles Ferdinand Wimar," *American Art Review* 2, part 1 (1881): 175–82; William Romaine Hodges, *Carl Wimar, a Biography* (Galveston, Tex.: Charles Reymershofer, 1908); "Journal of Dr. Elias J. Marsh: Account of a Steamboat Trip on the Missouri River, May–August, 1859," *South Dakota Historical Review* 1 (January 1936): 79–122; Reka Neilson, "Charles F. Wimar and Middle Western Painting of the Early Nineteenth Century" (M.A. thesis, Washington University, 1943); City Art Museum of Saint Louis, *Charles Wimar, 1828–1862: Painter of the Indian Frontier*, essay by Perry T. Rathbone (1946); Lincoln Bunce Spiess, "Carl Wimar: The Missouri Historical Society's Collection," *Gateway Heritage* 3 (Winter 1982–83): 16–29.

19. Lincoln Bunce Spiess, "Mat Hastings, Artist (1834–1919)," *Bulletin of the Missouri Historical Society* 36 (April 1980): 152–55; Gary N. Smith, "Mat Hastings: Artistic Chronicler of His Times," *Gateway Heritage* 3 (Winter 1982–83): 2–9.

20. Material made available from the unpublished papers in the John Francis McDermott Research Collection, Lovejoy Library, Southern Illinois University, Edwardsville.

21. James D. Birchfield, "Thomas Satterwhite Noble: 'Made for a Painter,' " *Kentucky Review* 6 (Winter 1986): 35–60, (Summer 1986): 45–73; University of Kentucky Art Museum, *Thomas Satterwhite Noble, 1835–1907*, essays by James D. Birchfield and Albert Boime (Lexington, 1988).

22. "A Great Artist in St. Louis," *Saint Louis Daily Globe Democrat*, June 8, 1875, p. 3; Lincoln Bunce Spiess, "Louis Schultze: A Lost Artist Rediscovered," *Gateway Heritage* 2 (Winter 1981–82): 3–10.

23. Mary M. Powell, "Three Artists of the Frontier," *Missouri Historical Society Bulletin* 5 (October 1948): 39–41; "St. Louis in the 1850's," *Antiques* 79 (April 1961): 384.

24. "St. Louis," *Crayon* 6 (December 1859): 381.

25. "Mr. Joseph Rusling Meeker," *Art Journal* (New York) 5 (1879): 42–45; Montgomery Museum of Fine Arts, *Joseph Rusling Meeker: Images of the Mississippi Delta*, essay by C. Reynolds Brown (Montgomery, Ala., 1981).

26. "Art," *Inland Monthly* 5 (January–April 1874): 157–58.

27. James William Pattison, "William Merritt Chase, N.A.," *House Beautiful* 25 (February 1909): 50–52, 56; "Janitor Brother Tells How Chance Aided W. M. Chase," *Indianapolis Star*, March 25, 1917; Thomas B. Brumbaugh, "William Merritt Chase Reports to St. Louis from Munich: A Correspondence," *Missouri Historical Society Bulletin* 15 (January 1959): 118–24; Ronald G. Pisano, *A Leading Spirit in American Art: William Merritt Chase, 1849–1916* (Seattle: Henry Art Gallery, 1983), p. 25.

28. "Art" (see n. 26); Frank Torrey Robinson, *Living New England Artists* (Boston, 1888), pp. 13–20; "Thomas Allen's Exhibition," *Collector* 2 (April 15, 1891): 139.

29. "Harry Chase," *Art Age* 2 (February 1884): 98.

30. Mab Mulkey, "History of the St. Louis School of Fine Arts, 1879–1909: The Art Department of Washington University" (M.A. thesis, Washington University, 1944). See also: Ernest Knaufft, "St. Louis, the School of Fine Arts," *Art Amateur* 25 (August 1891): 53–54; Sally Bixby Defty, *Washington University School of Fine Arts: The First Hundred Years, 1879–1979: Washington University School of Fine Arts* (Saint Louis: Washington University School of Fine Arts, 1979).

31. "Kindly Caricatures (3): Halsey C. Ives," *Mirror* (Saint Louis) 15 (June 8, 1905): 4–6; Walter B. Stevens, ed., *Halsey Cooley Ives, LL.D., 1847–1911* (Saint Louis: Ives Memorial Association, 1915).

32. Burton W. Morwood, "Paul Harney—Artist," typescript, Hayner Public Library, Alton, Ill., 1965, and information courtesy of Karen M. Goering, Acting Executive Director, Missouri Historical Society, Saint Louis; John C. Abbott, Librarian, Research and Special Collections, Southern Illinois University at Edwardsville; Professor Jeanne Colette Collester, Art History Department, Principia College, Elsah, Ill.; and Mrs. Maitland Timmermiere, Alton, Ill.

33. John Hemming Fry, *The Revolt against Beauty* (New York: Putnam, 1934); *Paint-*

ings, Drawings and Bronzes: A Collection Made by John Hemming Fry* (Canton, Ohio: Canton Art Institute, 1944).

34. John M. Tracy, "Practical View of High Art: Paper Read before the St. Louis Art Society," *Western* 4 (July 1878): 404–11; Marguerite Tracy, "With Horses and Dogs," *Quarterly Illustrator* 3 (1st quarter 1895): 109–15. Important documents for Tracy's subsequent career are his own "Recollections of Parisian Art Schools" (Brooklyn, 1883); Fifth Avenue Auction Rooms, *Catalogue of Paintings by the Late J. M. Tracy*, introduction by Alfred Trumble, New York, February 20–21, 1895.

35. "W.R.H.," [William Romaine Hodges], "Art: Some Plain Talk to Our Local Artists," *Spectator*, January 8, 1881, p. 179.

36. "Juries of Selection," *Arts for America* 5 (Midsummer 1896): 240.

37. Harold C. Evans, " 'Custer's Last Fight,' " *Kansas Magazine*, 1938, pp. 72–74; Robert Taft, "Custer's Last Stand—John Mulvany, Cassily Adams and Otto Becker," *Kansas Historical Quarterly* 14 (November 1946): 377–90; Vincent Mercaldo, "Cessilly [sic] Adams and His Custer Painting," *Westerners: New York Posse Brand Book* 4, no. 1 (1957): 17, 23; Don Russell, "Those Long-Lost Custer Panels," *Pacific Historian* 11 (Fall 1967): 29–35.

38. "Art and Artists," *Graphic* 7 (October 29, 1892): 312; *International Studio* 26 (July–October 1905): xxxix; "Charles Kurtz," *American Art News* 7 (March 27, 1909): 4.

39. J. F. Oertel, *A Vision Realized: A Life Story of Rev. J. A. Oertel, D.D.: Artist, Priest, Missionary* (Milwaukee: Young Churchman, 1917), pp. 162–64.

40. Karen McCoskey Goering, "Portrait of a Symbol: Artists' Views of the Eads Bridge," *Gateway Heritage* 6 (Spring 1986): 26–33.

41. "Paul Cornoyer," *Art Interchange* 51 (December 1903): 133; "A Painter of the City Tranquil," *Current Literature* 4 (July 1909): 54–56; Frederick J. Mulhaupt, "Paul Cornoyer, Painter—an Appreciation," *Cape Ann Shore*, July 14, 1923; Lakeview Center for the Arts and Sciences, *Paul Cornoyer: American Impressionist*, essay by Lowell Adams (Peoria, Ill., 1974).

42. "Kindly Caricatures, No. 112: Gustav Wolff," *Mirror* (Saint Louis) 17 (June 13, 1907): 6–7.

43. See Edmund H. Wuerpel's own writings: *American Art Association of Paris* (Philadelphia, 1894); "American Artists' Association Paris," *Cosmopolitan* 20 (February 1896): 402–9; "Art Development in St. Louis," in William Hyde and Howard L. Conrad, eds., *Encyclopedia of the History of St. Louis* (New York, 1899), vol. 1, pp. 43–53; for Wuerpel's reminiscences of James McNeill Whistler, see "My Friend Whistler," *Mirror* (Saint Louis) 13 (January 28, 1904): 18–20; and "Whistler—The Man," *American Magazine of Art* 27 (May–June 1934): 248–53, 312–21.

44. City Art Museum of Saint Louis, *A Collection of Paintings by Mr. Edmund H. Wuerpel* (1912); Saint Louis Artists' Guild, *Edmund H. Wuerpel: Retrospective Exhibition*, essay by Betty Grossman (1988).

45. Frederick Oakes Sylvester, *The Great River* (Chicago: Clark-Sprague, 1911); later editions, Chicago, 1913, Saint Louis, 1925, 1937. Also by Sylvester: "The Society of Western Artists," *Mirror* (Saint Louis) 15 (January 11, 1906): 9–10; "Is Art on the Bum in St. Louis?" *Mirror* (Saint Louis) 16 (March 22, 1906): 12. For Frederick Oakes Sylvester see: Laura Rogers Way, "A Notable School Room Decoration: Frederick Oakes Sylvester's Success in the High School of Decatur, Illinois," *School Arts Magazine* 12 (November 1912): 165–66; Clarence Stratton, "Frederick Oakes Sylvester, the Painter of the Mississippi," *Art and Progress* 4 (September 1913): 1094–98; Lulu Guthrie Emberson, "Life and Work of Frederick Oakes Sylvester" (M.A. thesis, University of Missouri—Columbia, 1930); Paul O. Williams, "Poet-Painter of the Mississippi," *Principia Alumni Purpose*, Spring 1971, pp. 14–17; Betty Jean Crouther, " 'The Artist Sings for Joy': Frederick Oakes Sylvester and Landscape Painting in St. Louis" (Ph.D. diss., University of Missouri—Columbia, 1985); Williams, *Frederick Oakes Sylvester: The Artist's Encounter with Elsah* (Elsah, Ill.: Historic Elsah Foundation, 1986); Thomas E. Morrissey, "Frederick Oakes Sylvester: Transcendental Regionalist," *Gateway Heritage* 8 (Summer 1987): 12–19; Jeanne Colette Collester, *Frederick Oakes Sylvester: The Principia Collection* (Saint Louis: Principia, 1988).

46. Mrs. Charles P. Johnson, "Miss Martha H. Hoke," *Saint Louis Star*, April 6, 1913; Johnson, *Notable Women of St. Louis* (Saint Louis: Mrs. Charles P. Johnson, 1914), pp. 96–99.

47. *Arts and Decoration* 4 (October 1914): 447–49.

48. A. Schön, "C. F. Von Saltza," *Ungdomsvännen* 11 (February 1906); Ernst W. Olson, ed., *History of the Swedes of Illinois*, 2 vols. (Chicago: Engberg-Holmberg, 1908), vol. 1, pp. 852–53.

49. "Carl Gustav Waldeck," *Art Review* 8 (July 1904): 117–18.

50. The standard study on Oscar E. Berninghaus is Gordon E. Sanders, *Oscar E. Berninghaus, Taos, New Mexico* (Taos, N.M.: Taos Heritage, 1985). For his connections with Saint Louis, see: Edmund H. Wuerpel, "Oscar E. Berninghaus," *New Mexico Quarterly* 21 (Summer 1951): 212–19; Martin Kodner, "Oscar Edmund Berninghaus, 1874–1952: St. Louis–Born Painter of Western Scenes," *Gateway Heritage* 4 (Winter 1983–84): 38–48; Bob Priddy, "The Taos Connection: New Mexican Art in Missouri's Capitol," *Missouri Historical Review* 79 (January 1985): 143–66.

51. Emily Grant Hutchings, "Richard Miller,

Portrait Painter," *Mirror* (Saint Louis) 16 (June 7, 1906): 7–8; Harry R. Burke, "St. Louis Artists, No. IV: Richard Miller," *Saint Louis Post-Dispatch*, October 4, 1945; Longmire Fund, *Richard E. Miller, N.A.: An Impression and Appreciation*, essays by Robert Ball and Max W. Gottschalk (Saint Louis, 1968); information courtesy of Marie Louise Kane, Newtown, Connecticut.

52. Saint Louis Artists' Guild, *Fred Green Carpenter, 1882–1965: Mildred B. Carpenter in Celebration of Her 90th Birthday: Paintings and Drawings, 1910–84* (1984).

53. "Kindly Caricatures, No. 99: Dawson Watson," *Mirror* (Saint Louis) 17 (March 19, 1907): 7–8; F.E.A. Curley, "Dawson Watson, Pinx," *Reedy's Mirror* 22 (December 5, 1913): 12–13; " 'Glory of the Morning,' " *Pioneer* 7 (April 1927): 5, 11.

54. "Last of the Riverfront Art Colony," *Saint Louis Post-Dispatch*, September 16, 1956; Goering, "Portrait of a Symbol . . ." (see n. 40).

55. Conrad Diehl, *Art: Its Relation to Education and the Industries* (Columbia: [University of the State of Missouri], 1880); Conrad Diehl, *Prevailing Errors in Art Education* (Columbia: [University of the State of Missouri], 1882).

56. "The Artist of the Missouri," in William B. Stevens, *Centennial History of Missouri* (Saint Louis, 1921), pp. 368–71.

57. Walt Whitman, "City Notes in August," *New York Tribune*, August 15, 1881, p. 5; Robert Taft, "Custer's Last Stand—John Mulvany, Cassily Adams and Otto Becker," *Kansas Historical Quarterly* 14 (November 1946): 368–77; Lowell E. Mooney, "Custer's Last Rally," *Westerners 1971 Brand Book: Denver Posse*, 27 (Boulder, Colo.: Johnson Publishing Company, 1972), pp. 213–31.

58. For Frederic Remington in Kansas City, see: Nellie Hough, "Remington at Twenty-three," *International Studio* 76 (February 1923): 413–15; articles in the *Kansas City Star*: January 23, 1910; February 5, 1911; and May 3, 1925.

59. Wally F. Galleries, *Loan Exhibition of Paintings by Alice Murphy (1871–1909)* (New York, 1971).

60. Theaterette of Jones Dry Goods, *The Home Coming of the Famous Painting 'Brutality'* (Kansas City[?], Mo., 1908), courtesy of Annette Blaugrund.

Kansas

1. Robert Taft, "Henry Worrall," *Kansas Historical Quarterly* 14 (August 1946): 241–64.

2. "Woodman's Portrait of John Brown," *Century*, July 1883, p. 447.

3. Florence L. Snow, "Kansas Art and Artists, II: George Melville Stone," *Kansas Teacher* 25 (October 1927): 10–12.

4. Ruth Lilly Westphal, *Plein Air Painters of*

California: The Southland (Irvine, Calif.: Westphal, 1982), pp. 138–43.

5. Florence L. Snow, "Kansas Art and Artists, IV: Helen Hodge," *Kansas Teacher* 26 (December 1927): 6–8.

6. Wichita Art Museum, *The Legendary Wichita Bill: A Retrospective Exhibition of Paintings by John Noble*, essay by Howard DaLee Spencer (Wichita, Kans., 1982). See also: Merwin Martin, "John Noble, from Kansas," *International Studio* 77 (September 1923): 457–65; M. K. Wisehart, " 'Wichita Bill,' Cowboy Artist, Rode into the Halls of Fame," *American Magazine* 104 (August 1927): 34–35; Florence L. Snow, "Kansas Art and Artists, VI: John Noble," *Kansas Teacher* 26 (February 1928): 20–21.

7. "Svensk-Amerikanska Konstnärer, I: Birger Sandzén," *Ungdomsvännen* 5 (May 1904): 146–49; Mary E. Marsh, "Birger Sandzén," *American-Scandinavian Review* 4 (May–June 1916): 172–77; "Birger Sandzén: Painter and Lithographer," *American Magazine of Art* 8 (February 1917): 148–53; Marsh, "The Work of Birger Sandzén," *International Studio* 69 (January–February 1920): xcix–cii; Vera Brady Shipman, "Birger Sandzén: Painter of Desert and Prairie," *Mentor* 12 (July 1924): 56–57; Elisabeth Jane Merrill, "The Art of Birger Sandzén," *American Magazine of Art* 18 (January 1927): 3–9; Florence L. Snow, "Kansas Art and Artists: Birger Sandzén," *Kansas Teacher* 26 (November 1927): 11–13; Jennie Small Owen, "Kansas Folks Worth Knowing: Birger Sandzén," *Kansas Teacher* 45 (September 1937): 30–32; Emory K. Lindquist, "Birger Sandzén: Six Decades of Artistic Achievement," *American-Scandinavian Review* 42 (December 1954): 329–35; "Birger Sandzén," *Kansas!* 14 (May–June 1959): 7–10; Margaret Sandzén Greenough, "From Sweden to Kansas," *American Artist* 25 (January 1961): 26–31, 72–74; Cynthia Mines, *For the Sake of Art* (n.p., 1979), pp. 41–61; John Diffily, "Birger Sandzén through the Corridors of Nature," *Southwest Art* 13 (August 1983): 42–51; Mary Em Kirn, "Reading Other People's Mail: Selected Correspondence of Charles Haag, Carl Milles and Birger Sandzén," and Janet Knowles Seiz, "Birger Sandzén: A Painter in His Paradise,"

in Augustana College Art Department, *Härute—Out Here: Swedish Immigrant Artists in Midwest America* (Rock Island, Ill., 1984), pp. 39–46 and 56–62; Charles Pelham Greenough, *The Graphic Work of Birger Sandzén* (Lindsborg, Kans.: Birger Sandzén Memorial Foundation, 1983); Wichita Art Museum, *Birger Sandzén: A Retrospective*, essay by Howard DaLee Spencer (Wichita, Kans., 1985); Emory Lindquist, "Birger Sandzén: A Painter and His Two Worlds," *Great Plains Quarterly* 5 (Winter 1985): 53–65. See also Sandzén's own "The Technique of Painting," *Fine Arts Journal* 32 (January 1915): 22–27; "The Southwest as a Sketching Ground," *Fine Arts Journal* 33 (August 1915): 333–52.

8. Effie Seachrest, "The Smoky Hill Valley Art Center," *American Magazine of Art* 12 (January 1921): 14–16; Emory Kempton Lindquist, *Bethany in Kansas* (Lindsborg, Kans.: Bethany College, 1975), pp. 175–85.

9. "A Saint John the Baptist of Art," *International Studio* 77 (April 1923): 65–69; Cynthia Mines, *For the Sake of Art: The Story of an Art Movement in Kansas* (Wichita and North Newton, Kans.: Privately printed, 1979), pp. 25–39.

Nebraska

1. "Art Notes," *Graphic* 8 (June 10, 1893): 388; Howard Erickson, "Fifty-four Years of Painting Omahans' Portraits," *Sunday World–Herald Magazine*, November 18, 1945, pp. 3–5C; Joslyn Art Museum, *J. Laurie Wallace Retrospective* (Omaha, 1954).

2. Frances E. Willard and Mary A. Livermore, *A Woman of the Century* (Buffalo, 1893), pp. 528–29.

3. Ibid., p. 517. See also Sarah Wool Moore, "History and Art," *Transactions and Reports of the Nebraska State Historical Society* 3 (1892): 37–43.

4. Holmes Smith, "Elizabeth Dolan's Habitat Backgrounds for the University of Nebraska," *American Magazine of Art* 20 (August 1929): 460–62; Don W. Sigler, "Murals by Elizabeth Dolan Add Much to Beauty of New Masonic Temple," *Lincoln Sunday Journal and Star*, September 8, 1935.

South Dakota

1. Doane Robinson, "John Banvard," *South Dakota Historical Collections* 21 (1942): 566–94; John Hanners, "The Adventures of an Artist: John Banvard (1815–1891) and His Mississippi Panorama" (Ph.D. diss., Michigan State University, 1979), pp. 133–39.

2. Mar Gretta Cocking, *My-Story of Art in the Black Hills* (n.p., 1965).

3. South Dakota Memorial Art Center, *Charles Greener: Paintings* (Brookings, 1986).

4. Ida B. Alseth, "She Never Dreamed She Could Paint," *Capper's Farmer* 70 (November 1959): 58–59.

5. *Ada B. Caldwell: A Tribute* (Brookings, S.D.: Privately published, 1940).

6. Ernest W. Watson, "Harvey Dunn, Milestone in the Tradition of American Illustration," *American Artist* 6 (June 1942): 16–21; Gerald Grotta, "The Prairie Painter," *South Dakota State College Dakotan*, June 1960, pp. 8–11; "The Prairie Is My Homeland," *Together* 4 (September 1960): 37–44; Edgar M. Howell, "Harvey Dunn: The Searching Artist Who Came Home to His First Horizon," *Montana, the Magazine of Western History* 16 (January 1966): 41–56; Charles W. Ferguson, "Americans Not Everybody Knows: Harvey Dunn," *PTA Magazine* 62 (January 1968): 10–12; Aubrey Sherwood, "Harvey Dunn," *South Dakota Conservation Digest* 4 (July–August 1968): 12–17; Robert R. Karolevitz, *The Prairie Is My Garden* (Aberdeen, S.D.: North Plains Press, 1969); Karolevitz, *The Story of Harvey Dunn, Artist: Where Your Heart Is . . .* (Aberdeen, S.D.: North Plains Press, 1970); William Henry Holaday, III, "Harvey Dunn: Pioneer Painter of the Middle Border" (Ph.D. diss., Ohio State University, 1970); *I Am My Work; My Work Is Me* (College Station, Tex.: Friends of the Texas A and M Library, 1980); South Dakota Memorial Art Center, *Harvey Dunn: Son of the Middle Border* (Brookings, 1984); Sherwood, *I Remember Harvey Dunn* (De Smet, S.D.: Privately printed, 1984[?]). See, also by Dunn, *An Evening in the Classroom* (Tenafly, N.J.: Mario Cooper, 1934).

The Rocky Mountain West

Montana

1. Mildred Goosman, "Karl Bodmer, Earliest Painter in Montana," *Montana, the Magazine of Western History* 29 (July 1970): 36–41; John G. Lepley, "The Prince and the Artist on the Upper Missouri," *Montana, the Magazine of Western History* 29 (July 1970): 42–54.

2. Franz Stenzel, *James Madison Alden: Yankee Artist of the Pacific Coast, 1854–1860* (Fort Worth: Amon Carter Museum, 1975), especially pp. 128–40.

3. Cornelius O'Keefe [pseudonym of Thomas F. Meagher], "Rides through Montana," *Harper's New Monthly Magazine* 35 (October 1867): 568–85; Robert Bigart and Clarence Woodcock, "Peter Tofft: Painter in the Wilderness," *Mon-*

tana, the Magazine of Western History 25 (Autumn 1975): 2–15.

4. The bibliography on Charles Marion Russell is enormous. A basic study is Frederic G. Renner, *Charles M. Russell* (New York: Harry N. Abrams, 1974). For Russell's relationships with, and indebtedness to, other artists, see: Brian W. Dippie, "Two Artists from St. Louis: The Wimar-Russell Connection," in Museum of Western

Expansion, *Charles M. Russell: American Artist* (Saint Louis, 1982), pp. 20–35; Dippie, *Looking at Russell* (Fort Worth: Amon Carter Museum, 1987).

5. The standard work on Edgar Samuel Paxson is William Edgar Paxson, Jr., *E. S. Paxson, Frontier Artist* (Boulder, Colo.: Pruett, 1984). See also: [Marian A. White], "E. S. Paxson, American Painter of Western Life," *Fine Arts Journal* 12 (February 1901): 5–7; Enos A. Mills, "A Western Artist," *Outdoor Life* 10 (August 1902); Helen Fitzgerald Sanders, "Edgar Samuel Paxson," *Overland Monthly* 48 (September 1906): 182–85; K. Ross Toole and Michael Kennedy, "A Portfolio of the Art of E. S. Paxson," *Montana, the Magazine of History*, Spring 1954; Franz R. Stenzel, *E. S. Paxson—Montana Artist* (Helena: Montana Historical Society, 1963); William Edgar Paxson, "Paxson," *Westerner*, no. 21 (November–December 1971): 46–47, 64–65; Sam L. Manatt, "Edgar Samuel Paxson (1852–1919), *Southwest Art* 8 (August 1978): 32–39. On Paxson's most famous work, see: Antoinette E. Simons, "Worked Twenty Years on One Picture," *American Magazine* 80 (July 1915): 50; W. E. Paxson, " 'Custer's Last Stand': The Painting and the Artist," *True West* 11 (September–October 1963): 14–16, 52–53.

6. The basic study on Joseph Henry Sharp is Forrest Fenn, *The Beat of the Drum and the Whoop of the Dance: A Study of the Life and Work of Joseph Henry Sharp* (Santa Fe, N.M.: Fenn, 1983). For Sharp in Montana, see Carolyn Reynolds Riebeth, *J. H. Sharp among the Crow Indians, 1902–1910* (El Segundo, Calif.: Upton and Sons, 1985); also, C. M. Russell Museum, *Joseph Henry Sharp and the Lure of the West*, essay by Carl Schaefer Dentzel (Great Falls, Mont., n.d.).

7. Information on Cyrenius Hall, courtesy of Steven Cotherman of the Museums and Historical Department, Wyoming State Archives, Cheyenne.

8. "Ralph E. DeCamp: Artist as Photographer," *Montana, the Magazine of Western History* 39 (July 1979): 50–55.

9. Ida E. Sternfels, "Montana Art and Artists," 1933, typescript at Butte–Silver Bowl Free Public Library, Butte, Mont.

10. John E. Ewers, "Winhold [*sic*] Reiss: His Portraits and Protégés," *Montana, the Magazine of Western History* 21 (July 1971): 44–55; Fenn Galleries, *Winold Reiss* (Santa Fe, N.M., 1978); C. M. Russell Museum, *Winold Reiss: Portraits of the Races*, essay by Paul Raczka (Great Falls, Mont., 1986), National Portrait Gallery, *To Color America: Portraits by Winold Reiss*, essay by Jeffrey C. Stewart (Washington, D.C., 1989).

11. "Lone Wolf Returns to That Long Ago Time as Related to Paul Dyck, His Adopted Son," *Montana, the Magazine of Western History* 22 (Winter 1972): 18–41.

Idaho

1. Nancy Miller in *Idaho Yesterdays* 10 (Fall 1966): 12–19.

2. See Lee Ann Johnson, *Mary Hallock Foote* (Boston: Twayne, 1980), on Foote's writing; and Foote's own *A Victorian Gentlewoman in the Far West*, ed. Rodman W. Paul (Pasadena, Calif.: Huntington Library, 1972). For Foote in Idaho, see: Thomas Donaldson, *Idaho of Yesterday* (Westport, Conn.: Greenwood Press, 1941), pp. 358–63; Mary Lou Benn, "Mary Hallock Foote in Idaho," *University of Wyoming Publications* 20 (July 15, 1956): 157–78; Paul, "When Culture Came to Boise: Mary Hallock Foote in Idaho," *Idaho Yesterdays* 20 (Summer 1972): 2–12, later published independently as part of the Idaho Historical Series, no. 19 (Boise, 1977).

3. "Idaho City Artist: Maggie Brown," *Idaho World*, July 2, 1980, p. 1.

4. Idaho Historical Museum, *Island in the Snake: The Idaho Paintings of Pioneer Artist J. P. McMeekin* (Boise, 1983).

5. Hiram French, *History of Idaho*, 3 vols. (1914), vol. 3, pp. 977–78; " 'Old West' Lives Again on Idaho Artist's Canvas," *Golden Idaho Motorist* 7 (January 1932): 2.

6. Museum of Church History and Art of the Church of Jesus Christ of Latter-day Saints, *The Art of Minerva Kohlhepp Teichert*, essays by Laurie Teichert Eastwood and Robert O. Davis (Salt Lake City, 1988).

7. Feodora L. Montgomery, *My Father Feodor von Luerzer* (Coeur d'Alene, Idaho[?]: Privately printed, 1973[?]).

Wyoming

1. For Frank Buchser in the West, see: H. Lüdeke, "Mit Frank Buchser im Fernen Westen," Sunday edition, *National-Zeitung, Basel*, March 13 and 20, 1938; Lüdeke, *Frank Buchsers amerikanische Sendung, 1866–1871* (Basel: Holbein-Verlag, 1941), pp. 26–38. For Blakelock in Wyoming and elsewhere in the West, see: Norman A. Geske, "Ralph Albert Blakelock in the West," *American Art Review* 3 (January–February, 1976): 123–35.

2. Frederick A. Mark, "Last of the Old West Artists," *Montana, the Magazine of Western History* 7 (Winter 1957): 58–63; Mark, "Last of the Old West Artists," *American Book Collector* 14 (April 1964): 21–22.

3. Marian A. White, "A Group of Clever and Original Painters in Montana," *Fine Arts Journal* 16 (February 1905): 89–93; Edward McBride, "A Cowboy Who Is an Artist," *World Today* 52 (July 1928): 188–90; "Autobiography of Elling William Gollings, the Cow-boy Artist," *Annals of Wyoming* 9 (October 1932): 704–14; R. H. (Bob) Scherger, "Paint Bill," *Montana* 15 (Spring 1965): 68–85; Scherger, *A Gollings Sketchbook* (Billings, Mont.: Alpine Publishing, 1973); James Taylor Forrest, *Bill Gollings: The Man and His Art* (Fort Worth: Northland Press in cooperation with Amon Carter Museum of Western Art, 1979); Forrest, *Bill Gollings, Ranahan Artist* (Big Horn, Wyo.: Bradford Brinton Memorial, n.d.).

Colorado

1. "Bierstadt's 'Storm in the Rocky Mountains,' " *Georgetown Courier*, July 17, 1884, p. 3; William Newton Byers, "Bierstadt's Visit to Colorado," *Magazine of Western History* 11 (January 1890): 237–40; Gerhard G. Spieler, "A Noted Artist in Early Colorado," *American-German Review* 11 (June 1945): 13–17.

2. Eliza Greatorex, *Summer Etchings in Colorado* (New York, 1873).

3. *History of the City of Denver, Arapahoe County, and Colorado* (Chicago, 1880), p. 470; "The John D. Howland Collection," *Colorado Magazine* 8 (March 1931): 60–63; Clarence S. Jackson, "I Remember Jack Howland," *Colorado Magazine* 26 (October 1949): 307–9; Kate Howland Charles, "Jack Howland, Pioneer Painter of the Old West," *Colorado Magazine* 29 (July 1952): 170–75.

4. "Art Notes," *Graphic* 4 (May 16, 1891): 311; Charles Stewart Stobie, "Crossing the Plains to Colorado in 1865," *Colorado Magazine* 10 (November 1933): 201–12.

5. Benjamin Draper, "Alfred Edward Mathews: Soldier, Pioneer, and Delineator," *Antiques* 35 (March 1939): 127–29; Robert Taft, "Alfred E. Mathews," *Kansas Historical Quarterly* 17 (May 1949): 97–121; Elizabeth R. Martin, "The Civil War Lithographs of Alfred Edward Mathews," *Ohio History* 72 (July 1963): 230–42.

6. R. H. Love Galleries, *Helen Hamilton (1889–1970)*, essay by Richard H. Love (Chicago, 1986), pp. 3–10.

7. *History of the City of Denver, Arapahoe County, and Colorado* (Chicago, 1880), pp. 511–12. *Buffalo Express*, November 5, 1916 (autobiographical letter, through courtesy of Buffalo and Erie County Public Library), published in Robert Taft, *Artists and Illustrators of the Old West, 1850–1900* (New York: Scribner's, 1953), pp. 345–46. See also John Harrison Mills's own "Letter Concerning Early Art in Colorado," 1916, typescript on deposit with the Western History Department, Denver Public Library.

8. *History of the City of Denver, Arapahoe County, and Colorado* (Chicago, 1880), pp. 574–75.

9. "Death of Mr. and Mrs. J. A. Chain," *Coloradan* 1 (October 1, 1892): 7–8. Carla Swan Coleman, "A Brief Biography for the Denver Fortnightly Club: 'Brobding-

nagian' Helen Henderson Chain (One of the 'Giants' of Fortnightly)," 1966, typescript manuscript in the Western History Department of the Denver Public Library.

10. Ann Condon Barbour, "Charles Partridge Adams, Painter of the West," *Denver Westerners Roundup* 32 (January–February 1976): 3–17.

11. "Alexis Compera, Landscape Painter," *Chicago Inter-Ocean*, January 24, 1904.

12. Alfred Frankenstein, *After the Hunt* (Berkeley and Los Angeles: University of California Press, 1969), pp. 128–31.

13. Reginald Poland, "Allen T. True: Painter of the West," *American Magazine of Art* 11 (January 1920): 79–85; Rose Henderson, "Allen True's New Indian Murals," *American Magazine of Art* 15 (November 1924): 566–68.

14. Patricia Trenton, *Harvey Otis Young: The Lost Genius, 1840–1901* (Denver: Denver Art Museum, 1975). See also "Harvey Young—Landscape Painter of the Western Plains (American)," *Fine Arts Journal* 12 (July 1901): 96–99.

15. Elaine Maher Harrison, "Frank Paul Sauerwein: Artist of the Southwest" (M.A. thesis, West Texas State College, Canyon, 1958); Harrison, "Frank Paul Sauerwein," *Panhandle–Plains Historical Review* 33 (1960): 1–67.

16. Barbara M. Arnest, "'These Eyes,'" *Colorado College Magazine* (Summer 1972): 18–22; Michel Thévoz, *Louis Soutter* (Zurich: Institut Suisse pour l'Etude de l'Art, 1974), pp. 20–24.

17. Alice Shinn, "The Impressionist School," in Colorado Springs Art Society, *Catalogue of the Second Exhibition of Oil Paintings* (Colorado Springs, Colo., 1913).

Utah

1. Solomon Nuñes Carvalho, *Incidents of Travel and Adventure in the Far West* (New York, 1857), pp. 140ff.; Joan Sturhahn, *Carvalho: Artist-Photographer-Adventurer-Patriot: Portrait of a Forgotten American* (Merrick, N.Y.: Richwood, 1976), pp. 99–113.

2. Linda Mary Jones Gibbs, "Enoch Wood Perry, Jr.: A Biography and Analysis of His Thematic and Stylistic Development" (M.A. thesis, University of Utah, 1981), pp. 43–48.

3. Elsie S. Heaton, "William Warner Major, 1804–1854: Pioneer of Utah Art," typescript, Utah State Historical Society.

4. David W. Evans, "Early Mormon Artist Proclaimed 'Art Discovery of 1970,'" *Improvement Era* 73 (May 1970): 18–29; Carl Carmer, "A Panorama of Mormon Life," *Art in America* 58 (May–June 1970): 52–65; Jane Dillenberger, "Mormonism and American Religious Art," *Sunstone* 3 (May–June 1978): 13–17;

Museum of Church History and Art, *C.C.A. Christensen, 1831–1912: Mormon Immigrant Artist*, essays by Richard L. Jensen and Richard G. Oman (Salt Lake City, 1984).

5. Terry John O'Brien, "A Study of the Effect of Color in the Utah Temple Murals" (M.A. thesis, Brigham Young University, Provo, Utah, 1968).

6. Heber G. Richards, "George M. Ottinger, Pioneer Artist of Utah," *Western Humanities Review* 3 (July 1949): 209–18; Carl Hugh Jones, "The Archaeological Paintings of George M. Ottinger," *Papers of the Fourteenth Annual Symposium on the Archaeology of the Scriptures*, April 1963, pp. 5–11. See also George M. Ottinger's own "Montezuma Receiving the News of the Landing of Cortez," *Western Galaxy* 1 (April 1888): 198–201.

7. See Alfred Lambourne's own articles: "A Cruise on the Great Salt Lake," *Western Galaxy* 1 (March 1888): 84–93; "Springtime on the Seashore: Monterey Mission and Their Environs," *Western Galaxy* 1 (April 1888): 300–305.

8. J. Kenneth Davies, *George Beard, Mormon Pioneer Artist with a Camera* (Provo, Utah[?], 1975[?]).

9. Lila Duncan-Larsen, "H.L.A. Culmer, Utah Artist and Man of the West, 1854–1914" (M.A. thesis, University of Utah, 1987). See also, Leonard J. Arrington, "H.L.A. Culmer—First President of Salt Lake Rotary," typescript, July 22, 1975, Manuscripts Library, University Libraries, University of Utah, Salt Lake City. See also Culmer's own writings on landscape: "Desolate Shores," *Contributor* 4 (October 1882): 22–24; "Scenic Attractions of Salt Lake City," *Western Galaxy* 1 (June 1888): 408–19; "Mountain Scenery of Utah," *Contributor* 13 (February–April 1892): 173–78, 201–7, 266–80; "Mountain Art," *Overland Monthly* 24 (October 1894): 340–52; "The Artist in Monterey," *Overland Monthly* 34 (December 1899): 514–29; "The Scenic Glories of Utah," *Western Monthly* 10 (August 1909): 35–41; "Vales of Fruitful Promise," *Utah Education Review* 6 (April 1913): 18–20.

10. On the Utah natural bridges, see W. W. Dyar, "The Colossal Bridges of Utah," *Century* 68 (August 1904): 505–11; Edwin F. Holmes, "The Great Natural Bridges of Utah," *National Geographic Magazine* 18 (March 1907): 199–204; Byron Cummings, "The Great Natural Bridges of Utah," *National Geographic Magazine* 21 (February 1910): 157–67. For Henry Culmer's expedition, see Charlie R. Steen, "The Natural Bridges of White Canyon: A Diary of H.L.A. Culmer, 1905," *Utah Historical Quarterly* 40 (Winter 1972): 55–87.

11. See the artist's own *A Basket of Chips: An Autobiography by James Taylor Harwood* (Salt Lake City: University of Utah Library, 1985). William Robert (Will) South has been studying Harwood's art

and life; see his "Life and Art of James Taylor Harwood, 1860–1940" (M.A. thesis, University of Utah, 1986); Utah Museum of Fine Arts, *James Taylor Harwood, 1860–1940*, essay by South (Salt Lake City, 1987). See also: "An American Who Has Won Fame Abroad," *Fine Arts Journal* 19 (November 1908); University of Utah, *Presenting . . . James Taylor Harwood*, essay by Ruth Harwood (Salt Lake City, 1940); Willard R. Harwood, *The Art of James T. Harwood*, with a "Life Sketch" by Ruth Harwood (Salt Lake City, c. 1979).

12. John Hafen, "An Art Student in Paris," *Contributor* 15 (September 1894): 485–87; John Hafen, "Mountains from an Art Standpoint," *Young Woman's Journal* 16 (September 1905): 403–6; B. F. Larsen, "A Brief from an Illustrated Paper on the Life of John Hafen," *Utah Academy of Sciences, Arts and Letters* 12 (November 1935): 93–94; Larsen, "The Meaning of Religion in the Life of John Hafen," *Improvement Era*, 39 (January 1936): 5–7, 56–57; William Lee Roy Conant, Jr., "A Study of the Life of John Hafen, Artist, with an Analysis and Critical Review of His Work" (M.A. thesis, Brigham Young University, Provo, Utah, 1969).

13. Museum of Church History and Art, the Church of Jesus Christ of Latter-day Saints, *Harvesting the Light*, essay by Linda Jones Gibbs (Salt Lake City, 1987).

14. John Henry Evans, "Some Men Who Have Done Things, IV: Edwin Evans," *Improvement Era* 13 (February 1910): 343–50; University of Utah, *Presenting . . . Edwin Evans*, essay by Mabel Frazer (Salt Lake City, 1941).

15. B. F. Larson, "A Preliminary Study of the Life of John Willard Clawson," *Utah Academy of Sciences, Arts, and Letters* 17 (December 1940): 57–58.

16. Miriam B. Murphy, "Mary Teasdel Followed a Dream," *Beehive History* 6 (1980): 27–28.

17. James Patterson Wilson, "A Sculptor and a Painter of Utah," *Fine Arts Journal* 24 (February 1911): 96–101.

18. Salt Lake Art Center, *Henri Moser, 1876–1951*, essay by James L. Haseltine (Salt Lake City, 1963).

19. B. F. Larsen and Ethel Strausser, "Donald Beauregard," *Utah Academy of Sciences, Arts, and Letters* 15 (November 1937): 7–8; Museum of New Mexico, *Paintings by Donald Beauregard* (Santa Fe, 1964); Salt Lake Art Center, *Paintings and Drawings by Donald Beauregard, 1884–1914* (Salt Lake City, 1968). On the murals, see Paul A. F. Walter, "The St. Francis Murals," *Art and Archaeology* 7 (January 1918): 84–89.

20. Museum of Church History and Art of the Church of Jesus Christ of Latter-day Saints, *Le Conte Stewart: The Spirit of Landscape*, essay by Robert O. Davis (Salt Lake City, 1985).

The Southwest

New Mexico

1. Julie Ann Schimmel, "John Mix Stanley and Imagery of the West in Nineteenth-Century American Art" (Ph.D. diss., New York University, 1983), pp. 60–70.

2. Forrest Fenn, *The Beat of the Drum and the Whoop of the Dance* (Santa Fe, N.M.: Fenn, 1983). See also: Laura A. Davies, "An Indian Painter of the West," *El Palacio* 13 (September 1, 1922): 65–69; Ina Sizer Cassidy, "Art and Artists of New Mexico," *New Mexico* 10 (August 1932): 31, 49; Mary Carroll Nelson, "Joseph Henry Sharp: Dedicated Observer," *American Artist* 42 (January 1978): 28–30, 95–97. Also, Joseph Henry Sharp's own articles: "An Artist among the Indians," *Brush and Pencil* 4 (April 1899): 1–6; "The Chant," *Brush and Pencil* 5 (March 1900): 284–85.

3. Ina Sizer Cassidy, "Art and Artists of New Mexico," *New Mexico* 10 (July 1932): 31, 46; Mary Carroll Nelson, "Bert Greer [*sic*] Phillips: Taos Romantic," *American Artist* 42 (January 1978): 32–35, 98–99.

4. "Blumenschein Is Interviewed," *El Palacio* 6 (March 1919): 84–86; Alexandre Hogue, "Ernest L. Blumenschein," *Southwest Review* 13 (July 1928): 469–74; Cassidy, "Art and Artists" (see n. 3), pp. 31, 45–46; "Ernest L. Blumenschein, Artist of Taos," *El Palacio* 53 (March 1946): 53–55; Howard Cook, "Ernest L. Blumenschein," *New Mexico Quarterly* 19 (Spring 1949): 18–24; James T. Forrest, "Ernest L. Blumenschein," *American Scene* 3 (Fall 1960): 6–7, 10; Mary Carroll Nelson, "Ernest L. Blumenschein: Intellect and Growth," *American Artist* 42 (January 1978): 36–41, 91–95; Colorado Springs Fine Arts Center, *Ernest L. Blumenschein Retrospective*, essay by William T. Henning, Jr. (Colorado Springs, 1978); Museum of Northern Arizona, *The Blumenscheins of Taos*, essay by Katherine Chase (Flagstaff, Ariz., 1979); Helen Greene Blumenschein, *Recuerdos: Early Days of the Blumenschein Family* (Silver City, N.M.: Tecolote Press, 1979). See also, by Ernest L. Blumenschein: "The Painting of Tomorrow," *Century* 87 (April 1914): 845–50; "Origins of the Taos Art Colony," *El Palacio* 20 (May 15, 1926): 190–93.

5. The standard study on Oscar E. Berninghaus is Gordon E. Sanders, *Oscar E. Berninghaus, Taos, New Mexico* (Taos, N.M.: Taos Heritage, 1985). See also: Ina Sizer Cassidy, "Art and Artists of New Mexico," *New Mexico* 11 (January 1933): 28, 41–42; Edmund H. Wuerpel, "Oscar E. Berninghaus," *New Mexico Quarterly* 21 (Summer 1951): 212–19; Mary Carroll Nelson, "Oscar E. Berninghaus: Modesty and Expertise," *American Artist* 42 (January 1978): 42–47; Martin Kodner, "Oscar Edmund Berninghaus, 1874–1952: St. Louis–Born Painter of Western Scenes," *Gateway Heritage* 4 (Winter 1983–84): 38–48.

6. The most important studies on Eanger Irving Couse are: Nicholas Woloshuk, *E. Irving Couse, 1866–1936* (Santa Fe, N.M.: Santa Fe Village Art Museum, 1976); Virginia Couse Leavitt, "Eanger Irving Couse (1866–1936)," in Muskegon Museum of Art, *Artists of Michigan from the Nineteenth Century* (Muskegon, Mich., 1987), pp. 160–67. See also: "Eanger Irving Couse," *Art Review* 7 (January 1904): 140–42; Joseph Lewis French, "A Remote North American Civilization and Its Portrayal in the Art of E. Irving Couse," *Craftsman* 18 (September 1910): 619–25; Rose Henderson, "A Painter of Pueblo Indians," *American Magazine of Art* 11 (September 1920): 400–405; Henderson, "A Veteran Painter of American Indians," *Southern Workman* 57 (January 1928): 17–23; Cassidy, "Art and Artists" (see n. 2), pp. 31–49; Oscar E. Berninghaus, "E. Irving Couse, N.A.—W. Herbert Dunton," *Western Artist* 2 (July–August 1936): 7–10; Alta Edmondson, "E. Irving Couse, Painter of Indians," *Panhandle Plains Historical Review* 42 (1969): 1–21; Betty Harvey, "E. Irving Couse," *Artists of the Rockies and the Golden West* 4 (Winter 1977): 28–37; Mary Carroll Nelson, "Eanger Irving Couse: The Indian as Noble Innocent," *American Artist* 42 (January 1978): 48–53.

7. The definitive study on William Herbert Dunton is Julie Schimmel, *The Art and Life of W. Herbert Dunton, 1878–1936* (Orange: University of Texas Press, 1984). See also: F. Warner Robinson, "Dunton—Westerner," *American Magazine of Art* 15 (October 1924): 501–8; Alexandre Hogue, "W. Herbert Dunton: An Appreciation," *Southwest Review* 13 (October 1927): 48–59; Ina Sizer Cassidy, "Art and Artists of New Mexico," *New Mexico* 10 (December 1932): 22, 43; Loraine Carr, "Painting Big Game," *New Mexico* 14 (June 1936): 30, 32, 50; Berninghaus, "Couse—Dunton" (see n. 6); Mary Carroll Nelson, "William Herbert Dunton: From Yankee to Cowboy," *American Artist* 42 (January 1978): 60–62, 100–101; Patricia Condon Johnston, "W. Herbert Dunton," *American West* 18 (May–June 1981): 24–33; Adra A. Johnson, "Quintessential Westerner," *Southwest Art* 13 (October 1983): 74–85. See also Dunton's "The Painters of Taos," *American Magazine of Art* 13 (August 1922): 247–52.

8. "The Santa Fe–Taos Art Colony: Julius Rolshoven," *El Palacio* 4 (July 1917): 70–79.

9. Robert R. White, *The Taos Society of Artists* (Albuquerque: University of New Mexico Press, 1983).

10. Anne Lisle Booth, "Two Moods of a Forceful Artist," *Fine Arts Journal* 34 (May 1916): 221–26; "The Santa Fe/Taos Art Colony: Walter Ufer," *El Palacio* 3 (August 1916): 75–81; Rose V. S. Berry, "Walter Ufer in a One-Man Show," *American Magazine of Art* 13 (December 1922): 507–13; Lula Merrick, "Walter Ufer—Painter of Indians," *International Studio* 77 (July 1923): 195–299; Berry, "Walter Ufer and Some of His Medal Pictures," *Art and Archaeology* 16 (July–August 1923): 66–74; "Walter Ufer and His Work," *El Palacio* 24 (May 19–26, 1928): 403–5; Ina Sizer Cassidy, "Art and Artists of New Mexico," *New Mexico* 11 (January 1933): 28, 42; Phoenix Art Museum, *Ufer in Retrospect* (1970); Ted and Kit Egri, "Walter Ufer: Passion and Talent," *American Artist* 42 (January 1978): 64–67, 101.

11. The standard work on Victor Higgins is: Art Gallery of the University of Notre Dame, *Victor Higgins*, essay by Dean A. Porter (Notre Dame, Ind., 1975); a definitive study of Higgins's art and life by Porter is due to be published soon. See also Mary Teresa Hayes, "The Landscape Paintings of Victor Higgins" (M.A. thesis, Memphis State University, 1987). Also: Alexandre Hogue, "With Southwestern Artists: Victor Higgins—Some Opinions of an Apothegmatic Artist," *Southwest Review* 14 (January 1929): 156–61; Ina Sizer Cassidy, "Art and Artists of New Mexico," *New Mexico* 10 (December 1932): 22, 42–43; Hester Jones, "The Victor Higgins Memorial Exhibition," *El Palacio* 64 (March–April 1957): 119–22; Museum of New Mexico, *Victor Higgins, 1884–1919*, essays by Sara Mack and Robert A. Ewing (Santa Fe, 1971); Mary Carroll Nelson, "Victor Higgins: Creative Explorer," *American Artist* 42 (January 1978): 54–59, 97–98; Art Museum of South Texas, *Victor Higgins in New Mexico* (Corpus Christi, 1984).

12. Bob Priddy, "The Taos Connection: New Mexican Art in Missouri's Capitol," *Missouri Historical Review* 79 (January 1985): 143–66.

13. Ina Sizer Cassidy, "Art and Artists of New Mexico," *New Mexico* 11 (February 1933): 27, 42; Reginald Fisher, "E. Martin Hennings, Artist of Taos," *El Palacio* 53 (August 1946): 212–13; Robert Rankin White, "Taos Founder, E. Martin Hennings," *Southwest Art* 4 (April 1974): 50–52. The fullest account of E. Martin Hennings's life can be found in White's essay in "The Lithographs and Etchings

of E. Martin Hennings,'' *El Palacio* 84 (Fall 1978): 21–36.

14. Lloyd Lozes Goff, ''Kenneth M. Adams,'' *New Mexico Artists*, New Mexico Artists Series, no. 3 (Albuquerque: University of New Mexico, 1952), pp. 314–19; University of New Mexico, *Kenneth Adams: A Retrospective Exhibition*, essay by Van Deren Coke (Albuquerque, 1964).

15. Arthur Hoeber, ''Famous American Women Painters,'' *Mentor* 2 (March 16, 1914): 4–5, [19–20]; Helen Greene Blumenschein, *Recuerdos*, passim (see n. 4); Museum of Northern Arizona, *Blumenscheins of Taos* (see n. 4).

16. Ina Sizer Cassidy, ''Art and Artists of New Mexico,'' *New Mexico* 9 (October 1931): 22; ''Vierra Memorial Show,'' *El Palacio* 44 (January 5–12, 1938): 10–12; Peter D. Harrison, ''Carlos Vierra: His Role and Influence on the Maya Image,'' in University of New Mexico Art Museum, *The Maya Image in the Western World*, ed. Peter Briggs (Albuquerque, 1987), pp. 21–28. See also Carlos Vierra, ''New Mexico Architecture,'' *Art and Archaeology* 7 (January–February 1918): 37–49. On the murals, see Paul A. F. Walter, ''The Saint Francis Murals,'' *Art and Archaeology* 7 (January 1918): 84–89.

17. Ina Sizer Cassidy, ''The Man Who Revived Indian Art,'' *New Mexico* 33 (October 1955): 30, 47.

18. Ina Sizer Cassidy, ''Art and Artists of New Mexico,'' *New Mexico* 12 (August 1934): 17, 34.

19. ''Gerald Cassidy and His Work,'' *El Palacio* 4 (November 1917): 77–86; ''Gerald Cassidy,'' *El Palacio* 24 (January 14, 1928): 43–47; ''In Memoriam,'' *El Palacio* 36 (April 11–18, 1934): 121–24; Ina Sizer Cassidy, ''Art and Artists of New Mexico,'' *New Mexico* 9 (November 1931): 31, 47; Edna Robertson, *Gerald Cassidy, 1869–1934* (Santa Fe: Museum of New Mexico, 1977).

20. ''The Santa Fe–Taos Art Colony: Sheldon Parsons,'' *El Palacio* 4 (January 1917): 84–98; Ina Sizer Cassidy, ''Art and Artists of New Mexico,'' *New Mexico* 9 (September 1931): 27.

21. N.C., ''A New Art in the West,'' *International Studio* 63 (November 1917): xiv–xvii.

22. Ina Sizer Cassidy, ''Art and Artists of New Mexico,'' *New Mexico* 15 (February 1937): 25, 39; Museum of New Mexico, *Henry C. Balink*, essay by Robert A. Ewing (Santa Fe, 1966).

23. Smithsonian Institution Travelling Exhibition Service, *John Sloan in Santa Fe*, essays by James Kraft and Helen Farr Sloan (1981–84). See also: Walter Pach, ''John Sloan,'' *New Mexico Quarterly Review* 19 (Summer 1949): 177–81; Bruce St. John, *John Sloan* (New York: Praeger, 1971), pp. 41–47; Thomas Folk, ''The Western Paintings of John Sloan,'' *Art and Antiques* 5 (March–April 1982): 100–107.

See also Ruth Laughlin Barker, ''John Sloan Reviews the Indian Tribal Arts,'' *Creative Art* 9 (December 1931): 444–49.

24. Randall Davey's early work is discussed in ''Randall Davey,'' *American Magazine of Art* 7 (June 1916): 314–17. Pertinent to his New Mexico experience is especially John Sloan, ''Randall Davey,'' *New Mexico Quarterly Review* 21 (Spring 1951): 19–25. See also: William B. McCormick, ''The New Randall Davey,'' *International Studio* 75 (March 1922): 56–60; Ina Sizer Cassidy, ''Art and Artists of New Mexico,'' *New Mexico* 10 (May 1932): 28; ''Randall Davey, Artist of Santa Fe,'' *El Palacio* 53 (April 1946): 89–90; *El Palacio* 64 (May–June 1957): 156–66, with essays by Reginald Fisher, David Gebhard, John Tatschl, Joseph Bakos [*sic*], and Wayne Mauzy; Museum of Fine Arts, Museum of New Mexico, *Randall Davey: Artist/Bon Vivant, A Retrospective Exhibition, 1910–1963*, essay by Donelson F. Hoopes (Santa Fe, 1984).

25. Ina Sizer Cassidy, ''Art and Artists of New Mexico,'' *New Mexico* 10 (February 1932): 18; ''Josef [*sic*] Bakos, Artist of Santa Fe,'' *El Palacio* 53 (May 1946): 116–17; Burchfield Art Center, *Jozef Bakos*, essay by Stanley L. Cuba (Buffalo, 1985).

26. Ina Sizer Cassidy, ''Art and Artists of New Mexico,'' *New Mexico* 13 (September 1935): 23, 48; Marian F. Love, ''Willard Nash, Painter,'' *Santa Fean Magazine* 9 (October 1981): 26–29.

27. Edna C. Robertson, *Los Cinco Pintores* (Santa Fe: Museum of New Mexico, 1975).

28. Henry Herbert Knibbs, ''The Santa Fe–Taos Colony: William Penhallow Henderson,'' *El Palacio* 4 (April 1917): 96–105; Ina Sizer Cassidy, ''Art and Artists of New Mexico,'' 10 (March 1932): 24, 43; Fine Arts Museum, Museum of New Mexico, *William Penhallow Henderson, 1877–1943: Retrospective Exhibition*, essays by James Taylor Forrest and Alice Henderson Rossin (Santa Fe, 1963); National Collection of Fine Arts, *William Penhallow Henderson, 1877–1943: An Artist of Santa Fe*, essay by Adelyn D. Breeskin (Washington, D.C., 1978).

29. Van Deren Coke, *Nordfeldt the Painter* (Albuquerque: University of New Mexico Press, 1972), pp. 50–75. See also Ina Sizer Cassidy, ''Art and Artists of New Mexico,'' *New Mexico* 10 (October 1932): 24, 37.

30. Ina Sizer Cassidy published three articles on Olive Rush in *New Mexico*: ''Art and Artists of New Mexico,'' 9 (December 1931): 27, 42; ''Olive Rush,'' 13 (April 1935): 20, 48; ''State College Murals,'' 14 (August 1936): 27, 48. See also: Grace Dunham Guest, ''Olive Rush, Painter,'' *New Mexico Quarterly* 21 (Winter 1951): 406–12; Gustave Baumann, ''Olive Rush,'' *El Palacio* 64 (May–June 1957): 173–76.

31. Ina Sizer Cassidy, ''Art and Artists of New Mexico,'' *New Mexico* 10 (April 1932): 26; Cassidy, ''Art and Artists of New Mexico: Silver City Murals,'' *New Mexico* 16 (June 1938): 29, 39–40; ''Theodore Van Soelen, Santa Fe Artist,'' *El Palacio* 53 (January 1946): 1–3; Roland Dickey, ''Theodore Van Soelen,'' *New Mexico Quarterly* 30 (Spring 1960): 60–62; Museum of New Mexico Art Gallery, *A Retrospective Exhibition of the Work of Van Soelen*, essay by Oliver LaFarge (Santa Fe, 1960).

Arizona

1. ''The Colyer Collection,'' Edward Eberstadt and Sons Sale Catalogue, No. 146, item no. 48 [12 pp.].

2. See Frederick Dellenbaugh's own *Romance of the Colorado River* (New York: Putnam, 1902); *A Canyon Voyage* (New York, 1908). See also: C. Gregory Crampton, ed., ''F. S. Dellenbaugh of the Colorado: Some Letters Pertaining to the Powell Voyages and the History of the Colorado River,'' *Utah Historical Quarterly* 37 (Spring 1969): 214–43; Robert C. Euler, ''Frederick Dellenbaugh, Grand Canyon Artist,'' *Journal of Arizona History* 28 (Spring 1987): 31–46; Martin J. Anderson, ''Artist in the Wilderness: Frederick Dellenbaugh's Grand Canyon Adventure,'' *Journal of Arizona History* 28 (Spring 1987): 47–68.

3. Nina Spalding Stevens, ''Pilgrimage to the Artist's Paradise,'' *Fine Arts Journal* 24 (February 1911): 105–13; ''Exhibition of Paintings by the Society of Men Who Paint the Far West at the Albright Art Gallery,'' *Academy Notes* 9 (April 1916): 62–64; Phoenix Art Museum, *An Exhibition of Paintings of the Southwest from the Santa Fe Railway Collection* (1966); Phoenix Art Museum, *Art of Arizona and the Southwest: Paintings from the Collection of the Santa Fe Industries, Inc.* (1975); ''Artists of the Santa Fe,'' *American Heritage* 27 (February 1976): 57–72; Keith L. Bryant, Jr., ''The Atchison, Topeka and Santa Fe Railway and the Development of the Taos and Santa Fe Art Colonies,'' *Western Historical Quarterly* 9 (October 1978): 437–42.

4. Maynard Dixon, ''Arizona in 1900,'' *Arizona Highways* 18 (February 1942): 17–20, 40; Raymond Carlson, ''Maynard Dixon: Artist,'' *Arizona Highways* 21 (September 1945): 14–23; University of Arizona Museum of Art, *Maynard Dixon, Portraits of the Southwest*, essay by Adeline Lee Karpiscak (Tucson, 1984). For Maynard Dixon generally, see: Arthur Millier, *Maynard Dixon, Painter of the West* (Tucson, Ariz.: Edith Hamlin Dixon, 1945); Wesley M. Burnside, *Maynard Dixon: Artist of the West* (Provo, Utah: Brigham Young University Press, 1974).

5. Elaine Maher Harrison, "Frank Paul Sauerwein: Artist of the Southwest" (M.A. thesis, West Texas State College, Canyon, 1958); Harrison, "Frank Paul Sauerwein," *Panhandle-Plains Historical Review* 33 (1960): 1–67.

6. On Albert Lorey Groll's early painting, see: Sidney Allen [Sadakichi Hartmann], "An Appreciation of Albert L. Groll—Landscape Painter," *Brush and Pencil* 11 (October 1902): 36–41; Charles N. Nordhoff, "A New American Painter," *Art Interchange* 50 (May 1903): 108–10. For his Arizona work, see: Clara Ruge, "A Landscape Painter Who Had Discovered the Color Values of Western Plains," *Craftsman* 9 (March 1906): 826–35; "The Recent Work of Albert L. Groll," *Brush and Pencil* 18 (August 1906): 43–51; Charles H. Parker, "A Painter of Silent Places," *International Studio* 44 (June 1918): cv–cx; William B. McCormick, "Groll Rebels against Groll," *International Studio* 75 (September 1922): 498–501.

7. The basic study of Louis Akin is: Bruce E. Babbitt, *Color and Light: The Southwest Canvases of Louis Akin* (Flagstaff, Ariz.: Northland Press, 1973). See also: Marian A. White, "Louis Akin—American Artist," *Fine Arts Journal* 16 (April 1905): 143–48; George MacDonald, "The Indian Pictures of Louis Akin," *Brush and Pencil* 18 (September 1906): 112–15; Robert L. Warner, "Louis Akin, American Artist," *American Museum Journal* 13 (March 1913): 112–17; "Louis Akin, Painter: A Memory," *Craftsman* 23 (March 1913): 676–79; Earle R. Forrest, "Louis Akin . . . Artist of Old Arizona," *Westerners Brand Book: Los Angeles Corral* 6 (1956): 31–47. See also Akin's own "Frederick Monsen of the Desert—The Man Who Began Eighteen Years Ago to Live and Record the Life of the Hopiland," *Craftsman* 11 (March 1906): 678–82; "Hopi Indians—Gentle Folk: A People without Need of Courts, Jails or Asylums," *Craftsman* 10 (June 1906): 314–29.

8. Sharlot M. Hall, "An Arizona Artist," *Arizona* 3 (October 1912): 7; Roy George, *The Cowboy Builds a Loop* (Phoenix: Privately printed, 1933); Oren Arnold, "His Art Is Lusty and Bold," *Desert Magazine* 6 (October 1943): 9–12; Anson B. Cutts, "Lon Megargee: The Man and His Art—An Arizona Legend," *Point West* 2 (March 1960): 21–23; "Lon Megargee," *Arizona Highways* 50 (February 1974): 6–9, 38–41.

9. Kate Cory, "Life and Its Living in Hopiland," *Border* 1 (May 1909): 1–11; Charles Franklin Parker, "Sojourn in Hopiland," *Arizona Highways* 19 (May 1943): 10–14, 41.

10. Henry M. Norton, "Lillian Wilhelm Smith—Southwestern Artist," *Progressive Arizona* 12 (December 1932): 6, 16.

11. Florence Seville Berryman, "An Artist of the Salt River Valley," *American Magazine of Art* 20 (August 1929): 450–55.

Nevada

1. Phillip I. Earl, "Nevada through an Artist's Eyes," *Apple Tree*, June 13, 1982.

2. La Verne Bradley Rollin, "Maynard Dixon Remembered," *Nevada Highways and Parks* 27 (Fall 1967): 3–7, 32–33, 38–39.

The Pacific

1. Edward G. Porter, "The Ship Columbia and the Discovery of Oregon," *New England Magazine* 6 (June 1892): 472–88; Frederick William Howay, ed., *Voyages of the Columbia to the Northwest Coast* (Boston: Massachusetts Historical Society, 1941).

2. David B. Tyler, *The Wilkes Expedition* (Philadelphia: American Philosophical Society, 1968); William Stanton, *The Great United States Exploring Expedition* (Berkeley: University of Calfornia Press, 1975); John Frazier Henry, *Early Maritime Artists of the Pacific Northwest Coast, 1741–1841* (Seattle: University of Washington Press, 1984), pp. 195–224; Herman J. Viola and Carolyn Margolis, eds., *Magnificent Voyagers: The U.S. Exploring Expedition, 1838–1842* (Washington, D.C.: Smithsonian Institution Press, 1985).

Oregon

1. Julie Ann Schimmel, "John Mix Stanley and Imagery of the West in Nineteenth-Century American Art" (Ph.D. diss., New York University, 1983), pp. 71–79.

2. "Reminiscences of Early Days in Washington," *Washington Historian* 1 (September 1899): 19–22; Raymond Settle, ed., *March of the Mounted Riflemen* (Glendale, Calif.: Privately printed, 1940), pp. 27–29.

3. For William Birch McMurtrie, see Robert D. Monroe, "William Birch McMurtrie: A Painter Partially Restored," *Oregon Historical Quarterly* 60 (September 1959): 352–74; Betty Lochrie Hoag, "McMurtrie on the Pacific Coast," *La Peninsula, Journal of the San Mateo County Historical Association* 16 (October 1972): 11–15. For James Madison Alden, see Franz Stenzel, *James Madison Alden: Yankee Artist of the Pacific Coast, 1854–1860* (Fort Worth: Amon Carter Museum, 1975).

4. Nancy Dustin Wall Moure, "Five Eastern Artists Out West," *American Art Journal* 5 (November 1973): 29–31.

5. Information on Cyrennius Hall courtesy of Steven Cotherman of the Wyoming State Archives, Cheyenne.

6. Elbridge A. Burbank, *Burbank among the Indians* (Caldwell, Idaho: Caxton, 1944), pp. 175–84.

7. E. P. Irwin, "San Francisco Women Who Have Achieved Success," *Overland Monthly and Out West Magazine* 44 (November 1904): 515–17; Vella Winner, "Art Foils Life in a Nunnery: Miss O'Ryan Wins by Brush," *Oregon Journal*, September 10, 1916.

8. Franz Stenzel, *Cleveland Rockwell: Scientist and Artist, 1837–1907* (Portland: Oregon Historical Society, 1972); Marian A. White, "Cleveland Rockwell, Distinguished Painter of the Pacific Slope," *Fine Arts Journal* 15 (December 1904): 420–25. Rockwell also wrote and illustrated an article on the Columbia River: Cleveland Rockwell, "The Columbia River," *Harper's New Monthly Magazine* 71 (December 1882): 3–11.

9. "W. S. Parrot [sic] Who Has Immortalized Southern Oregon on Canvas," *Fine Arts Journal* 15 (December 1904): 430–31.

10. Agnes Barchus, *Eliza R. Barchus: The Oregon Artist* (Portland, Oreg.: Binford and Mort, 1974).

11. Stuart Gallery, *Collection of Famous Paintings by James E. Stuart* (San Francisco, n.d.).

12. E. J. Montgomery, "A Nineteenth-Century California Black Artist," *ABA: A Journal of Affairs of Black Artists* 1, no. 1 (1971): 17–18; Oakland Museum, *Grafton Tyler Brown: Black Artist of the West* (Oakland, Calif., 1972); T. W. Paterson, "Grafton Tyler Brown, Mystery Painter," *Real West* 18 (December 1974): 36–37, 50; Evans–Tibbs Collection, *Grafton Tyler Brown, Nineteenth-Century American Artist* (Washington, D.C., 1988).

13. California Historical Society, *Nels Hagerup, 1864–1922* (San Francisco, 1963).

14. Ernst Skarstedt, *Oregon och Washington* (Portland, Oreg., 1890), pp. 296–97; Brian Magnusson, "From Kvikkjokk to the Mississippi: Glimpses into the Career of Olof Grafström—Artist, Immigrant and College Professor," in Augustana College Art Department, *Härute—Out Here: Swedish Immigrant Artists in Midwest America* (Rock Island, Ill., 1984), pp. 21–31.

15. Erskine Wood, *Life of Charles Erskine Scott Wood* (Privately printed, 1978), especially pp. 69–72.

16. Nicholas Woloshuk, *E. Irving Couse, 1866–1936* (Santa Fe, N.M.: Santa Fe Village Art Museum, 1976), pp. 7–10; Vir-

ginia Couse Leavitt, "Eanger Irving Couse," in Muskegon Museum of Art, *Artists of Michigan from the Nineteenth Century* (Muskegon, Mich., 1987), pp. 160–67.

17. Rachel Gerstenhaber, "The Early Works of Frank Vincent DuMond (1865–1951)" (senior essay, Yale University, April 1987).

18. Nancy Lee, "Work of Childe Hassam on Exhibit at Museum of Art," *Morning Oregonian*, November 9, 1908; "Hassam's Pictures Delight Lovers of Oregon Scenery," *Morning Oregonian*, November 21, 1908; "A Public Spirited Act," *Spectator*, December 5, 1908; Charles Erskine Scott Wood, "The Exhibition of Paintings of Eastern Oregon by Childe Hassam," *Pacific Monthly* 21 (February 1909): 141–44; Priscilla C. Colt, "Childe Hassam in Oregon," *Portland Art Museum Bulletin* 14 (March 1953), n.p.

19. Alfred Frankenstein, *After the Hunt* (Berkeley and Los Angeles: University of California Press, 1969), pp. 131–35. Information on the Roosevelt cabin courtesy of Bruce M. Kaye, Chief of Interpretation, Theodore Roosevelt National Park, Medora, North Dakota.

20. "Artist's Painting Unveiled," *Oregon State Parks Quarterly*, Spring 1979, [pp. 1–2].

21. Marian A. White, "Other Oregon Artists of Note," *Fine Arts Journal* 15 (December 1904): 426–34.

22. Dean Collins, "Portland's Successful Women," *Sunday Oregonian*, December 13, 1914.

23. Selma N. Steele, Theodore L. Steele, Wilbur D. Peat, *The Life and Work of T. C. Steele: The House of the Singing Winds* (Indianapolis: Indiana Historical Society, 1966), pp. 50–51.

24. Information from the artist's daughter, Mildred Wiggins Benz. See also: Queena Davison Miller, "Half a Century an Artist," *Seattle Times*, November 24, 1946, p. 8; Charlotte D. Widrig, " 'Dean of Northwest Women Painters,' " *Seattle Times*, December 13, 1953; Margaret Marshall, "Classic Art Style Favored," *Christian Science Monitor*, May 4, 1954, p. 6P; Private exhibition, *Exhibit of Oils and Water Colors by Myra Albert Wiggins* (Yakima, Wash., 1957).

Washington

1. Society for the Preservation of Long Island Antiquities, *Edward Lange's Long Island*, essay by Dean F. Failey and Zachary N. Studenroth (Setauket, N.Y., 1979), pp. 14–15.

2. E. J. Montgomery, "A Nineteenth-Century California Black Artist," *ABA: A Journal of Affairs of Black Artists* 1, no. 1 (1971): 17–18; Oakland Museum, *Grafton Tyler Brown: Black Artist of the West* (Oakland, Calif., 1972); T. W. Paterson, "Grafton Tyler Brown, Mystery Painter," *Real West* 18 (December 1974): 36–37, 50; Evans–Tibbs Collection, *Grafton Tyler Brown, Nineteenth-Century American Artist* (Washington, D.C., 1988).

3. Ronald Fields, *Abby Williams Hill, 1861–1943* (Tacoma, Wash.: University of Puget Sound, 1979); Fields, "Abby Williams Hill: Northwest Frontier Artist," *Landmarks* 2, no. 4 (1984): 2–7; Fields, *Abby Williams Hill and the Lure of the West* (Tacoma: Washington State Historical Society, 1989).

4. William Garrand Prosser, *A History of the Puget Sound Country*, 2 vols. (New York, 1903), vol. 2, pp. 272–74; Marian A. White, "Art in the State of Washington: Its Evolution and Promise," *Fine Arts Journal* 16 (January 1905): 3–13 (almost totally devoted to William Gilstrap).

5. "Sarah Cheney Willoughby," anonymous, undated typescript, Pacific Northwest Room, Suzzallo Library, University of Washington, Seattle.

6. See Emily Inez Denny's own *Blazing the Way* (Seattle: Rainier, 1909), and her "Concerning the Development of Art in Seattle, Reminiscences by E. I. Denny," manuscript, 1915, Historical Society of Seattle and King County.

7. Ella Shepard Bush to Mrs. Beecher, March 12, 1915, Historical Society of Seattle and King County.

8. On Gertrude Willison, see "Well-Known Miniature Painter," *Westerner* 7 (June 1907): 21.

9. Helen Ross, "Coming to the Front, No. 6: Clare Shepard," *Town Crier* 8 (March 15, 1913): 5.

10. Laura Ihde, "The Versatile Art of Kathleen Houlahan Commands National Recognition," *Charmed Women's Magazine* 3 (May 1926): 26–28.

11. Helen Ross, "Coming to the Front, No. 9: Paul M. Gustin," *Town Crier* 8 (April 5, 1913): 13; Madge Bailey, "Paul Morgan Gustin," *American Magazine of Art* 13 (February 1922): 82–86.

12. "L'Exposition Yasushi Tanaka," *L'Art et les artistes* 4 (November 1921): 81–83.

13. Milwaukee Public Library, *John Fery Paintings* (1974); Minnesota Museum of Art, *Iron Horse West*, essays by Ann Walton, Malcolm E. Lein and Patricia J. Heikenen (Saint Paul, 1976); Ann Thorson Walton, *The Burlington Northern Collection* (Saint Paul: Burlington Northern, 1982).

14. Carolyn Staley Fine Arts, *Ambrose Patterson: Modernist Painter and Printmaker*, essays by Laura Brunsman and Spencer Moseley (Seattle, 1989).

15. Helen Ross, "Coming to the Front, No. 5: John Butler," *Town Crier* 8 (March 8, 1913): 5.

16. My thanks to Sue Burros of Alaska Public Television, Anchorage, for information about the short-lived but fascinating Beaux Arts Academy and village.

17. *Miss Aunt Nellie: The Autobiography of Nellie C. Cornish* (Seattle: University of Washington Press, 1964).

18. Julie Ann Schimmel, "John Mix Stanley and Imagery of the West in Nineteenth-Century American Art" (Ph.D. diss., New York University, 1983), pp. 71–79, 99–108.

19. John C. Ewers, "Gustavus Sohon's Portraits of Flathead and Pen d'Oreille Indians, 1854," *Smithsonian Miscellaneous Collections* 110, no. 7 (1948): 1–68.

20. Ernst Skarstedt, *Oregon och Washington* (Portland, Oreg., 1890), p. 297; Brian Magnusson, "From Kvikkjokk to the Mississippi: Glimpses into the Career of Olof Grafström—Artist, Immigrant and College Professor," in Augustana College Art Department, *Härute—Out Here: Swedish Immigrant Artists in Midwest America* (Rock Island, Ill., 1984), p. 24.

Alaska

1. See John Frazier Henry, *Early Maritime Artists of the Pacific Northwest Coast, 1741–1841* (Seattle: University of Washington Press, 1984), for the early expedition artists who traveled to the Northwest, including the Alaskan coast.

2. Georg Heinrich von Langsdorff, *Voyages and Travels in Various Parts of the World. . . .*, 2 vols. (London, 1813–14).

3. Louis Choris, *Voyage pittoresque autour du monde* (Paris, 1822).

4. L. A. Shur and R. A. Pierce: "Artists in Russian America: Mikhail Tikhanov (1818)," *Alaska Journal* 6 (Winter 1976): 40–48; Shur and Pierce, "Pavel Mikhailov: Artist in Russian America," *Alaska Journal* 8 (Autumn 1978): 360–63.

5. Friedrich Heinrich von Kittlitz, *Twenty-four Views of Coasts and Islands of the Pacific* (London, 1861).

6. "Sketches in Alaska," *Harper's Weekly* 14 (February 19, 1870): 124–26.

7. Henry Wood Elliott, "Ten Years Acquaintance with Alaska: 1867–1877," *Harper's New Monthly Magazine* 55 (November 1877): 801–16; James Thomas Gay, "Henry W. Elliott: Crusading Conservationist," *Alaska Journal* 3 (Autumn 1973): 211–15; Anchorage Historical and Fine Arts Museum, *Henry Wood Elliott, 1846–1930: A Retrospective Exhibition*, essay by Robert L. Shalkop (1982).

8. William H. Goetzmann and Kay Sloan, *Looking Far North: The Harriman Expedition to Alaska, 1899* (New York: Viking Press, 1982). It is based in part on Dellenbaugh's diaries, in the collection of Yale University.

9. Lila Duncan-Larsen, "H.L.A. Culmer, Utah Artist and Man of the West, 1854–1914" (M.A. thesis, University of Utah, 1987), pp. 114–16.

10. See *It's Me O Lord: The Autobiography of Rockwell Kent* (New York: Dodd, Mead, 1955), pp. 327–38. See also: C. Lewis

No

Hind, "Rockwell Kent in Alaska and Elsewhere," *International Studio* 47 (June 1919): cv–cxii; "Alaska Drawings by Rockwell Kent," *Arts and Decoration* 11 (June 1919): 71–72.

11. Frank A. Crane, "Who Is Who in Minnesota Art Annals," *Minnesotan* 1 (December 1915): 19–21; Michael S. Kennedy, "Alaska's Artists: Theodore J. Richardson," *Alaska Journal* 3 (Winter 1973): 31–40.

12. Katherine Wilson, "A Sporting Parson-Painter," *Sunset Magazine* 53 (August 1924): 29–30; Phyllis D. Carlson, "Alaska's Hall of Fame Painter," *Alaskana* 1 (November 1971):1–3; Anchorage Historical and Fine Arts Museum, *Eustace Ziegler: A Retrospective Exhibition,* essay by Robert L. Shalkop (Anchorage, 1977); Nicki J. Nielsen, *The Red Dragon and St. George's: Glimpses into Cordova's Past* (Cordova, Alaska: Fathom, 1983), pp. 7–24. Entertaining aspects of Ziegler's career are reported in the various articles that he and his wife published in the *Alaskan Churchman*; see, for instance, Mary Neville Ziegler, "Natives of Southwestern Alaska," *Alaskan Churchman* 8 (November 1913): 19–21; E[ustace] P. Ziegler, "Cordova's Opportunities," *Alaskan Churchman* 11 (August 1917): 109–10.

13. H. Wendy Jones, *The Man and the Mountain* (Anchorage: Alaskan, 1962); Jones, "Sydney Laurence, Alaska's Celebrated Painter," *American Artist* 26 (April 1962): 46–51, 84–85; Jeanne Laurence, *My Life with Sydney Laurence* (Seattle: Salisbury Press, 1974); Robert L. Shalkop, *Sydney Laurence: His Life and Work* (Anchorage: Anchorage Historical and Fine Arts Museum, 1982); Kesler Woodward, *Sydney Laurence, Painter of the North* (Seattle: University of Washington Press, 1990).

14. Michael S. Kennedy, "Belmore Browne and Alaska," *Alaska Journal* 3 (Spring 1973): 96–104.

Northern California

1. Donald C. Cutter, *Malaspina in California* (San Francisco: John Howell, 1960); Henry R. Webber, "Four Early Sketches of Monterey Scenes," *California Historical Society Quarterly* 15 (September 1936): 213–15.

2. Louis Choris, *Voyage pittoresque autour du monde* (Paris, 1822); Choris's *San Francisco One Hundred Years Ago,* translated by Porter Garnett, was not published in San Francisco until 1913 (by A. M. Robertson).

3. Bruce Kamerling, "The Portraits of Signor Barbieri," *California History* 66 (December 1987): 262–77.

4. Marjorie Arkelian, "An Exciting Art Department 'Find,'" *Art* (Art Guild of the Oakland Museum Association) 2 (January–February 1974): [pp. 4–5].

5. Jeanne Van Nostrand, "Thomas A. Ayres, Artist-Argonaut of California," *California Historical Society Quarterly* 20 (September 1941): 275–79; Elizabeth H. Godfrey, "Thomas A. Ayres (First Yosemite Artist)," *Yosemite Nature Notes* 23 (February 1944): 22–25; Nancy K. Anderson, "Thomas A. Ayres and His Early Views of San Francisco: Five Newly Discovered Drawings," *American Art Journal* 19, no. 3 (1987): 19–28.

6. Helen Carlotta Nelson, "The Jewetts: William and William S.," *International Studio* 83 (January 1923): 39–42; Nelson, "A Case of Confused Identity: Two Jewetts Named William," *Antiques* 42 (November 1942): 251–53; Elliot A. P. Evans, ed., "Some Letters of William S. Jewett, California Artist," *California Historical Society Quarterly* 23 (June 1944): 149–77 (September 1944): 227–46; Evans, "William S. and William D. Jewett," *California Historical Society Quarterly* 33 (December 1954): 309–20; Evans, "Promised Land," *Society of California Pioneers Quarterly* 8 (November 1957): 1–11.

7. "Officer, Thomas Story," from the manuscript records of Mrs. Thomas Kirby Davis, in the files of Theodore Bolton; on

8. Charles Dormon Robinson, "Off the Cuff: The Artists of California," typescript, n.d., collection of Dr. Joseph Baird.

9. E. B. Crocker Art Gallery, *Charles Christian Nahl: Artist of the Gold Rush, 1818–1878,* essay by Moreland L. Stevens (Sacramento, Calif., 1976). See also: Eugen Neuhaus, "Charles Christian Nahl: The Painter of California Pioneer Life," *California Historical Society Quarterly* 15 (December 1936): 295–305; Gene Hailey, ed., *California Art Research,* 20 vols. (San Francisco: Federal WPA Project, 1937), vol. 1, pp. 12–106; Erwin Gustav Gudde, "Carl Nahl, California's Pioneer of Painting," *American-German Review* 7 (October 1940): 18–21; Joseph Armstrong Baird, Jr., "Charles Christian Nahl, Artist of the Gold Rush," *American Art Review* 3 (September–October 1976): 56–70.

10. Gary Reynolds, "The Life and Work of Alburtus Del Orient Browere (1814–1887)" (M.A. thesis, Brooklyn College, 1977). See also Charles C. Wright, "Alburtus D. O. Browere, 1814–1887: A Genre Painter of the Hudson River School and Resident of Catskill, N.Y., 1840–1887," 1971, typescript on deposit with the Greene County Historical Society, Catskill, New York.

11. Albert Dressler, *California's Pioneer Artist, Ernest Narjot* (San Francisco: Privately printed, 1936).

12. Linda Mary Jones Gibbs, "Enoch Wood Perry, Jr.: A Biography and Analysis of His Thematic and Stylistic Development"

(M.A. thesis, University of Utah, 1981).

13. "Inigo," "Bierstadt's Sketches," *Golden Era,* September 27, 1863.

14. California Historical Society, *Fortunato Arriola (1827–1872),* essay by Catherine Hoover (San Francisco, 1974). See also "Toby Edward Rosenthal: An Artist's Boyhood in California," in Jacob Rader Marcus, ed., *Memoirs of American Jews, 1775–1865,* 2 vols. (Philadelphia: Jewish Publication Society of America, 1955), vol. 2, pp. 149–53.

15. "Butman's Pictures," *Watson's Art Journal* 8 (November 23, 1867): 76.

16. The standard study of Thomas Hill is Oakland Museum, *Thomas Hill: The Grand View,* essay by Marjorie Dakin Arkelian (Oakland, Calif., 1980). See also: Hailey, *California Art Research* (see n. 9), vol. 2, pp. 66–98; Elizabeth H. Godfrey, "Thomas Hill," *Yosemite Nature Notes* 23 (March 1944): 29–31; Louise Stein, "Thomas Hill," *Artists of the Rockies and the Golden West* 6 (Winter 1979): 46–55; Birgitta Hjalmarson, "Thomas Hill," *Antiques* 126 (November 1984): 1200–207. There is also a considerable bibliography concerned specifically with Hill's *Driving of the Last Spike.* See especially Hardy George, "Thomas Hill's Driving of the Last Spike, A Painting Commemorating the Completion of America's Transcontinental Railroad," *Art Quarterly* 27 (Spring 1964): 83–93.

17. "The Late Juan B. Wandesforde," *Mark Hopkins Institute Review of Art* 1 (December 1902): 32–34.

18. M.M.B., "Virgil Williams: Painter and Teacher," *Bancroftiana* 75 (June 1980): 10–11; Hailey, *California Art Research* (see n. 9), vol. 4, pp. 138–59; Ruth N. Post, "The California Years of Virgil Macey Williams," *California History* 66 (June 1987): 115–29.

19. The latest, most authoritative study of William Keith's art is Hearst Art Gallery, *William Keith: The Saint Mary's College Collection,* essay by Alfred C. Harrison, Jr. (Moraga, Calif., 1988). The fullest treatment of Keith's life is Brother Fidelis Cornelius, F.S.C., *Keith: Old Master of California,* vol. 1 (New York: Putnam, 1942), vol. 2 (Fresno, Calif.: Academy Library Guild, 1956). See also: Mary Bell, "William Keith," *University of California Magazine* 3 (April 1897): 92–100; "William Keith: An Appreciation," *Impressions Quarterly* 4 (September 1904): 74–78; Emily P. B. Hay, *William Keith as Prophet Painter* (San Francisco: Paul Elder and Company, 1916); Hailey, *California Art Research* (see n. 9), vol. 2, pp. 1–80; Eugen Neuhaus, *William Keith: The Man and the Artist* (Berkeley: University of California Press, 1938); Oakland Museum, *An Introduction to the Art of William Keith,* essay by Paul Mills (Oakland, Calif., 1957). Almost all of the periodical literature, eastern and western, deals with Keith's later work; see Charles A. Keeler, "The

American Turner: William Keith and His Work," *Land of Sunshine* 8 (May 1898): 253–59; George Wharton James, "William Keith," *Craftsman* 7 (December 1904): 299–309; Henry Atkins, "William Keith, Landscape Painter, of California," *International Studio* 33 (November 1907): 36–42; "M.S.," "William Keith," *Art and Progress* 2 (June 1911): 227–30; Everett Carroll Maxwell, "William Keith—The Man and the Artist," *Fine Arts Journal* 25 (September 1911): 131–37; Art Institute of Chicago, *Exhibition of Paintings by the Late William Keith*, essay by Robert W. Macbeth (1913); James William Pattison, "William Keith—Poetical Painter," *Fine Art Journal* 28 (June 1913): 366–78; Mrs. F. H. Seares (Mabel Urmy Seares), "The Later Work of William Keith," *Arts and Decoration* 3 (September 1913): 367–70; Seares, "William Keith and His Times," in *California's Magazine*, 2 vols. (San Francisco, 1916), vol. 2, pp. 105–10. Keith also authored a short article, "The Future of Art in California," for *San Francisco Call*, December 25, 1895, p. 2.

20. Denver Art Museum, *Harvey Otis Young: The Lost Genius, 1840–1901*, essay by Patricia Trenton (1975).

21. "Samuel M. Brookes," *California Art Gallery* 1 (May 1873): 67–68; Lucy Agar Marshall, "Samuel Marsden Brookes," *California Historical Society Quarterly* 36 (September 1957): 193–203 (reprinted in *Wisconsin Magazine of History* 52 [Autumn 1968]: 51–59); California Historical Society, *Samuel Marsden Brookes (1816–1892)*, essay by Joseph Armstrong Baird, Jr. (San Francisco, 1962).

22. Ernest R. May, "Benjamin Parke Avery, Including a Review of the Office of State Printer, 1850–1872," *California Historical Society Quarterly* 30 (June 1951): 125–49. See Benjamin Parke Avery's own two-part "Art Beginnings on the Pacific," *Overland Monthly* 1 (July 1868): 28–34, (August 1868): 113–19, and his "Art in California," *Aldine* 7 (April 1874): 72–73.

23. Theophilus Hope d'Estrella, "Virgil Williams' Art Notes to a Deaf-Mute Pupil," *Overland Monthly* 9 (March 1887): 285–94.

24. Kate Montague Hall, "The Mark Hopkins Institute of Art," *Overland Monthly* 30 (December 1897): 539–48; California Historical Society, *Artist-Teachers and Pupils: San Francisco Art Association and California School of Design: The First Fifty Years, 1871–1921*, essay by Kent L. Seavey (San Francisco, 1971); Raymond L. Wilson, "The First Art School in the West: The San Francisco Art Association's California School of Design," *American Art Journal* 14 (Winter 1982): 42–55.

25. *San Francisco Call*, January 28, 1894, p. 23.

26. Andrew McF. Davis, "High Jinks," *Californian* 1 (May 1880): 418–22; *The Annals of the Bohemian Club*, 5 vols. (San Francisco, 1898–1972); Jerome A. Hart, *In Our Second Century* (San Francisco: Pioneer Press, 1931), pp. 327–67.

27. Information on John Ross Key courtesy of Alfred C. Harrison, Jr., North Point Gallery, San Francisco.

28. "Gilbert Munger," *Coburn's New Monthly Magazine* 117 (June 1880): 656–62; [Roger S. Munger?], *Memoir: Gilbert Munger: Landscape Artist, 1836–1903* (n.p., 1904); Myra Dowd Monroe, "Gilbert Munger, Artist—1836–1903," in Philip S. Platt, ed., *Madison's Heritage: Historical Sketches of Madison, Connecticut* (Madison, Conn.: Madison Historical Society, 1964), pp. 118–28.

29. "Albert Bierstadt," *California Art Gallery* 1 (April 1873): 48–50; Gordon Hendricks, *Albert Bierstadt, Painter of the American West* (New York: Harry N. Abrams, 1973), pp. 203–30. Nancy Kay Anderson has written a dissertation entitled "Albert Bierstadt: The Path to California, 1830–1874" (University of Delaware, 1985); in a letter to the author dated August 1988, she stated her unwillingness to allow *any* scholar access to her work—the only such case encountered in the course of this study.

30. Brooklyn Museum, *James Hamilton, 1819–1878: American Marine Painter*, essay by Arlene Jacobowitz (1966).

31. De Cordova Museum, *William Bradford, 1823–1892*, essay by John Wilmerding (Lincoln, Mass., 1969). See also *Art Amateur* 5 (November 1881): 115–16.

32. California Historical Society, *Raymond Dabb Yelland (1848–1900)*, essay by Kent L. Seavey (San Francisco, 1964).

33. Charles S. Greene, "C. D. Robinson, Painter and Man," *Overland Monthly* 27 (January 1896): 34–42; Hailey, *California Art Research* (see n. 9), vol. 3, pp. 73–98; California Historical Society, *Charles Dorman* [sic] *Robinson (1847–1933)*, essay by Kent L. Seavey (San Francisco, 1966); Howard Weamer, "C. D. Robinson, Painter and Eccentric," *Pacific Historian* 15 (Summer 1971): 31–34. See Robinson's own "The Two Redwoods," *Californian* 5 (June 1882): 481–91; "Painting a Yosemite Panorama," *Overland Monthly* 22 (September 1893): 243–56; "Off the Cuff—The Artists of California," typescript, n.d., collection of Dr. Joseph Baird.

34. Chris Jorgensen, "My Studio in the Yosemite," *Sunset* 6 (January 1901): 113–14; George Wharton James, "Chris Jorgensen—A Versatile California Artist," *National Magazine* 42 (August 1915): 1–8; Mary Goodrich, "A Western Painter in Oils," *Overland Monthly* 87 (August 1929): 238, 256; Mira Maclay, "Chris Jorgensen and His Canyon Garden," *California Arts and Architecture* 38 (March 1930): 45–47; Hailey, *California Art Research* (see n. 9), vol. 4, pp. 89–113; Fritiof Fryxell, "A Painter of Yosemite," *American-Scandinavian Review* 27 (Winter 1939): 329–33; Elizabeth H. Godfrey, "Chris Jorgensen," *Yosemite Nature Notes* 23 (June 1944): 94–97; Katherine M. Littell, *Chris Jorgensen, California Pioneer Artist* (Sonora, Calif.: Fine Arts Research Publishing, 1988).

35. George Wharton James, "Harrie [sic] Cassie Best, Painter of the Yosemite Valley and the California Mountains," *Out West* 62 (January 1914): 3–16; Elizabeth H. Godfrey, "Harry Cassie Best," *Yosemite Nature Notes* 24 (March 1945): 42–44.

36. Elizabeth Muir Robinson, *W. A. Coulter, Marine Artist* (San Francisco: James V. Coulter, 1981).

37. George Wharton James, "Charles H. Grant: Marine Painter," *Arena* 35 (May 1906): 480–91; Esther Laurentine Mugan, "Charles H. Grant, Noted Marine Painter," in *California's Magazine*, 2 vols. (San Francisco, 1916), vol. 2, pp. 277–80; Hailey, *California Art Research* (see n. 9), vol. 5, pp. 42–63; Daniel A. Williams, "Oswego County Painters," *Oswego Historical Society Publications* 7 (1943): 27–28.

38. Hailey, *California Art Research* (see n. 9), vol. 4, pp. 1–26; H. M. Luquiens, *Honolulu Academy of the Arts Annual Bulletin* 2 (1940): 25–31; Robert Nichols Ewing, "Jules Tavernier (1844–1889): Painter and Illustrator" (Ph.D. diss., University of California, Los Angeles, 1978).

39. Alexander Black, "An American Landscapist," *Quarterly Illustrator* 1 (January–March 1893): 181–87; Grace Isabel Colbron, "Julian Rix," *Art Interchange* 52 (January 1903): 5–8; Hailey, *California Art Research* (see n. 9), vol. 4, pp. 114–37.

40. "A Rising Californian Artist," *Californian* 3 (December 1880): 571; Eufina C. Tompkins, "Story of Two California Artists," *Sunset* 13 (June 1904): 131–36; Helen Vernon Reid, "Thad Welch—Pioneer and Painter," *Overland Monthly and Out West Magazine* 82 (1924), published monthly March–July and republished by author, now as Helen V. Broekhoff, *Thad Welch, Pioneer and Painter* (Oakland, Calif.: Oakland Art Museum, 1966); Hailey, *California Art Research* (see n. 9), vol. 3, pp. 41–73; Richard Dillon, "Pilgrimage to Steep Ravine," *Westways* 71 (August 1979): 44–47, 68–69.

41. Los Angeles County Museum of Natural History, *A Gallery of California Mission Paintings*, essay by Paul Mills (1966). See also: Pauline R. Bird, "The Painter of the California Missions," *Outlook* 76 (January 1904): 74–80; Robert L. Hewitt, "Edwin Deakin, an Artist with a Mission," *Brush and Pencil* 15 (January 1905): 1–8; George Watson Cole, "Missions and Mission Pictures: A Contribution Towards an Iconography of the Franciscan Missions of California," *News Notes of California Libraries* 5 (July 1910): 404.

42. Hudson River Museum, *William Hahn, Painter of the American Scene*, essay by H. Armour Smith (Yonkers, N.Y., 1942);

Oakland Museum, *William Hahn: German Painter, 1829–1887*, essay by Marjorie Dakin Arkelian (Oakland, Calif., 1976); Arkelian, ''William Hahn: German-American Painter of the California Scene,'' *American Art Review* 4 (August 1977): 102–15.

43. Marian R. McNaughton, ''James Walker—Combat Artist of Two American Wars,'' *Military Collector and Historian* 9 (Summer 1957): 31–35.

44. Hailey, *California Art Research* (see n. 9), vol. 4, pp. 23–44; Gleeson Library Associates of the University of San Francisco, *Domenico Tojetti, 1817–1892* (1959).

45. *New York Post*, June 14, 1876, p. 1.

46. Samuel G. W. Benjamin, *Our American Artists* (Boston, 1879), pp. 51–54; John R. Tait, ''David Neal,'' *Magazine of Art* 9 (1886): 95–101; Dayton Art Institute, *American Expatriate Painters of the Late Nineteenth Century*, essay by Michael Quick (Dayton, Ohio, 1976), p. 119.

47. William M. Kramer and Norton B. Stern, ''The Great 'Elaine' Robbery: The Crime against Civilization,'' *Journal of the West* 10 (October 1971): 585–608.

48. Walt M. Fisher, ''Toby Rosenthal, How He Became a Painter,'' *Overland Monthly* 14 (March 1875): 184–87; Palace of Fine Arts, *Toby E. Rosenthal: Memorial Exhibition*, essay by J. Nilsen Laurvik (San Francisco, 1919); Hailey, *California Art Research* (see n. 9), vol. 3, pp. 1–23; ''Toby Edward Rosenthal: An Artist's Boyhood in California'' (see n. 14), vol. 2, pp. 145–53; *American Expatriate Painters* (see n. 46), p. 128; William M. Kramer and Norton B. Stern, *San Francisco's Artist: Toby E. Rosenthal, with Rosenthal's Memoir of a Painter* (Northridge, Calif.: Santa Susana Press, 1978). For David Dalhoff Neal and Toby Edward Rosenthal as early Americans in Munich, see Edgar M. Ward, ''Carl [sic] von Piloty and His Pupils,'' *Monthly Illustrator* 12 (1896): 162.

49. Mary Bell, ''The Chinese Motif in Current Art,'' *Overland Monthly* 31 (March 1898): 240–41.

50. Theodore Wores, ''Ah Gau's New-Year's Celebration,'' *St. Nicholas* 24 (February 1897): 293–98. Wores illustrated Will Brooks, ''A Fragment of China,'' *Californian* 6 (July 1882): 6–15; Henry Burden McDowell, ''A New Light on the Chinese,'' *Harper's New Monthly Magazine* 86 (December 1892): 2–17.

51. Hailey, *California Art Research* (see n. 9), vol. 10, pp. 90–150; Lewis Ferbraché, *Theodore Wores: Artist in Search of the Picturesque* (San Francisco: Privately printed, 1968); Oakland Museum, *Theodore Wores: The Japanese Years*, essay by Joseph A. Baird, Jr. (Oakland, Calif., 1976); Gary A. Reynolds, ''A San Francisco Painter, Theodore Wores,'' *American Art Review* 3 (September–October 1976): 101–17; Baird, ed., *Theodore Wores and the Beginnings of Internationalism in Northern*

California Painting: 1874–1915 (Davis: University of California, Davis, Library Associates, 1978); Huntsville Museum of Art, *Theodore Wores, 1859–1939*, essay by Michael Preble (Huntsville, Ala., 1980); Chad Mandeles, ''Theodore Wores's Chinese Fishmonger in a Cosmopolitan Context,'' *American Art Journal* 16 (Winter 1984): 65–75; Asahi Shimbun, *The Art of Theodore Wores*, essay by Baird (Tokyo, 1986). Among Theodore Wores's own writings, see especially ''American Artist in Japan,'' *Century* 38 (September 1889): 670–86.

52. Reports of Amédée Joullin's activities appeared in *Wave*; see especially August 29, 1891, p. 7, and October 3, 1891, p. 14; Arthur I. Street, ''The Work of Amédée Joullin,'' *Overland Monthly* 33 (January 1899): 3–13; Hailey, *California Art Research* (see n. 9), vol. 4, pp. 63–90.

53. [Alfred Trumble], *Collector* 5 (June 1, 1894): 227–28; Raymond J. Wilson, ''Henry Alexander: Chronicler of Commerce,'' *Archives of American Art Journal* 20, no. 2 (1980): 10–13; Paul J. Karlstrom, ''The Short, Hard and Tragic Life of Henry Alexander,'' *Smithsonian* 12 (March 1982): 108–17.

54. Pierre N. Boeringer, ''Original Sketches of San Francisco Painters, II: Henry Raschen,'' *Overland Monthly* 27 (April 1896): 361–69; Harry Flayderman, *Henry Raschen, Painter of the American West* (n.p., 1958).

55. California Historical Society, *Grace Carpenter Hudson (1865–1937)*, essay by Joseph Armstrong Baird, Jr. (San Francisco, 1962); Searle R. Boynton, *The Painter Lady: Grace Carpenter Hudson* (Eureka, Calif.: Interface California, 1978).

56. The primary study of Maynard Dixon is Wesley M. Burnside, *Maynard Dixon* (Provo, Utah: Brigham Young University Press, 1974). See also: Charles F. Lummis, ''A California Illustrator: L. Maynard Dixon and His Work,'' *Land of Sunshine* 10 (December 1898): 4–11; ''L. Maynard Dixon's Frontier Studies,'' *Mark Hopkins Institute Review of Art* 1 (Christmas 1903): 16–22; Hill Tolerton, ''The Art of Maynard Dixon,'' *International Studio* 55 (May 1915): xcii–xcv; Wilbur Hall, ''Interesting Westerners,'' *Sunset Magazine* 46 (January 1921): 44–45; Ruth Pielkovo, ''Dixon, Painter of the West,'' *International Studio* 78 (March 1924): 467–72; Hailey, *California Art Research* (see n. 9), vol. 8, pp. 1–101; Arthur Millier, *Maynard Dixon: Painter of the West* (Tucson, Ariz.: Edith Hamlin Dixon, 1945); Don Louis Percival, *The Maynard Dixon Sketchbook* (Flagstaff, Ariz.: Northland Press, 1967); Ansel Adams, ''Free Man in a Free Country,'' *American West* 6 (November 1969): 40–47; Dudley Gordon, ''Lummis and Maynard Dixon: Patron and Protégé,'' *Los Angeles Corral*, no. 102 (September 1971): 8–10; ''Maynard Dixon, Artist of the West as Remembered by Edith Hamlin,''

California Historical Society Quarterly 53 (Winter 1974): 361–76; Lawrence Clark Powell, ''Maynard Dixon's Painted Desert,'' *Westways* 66 (May 1974): 24–29, 86–87; Kevin Starr, ''Painterly Poet, Poetic Painter: The Dual Art of Maynard Dixon,'' *California Historical Society Quarterly* 56 (Winter 1977–78): 290–309; California Academy of Sciences, *Maynard Dixon: Images of the Native American*, essay by Donald J. Hagerty (San Francisco, 1981); André Marechal Workman, ''Modernism and the Desert: Maynard Dixon,'' *Vanguard Magazine* 11 (March 1982): 22–25; University of Arizona Museum of Art, *Maynard Dixon: Portraits of the Southwest*, essay by Adeline Lee Karpiscak (Tucson, Ariz., 1984).

57. Charles S. Greene, ''California Artists, II: Joseph D. Strong, Jr.,'' *Overland Monthly* 24 (May 1896): 501–10; Isobel Field, *This Life I've Loved* (New York: Longmans, Green, 1937).

58. ''Mr. Orrin Peck's Picture Exhibit,'' *New York Herald*, March 20, 1901, p. 11; Richard H. Peterson, ''The Philanthropist and the Artist: The Letters of Phoebe A. Hearst to Orrin M. Peck,'' *California History* (December 1987): 278–85, 316–18.

59. ''Art Business,'' *Philopolis* 3 (December 25, 1908): 66–68.

60. E. P. Irwin, ''San Francisco Women Who Have Achieved Success,'' *Overland Monthly and Out West Magazine* 44 (November 1904): 517; ''Foster and Richardson at Macbeth's,'' *American Art News* 8 (June 29, 1910): 16; Hailey, *California Art Research* (see n. 9), vol. 5, pp. 15–33.

61. Pierre N. Boeringer, ''Original Sketches by San Francisco Painters, I: Eva Withrow,'' *Overland Monthly and Out West Magazine* 27 (February 1896): 161–66; George Wharton James, ''Evelyn Almond Withrow, Painter of the Spirit,'' *National Magazine* 44 (August 1916): 763–75; Hailey, *California Art Research* (see n. 9), vol. 5, pp. 1–16.

62. Irwin, ''San Francisco Women'' (see n. 60), 515–17; Vella Winner, ''Art Foils Life in a Nunnery: Miss O'Ryan Wins by Brush,'' *Oregon Journal*, September 10, 1916.

63. N. L. Murtha, ''The Sketch Club: 'Art for Art's Sake,' '' *Overland Monthly* 29 (June 1897): 578–80.

64. Arthur Edwin Bye, *Pots and Pans; or, Studies in Still-Life Painting* (Princeton, N.J.: Princeton University Press, 1921), p. 213. Though there is no thorough study of Emil Carlsen's art, numerous early twentieth-century writers, such as Eliot Clark, Duncan Phillips, John Steele, and Frederic Newlin Price, wrote essays about him. These were incorporated into Wortsman-Rowe Galleries, *The Art of Emil Carlsen, 1853–1932* (San Francisco, 1975). For Carlsen in San Francisco, see ''Pot Pourri,'' *Wave*, October 3, 1891, p. 14; ''Art and Business,'' *Philopolis* 3 (December 25, 1908): 70–71; Hailey, *Cal-*

ifornia Art Research (see n. 9), vol. 4, pp. 26–65. See also Carlsen's own writings: "Portrait Painting," *Wave*, September 26, 1891, p. 8; "On Still-Life Painting," *Palette and Bench* 1 (October 1908): 6–8.

65. Hailey, *California Art Research* (see n. 9), vol. 12, pp. 18–55; M. H. de Young Memorial Museum, *Sixty Years of Painting: Genève Rixford Sargeant*, essay by Jehanne Bietry Salinger (San Francisco, 1948).

66. Alfred Frankenstein, *After the Hunt* (Berkeley and Los Angeles: University of California Press, 1969), pp. 131–35.

67. Hart, *Second Century* (see n. 26), pp. 355–56; Eugene A. Hajdel, *Harry H. Moore* (Jersey City, N.J.: Privately printed, 1950).

68. Louise E. Taber, "Jules Pagès—An American Artist," *Fine Arts Journal* 31 (July 1914): 511–12; Louise E. Taber, "Jules Pagès," *Art and Progress* 5 (September 1914): 385–87; Monica E. Garcia, "Jules Pages [*sic*]," *Art of California* 3 (March 1990): 17–22.

69. Hailey, *California Art Research* (see n. 9), vol. 7, pp. 1–32; Oakland Museum, *Mathews: Masterpieces of the California Decorative Style*, essay by Harvey L. Jones (Oakland, Calif., 1972). For Arthur F. Mathews's own writings, see "House Decoration in San Francisco," *Mark Hopkins Institute Review of Art* 1 (December 1901): 9–17; and his many articles in *Philopolis*, especially "Mural Painting, or Painting as a Fine Art," 2 (December 25, 1907): 53–60.

70. Phyllis Ackerman, "A Woman Painter with a Man's Touch," *Arts and Decoration* 18 (April 1923): 20, 73; *Tributes to Anne Bremer* (San Francisco: John Henry Nash, 1927); Hailey, *California Art Research* (see n. 9), vol. 7, pp. 87–129; Sharon Chickanzeff, "The Unspoken Anne Bremer," *San Francisco Art Institute Alumni Association Newsletter* 4 (Summer 1981): 1.

71. Rowena Meeks Abdy, *Old California* (San Francisco: J. H. Nash, 1924); H. Bennett Abdy, "Paintings by Rowena M. Abdy," *International Studio* 81 (June 1925): 193–97; Hailey, *California Art Research* (see n. 9), vol. 12, pp. 1–19.

72. F. W. Ramsdell, "Charles Rollo Peters," *Brush and Pencil* 4 (July 1899): 203–12; *Collector and Art Critic* 11 (November 1, 1899): 21; Hailey, *California Art Research*, vol. 10, pp. 61–91; Betty Lochrie Hoag, *The Gifted Peters Family*, published to accompany an exhibition held September 1968 at the Carmel Museum of Art, Carmel, Calif.; Stanley Worth, *The Peters' Heritage: Biographical Notes*, published to accompany an exhibition held February 1987 at the Monterey Peninsula Museum of Art, Monterey, Calif.

73. Josephine Mildred Blanch, "A Western Painter: The Art of Gottardo Piazzoni," *Overland Monthly* 54 (November 1909): 460–64; Hailey, *California Art Research* (see n. 9), vol. 7, pp. 30–89; Mildred Rosenthal, "California's Piazzoni," *San Francisco Art Association Bulletin* 4 (December 1937): 1–2, 5; Theodore W. Lilienthal, "A Note on Gottardo Piazzoni, 1872–1945," *California Historical Society Quarterly* 38 (March 1959): 7–9.

74. Hailey, *California Art Research* (see n. 9), vol. 10, pp. 34–60; Oakland Museum, *Xavier Martínez (1869–1943)*, essay by George W. Neubert (Oakland, Calif., 1974).

75. Hugh Gordon Maxwell, "Giuseppe Cadenasso," *Impressions Quarterly* 5 (December 1904): 101–5; Edward F. O'Day, *Varied Types* (San Francisco: Town Talk Press, 1915), pp. 45–49; Esther Laurentine Morgan, "A Visit to the Picturesque Hillside Studio of Giuseppe Cadenasso," in *California's Magazine*, 2 vols. (San Francisco, 1916), vol. 2, pp. 273–76; Hailey, *California Art Research* (see n. 9), vol. 11, pp. 1–34.

76. *Arthur Atkins* (San Francisco: A. M. Robertson, 1908); Hailey, *California Art Research* (see n. 9), vol. 5, pp. 94–112.

77. Laurence Hague, "Francis M. [*sic*] McComas, a Painter of the West," *Arts and Decoration* 14 (December 1920): 104; Hailey, *California Art Research* (see n. 9), vol. 9, pp. 63–89; California Historical Society, *Francis John McComas (1875–1938)*, essay by Kent L. Seavey (San Francisco, 1965); Terry Ingram, "The Australians Who Painted America," *Airways*, January–February 1983, pp. 28–31.

78. Hailey, *California Art Research* (see n. 9), vol. 11, pp. 100–141.

79. Eugen Neuhaus, *Drawn from Memory: A Self-Portrait* (Palo Alto, Calif.: Pacific Books, 1964).

80. Nancy Boas, *The Society of Six: California Colorists* (San Francisco: Bedford Arts, 1988), pp. 14–16.

81. Hailey, *California Art Research* (see n. 9), vol. 5, pp. 31–43; California Historical Society, *An Exhibition of Rediscovery: Joseph Raphael, 1872–1950*, essay by Theodore M. Lilienthal (San Francisco, 1975); Anita Ventura Mozley, "Joseph Raphael: Impressionist Paintings and Drawings," typescript essay and catalog information for an exhibition held at the Stanford University Museum of Art, 1980; Singer Museum, *Joseph Raphael, 1869–1950*, essay by Emke Raassen-Kruimel (Laren, the Netherlands, 1982).

82. Monterey Peninsula Museum of Art, *Colors and Impressions: The Early Work of E. Charlton Fortune*, essays by Robert E. Brennan and Merle Schipper (Monterey, Calif., 1989); Hailey, *California Art Research* (see n. 9), vol. 12, pp. 53–76.

83. Eunice T. Gray, "The Chase School of Art at Carmel-by-the-Sea, California," *Art and Progress* 6 (February 1915): 118–20; Katherine Metcalf Roof, *The Life and Art of William Merritt Chase* (New York: Scribner's, 1917), pp. 247–50; "Notes from Talks by William M. Chase, Summer Class, Carmel-by-the-Sea, California," *American Magazine of Art* 8 (September 1919): 132–36.

84. Josephine Blanch, "Armin Hansen, Painter of the Sea," *Game and Gossip* 1 (February 1927): 22–23; Hailey, *California Art Research* (see n. 9), vol. 9, pp. 104–34; "Dean of Western Painters," *Western Woman* 7 (October–December 1944): 3–4; Marjorie Warren, "Armin Hansen, Painter of the Sea," *What's Doing Magazine* 1 (September 1946): 22–23, 49; "The Touch of the Master Hand," *Western Woman* 13 (April 1952): 5–8; "The Sea and the Men Who Sail: A Story of Armin Hansen," *Spectator* (Carmel, Calif.) 11 (February 18, 1954): 3, 8; Anthony R. White, *The Graphic Art of Armin C. Hansen: A Catalogue Raisonné* (Los Angeles: Hennessey and Ingalls, 1986).

85. Hailey, *California Art Research* (see n. 9), vol. 11, pp. 60–101.

86. Ibid., vol. 8, pp. 101–25; John Maxwell Desgrey, "Frank Van Sloun: California's Master of the Monotype and the Etching," *California Historical Quarterly* 54 (Winter 1975): 345–58; Desgrey, "Frank Van Sloun: American Realist," n.d., typescript in the collection of Walter A. Nelson-Rees, Oakland, California.

87. The definitive study on the Group of Six is Boas, *Society of Six* (see n. 80). See also Oakland Museum, *Society of Six*, essay by Terry St. John (Oakland, Calif., 1972). For Selden Connor Gile, see: Sohlman Art Gallery, *Paintings by Selden Connor Gile, 1877–1947*, essay by Walter A. Nelson-Rees (Oakland, Calif., 1982); WIM Fine Arts, *Paintings by Selden Connor Gile, 1877–1947*, vol. 2 (Oakland, Calif., 1983); Civic Arts Gallery, *A Feast for the Eyes: The Paintings of Selden Connor Gile*, essays by Terry St. John and Peter William Brown (Walnut Creek, Calif., 1983).

88. Alfred Lambourne, "Springtime on the Seashore: Monterey Missions and Their Environs," *Western Galaxy* 1 (April 1888): 300–305; H.L.A. Culmer, "The Artist in Monterey," *Overland Monthly* 34 (December 1899): 514–24.

89. Hailey, *California Art Research* (see n. 9), vol. 10, pp. 1–33.

90. Donald C. Whitton and Robert E. Johnson, *Percy Gray, 1869–1952* (San Francisco: East Wind, 1970). See also Donald C. Whitton, *The Grays of Salisbury* (San Francisco: East Wind, 1976).

91. Hailey, *California Art Research* (see n. 9), vol. 12, pp. 76–104.

92. Leila Mechlin, "William P. Silva—An Appreciation," *American Magazine of Art* 14 (January 1923): 26–28.

93. Eleanor Taylor Houghton, "A Woman Painter," *Overland Monthly* 83 (February 1925): 62–63, 91.

94. Walter A. Nelson-Rees, *John O'Shea, 1876–1956: The Artist's Life As I Know It* (Oakland Calif.: WIM, 1985).

95. Thomas A. Parkhurst, "Little Journeys to the Homes of Great Artists," *Fine Arts Journal* 33 (October 1915): 4–7, supplement; Theresa Homet Patterson, "Painters and Sculptors in the West: William

Ritschel, California's Painter of the Sea," *California Southland* 8 (August 1926): 9–11; "California Artists," *Pictorial California and the Pacific* 5 (May 1930): 18–19; Janet B. Dominik, "William Ritschel," *Art of California*, February–March 1989, pp. 20–27.

96. Santa Cruz City Museum, *Frederick William Billing*, essay by Mackenzie Gordon (Santa Cruz, Calif., 1975); University Art Gallery, University of California, Riverside, *Frederick William Billing (Friedrich Wilhelm Billing), 1835–1914: A Gentleman Artist*, essay by Gordon (1976).

97. Bertha Berner, *Mrs. Leland Stanford: An Intimate Account* (Stanford, Calif.: Stanford University Press, 1934–35), pp. 105–7; Eugene T. Sawyer, *History of Santa Clara County* (Los Angeles: Historic Record Co., 1922), pp. 676–77; Triton Museum of Art, *A.D.M. Cooper, Early California Artist* (Santa Clara, Calif., 1970).

98. Society of California Pioneers, *Benjamin Willard Sears, "Sonora's Lost Genius,"* essay by Kenneth Castro and Doris Castro (San Francisco, 1965); Kenneth M. Castro and Doris M. Castro, "Benjamin W. Sears, Early California Artist," *Stockton Corral's Valley Trails*, 1966, pp. 42–58.

Southern California

1. See, for instance, Antony Anderson, "Six Landscape Painters of Southern California," in *California's Magazine*, 2 vols. (San Francisco, 1916), vol. 1, pp. 65–70; Arthur Millier, "The Art Temperaments of Northern and Southern California Compared," *Argus* 1 (August 1927): 32.

2. Bruce Kamerling, "The Portraits of Signor Barbieri," *California History* 66 (December 1987): 262–77.

3. Yda Addis Storke, *A Memorial and Biographical History of the Counties of Santa Barbara, San Luis Obispo, and Ventura, California* (Chicago, 1891), pp. 485–87; George Watson Cole, "Missions and Mission Pictures: A Contribution Towards an Iconography of the Franciscan Missions of California," *News Notes of California Libraries* 5 (July 1910): 402–7; "Some Detached Notes by Henry Chapman Ford on the Missions of California," *California Historical Society Quarterly* 3 (October 1924): 238–44; Henry Chapman Ford, *Etchings of California* (Santa Barbara[?]: Pacific Coast Publishing, 1961); Norman Neuerburg, "Ford Drawings at the Southwest Museum," *Masterkey* 54 (April–June 1980): 60–64; California State Capitol, *The Return of the Missions: An Exhibition of Oil Paintings of California Missions by Henry Chapman Ford (1828–1894)*, essay by Charlotte Berney (Sacramento, 1989).

4. Dayton Art Institute, *The Paintings of Edward Edmondson (1830–1884)*, essay by Bruce H. Evans (Dayton, Ohio, 1972).

5. Charles F. Lummis, "A Painter of Old California," *Land of Sunshine* 12 (December 1899): 22–27; Arthur Woodward, *A Biographical Sketch of Alexander Francis Harmer* (Santa Barbara, Calif.: Santa Barbara Historical Society, n.d.); H. D. Watkins, *Alexander F. Harmer, 1856–1925* (Santa Barbara: Victor H. Bartholome, 1981); James M. Hansen, *Alexander F. Harmer, 1856–1925* (Santa Barbara, Calif., 1982).

6. Thomas H. Parkhurst, "Little Journeys to the Homes of Great Artists," *Fine Arts Journal* 33 (December 1915): 291–94; *Fernand Lungren, 1857–1932: Some Notes on His Life* (Santa Barbara, Calif.: Santa Barbara School of the Arts, 1933); John A. Berger, *Fernand Lungren: A Biography* (Santa Barbara, Calif.: Schauer, 1936), pp. 143ff; Saralie E. Martin Neal, "Romance and Realism—The Grand Canyon Painters between 1874–1920: Thomas Moran, William Robinson Leigh, and Fernand Lungren" (M.A. thesis, University of Arizona, 1977), pp. 191–241.

7. "Wild Gardens of California Interpreted by John M. Gamble," *California Southland* 10 (March 1928): 12–13.

8. "G.E.," "Studio Talk," *International Studio* 49 (June 1913): 334–39; Thadée de Gorecki, "Carl Oscar Borg," *Art et les artistes* 17 (September 1913): 168–274; Amy Dudley, "Carl Oscar Borg's Desert Pictures," *Federation Magazine*, July 1919, p. 2; Dudley, "Carl Oscar Borg's Pictures," *Federation Magazine*, June 1922, pp. 12–13; Jessie A. Selkinghaus, "The Art of Carl Oscar Borg," *American Magazine of Art* 18 (March 1927): 144–47; Everett Carroll Maxwell, "Painters of the West: Carl Oscar Borg," *Progressive Arizona* 11 (December 1931): 12–13, 23–24; Robert Hessby, "Carl Oscar Borg, Portrayer of American Indians," *American Swedish Monthly* 29 (January 1935): 7–8, 34; Albin Widén, *Carl Oscar Borg ett Konstnärsöde* (Stockholm: Nordisk Rotogravyr, 1953); Raymond E. Lindgren, "The Wanderer: Carl Oscar Borg," *American Swedish Historical Foundation Yearbook*, 1962, pp. 68–77; *Noticias* 11 (Summer 1965), issue devoted to Carl Oscar Borg; Helen Laird, *Carl Oscar Borg and the Magic Region* (Layton, Utah: Gibbs M. Smith, 1986); Palm Springs Desert Museum, *Carl Oscar Borg: A Niche in Time*, essays by Catherine Plake Hough, Michael R. Grauer, and Helen Laird (Palm Springs, Calif. 1990).

9. Charles F. Lummis, "A Cowboy's Pencil," *Land of Sunshine* 2 (August 1899): 159–67; Edwin Emerson, "A Second Frederic Remington," *Columbian Magazine* 2 (July 1910): 1535–47; A. B. Stewart, "Stories of the Old West as Told and Painted by the Cow Puncher and Artist, Ed Borein," *Craftsman* 23 (October 1912): 44–53; Edward Selden Spaulding, *Ed Borein's West* (Santa Barbara, Calif.: Schauer, 1952); Nicholas Woloshuk, Jr., *Edward Borein: Drawings and Paintings of the Old West*,

vol. 1, *The Indians* (Flagstaff, Ariz.: Northland Press, 1968); vol. 2, *The Cowboys* (Santa Fe, N.M.: Sante Fe Village Art Museum, 1974); Harold G. Davidson, *Edward Borein, Cowboy Artist* (New York: Doubleday, 1974); Gerald Peters Gallery, *Edward Borein, Artist of the Old West*, essay by Harold G. Davidson (Santa Fe, N.M., 1984).

10. For Thomas Moran in Santa Barbara, see Gustave E. Buek, "Thomas Moran—N.A.: The Grand Old Man of American Art," *Mentor* 12 (August 1924): 29–37; Harriet Sisson Gillespie, "Thomas Moran, Dean of Our Painters," *International Studio* 79 (August 1924): 361–66.

11. On Albert Herter's California work, see Mary Ellen Shaw, "A Spanish Sunflower," *Art World* 2 (August 1917): 480–82; M[abel] Urmy Seares, "The Herter Murals in Los Angeles," *California Arts and Architecture* 35 (March 1929): 38–40; "'California' in a New Setting: A Mural by Albert Herter, A.N.A.," *California Arts and Architecture* 48 (December 1935): 14–16, 32. On Adele Herter's murals, see "Walls with a Desert Glow," *California Arts and Architecture* 36 (December 1929): 38–39; "The Cactus Dining Room at Casa del Sueño, Montecito," *California Arts and Architecture* 40 (May 1931): 38–39; "Walls with a Desert Glow," *House Beautiful* 69 (May 1931): 510–12.

12. James M. Hansen, *An Exhibition of Paintings by Colin Campbell Cooper* (Santa Barbara, Calif., 1981).

13. John Dewar, *Adios Mr. Penelon* (Los Angeles: Los Angeles County Museum of Natural History, 1968).

14. Sigmund J. Cauffman, "This Year's Paris Salon," *Philadelphia Sunday Press*, May 14, 1893; Alice M. Van Natta, "Noted Painter Exhibits Work at Siskiyou Camp," *Oregonian*, July 26, 1925. I wish to express my appreciation to Robert Canete of Pacific Grove, California, for supplying me with these items and other documentation on the McCloskeys.

15. John Gutzon Borglum, "An Artist's Paradise," *Land of Sunshine* 2 (May 1895): 106; Robert J. Casey and Mary Borglum, *Give the Man Room* (Indianapolis: Bobbs-Merrill, 1952), pp. 36–54.

16. Spencer Museum of Art, University of Kansas, *Charles Walter Stetson: Color and Fantasy*, essay by Charles C. Eldredge (Lawrence, Kans., 1982).

17. George Wharton James, "J. Bond Francisco, Musician and Painter," *Out West* 6 (September 1913): 78–94.

18. For Elmer Wachtel, see: "Wachtel and His Work," *Land of Sunshine* 4 (March 1896): 168–72; Florence Williams, "Elmer Wachtel, an Appreciation," *International Studio* 36 (January 1909): xcvii–xcviii; Antony Anderson, "Elmer Wachtel and California Landscape," *Out West* 33 (March 1917): 72, 93; Anderson, *Elmer Wachtel, a Brief Biography* (Los Angeles: Carl A. Bundy Quill, 1930). For Elmer

and Marion Wachtel, see Anderson, "Six Landscape Painters of Southern California," in *California's Magazine*, 2 vols. (San Francisco, 1916), vol. 1, pp. 67–68. See also Elmer Wachtel's paean to California scenery, "Western Landscape," *Western Art!* 1 (April 1914): 21.

19. Paul de Longpré was the subject of almost annual discussions in the periodical press from shortly after his arrival in this country until his death in 1911. See: "Paul de Longpré," *Art Interchange* 30 (February 1893): 38; "America's Foremost Flower Painter," *Art Interchange* 35 (November 1895): 118; "M. de F.," "Paul de Longpré," *New York Times Illustrated Magazine*, December 26, 1897, pp. 10–11; Pierre N. Beringer, "Le Roi des Fleurs: A Citizen of the Republic," *Overland Monthly* 36 (March 1900): 234–36; Marian A. White, "Paul de Longpré—King of Flower Painters," *Fine Arts Journal* 12 (August 1901): 448–54; Louis N. Richards, "The King of the Flower Painters in His California Home," *Overland Monthly* 43 (May 1904): 395–402; "Paul de Longpré: The 'King of Flower Painters,'" *Woman's Home Companion* 23 (May 1905): 20–21; "Paul de Longpré, Flower Painter," *Craftsman* 8 (July 1905): 498–510; John S. McGroarty, "'Le Roi Des Fleurs,'" *West Coast Magazine* 5 (March 1909): 708–19; Addison Edward Avery, "Paul de Longpré, Painter of Roses," *American Rose Annual* 33 (1948): 72–76; Bruce Torrence, *Hollywood: The First Hundred Years* (New York: Zoetrope, 1982), pp. 39–42; William Wurtz, "Paul De Longpré [*sic*]: Hollywood's Eccentric 'Flower Painter,'" *California Historical Courier* 35 (June 1983): 4–5.

20. Grace Hortense Tower, "California's State Flower," *Overland Monthly* 39 (May 1902): 884–89.

21. Everett Carroll Maxwell, "Art and Drama Department," *West Coast Magazine* 13 (December 1912): 347–50; Nancy Moure, "Five Los Angeles Artists in the Collection of the Los Angeles County Museum of Art," *Southern California Quarterly* 57 (Spring 1975): 42–47; Mildred Albronda, "Granville Redmond: California Landscape Painter," *Art and Antiques* 5 (November–December 1982): 46–53; Oakland Museum, *Granville Redmond*, essay by Mary Jean Haley (Oakland, Calif., 1988); Albronda, "Granville Redmond," *Art of California*, December–January 1989, pp. 44–50.

22. William L. Judson, "How I Became an Impressionist," *Overland Monthly* 30 (November 1897): 417–22; George Wharton James, "William Lees Judson, Painter," *Out West* 60 (May 1913): 242–54.

23. The standard studies of William Wendt are Laguna Beach Museum of Art, *William Wendt, 1865–1946*, essay by Nancy Dustin Wall Moure (Laguna Beach, Calif., 1977; and University Art Museum, California State University, *In Praise of Nature: The Landscapes of William Wendt* (Long Beach, Calif., 1989). See also the important exhibition catalog, Stendahl Art Galleries, *William Wendt and His Work*, essays by Antony Anderson, Fred S. Hogue, Alma May Cook, and Arthur Millier (Los Angeles, 1926). See also: Charles Francis Browne, "Some Recent Landscapes by William Wendt," *Brush and Pencil* 6 (September 1900): 257–63; Mabel Urmy Seares, "William Wendt," *American Magazine of Art* 7 (April 1916): 232–35; Mildred McLouth, "William Wendt—An Appreciation," *Museum Graphic* (Los Angeles County Museum) 1 (November 1926): 54–56. John Alan Walker has interpreted Wendt's landscape vision as one of paradise, an updating of the ethical purposefulness of Frederic Edwin Church and other artists of the Hudson River School. See "William Wendt, 1865–1946," *Southwest Art* 4 (June 1974): 42–45; "William Wendt Retrospective," *American Art Review* 4 (January 1978): 52–57, 102–5; *William Wendt's Pastoral Visions and Eternal Platonic Quests* (Big Pine, Calif.: Privately printed, 1988).

24. Marie Louise Handley, "Gardner Symons—Optimist," *Outlook* 105 (December 27, 1913): 881–87; Thomas Shrewsbury Parkhurst, "Little Journeys to the Homes of Great Artists: Gardner Symons," *Fine Arts Journal* 33 (October 1915): 7–9, supplement; Thomas Shrewsbury Parkhurst, "Gardner Symons, Painter and Philosopher," *Fine Arts Journal* 34 (November 1916): 556–65.

25. "Hanson Puthuff," *Arroyo Craftsmen* 1 (October 1909): 31–37; Everett Carroll Maxwell, "Painter of the West—Hanson Puthuff," *Progressive Arizona* 11 (September 1931): 10–11. See also Hanson Duvall Puthuff's own "Background," *Museum Graphic* (Los Angeles County Museum) 2 (November–December 1926): 73–75; *Hanson Duvall Puthuff: The Artist, The Man, 1875–1972: An Autobiography with Correspondence and Notes by Louise Puthuff* (Costa Mesa, Calif.: Spencer, 1974).

26. Everett C. Maxwell, "Rob Wagner—Painter," *West Coast Magazine* 13 (May 1913): 41–42.

27. "Max Wieczorek's Personalities," *Western Art* 1 (March 7, 1916): 8–9; Everett Carroll Maxwell, "The Portraits of Max Wieczorek," *International Studio* 68 (September 1919): lii–liv; "Beauty More Than Skin Deep," *Mentor* 14 (December 1926): 41–47; Maxwell, "The Decorative Figure Paintings of Max Wieczorek," *American Magazine of Art* 19 (January 1928): 32–35; Maxwell, *Max Wieczorek* (Los Angeles: Max Wieczorek, 1930); Maxwell, "These Charming People Portrayed by Max Wieczorek," *Overland Monthly* 90 (July 1932): 142, 157; Maxwell, "The Personal Art of Max Wieczorek," *Overland Monthly* 91 (June–July 1933): 90, 92.

28. M[abel] Urmy Seares, "Art Appreciation in the Woman's Club," *California Southland* 6 (February 1924): 10–11, 18; Seares, "Kathryn Leighton's Paintings of the Blackfoot Tribe," *California Southland* 8 (November 1926): 14–15, 31; John Collier, "Our Indians We Should Know," *California Southland* 9 (November 1927): 10–11.

29. Petersen Galleries, *The Paintings of Franz A. Bischoff (1864–1929)*, essay by Jean Stern (Beverly Hills, Calif., 1980).

30. *Los Angeles Times*, April 8, 1917, section 3, p. 4.

31. Mabel Urmy Seares, "California as a Sketching Ground, Illustrated by the Paintings of Benjamin Chambers Brown," *International Studio* 43 (April 1911): 121–32; William Howe Downes, "California for the Landscape Painters: Illustrated by Benjamin C. Brown," *American Magazine of Art* 11 (December 1920): 491–502; Edna Gearhart, "Benjamin Brown of Pasadena," *Overland Monthly and Outwest Magazine* 82 (July 1924): 314–16; Rose V. S. Berry, "A Patriarch in Pasadena," *International Studio* 81 (May 1925): 123–27; Gearhart, "The Brothers Brown—California Painters and Etchers," *American Magazine of Art* 20 (May 1929): 183–89. Much of the literature on Brown has been brought together in John Alan Walker, comp., *Benjamin Chambers Brown (1865–1942): A Chronological and Descriptive Bibliography* (Big Pine, Calif.: John Alan Walker, 1989).

32. Marie Angelino, "Nelbert Chouinard," *American Artist* 32 (May 1968): 28–32.

33. Everett Carroll Maxwell, "The Art of Jean Mannheim," *Overland Monthly and Outwest Magazine* 91 (September 1933): 125, 127.

34. Stendahl Art Galleries, *Guy Rose: Paintings of France and America*, essay by Earl Stendahl (Los Angeles, 1922); Rose V. S. Berry, "A Painter of California," *International Studio* 80 (January 1925): 332–37; Stendahl Art Galleries, *Guy Rose: Memorial Exhibition*, essays by Peyton Boswell and Anthony [*sic*] Anderson (Los Angeles, 1926).

35. M[abel] Urmy Seares, "Richard Miller in a California Garden," *California Southland* 38 (February 1923): 10–11.

36. Moure, "Five Los Angeles Artists" (see n. 21), pp. 27–30.

37. Downey Museum of Art, *Donna Norine Schuster, 1883–1953*, essay by Leonard R. de Grassi (Downey, Calif., 1977).

38. Elizabeth Whiting, "Painting in the Far West: Alson Clark, Artist," *California Southland* 3 (February 1922): 8–9; "Alson Skinner Clark, Artist," *California Southland* 9 (March 1927): 28–29; "Architecture and Art: The Work of Alson Clark, Painter, and of Bennett and Haskell, Architects," *California Southland* 11 (January 1929): 19; John Palmer Leeper, "Alson S. Clark (1876–1949)," *Pasadena Art Institute Bulletin* 1 (April 1951): 15–19; Jean Stern, *Alson S. Clark* (Los

39. Angeles: Peterson, 1983).

39. Nancy Dustin Wall Moure, "Eucalyptus School," in Ruth Lilly Westphal, *Plein Air Painters of California: The Southland* (Irvine, Calif.: Westphal Publishing, 1982), pp. 11–14, quoting Merle Armitage, writing in *West Coaster*, September 1, 1928.

40. John W. Hilton, "Artist Who Grinds His Own Pigments," *Desert Magazine* 4 (March 1941): 22.

41. Neeta Marquis, "Jack Wilkinson Smith, Colourist," *International Studio* 69 (December 1919): lxxiv–lxxvi; "Jack Wilkinson Smith, California Artist," *Arrowhead Magazine*, March 1923, pp. 8–9; Everett Carroll Maxwell, "Jack Wilkinson Smith, Constructive Artist," *Overland Monthly* 90 (October 1932): 237–38.

42. The major study of Edgar Alwin Payne and of the life and work of his artist-wife, Elsie Palmer Payne, is Rena Neumann Coen, *The Paynes, Edgar and Elsie: American Artists* (Minneapolis: Payne Studios, 1988). See also: Stendahl Art Galleries, *Edgar Alwin Payne and His Work*, essays by Antony Anderson and Fred S. Hogue (Los Angeles, 1926); Goldfield Galleries, *Edgar Payne, 1882–1947*, essay by Nancy Moure (Los Angeles, 1987).

43. Neeta Marquis, "The Paintings of Ralph Davison Miller," *International Studio* 65 (July 1918): iii–vii.

44. Edmund C. Jaeger, "Art in a Desert Cabin," *Desert Magazine* 11 (September 1948): 15–19; Desert Museum, *Forgotten Desert Artist*, essay by Roy F. Hudson (Palm Springs, 1979).

45. "Who's Who in American Art," *Arts and Decoration* 6 (September 1916): 517.

46. John Breck, "A Painter of the Southwest," *International Studio* 82 (October 1925): 67–72.

47. John Hilton, "Big Paintings with a Little Brush," *Desert Magazine* 13 (June 1950): 27–29.

48. Laguna Beach Art Association, *Clarence Hinkle, 1880–1960* (Laguna Beach, Calif., 1963); Art Department, University of the Pacific, *Clarence Keiser Hinkle (1880–1960): A Selection of His Paintings* (Stockton, Calif., 1978).

49. M. Knoedler and Co., *Rex Slinkard, 1887–1918: Memorial Exhibition*, essay by Marsden Hartley (New York, 1920), reprinted in *Adventures in the Arts* (New York: Boni and Liveright, 1921), pp. 87–95; "Rex Slikard's [sic] Letters," *Contact*, no. 1 (December 1920): 2–4, no. 2 (January 1921): n.p., no. 3 (Spring 1921): 1–8; Arthur Millier, "A Calm Declaimer of Everlasting Beauty," *Argus* 5 (April 1929): 2; John Alan Walker, "Rex Slinkard (1887–1918): Pioneer Los Angeles Modernist Painter," *Los Angeles Institute of Contemporary Art Journal*, no. 3 (December 1974): 20–23; Marsden Hartley, "Dear Rex Slinkard," in "Letters to the Dead," and "Rex Slinkard's Spirit and Purpose," Beinecke Rare Book and Manuscript Library, Yale University, New Haven, Conn.

50. "Henrietta M. Shore, Portrait and Figure Painter," *Western Art!* 1 (June–August 1914): 17–19; Merle Armitage, *Henrietta Shore* (New York: E. Weyhe, 1933); *Jean Charlot, Art from the Mayans to Disney* (New York: Sheep and Ward, 1939), pp. 175–79; Monterey Peninsula Museum of Art, *Henrietta Shore: A Retrospective Exhibition, 1900–1963*, essays by Roger Akin and Richard Lorenz (Monterey, Calif., 1986).

51. There is a sizable bibliography on Stanton Macdonald-Wright and on Synchromism. See Los Angeles County Museum, *A Retrospective Showing of the Work of Stanton Macdonald-Wright*, introduction by Richard F. Brown (Los Angeles, 1956); National Collection of Fine Arts, *The Art of Stanton Macdonald-Wright*, introduction by David Scott (Washington, D.C., 1967), which includes Macdonald-Wright's "A Treatise on Color"; UCLA Art Galleries, *Stanton Macdonald-Wright: A Retrospective Exhibition, 1911–1970*, interview with the artist by Frederick Wight (Los Angeles, 1970). Also see Gene Hailey, "The Work of Wright and Russell," *Argus* 1 (June 1927): 6–7; "The Artist Speaks: Stanton Macdonald-Wright," *Art in America* 55 (May–June 1967): 70–73; and, in the *American Art Review* 1 (January–February 1974): David W. Scott, "Stanton Macdonald-Wright: A Retrospective," pp. 49–53; Nick Brigante and Lorser Feitelson, "Tribute to Stanton Macdonald-Wright," p. 54; Henry Clausen, "Recollections of Stanton Macdonald-Wright," pp. 55–58; and John Alan Walker, "Interview: Stanton Macdonald-Wright," pp. 59–68. On Synchromism, see M. Knoedler and Co., *Synchromism and Color Principles in American Painting, 1910–1930*, essay by William C. Agee (New York, 1965); and Whitney Museum of American Art, *Synchromism and American Color Abstraction, 1910–1925*, essay by Gail Levin (New York, 1978).

52. Everett Carroll Maxwell, "A Tribute to the Work of the Late Norman St. Clair, a Western Water-Colorist," *International Studio* 13 (July 1913): viii–x.

53. California State University Art Galleries, *Anna Althea Hills, 1882–1930* (Long Beach, Calif., 1976). See also Anna Althea Hills's article "The Laguna Beach Art Association," *American Magazine of Art* 10 (October 1919): 458–63.

54. Thomas Shrewsbury Parkhurst, "The Art of Joseph Kleitsch," *Fine Arts Journal* 37 (June 1919): 46–52.

55. Evelyn Marie Stuart, "The Dawn of a Colorist," *Fine Arts Journal* 34 (February 1916): 79–84; Antony Anderson, "Hovsep Pushman: An Appreciation," *International Studio* 61 (April 1917): xxxvii–xliii; Anderson, "Pictures by Hovsep Pushman," *International Studio* 67 (May 1919): lxxix–lxxxi; "The Armenian Spirit Glorified in Art," *Fine Arts Journal* 37 (September 1919); [Robert Preato], "Hovsep Pushman: Painter and Poet," *Illuminator*, Winter 1978–79, pp. 30–32.

56. On Emma M. Chapin, William Thurston Black, and Ammi Farnham, see Bruce Kamerling, "The Start of Professionalism: Three Early San Diego Artists," *Journal of San Diego History* 30 (Fall 1984) pp. 241–51; on Farnham, see also: Michael C. Rockefeller Arts Center Gallery, State University College, *Three Nineteenth-Century Masters of Western New York*, essay by Nancy Weekly (Fredonia, N.Y., 1980).

57. Esther Mugan Bush, "California's Beauty and Charm as Told on Canvas," *Santa Fe Magazine* 11 (November 1917): 51–54; Fine Arts Society of San Diego, *Charles Arthur Fries* (San Diego, 1941); Ben F. Dixon, " 'Too Late': The Story of a Famous Painting of Mission San Juan Capistrano," *Journal of San Diego History* 17 (Spring 1970): 1–2.

58. Bruce Kamerling, "Anna and Albert Valentien: The Arts and Crafts Movement in San Diego," *Journal of San Diego History* 24 (Summer 1978): 343–66.

59. [Edith White], *Memories of Pioneer Childhood and Youth in French Corral and North San Juan Nevada County, California, with a Brief Narrative of Later Life, Told by Edith White, Emigrant of 1859, to Linnie Marsh Wolfe* (n.p., 1936).

60. "Maurice Braun, Landscapist," *Western Art!* 1 (June, July, August, 1914): 27.

61. "Landscapes of Maurice Braun," *Western Art* 1 (April 7, 1916): 10–11; Esther Mugan Bush, "A Master Brush Which Breathes Its Inspiration from Point Loma," *Santa Fe Magazine* 11 (August 1917): 13–21; "A Master-Brush of Point Loma," *Theosophical Path* 14 (January 1918): 13–18; Hazel Boyer, "The Homecoming of Maurice Braun," *Southwest Magazine* 1 (March 1924): 7; Boyer, "A Notable San Diego Painter," *California Southland*, no. 52 (April 1924): 12; Helen Comstock, "Painter of East and West," *International Studio* 80 (March 1925): 485–88; "Maurice Braun: Painter," *San Diego Magazine* 4 (December–January 1951–52): 13–16, 43–44; Martin E. Petersen, "Maurice Braun: Master Painter of the California Landscape," *Journal of San Diego History* 23 (Summer 1977): 20–40. For a Theosophical interpretation of Maurice Braun's art, see Reginald Poland, "The Divinity of Nature in the Art of Maurice Braun," *Theosophical Path* 34 (May 1928): 473–76, and, by Braun himself: "Theosophy and the Artist," *Theosophical Path* 14 (January 1918): 7–13; "What Theosophy Means To Me," *Theosophical Path* 35 (October 1928): 367–68.

62. Martin E. Petersen, "Alfred R. Mitchell, Pioneer Artist in San Diego," *Journal of San Diego History* 19 (Fall 1973): 42–50; San Diego Historical Society, *The Art of Alfred R. Mitchell, 1888–1972*, essay by Thomas R. Anderson (San Diego, 1988).

63. Maurice Braun, "Art at the Southern California Exposition," *Fine Arts Journal* 33 (August 1915): 371–76.

64. Henry McBride, "Robert Henri's California Paintings," *Sun*, November 22, 1914, reprinted in *The Flow of Art: Essays and Criticisms of Henry McBride* (New York: Atheneum, 1975), pp. 72–75.

65. Jean Stern, "Robert Henri and the 1915 San Diego Exposition," *American Art Review* 2 (September–October 1975): 108–17.

66. Ruth Rowe, "History," *San Diego Art Guild Membership Roster* (San Diego, 1970), courtesy of Bruce Kamerling, San Diego Historical Society, and Martin E. Petersen, curator, San Diego Museum of Art.

67. See the two articles with identical titles by Eugene De Vol in *San Diego Magazine*, "Art Education in San Diego," 3 (September 1927): 14, 35; 4 (July 1928): 14.

68. Charles Reiffel, unlike Otto Schneider, was the subject of a good deal of attention during his lifetime; see Martin E. Petersen, "Success at Mid-Life: Charles Reiffel, 1862–1942, San Diego Artist," *Journal of San Diego History* 31 (Winter 1985): 24–37.

69. Martin E. Petersen, "Contemporary Artists of San Diego," *Journal of San Diego History* 16 (Fall 1970): 3–8.

Hawaii

1. Douglas Cole, "John Webber, A Sketch of Captain James Cook's Artist," *British Columbia Historical News* 13 (Fall 1979).

2. Jessie Poesch, *Titian Ramsay Peale and His Journals of the Wilkes Expedition* (Philadelphia: American Philosophical Society, 1961). See also Herman J. Viola and Carolyn Margolis, eds., *Magnificent Voyagers: The U.S. Exploring Expedition, 1838–1842* (Washington, D.C.: Smithsonian Institution Press, 1985).

3. Julie Ann Schimmel, "John Mix Stanley and Imagery of the West in Nineteenth-Century American Art" (Ph.D. diss., New York University, 1983), pp. 80–84.

4. Linda Mary Jones Gibbs, "Enoch Wood Perry, Jr.: A Biography and Analysis of His Thematic and Stylistic Development" (M.A. thesis, University of Utah, 1981), pp. 41–43.

5. Ethel M. Demon, *Sanford Ballard Dole and His Hawaii* (Palo Alto, Calif., 1957), pp. 162–63.

6. "Art and Artists in Hawaii," *Paradise of the Pacific*, May 1888, p. 6; Charles S. Greene, "Joseph D. Strong, Jr.," *Overland Monthly* 24 (May 1896): 501–10; Isobel Strong Field, *This Life I've Loved* (New York: Longmans, Green, 1937), pp. 150–251.

7. "Jules Tavernier," *Daily Pacific Commercial Advertiser*, May 20, 1889, p. 2; H. M. Luquiens, "Jules Tavernier," *Honolulu Academy of Arts Annual Bulletin* 2 (1940): 25–31; Robert Nichols Ewing, "Jules Tavernier (1844–1889): Painter and Illustrator" (Ph.D. diss., University of California, Los Angeles, 1978), pp. 202–22.

8. John La Farge, *Reminiscences of the South Seas* (New York: Doubleday Page, 1912), pp. 12–67; James L. Yarnall, "John La Farge and Henry Adams in the South Seas," *American Art Journal* 20, no. 1 (1988): 52–61.

9. "Art Notes," *Graphic* 6 (January 23, 1892); *Hawaii: The Burning Crater of Kilauea . . . Reproduced on the Midway-Plaisance, World's Fair* (Chicago, 1893).

10. Lewis Ferbraché, *Theodore Wores: Artist in Search of the Picturesque* (San Francisco: Privately printed, 1968), pp. 38–40.

11. The definitive study of Hitchcock is by his daughter, Helen Hitchcock Maxon, *D. Howard Hitchcock, Islander* (Honolulu: Topgallant, 1987). See also Edna B. Lawson, "The Grand Old Artist of Hawaii," *Paradise of the Pacific*, May 1936, p. 6.

Acknowledgments

Art Across America required the assistance of myriad individuals throughout the country, almost all of whom came through with generous cooperation that exceeded my expectations. The most consistent support came from my colleagues at Abbeville Press, where the publisher, Robert E. Abrams, never wavered in his support of this daunting project. Nancy Grubb, my editor on this as on *American Impressionism,* not only championed the concept of this study from the first but also has stood firmly behind its growth far beyond the single volume originally conceived. She and Andrea Belloli have sensitively honed my text, achieving an amazing consistency of both style and substance. Laura Lindgren has coordinated the many operations required to get these hundreds of thousands of words into type. Nai Chang has created a design that is both beautiful and user-friendly. An indomitable team of photo "detectives" has tracked down nearly a thousand photographs, many never before reproduced, from every corner of the country. Dana Cole has made sure that these marvelous images have been printed promptly and well. All have coped with the project's prolonged and diverse demands with unfailing good cheer and heartfelt commitment.

Perhaps even more than with previous projects, my wife, Abigail, has offered constant encouragement, enthusiastically sharing my interest in the exploration of regional American painting. *Art Across America* more often travels the byways than the highways of American art history, and without her companionship it would, at times, have been a lonely journey.

Before listing the great number of individuals and institutional personnel who have aided me both in accumulating the information presented here and in interpreting that material, I would like to single out four groups who have had a particular impact on this project.

First, there are those who came before me in beginning serious, scholarly investigation of regional art. The results of their efforts are listed in the bibliography, but a few individuals nevertheless deserve additional mention because of the inspiration they provided. I am referring to Porter Butts, who wrote on Wisconsin artists; J. Hall Pleasants, who focused on Maryland; Wilbur Peat, who produced splendid studies of art in Indiana; Robert Taft, who specialized in artists of the Old West; and Anna Wells Rutledge, who contributed a variety of publications.

Second, there are those scholars actively working today who have been of inestimable assistance to me personally and whose expertise has often extended far beyond the specific regions with which they are associated and recognized. Among these are Dr. Jeffrey W. Andersen, Marjorie Dakin Arkelian, Dr. Joseph Armstrong Baird, Jr., Dr. Rena Neumann Coen, Alfred Harrison, Arthur F. Jones, James C. Kelly, Nancy Dustin Wall Moure, Chris Petteys, Ronald G. Pisano, Dr. Jessie Poesch, Lewis Hoyer Rabbage, J. Gray Sweeney, Dr. Patricia Trenton, Dr. Bruce Weber, and Dr. H. Barbara Weinberg.

Third, there is that sextet of librarians who over so many years have accepted with such good grace and humor my importuning for assistance and then for more assistance: Anne Abid, formerly of the Saint Louis Art Museum and now at the Cleveland Museum of Art; Patricia P. Rutledge at the Cincinnati Art Museum; Annette Masling at the Albright-Knox Art Gallery in Buffalo; Martha Blocker at the Indianapolis Museum of Art; Florence M. Jumonville at the Historic New Orleans Collection; and Shirley B. Solvick at the Detroit Public Library. I am forever beholden to them.

Finally, I wish to thank the group of graduate students who undertook original research for me in my classes on regional art: Suzaan Boettger, Kathleen Burnside, Margaret Conrads, David Dearinger, Margaret Favretti, Leslie E. Heiner, April Kingsley, Carol Lowrey, Carl Palusci, Kate Walsh, and Karen Zukowski. Their specific areas of study are mentioned below and in the bibliography.

I am grateful to the individuals noted below for their assistance with information related to the following states. The titles indicated refer to the positions they held at the time they provided assistance and may have since changed.

The Far Midwest

Iowa

Carol Hunt, Registrar, Putnam Museum, Davenport; Gordon Keyte, Secretary, Iowa Art Guild, Inc., Des Moines; Marie V. Sedlacek, Librarian, Joslyn Art Museum, Omaha, Nebraska.

Kansas

Larry L. Griffis, Director, Birger Sandzén Memorial Gallery, Lindsborg; Larry Jochims, Research Historian, Kansas State Historical Society, Topeka; Dr. Anne M. Marvin, Curator, Kansas State Historical Society, Topeka; Glenice Lesley Matthews, Director, Wichita Art Association, Inc.; Dr. Andrew J. Svedlow, Director, Mulvane Art Center, Washburn University, Topeka.

Minnesota

Dorothy M. Burke, Librarian, Minneapolis History Collection, Minneapolis Public Library; Dr. Rena Neumann Coen, Professor of Art, Saint Cloud State University, Saint Cloud; Patricia Harpole, Chief of Reference Library, Minnesota Historical Society, Saint Paul; Brian J. Mulhern, Museum Archivist, Minneapolis Institute of Arts; Marion J. Nelson, Director, Vesterheim, Norwegian-American Museum, Decorah, Iowa; Thomas O'Sullivan, Curator of Art, Minnesota Historical Society, Saint Paul; Douglas Skrief, Librarian, Minneapolis Institute of Arts.

Missouri

John C. Abbott, Librarian, Research and Special Collections, Southern Illinois University at Edwardsville; Ann B. Abid, Head Librarian, Richardson Memorial Library, Saint Louis Art Museum; Gerald D. Bolas, Director, Washington University Museum of Art, Saint Louis; Jeanne Colette Collester, Professor, Art History Department, Principia College, Elsah, Illinois; Karen M. Goering, Acting Executive Director, Missouri Historical Society; Martha Hillegoss, Head, Art Department, Saint Louis Public Library; Carol Rosine Schroeder, Kansas City Public Library; Stephanie C. Sigala, Head Librarian, Richardson Memorial Library, Saint Louis Art Museum; Erik Bradford Stocker, Rare Books Librarian, Saint Louis Public Library; Jo Ann Tuckwood, Acquisition Librarian, State Historical Society of Missouri, Columbia; Melissa Pierce Williams, Columbia, Missouri; Tanya Sue Yatzeck, Saint Louis.

Nebraska

Sue Annett, Art Librarian, Joslyn Art Museum, Omaha; Susan Enns Frechette, Art Librarian, Joslyn Art Museum, Omaha; Norman A. Geske, Director Emeritus, Sheldon Memorial Art Gallery, University of Nebraska-Lincoln; Karen Janovy, Sheldon Memorial Art Gallery, University of Nebraska-Lincoln; Ann Reinert, Library Department Head, Nebraska State Historical Society, Lincoln; Ellen Simak, Curator of American Art, Joslyn Art Museum, Omaha; Gary Zaruba, Department of Art, Kearney State College, Kearney.

North Dakota

Forrest Daniel, Reference Specialist, State Historical Society of North Dakota, Bismarck; Gerald G. Newborn, State Archivist, State Historical Society of North Dakota, Bismarck.

South Dakota

Sheila M. Agee, Assistant to the Director, South Dakota Memorial Art Center, Brookings; Philip Brown, Public Services Librarian, South Dakota

State University, Brookings; Lawrence E. Hibpshman, State Archivist, South Dakota State Library and Archives, Pierre; Aubrey Sherwood, De Smet.

The Rocky Mountain West

Colorado

Georgianna Contiguglia, Curator, Colorado Historical Society, Denver; Stanley Cuba, Denver; Elizabeth Cunningham, Curator, Anschutz Collection; Dr. David Park Curry, Curator, American Art, Denver Art Museum; Mary M. Davis, Library Assistant, Pikes Peak Library District, Colorado Springs; Roderick Dew, Librarian, Colorado Springs Fine Arts Center; Eleanor M. Gehres, Manager, Western History Department, Denver Public Library; Barbara L. Neilon, Curator, Special Collections, Charles Leaning Tutt Library, Colorado College, Colorado Springs; Chris Petteys, Sterling; Mary Elizabeth Ruwell, Archivist, Colorado Springs Pioneers Museum; Dr. Patricia Trenton, Curator, Los Angeles Athletic Club.

Idaho

Arthur Hart, Director, Idaho Historical Society, Boise.

Montana

Donna M. Forbes, Director, Yellowstone Art Center, Billings.

Utah

Linda Jones Gibbs, Art Curator, Museum of Church History and Art, The Church of Jesus Christ of Latter-day Saints; Dr. Robert Olpin, Chairman, Department of Art History, University of Utah, Salt Lake City; Will South, Bountiful; Dr. Vern G. Swanson, Director, Springville Museum of Art; Steven R. Wood, Reference Librarian, Utah State Historical Society, Salt Lake City.

Wyoming

Steven Cotherman, Museums Division Administrator, Wyoming State Archives, Museums and Historical Department, Cheyenne; Dr. Donald Keyes, Curator, Georgia Museum of Art, University of Georgia, Athens; Arthur J. Phelan, Jr., Chevy Chase, Maryland.

The Southwest

Arizona

James K. Ballinger, Director, Phoenix Art Museum; Paul Benisek, Santa Fe Collection of Southwestern Art, Chicago; Dr. Peter Bermingham, Director, University of Arizona Museum of Art, Tucson; Patricia Ryan, General Manager, Royal Palms Inn, Phoenix.

Nevada

A. P. Hays, Arizona West Galleries, Scottsdale, Arizona; Chelsea Miller, Curator, Sierra Nevada Museum of Art, Reno; Lee Mortensen, Research Librarian, Nevada Historical Society, Reno.

New Mexico

Phyllis M. Cohen, Librarian, Museum of Fine Arts Library, Museum of New Mexico, Santa Fe; Albert F. Donlan, Librarian, Museum of Fine Arts Library, Museum of New Mexico, Santa Fe; Teresa Hayes, Registrar, Roswell Museum and Art Center; Leslie Heiner, New York City; Virginia Couse Leavitt, Tucson, Arizona; Dean Porter, Director, Snite Museum of Art, University of Notre Dame, Notre Dame, Indiana; Dr. Bruce Weber, Curator, Norton Gallery and School of Art, West Palm Beach, Florida.

The Pacific

Alaska

Len Braarud, Braarud Fine Art, La Conner, Washington; Walter A. Van Horn, Curator, Anchorage Historical and Fine Arts Museum.

Hawaii

Marguerite K. Ashford, Head Librarian, Bishop Museum, Honolulu; Dr. Leon H. Bruno, Director, Lyman House Memorial Museum, Hilo; Sanna Saks Deutsch, Registrar, Honolulu Academy of Arts; Constance Hagiwara, Librarian, Hawaii and Pacific Section, Hawaii State Library, Honolulu; June Hitchcock Humme, Hilo; James Jensen, Curator of Western Art, Honolulu Academy of Arts; Nancy H. and Roy Farrington Jones, Ross, California; Rob R. Kral, Kral Fine Arts, Oakland, California; Helen Hitchcock Maxon, Berkeley, California; Anne T. Seaman, Librarian, Honolulu Academy of Arts.

Northern California

Marjorie Dakin Arkelian, Art Historian Emeritus, Oakland Museum; Dr. Joseph Armstrong Baird, Jr., Tiburon; Eugenie Candau, Librarian, San Francisco Museum of Modern Art; Derrick R. Cartwright, National Endowment for the Arts Intern, American Paintings Department, Fine Arts Museums of San Francisco; Jim Delman, The Delman Collection, San Francisco; John H. Garzoli, San Rafael; Pat Goyan, Volunteer Coordinator, California Historical Society, San Francisco; Jeff Gunderson, Librarian, San Francisco Art Association; Alfred C. Harrison, Jr., North Point Gallery, San Francisco; Jo Farb Hernandez, Director, Monterey Peninsula Museum of Art; Catherine Hoover, Curator, California Historical Society; Sally Mills, Assistant Curator of American Painting, Fine Arts Museums of San Francisco; Anita Ventura Mozley, Curator, Stanford University Museum of Art; Walter A. Nelson-Rees, Oakland; Drs. A. Jess and Ben Shenson, San Francisco; Johanna Raphael Sibbett, San Francisco; Marc Simpson, Edna Root Curator of American Painting, Fine Arts Museums of San Francisco; Elizabeth Smart, Chief Curator of California Parks and Recreation, San Francisco; Kevin Starr, Chairman, Library Committee, Bohemian Club, San Francisco; Donald C. Whitton, San Francisco; Raymond L. Wilson, Mountain View.

Oregon

Mildred Wiggins Benz, Yakima, Washington; Kathleen Burnside, New York City; John D. Cleaver, Curator, Oregon Historical Society, Portland; Steven Cotherman, Wyoming State Archives, Cheyenne; Emily Evans Elsner, Librarian, Oregon Art Institute, Portland; Chester Helms, Atelier Doré, Inc., San Francisco; Gordon Manning, Assistant Librarian, Oregon Historical Society, Portland; Barbara K. Padden, Head, Art and Music Department, Multnomah County Library, Portland; Elisabeth Walton Potter, Coordinator, National Register Nominations, State Historic Preservations Office, Salem.

Southern California

Suzaan Boettger, New York City; Gary Breitweiser, Santa Barbara; Dr. Rena Neumann Coen, Department of Art, Saint Cloud State University, Saint Cloud, Minnesota; Ilene Fort, Associate Curator of American Art, Los Angeles County Museum of Art; Theresa Hanley, Mission Inn Foundation, Riverside; Bruce Kamerling, Curator of Collections, San Diego Historical Society; Marie Louise Kane, Newtown, Connecticut; Janet Marqusee, Janet Marqusee Fine Arts, Ltd., New York City; Nancy Dustin Wall Moure, Glendale; Judith O'Toole, Sordoni Art Gallery, Wilkes College, Wilkes-Barre, Pennsylvania; Martin Petersen, Curator of Western Arts, San Diego Museum of Art; Michael Redmon, Librarian, Santa Barbara Historical Society; Roy C. Rose, Avalon; Dr. Patricia Trenton, Curator, Los Angeles Athletic Club; John Alan Walker, Big Pine.

Washington

Rick Caldwell, Librarian, Historical Society of Seattle and King County; Jeanne Engerman, Assistant Librarian, Washington State Historical Society, Tacoma; Beverly Criley Graham, Bellevue; Frank L. Green, Librarian, Washington State Historical Society, Tacoma; Barbara Johns, Luce Foundation Research in American Art, Seattle Art Museum; Glenn Mason, Director, Eastern Washington State Historical Society, Spokane; Gervais Reed, Professor of Art History, University of Washington, Seattle; Carla Richardson, Head, Pacific Northwest Collection, Suzzallo Library, University of Washington, Seattle; Judy Sourakli, Registrar, Henry Art Gallery, University of Washington, Seattle; Lauren Tucker, Assistant Registrar, Seattle Art Museum.

Bibliography

This bibliography, which is organized by region and state, contains only general references: some are art historical sources, others are civic, county, and state histories, which frequently contain information on local art organizations and art schools. Monographic sources for individual artists appear in the notes, but for many once well-known and today overlooked painters the only useful published material has been gleaned from the general references cited in this bibliography. Examinations of individual artists have been included here only when they encompass significant information about the community of painters within which an artist worked. Exhibition catalogs are cited under the name of the organizing institution.

The Far Midwest

Iowa

De Long, Lea Rosson, and Gregg R. Narber. *A Catalog of New Deal Mural Projects in Iowa.* Des Moines: Privately printed, 1982.

Drake, Jeannette M. *Brief Information Concerning Iowa Artists.* Sioux City: Iowa Federation of Women's Clubs, 1917.

Ferguson, Bess, Velma Wallace Rayness, and Edna Patzig Gouwens. *Charles Atherton Cumming, Iowa's Pioneer Artist-Educator.* Des Moines: Iowa Art Guild, 1972.

Hamlin, Gladys E. "Mural Painting in Iowa." *Iowa Journal of History and Politics* 37 (July 1939): 227–307.

Kern, Jean B. "Art Centers in Iowa." *Palimpsest* 30 (January 1949): 1–32.

National Society of the Colonial Dames of America in the State of Iowa. *Portraits in Iowa.* [Des Moines?], 1975.

Ness, Zenobia B., and Louise Orwig. *Iowa Artists of the First Hundred Years.* Des Moines: Wallace-Homestead Company, 1939.

Sage, Leland Livingston. "Iowa Writers and Painters: An Historical Survey." *Annals of Iowa* 42 (1974): 241ff.

Kansas

Historical Activities Committee of the National Society of the Colonial Dames of America. *The Kansas Portrait Index.* [Topeka, Kans.?], 1970.

"Kansas Art and Artists." Topeka: Kansas State Historical Library, 1928.

Lindquist, Emory Kempton. *Bethany in Kansas.* Lindsborg, Kans.: Bethany College, 1975.

Mines, Cynthia. *For the Sake of Art: The Story of an Art Movement in Kansas.* Wichita and North Newton, Kans.: Privately printed, 1979.

Newlin, Gertrude. "Development of Art in Kansas." Typescript, Lawrence, Kans., 1942.

Reinbach, Edna. "Kansas Art and Artists." *Collections of the Kansas State Historical Society* 17 (1928): 571–85.

Seachrest, Effie. "The Smoky Hill Valley Art Center." *American Magazine of Art* 12 (January 1921): 14–16.

Snow, Florence L. "Kansas Art and Artists." *Kansas Teacher* 27 (September 1927–July 1928).

University of Kansas. *Arts and Crafts of Kansas.* Lawrence, 1948.

Van Schaack, Elisabeth D. "The Arts in Kansas." In *Kansas: The First Century,* edited by John D. Bright, pp. 241–65. New York: Lewis Historical Publishing Company, 1956.

Whittemore, Margaret E. "Some Topeka Artists." *Community Arts and Crafts* 1 (December 1927): 19.

Minnesota

Atwater, Isaac, ed. *History of the City of Minneapolis, Minnesota.* 2 vols. New York: Munsell and Company, 1893, vol. 1, pp. 163–65, 282–97.

Baldwin, Laura L. V. "Minneapolis Artists and the World's Fair." *Literary Northwest* 2 (January 1893): 151–57.

Coen, Rena Neumann. *Painting and Sculpture in Minnesota, 1820–1914.* Minneapolis: University of Minnesota Press, 1976.

Hess, Jeffrey A. *Their Splendid Legacy: The First Hundred Years of the Minneapolis Society of Fine Arts.* Minneapolis: Minneapolis Society of the Fine Arts, 1985.

Hudson, Horace B., ed. *A Half Century of Minneapolis,* pp. 124–33. Minneapolis: Hudson Publishing Company, 1908.

Loran, Erle. "Artists from Minnesota." *American Magazine of Art* 29 (January 1936): 25–34.

"Robert Koehler and Art in Minneapolis." *Art Interchange* 44 (February 1900): 36.

Shutter, Marion D. *History of Minneapolis, Gateway to the Northwest.* 2 vols. Chicago: S. J. Clarke Publishing Company, 1923, vol. 1, pp. 462–67.

Torbert, Donald R. "A Century of Art and Architecture in Minnesota." In John K. Sherman, Grace Lee Nute, and Donald R. Torbert, *A History of the Arts in Minnesota.* Minneapolis: University of Minnesota Press, 1958.

Tweed Museum of Art. *Accomplishments: Minnesota Art Projects in the Depression Years.* Essay by Nancy A. Johnson. Duluth, Minn., 1976.

Missouri

"Art." *Inland Monthly* 5 (January–April 1874): 156–58.

Art Gallery of the Missouri State Building, Lewis and Clark Exposition. *Illustrated Handbook of the Missouri Art Exhibit Made under the Auspices of the Saint Louis Artists' Guild.* Essay by George Julian Zolnay. Portland, Oreg., 1905.

Breckenridge, James Malcolm. "Early Portrait Painters in Saint Louis and the West." In *William Clark Breckenridge,* pp. 227–28. Saint Louis: Privately printed, 1932.

Bryant, William M. "The Loan Exhibition of Paintings at the Crow Museum." *Western* 7 (November 1881): 400–419.

Byars, W. V. "Artists in Arcadia." *Art and Music* 1 (September 1881): 10–15.

Crouther, Betty Jean. " 'The Artist Sings for Joy': Frederick Oakes Sylvester and Landscape Painting in St. Louis." Ph.D. diss., University of Missouri-Columbia, 1985.

Dacus, J. A., and James W. Buel. *A Tour of St. Louis,* pp. 65–78. Saint Louis, 1878.

Defty, Sally Bixby. *The First Hundred Years, 1879–1979: Washington University School of Fine Arts.* Saint Louis: Washington University School of Fine Arts, 1979.

"Fine Arts." *Western Journal* 7 (October 1851): 73.

"Fine Arts." *Western Journal* 7 (December 1851): 217–19.

Goering, Karen McCoskey. "St. Louis Women Artists, 1818–1945: An Exhibition." *Gateway Heritage* 3 (Summer 1981): 14–21.

Helmuth, William Tod, ed. *Arts in St. Louis.* Saint Louis, 1864.

Hodges, William R. "Art." *Spectator,* January 8, 1881, p. 179; May 21, 1881, pp. 509–10.

Knaufft, Ernest. "St. Louis, the School of Fine Arts." *Art Amateur* 25 (August 1891): 53–54.

McDermott, John Francis. "Art in St. Louis." Typescript, n.d., Lovejoy Library, Southern Illinois University at Edwardsville, Edwardsville, Illinois.

———. "Museums in Early Saint Louis." *Missouri Historical Society Bulletin* 4 (April 1948): 129–38.

"Mephisto." "Fine Arts in St. Louis." *American Art Journal* 32 (March 6, 1880): 296–97.

Missouri, Heart of the Nation: A Pictorial Record by Fourteen American Artists. New York: American Artists Group, 1947.

Morgan, H. H., and William M. Bryant. "Art and Artists." In J. Thomas Scharf, *History of Saint Louis City and County, from the Earliest Periods to the Present Day: Including Biographical Sketches of Representative Men,* pp. 1617–28. Philadelphia, 1884.

Mulkey, Mab. "History of the St. Louis School of Fine Arts, 1879–1909: The Art Department of Washington University." M.A. thesis, Washington University, Saint Louis, 1944.

National Society of the Colonial Dames in America in the State of Missouri. *Portraits in Missouri Painted before 1860.* N.p., 1974.

Owens, Mazee Bush, and Frances S. Bush. *The Kansas City Art Institute and School of Design.* Kansas City, 1964.

Shoemaker, Floyd Calvin. *Missouri and Missourians: Land of Contrasts and People of Achievements.* 5 vols. Chicago: Lewis Publishing Company, 1943, vol. 2, pp. 747–60.

Smith, Holmes, George S. Johns, and Scott MacNutt. *The Story of the St. Louis Artists' Guild, 1886–1936.* [Saint Louis, 1936?].

Spiess, Lincoln Bunce. "St. Louis Women Artists in the Mid-Nineteenth Century." *Gateway Heritage* 3 (Spring 1983): 10–23.

Stevens, Walter B. *St. Louis: The Fourth City, 1764–1911.* 2 vols. Saint Louis and Chicago: S. J. Clarke Publishing Company, 1911, vol. 2, pp. 651–52, 655–56.

"Visit to a 'Gallery of Art.'" *Western Journal* 6 (April 1851): 62–67.

Whitney, Carrie W. *Kansas City, Missouri: Its History and Its People, 1808–1908.* 3 vols. Chicago: S. J. Clarke Publishing Company, 1908, vol. 1, pp. 596–616.

Williams, Melissa. "A Brief History of Art in Kansas City, 1860–1940." In Melissa Williams and Thomas McCormick, *American Paintings.* Columbia, Mo., 1984.

———. "Artists of Missouri." *Antique Review,* June 1986, pp. 23–25.

WPA. "Art and the Crafts." *Missouri: A Guide to the "Show Me" State,* pp. 167–77. New York: Duell, Sloan and Pearce, 1941.

Wuerpel, Edmund H. "Art Development in St. Louis." In *Encyclopedia of the History of St. Louis,* edited by William Hyde and Howard L. Conrad, vol. 1, pp. 43–53. New York, Louisville, and Saint Louis, 1899.

Zeiss, Harry L. "St. Louis Art at the Portland Exposition." *Brush and Pencil* 16 (September 1905): 73–81.

Nebraska

Art Gallery, Kearney State College. *A Survey of Nebraska Art.* Kearney, Nebr., 1978.

Bucklin, Clarissa, ed. *Nebraska Art and Artists.* Lincoln: School of Fine Arts, University of Nebraska, 1932.

Duryea, Joseph T. "Art in Omaha, Etc." In James W. Savage and John T. Bell, *History of the City of Omaha, Nebraska, and South Omaha,* pp. 449–54. New York, 1894.

Joslyn Art Museum. *The Lininger Era.* Omaha, 1972.

——— and Sheldon Memorial Art Galleries. *Nebraska Art Today: A Centennial Invitational Exhibition.* Omaha and Lincoln, Nebr., 1967.

Martin, Francis T. B. "Early Omaha Art Organizations and Activities." Typescript, 1953, Joslyn Art Museum, Omaha.

Nebraska Art Association (Haydon Art Club), Lincoln, U.S.A. Lincoln, Nebr., n.d. [after 1900].

Sheldon Memorial Art Gallery. *Art and Artists in Nebraska.* Essay by Norman A. Geske. Lincoln, Nebr., 1982.

Wells, Fred N. *The Nebraska Art Association: A History, 1888–1971.* Lincoln, Nebr., [1971?].

North Dakota

Barr, Paul E. *North Dakota Artists.* University of North Dakota Library Studies, no. 1. Grand Forks, N.D., 1954.

Robinson, Elwyn B. *History of North Dakota,* pp. 516–22. Lincoln: University of Nebraska Press, 1966.

State Historical Society of North Dakota. *North Dakota Artists.* Bismarck, n.d.

South Dakota

Allie, John. "The Coyote State Accounts for a Good Measure of Fine Art." *State College Dakotan* 4 (November 1959): 8–9, 11.

Cocking, Mar Gretta. *My-Story of Art in the Black Hills.* N.p., 1965.

McLoughlin, Nellie. *Art in South Dakota.* Brookings, S.D., [196?].

South Dakota Memorial Art Center. *The Art of South Dakota.* Essay by Joseph Stuart. Brookings, 1974.

———. *Other Times, Other Places.* Brookings, 1982.

South Dakota State College. *A Future for Art.* Brookings, 1956.

Stuart Joseph, ed. *Index of South Dakota Artists.* Brookings: South Dakota State University, 1974.

The Rocky Mountain West
General

Trenton, Patricia, and Peter H. Hassrick. "The Regional Scene." In *The Rocky Mountains,* pp. 297–315. Norman: University of Oklahoma Press, 1983.

Colorado

Adams, Charles Partridge. "The Art Situation in Denver." *Brush and Pencil* 2 (April 1898): 57–61.

Arvada Center for the Arts and Humanities. *Colorado Women in the Arts.* Essay by Katherine Smith Chafee. Arvada, Colo., 1979.

———. *Colorado Women Artists, 1859–1950.* Essay by Stanley L. Cuba. Arvada, Colo., 1989.

Bader, James H., and LeRoy R. Hafen. *History of Colorado,* pp. 1264–72. Denver: Linderman, 1927.

"Colorado's First Women Artists." *Denver Post, Empire Magazine,* May 6, 1979, pp. 36–47.

Colorado Springs Fine Arts Center. *Pikes Peak Vision: The Broadmoor Art Academy, 1919–1945.* Essays by Stanley L. Cuba and Elizabeth Cunningham. Colorado Springs, 1989.

Fine Arts Committee of the City Club of Denver. "Art in Denver." *Lookout* 1 (January 1928): 1–59.

Fisher, Theo Merrill. "The Broadmoor Art Academy, Colorado Springs." *American Magazine of Art* 11 (August 1920): 355–59.

Gallery Public Library. *The Denver Art Association: Its Past and Future, 1893–1919.* Denver, 1919.

Grove, R. "Notes on Art in Colorado Springs, 1820–1936." Typescript, 1958, Library, Colorado Springs Fine Arts Center.

Hagerman, Percy. "Notes on the History of the Broadmoor Art Academy and the Colorado Springs Fine Arts Center, 1919–1945." Typescript, n.d., library, Colorado Springs Fine Arts Center.

History of the City of Denver, Arapahoe County, and Colorado. Chicago, 1880.

Marturano, Mary Lou. "Artists and Organizations in Colorado." M.A. thesis, University of Denver, 1962.

McClurg, Gilbert. "Brush and Pencil in Early Colorado Springs." Western History Department, Denver Public Library. Typescript, from articles in the *Colorado Springs Gazette and Telegraph,* November 16–December 21, 1924.

McMechen, Edgar C. "Art, Drama, and Music." In *Colorado and Its People,* edited by Leroy R. Hafen. 2 vols. New York: Lewis Historical Publishing Company, 1948, vol. 2, pp. 419–41.

"Memo Re: Broadmoor Art Academy and Colorado Springs Fine Arts Center." Typescript, 1953, library, Colorado Springs Fine Arts Center.

Mills, John Harrison. "Letter Concerning Early Art in Colorado." Typescript, 1916, Western History Department, Denver Public Library.

Musick, Archie. *Musick Medley: Intimate Memories of a Rocky Mountain Art Colony* [Broadmoor Art Academy]. Colorado Springs, 1971.

Ormes, Manly Dayton, and Eleanor R. Ormes. *The Book of Colorado Springs,* pp. 337–45. Colorado Springs: Dentan, 1933.

Shalkop, Robert L. *A Show of Color: One Hundred Years of Painting in the Pikes Peak Region.* Colorado Springs: Colorado Springs Fine Arts Center, 1971.

Sprague, Marshall. "Colorado Springs Fine Arts Center: Its Formative Years." In *Colorado Springs Fine Arts Center: A History and Selections from the Permanent Collections.* Colorado Springs: Colorado Springs Fine Arts Center, 1986.

Steinberg, N. P. "Colorado and New Mexico and Their Painters." *Palette and Chisel,* November 1931, p. 3.

Taylor, Bayard. *Colorado: A Summer Trip*, pp. 144–77. New York, 1867.

Trenton, Patricia Jean. "Prologue: Evolution of Colorado as a Mecca for Scenic Artists of the Nineteenth Century." In *Harvey Otis Young: The Lost Genius, 1840–1901*, pp.1–15. Denver: Denver Art Museum, 1975.

———. "The Evolution of Landscape Painting in Colorado, 1820–1900." Ph.D. diss., University of California, Los Angeles, 1980.

Trenton, Patricia, and Peter H. Hassrick. *The Rocky Mountains*. Norman: University of Oklahoma Press, 1983. Based, in part, on Trenton's "The Evolution of Landscape Painting in Colorado, 1820–1900" (Ph.D. diss., University of California, Los Angeles, 1980).

Idaho

Hart, Arthur. "Idaho Yesterdays." A series of articles that appeared in *Idaho Statesman* (Boise) in the late 1970s, dealing with the state's art.

Wilkinson, Augusta. "Art in Idaho." *American Magazine of Art* 18 (May 1925): 270–71.

Montana

"Editorial." *Rocky Mountain Magazine* 1 (December 1900): 210–33.

Malone, Michael P., and Richard B. Roeder. *Montana: A History of Two Centuries*, pp. 283–89. Seattle: University of Washington Press, 1976.

White, Marian A. "A Group of Clever and Original Painters in Montana." *Fine Arts Journal* 16 (February 1905): 70–92.

Yellowstone Art Center. *Art and Illustration of Nineteenth-Century Montana*. Essay by C. Adrian Heidenreich. Billings, Mont., 1976.

———. *Montana Landscape: One Hundred Years*. Essay by C. Adrian Heidenreich and Virginia L. Heidenrich. Billings, Mont., 1982.

Utah

Bradley, Martha Elizabeth, and Lowell M. Durham, Jr. "John Hafen and the Art Missionaries." *Journal of Mormon History* 12 (1985): 91–105.

Carter, Kate B. "Early Arts and Crafts of the West." In *Heart Throbs of the West*, vol. 2, pp. 463–75. Salt Lake City: Daughters of Utah Pioneers, 1940.

Culmer, Henry L. A. "The Scenic Glories of Utah." *Western Monthly* 9 (January[?] 1909): 34–41.

Daughters of Utah Pioneers. *Utah Art Exhibition*. Salt Lake City, 1966.

Haseltine, James L. "One Hundred Years of Utah Painting: Some Further Thoughts." *Utah Architect* 40 (Winter 1965–66): 15–18.

Horne, Alice Merrill. *Devotees and Their Shrines: A Handbook of Utah Art*. Salt Lake City: Deseret News, 1914.

Huntington, Mae. "An Investment in Culture."

Improvement Era 35 (April 1932): 336–39.

James, George Wharton. *Utah, Land of Blossoming Valleys*, pp. 288–307. Boston: Page Company, 1922.

Kaysville Art Club. *Pioneers of Utah Art*. Logan, Utah: Educational Printing Service, 1968.

Larsen, B. F. "Random Thoughts on Utah Art." *Scratch* 3 (December 1930): 9–10, 28.

Leek, Thomas A. "A Circumspection of Ten Formulators of Early Utah Art History." M.A. thesis, Brigham Young University, Provo, Utah, 1961.

Mulder, William. *Homeward to Zion*. Minneapolis: University of Minnesota Press, 1957.

Museum of Church History and Art, the Church of Jesus Christ of Latter-day Saints. *Masterworks from the Collection of the Church of Jesus Christ of Latter-day Saints*. Essay by Linda Jones Gibbs. Salt Lake City, 1984.

———. *Harvesting the Light: The Paris Art Mission and Beginnings of Utah Impressionism*. Essay by Linda Jones Gibbs. Salt Lake City, 1987.

O'Brien, Terry John. "A Study of the Effect of Color in the Utah Temple Murals." M.A. thesis, Brigham Young University, Provo, Utah, 1968.

Olpin, Robert S. *Dictionary of Utah Art*. Salt Lake City: Salt Lake Art Center, 1980.

Reynolds, Alice Louise. "Art in Utah in Pioneer Days." In *Women of the West*, edited by Max Binheim, pp. 170–71. Los Angeles, 1928.

"Roster of Utah Artists." *Utah Educational Review* 18 (May 1925): 387.

Salt Lake Art Center. *One Hundred Years of Utah Painting*. Essay by James L. Haseltine. Salt Lake City, 1965.

Seifrit, William C. "Letters from Paris." *Utah Historical Quarterly* 54 (Spring 1986): 179–202.

Smith, Mary. "Utah Artists." Typescript, n.d., Utah State Historical Society.

Springville High School Art Gallery. *Permanent Gallery Catalogue, 1947*, compiled by Mae Huntington. Springville, Utah, 1947.

Springville Museum of Art. *Collectors of Early Utah Art*. Springville, Utah, 1983.

———. *Women Artists of Utah*. Essays by Vern G. Swanson and Judith McConkie. Springville, Utah, 1984.

———. *Image of the Artist: Self-Portraits and Portraits of Utah Artists*. Essay by Vern G. Swanson. Springville, Utah, 1986.

Talmadge, James E. *The House of the Lord*. Salt Lake City, 1912.

Tullidge, Edward W. "Art and Artists in Utah." *Tullidge's Quarterly Magazine* 1 (January 1881): 213–20.

———. *History of Salt Lake City*, pp. 810–18. Salt Lake City, 1886.

"Utah Artists in Paris." *Deseret Weekly* 39 (August 10, 1889): 293.

Winters, Nathan. "Pioneer Art and Artists." In *An Enduring Legacy*, vol. 7, pp. 233–72. Salt Lake City: Daughters of Utah Pioneers, 1984.

Writers' Program of the Works Projects Admin-

istration. *Utah: A Guide to the State*, pp. 153–87. New York: Hastings House, 1941.

Young, Levi Edgar. *The Founding of Utah*, pp. 361–65. New York: Charles Scribner's Sons, 1923.

Young, Mahonri Sharp. "Mormon Art and Architecture." *Art in America* 58 (May–June 1970): 66–69.

Wyoming

Barr, Maurice Grant. "Art Trails of Frontier Wyoming." M.A. thesis, University of Wyoming, Laramie, 1956.

Dieterich, H. R., and Jacqueline Petravage. "New Deal Art in Wyoming." *Annals of Wyoming* 45 (Spring 1973): 53–67.

Lawson, T. A. *History of Wyoming*, pp. 602–5. Lincoln: University of Nebraska Press, 1978.

Nottage, James H. "A Centennial History of Artist Activity in Wyoming, 1837–1937." *Annals of Wyoming* 48 (Spring 1976): 77–100.

University of Wyoming Art Museum. *One Hundred Years of Artist Activity in Wyoming, 1837–1937*. Laramie, 1976.

Wills, Oliver. "Artists of Wyoming." *Annals of Wyoming* 9 (October 1932): 688–714.

The Southwest
General

"Artists of Santa Fe." *American Heritage* 27 (February 1976): 57–72.

Hewett, Edgar L. "Recent Southwest Art." *Art and Archaeology* 9 (January 1920): 30–48.

Hogue, Alexander. "Protest and Comment: Errors in 'Art in the Southwest.'" *Southwest Review* 13 (October 1926): 75–76.

Lummis, Charles F. "The Artist's Paradise." *Out West* 28 (June 1980): 437–51; 29 (September 1908): 173–91.

Maxwell, Everett Carroll. "Genre and Figure Painters of the Southwest." *Fine Arts Journal* 24 (April 1911).

———. "The 'Great Southwest' as the Painters of that Region See It." *Craftsman* 20 (June 1911): 263–71.

Mowat, Jean. "The Artist in the Southwest." *El Palacio* 20 (May 1926): 194–200.

Murray, Marion. "Art in the Southwest." *Southwest Review* 12 (July 1926): 281–93.

Pearce, T. M. "Southwestern Culture: An Artificial or a Natural Growth?" *New Mexico Quarterly* 1 (August 1931): 195–209.

Phoenix Art Museum. *An Exhibition of Paintings of the Southwest from the Santa Fe Railway Collection*. 1966.

———. *Art of Arizona and the Southwest*. 1975.

Sandzén, Birger. "The Southwest as a Sketching Ground." *Fine Arts Journal* 33 (August 1915): 335–52.

"Sculptors of the Southwest: Their Inspiration and Their Achievement." *Craftsman* 28 (May 1915): 150–55.

Smith, Henry. "A Note on the Southwest."

Southwest Review 14 (Spring 1929): 267–78.

University of Arizona Museum of Art. *The New Deal in the Southwest.* Essay by Peter Bermingham. Tucson, 1980.

Wynn, Dudley. "The Southwestern Regional Straddle." *New Mexico Quarterly* 5 (February 1935): 7–14.

Arizona

Chase, Katherin L. "Brushstrokes on the Plateau: An Overview of Anglo Art on the Colorado Plateau." *Plateau* 56, no. 1 (1984): 1–33.

Cincinnati Art Museum. *Exhibition of Paintings of the Grand Canyon of Arizona by a Group of Contemporary American Painters.* 1912.

DuBose, Doris. "Art and Artists in Arizona, 1847–1912." M.A. thesis, Arizona State University, Tempe, 1974.

Mesa Southwest Museum. *Capturing the Canyon Artists in the Grand Canyon.* Essay by Holly Mitchem. Mesa, Ariz., 1987.

Noble, May. "Arizona Artists." *Arizona Teacher and Home Journal* 11 (February 1923): 7–10.

Phoenix Art Museum. *Art of Arizona and the Southwest: Paintings from the Collections of the Santa Fe Industries, Inc.* 1975.

———. *Visitors of Arizona, 1846 to 1980.* Essays by James K. Ballinger and Andrea D. Rubinstein. 1980.

New Mexico

Adams, Kenneth M. "Los Ocho Pintores." *New Mexico Quarterly* 21 (Summer 1951): 146–52.

"Artists of Santa Fe." *American Heritage* 27 (February 1976): 57–72.

Bickerstaff, Laura. *Pioneer Artists of Taos.* Denver: Sage Books, 1955. Rev. ed. Denver: Old West, 1983.

Black, Dorothy Skousen. "A Study of Taos as an Art Colony and of Representative Taos Painters." M.A. thesis, University of New Mexico, Albuquerque, 1959.

Blumenschein, Ernest L. "The Taos Society of Artists." *American Magazine of Art* 8 (September 1917): 445–51.

———. "Origins of the Taos Art Colony." *El Palacio* 20 (May 15, 1926): 190–93.

Blumenschein, Helen Greene. *Sangre de Cristo: A Short Illustrated History of Taos.* Taos, N.M.: Taos News, 1963.

Booth, Mary Witter. "The Taos Art Colony." *El Palacio* 53 (November 1946): 318–23.

Broder, Patricia Janis. *Taos: A Painter's Dream.* Boston: New York Graphic Society, 1980.

———. *The American West: The Modern Vision.* Boston: New York Graphic Society, 1984.

Bryant, Keith L., Jr. "The Atchison, Topeka and Santa Fe Railway and the Development of the Taos and Santa Fe Art Colonies." *Western Historical Quarterly* 9 (October 1978): 436–53.

Cassidy, Ina Sizer. "Art and Artists of New Mexico." *New Mexico* 10–12 (April 1932–September 1934).

———. "Art in Santa Fe." In *This Is Santa Fe,* edited and published by Charles Haines Comfort and Mary Apolline Comfort, pp. 53–65. Santa Fe, 1955.

Coke, Van Deren. "Taos and Santa Fe." *Art in America* 51 (October 1963): 44–47.

———. "Why Artists Came to New Mexico." *Artnews* 73 (January 1974): 22–24.

Colorado Springs Fine Arts Center. *Taos Painting—Yesterday and Today.* Colorado Springs, 1952.

Crawford, R. P. "Discovering a Real American Art." *Scribner's Magazine* 73 (March 1923): 380–84.

Denver Art Museum. *Picturesque Images from Taos and Santa Fe.* Essay by Patricia Trenton. 1974.

Dunton, Herbert W. "The Painters of Taos." *American Magazine of Art* 13 (August 1922): 247–52.

Edgerton, Giles (Mary Fanton Roberts). "A Group of Brilliant New Mexico Painters." *Arts and Decoration* 20 (December 1923): 15, 64.

Eldredge, Charles C., Julie Schimmel, and William H. Truettner. *Art in New Mexico, 1900–1945: Paths to Taos and Santa Fe.* New York: Abbeville Press, 1986.

Fisher, Reginald, ed. and comp. *An Art Directory of New Mexico.* Santa Fe: Museum of New Mexico and School of American Research, 1947.

Gaither, James Mann. "A Return to the Village: A Study of Santa Fe and Taos, New Mexico, as Cultural Centers, 1900–1934." Ph.D. diss., University of Minnesota, Minneapolis, 1957.

Gerald Peters Gallery. *Sante Fe Art Colony, 1900–1942.* Essay by Sharyn Rohlfsen Udall. Santa Fe, N.M., 1987.

Gibson, Arrell Morgan. *The Santa Fe and Taos Colonies: Age of the Muses, 1900–1942.* Norman: University of Oklahoma Press, 1983.

Grant, Blanche C. "Richard H. Kern's Diary," "An Artist in Trouble," and "The Taos Art Colony." In *When Old Trails Were New: The Story of Taos,* pp. 116–41, 212–16, 254–71. New York: Press of the Pioneers, 1934.

Hewett, Edgar L. "Art in New Mexico." *El Palacio* 10 (June 15, 1921): 11–14.

———. *Representative Art and Artists of New Mexico.* Santa Fe: School of American Research, Museum of New Mexico, 1940.

Hogue, Alexander. "A New Gallery for Taos." *Southwest Review* 15 (Autumn 1929): 126–27.

Hunter, Mary. "Modern Painters of Santa Fe." *Southwest Review* 13 (April 1928): 401–6.

James, George Wharton. *New Mexico: The Land of the Delight Makers,* pp. 373–402. Boston: Page Publishers, c. 1920.

Jensen, A. N. "The Académie Julian and the Academic Tradition in Taos." *El Palacio* 79 (December 1973): 37–42.

Luhan, Mabel Dodge. "Taos—A Eulogy." *Creative Art* 9 (October 1931): 289–95.

———. *Taos and Its Artists.* New York: Duell, Sloan and Pearce, 1947.

———. "Paso por Aqui!" *New Mexico Quarterly* 21 (Summer 1951): 137–46.

McGinnis, John H. "Taos." *Southwest Review* 13 (October 1927): 36–47.

Mowat, Jean. "The Artist in the Southwest." *El Palacio* 20 (May 1926): 194–200.

Mozley, Loren. "The Taos Moderns." *Southwest Review* 14 (Spring 1929): 370–76.

Museum of Fine Arts, Santa Fe. *Handbook of the Collections, 1917–1974.* Albuquerque, N.M., 1974.

Nelson, Mary Carroll. *The Legendary Artists of Taos.* New York: Watson-Guptill, 1980.

———, Ted Egri, and Kit Egri. "The Pioneer Artists of Taos." *American Artist,* January 1978, entire issue.

Ortega, Joaquin, ed. *New Mexico Artists.* Albuquerque: University of New Mexico Press, 1952.

"Paintings of the Taos Society of Artists." *Art and Archaeology* 5 (January 1917).

Peixotto, Ernest. "The Taos Society of Artists." *Scribner's Magazine* 60 (August 1916): 257–60.

Pennington, J. "Taos—An Art Center on the Edge of the Desert." *Mentor* 12 (July 1925): 23–28.

Perry, Lawrence. "Rear Platform Impressions of the Southwest." *Scribner's* 65 (March 1919): 257–71.

"The Pioneer Artists of Taos." *American Scene* 3 (Fall 1960): 1–11.

Pollock, Duncan. "Artists of Taos and Santa Fe: From Zane Grey to the Tide of Modernism." *Artnews* 73 (January 1974): 13–21.

"Recent Paintings by the Santa Fe–Taos Art Colony in Pueblo Land." *El Palacio* 4 (April 1917): 81–95.

Reeve, Kay Aiken. "The Making of an American Place: The Development of Santa Fe and Taos, New Mexico, as an American Cultural Center, 1898–1942." Ph.D. diss., Texas A and M University, College Station, 1977.

———. *Santa Fe and Taos, 1898–1942: An American Cultural Center.* El Paso: Texas Western Press, 1982.

Ringe, Fred Hamilton. "Taos: A Unique Colony of Artists." *American Magazine of Art* 28 (September 1926): 447–53.

Robertson, Edna C. *Los Cinco Pintores.* Santa Fe: Museum of New Mexico, 1975.

———, and Sarah Nestor. *Artists of the Canyons and Caminos: Santa Fe, the Early Years.* Layton, Utah: Peregrine Smith, 1976.

Santa Fe New Mexican. *New Mexico Artists and Writers: A Celebration, 1940.* Reprint. Sante Fe, 1982.

Schwartz, Sanford. "When New York Went to New Mexico." *Art in America* 64 (July–August 1976): 92–97.

Steinberg, N. P. "Colorado and New Mexico and Their Painters." *Palette and Chisel* 8 (November 1931): 3.

Stuart, Evelyn Marie. "Taos and the Indian in Art." *Fine Arts Journal* 35 (May 1917): 341–50.

Taft, Robert. "Pictorial Record of the Old West: The Beginning of the Taos School." *Kan-*

sas Historical Quarterly 19 (August 1951): 247–53.

"This Place Called Taos." *American Scene* 15, no. 2 (1974): 2–18.

Twitchell, Ralph Emerson. *The Leading Facts of New Mexico History.* 5 vols. Cedar Rapids, Iowa: Torch Press, 1911–17, vol. 5, pp. 334–62.

Udall, Sharyn Rohlfsen. *Modernist Painting in New Mexico, 1913–1935.* Albuquerque: University of New Mexico Press, 1984.

University of New Mexico. *Taos and Santa Fe: The Artist's Environment, 1882–1942.* Essay by Van Deren Coke. Albuquerque, 1963.

Walter, Paul A. F. "The Sante Fe–Taos Art Movement." *Art and Archaeology* 4 (December 1916): 330–38.

Weber, David. "Our Museums: Active Cultural Centers." In *This Is Santa Fe,* edited and published by Charles Haines Comfort and Mary Apolline Comfort, pp. 66–71. Santa Fe, 1955.

White, Robert R. *The Taos Society of Artists.* Albuquerque: University of New Mexico Press, 1983.

Witt, David L. *The Taos Artists: A Historical Narrative and Biographical Dictionary.* Colorado Springs: Ewell Fine Art Publications, 1984.

The Pacific
General—The Northwest

Appleton, Marion Brymner, ed. *Who's Who in Northwest Art.* Seattle: Frank McCaffrey, 1941.

———. *Index of Pacific Northwest Portraits.* Seattle: University of Washington Press, 1972.

Hart, William S. "Eighteenth-Century Naval Artists on the Northwest Coast." *Alberta Historical Review* 17 (Summer 1969): 1–9.

Henry, John Frazier. *Early Maritime Artists of the Pacific Northwest Coast, 1741–1841.* Seattle: University of Washington Press, 1984.

Montana Historical Society. *An Art Perspective of the Historic Pacific Northwest.* Helena, 1863.

"The People and the Places of the Old Northwest Territory." *Antiques* 87 (March 1965): 302–9.

Portland Art Museum. *Early Days in the Northwest.* Portland, Oreg., 1959.

Seattle Art Museum. *Lewis and Clark's America: A Voyage of Discovery.* Essay by Willis F. Woods. 1976.

State Capitol Museum. *Pacific Northwest Art Heritage.* Olympia, Wash., 1971.

Washington State Historical Society. *Northwest History in Art, 1778–1963.* Tacoma, 1963.

———. *Exploration Northwest.* Tacoma, 1969.

White, Marion. "Art in the Northwest." In *The Souvenir of Western Women,* edited by Mary Osborn Douthit, p. 196. Portland, Oreg., 1905.

General—The West

"The Art Boom in the West." *Collector* 1 (September 1, 1890): 152.

"Artist Colonies of the Far West." *Brooklyn Museum Quarterly* 13 (October 1926): 125–28.

Austin, Mary. "Art Influence in the West." *Century* 89 (April 1915): 829–33.

Babcock Galleries. "Paintings of the West." *El Palacio* 8 (July 1920): 231–44.

Binheim, Max, ed. *Women of the West.* Los Angeles: Publishers Press, 1928.

Birmingham Museum of Art. *Art of the American West.* Birmingham, Ala., 1983.

Broder, Patrica Janis. *The American West.* Boston: Little, Brown, 1984.

City Art Museum of Saint Louis. *Westward the Way.* Essays by Perry T. Rathbone. 1954.

Condit, Ida M. "Art Conditions in Chicago and Other Western Cities." *Brush and Pencil* 4 (April 1899): 7–11.

Dawdy, Doris Ostrander. *Artists of the American West.* 3 vols. Chicago: Swallow Press and Ohio University Press, 1974–85.

Fine Arts Museum of New Mexico. *The Artist in the American West, 1800–1900.* Santa Fe, 1961.

Hutchins, Will. "The Painters of the Far West." *Trend* 6 (January 1914): 729–36.

Kovinick, Phil, and Gloria Ricci Lothrop. "Women Artists: The American Frontier." *Artnews* 75 (December 1976): 74–76.

Los Angeles County Museum of Art. *The American West.* Essay by Larry Curry. 1972.

Maxwell, Everett Carroll. "The Structure of Western Art." In *California's Magazine.* 2 vols. San Francisco, 1916, vol. 1, pp. 33–37.

———. "The Value of Western Art." *Overland Monthly* 90 (September 1932): 263–64.

Mechlin, Leila. "The Awakening of the West in Art." *Century* 81 (November 1910): 75–80.

Muckenthaler Cultural Center. *The Woman Artist in the American West, 1860–1960.* Essay by Phil Kovinick. Fullerton, Calif., 1976.

Samuels, Peggy, and Harold Samuels. *The Illustrated Biographical Encyclopedia of Artists of the American West.* Garden City, N.Y.: Doubleday, 1976.

Southwest Arts Foundation. *Art of the American West.* Houston, 1982.

Taft, Robert. *Artists and Illustrators of the Old West, 1850–1900.* New York: Charles Scribner's, 1953.

Teall, Gardner. "Our Western Painters: What Chicago Is Doing toward the Development of a Vital National Spirit in American Art." *Craftsman* 15 (November 1908): 139–53.

Thomas, Phillip Drennon. "The Art and Artists of the American West." *Journal of American Culture* 3 (Summer 1980): 389–406.

University of Southern California Art Galleries. *Pack-in Painters of the American West.* Essay by Donald Brewer. Los Angeles, 1976.

California

"Art Department." In *Final Report of the California World's Fair Commission . . . Chicago, 1893,* pp. 53–55, 125–27, 168–70. Sacramento, 1894.

Art in California: A Survey of American Art with Special Reference to California Painting, Sculpture and Architecture, Past and Present, Particularly as Those Arts Were Represented at the Panama-Pacific International Exposition. Essays by Bruce Porter et al. San Francisco, 1916. Also published as *De Luxe Edition of California's Magazine.* 2 vols. San Francisco: California's Magazine Company, 1916.

Austin, C. P. "The California Art Club." *Out West* 2 (December 1911): 3–11.

Austin, Mary. "Art Influence in the West." *Century* 89 (April 1915): 829–33.

Avery, Benjamin Parke. "Art Beginnings on the Pacific." *Overland Monthly* 1 (July 1868): 28–34; (August 1868); 113–19.

———. "Art in California." *Aldine* 7 (April 1874): 72–73.

Baird, Joseph Armstrong, comp. *Catalogue of Original Paintings, Drawings and Watercolors in the Robert B. Honeyman, Jr., Collection.* Berkeley: Friends of the Bancroft Library, University of California, 1968.

———, ed. *Theodore Wores and the Beginning of Internationalism in Northern California Painting, 1874–1915.* Davis: Library Associates, University Library, University of California, 1978.

——— and Ellen Schwartz. *Northern California Art: An Interpretive Bibliography to 1915.* Davis: Library Associates, University Library, University of California, 1977.

Bartlett, William C. "Literature and Art in California: A Quarter-Centennial Review." *Overland Monthly* 15 (December 1875): 533–46.

Bennett, John. "Some Artists of California." *Art Interchange* 38 (December 1895): 122–26.

Berry, Rose V. S. "California and Some California Painters." *American Magazine of Art* 15 (June 1924): 279–91.

Blanch, Josephine M. "The Del Monte Art Gallery." *Art and Progress* 5 (September 1914): 387–92.

Boas, Nancy. *The Society of Six: California Colorists.* San Francisco: Bedford Arts, 1988.

Boeringer, Pierre N. "Some San Francisco Illustrators: Curbstone Bohemia." *Overland Monthly* 26 (July 1895): 70–90.

Boettger, Suzaan. "The Art History of San Diego to ca. 1935." Seminar paper, Graduate School of the City University of New York, January 1986.

Breitweiser, Gary. "Art in Santa Barbara: A Brief History." Typescript, Santa Barbara. 1982.

Brown, Benjamin Chambers. "The Beginnings of Art in Los Angeles." *California Southland* 6 (January 1924): 7–8.

Burlingame, Margaret R. "The Laguna Beach Group." *American Magazine of Art* 24 (April 1932): 259–66.

"California Artists." *Wasp*, December 23, 1911, pp. 21–23.

California Arts Commission. *Horizon: A Century of California Landscape Painting.* Sacramento, 1970.

California Historical Society. *Pictorial Treasures.* San Francisco, 1956.

———. *Louis Sloss, Jr., Collection of California Paintings.* Essay by Jean Martin. San Francisco, 1958.

———. *California Painters Abroad.* San Francisco, 1963.

———. *Artist-Teachers and Pupils: San Francisco Art Association and California School of Design: The First Fifty Years, 1871–1921.* Essay by Kent L. Seavey. San Francisco, 1971.

California's Magazine. 2 vols. San Francisco, 1916.

California Society of Miniature Painters. Art Biographies. N.p., [1924–25?].

Carmel Museum of Art. *Del Monte Revisited.* Essay by Betty Lochrie Hoag. Carmel, Calif., 1969.

Cleland, Robert Glass. "California: The Spanish-Mexican Period." *Antiques* 64 (November 1953): 367–73.

Coan, Helen E. "Art in Southern California: A Few Notes." In "Art and Music in California," *News Notes of California Libraries* (California State Library) 3 (January–October 1908): 3–29.

Cole, George Watson. "Missions and Mission Pictures: A Contribution towards an Iconography of the Franciscan Missions of California." *News Notes of California Libraries* 5 (July 1910): 390–412.

Comstock, Sophia P. "Painters of Northern California." Paper presented at the Kingsley Art Club, Sacramento, March 15, 1909. Typescript, California State Library, Sacramento.

Crocker Art Museum. *From Exposition to Exposition: Progressive and Conservative Northern California Painting, 1915–1939,* edited by Joseph Armstrong Baird. Sacramento, 1981.

Crocker-Citizens National Bank. *A Century of California Painting, 1870–1970.* Essay by Joseph A. Baird. Los Angeles, 1970.

Culmer, H.L.A. "The Artist in Monterey." *Overland Monthly* 34 (December 1899): 514–24.

Cutter, Donald C. "Artists and Art from California." In *Malaspina in California,* pp. 11–24. San Francisco: J. Howell, 1960.

Davis Art Center, University of California. *Sacramento Valley Landscapes,* edited by L. Price Amerson, Jr. Davis, 1979.

"Days Gone By, Norton Bush Recalls Them." *San Francisco Chronicle,* July 14, 1889.

De Saisset Art Gallery and Museum, University of Santa Clara. *New Deal Art: California.* Essay by Charles Shere. Santa Clara, Calif., 1976.

"Directory of California Artists, Craftsmen, Designers and Art Teachers." *California Arts and Architecture* 42 (December 1932): i–xv.

Donovan, Ellen Dwyer. "California Artists and Their Work." *Overland Monthly* 51 (January 1908): 25–33.

Donovan, Percy Vincent. "The Western Ideal." *Sunset* 16 (February 1906): 379–81.

Downes, William Howe. "California for the Landscape Painter." *American Magazine of Art* 11 (December 1920): 491–502.

E. B. Crocker Art Gallery. *California Painters, 1860–1960.* Sacramento, Calif., 1965.

Evans, Elliott A. P. "A Catalogue of the Picture Collections of the Society of California Pioneers." *Society of California Pioneers,* 1955, pp. 11–39.

Fletcher, Robert H. "Memorandum of Artists." Manuscript, 1906, California State Library, Sacramento.

———. "The Progress of Art in California." In "Art and Music in California," *News Notes of California Libraries* (California State Library) 3 (January–October 1908): 3–29.

———, ed. *The Annals of the Bohemian Club.* 5 vols. San Francisco, 1898–1972.

Frash, Robert M. "Impressionistic Challenge: A Regional Response to the Painters of Laguna Beach, 1900–1940." *California History* 63 (Summer 1984): 252–55.

Fresno Arts Center. *Views of Yosemite: The Last Stance of the Romantic Landscape.* Essay by Joseph Armstrong Baird, Jr. Fresno, Calif., 1982.

Gelber, Steven M. "Working to Prosperity: California's New Deal Murals." *California History: The Magazine of the California Historical Society* 58, no. 2 (1979): 98–127.

Golden Gate International Exposition, Palace of Fine Arts. *California Art in Retrospect—1850–1915.* San Francisco, 1940.

Hailey, Gene, ed. *California Art Research,* 20 vols. San Francisco: Federal WPA Project, 1937.

Hall, Kate Montague. "The Mark Hopkins Institute of Art." *Overland Monthly* 30 (December 1897): 539–48.

Hart, Ann Clark. *Clark's Point: A Narrative of the Conquest of California and of the Beginning of San Francisco,* pp. 37–47. San Francisco: Pioneer Press, 1937.

Higgins, Winifred Haines. "Art Collecting in the Los Angeles Area, 1910–1960." Ph.D. diss., University of California, Los Angeles, 1963.

Hills, Anna A. "The Laguna Beach Art Association." *American Magazine of Art* 10 (October 1919): 458–63.

Hittell, John S. "Art in San Francisco." *Pacific Monthly* 10 (July 1863): 99–111.

Housh, Henrietta. "California, the Mecca for the Landscapist." *Out West* 41 (March 1915): 119–21.

Howe, Thomas Carr, Jr. "California Art Today and Yesterday." *Artnews* 38 (July 13, 1940): 15–16, 24.

Howell, Warren R. "Pictorial California." *Antiques* 65 (January 1954): 62–65.

Hughes, Edan Milton. *Artists in California, 1786–1940.* San Francisco: Hughes Publishing Company, 1986.

Irwin, E. P. "San Francisco Women Who Have Achieved Success." *Overland Monthly and Out West Magazine* 44 (November 1904): 512–20.

James, Eleanor Minturn. "Sculptors of Pasadena." *American Magazine of Art* 22 (April 1931): 290–94.

Judah L. Magnes Museum, Berkeley, and Temple Emanu-El Museum, San Francisco. *The Creative Frontier: A Joint Exhibition of Five California Jewish Artists, 1850–1928.* Berkeley and San Francisco, 1975.

Judson, W. L. "Early Art in California." *Annual Publication of the Historical Society of Southern California and of the Pioneers of Los Angeles County* 5, part 3 (1902): 215–16.

Kahn, Gerrie E. "Images of the California Landscape, 1850–1916, Highlighting the Collection of the California Historical Society." *California History* 60 (Winter 1981–82): 318–31.

Kamerling, Bruce. "Theosophy and Symbolist Art: The Point Loma Art School." *Journal of San Diego History* 26 (Fall 1980): 231–55.

———. "The Start of Professionalism: Three Early San Diego Artists." *Journal of San Diego History* 30 (Fall 1984): 241–51.

———. "Painting Ladies: Some Early San Diego Women Artists." *Journal of San Diego History* 32 (Summer 1986): 147–91.

Keeler, Charles. "California's Painters, Poets, Sculptors and Fiction Writers That Have Won for Her Undying World-wide Fame." *New York World,* March 20, 1904, magazine section, pp. 4–5.

Kirk, Chauncey A. "Bohemian Rendezvous: Nineteenth-Century Monterey: Sanctuary and Inspiration for Early Western Artists." *American West* 16 (November–December 1979): 34–44.

Korb, Edward L. *A Biographical Index to California and Western Artists.* Lawndale, Calif.: DeRu's Fine Arts, 1983.

Laguna Art Museum. *Early Artists in Laguna Beach: The Impressionists.* Essays by Janet B. Dominik and Jean Stern. Laguna Beach, Calif., 1986.

——— and Saddleback College Art Gallery. *Reaching the Summit: Mountain Landscapes in Southern California, 1900–1986.* Essays by Phil Kovinick and Lynn Gamwell. Laguna Beach, Calif., 1986.

Laguna Beach Art Association. *Fiftieth Anniversary History and Catalogue, 1918–1968.* Essay by Tom K. Enman. Laguna Beach, Calif., 1968.

Laguna Beach Museum of Art. *Southern California Artists, 1890–1940.* Essay by Nancy Moure. Laguna Beach, Calif., 1979.

———. *Drawings and Illustrations by Southern California Artists before 1950.* Essays by Nancy Dustin Wall Moure, Norman Neuerburg, Herbert Ryman, and Susan Ehrlich. Laguna Beach, Calif., 1982.

Larsen, Hanna Astrup. "California Landscapes in Which the Vigor and Wild Beauty of the Golden State Are Manifest." *Craftsman* 16 (September 1909): 630–37.

Latimer, L. P. "The Redwood and the Artist." *Overland Monthly* 32 (October 1898): 354–56.

Lloyd, Benjamin E. *Lights and Shades of San Francisco*, pp. 414–19. San Francisco, 1876.

Los Angeles County Museum. *California Centennials Exhibition of Art*. Essay by Arthur Woodword. Los Angeles, 1949.

Los Angeles County Museum of Art. *Los Angeles Prints, 1883–1980*. Essays by Ebria Feinblatt and Bruce Davis. Los Angeles, 1980.

———. *Painting and Sculpture in Los Angeles, 1900–1945*. Essay by Nancy Dustin Wall Moure. Los Angeles, 1980.

Lytle, Rebecca Elizabeth. "People and Places: Images of Nineteenth-Century San Diego." M.A. thesis, San Diego State University, 1978.

———. "People and Places: Images of Nineteenth-Century San Diego in Lithographs and Paintings." *Journal of San Diego History* 24 (Spring 1978): 153–71.

Mansion. *Member's Choice: Exhibition of California Paintings Lent by Members from Their Private Collections*. San Francisco, 1965.

Marquis, Neeta. "Laguna: Art Colony of the Southwest." *International Studio* 70 (March 1920): xxvi–xxvii.

Mary Porter Sesnon Art Gallery, University of California, Santa Cruz. *Plein Air Paintings: Landscapes and Seascapes from Santa Cruz to the Carmel Highlands, 1898–1940*. Essay by Terry St. John. 1985.

Masterworks of California Impressionism: The FFCA, Morton H. Fleischer Collection. Phoenix: FFCA Publishing, 1986.

Maxwell, Everett Carroll. "Development of Landscape Painting in California." *Fine Arts Journal* 34 (March 1916): 138–42.

Maxwell Galleries. *A Woman's Vision: California Painting into the Twentieth Century*. Essay by Raymond L. Wilson. San Francisco, 1983.

Men of California: 1900 to 1902, pp. 258–65. San Francisco: Western Press Reporter, 1901.

Millier, Arthur H. "California's Etchers." *California Southland* 42 (June 1923): 12–13.

———. "The Art Temperaments of Northern and Southern California Compared." *Argus* 1 (August 1927): 32.

———. "Growth of Art in California." In Taylor, Frank J., *Land of Homes*, pp. 311–41. Los Angeles, 1929.

———. "New Developments in Southern California Painting." *American Magazine of Art* 27 (May 1934): 241–47.

Miner, Frederick Roland. "California—the Landscapist Land of Heart's Desire." *Western Art* 1 (June–August 1914): 31–35.

Mission San Francisco Solano de Sonoma. *A Selection of American Paintings by Artists of the Nineteenth Century Working in Northern California*. Sonoma, Calif., 1976.

Monterey Peninsula Museum of Art. *Yesterday's Artists on the Monterey Peninsula*. Essay by Helen Spangenberg. Monterey, Calif., 1976.

———. *Monterey: The Artist's View, 1925–1945*. Essay by Kent Seavey. Monterey, Calif., 1982.

Montgomery Gallery, Pomona College. *Myth and Grandeur: California Landscapes, 1864–1900*. Essay by Kay Koeninger. Claremont, Calif., 1987.

Moure, Nancy Dustin Wall. *The California Water Color Society: Prize Winners, 1931–1945; Index to Exhibitions, 1921–1954*. Los Angeles: Privately printed, 1975.

———. *Dictionary of Art and Artists in Southern California before 1930*. Glendale, Calif.: Dustin Publications, 1975.

——— and Phyllis Moure. *Artists' Clubs and Exhibitions in Los Angeles before 1930*. Los Angeles: Privately printed, 1975.

Mulford, Henry, "History of the San Francisco Art Institute." *San Francisco Art Institute Alumni Newsletter*, 7 parts, May 1978–Spring 1980.

Murtha, N. L. "The Sketch Club: 'Art for Art's Sake' " [in San Francisco]. *Overland Monthly* 29 (June 1897): 577–90.

Neuerburg, Norman. "The Old Missions: A Popular Theme in Southern California Art before 1900." In *Drawings and Illustrations by Southern California Artists before 1950*, pp. 32–37. Laguna Beach, Calif.: Laguna Beach Museum of Art, 1982.

Newport Harbor Art Museum. *California: The State of Landscape, 1872–1981*. Essay by Betty Turnbull. 1981.

Oakland Museum. *The California Collection of William and Zelma Bowser*. Oakland, Calif., 1970.

———. *Tropical: Tropical Scenes by the Nineteenth-Century Painters of California*. Essay by Marjorie Arkelian. Oakland, Calif., 1971.

———. *Society of Six*. Essay by Terry St. John. Oakland, Calif., 1972.

———. *The Kahn Collection of Nineteenth-Century Paintings by Artists in California*. Essay by Marjorie Arkelian. Oakland, Calif., 1975.

———. *Impressionism: The California View*. Essays by John Caldwell and Terry St. John. Oakland, Calif., 1981.

———. *One Hundred Years of California Sculpture*. Essays by Harvey L. Jones, Paul Tomidy, Terry St. John, and Christopher Knight. Oakland, Calif., 1982.

———. *The Art of California: Selected Works from the Collection of the Oakland Museum*. Oakland, Calif.: Oakland Museum Art Department; San Francisco: Chronicle Books, 1984.

———. *The Artists of California: A Group Portrait in Mixed Media*. Oakland, Calif., 1987.

Palm Springs Desert Museum. *California's Western Heritage*. Essay by Katherine Plake Hough. Palm Springs, Calif., 1986.

Pasadena Center. *California Design, 1910*. Essays by Robert W. Winter and Eudorah M. Moore. Pasadena, Calif., 1974.

Peters, Harry T. *California on Stone*. Garden City, N.Y.: Doran and Company, 1935.

Peters, Mary T. "The Lithographs of California." *Prints* 5 (March 1935): 1–9.

Petersen, Martin E. " 'Contemporary Artists of San Diego.' " *Journal of San Diego History* 16 (Fall 1970): 3–8.

Plagens, Peter. "Seventy Years of California Modernism in 340 Works by 200 Artists." *Art in America* 65 (May–June 1977): 63–69.

Pomona College Gallery. *Scenes of Grandeur: Nineteenth-Century Landscape Paintings of California*. Claremont, Calif., 1962.

———. *Painters of the Nineteen-Twenties*. Essay by Arthur Millier. Claremont, Calif., 1972.

Porter, Bruce. "Art and Architecture in California." In *History of California*, edited by Zoeth Skinner Eldredge. 5 vols. New York: Century History Company, 1915, vol. 5, pp. 461–84.

Pratt, Harry Noyes. "The Beginning of Etching in California." *Overland Monthly and Out West* 82 (March 1924): 114.

Ramsey, Merle, and Mabel Ramsey. *Pioneer Days of Laguna Beach*. Laguna Beach, Calif.: Hastie Printers, 1967.

Robertson, David. *West of Eden: A History of the Art and Literature of Yosemite*. Yosemite, Calif.: Yosemite Natural History Association, 1984.

Robinson, Charles Dormon. "Off the Cuff: The Artists of California." Typescript, n.d., collection of Dr. Joseph Armstrong Baird, Jr.

———. "A Revival of Art Interest in California." *Overland Monthly* 18 (June 1891): 52–56.

Robinson, W. W. "The Laguna Art Colony." *California Southland* 6 (July 1924): 10.

Rogers, R. C. "Art Patronage in California." *California Art Gallery* 1 (March 1873): 33.

Roorbach, Eloise J. "The Indigenous Art of California: Its Pioneer Spirit and Vigorous Growth." *Craftsman* 22 (August 1912): 289–496.

Ryan, Beatrice Judd. "The Rise of Modern Art in the Bay Area." *California Historical Society Quarterly* 38 (March 1959): 1–5.

San Diego Museum of Art. *The Golden Land*. Essay by Paul Chadbourne Mills. 1986.

San Francisco Museum of Modern Art. *Painting and Sculpture in California: The Modern Era*. Essay by Henry T. Hopkins. 1976.

San Jose Historical Museum. *Nineteenth-Century San Jose Portraits*. San Jose, Calif., 1978.

San Jose Museum of Art. *One Hundred Twenty Years of California Paintings, 1850–1970*. San Jose, Calif., 1971.

Santa Barbara Museum of Art. *California Pictorial, 1800–1900*. Essays by Paul Mills and Donald C. Biggs. Santa Barbara, Calif., 1962.

Santa Cruz City Museum. *Art and Artists in Santa Cruz: A Historic Survey*. Essay by Nikki Silva. Santa Cruz, Calif., 1973.

Schallert, Edwin. "The Future of Art in America." *West Coast Magazine* 10 (September 1911): 711–14.

Schwartz, Ellen. *Guide to the Baird Archive of California Art: University Library, University of California*. Davis: Department of Special Collections and Library Associates, University Library, University of California, 1979.

———. *Nineteenth-Century San Francisco Art Exhibition Catalogues: A Descriptive Checklist and Index*. Davis: Library Associates, University Library, University of California, 1981.

Seares, Mabel Urmy. "The Spirit of California Art." *Sunset* 23 (September 1909): 264–66.

———. "California as a Sketching Ground." *International Studio* 43 (April 1911): 121–32.

———. "The Art of Los Angeles." *Western Art* 1 (June–August 1914): 21–23.

———. "San Francisco's First Half-Century of Art." *Arts and Decoration* 4 (September 1914): 410–13.

———. "Modern Art and Southern California." *American Magazine of Art* 9 (December 1917): 58–64.

———. "A California School of Painters." *California Southland* 3 (February 1921): 10–11.

———. "California as Presented by Her Artists." *California Southland* 6 (June 1924): 7–13.

Selkinhaus, Jessie A. "The Laguna Beach Art Colony." *Touchstone* 8 (January 1920): 250–55.

———. "Etchers of California." *International Studio* 78 (February 1924): 383–91.

Semple, Elizabeth Anna. "Successful Californians in New York." *Overland Monthly* 60 (August 1912): 105–16.

Sheldon, Francis E. "Pioneer Illustration in California." *Overland Monthly* 11 (April 1888): 337–55.

———. "Some Western Caricature." *Overland Monthly* 11 (May 1888): 449–63.

Shuck, Oscar T., comp. "Science and Art." In *California Anthology; or, Striking Thoughts on Many Themes, Carefully Selected from California Writers and Speakers*, pp. 9–47. San Francisco: A. J. Leary, 1880.

Snipper, Martin. *A Survey of Art Work in the City and County of San Francisco.* San Francisco: Art Commission, City and County of San Francisco, 1975.

Splitter, Henry Winifred. "Art in Los Angeles before 1900." *Historical Society of Southern California Quarterly* 41 (March 1959): 38–57; (June 1959): 117–38; (September 1959): 247–56.

Stackpole, Ralph. "Decorative Sculpture in California." *Pacific Coast Architect* 13 (January 1917): 51–53.

Stanford Art Gallery. *California Landscape Painting, 1860–1885: Artists around Keith and Hill.* Essay by Dwight Miller. Stanford, Calif., 1975.

Taylor, Rose Schuster. "Early Artists in Yosemite." In *Yosemite Indians, and Other Sketches*, pp. 77–92. San Francisco: Johnck and Seeger, 1936.

Thiel, Yvonne Greer. *Artists and People.* New York: Philosophical Library, 1959.

Tilden, Douglas. "Art, and What California Should Do about Her." *Overland Monthly* 19 (May 1892): 509–15.

Titus, Aime Baxter. "Artists of San Diego County." *San Diego Magazine* 3 (September 1927): 11–12, 30.

Transamerica Corporation. *A Sense of Place: California Landscape Painting, 1870–1930.* San Francisco, 1978.

University Art Museum, California State University, Long Beach. *The Landscapes of William Wendt.* Essays by Constance W. Glenn, Diane M. Roe, Lynn O'Brien, and Patricia Colby-Hanks. 1989.

University of California, Davis. *From Frontier to Fire: California Painting from 1816 to 1906.* Edited by Joseph Armstrong Baird, Jr. 1964.

———. *Fifteen and Fifty: California Painting at the 1915 Panama-Pacific International Exposition, San Francisco on Its Fiftieth Anniversary.* Edited by Joseph Armstrong Baird, Jr. 1965.

———, Library. *France and California.* 1967.

Van Nostrand, Jeanne. *A Pictorial and Narrative History of Monterey, Adobe Capital of California, 1770–1847*, pp. 81–95. San Francisco: California Historical Society, 1968.

———. *San Francisco, 1806–1906, in Contemporary Paintings, Drawings and Watercolors.* San Francisco: Book Club of California, 1975.

———. *The First Hundred Years of Painting in California, 1775–1875.* San Francisco: J. Howell Books, 1980.

——— and Edith M. Coulter. *California Pictorial.* Berkeley and Los Angeles: University of California Press, 1948.

Vreeland, Francis William. "A New Art Centre for the Pacific Coast." *Arts and Decoration* 28 (November 1927): 64–65.

Westphal, Ruth Lilly. *Plein Air Painters of California: The Southland.* Irvine, Calif.: Westphal Publishing, 1982.

———, ed. *Plein Air Painters of California: The North.* Essays by Janet Blake Dominik, Harvey L. Jones, Betty Hoag McGlynn, Paul Chadbourne Mills, Martin E. Petersen, Terry St. John, Jean Stern, Jeffrey Stewart, and Raymond L. Wilson. Irvine, Calif.: Westphal Publishing, 1986.

Wilkinson, J. Warring. "Our Art Possibilities." *Overland Monthly* 2 (March 1869): 248–54.

Williamson Lyncoya Smith Memorial Gallery. *The Boggs Collection: Paintings by Artists in California.* Shasta State Historic Park, Calif., 1978.

Wilson, L. W. "Santa Barbara's Art Colony." *American Magazine of Art* 12 (December 1921): 411–14.

Wilson, Raymond L. "The First Art School in the West: The San Francisco Art Association's California School of Design." *American Art Journal* 14 (Winter 1982): 42–55.

———. "Painters of California's Silver Era." *American Art Journal* 16 (Autumn 1984): 71–92.

Hawaii

"Art and Artists in Hawaii." *Paradise of the Pacific*, May 1888, p. 6.

"Art in Hawaii." *Sales Builder*, December 1938, pp. 2–14.

Bernice Pauahi Bishop Museum. *Hawai'i: The Royal Isles.* Essay by Adrienne L. Kaeppler. Honolulu, 1980.

"Early Pacific Travellers." *Honolulu Academy of Arts News Bulletin and Calendar* 5 (February 1943): n.p.

Honolulu Academy of Arts. *Master Artists of Hawaii.* Honolulu, 1964.

Lyman House Memorial Museum. *Hilo, 1825–1925: A Century of Paintings and Drawings.* Essays by David W. Forbes and Thomas K. Kunichika. Hilo, Hawaii, 1984.

"Modern Art in Hawaii." *Paradise of the Pacific*, October 1897, pp. 149–50.

Newton, John Lee. *Image-makers of Hawaii.* N.p., n.d. [c. 1950]. Copy on file at Hawaii State Library, Honolulu.

Oregon

Burnside, Kathleen. "Regionalism in American Art: Oregon." Term paper, Graduate School of the City University of New York, January 1986.

Cleaver, Jack. "Oregon Women in the Arts." Curatorial offices, Oregon Historical Society, Portland.

Gleason, Norma Catherine, and Chet Orloff. *Portland's Public Art.* Portland: Press of the Oregon Historical Society, 1983.

Griffin, Rachel. "Portland and Its Environs." In *Art of the Pacific Northwest from the 1930s to the Present*, pp. 1–38. Washington, D.C.: National Collection of Fine Arts, 1974.

Museum of Art, University of Oregon. *Art of the Oregon Territory.* Essay by Franz R. Stenzal. Eugene, 1959.

"Other Oregon Artists of Note." *Fine Arts Journal* 15 (December 1904): 426–34.

Rasmussen, Louise. "Notes Re Art and Artists in Oregon from 1500 to 1900." 3 vols. Typescript, 1940, Oregon Historical Society, Portland.

———. "Artists of the Explorations Overland, 1840–1860." *Oregon Historical Quarterly* 43 (March 1942): 56–62.

Reyes, Karen Stone. "Examination of the Origins of Expositions: Portland and Vicinity from 1878 through 1905." Typescript, 1980, Oregon Historical Society, Portland.

White, Frank Ira. "Civic Art in Portland, Oregon." *Craftsman* 8 (September 1908): 796–803.

Willis, Adeline B. "Three Oregon Artists of the Late Nineties." Typescript, 1935, Oregon Historical Society, Portland.

Washington

"The Art Spirit in Seattle and How It Is Developing." *Seattle Post-Intelligencer*, April 14, 1907.

Ballard, Adele M. "Some Seattle Artists and Their Work." *Town Crier* 10 (December 18, 1915): 25–36.

Calhoun, Anne H. *A Seattle Heritage: The Fine Arts Society.* Seattle: Lowman and Hanford, 1942.

Dodds, Anita Galvan. "Women and Their Role in the Early Art of Seattle." M.A. thesis, University of Washington, Seattle, 1981.

Edwards, Jonathan. *An Illustrated History of Spokane County, State of Washington*, pp. 199–201. N.p., 1900.

Fidelity to Nature: Puget Sound Pioneer Artists, 1870–1915. Seattle: Museum of Science and Industry, 1984.

Hanford, Cornelius Holgate, ed. "Fine Arts." In *Seattle and Environs, 1852–1924*. 3 vols. Chicago: Pioneer Historical Publishing Company, 1924, vol. 1, pp. 630–55.

Kingsbury, Martha. "Seattle and the Puget Sound." In *Art of the Pacific Northwest from the 1930s to the Present*, pp. 39–92. Washington, D.C.: National Collection of Fine Arts, 1974.

Koping, Runar. "Art." In *Building a State: Washington, 1889–1939*, edited by Charles Miles and O. B. Sperlin, pp. 166–70. Tacoma: Washington State Historical Society Publications 3, 1940.

Museum of History and Industry. *The Regional Painters of Puget Sound, 1870–1920: A Half-Century of Fidelity to Nature*. Essays by William H. Gerdts and Erika Michael. Seattle, 1986.

Pierce, Mrs. Harry Paul, comp. *Roll of Artists of the State of Washington*. Snoqualmie Falls: Washington State Federation Women's Clubs, 1926.

Reed, Gervais. "A Chronology of Art: Seattle and Environs." Typescript, n.d., University of Washington, Seattle.

————. "Concerning the School of Art." In *Faculty Exhibition*. Seattle: Henry Gallery, University of Washington, 1966.

State Capitol Museum. *Two Centuries of Art in Washington, 1776–1976*. Olympia, Wash., 1976.

Stokes, Charlotte. "Patron and Patronage of the Arts: Seattle, 1851–1930." In *Henry Gallery/Five Decades*. Seattle: Henry Art Gallery, University of Washington, 1977.

Tilley, Erna Spannagel. "Random Impressions of Early Days in Tacoma: Fine Arts Interests in Early Days in Tacoma." Typescript, 1970, Washington State Historical Society, Tacoma.

Washington State Capital Museum. *Snowy Mountains: The Cascades as an Artistic Vision*. Essay by Susan J. Torntore. Olympia, Wash., 1987.

Washington State Historical Society. "Early Washington Communities in Art." *Pacific Northwest Historical Pamphlet*, no. 4 (December 1965).

White, Marian A. "Art in the State of Washington: Its Evolution and Promise." *Fine Arts Journal* 16 (January 1905): 2–13.

Index

Page numbers in italics refer to illustrations.
Cross-references to volumes 1 and 2 are included for states and for artists with illustrations in those volumes.

PHOTOGRAPHY CREDITS